目錄 Contents

序
道與技之間

林麗真 │ 國立台灣大學名譽教授、美國史丹佛大學訪問學人

「道」與「技」之間的關係,是討論哲學與藝術的重要課題。一件藝術作品能傳達出一種信念、一種思想、一種對於宇宙人生根本之學的反省與檢討,並藉著有形、有體、有色、有象的藝術型態表現出來,甚至達到「神乎其技」的境界,這絕對不只在乎一個藝術工作者的技術表現本身,更在乎其技背後所透顯出來的神理神思!這種神理神思,應是出自作者對宇宙真理、人群社會、個己生命中諸種課題的真實關懷和生命體認。若說道是技的所以然之理,技便是道的所然之跡;若說道是技的形上根據,技便是道的形下展現。觀看林珮淳教授的藝展,觸動了我對「道」與「技」之間的哲學省思,也被她的生命體認所感動;因為她的藝術作品好像是在講道、傳道,並揭開、引發又激盪起人們對科技文明的「迎/拒」情結,並非自然之人工景觀、人工生命的「實/幻」感受,以及對人生哲學課題的深思與反省⋯在科技與自然、人造與初創、破壞與開發、虛幻與真實、叛逆與敬虔、人本與神本⋯之間,這個世界將會流向何方?你我究該如何抉擇?

林珮淳教授自 1995 年獲得澳大利亞國立沃隆岡大學藝術創作博士學位後,即靈思泉湧又努力不懈地發表了許多藝術創作。她的創作蓋以「大自然與科技文明之間的對立關係」作為思考主軸,運用隱喻、諷刺、反襯等手法,透過科技符號與科技媒材以反科技,批判了人工、人造、非自然的虛擬假象,傳達出「回歸自然」的理念。她曾自我表白對於 21 世紀科技文明發展的憂思,說:「我從作品中不斷的對這種人造、人工、複製、數位、虛擬等文明產物與現象作批判,企圖透過廣告燈箱與輸出圖像,建構出各式各樣的人造美景,以模仿『都會文明』的那種艷麗與虛華,以及那種生硬、不自然的外表。這種反思、反諷的創作理念與手法則成為我從 1999 年至今的作品主軸。壓克力燈箱的發光體的確奪人目光,展出時受到許多觀眾喜愛,然而這正是我藉著作品試圖批判的意圖,因為它反射出都會人的心態——習慣於人造景觀而不自覺它的荒謬。人類似乎早已習慣於複製或模仿大自然,卻無法警覺到這種『人造物』已取代了真正的大自然。這類作品愈加吸引人就愈加印證人們對於人工假象的親切,也就更凸顯出我的創作理念:人類若不回歸大自然,若不走出文明的迷思,恐怕有朝一日,大自然只是一些數位的圖像、燈箱、虛擬影像⋯等所建構的假象,而人類真正賴以維生的大自然,其存在意義又將會如何呢?」林教授所發表的一系列「回歸大自然」的作品,的確相當成功地傳達了這個訊息。

尤自 2004 年起,林教授在「回歸大自然系列—人工生命」系列作品中發表《夏娃克隆I》與《捕捉》,特以 3D 影像及標本的形式虛擬人工的假生命,批判此種假生命可以任意被存檔、編碼、

變造或刪除的數位檔案。2007 年又以互動裝置發表《創造的虛擬》與《夏娃克隆 II》，建構虛擬的人蛹合體、人蝶合體等影像，直批人類所創造的虛幻生命何等遠離神的初創。2010 年後又繼續發表《夏娃克隆肖像》、《夏娃克隆手》、《夏娃克隆 III》、《透視夏娃克隆》、《量產夏娃克隆》與《夏娃克隆啟示錄》等作品，更將夏娃克隆的頭部與手部烙印上《聖經 · 啟示錄》所記載的 666 獸印，以人獸同體的邪惡意象，警惕科技文明所帶來的毀滅危機。

「夏娃克隆」肖像，美則美矣，但眼神中充滿著狐疑、不安、窺視、孤獨。此一肖像被放置在壓克力透明材質所製成的黑框中，仿若一具具死體的標本，但因眼神會隨著觀者的移動而轉動，於是又像是一具具活體。這樣的肖像彷若現代宅男宅女的形象，是美還是不美？「夏娃克隆」的手採用立體雕塑，手腕、手指的姿態均甚美麗，但卻蓋有 666 獸印，又被置放在醫學用罐中，猶如器官被存放在福馬林而處於被實驗的狀態。因此這一具具美麗的手，看起來卻相當恐怖，不但毫無生機，也極詭異。《夏娃克隆 III》則以六角環場大型互動投影裝置，呈現六個不同巨形的水中夏娃克隆臉部，隨著觀眾左右位移而控制臉部轉動的角度，夏娃克隆的眼神也隨之跟蹤。背景聲音則呈現水中的氛圍以及左右移動的聲響，觀眾在環繞六面投影的環場中，猶如置身於詭譎的環境中與巨形夏娃克隆進行對話，這便帶給觀眾反思科技文明的背後所暗藏的危機。在暗室中，這類作品所帶給人的震撼，是久久難以忘懷的！

林珮淳教授的作品的確會講道、會傳道。而其道之來源，則得自列國先知對《聖經》真理的開啟與講論，也得自新約教會對人類終極命運的關懷。林教授是一位敬神愛人的基督徒，她信耶和華神也信神所差來的先知；因此她的藝術思維，總不離人與造物主的關係問題，也不離文明與大自然的關係問題。在「夏娃克隆」系列中，更是嚴肅地省思到《聖經 · 啟示錄》中所預示的「神魔對決」的問題了。《聖經》說：「敬畏耶和華神是智慧的開端，認識至聖者便是聰明。」由於珮淳教授是一位敬畏神的聰明人，因此所揭舉的藝術思維課題，已觸及哲學和宗教的領域而引起國際藝術界的重視。她的藝術成就自不僅限於一時一地！

一、導論・論述
Introduction・Statement

導論

林珮淳

藝術是創造視覺，聽覺或表演等各種人類的活動，是表達作者的想像力，觀念、技術技能。藝術體系則包括作品的創造、藝術的批評與藝術史的研究。

本書是我個人近三十年的創作記錄，以及納編了近三十篇由國內外重要藝術史學家、評論家、策展人及教授學者們對我作品的研究與評論。他們從各種研究觀點與美學理論來剖析我的藝術，使我作品更具學術價值與影響力。而這些文章皆已在國內外重要藝術雜誌與專欄發表過，甚至有多篇已被國際知名藝術期刊與學術網站登刊且發行全球，令我非常的珍惜與佩服。希望透過此書來表達我對他們的謝意，也成為研究者、讀者及觀眾們在研究我作品時的重要參考文獻。

當然，因著年代已久或篇幅過大，以及人力與時間限制，仍有許多曾發表過的論述沒有收錄在此書，如：碩博士論文、教科書、藝術史書、研討會論文、策展論述、雜誌與書籍以及對我的訪談等，相當可惜。但幸運的是，本書納編有一篇文章《從林珮淳〈相對說畫〉系列探討女性主體意識中的互文與辯證》，作者許佩純有參考了眾多的文獻，如：陳瓊花教授的科技部研究《藝術、性別與教育：六位女性傳播者的生命圖像》；高美館委託張金玉教授的研究《台灣女性藝術大事紀年表譜建置計畫》；簡瑛瑛教授所指導的多篇博士論文；徐婉禎在《台灣當代美術通鑑》主寫的「藝術家 40 年：林珮淳〈夏娃克隆啟示錄〉（2011）焦點作品」；姜麗華與呂筱渝博士的研究《過程中的女性主體：台灣女性藝術家的陰性特質調查研究》等。另外，於 2015 年，在清華大學藝術中心賴小秋教授為我主辦的「啟示與警示—林珮淳創作研究展」時，已由我實驗室成員協助收集並掃描評論的圖版與出處，這些資料也將在本書的「文獻節錄」呈現以補上遺憾，但相信仍有許多的缺漏，在此先致上歉意。

由於我多數作品已在我之前幾本書冊出版過，本書將以近十年的「夏娃克隆系列」作品評論及圖版為主，其它系列為輔。因此，整個結構將以七大章節來作編輯：第一章是導論與我個人的一篇論述；第二章是全系列作品的圖版；第三章則收錄有評論到我「全系列」作品的文章，包含有探討到我「夏娃克隆系列」前系列的「女性詮釋系列」、「解構父權系列」及「回歸大自然系列」共六篇（作者：蕭瓊瑞、鄭芳和、葉謹睿、邱誌勇、賴小秋、郭冠英）。之後，則針對「回歸大自然系列」作品的評論共七篇（作者：石瑞仁、李美華、張惠蘭、曾鈺涓、馬肇石 Pierre Martin、康居易 Susan Kendzulak、陳香君）。第四章是論述「夏娃克隆系列」的八篇文章（作者：林宏璋、邱誌勇、陳明惠、曾鈺涓、吳介祥、安托列塔·伊凡諾娃 Antoanetta Ivanova、蘇珊娜·斐爾茲·陶德 Susana Perez Tort、潘正育）；第五章是「夏娃克隆創造計畫」

三篇的論述（作者：陳明惠、林宏璋、邱誌勇）；第六章是全英文評論共二十一篇；最後一章則是「林珮淳創作生涯與作品研究節錄」，包含許佩純的碩士論文摘錄與曾燕玲發表於英國牛津大學的研討會文章，以及我實驗室所整理的「文獻節錄」、「報導與評論」等。因此，此書不只是我的作品集，更是集眾多評論與研究觀點所匯整而成的重要創作研究專輯，而所有文章皆已在國際學術教育網 Academia.edu 登出，持續獲得全世界眾多學者的閱讀與研究。

本書的標題乃以台大名譽教授（我台北教會的牧師）林麗真博士的文章「道與技之間」來命名，我也以此標題來敘述我的創作理念，以及我如何透過藝術語彙、符號、媒材來再現我藝術的啟示與警世內涵。當然，本書所有的文章都有敘述到我作品所要表達的理念，他們也以不同的角度將我作品置在藝術史觀內，或從女性藝術、數位藝術、生態女性主義與數位女性主義美學切入，內容相當精彩與獨特。以下是我匯整的重點導論：

在第三章「全系列論述」的第一篇文章，是最具影響力及著名的台灣美術史家蕭瓊瑞教授的史學研究《天啟與創生—林珮淳的夏娃克隆系列》。蕭教授不但觀察出我長期的創作思維和藝術語彙，更定義了我作品的獨特美學。他指出：「林珮淳自 1995 年在台北市立美術館的《相對說畫》以來，她始終有一種二元辨證、彼此互文的基本思想模式，如：真實／虛假（1996）、景觀／觀景（2000）、非自然／大自然（2004）…等；『夏娃克隆』系列創作，固然帶著反科技過度膨脹的原始動機，甚至在創作的過程中，加入了宗教『天啟』的強化，但到了《夏娃克隆創造計劃》，我們慕然發現：一度不再被提及、關注的『女性主義』思維，反而在這些作品中，竟是如此自然而明確地被舖陳、展現出來。」

另一篇是知名女性藝術史學家鄭芳和所發表的《正說話的主體—林珮淳的夏娃克隆》，是陰性書寫的代表作。她先訪談我創作的發展，再從我女性與基督徒的觀點論述了我近三十年的創作發展。她敘述：「林珮淳已有自己虔誠的宗教信仰，而在藝術上也已找到女性『說話主體』的信仰，雙重信仰的加持，加上她犀利的批判性格與悲憫的宗教情操，交揉並用，相信將使她的生命更加流動、奔騰，更加波濤壯麗。」

第三篇文章《人生美麗嗎？談林珮淳反科技的科技藝術創作》是知名國際藝術家又出版多本數位藝術美學專書的葉謹睿教授之論述。他指出：「林珮淳的作品，以炫麗的五光十色來反諷人類不斷追求科技，卻不自覺地被科技所囚禁之事實。網路和手機，到底是無遠弗屆的觔斗雲還是綁束你我的緊箍咒？過度開發對於自然環境所造成的嚴重傷害，是否還來的及彌補？

生物科技是人定勝天還是逆天行道？現代人用科技所打造出來的人生，真的美麗嗎？這些問題都是我們這一個世代，所必須要有勇氣去回答和面對的挑戰。」

分別在第三章和第四章的兩篇論述《藝術作為信仰實踐的場域》、《是神的意旨，抑或是人的慾望》，是知名跨領域創作的研究學者暨國際策展人邱誌勇教授的文章。他從網路虛擬空間藝術美學切入而指出：「林珮淳的創作底蘊中隱含著一種對當代『集體共同幻想』（collective consensual hallucination）的批判，反諷著人類嘗試扮演造物主的想望。在『夏娃克隆系列』中，作品彷彿述說著：當代社會對於科技所懷抱的期許，就好像用盲目的眼睛來看待我們所生活的世界，總是盲目地將網路的虛擬空間視為一個與現在不同……但像基改一樣，美其名造福人類，卻可能帶來災害。林珮淳的創作策略，則是利用『迷思化』新媒體科技的優越性，反諷性地批判此一人們所信仰的迷思。」

第五篇是「清華大學藝術中心」策展人賴小秋教授的論述：《啟示與警世—林珮淳創作研究展》。她在策展藝評敘述：「林珮淳創作態度超然傳達其解讀現代生活與文化的深沉認知與見解，科技系列藝術作品在在揭示逆向反思，並隱含《啟示錄》警世自然反噬的巨大力量，可說是一路走來、一以貫之，以虔誠的信仰與毅力追求富含哲思義理的藝術境界與極致表現。」

第六篇是評論家郭冠英教授以《從蛹到夏娃克隆：林珮淳藝術的女體賦權》一文將我「女性詮釋系列」的「蛹意象」與「夏娃克隆」作對照。她指出：「林珮淳的作品超脫了性別、文化的界線，國際藝評對夏娃克隆的評析不斷，從聖經典故、女性角色、科幻人 (cyborg)、科技美學等多重角度解讀夏娃克隆這個 complex 誘惑角色的存在意義，被注視、論述下的夏娃克隆因此有了藝術生命，並不斷延伸。看似她已跳脫女權 – 男權、藝術 – 科技的狹隘論爭，但她作品並非遠離「蛹」時期的理想，而是通融包裹這一切，昇華為一個更誘人的詭辯形象『夏娃克隆』。」

之後，是六篇針對我「回歸大自然系列」作品的評論。首先是台灣當代藝術的推手與國際策展人石瑞仁館長的文章《軟硬兼施、面貌兩極的藝術》。他以視覺符號、元素解析了我創作的語彙：「在藝術家將原來的圖像去背、改色、糊化、局部剪裁及放大輸出之後，雖然事物的徵貌還是依稀可辨，但它們其實已經離開了既有的文本，而變成一種單純的圖形或獨立的符號了；不難想像，藝術家刻意把自然圖形化約成為一種視覺符號，目的是把它們當成一種『軟體』元素，用來放入自己的思想架構及敘述系統中去書寫或傳輸意義的。」

另一篇《再造一個自然的視野—林珮淳的「回歸大自然」系列》是紐約推動台灣當代藝術最重要的國際策展人李美華的文章。她文中敘述：「不論珮淳藝術表現是多麼的不服從規律或是有呈現明顯的愛好傾向，藝術對於珮淳是心靈提昇的力量，不論的當代藝術表現如何的解構或是顯得粗略急燥，以及追求某種虛幻的感覺，珮淳更重視道德及心靈的問題。」

另一篇《輕盈回歸—林珮淳的創作》是知名藝術家及台灣女性藝術協會理事長張惠蘭教授的文章。她敘述：「與其說珮淳想回到自然界的原生狀態，更貼切的說法是她想傳達出一種真理，試圖引領觀者深刻的省思，及早從人類所創造的文明的迷思中覺醒而回歸自然，而這份對自然與造物主的信仰所構成的使命感，化為藝術家源源不斷能量的來源。」

知名網路藝術家兼國際策展人曾鈺涓教授的兩篇文章《控制幻影—談林珮淳之創造的虛擬》

作品中之科技警訊》與《「夏娃克隆的誕生」基因生殖實驗室的科技反諷》，皆討論到我作品中的科技、人與自然間之共生關係：「觀看林珮淳作品，不能僅從作品符號、型式呈現與科技使用來觀看其表象，而是從其作品中呈現的『過程』所傳達之『警訊』來探討其作品意義，而這個警訊提醒人類隱藏科技美夢下的陷阱，並傳達出人類與大自然的純真與主體性正離我們遠去的憂慮。」

另一篇是國際藝術學者馬肇石 Pierre Martin 在觀看我的展覽後的評論：《你所得並非如你所見─台北當代藝術館林珮淳創作〈捕捉〉》，他欣賞我作品具有多層次的詮釋，閱讀他的文章彷彿浸泡在我的展覽內。他敘述：「需要觀眾的行動介入；再來，是透過影像的移動而產生的時間探索；最後的重點是指出觀眾臨場的重要性，因為這是為觀眾所創造的一件作品，需要觀眾的眼睛和身體的參與。我可以肯定林珮淳在這件作品中空間的運用非常精心和多層次的詮釋。……對我來說，一件作品優秀與否決定於創作本身多層面的議題發揮。」

之後，是國際藝評與編輯學者康居易 Susan Kendzulak 的文章《荒謬感背後的內省－評林珮淳「回歸大自然」系列創作》。她指出：「不可思議的生存奇蹟及不幸的土地災難是林珮淳創作中，最強而有力的兩大素材，作品透露出對上帝存在及美好生命的驚呼，並對人類漠視自然環境的無情投以高度關注。一位台灣著名的女權藝術家，轉而以不受政治力干擾的創作語法，來詮釋出九二一地震在她內心所產生的撼動。」另一篇則由台灣重要女性藝術研究學者陳香君教授的文章《回歸大自然衷情烏托邦：閱讀林珮淳的「回歸大自然」系列》。她寫：「在藝術家林珮淳追求『純淨自然』的歷程裡，有憤怒難耐的控訴，也有頑強實現欲求的希望。」

第四章「夏娃克隆系列」的第一篇文章，是身兼多重角色的國際威尼斯雙年展策展人、藝術家及關渡美術館館長林宏璋教授的研究。他在《互被動，從克隆之中》一文指出：「林珮淳的作品創造出一個『越過』（traverse）科技的幻見情境，如何能克隆『匱乏』？只有在一個缺陷而不完整的擬像中顯現，讓我們一起陷入的科技作為廢墟的情境。」另一篇是評論我的「夏娃克隆創造計畫」系列的文章：《女人創造女人：林珮淳的夏娃克隆的主體性》：「在一個圖像的虛擬現實實驗室裡中誕生，夏娃不再是『男人造女』的狀態，而是由女性藝術家林珮淳所造，其長相、身段與表情，是一位帶著如摩納莉莎的淺淺微笑，在額頭上有著『666 獸印』（the number of the beast）烙印。」

另一篇的文章《美學的僭越─林珮淳「夏娃克隆」系列》是擁有德國博士學位且致力於科技藝術研究的知名學者吳介祥教授之的評論。她評論：「林珮淳以聖經為腳本，以多重的夏娃代表誘惑，又賦予她們和觀者平等對視的地位，作品的互動設計啟動了觀者的操控權，卻也同時是被夏娃監視的裝置。在虛擬互動的環境下，主客易位，也預示了人因科技喧賓奪主的未來。延續林珮淳一貫的科技與美學真相之探討，『夏娃克隆』展場上，由程式完全打造的絕世美人，猶如正在戲弄著拖帶沉重肉身的我們。」

國際藝術史學家蘇珊娜 Susana Pérez Tort 的文章，她也同樣以《夏娃克隆肖像》來解析我作品，從「西方」美術史觀點的評論：「神奇的隨著觀夏娃克隆肖像的裝置，以西方將畫布掛在牆上的傳統呈現；她這種以科技技術來質問科技的手法，巧妙地牽引出人類在面對自然時，那種自以為是的一種反諷觀點。」另一篇《異形佳人：林珮淳「夏娃克隆個展」的驚奇世界》的文章，是國際數位藝術策展人安托列塔 Antoanetta Ivanova 的重要評論。她指出我作品與《聖

經》之密切關係：「從西方基督教對夏娃的描述而衍生出的靈感"她是一位坐在水面妓女，是她引誘了人間之王犯下了淫邪之罪"，她的水成為"人類、種族和語言"，林珮淳展示了一種來自新科技罪惡的生命形態。」

獲法國藝術博士的潘正育教授也選擇《夏娃克隆肖像》來論述，他文章《來自末世的凝視：林珮淳〈夏娃克隆肖像〉作品評析》也被高美館期刊與知名 InSEA 國際雜誌收錄。潘教授寫：「林珮淳在這方面是成功的：3D 呈現的動態影像往往是電子或數位媒材方能做到的效果，這件作品卻不需任何設備或電源就能達成。此外，透過藝術家的設計，不論從什麼角度觀看，畫面中的人物總是凝視著觀者。這使得作品在某種程度上擁有與觀眾的『互動性（interactivité）』，使其儼然成為一件『不插電』的 3D 互動作品。」

另兩篇文章是國際女性藝術研究學者及國際策展人陳明惠博士的評論，她也以英文發表在國際期刊 "East Asian Journal of Popular Culture" (2016) 以及 "n. paradoxa" (2012)) 提出「科技」、「女性」與「藝術」最具前瞻性的研究，成功把我作品推薦給全球藝壇，引起國際矚目。她在《擬皮層與超宗教》一文評論：「僅管 666 圖像本身帶有強烈的基督教象徵之圖像，在解讀林珮淳的作品時，並不適合以"宗教藝術"之角度切入，因為其作品在美學上、技術上，與結構上之專業性，遠勝過其作品圖像本身之宗教性，而作品中"擬皮層"的物質性與作品呈現介於死亡與生命之象徵性，與作品所散發出的詭異、幻化，與不真實感，是林珮淳《夏娃克隆系列》之獨特特質。」

陳明惠教授又在第五章「夏娃克隆創造計畫」的策展文章《當代美學中的數位女性主義》，觸及當今最重要的「後人類」(Post-human) 與「數位女性主義」(Cybersexuality) 議題。她評論我作品：「早期女性主義者對於夏娃是第二性的說法，具有極大的批評，並試圖顛覆這樣具父權思維的意識形態。然而，林珮淳的創作不同於早期女性主義對於性別二元論的批判，她對於夏娃所代表的象徵性更具興趣，且透過科技技術所創造出來的虛擬夏娃身體，反應科技帶給我們當代生活的影響，這樣的創作思維，已跳脫早期女性主義者對於父權的顛覆與批評。」

最後一篇是邱誌勇教授的論述《警世的數位神諭：林珮淳〈夏娃克隆製造計畫〉對科技的批判與反思》。他提到我作品蘊含著「生態女性神學觀」（Ecofeminism），也體現著「女性科學主義觀」：「林珮淳用藝術化的手法對科技發展所帶來的問題以及社會對女性的束縛做了更為深入的思考與批評。神讓夏娃在亞當身體中蘊育而生，正如人類創造了以人為延伸的科技以及賽伯格，這種美麗的誘惑，是一種時代的進步，也是一種對自然的挑戰和對人性的滅絕，及其矛盾的生存之道。」

第六章是「全英文的評論文章」共二十一篇，包含我發表在全球女性博物館 IGNITE 的創作論述；陳明惠發表於 "East Asian Journal of Popular Culture" and "n.paradox" 的兩篇文章；潘正育發表於 IMAG InSEA Magazine 的論述，以及多位作者的英文論述。第七章則包含有許佩純的研究和曾燕玲發表於英國牛津大學的研討會英文論述。尤其許佩純的文章是從她近 12 萬字研究我作品的碩士論文中摘錄而出，其中除了深入研究我《相對說畫》作品外，還包含我的「創作生涯－信仰對藝術創作的啟發」、「藝術教育的推動－林珮淳數位藝術實驗室」、「展覽及成就」等研究。最後則是列出我實驗室成員所整理的「文獻節錄」、「報導與評審」、「展歷」等，為本書做了完整的文獻呈現。感謝所有作者容許我把他們的大作納編於此書，在此致上最大的感謝與敬意。

在道與技之間再現藝術的啟示與警世

林珮淳

「道」：藝術、宗教與哲學

台大名譽教授林麗真以「道與技之間」論我的作品，她指出：「『道』對一件藝術作品來說，是指能能傳達出一種信念、一種思想、一種對於宇宙人生根本之學的反省與檢討……」。[1] 我很感謝林教授以中文教授與教會牧師的身份來為我寫序，因她知道我敬畏神，我的創作思想與信念皆來自我內在生命的感動與對列國先和所傳信息的開啟，尤其「回歸大自然系列」和「夏娃克隆系列」就是我批判人類破壞大自然與改造神原創的代表作。作品本乎《聖經》真理，甚至直接引用《聖經》章節來定義「夏娃克隆」的角色，指涉人類挑戰神原創的結局，這是我作品獨特的觀念和語彙。黑格爾指出：「最好的藝術作品是通過感知／感性手段傳達最深刻的形而上學……。因此，藝術作為一種文化表達，在與宗教和哲學相同的領域中運作，並表達出與它們相同的內容。」[2]

女性主義藝術觀點

1995 年個展於台北市立美館的《相對說畫》系列，我挪用了廣告標語與纏足文件，揭示女性身體從古至今仍陷在父權審美標準下無法自主掌握。之後，我以《黑牆、窗裡與窗外》、《向造成 228 事件的當局者致意》兩件作品，詮釋 228 受害者與加害者的不平等地位；另一系列《經典系列》、《骰子系列》乃反諷讀書人追求功利的現象；《繁複與思源》、《美麗人生》則試圖揭示台灣社會的亂象。這些作品皆是我以「女性主義觀點」解構父權文化的性別、歷史、社會、政治、教育的系列創作，表述了我所要傳達的「一種信念、一種思想」，也就是我的創作理念。

我的作品所以會具「女性主義藝術觀點」，是因 1989 年從美國學成後加入「2 號公寓」團體而投入台灣當代藝術，但同時深感傳統文化的壓抑，常在身為人妻、人母、人女以及藝術工作者所承受的多重角色中掙扎。1992 年於國立台灣美術館的個展「女性詮釋系列」，即以一坨坨「蛹形」、「蜷曲的女體」，且加入女性包鞋和高跟鞋等圖象，隱寓當代女性難以突破傳統束縛的膠著與困惑的種種狀態，我覺得自己好像「蛹」般的期待著破繭而出。

為了尋求屬於自己的創作空間，1993 年我終於突破重重困難到澳洲攻讀藝術創作博士，大量接觸了「女性主義藝術」的論述觀點與相關作品。女性主義藝術學者琳達·諾赫琳（Linda

1　林麗真，《道與技之間》，Academia .edu
2　"Art", Encyclopædia, Britannica

Nochlin）的論文《為何沒有偉大的女藝術家》(Why Have There Been No Great Women Artists?) 指出多數的藝術史均是本從男性的觀點出發，在男性的標準下被選擇、被定位、被評價。[3] 於是我終於跳脫過去的困惑，不再表現自己如受壓抑的蛹形，所使用的媒材也不局限於油彩與畫布了。當我明白父權文化壓制女性發展空間的結構問題後，終能客觀地以「女性觀點」去檢視父權文化的產物，如《相對說畫》系列即是以絹印、電繡、人工絲、繪製等手法，「再現」美女古畫、纏足文獻以及現代美容塑身廣告標語，反諷女性身體一直被父權的審視標準所掌握之事實。

當這系列作品展出後，藝術界及媒體評論就定位我是「溫和」的女性主義藝術家，因為我的作品並沒有如西方女性主義藝術家以自己的身體或性器官作表現，我認為我的「再現」語彙是更有力的控訴手法，因重現事實就是最有力的證據。這種創作語彙就如瑪莉‧凱麗 Mary Kelly 的作品「產後文件」（Post-Partum Document）。[4] 她「再現」了兒子成長的物件如：尿布、牙牙學語的錄影帶、塗鴉等，以展現母親與女性的主體性，也避免女性身體再次被男性所「窺視」。

1997、1998 年我受邀北美館的「228 美展」，分別展出兩件解構政治議題的作品，如《黑牆、窗裡與窗外》，是以受害人的全家福合照、家書、公文等絹印於鉛板上，再刻意以硫酸將受害者的臉部圖像腐蝕掉，「再現」受難者悲慘的人生；又以「百葉窗」現成物的「開與閉」，表現那曾被關閉又逐漸被平反（打開）的悲慘歷史過程。

另一件《向造成 228 悲劇的當權者致意》則大膽把「獎盃」現成物陳列一整排，且獎盃上還刻出反諷當權者的文字，如：「向隱藏事件的當局者致意」、「向屠殺無辜的當權者致意」、「向寧可錯殺一百也不願放過任何一人的陳儀致意」、「向造成 228 受難者家屬一生羞辱懼怕的當局者致意」……，此種所謂的「致意」，就是「控訴」，所謂的「豐功偉績」，就是反諷卑鄙、殘忍的屠殺等陰謀暴行。之後，我在另一系列《經典之作系列》、《骰子系列》中，質疑當今的教育，反諷讀書人在「四書五經」的傳統道德教育下是更加的虛偽、投機與功利；在《美麗人生》大型裝置中，將上萬張記載台灣亂象的日報掃描於馬賽克處理後的「清明上河圖」上，再列印於長形捲軸懸掛成可進出的旋轉式空間，遠遠看去卻是幅「清明上河圖」的國畫裝置，「再現」了台灣富裕社會底層下的社會真相與亂象。

3　Nochlin Linda, "Why Have There Been No Great Women Artists?" ART news, January 1971, pp.67-71
4　Mary Kelly website, http://www.marykellyartist.com/post_partum_document.html

列國先知洪以利亞以「神的話」，開啟我所想表述的「道」

1999 年「921 大地震」，震醒了我的良知。若不是我目睹人類遭大自然反撲的這場大浩劫，我也無法體認先知帶出的「走出文明、回歸伊甸」真理。從此我作品所要傳達的不再只是我個人的女性主義觀點，而是蒙列國先知洪以利亞以「神的話」所開啟的「道」。在《聖經》〈約翰福音〉中的「道」就是「神的話」：「太初有道，道與神同在，道就是神。」（In the beginning was the Word, and the Word was with God, and the Word was God.（〈約翰福音〉1:1-2)）。另外，在《聖經》〈啟示錄〉：「耶穌基督的啟示，就是神賜給他，叫他將必要快成的事指示他的眾僕人，他就差遣使者，曉諭他的僕人約翰。約翰便將神的道和耶穌基督的見證，凡自己所看見的都證明出來。念這書上預言的和那些聽見又遵守其中所記載的，都是有福的，因為日期近了。」(〈啟示錄〉1:1-3)。在現今世代，列國先知洪以利亞就如當年的使徒約翰一樣，將神的「道」和耶穌基督的見證表明出來，先知所傳揚的「道」都是向這個時代所發出的「神的話」。

先知在錫安聖山傳道，他告訴這世代的人：「在伊甸園，一切都是神所創造的，沒有科學文明的玷污。但是，自從人類墮落以後被趕出伊甸園，人就遠離神，人也就得不到神的祝福。其後，魔鬼撒但鼓動人用自己的聰明，發明許多科技，就不再依靠神，乃是依靠人的聰明智慧，結果帶來了無窮的禍患。……我們回錫安以後，一直要回歸伊甸、回歸神治、回歸自然；要走出文明、唾棄墮落人類的無神文化。……這些都是從神的啟示而來的，當時很難被這個世代的人接受，因為墮落人類都活在無神的文化中，崇拜墮落的文化、迷信人為科學。但是，神的話永遠安定在天！」[5]

的確，人類自從被趕出伊甸園就逐漸遠離神，以墮落的智慧極致發展無神文化和科技文明，依靠自己的聰明建構巴別塔，在父權體制下發展人國政治、軍事、經濟、文化、科技、教育等等……，其結果卻是使人陷在更多的禍患與痛苦中。多年來我以「女性主義觀點」的創作論述來爭取女性資源，但其果效是顯然有限的。先知揭示「回歸伊甸、回歸神治、回歸自然」的真諦，強調人類必須走出文明、唾棄墮落的無神文化才能達到「物我同榮、天人合一」之境。當我明白了這真理，知道人需敬神才能彼此相愛，如此才能解決所有父權結構下所衍生的問題，於是我的創作開始思考人與創造主的關係。

「回歸大自然系列」：壓克力燈箱的「人工自然」

1999 年，神的靈引領我開始發展「回歸大自然系列」，如《生生不息‧源源不斷》、《景觀‧觀景》、《花柱》、《寶貝》、《蛹之生》等。我企圖「再現」人類遠離大自然所建構的都會文明與人工自然，我以都會五光十色的符號「廣告燈箱」來與「大自然」作強烈對照。當時我花了很多時間與製作招牌的廠商討論，特意依招牌製成的方法來表現，且選擇大自然的圖案如花卉、天空、海景等，以數位輸出貼在壓克力燈箱上，創造了各種幾何形狀的方塊、柱形、錐形、貝殼形、蛹形等的「人工幾何自然」，並刻意放置在大自然的公園、樹間、草原或室內空間，再現矯揉荒謬的人工造景。然而，很弔詭的現象是，此系列作品反而吸引了更多觀眾的目光，觀眾不覺得人工的假自然有何不妥，反而更加喜愛這種發光體。當我看到觀眾在作品前面駐留許久的奇特景象時，就更加印證了我所批判的議題，人們對於「人工自然」的驚

5 錫安山網站 https://ziongjcc.org/zion/chinese/zion/zion_01.html

艷與喜愛更說明了大自然被墮落文明寢染的危機。此系列作品也獲得許多公共藝術節的邀展，如《聆聽雲光 II》、《交融與共構》、《雨林》等，因亮麗的作品更吸引現代人的目光。

具「人工生命」的虛擬蝶與人蝶合體的「夏娃克隆」

2001 年我執教台灣藝術大學多媒體動畫藝術研究所，更有機會接觸電腦科技媒材，於是我開始藉著 3D 動態影像來「再現」科技所建構的虛擬的幻景，如：2004 年的「非自然」和 2005 年的「情迷意亂」這兩項個展中，作品《花柱》是我刻意建構的四座柱形花園的壓克力燈箱，中間一座較低的燈箱則裝置了一個小螢幕，螢幕內呈現了一隻 3D 動畫的蝴蝶影像，比喻花與蝶只需作遠距傳情；另一作品《城市母體》則呈現蝴蝶與霓虹燈所孕育出的許多數位標本。2006 年在台北當代館的個展「浮空掠影一捕捉」中，更以 4D 眼鏡和雙投影來展現立體影像的蝴蝶動畫，蝴蝶雖在銀幕上栩栩如生，卻無法被觀眾捕捉到手。展覽空間內也懸掛了很多以「光柵」做成的錯視動態「標本」，表現了人造蝴蝶是可以在數位系統中被儲存、存檔、重組與刪除的。之後我受邀到北京 798 藝術村的個展「美麗新世界」，更大膽的創作了第一件的互動裝置《創造的虛擬》，以互動平台邀請觀眾在介面上繪製自己的蝴蝶圖案，等觀眾完成「創造」後會看到自己畫的蝴蝶影像緩緩飛入前方的海底投影內，但蝴蝶卻很快的消逝。藉此作品反諷人造物的虛擬與短暫，啟迪人對「真與假」、「實與虛」、「久與暫」等哲學課題的深思。

2007 年後，我更看到人類不但以電腦科技建構智慧城市，更大膽挑戰神的原創，如基因改造農作物、基因複製生物、胚胎混種等極端科技。因此，為了「再現」這種人工培育生命的行為，我又創作了四件組的作品《溫室培育》。以壓克力建構了圓形花瓣造型，中間以小螢幕呈現一個女體，從 3D 動畫網格慢慢轉變成具有肉身的女體影像，又以馬達運轉與 LED 燈照射之，呈現科技化的人工培育過程。2008 年又發展了一個大型投影的蝶女物種，且將之命名為「夏娃克隆」；因神創「夏娃」，人也想扮演上帝的角色創另一個複製夏娃。為了表現她的「人工生命」，我以互動電腦程式、互動介面設計、感應器邀請觀眾與她互動，一旦有人介入時，「夏娃克隆」即可從「蛹」變為「蝴蝶美女」，再到「美女影像」的具體成形。觀眾愈多則她蛻變愈大，一旦沒有觀眾時立刻便會回到蛹型的狀態。此一人工的互動裝置反諷這物種乃因着人類的涉入才能演化，卻無法獨立生存，因只是「人工的假生命」，唯有神的原創才是自然與真實的生命。

具複製性與人工生命的「巴比倫大淫婦」

人類發展墮落智慧的產物已經成為轄制人類的反撲力量：化工污染導致的「全球暖化」，達到回不去的臨界點；猛夏高溫破記錄；南北極巨大冰融、冰川斷裂引發海嘯及全球水平面升高等災難……。除了大自然的反撲外，人類更妄圖改造神的原創定律，如人工繁殖動植物加快了基因突變；基改工程、基因複製工程、混種等僭越了物種的界限，所產生的生物變種、生態浩劫及道德危機將人類帶上滅絕之路。[6] 另外，以晶片、監控器、網路、電腦、WIFI、超微波，超電磁波、人工智慧、生化科技、機器人等……發展所謂的「智慧城市」、「未來世界」和「網路科技虛擬世界」，使人類浸淫在自己所創的科技網羅，人類已全面性地被科技監視、控制、操縱，又難以脫逃自作孽的重重誘惑與危害中。霍金（Stephen William Hawking）去逝前也說出：「人工智慧繼續發展下去，恐會導致人類滅絕。」[7] 特斯拉汽車創辦人馬斯克（Elon

6　易象乾博士，孔果憲 中譯，http://microbiology.scu.edu.tw/MIB/lifescience/wong1/fooli504.htm

7　編者，自由時報，《科技反撲？霍金：人工智慧恐使人類滅絕》，http://news.ltn.com.tw/news/life/breakingnews/1172747

Musk）也警告：「人工智慧將是我們最大的生存威脅。」他甚至形容人工智慧就像惡魔，而人類卻無以自拔地正在召喚惡魔。[8]

因著先知所開啟的「道」，我發現這階段的「夏娃克隆」已無法詮釋當今人類發展科技文明之惡，於是 2011 年我決定以「人蛹及人獸合體」來形塑「夏娃克隆」兼具迷人與邪惡的雙重化身。我引用《聖經》〈啟示錄〉所記載的「巴比倫大淫婦」（「地上的君王與他行淫，住在地上的人喝醉了他淫亂的酒。（〈啟示錄〉 17:2），以及將撒但的記號「666 獸印」置入「夏娃克隆」的額頭與右手上（啟示錄 13:16），喻表科技文明如「巴比倫大淫婦」與「666 獸印」地勾引並轄制著人類。於是，2011 年展於台北當代館的《夏娃克隆肖像》即以 3D 動畫「全像」(Hologram) 的媒材表現迷人的眼神與姿態，她在聚光燈投射下「活現」而出（因沒有光線就看不到「夏娃克隆」）。更稀奇的是，當觀者左右移動觀看她時，她的眼神也緊隨著、注視著觀眾；又當觀眾停止觀看時，她也就跟著停止不動了。「再現」人類所創造的科技文明就如「夏娃克隆」般的美麗動人，也猶如「巴比倫大淫婦」般的誘惑且控制著人類。

延續《夏娃克隆肖像》的觀念，我接著又創作了六角形大型投影的《夏娃克隆 III》互動裝置，表現六個龐大臉部跟隨且注視著觀眾，而背景音響配上水聲以及觀眾左右移動時趨動肖像影像的音效，更強調那巨大的肖像有如科技強權般的籠罩與充斥在生活周遭，人類對如此龐大的科技文明顯得很渺小。另外，也以樹脂塑造六雙刻有「666 獸印」的立體雕塑《夏娃克隆手》與《夏娃克隆手指》，表現存放在培養水的試管與實驗玻璃罐裡，藉以批判這種混種、被人工培養的物種正成為反撲人類的邪惡變種，就如電腦、科技、化工、核能等人工智能的發明，到最後反而成為危害人類的元兇。《夏娃克隆 III》在台北當代館展出後，隔年受邀在國美館「台灣雙年展」展出時，我加入了網路攝影機（webcam），試圖將觀眾影像置入作品而發展出《夏娃克 IV》。

2011 年受邀新苑藝術畫廊個展中，則以同樣觀念發展出「全身的夏娃克隆」：頭部微低、雙手放於胸前如胎兒，身體則是人蛹合體的形態與質感。我先以十八個小螢幕表現《量產夏娃克隆》，強調「夏娃克隆」如工廠的產品正被量產中。在《透視夏娃克隆肖像》的六件數位圖像，則表現如 X 光片透視了「夏娃克隆」，顯露出她在美麗的外表下有著刺青的符號如：蛇、蠍子、龍等危險的象徵。

另一件《夏娃克隆啟示錄 I》的大型投影互動裝置，進一步表現「夏娃克隆」具「人工生命性」與「複製性」。當觀眾進入作品場域時，就啟動了她的生命指數（電腦時間碼 Time Code），且身體從黑白慢慢轉成色彩，以及複製成整排的身體。複製出來的一尊尊「夏娃克隆」數量，則可依投影場地來決定；場地愈大「夏娃克隆」就可複製愈多。此中討論了被複製的生命，因著人類介入後而啟動了生命值與複製性。她的生命指數（電腦時間碼 Time Code）一直隨著時間以毫秒跳動著，表示她與人類共存於當下的生命。最後，我為了定義與揭露「夏娃克隆」轄制人類的身份與權勢，更大膽加入《聖經》〈啟示錄〉有關「巴比倫大淫婦」與「666 獸印」的聖經章節，以六種強權文字呈現於每尊「夏娃克隆」的底部。其中有拉丁文、希臘文、希伯來文，代表政治、文化、宗教三大權勢，因把主耶穌釘在十字架上的就是這三種文字，寫著：「猶太人的王，拿撒勒人耶穌。」（〈約翰福音〉 19：19-20）；此外又加入中文、英文與阿拉伯文，代表今日三大強權，並由電腦隨機顯示於底部，而其背景音樂則是神聖詩歌夾雜著

8　同註 7

如鐵器磨擦的怪音效，強調它的假神聖。作品每次展示的時間不同，呈現「夏娃克隆」的生命值也不同。之後，我為了記錄她每次展出的生命值，特別為她創造了一系列的《夏娃克隆啟示錄文件》。

可與人互動的「大偶像」

在 2013 年受邀於台北當代館的國際展之前，我便思考「夏娃克隆」下一階段應該要演化得更擬真如人類，於是我找來模特兒扮裝，試圖把「夏娃克隆」半蛹半獸的形象用真人來表現，但因技術與化妝很難克服，花費也相當龐大而告停。我遇此瓶頸的困難時，經迫切向神禱告後，神啟示我想到先知的信息，即《聖經》〈但以理書〉第二章 32-33 節所預言的「大偶像」（金頭、銀身、銅腹、鐵腿、半鐵半泥的腳）就是「人的國」。[9] 我頓時豁然開朗，原來「夏娃克隆」所要傳達的理念，不單涉及複製人或人工物種，也不單涉及科技文明的化身而已，更進一步係要批判人類以墮落智慧、無神文化所發展出來的「人的國」，就是《聖經》〈但以理書〉所預言的那座敵基督的「大偶像」。

終於《夏娃克隆啟示錄 III》成功展於台北當代藝術館「後人類慾望國際藝術展」。我以 3D 動畫重新塑造了具有《夏娃克隆啟示錄 I》所有的特性，如複製性與生命值，以及放入有關「巴比倫大淫婦」、「666 獸印」與〈但以理書〉有關「大偶像」的聖經章節。在這次的展出中，「夏娃克隆」的身體已經是金頭、銀身、銅腹、鐵腿、半鐵半泥腳的形體質感了，而她原來低頭如胎兒的形體則演化成更具魅力的女體。另外，為了展現它是被崇拜的「大偶像」，我還以「夏娃克隆」原動畫檔複製列印成 3D 的金色立體頭形，將她放置在影像前面正中間，讓觀眾可用手觸摸她前額的「666 獸印」，表示多重含義的動作，如：與她交媾、被她烙印「666 獸印」、舉手崇拜她，更可趨動「夏娃克隆」抬頭與手舞足蹈，彷彿給予她生命般的神奇。頭頂上一直跳動的生命值（Time Code）及腳底部隨機（Random）出現的聖經章節，以及帶有如鐵器磨擦怪音效的背景音樂，如偽造的詩歌般的令人聽了毛骨悚然。《夏娃克隆啟示錄 I》與《夏娃克隆啟示錄 III》作品中所引用的《聖經》〈啟示錄〉與〈但以理書〉之章節如下：

· 他又叫眾人、無論大小貧富、自主的為奴的、都在右手上、或是在額上、受一個印記。
（〈啟示錄〉13:16）
· 除了那受印記、有了獸名、或有獸名數目的、都不得作買賣。（〈啟示錄〉13:17）
· 在這裡有智慧。凡有聰明的、可以算計獸的數目．因為這是人的數目、他的數目是
六百六十六。（〈啟示錄〉13: 18）
· 拿著七碗的七位天使中、有一位前來對我說、你到這裡來、我將坐在眾水上的大淫婦所要
受的刑罰指給你看。（〈啟示錄〉17:1）
· 地上的君王與他行淫．住在地上的人喝醉了他淫亂的酒。（〈啟示錄〉17:2）
· 在他額上有名寫著說、奧秘哉、大巴比倫、作世上的淫婦和一切可憎之物的母。
（〈啟示錄〉17:5）
· 天使又對我說、你所看見那淫婦坐的眾水、就是多民多人多國多方。（〈啟示錄〉17:15）
· 你所看見的那女人、就是管轄地上眾王的大城。（〈啟示錄〉 17:18〉）
· 因為列國都被他邪淫大怒的酒傾倒了．地上的君王與他行淫、地上的客商、因他奢華太過
就發了財。（〈啟示錄〉 18:3）
· 王啊，你夢見一個大像，這像甚高，極其光耀，站在你面前，形狀甚是可怕。（〈但以理書〉2:31）

9　自從八〇年開始，也就是新約教會從錫安山被趕下山的那一年開始，神就讓先知洪以利亞在被趕散的時候被趕到散之地，傳出但以理書的信息：「天上的神要打碎一切人的國！」先知引經上的話說：「當列王在位的時候，天上的神必另立了一國，這國永不被滅，也不歸別國，卻要打碎滅絕一切人的國。那個大偶像─金、銀、銅、鐵、半鐵半泥的偶像，就是人國的象徵，到了末了要被打碎，要分裂而亡。」這是八〇年代神感動列國先知，啟示他所傳的時代信息，也是神賜給新約教會的時代異象。同註 5

- 這像的頭是精金的，胸膛和膀臂是銀的，肚腹和腰是銅的，（〈但以理書〉 2:32）
 腿是鐵的，腳是半鐵半泥的。（但以理書 2:33）
- 你觀看，見有一塊非人手鑿出來的石頭打在這像半鐵半泥的腳上，把腳砸碎；
 （〈但以理書〉2:34）

被神打碎，成為夏天禾場上的糠秕被風吹散無處可尋

列國先知說道：「世界的日子不多了，還有一點點的時候，那要來的就要來。但以理書所記載的王所看見的大像，頭是精金的，胸膛和膀臂是銀的，肚腹和腰是銅的，腿是鐵的，腳是半鐵半泥的。你觀看，見有一塊非人手鑿出來的石頭，打在這像半鐵半泥的腳上，把腳砸碎，於是金、銀、銅、鐵、泥都一同砸得粉碎，誠如夏天禾場上的糠粃，被風吹散，無處可尋。打碎這像的石頭變成一座大山，充滿天下。」又說：「從前的世界敗壞了，神用洪水來毀滅它；現在神不再是用洪水來毀滅，乃是要用烈火來焚燒。這世界已經來到盡頭了！」[10]

於是我依着先知對「人國大偶像」的結局來表現「夏娃克隆」的終極命運終。2014 年受邀展於美國紐約皇后美術館的 "Raising the Temperature" 的《夏娃克隆啟示錄 IV》，呈現「夏娃克隆」在廢墟中被海水淹沒，水被染紅變成血，好像死人的血，她雖奮力逃出水面，卻被天上非人所鑿的一塊石頭砸得粉碎，成為夏天禾場上的糠秕被風吹散無處可尋。（〈但以理書〉2：31-35）在作品影片的末了，則將那「大偶像」打碎變成一座大山，充滿天下，最後以《聖經》〈啟示錄〉的章節作結尾，並與聖歌背景音樂相互呼應，企圖傳達科技文明的終極命運。藉此提醒人類所崇拜的科技文明以及整個人國的權威與體制的「大偶像」，至終必被神打得粉碎。影片中的石頭造型是參考「錫安山」的大石牌，因「錫安山」就是喻表「神的國」。作品中所引用的《聖經》章節如下：

- 第一位天使便去，把碗倒在地上，就有惡而且毒的瘡生在那些有獸印記、拜獸像的人身上。第二位天使把碗倒在海裡，海就變成血，好像死人的血，海中的活物都死了。第三位天使把碗倒在江河與眾水的泉源裡，水就變成血了。我聽見掌管眾水的天使說：昔在、今在的聖者啊，你這樣判斷是公義的；他們曾流聖徒與先知的血，現在你給他們血喝；這是他們所該受的。（〈啟示錄〉16：2-6）
- 王啊，你夢見一個大像，這像甚高，極其光耀，站在你面前，形狀甚是可怕。這像的頭是精金的，胸膛和膀臂是銀的，肚腹和腰是銅的，腿是鐵的，腳是半鐵半泥的。你觀看，見有一塊非人手鑿出來的石頭打在這像半鐵半泥的腳上，把腳砸碎；（〈但以理書〉2:31-34）

燒「巴比倫大淫婦」的煙往上冒

2014 年底，我又受邀美國紐約 JCAL 藝術館的 "Culture Capsules" 國際展，想到世界文明之最的「紐約」城正是今日的「大巴比倫城」，而《聖經》也指出「大巴比倫城」就是「大巴比大淫婦」。我巧妙的將「夏娃克隆」虛擬影像與 Google 建構的紐約虛擬影像結合。「夏娃克隆」驕傲展開雙手站在「帝國大廈」之頂，影片表現「夏娃克隆」與整個城市從平行到從天空鳥瞰的視角作環繞，彷彿她狂傲地從高天睥睨下地，企圖統管萬有與全地。這大城象徵人類每天忙碌追逐政治、經濟、文化、科技、宗教、教育、藝術等活動之中心，是人類所有慾望的象徵，也是人類崇拜的「大偶像」，但依照神的預言，神發烈怒從天降下烈火，將這大城燒燬淨盡，而燒此「巴比倫大淫婦」的煙往上冒。作品中所引用的《聖經》之章節：

- 你所看見的那女人就是管轄地上眾王的大城。（〈啟示錄〉17：18）
- 此後，我看見另有一位有大權柄的天使從天降下，地就因他的榮耀發光。他大聲喊著說：

10　同註 5

巴比倫大城傾倒了！傾倒了！成了鬼魔的住處和各樣污穢之靈的巢穴，並各樣污穢可憎之雀鳥的巢穴。（〈啟示錄〉18：1-2）

· 此後，我聽見好像群眾在天上大聲說：哈利路亞（就是要讚美耶和華的意思）！救恩、榮耀、權能都屬了我們的神。他的判斷是真實公義的；因他判斷了那用淫行敗壞世界的大淫婦，並且向淫婦討流僕人血的罪，給他們伸冤。又說：哈利路亞！燒淫婦的煙往上冒，直到永永遠遠。（〈啟示錄〉19：1-3）

· 第七位天使吹號，天上就有大聲音說：世上的國成了我主和主基督的國；他要作王，直到永永遠遠。（〈啟示錄〉11：15）

夏娃克隆創造計畫 VS.「達文西」

2017 年因受邀北師美術館的「新樂園」聯展及新苑藝術的個展，我當時思考是否持續此系列的創作還是展開另一新的作品，因「夏娃克隆」已經照著聖經預言被終結了。這個問題在經多次禱告後，神又開啟了我繼續創作「夏娃克隆創造計畫系列」。我想起「達文西密碼」電影中所描述的達文西之企圖心，他於畫中褻瀆了主耶穌的神性，也大膽解剖當時教會認為神聖不可侵犯的人類身體。達文西被稱為人類史上最具全方位的鬼才，是藝術家、軍事家、科學家等，一生致力於運用他的創造力，不斷地從事各項發明設計及科學研究。他幾乎可稱為人類發展智慧的代表人物，若達文西活在現今科技時代，相信他的創造慾望將不可限量，而挑戰神的原創更是難以想像。達文西的智慧及慾望就是追求無神文化甚至敵神文化的代表人物，就是列國先知警告的：「世界上一般人的智慧，那是聖經所說將要滅亡、將要沒落之人的智慧。……這是魔鬼撒旦試探人、叫人墮落的最可怕的詭計！也就是亞當和夏娃在伊甸園受試探非常屬害的一點、關鍵性的一點。」[11]

於是我開始研究達文西及他的作品，最後決定在《夏娃克隆創造計畫 I》挪用達文西的維特魯威人（Vitruvian Man）手稿，因此手稿乃是他以黃金比例來描繪人體的完美尺寸，也誇耀人類是天地方圓之中心。我更發現達文西畫的維特魯威人居然與我創造的「夏娃克隆」比例相符，如臉部五官、四肢、身體等比例。此系列作品除了指出「夏娃克隆」的完美比例恰巧就是達文西的「黃金比例」外，更將達文西強烈創作慾望與驚人的企圖心轉譯在「夏娃克隆」被生產之創造過程上；因達文西解剖人體、解析肌肉、血脈、骨頭……之大膽行為與當今一些科學家大膽想改造神原創的慾望雷同，而我的「夏娃克隆」作品即批判人類以「人本」為中心，妄圖挑戰神原創之本質思維，於是將「夏娃克隆」與「維特魯威人」兩相作對照，藉此作品「再現」人類的慾望。

《夏娃克隆創造計劃 1》影片中，我回朔並重現之前我創造「夏娃克隆」的過程與她每一時期的形體演化，從我發想繪製的「夏娃克隆」原線稿到以電腦 3DMaya 軟體建構的網格，到每一階段的貼圖如：仿人的膚色、仿金屬色、仿全像的綠光色、仿金頭大偶像的金頭、銀身、銅腹、鐵腿、半鐵半泥的腳，且以 360 度自轉，每旋轉一次身體就形變一次。因着 3D 錯視效果，「夏娃克隆」彷彿從達文西的手稿浮現成立體的 3D 身體，再配合音效表現一種神秘與詭譎感。影片中段，我特別呈現如何在電腦軟體空間檢視「夏娃克隆」身體比例的真實記錄，呈現電腦介面、360 度空間、鏡頭、時間軸，還刻意存留了這些只有電腦能繪製的紋路、符號、icon 與影像，企圖與達文西當時只能用平面手繪的方式作對照，暗示了我所創造的「夏娃克隆」形體是比達文西的「維特魯威人」更具擬真、立體及電腦數位化效果。另外，原底部達文西的鏡

11　同註 5

像文字也被巧妙地更換成以「達文西鏡像字體」呈現的《聖經》「大偶像」及「巴比倫大淫婦」的聖經章節，也把達文西的簽名改成我的簽名當成一種密碼，因觀眾其實是很難發現達文西的文字與簽名已經被我改過了。

《夏娃克隆創造文件 I》系列是延續以上的觀念，我以「夏娃克隆」3D 檔案發展的頭部與手部線條、網格、貼圖等，與達文西手稿的頭部與手部手稿結合，表現「夏娃克隆」有如達文西手稿中的人體黃金比例標準。此系列共有五件作品，從達文西素描的頭部與夏娃克隆線條的頭部結合；達文西素描的頭部與夏娃克隆頭部網格結合；夏娃克隆網格頭部逐漸浮現，最後夏娃克隆金頭完整出現並刻有「666 獸印」。作品特意保留達文西的鏡像文字以及 3D 動畫的電腦軟體繪製的線條、網格、icon、攝影機、控制器等符號，表現手稿文件與數位檔案兩者間的互文與對照的觀念。在作品數位輸出後，我還在畫面加入我手繪的金色線條、聖經記載的日期與數字符號如 666 等。

在《夏娃克隆創造文件 I》頭與手部的四件作品，我利用「擴增實境」(AR) 技術，將「夏娃克隆」從靜態轉換成動態影像，彷彿「夏娃克隆」真的從平面走到現實空間與觀眾對話。以「擴增實境」(AR) 互動技術來表達「夏娃克隆」就如各種科技產物存在人類的生活週遭裡，因當觀眾拿起「擴增實境」(AR) 對著「夏娃克隆」的頭部與手部平面文件互動時，會驚訝發現平面的頭部與手部在螢幕內居然動了起來，如「夏娃克隆」的頭部是仰睡逐漸抬頭睜開眼睛且左右轉頭，之後再閉眼回到原來的姿勢，而手部也以六字形的誘人勾引態勢且如魔鬼撒旦的雙角手姿一再擺動，喻指「夏娃克隆」其實就與人類同在空間與時間存活著。

「神乎其技」的語彙、符號、科技媒材

林麗真教授的文章指出：「藉著有形、有體、有色、有象的藝術型態表現出來，甚至達到『神乎其技』的境界。」[12] 的確，藝術可以指著藝術家具有能力掌握媒材，使藝術語言有效的發展和使用，以傳達其藝術深度的意義。[13] 藝術是視覺、聽覺、表演或人類活動的多元創造，是作者的想像力、藝術觀念與技術的表現。[14] 足見藝術的思想、語言、信念與觀念，是必須藉著技術掌握才能被完整呈現，因此「道」與「技」之間相輔相成，委實具有內外一契的緊密關係。在我每一系列作品的創作過程，為了能充分表達我藝術的觀念（道），我總竭力尋找最合適的媒材，將之轉換成為一種語彙、符號，甚至成為觀念的本身，可說是「道」與「技」互為主體。在「夏娃克隆系列」所使用的科技媒材，不僅「再現」人工生命的虛擬性，也成為我批判科技本質的關鍵語彙，如：可以表現具人工生命女體的 3D 動畫虛擬性；可以拍攝與認知觀眾定位的網路攝影機（webcam）；可以跟隨觀眾的視角成功地把媒材與觀念結合成多層次語彙的全像（Hologram）；可以表現與觀眾互動的電腦系統、紅外線感測器 (Kinect) 及互動程式；可以表現「夏娃克隆」與人類同時俱在的電時間碼（Time Code）；可以表現「夏娃克隆」被複製的電腦延遲（Delay）程式；可以把「夏娃克隆」置在現實空間的 AR 技術等，皆說明了「技」就是詮釋「道」的關鍵語言。尤其在《夏娃克隆啟示錄 III》這件大型裝置，克服了許多的高科技技術，如：融接三台投影機成曲面投影的軟體與技術；即時控制時間電

12　林麗真，《道與技之間》，Academia .edu

13　Breskin, Vladimir, "Triad: Method for studying the core of the semiotic parity of language and art", Signs, International Journal of Semiotics 3, pp. 1–28.

14　Stephen Davies (1991). Definitions of Art, Cornell University, 牛津大學出版社。http://www.oed.com

腦碼（Time Code）的毫秒跳動，又如立體金頭可與觀眾即時互動的感應系統；以電腦延遲程式（delay）複製出一尊尊的「夏娃克隆」影像，以及控制她如何從靜態的黑白影像逐漸變成彩色的自轉與舞動的影像等等的高科技。

若沒有這些科技就無法淋漓盡致地把「夏娃克隆」表現得如此迷離、虛幻，令人神疑。她既可與人對話，又可被複製、似乎可一直虛幻地活在當下的生命中。以「再現」的語彙，表現「人工自然」與「人工生命」的炫麗與外表誘人的本質，以反諷的手法，讓觀眾去省思隱藏在美麗的糖衣背後的陷阱。就如羅蘭 · 巴特 (Roland Barthes) 曾說：「反迷思最好的武器可能是以他的方式將他迷思化，並製作一個矯揉造作的迷思。」(The best weapon against myth is perhaps to mythify it in its turn, and to produce an artificial myth.) [15] 也如林麗真教授說的「神乎其技」：「這絕對不只在技術表現本身，更在乎其技背後所透顯出來的神理神思！這種神理神思，應是出自作者對宇宙真理、人群社會、個己生命中諸種課題的真實關懷和生命體認。」[16]

結語

卡茨曾提出「…藝術家的創作不在於科技使用的最新或最晚，而在於以有意義的方式去告知觀者與參與者科技問題與迷思。」[17] 今日反觀我的創作，彷彿是神早就指引我去認識與解構「人國」的真面目。因著先知所啟迪的「道」而明白了人類唯有「回歸伊甸、回歸自然，回歸神治」才能有敬神愛人的生命，也才能解決所有人類無神文化結構下所衍生的種種問題。尤其我形塑了人類挑戰神原創的慾望的「夏娃克隆」，她每一代的演化與繁衍從《夏娃克隆 II》人蛹合體的女體，到烙有「666 獸印」的「巴比倫大淫婦」；到了《夏娃克隆啟示錄》更成了以聖經《但以理書》所喻指的「人國大偶像」了。這演化過程敘述了人類與科技的互存關係，藉此系列作品揭示人類建構的無神文化與科技文明反而成了反撲、轄制人類的邪惡權勢，更是神要燒滅的「巴比倫大淫婦」，以及神要打碎的「人國大偶像」。最後我在「夏娃克隆創造計畫系列」中把「夏娃克隆」與達文西的草稿結合，指出「夏娃克隆」正是人類極致發展的墮落智慧以及挑戰神原創的產物，而她早已充斥在人類生活周邊的每個角落裡。

本書編輯即將結束之際，我目睹「燕子」颱風淹沒了日本關西機場，緊接而來的是北海道 6.7 級大地震，造成當地嚴重土石流、走山滅村、土壤液化、路崩屋倒的慘狀。近日「山竹」颱風又狂掃菲律賓、香港、中國，另一佛羅倫斯颶風撲向美國，造成當地百年來未見的災情，這都是正在發生的災難，未來的災難只會愈來愈多、愈來愈嚴重，這是人類發展科技文明的後果。列國先知洪以利亞再三警告：「今天，人類受到世上智慧的殘害已到了飽和點，我們什麼時候還沉迷於世上的智慧，什麼時候我們就被敗壞的權勢所轄制，就無安寧之日。」[18] 這就是我要藉著藝術「再現」人類正發展的「夏娃克隆」，也藉著作品傳達這末日的啟示與警世：人類唯有回歸伊甸、敬天順天，才能免於末日的大災難。

15 Roman in Englisch-deutscher Perspektiven : Kulturelle .https://books.google.com.tw/books?isbn=9042006986

16 林麗真，《道與技之間》，Academia .ed

17 SAIC professor Eduardo Kac and students(2000). Behold, Alba. F Newsmagazine, School of the Art Institute of Chicago(Nov. 2000). p13-15. http://www.ekac.org/fdeb.html. 2006.6

18 同註 5

1990～2018

二、全系列作品
All Series Works

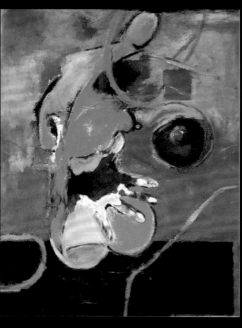

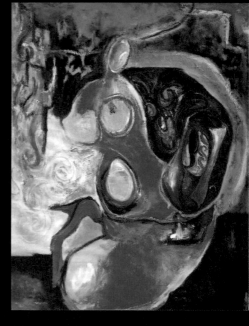

女性詮釋系列
Women's Interpretation Series
油畫 Oil on Canvas, 117 x 91cm / 50F, 1993

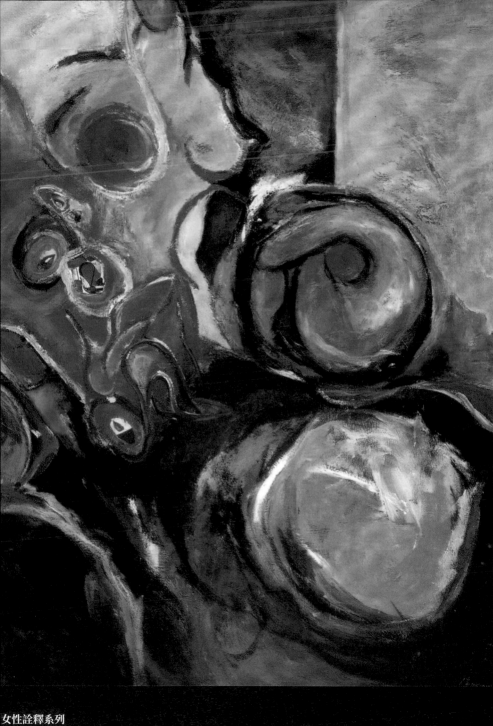

女性詮釋系列
Women's Interpretation Series
油畫 Oil on Canvas, 130 x 162 cm / 100F, 1993

女性詮釋系列
Women's Interpretation Series
油畫 Oil on Canvas, 117 x 91cm / 50F, 1993

女性詮釋系列
Women's Interpretation Series
油畫 Oil on Canvas, 117 x 91cm / 50F, 1993

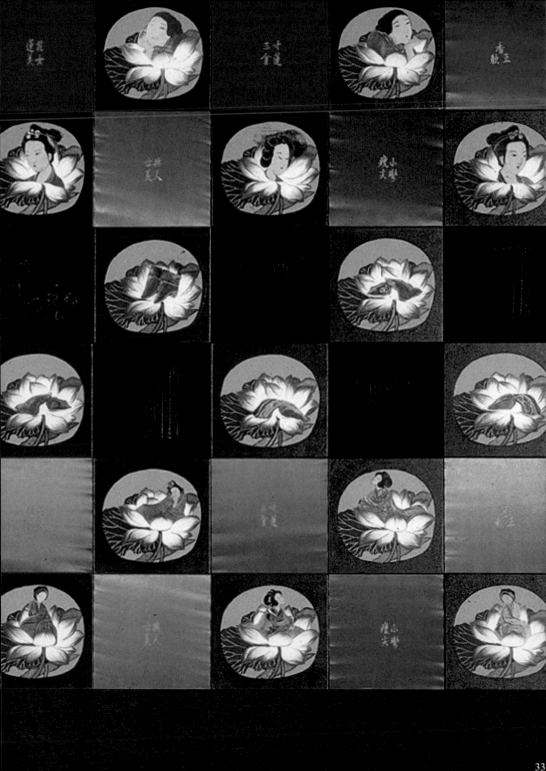

黑牆、窗裡與窗外
Black Wall, Inside and Outside of Windows
人造花、百葉窗現成物、絹印、化學腐蝕劑、 鉛板
Artificial flowers、Blind Window、Serigraph、Chemical Corrosive、Lead Plate, 450 x 300 x 250 cm , 1997

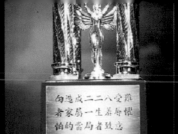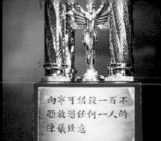

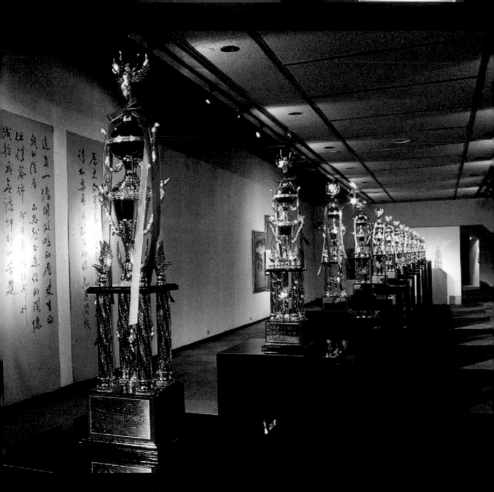

向造成 228 台灣歷史大悲劇的當局者致意
Regards to the Authorities Making 228 Incident Historical Tragedy in Taiwan
獎盃現成物、木座、紅地毯 Cup、Wood Base、Red Carpet, 1500 x 150 x 180 cm, 1998

綠衣雖多，無貴於色。
爾聲信清，譽亦不濁。
爾行信直，影亦不曲。
玉不厭潔，蘭不厭馨。
高不厭鮮，女不厭清，

女史箴

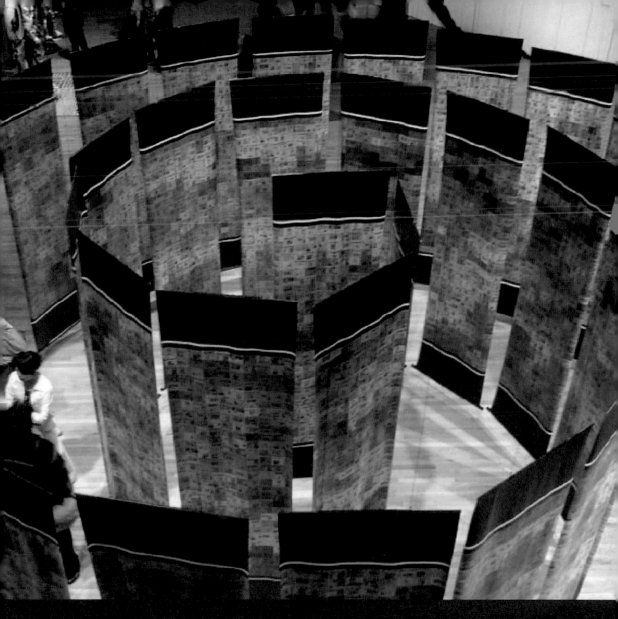

美麗人生
Beautiful Life
數位圖像輸出、塑膠布、木軸
Digital Image Print、Plastic Plate、Wooden Shaft, 300 x 90 cm x 32 pcs, 2004

回歸大自然系列 Back to Nature Series

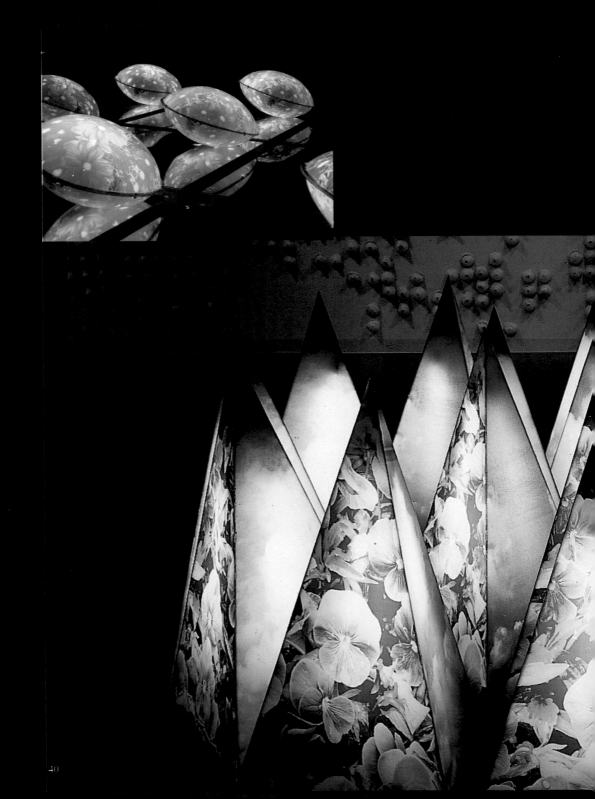

上海當代藝術館，中國
Shanghai Museum of Contemporary Art, Shanghai, China

高雄市立美術館
Kaohsiung Museum of Fine Arts

寶貝
Treasure
◀ 數位圖像絹印，壓克力燈箱 Digital Prints, Acrylic Light Box
60 x 50 x 40 cm x 20 pcs, 2006

生生不息 · 源源不斷
Substantial Life
數位圖像輸出，壓克力燈箱 Digital Prints, Acrylic Light Box
123 x 80 x 80 cm x 20 pcs, 1999

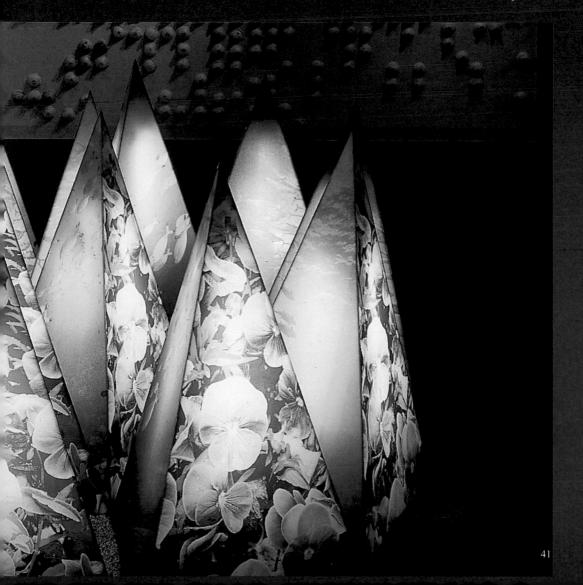

台北‧上海雙城記，台北國際藝術村，台北 / 上海
Taipei Artist Village, Taipei, Shanghai, Tawan / China

城市母體

City Matrix

壓克力板、電線、光柵片、數位影音、LED 燈、鏡面反光板、凹凸鏡片

Acrylic board, electric wire, lenpicular lens, digital video, LED, DVD player,

TFT screen, specula reflector, oncave and convex lens

主造型：直徑 65 cm x 高 75 cm Main object: 65 x 75 cm

觸角末端造型 25 cm x 20 cm x 11 cm Butterfly Shapes: 25 x 20 x 11 cm, 2005

聆聽雲光 #2

Listening to Cloud-light #2

三菱鏡玻璃、強化玻璃、金屬固定架

1018 x 202 cm, 2008

高雄捷運青埔站 Kaohsiung MRT

創造的虛擬
Virtual Creation
大型投影裝置、觸控式螢幕、互動系統、電腦程式、動畫影像
Large Projection Installation, Computer Touch Screen, Interactive System, Computer, 3D Animation, 2008

皇后藝術中心，紐約，美國
Queens Art Pavilion, Flushing, New York, USA

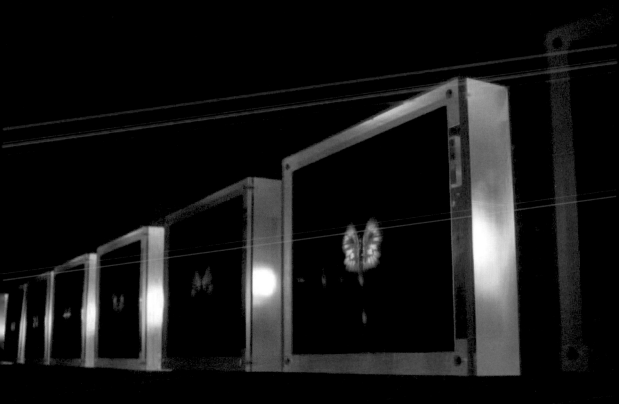

標本
Specimens
3D 動畫，光柵片，LED 3D Animation, Lenpicular Lens, LED, 2
5 x 20 x 6 cm pcs, 2006

◀**溫室培育**
Cultivation
壓克力，數位圖像輸出，3D 動畫，電動轉盤，LED 燈，DVD 放映機
Digital Prints, Acrylic Light Box,3D Animation,Motor, LED, DVD Player,
80 x 80 x 70 cm x 4 pcs, 2004

北京 798 藝術村，帝門藝術中心，北京，中國
798 Artist Village, Dimensions Art Center, Beijing, China

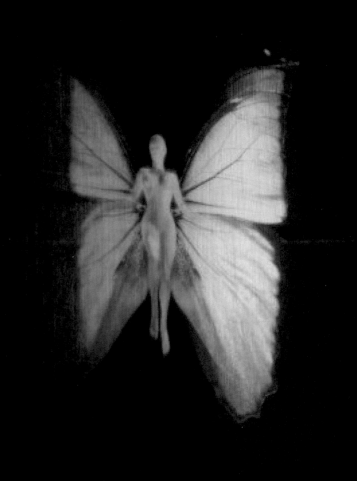

夏娃克隆標本
EVE Clone Specimens
3D 動畫，光柵片，LED 3D Animation, Lenpicular Lens, 2009

夏娃克隆 II ▶
EVE Clone II
3D 電腦動畫，網路攝影機，互動系統
3D Animation, Computer, Webcam, Interactive installation, 2007

《 Exit and Via 藝術節》，Creteil，法國
"Exit and Via Art Festival", Creteil, France

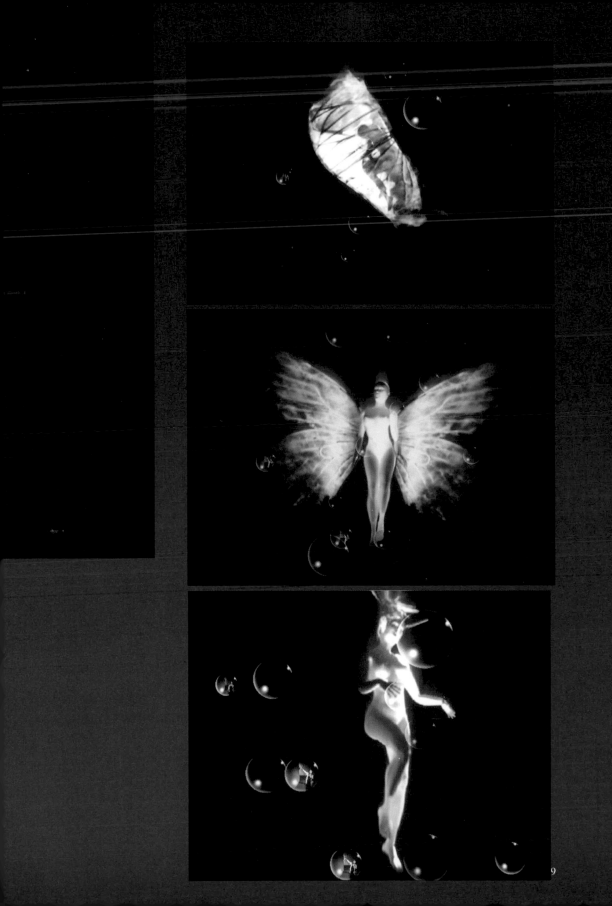

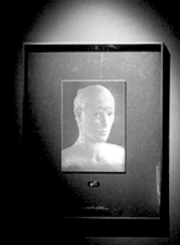

台北當代藝術館 Museum of Contemporary Art, Taipei

夏娃克隆肖像
Portrait of Eve Clone
3D 動畫、動態全像、壓克力鋁框、聚光燈
3D Animation, Moving Hologram, Acrylic Frame, Spotlight
46 x 58 x 4 cm, 2010 ~

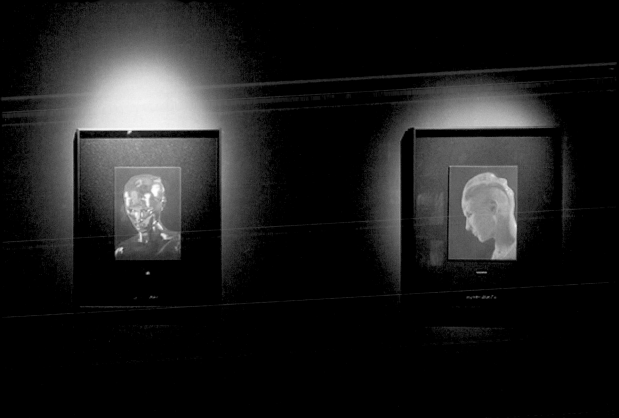

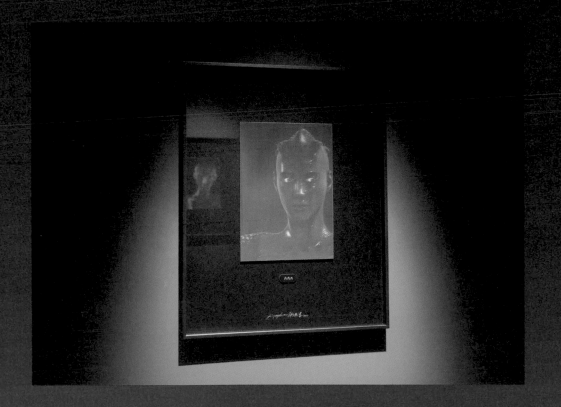

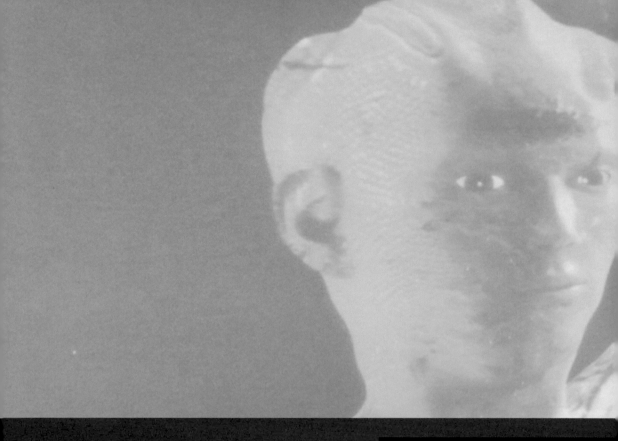

台北當代藝術館 Museum of Contemporary Art, Taipei

夏娃克隆 III
Eve Clone III
六面投影大型互動裝置
3D 電腦動畫、電腦、互動系統、Kinect 感測攝影機 3D Animation, Computer, Interactive System, Kinect,
2011

國立台灣美術館 National Taiwan Museum of Fine Arts

夏娃克隆 IV ▶
Eve Clone IV
六面投影大型互動裝置
3D 電腦動畫、電腦、互動系統、Kinect 感測攝影機、Webcam
3D Animation, Computer, Interactive System, Kinect, Webcam, 2012

夏娃克隆手
Eve Clone Hands
六件立體造形於醫學玻璃罐
醫學玻璃罐、透明樹脂雕塑、雷射燈
Medical Glass Jar, Poly Sculpture, Laser
25 x 25 x 43 cm x 6 pcs, 2011

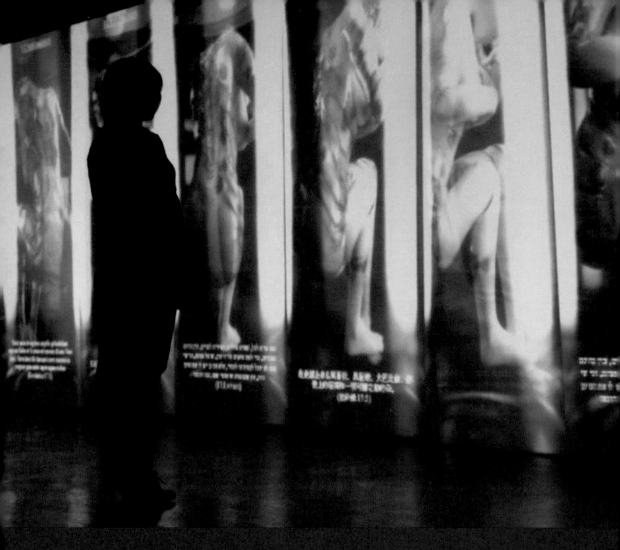

新加坡藝術博覽會，新加坡　ART STAGE Singapore

夏娃克隆啟示錄 I
Revelation of Eve Clone I
大型投影互動裝置、動態影像、3D 動畫、互動系統、網路攝影機、電腦、投影機、數位聲響
Interactive Installation, 3D Animation, Computer, Interactive System,
Webcam, Projectors, Stereo, Dimensions Variable, Digital Sound, 2011

夏娃克隆啟示錄文件 ▶
Revelation of Eve Clone Documentation
數位圖像輸出 Digital Image Prints
21x 29.7 cm x 40 pcs, 2011

那七碗的七位天使中、有一位前來對我說、
你到這裡來、我將坐在眾水上的大淫婦所要受
的刑罰指給你看。
（啟示錄17:1）

Then one of the seven angels wh
bowls came and said to me, "Co
you the judgment of the grea
seated upon many w
(Revelation 17:1

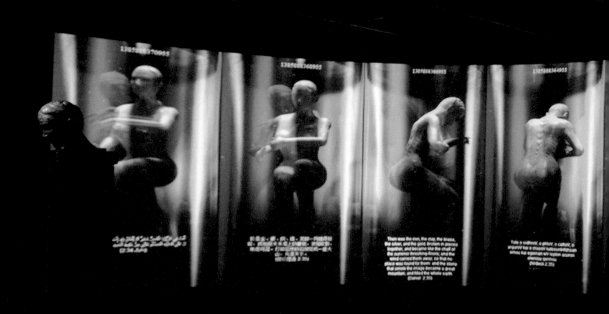

夏娃克隆啟示錄 III
Revelation of Eve Clone III
3D 動畫、 數位聲響、3D 列印、互動系統、電腦、投影機
Interactive installation
Moving image 3D Animation,3D Printing, Interactive Systems,
Computers, Projectors, Stereo System, Digital Sound, 2013

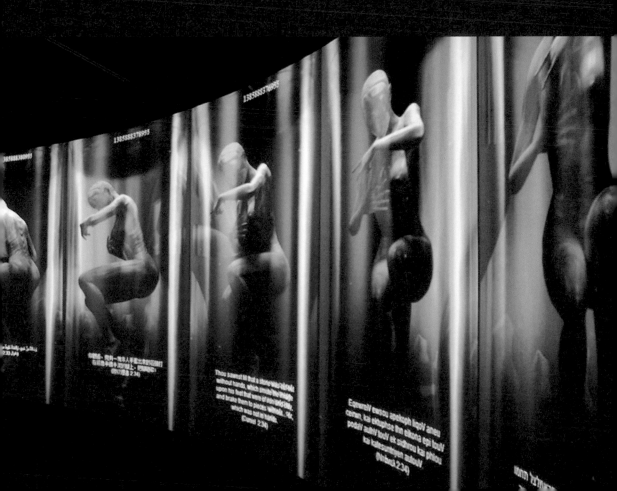

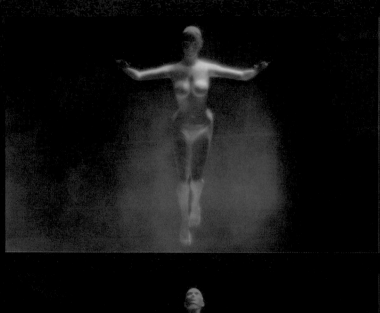

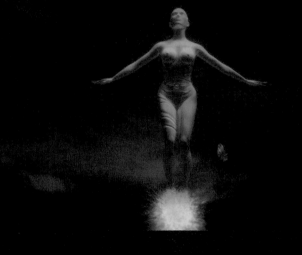

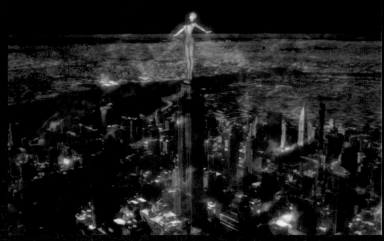

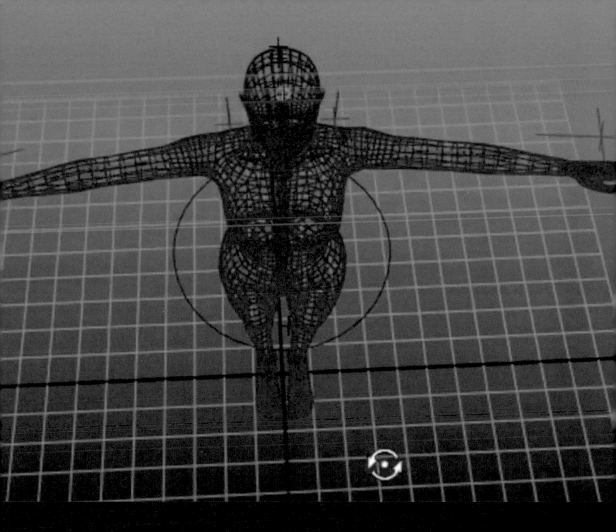

北師美術館 MONTUE, Taipei

夏娃克隆創造計畫 I
Making of Eve Clone I
投影、3D 動畫、數位影音
Digital Sound, 3D Animation, Projector,Stereo System ,Seamless Paper, 10:00, 2016

皇后美術館，紐約，美國 Queens Museum of Art, New York, USA

◀ **夏娃克隆啟示錄 IV**
Revelation of Eve Clone IV
3D 動畫、數位聲響、單頻道影片
Moving Image, 3D Animation, Digital Sound, 08:01, 2014

JCAL 藝術館，紐約，美國 JCAL Art Center, New York, USA

◀ **大巴比倫城**
Great Babylon
3D 動畫、數位聲音 3D Animation、Digital Sound, 04:07, 2016

夏娃克隆創造計畫 I
Making of Eve Clone I
投影、3D 動畫、數位影音
Digital Sound, 3D Animation, Projector,Stereo System ,Seamless Paper, 2016
10:00

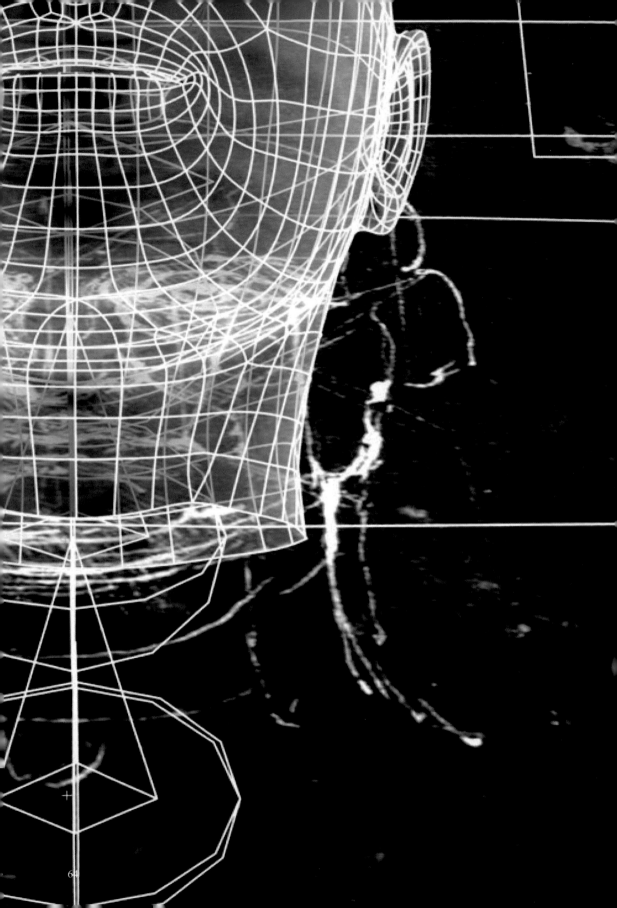

1990~2018

三、全系列評論

All Series Essays

天啟與創生
林珮淳的夏娃克隆系列

蕭瓊瑞 │ 藝術史學家

《藝術家雜誌》，2017 年 │ Academia. edu

作為虔誠的基督徒，林珮淳曾經是台灣 1990 年代「女性主義」藝術運動中，最重要的推動者之一，也曾主編《女藝論》(1998) 這樣具時代經典意義的論文集。

但就在新世紀展開之際的 2001 年，她受聘擔任國立台灣藝術大學多媒體動畫藝術研究所所長，兼任數位藝術實驗室主持人；並在 10 年後的 2011 年，正式推出「夏娃克隆系列」大型個展，驚艷藝壇，成為當代台灣結合女性藝術與數位藝術，最具震撼性與反思性的代表作品之一。

「夏娃克隆系列」首次大型個展是發表於台北當代藝術館，到了 2017 年台北新苑藝術中心的「夏娃克隆創造計劃」，前後 7 年，這是一整套的創作思維與發展，且持續進行中；當中既有「天啟」的宗教感應，也有藝術家對人類命運的自省與「創生」，是台灣近年來前衛藝術創作中罕見的傑出類型與範例。

「夏娃」是人類理解中的第一位女性。上帝依祂的形像創造「亞當」之後，認為：一個人單獨生活不好。於是取下亞當的一根肋骨，創造了夏娃。夏娃從一開始，似乎就註定了「附屬於男性」的命運。

作為長期關懷「女性主義」議題的藝術家，同時又是基督徒，林珮淳以夏娃作為創作的題材，顯然是極為自然、合理的選擇。

2004 年初版的〈夏娃克隆 I〉，是結合一個較平常的裸體少女，和藝術家此前「蝴蝶系列」的翅膀，以 3D 動畫的方式，在大型螢幕中，呈顯夏娃展翅的動態影像。2006 年的〈夏娃克隆 II〉，夏娃的翅膀開始蛻變成包裹身體的蛹，在猶如巨型試管的情境中，因觀眾的介入，出現許多飄浮的水泡 (Bubbles)，隨著觀眾人數的多寡，而產生數量不同的水泡，也決定了蛹→翅膀→夏娃之間幻變的狀態與速度。2009 年的〈夏娃克隆標本〉，則以光柵片呈現擁有美麗多彩翅膀的夏娃，猶如標本般的陳列。

等到 2010 年的〈夏娃克隆肖像系列〉，這是一個重要的變化，原本較似平常少女的夏娃，此時強化了她克隆人（複製人）的特徵，且和《聖經》〈啟示錄〉當中的描述結合，在頭像特寫的巨大 3D 影像中，夏娃原本光滑的頭頂和背部，開始出現神秘的雕紋，那是啟示錄中代表「獸印」的「666」，分別以中、英、阿拉伯、埃及等文字標示，給人一種人獸合體的感覺，尤其那美艷卻冷酷的眼神，會隨著觀眾觀看角度的改變，靈活地轉身、回首、凝視，在藍綠的冰冷色調中，系列排開，給人極大的衝擊與震撼。

2011 年，在台北當代藝術館大型的個展，正是以〈夏娃克隆肖像〉為主體，改成六角環場大型互動投影的展示方式，且加入了浸泡在水中（試管藥劑）的效果與背景音響，取名〈夏娃克隆Ⅲ〉，搭配〈夏娃克隆手〉及〈夏娃克隆手指〉，這兩件以樹脂雕成的雙手及斷指的模型，放置在醫學生物標本的試管中。《聖經》記載：666 的獸印，不僅出現在額頭上，也會出現在右手上。因此，藝術家以六雙不同姿勢、印有獸印的雙手，擺置在猶如醫學用福馬林藥劑的大型玻璃試管中，模擬一種「實驗中」的狀態；且六支右手，又刻有不同材質如蛇皮、樹皮、蛹皮、貝殼、五金、與礦石的質感，凸顯「基因突變」的「夏娃克隆」。而被切斷的六支手指，加上 666 獸印的編號名牌，更強化了生物實驗基因器官被「切除」、「保存」的物化印象。

同年（2011）的〈夏娃克隆Ⅳ〉，則是〈夏娃克隆Ⅲ〉的擴大，在國立台灣美術館《2012 台灣美術雙年展：台灣報到》中展出；除了六面體尺寸的擴大，更加入現場影像的合成，讓觀眾與作品間有更緊密的結合；同時在色彩上也改為六種色澤的變化，豐富了情境變化的感受。

2011 年，是藝術家創作豐收的一年；在〈夏娃克隆Ⅲ〉一作中，不論數位科技運用或創作思維，創作能量也進入高峰；同年，又有〈量產夏娃克隆〉、〈透視夏娃克隆〉，及〈夏娃克隆啟示錄〉的完成。

在〈量產夏娃克隆〉一作中，獸化後的夏娃發展成全身式的坐姿，原本以 6 為數量的呈現，更擴展 3 倍成為 18 件；在一字排開的數位相框內，每一個夏娃克隆各有不同的色澤和 18 種文字標記的「666」獸印，以同樣動作的 360 度自轉，表現複製人製造過程的量產化與規格化。

而〈透視夏娃克隆〉，則是挪用紅外線攝影的意象，刻意凸顯夏娃克隆身上的 666 獸印，和刺青的圖騰，包括：玫瑰、龍、鳳、蛇、蠍子等，那是一種美麗的危險；而影像上方的文字，則模擬紅外線攝影經常有的系列編碼，記錄診斷日期、時間，及診斷者等資訊，也是一種醫學與生技的意象強化。

〈夏娃克隆啟示錄Ⅰ〉是此後系列作品的重要開端。在此，藝術家將夏娃克隆比擬成〈啟示錄〉中管轄地上眾王的女人。〈啟示錄〉17 章第 5 節記載：「在他頭上有名寫著說：奧秘哉！大巴比倫，作世上的淫婦和一切可憎之物的母。」同樣的經節，分別以中、英、希臘、拉丁、希伯來等文字呈現，書寫於畫面下方；而畫面上方則是以電腦自動運算的數字，來表達生命指數，當觀眾進入現場，生命指數就開始啟動，並快速累進；當觀眾離去，生命指數馬上停止，夏娃克隆身上的色澤也逐漸褪去。

這件作品首展於台北新苑藝術中心；之後，多次受邀參展，包括：2011 年台北華山文創園區的「未來之身：數位藝術展」、2012 年新加坡藝術博覽會、2013 年波蘭弗羅茨瓦夫的「波蘭媒體藝術雙年展」，及 2015 年台北市立美術館的「末日感性：台灣新媒體藝術展」等。

〈夏娃克隆啟示錄〉在 2012、2013、2014 年，陸續發展出 II、III、IV 等系列。在發展〈夏娃克隆啟示錄 I〉的同時（2011），藝術家也曾經以平面輸出方式，並註以六種不同文字的〈啟示錄〉經節，推出〈夏娃克隆啟二錄文件〉展；2012 年的〈夏娃克隆啟示錄 II〉，則是以全像成影的科技手法，將原本〈夏娃克隆啟示錄 I〉中的動態影像、時間，與經文，呈顯在一幅平面上，試圖討論「時間被凝固，卻又依觀眾的視點被瞬間轉動」的新式文件觀，這些畫面被框架在一種古典、華美的寬大畫框之間，對比了古典與科技之間的並存、拉扯與張力。

2013 年的〈夏娃克隆啟示錄 III〉，除了大型曲面寬景投影和程式運算的互動影像，加上聖樂般的背景音樂和空間氛圍，藝術家又加入了位於弧形畫面正前方的一座夏娃克隆頭像，這是《聖經》舊約〈但以理〉書中記載的金色大偶像，觀眾只要用手觸摸其頭部的 666 印記，後面弧形螢幕中的夏娃克隆便會抬頭並開始舞動身體。

至於 2014 年的〈夏娃克隆啟示錄 IV〉，則將實體在前、螢幕在後的場景，完全影像化，同時，頭像也改成全身坐像。這尊夏娃克隆，已經完全是〈但以理〉書中形容的「大偶像」：「形狀甚是可怕，……頭是精金的，胸膛和膀臂是銀的，肚腹和腰是銅的，腿是鐵的，腳是半鐵半泥的。」（2 章 31-33 節）她在廢墟中被海水所淹沒，海水被染紅變成血；最後，她逃出水面，卻被一塊石頭砸得粉碎，變成「……如夏天禾場上的糠粃，被風吹散，無處尋得，………。」

〈夏娃克隆啟示錄〉系列，在 2014 年以〈大巴比倫城〉作為總結。在〈但以理〉書記載的「毀滅之城」，成了現實世界中的紐約城，影片中的夏娃克隆，站在帝國大廈之頂，鳥瞰高密度的建築與街道，似乎夏娃克隆正像那掌管大巴比倫城的「大偶像」，最後卻眼睜睜地看著這城的被大火焚燬，包括她自己。

林珮淳的「夏娃克隆系列」，在 2015 年進入一個新的階段，也就是〈夏娃克隆創造計劃〉系列。從《聖經》的故事、預言，重新回到夏娃克隆本人。藝術家回溯自我創造（創作）夏娃克隆的整個過程，在設備、資源極其受限的情況下，如何從線稿的發想出發，進入電腦軟體建構的人形網格，到漫長的逐步貼圖：仿人的膚色、仿金屬色、仿全像的綠光色、仿金頭大偶像，再以 360 度自轉而展現每一階段的形變……。這是一個創造（創作）的過程，既受「天啟」的感應，也是藝術家不自覺介入「創生」的歷程。

在〈夏娃克隆創作計劃〉中，藝術家將〈大巴比倫城〉中那個雙手十字形張開、俯視大地的夏娃克隆，疊合到達文西知名的人體比例圖稿，發現兩者之間神奇的相似：不僅是身體比例的相近，在尋求「挑戰神的原創」這樣的思維上，也是高度的吻合；而在兩者間，也都同時映現了藝術與科技間的對照與互文。

2017 年在台北新苑藝術中心的展出，包括了〈夏娃克隆創造計劃 I〉這件和達文西手稿疊合的主要作品，以及〈夏娃克隆女神的誕生〉、〈夏娃克隆創造文件 I—手部、頭部正面、背部、頭部側面〉、〈夏娃克隆創造文件 II—金頭與銀胸、銀胸與銅腹、鐵腿與半鐵半泥腳部〉等組作品，結合平面輸出與電腦 3D 影像，藝術家全面回溯、整理了夏娃克隆自 2004 年以來創造（創

作）的歷程與細節。

從 2011 年的首次大型個展以來，藝術家便標示：創作「夏娃克隆」的用心，是在扎判科技的過度自我膨脹，以及人類企圖挑戰上帝原創本質的迷失。這是對人類自 1996 年以複製生殖科技培養出第一隻複製羊桃莉以來，高度發展人工生命的一種深沈反省，也是藝術家自 2004 年以來，一系列《非自然—回歸大自然系列》（台藝大藝術中心，2004）、《人工生命—回歸大自然系列》（中央大學藝術中心，2006）創作的思維延續。然而藝術家批判科技過度膨脹所採取的手法，偏偏就是她所一心批判的科技。或許就如羅蘭·巴特所說：「反迷失最好的武器，可能就是以他的方式將他迷失化，並製作一個矯揉造作的迷失。」

長期以來，評論者也都以「反科技」的角度，來理解、詮釋林珮淳「夏娃克隆」的系列作品。不過，如果我們重新回到林珮淳作為一位創作者，長期的創作思維與手法，包括自 1995 年在台北市立美術館的《相對說畫》以來，她始終有一種二元辨證、彼此互文的基本思維模式，如：真實／虛假（1996）、景觀／觀景（2000）、非自然／大自然（2004）……等；「夏娃克隆」系列創作，固然帶著反科技過度膨脹的原始動機，甚至在創作的過程中，加入了宗教「天啟」的強化，但到了《夏娃克隆創造計劃》，我們慕然發現：一度不再被提及、關注的「女性主義」思維，反而在這些作品中，竟是如此自然而明確地被舖陳、展現出來。夏娃不再只是從亞當胸前取出的一支肋骨，夏娃克隆在自我建構、創生的過程中，和達文西〈維特魯威人〉（V truvian Man）圖中的那個男人，擁有完全同樣的比例、思維，與價值。

甚至早在〈夏娃克隆肖像〉中，那雙美艷、冷艷、逼視觀眾的眼睛，就讓人不自覺地想起馬奈〈奧林比亞〉中那雙直視畫外觀眾的眼神。

林珮淳在長期堅持、辛苦耕耘的努力中，已然成為 90 年代崛起的一批女性藝術創作者中，迄今擁有最強活力與傑出表現的藝術家，且持續開展中，值得密切關注與期待。

夏娃克隆創造文件 II Making of Eve Clone Documentation II

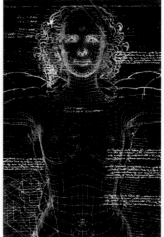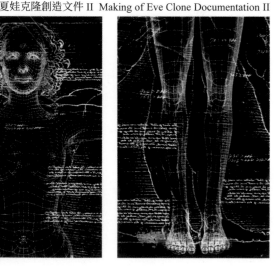

正說話的主體
林珮淳的夏娃克隆

鄭芳和

《藝術家雜誌》，2014 年 ｜ Academia. edu

林珮淳一位敬神愛人的基督徒，當基督徒與女性主義相遇後的創作火花，是美學的、也是哲思的，更是藝術與宗教交纏的心靈圖象。

進入魔幻的天堂

林珮淳這幾年潛心創作大型影音互動裝置〈夏娃克隆啟示Ⅲ〉（2013），在台北當代藝術館展出，展場漆黑一片，當觀眾觸摸夏娃克隆雕塑的頭部，現場響起如聖歌般的史詩音樂，同時環形屏幕中的夏娃克隆影像絢麗光彩，旋轉自如，撩撥觀眾的耳目，影像上方的數字條碼與下方的啟示錄文字，歷歷在目，宣告末日的浩劫。

青春處女的華麗轉身與文字、條碼的天遣懲罰，對比張力強大，加上聖詠般的樂音，在視覺、聽覺、觸覺的感官奏鳴下，讓人彷彿瞬間進入魔幻的天堂，旋即又掉入被逐出樂園的夢魘，肉身的享樂與靈魂的燃燒並生共存。

夏娃成為林珮淳影音創作中最致命的吸引力，而她為何選擇夏娃作為這幕影音劇的主角呢？

第一位女性夏娃

夏娃是聖經所描述的第一位女人，而基督教長久以來又視裸體為罪惡，在中世紀裸體畫無法被呈現，直到 15 世紀末文藝復興時期，藝術家違抗教會禁令，終於形塑出與世人裸裎相見的夏娃圖像。如馬薩其奧〈亞當和夏娃被逐出伊甸園〉（1425-1428），夏娃頭上仰，神情哀慟，一手掩胸，一手掩下體，亞當雙手掩面，雙雙步出伊甸園。馬索利亞的〈亞當和夏娃在智慧樹下〉（1425-1428）、杜勒的〈亞當與夏娃〉（1507）、老魯卡斯 · 克爾阿那赫的〈亞當和夏娃〉（1526）及阿德利安 · 伊森布蘭德特的〈亞當和夏娃〉，畫中象徵罪與罰的亞當與夏娃，以裸體畫現世，也暗喻他們的墮落與羞恥感。夏娃作為地球上的第一位女性，依《聖經》創世紀的記載，上帝創造了亞當，又取他的一根肋骨創造了夏娃，兩人在伊甸園盡情享受一切，卻因夏娃受到蛇的誘惑吃食智慧果，亞當又在夏娃的慫恿下也食用禁果，種下人類的原罪，雙雙被上帝逐出伊甸園。

邪惡又美麗的夏娃克隆

夏娃在林珮淳的創作表現中，仍延續文藝復興時期的裸體形象，只是她不是用畫的，卻以多媒體藝術打造虛擬實境的夏娃，她喚名為「夏娃克隆」。究竟林珮淳如何以女性獨特的經驗與觀點，顛覆男性一手建制的主流美學，而她又如何解構夏娃成為夏娃克隆，重新找回女性「說話的主體」權？

女性裸體禁區本為男性藝術家所專屬，然而 21 世紀的女性藝術家也不甘示弱地攻城掠地，大膽解放女體。林珮淳認為西方女性藝術家以女性自己的身體器官去顛覆父權文化中對女性的意念與形象，是相當犀利、叛逆、反傳統的策略，主要的目的是反西方「傳統」藝術中「裸女畫」背後的意識型態，意即男人從靜態的事物中為自己創造了一個理想的色情物，依他的慾望將女人剪裁成特定的模式，所以女性藝術家以「身體」抗議女性在父權文化長期被情色支配，被當成男性創作的客體位置。

解構父權文化一向是清醒、自覺的女性主義林珮淳的創作本色，她的「夏娃克隆」系列雖不是如西方女性主義藝術家以自己的身體直接作為載體，然而她以「藝術之名」所形塑的夏娃克隆，宛如替代她的身體意識發言。

在〈夏娃克隆啟示錄〉（2011-2012）中，那一位位裸身低首半蹲、雙手撫胸、杏臉美眉、細皮嫩肉，彷如蛹般，即將破繭而出，她全身淋漓盡致地暴露在觀者眼前，溢滿官能美與挑逗性，完全符合男性所慾望的女體。而在〈透視夏娃克隆〉（2011）中，嫵媚的夏娃克隆在紅外線的透視下，比古典的維納斯更嬌媚，額頭、臉頰、乳房、臀部等皆佈滿玫瑰、龍、鳳、蠍子、蛇等刺青圖騰，夏娃克隆玲瓏有致，細腰豐胸美臀，完全符合男性眼中理想的完美女體身段。林珮淳欲以男性所最慾望的標準女體，反思鼓勵凝視女體的父權文化。

在說話中的主體

夏娃克隆美則美矣，卻不是只一昧地嬌美、柔美，她美得充滿個性，也美得冷峻。在〈夏娃克隆肖象〉（2010-）中，每一個被裝框、封存的夏娃克隆，她的頭部人蛹合一，殘留著蛻變的表皮膚層，她的前額髮梢覆蓋，藏著印記，雙眼炯然有神，充滿獸的魔力。

弔詭的，當你觀看她，她也同樣地觀看你，兩人四目交并，相互對視，直到你的眼光離去，她的眼光始落下。以 3D 動態全像高科技材質製作的肖像是林珮淳欲塑造一位「在說話中的主體」的女性自我表達，那種表達不是主從關係、不是尊卑關係，是潛藏於女性身體能量的勾魂攝魄，欲以一種不馴服的身體方式，挑戰千瘡百孔的男性美學。其實男性無孔不入的凝視，難道不會造成女性無所不在的心理壓力嗎？

林珮淳的創作，總是不斷尋尋覓覓，尋求一個能與男性中心主義相抗衡的藝術表達系統，她希望透過她所打造的身體與姿態來說話，印證女性在赤裸的肉身裡仍藏有她的主體慾望。林

珮淳摻和了梅洛龐蒂的身體「姿態表達論」與克里斯瓦尋求「正說話的主體」的自我表達體系，創作具有主體性的夏娃克隆，雖然她既邪惡又美麗，誘惑人又箝制人，且散播著末世論。

女性的身體風華，有時如前青春期雌雄同體的清純嬌嗔，有時如青春期的含苞欲滴，有時如熟齡時的華麗飽滿，香豔迷人，而垂垂老矣時，身體鬆垮如花之凋謝，是自然節奏的循環。在〈透視夏娃克隆〉中，夏娃克隆那有血有肉可欲的身體，自由自主地展現自己楚楚動人的身軀，擁有傲人的身體曲線，但曲線美不是唯一，是自我覺醒的女性意識才是唯一，當女人能真正擁有自己的身體，不再是社會、文化制約下的身體，才能反轉以男性為中心的文化史觀。

在〈夏娃克隆啟示錄〉中，女體是蹲在有如充滿液體的試管中，那透明的流液有如女性孕育嬰兒時流淌於體內的羊水，那是身為母親的特殊、獨有的經驗，正是男性天生無法也不能享有、擁有的經驗。而那流液也象徵著女性如潮騷般的流動慾望。

人的全能凌越上帝

以聖經所載的聲色場域中的巴比倫大淫女的美麗與邪惡的女體媚惑作為「夏娃克隆」系列的主軸，再經由凝視／被凝視翻轉客體為主體，林珮淳的女性觀點以露骨大膽的女性裸體來抗衡男性的大敘述美學，十分突出。然而她更關注的是夏娃的「克隆」身份。

克隆（clone）是複製，是無性繁殖，夏娃被無性繁殖為一個群體，在〈量產夏娃克隆〉（2011）中，她正在試管中成形，以不同的色澤面世，只是她一出生額頭上即烙印下一道鮮明的胎記「666獸印」，且以英、法、德、中等18國語言書寫，360度轉身示人。

當夏娃像複製羊、複製牛一般，被量產、被規格化，缺乏倫理觀念的科學研究，是人類的福祉或苦難呢？在各國人士的醫療倫理觀點上，對「複製人」的反對，紀靜惠歸納出七項原因，一是破壞人的尊嚴和獨特性，二是科學的不確定性，三是扮演上帝，四是違反自然，五是破壞家庭的完整性、六是減少基因多元性、七是可能被獨裁者濫用。

身為虔誠的基督徒的林珮淳也與神學家的看法一致，認為人類科技所欲製造的複製人，危損了人類自身的尊嚴，而人類的全能是否已凌越了全能的上帝？林珮淳在科技的震撼下，也以震撼的3D動態影像的多媒體藝術，意圖揭示科技危機。

量產夏娃，末世劫難

當夏娃在純淨無染、無塵的試管中，為科學家隨心所欲地量產，生命可以量產，無疑是對天下母親的致命挑戰，母親的神聖天職，無端為實驗室的產物所解構，對母親而言，真是情何以堪。

當生命不再是來自上帝，亞當與夏娃不再是經由性愛而自然受精、妊娠、分娩，當科技僭越女性的天職，林珮淳所量產的夏娃克隆，注定天生背負獸印的苦難。不同語言的666獸印跨文化、跨語言、跨文字、跨國界，無所不在。林珮淳說：「各族各民將無法逃脫獸的挾制。」自2010年以來林珮淳一再以她的「夏娃克隆」系列傳播末世預言，反對複製人（克隆人）。

此外，林珮淳也以透明樹脂雕塑製作〈夏娃克隆手〉（2011）一罐罐有如浸泡在福馬林裡的雙手，既有獸印，也呈現蛇皮、蛹皮、貝殼、五金與礦石等基因突變的可怖變化。隻隻試管如標本，女人的肢體可以如此被切割、被支解、被變種、被繁衍、被實驗，一切都被「去自然化」，

取而代之的是「標本化」，宇宙的生成化育將會繼續運轉嗎？林珮淳不斷拋出刺點，以她的問題意識及模擬科學家的實驗的〈夏娃克隆〉，反諷人類肆無忌憚地製造克隆生物，終將遭禍。

獸印，現代啟示錄圖騰

近十幾年來人類基因圖譜完成，導致科技基因改造工程甚囂塵上，使得林珮淳以女性主義的角度思考《聖經》啟示錄經文，作為創作關懷與批判。她引用啟示錄的章節，如：「祂又叫眾人，無論大小貧富、自主的、為奴的，都在手上或是在額上，受一個印記。」（13：16）「除了那受印記，有了獸名，或有獸名數目的，都不得作買賣。」（13：17）

獸印這個啟示錄上所記載的文字，在林珮淳的作品裡化為似神聖又似魔鬼的視覺圖騰，用以批判迷戀於複製克隆人的科學家，因為他們與上帝爭相造人，早已僭越職權，必將擾動宇宙自然的循環，終將導致災難降臨。一位女性基督徒的驚世之作，並非危言聳聽，作為母親／妻子／藝術家／教授／女兒的林珮淳企圖在扭曲、壓抑的父權傳統中，以多媒體藝術闖蕩山女性自主的原始活力、魅力，一如她所說的「上帝創造夏娃，我創造夏娃克隆」。

「夏娃克隆」系列在藝術呈現上，以3D動態全像，3D電腦動畫，數位圖像及聚光燈等多媒體整體呈現，講究燈光色澤運用與身體的表達姿態。林珮淳所創造的夏娃克隆，不必是驍悍跋扈，可以是嫵媚撩人、搔首弄姿，但別具主體意識。

「夏娃克隆」系列作品是穿梭在男性窺視，女性暴露的情色美學與宗教的神聖、聖潔及科學的操弄、僭越之間的藝術，林珮淳既在打破女人的身體在父權文化中被物化的命運，為女人找到發聲的主體性，也為她的宗教信仰找到救贖的力量。

追求性別的自主

大多數的人都認為女人結婚生子後就無學術生命，遑論藝術生命。回想二十多年前（1992），林珮淳在銘傳商專任專任講師，在身為母親育有一子的處境下，為追求自己的理想，拋棄穩定的教職，克服夫婿的全力反對，承受婚姻的壓力與家庭經濟負擔，毅然決然攜子遠赴澳洲攻讀藝術創作博士。初到澳洲除了為適應當地的學制外，又須寫小論文及創作並照顧孩子，多少次她擒著淚獨自在異鄉背著孩子從工作室回家，在身心交瘁下，她更深入感受女性在現實與理想之間的掙扎，萌發她在澳洲研究西方女性主義，她開始覺知到身為女性的處境，體會兩性不平等的社會結構，更意識到女性的尊嚴與價值，從而啟迪她的女性意識。學成歸國後她在台北市立美術館舉辦「相對說話」個展（1995），以古代女子最美的至高標準三寸金蓮對比今日的美容塑身，反思女人長期以父權文化的標準為標準，無知無覺，無法真實掌握自己的身體與思想，由古至今竟如出一轍。

以女性意識批判父權文化

「為什麼寫藝術史的手都是男人？」「為什麼藝術史上沒有偉大的女性藝術家？」西方女性主義的至理名言，支撐她在創作中以「女性之眼」持續關懷女性議題並將創作觸角擴大至社會議題，如〈黑牆、窗裡與窗外〉（1996）以裝置藝術關懷受難家屬的內在辛酸苦楚，尤其是女性的悲涼印記，另一件〈向造成台灣歷史大悲劇的當局致意〉（1997）以一長桌金碧輝煌的獎杯頒贈政府，以反立碑的裝置藝術，強烈批判官方的強權。而〈安全窩〉（1997）訴求社會對婦女生命安全的侵害。

由於林珮淳身為教育工作者，對教育價值的淪失，感同身受。她以影像的合成、輸出，將中國經典中的文字與古今圖片對照的〈泰伯第八〉（1998）或〈女史箴〉（1998），凸顯傳統與現代的矛盾，反諷台灣教育與價值、倫理體系的崩解。〈骰子〉（1998）則以刻有古訓文字的平面壓克力板結合骰子的圓點，批判台灣人追逐金錢的投機行為。

自 80 年代解嚴之後台灣的價值分崩離析，林珮淳以悲憫之心不斷批判當今社會的種種亂象，從 228 政府的不當行為到婦女被性侵，再到台灣成為投機者的天堂—貪婪之島，而這一切現象都在以父權文化為主流的社會發生，她一再以作品作為針貶社會的利器如〈安全窩〉、〈美麗人生〉等。

從對倫理道德的淪喪到人心險惡、人性貪婪的批判，林珮淳在經歷 921 大地震的身心震撼後，1999 年開始進行「回歸大自然」，如〈生生不息，源源不斷〉、〈寶貝〉、〈景觀、觀景〉等以人造、複製、數位、虛擬等科技與媒材，反思科技文明與大自然的對立關係。千禧年後，她的創作運用更多的數位科技，以更高階的互動科技與「即時互動」影像，在「浮光掠影」（2004）、「情迷意亂」（2005）、「美麗新世界」與人工生命（2006）等等個展中，再度對人造自然與人工生物進行智性與感性的批判。

林珮淳說：「生命的體悟、感動與信仰才是驅動我創作欲望的來源。」當全球的藝術家紛紛關注身體與性別認同及科技與生命繁衍，在複製人、跨性人、變種人的新興議題上，發揮充沛的藝術想像力與批判力，林珮淳以她的宗教信仰與生命關懷，從陰性思維出發，運用她所擅長的數位藝術，讓人進入她的藝術場域，彷彿跌入極樂與死亡的黑洞，經歷魔與神的試煉。

以藝術載道，召喚世人

2014 年終極版的〈夏娃克隆IV〉，夏娃克隆終於由滿溢水漾的試管中誕生於世。只是她一誕生便遭遇大洪水，她奮力漂浮，雙手左右擺盪，有如耶穌受難的十字架，當她躍出海面那一剎那，竟遭從天而降的巨石砸中腳部，致命的一擊，令她半鐵半泥的腳部開始破裂，進而鐵腿、銅腰、銅腹、銀胸、銀臂再到金頭，全身一一碎裂，消失在無垠的大水中，化為一片雲／靈光，恢宏的聖歌全場響起。一條條《聖經》啟示錄文字再現於銀幕。

林珮淳直言：「人類終究要接受神的審判，看見自身的高傲。」又說：「人心變了，人心變得太功利、太自私，掠奪大自然，無法敬天愛人。我創造夏娃克隆，只是個隱射，真正要批判的是人的狂傲，只想扮演神。」如果人類無限上綱克隆技術將人的誕生不斷格式化，相信林珮淳將會義無反顧地以她所建構的「數位藝術實驗室」繼續反噬人類的「複製生殖實驗室」。林珮淳不諱言：「神愛祂所創造的全人類。」神創造了夏娃，而夏娃克隆不是神所創造，終遭致毀滅。林珮淳的「夏娃克隆」系列的創作思維就在夏娃／夏娃克隆的真人／假人，真實／虛擬的辯證中由 2011 年到 2014 年逐步推演，讓人看到基督徒的女性主義藝術家以最科技的 3D 影音互動，鋪陳虛擬出她所演繹的現代版創世紀與啟示錄。她本著「神愛世人」與「藝術載道」的精神，喚起宗教與藝術的啟明／啟靈的神聖力量，召喚世人尊重神所創造的世界。

雙重信仰加持

林珮淳由早期油畫作品中首度出現的蛹，一個受父權文化壓抑的蛹，到關懷大自然女體與蝴蝶混種的蝶女，再到蝶女翅膀蛻化為人蛹一體的夏娃克隆，作品由靜態的平面到裝置再到影

音互動，不斷蛻變，她所關心的論述主題也逐步由女性主義轉而關注神所創造的「人」，人類生命存在的生命品質的更大命題。

走入夏娃克隆的世界，在酷炫的女體與各色聲光的感官刺激下，卻存在著一個發人深省的科技與人的弔詭。科技非全能，它可以為惡也可以為善，它的為惡為善都將衝擊全宇宙的能量。人與科技之間的平衡，唯有擺脫以自我為中心的「自我意識」，才能看見浩瀚宇宙中人的渺小，而敬畏一切，同時也看見自己的偉大，活在精神的富足中，而不再被永不饜足的「自我意識」所驅使，奔馳在物質世界的欲望中。

林珮淳是一位當代女性以數位藝術在高科技年代，走出自己創作主體的難得又傑出的數位藝術家／多媒體藝術家，尤其在近幾年全力創作的「夏娃克隆」系列，探究大自然與科技文明的辯證及複製人的生物倫理議題，進而關懷人類存在的生命哲學課題。作品的獨特性、批判性、藝術性與震撼性已引起國際認同。

林珮淳已有自己虔誠的宗教信仰，而在藝術上也已找到女性「說話主體」的信仰，雙重信仰的加持，加上她犀利的批判性格與悲憫的宗教情操，交揉並用，相信將使她的生命更加流動、奔騰，更加波濤壯麗。

參考書目
· 王建元〈梅露彭迪的知覺藝術與女性主義的身體論述〉，中外文學，28 卷 12 期，2000 年 5 月。
· Claudia Rehberger，余曉雯譯〈女性的生活與夢想空間〉，當代 167 期，2001 年 7 月。
· 紀靜惠《各類人士對醫療倫理觀點差異之探究》，中山大學人力資源管理研究所碩士論文，2002 年 6 月。
· 林珮淳《林珮淳 - 夏娃克隆系列》，新苑藝術，2012 年 1 月。
· 林珮淳《從女性創作觀解構台灣歷史、文化的社會現象，》女書文化，1999 年 9 月。

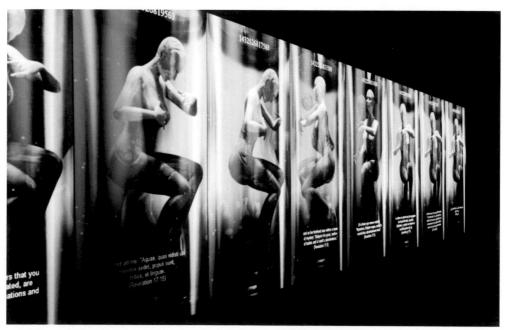

夏娃克隆啟示錄 III Revelation of Eve Clone III

人生美麗嗎？
談林珮淳反科技的科技藝術創作

葉謹睿 | 藝術家、藝術作家、國際策展人

對我而言，解讀林珮淳的作品，其實是一件具有挑戰性的工作。第一次看見林教授的作品，是她展出於紐約皇后美術館的《美麗人生》。這一件大型裝置作品，以 32 件國畫立軸形式的巨型數位輸出所組成。利用懸空吊掛的方式，在空間中建構出一個螺旋型的通道。遠看，黃褐的色澤和圓弧的造型，古典、優雅，似乎是一個古色古香的文化迴廊；近看，才發現畫面的構成元素，是無以數計的泛黃社會新聞和廣告。狹隘的通道讓人毫無選擇，陷身其中，你只能摩肩擦踵地去體認那些並不美麗的現代生活社會版。

頗為耐人尋味的，是這件作品與原始展出地的對應關係。《美麗人生》於 2004 年首次發表於美國紐約，而林珮淳所選擇的新聞資訊來源，卻大多都來自中文的媒體。也就是說，當地的非華裔觀眾，其實無法以知性來了解這些新聞和廣告的文字內容。那麼，這些美國藝術愛好者真能夠欣賞這件作品嗎？答案是肯定的。不諳義大利文者，也可以隨歌劇「波西米亞人」的動人旋律而潛然淚下；不識歐洲歷史者，同樣也能夠為 Goya 的史畫「1808 年 5 月 2 日起義」而動容。藝術語言跨越時代、種族，淵遠而流長的軟實力，就是來自於它能夠超越文化和語言侷限的感性特質。這一點，其實是毫無疑問的。但，《美麗人生》對於非華裔觀者的衝擊，是否與你我所感受到的全然相同？這個問題的答案則是否定的。因為對於非華裔的觀者而言，中文報紙頭條新聞所代表的，是一種對於遙遠社群生活脈動的想像。中國傳統的水墨捲軸形式，進一步將《美麗人生》推向歷史的浪漫懷抱。但這種感性浪漫想像成立的主要原因，其實是來自於對於主題認知不甚解所造成的迷濛。距離，是最優美的化妝師。

距離與美感

以距離創造美感的方式有兩種。台北當代館的石瑞仁館長，曾經在介紹林珮淳作品的時候，把她的創作與著名美國女畫家 Georgia O'Keeffe 做連結。[1] 這個對照方式是合理的，因此我們在這裡可以延續石館長的論述，藉此說明距離與美感之間的關係。第一種距離美感，是因為太過貼近所以將局部無限放大，因而所造就出來的一種以偏概全的遐想。很明顯地，Georgia O'Keeffe 以花為主題的油畫，就是這種型態的代表作品。Georgia O'Keeffe 在 1924 年前後，開始以放大的花卉特寫為創作主題。極度貼近的零距離局部放大，將花朵從現實環境之中抽離出來，成為引人入勝的優美視覺律動。有趣的是，在局部萃取花卉美感的同時，卻也留下了無限的想像空間。因此，儘管 Georgia O'Keeffe 在有生之年，多次聲明這些作品根本沒有影射女性生殖器官的意圖，也不是一種為突顯女性主義思想而採取的創作手段，但，依舊無法阻止

1　石瑞仁（2004）軟硬兼施、面貌兩極的藝術 - 解讀林珮淳的複合媒體裝置，走出文明、回歸伊甸，page 2-3

以男性主觀之性別想像所建構出來的解讀。[2] 第二種距離所造成的美感，則是因為抽離而產生的憧憬。這種可能性，可以用 Georgia O'Keeffe 在新墨西哥的畫作為代表。對於 Georgia O'Keeffe 而言，看似荒蕪的新墨西哥原野，其實是她精神的避風港。在這裡，她經常以乾枯的動物骨骸以及不起眼的枯枝為主題，透過對於蒼漠景物的深刻描繪，營造出近乎神性的空靈。生命的殘骸為什麼能夠如此美麗？答案的關鍵，就是在於時空間隔所造成的抽離，讓泛白的骨骸遠離垂死掙扎的悲鳴，一望無垠的蒼穹與歷經風霜的過往對仗，更是讓一片蔚藍有如未來一般地讓人充滿無限期待。

從主題物來討論，林珮淳與 Georgia O'Keeffe 可以說是有其相近之處。在 1999 年的 921 大地震之後，林珮淳改變她的創作方向，花卉、藍天與大海等等自然景觀，成為林珮淳所經常運用的視覺元素。與 Georgia O'Keeffe 以極度貼近或者完全抽離的手法恰恰相反，林珮淳所堅持的創作策略，是一種刻意保持安全距離的冷漠。因為，她所呈現的是一種文化現況，因此遐想或憧憬都並不適合。

林珮淳對於科技發展的看法是悲觀的，在她近十年來的創作裡面，毫不猶豫地運用各種方式來強調她對於文明和科技的控訴。從表象上來看，林珮淳的作品很「漂亮」，但是當你真的想要去接近它時，就會意識到那種亮麗是冷漠、虛假、人工和造做的。比較早期的作品如《生生不息，源源不斷》、《觀海》、《觀天》、《大地之光》和《寶貝》等等，都是這種性質的作品。色彩明艷、造型俐落，活像是都會街頭亮眼的廣告看板，無關過去也不保證將來，一切以現在、當下為基準，冷漠地呈現著你我已然習慣身處於人工環境之內的事實現況。在「回歸大自然系列」的創作自述中，林珮淳坦言：「這種壓克力燈箱的發光體的確奪人目光，展出時受到許多觀眾喜愛，這正是我想要批判的意圖，因為它正『反射』出都會人的心態－習慣人造景觀而不自覺它的荒謬。」[3]

創作技法的轉變

林珮淳以藝術創作來達到警世效果的企圖，在隨後的幾套系列作品，例如《溫室培育》、《花非花》以及前面提過的《美麗人生》之中，都有著更鮮明、直接的表現。在《溫室培育》系列作中，以數位 3D 技術繪製的縮影人體，被「保護」（囚禁）在一個半球型、透明的科技空

2　Stiles, A. & Selz, P. (ed), Theories and Documents of Contemporary Art, University of California Press, 1996, page 7
3　林珮淳（2004），「回歸大自然系列」創作自述，走出文明、回歸伊甸，page 20

間裡面。在《花非花》以及《美麗人生》兩個系列之中，林珮淳則是選擇直接將新聞、廣告、色情網站以及貨幣等等科技和資本主義的象徵物，直接融入作品成為視覺影像的一部分。

林珮淳所完成的第一件大型互動裝置作品，是在工業研究院光電所的技術支援下所完成的《捕捉》。這個系列作品的呈現，主要分為三個部分：以雙投影呈現的蝶影紛飛，讓觀者能夠透過偏光眼鏡來感受 3D 的立體視覺效果；主要的互動場域，則是以兩台投影機由上而下所做出的垂直投影，在這裡觀者可以選擇戴上白手套，試著去承接那些虛無飄渺的蝴蝶影像；整體裝置的最後一個部分，則是展場兩側所展示的 15 件「光柵」蝴蝶影像標本。所謂的「光柵」，是一種結合數位科技與印刷的技術，利用特殊軟體將圖像轉換成為符合光柵角度的影像，並且透過特殊的光柵板來呈現出立體影像的效果。從 2004 年開始，林珮淳曾經多次運用「蝴蝶」來暗喻「自然」。[4] 這件作品中出現把虛擬蝴蝶做成標本的手法，看似荒謬，卻是畫龍點睛地延續著林珮淳對於自然生態的關懷。對此，她在創作自述中如此表示：「這系列的作品乃再次強調人類若不珍惜大自然，總有一天只能欣賞、捕捉、悼念曾經擁有的『真實』，而取而代之的卻是一種幻象、幻影的虛擬實境。」[5] 如果我們說標本所代表的是一種封存的記憶，那麼光柵板中保存的虛擬蝴蝶影像，象徵的就是一種連記憶都只能虛擬的極度空虛。

這個階段另外一個值得注意的重點，則是科技在林珮淳作品中地位和角色。2000 年前後的燈箱作品，儘管在議題上直接挑戰科技在生活中的地位，但終極的呈現手法，幾乎都是以單純的數位輸出影像為主。儘管加上了幾何的立體造型和燈光，但其實最核心的創作語法，還是比較接近她早年繪畫背景所累積出來深厚的視覺詞彙。從 2000 年中期開始，先進的互動科技逐漸滲入林珮淳的創作之中，讓她在對於視覺表現的堅持和自我要求之外，也開始持續挑戰藝術媒材、技術和形式方面的創新。這一點，其實是有相當衝突和弔詭的，因為就在林珮淳的作品逐漸以「科技藝術」甚至於「高科技藝術」而受到重視的同時，她對於科技的批評和省思，不但絲毫不減力道，甚至可以說是與日俱增。

夏娃克隆系列

從呈現的形式上來觀察，林珮淳最新的作品《夏娃克隆》系列，和先前所介紹過的《捕捉》系列相似，這一個系列也同樣包含有立體 3D 影像以及互動裝置。在創作的主題方面，則是延續「回歸大自然－人工生命系列」中的《夏娃 Clone》，同樣以虛擬克隆人「夏娃」艷麗但脆弱的影像，來批判人類企圖模仿上帝造物能力的複製科技實驗，並且進一步警示濫用科技將會帶來的無窮禍害。《夏娃克隆》系列的展覽呈現，主要包含有以下三個部分：夏娃克隆人全像－以 3D 動態全像攝影技術，來展現這個虛擬生物各種角度的逼真樣貌；夏娃克隆人胴體－以裸眼 3D 技術，來描繪 8 種不同身體材質的夏娃克隆人，包括金、銀、銅、鐵、泥、水晶、螢光和皮革；大型夏娃克隆人互動投影裝置－結合先進的虛擬實境軟體、紅外線感應器和動態擷取技術，讓觀眾和虛擬的夏娃克隆人做即時性互動。同時，與先前的《夏娃克隆》相仿，這個美艷的虛擬夏娃克隆人，也同樣必須要仰賴觀者與它互動才能夠持續進行演化，藉此象徵現代高科技虛有其表的脆弱本質。

4　曾鈺涓（2004），控制幻影－談林珮淳之《創造的虛擬》作品中之科技警訊，原文刊於《林珮淳「人工生命－回歸大自然」個展邀請函》

5　林珮淳（2004），「回歸大自然系列」創作解析，走出文明、回歸伊甸，，page 85

林珮淳的創作源自於對生命的體認、感動、關懷以及她對於主的虔誠信仰。與先前的作品相較，《夏娃克隆人》系列運用了更多、也更明確的宗教符號。除了引用創世紀之中的伊甸園故事之外，還在克隆人額頭上以各國語言標示出代表獸印的 666，喻表各個種族和國家，都無法逃脫啟示錄所預言的末日災難。

毫無疑問地，人類社會正面臨著種種嚴苛的考驗，氣候環境的變遷、自然資源的短缺、各國之間經濟與政治的角力，一切的衝突與紛爭，都顯示了人性之中聰明有餘、智慧不足的短視。我在本文一開始，就曾經很坦白地表示，解讀林珮淳的作品，對我而言是一件極具挑戰性的工作。主要的原因，是由於我自認對於基督教和聖經故事理解的淺薄。為了進一步認識林珮淳的作品，我甚至有生以來第一次坐下認真地去研讀聖經，後來才發現，我的顧慮似乎是一種多餘的庸人自擾。不懂中文的外國人，都可以直觀地去感受以中文報頭建構出來的《美麗人生》，我雖非基督徒，但一樣也能夠從林珮淳反科技的科技藝術創作中聽到她殷切的呼喊：技術的傲慢使我們看不清楚自己在自然秩序中的地位，並且以為我們可以予取予求，要什麼、有什麼。[6]

林珮淳的作品，以炫麗的五光十色來反諷人類不斷追求科技，卻不自覺地被科技所囚禁之事實。網路和手機，到底是無遠弗屆的觔斗雲還是綁束你我的緊箍咒？過度開發對於自然環境所造成的嚴重傷害，是否還來的及彌補？生物科技是人定勝天還是逆天行道？現代人用科技所打造出來的人生，真的美麗嗎？這些問題都是我們這一個世代，所必須要有勇氣去回答和面對的挑戰。

參考書目

· Dempsey, A. (2002) Art in the Modern Era: Style, School, Movements, Thames & Hudson
· Hansen, M.（2004）New Philosophy for New Media. MIT Press
· Walker, J. (2001) Art in the Age of Mass Media, Pluto Press
· Harrison, C. & Wood, P. (ed)(1994), Art in Theory 1900-1990, Black Well Publisher
· Hopkins, D. (2000) After Modern Art, Oxford
· Lucie-Smith, E. (1999), Lives of the Great 20th Century Artists, Thames and Hudson

6 Al Gore 瀕危的地球，台灣地球日出版社，1996 年，page 231

藝術作為信仰實踐的場域
評〈啟示與警世－林珮淳創作研究展〉

邱誌勇 | 數位藝術國際策展人、藝評家

《台灣數位藝術知識與創作流通平台專欄》，2015 年 | Academia. edu

作為一位國際知名的藝術家一學者（artist-scholar），林珮淳長期以來的藝術創作與宗教信仰皆呈現出緊密扣合的關係，並存在著一個重要的命題：「藉由批判科技以關注人與自然世界的關係」。無論是早期的《生生不息．源源不斷》（1999）、《蛹之生》（2004）、《創造的虛擬》（2004），或是「夏娃克隆系列」（2006~ 今）；無論是藉由虛擬的「蝴蝶」或是「女體」，這些看似有著生命的虛擬創造物，皆是將人類文明世界認知中的生命體，轉化成「擬真」（看似虛假，卻比真實還真）的藝術客體。從二十世紀九十年代開始，因受女性主義藝術啟發，林珮淳的創作主題與內容皆源自於自身對生命的體認、感動與信仰，並「女性觀點」創作了解父權的系列作品，更重要的是，作為台灣數位藝術先行者，林珮淳近年來的創作以 3D 立體動畫、互動系統等科技媒介，營造一個末世現象，批判著若人類再盲目追求文明與滿足物慾，終將走向滅絕的警世隱喻。

法國文化社會學家布迪厄（Pierre Bourdieu）曾提倡反身社會學（reflexive sociology），認為社會學家必須利用自己的研究工作來了解自己的領域，亦即將社會世界的各個面向轉化成研究的對象。若以布迪厄的觀點來閱讀這次的《啟示與警世一林珮淳創作研究展》可以發現，林珮淳將自身及其創作客體化，並透過藝術創作的慣習與實踐，以及與社會世界之間的關係，讓信仰成為藝術實踐場域中的重要課題。在《啟示與警世一林珮淳創作研究展》中，林珮淳以她三十年來藝術創作領域的經典系列為主，並以文件形式揭示歷來出版與論述的研究文本，透過「創作研究」的方法論，完整展現其藝術創作歷程。展覽主題「啟示與警世」，數位作品以聖經啟示錄、但以理等篇章為基調，創造出「夏娃克隆的肖像」及「夏娃克隆啟示錄」系列。

以歷史系譜的軸線探究林珮淳的創作更可以發現，無論是早期創作中的傳統媒材（如繪畫、裝置），或是近年來擅用的數位科技（如全像、互動），其作品總是深刻地訴說著人類與生活世界（Lebenswelt）中的宗教哲學，如解構女性身體被物化的「相對說畫系列」、解構政治的 228 展作品（《黑牆、窗裡窗外》與《向造成 228 事件的當局者致意》）、解構功利主義，反諷讀書人追求功利的作品（如《經典系列》、《骰子》），以及解構文化、社會等議題的作品（《真實與虛假》、《繁複與思源》與《美麗人生》）等，或是批判科技複製與基因改造的「夏娃克隆系列」。透過「啟示與警世創作研究展」真實讓人感受創作者關懷生命、體悟生命、敬天愛人與個人的虔誠信仰。

更特別的是，此次的「創作研究展」所展現的皆是林珮淳近年來持續創作的「夏娃克隆系列」，包括：《創造的虛擬》（2006）、《標本 I》（2006）、《夏娃克隆 II》（2006）、《夏娃克

隆啟示錄 II》（2012）、《夏娃克隆肖像》（2010~今）、《夏娃克隆啟示錄 III》（2013）、《夏娃克隆啟示錄 IV》（2014），以及《大巴比倫城》（2014）。這一系列作品涉及到了當代最為先進的創作媒材（網路、互動程式、3D 動畫，與全像攝影術），透過科技的運用，再現「科技文明」的危險與「人工生物」的虛幻，以及與觀眾互動的關係（有觀眾就會形變），且將獸印 666 符號置放入「夏娃克隆」的額頭與右手上喻表邪惡的象徵，又大量應用宗教啟示錄章節中的典故，定義了「夏娃克隆」就是「巴比倫大淫婦」的化身，隱喻著科技美麗誘人的外表，卻是控制人類的惡魔。

此種「藉科技之身批判科技之惡」的景況猶如科技文化學者海姆（Mickael Heim）所批判的命題。在〈網路空間的愛慾本體論〉（The Erotic Ontology of Cyberspace）一文中，海姆指出：人們用來理解網路空間本體結構的方式，已決定了真實如何存在於其中。亦言之，網路實體的現象真實存在於人們對科技的迷戀上；而且，這個迷戀是一種類似於「美學式」的迷戀，也就是說，在網路空間裡，人們就像飛蛾撲火一般，那燈火闌珊處，可能僅是夢與渴求的虛幻光影罷了。我們與科技產物（電腦與網路）所產生的感情，遠比美學式的迷戀還要深刻，因為我們所尋找的是一個可以讓心靈、心思駐足的家。我們對於電腦的迷戀不僅止於感官上的滿足，更是一種「愛慾」；不僅止於功利性的使用，更是一種「精神性的寄託」。甚至，我們與這些資訊機器之間的關係，絕不僅止於娛樂或工具，我們與電腦之間的關係是一種共生的關係，最終，將是一種心靈的聯姻！[1] 承續著海姆的立論觀點，正好與林珮淳的「夏娃克隆系列」創作意圖相互呼應，意即：藉著影像、裝置、互動等多元媒材的併置，型塑出虛擬的「夏娃」與真實「科技」之間兩者互不可分的關係，試圖反諷性地批判由數位科技（包含網路空間）與現實生活相互交疊的「同一個」世界的特殊景況，更進一步地延伸思考如何將人們的身軀重新寫入網路的虛擬世界中。

某種程度而言，在現今後媒體的時代中，數位科技的日新月異終將人類帶領至一個「去物質性」的人工世界，虛擬實境更是藉由身體的感知，將人從物理世界帶領至虛擬的想像世界。[2] 甚至人們可以藉著虛擬科技創造出任何一種想像得到的虛擬世界，因為虛擬環境端視設計者而定，「設計者」就像是扮演「上帝／造物主」的角色，只要克服技術上的問題，即可創造出任何一個國度，任何一個以他為首的國界。由是可以發現，在林珮淳的創作底蘊中隱含著一種對當代「集體共同幻想」（collective consensual hallucination）的批判，反諷著人類嘗試扮

1　Michael Heim. Reading Digital Culture (London: Blackwell 2001) pp. 70-73.
2　Margaret Morse. Virtualities : Television Media Art and Cyberculture (Indiana: Indiana University 1998) p. 25.

演造物主的想望。在「夏娃克隆系列」中，作品彷彿述說著：當代社會對於科技所懷抱的期許，就好像用盲目的眼睛來看待我們所生活的世界，總是盲目地將網路的虛擬空間視為一個與現在不同、一個更教人期待、想望的世界，但究其實，這都是來自於一種對於「超越」的狂熱信仰（如達到網路永生之境界），信仰著虛擬空間這種新科技將能超越時空的限制與身體的桎梏，將人們送離這不完美的現實之地。[3] 正如林珮淳指出，「夏娃克隆」是「人與蛹」或「人與獸」的合體，雖擁有美妙的臉孔與身體，但像基改一樣，美其名造福人類，卻可能帶來災害。林珮淳的創作策略，則是利用「迷思化」新媒體科技的優越性，反諷性地批判此一人們所信仰的迷思。

對林珮淳而言，藝術創造作為生活實踐的場域總是離不開以宗教情懷關切著現世社會，她不僅提醒著人們身處數位科技時代需有的警覺心，也對世人展現出其作為藝術家的批判性格。透過《啟示與警世－林珮淳創作研究展》足見林珮淳創作態度超然傳達其解讀現代生活與文化的深沈認知與見解，科技藝術系列作品在在揭示反思性思考，並隱含《啟示錄》警世自然反噬的巨大力量，可謂是以虔誠的信仰與毅力追求富含哲思義理的藝術境界與極致表現。

3　Kevin Robins. Cyberspace/ Cyberbodies/ Cyberpunk: Cultures of Technological Embodiment　(London:　Sage 1995) p. 135.

夏娃克隆啟示錄 III　Revelation of Eve Clone III

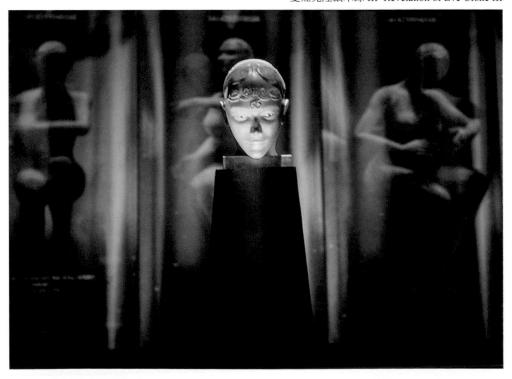

啟示與警世
林珮淳創作研究展

《藝術家雜誌》，2015 年 | Academia. edu

思辨自決・意識鮮明

清大藝中聚焦於完整呈現藝術家林珮淳卅年來戮力於藝術領域上的創作經典系列與啟悟，審視藝術家的創作經歷、典藏、論述、出版等研究，奧圖碼科技股份有限公司與藝數網公司不約而同地贊助此展，水到渠成以尖端科技完整呈現所有的科技藝術作品，詳究其由美國中央密蘇里大學踏入抽象藝術創作的開始，窩居於二號公寓藝術生命青澀歲月的最初源頭，澳洲攻讀博士時接受女性主義的啟蒙與洗禮，持續催化出多元豐富的藝術發想與創作系列，林珮淳不斷審視自我藝術創作，思辨創作行為與女性自決的鮮明意識，交接撞擊觀眾當下的意識流動，形塑新穎的藝術觀感，展覽現場完整呈現林珮淳生平大記事與四大藝術創作系列樹狀創作，研究年表與文獻是由台藝大造形所許佩純研究整理，台藝大多媒體動畫新媒體藝術學系研究生蔡佩宜編排。

林珮淳任教於國立台灣藝術大學新媒體藝術所，長期推動台灣數位藝術並創建此領域重要的實驗室：林珮淳數位藝術實驗室，近期策畫的「蟲聲幻影」數位藝術互動特展，完美結合科學與藝術更引起巨大關注與迴響。而其自身的藝術創作脈絡能駕馭大環境整體的社會文化，並反思文明科技所引領的毀滅力量，諷刺批判人類的貪婪妄想，因其作品的深沉理念與爆發力，作品也成為全球藝界焦點。

生命課題・永恆不變

「啟示與警世—林珮淳創作研究展」呈現藝術家藝術精神本質的實踐歷程，作品含括「女性詮釋」系列、「解構父權」系列、「回歸大自然」系列與「夏娃克隆」系列。藝術家負笈異鄉時意識到東方女性長期在父權體系下依附生存，強烈質疑刻板僵化的社會體制下狹隘的創作空間，她體悟需擺脫僵化體制的桎梏，女性創作風格才能獨立自主，藝術革新精神方能植根，「相對說畫」系列與「經典」系列的批判表現手法含蓄婉約，卻遠凌駕於西方女性主義創作者赤裸的呈現，彷彿長期壓制下的吶喊發聲。「回歸大自然」系列的人工自然散發光能與熱量，警示人們現代文明彷彿披著羊皮顯現炫爛華麗，卻只能祭弔逐步被吞噬的真實自然世界。本展展出此系列的〈創造的虛擬〉與〈標本 I〉，〈創造的虛擬〉由觀眾動手書畫蝴蝶，激發無限的生命力，蝴蝶翩然交織起舞，林珮淳批判人造景觀與生命的謬誤本質，企圖使觀者比較短暫虛幻的人工生命與真實靈動的自然生命，觀者自行醒悟生命課題：究竟何者是永恆不變。

「標本 I」系列作品哀悼人類暴殄天物的習性，自然原始的質樸意象畢竟無法以人工再現，反諷蝴蝶標本也是虛擬標本，幻影雖然生動美麗卻仍是 3D 科技合體。

夏娃克隆・眾所矚目

「女性詮釋」系列、「解構父權」系列、「回歸大自然」系列中的象徵符號「蛹」蛻變成蝶女，幻化成「夏娃克隆」系列科技複製之女子，基因複製人夏娃克隆具備維納斯般的完美身形，烙印著毀滅印記，藉由科技的催化在展場中甦醒，破繭而出，優雅地轉動身軀，感受四方投注的關懷眼神、引領期盼與慾望交融，虔誠聖樂營造聖殿般的臨場感知，仔細聆聽卻間有雜音，反諷科技造物的人類，企圖模擬自渾沌之初以來開天闢地的創造主，畫虎不成反類犬，似人非人，似蝶非蝶，科技造物野心十足卻引發毀滅性的力量，隱喻人類社會氾濫的利益薰心、色慾橫流、破壞自然、窮兵黷武均步步踱向啟示錄所預言的末世危機。

「夏娃克隆」系列是眾所矚目的焦點，本展展出此系列的〈夏娃克隆Ⅱ〉、〈夏娃克隆啟示錄Ⅱ〉、〈夏娃克隆肖像〉、〈夏娃克隆啟示錄Ⅲ〉具有其獨特的藝術風格，婉約卻精準犀利，批判複製基因改造或複製人體的尖端科技，深思人類窮究生命源起的祕密是否倒行逆施？質疑人工生命的虛幻與毀滅力量，此展真實讓人感受林珮淳關懷生命，體悟生命，敬天愛人與個人的虔誠信仰。

近期全球研究夏娃克隆的論述風起雲湧，即將出版的藝術年鑑登錄其為台灣最具代表性與重要的作品之一，林珮淳廣受當代重要藝術機構與巨型展覽邀約，曾展於蘇俄當代藝術平台、紐約皇后美術館、法國 Exit and Via 藝術節、當代美術館後人類國際展、波蘭媒體雙年展、國美館台灣雙年展、高雄市立美館亞洲當代女性展等。「夏娃克隆」系列也成全球藝文界爭相邀請展出的國際經典創作，全球女性博物館 IGNITE 專訪藝術家林珮淳並將影片列於首頁，世界知名英國女性藝術研究期刊以全彩介紹，澳洲 AGIDEA 國際研討會專題演講以及受邀美國學術研究大學作品授權研究等。

體悟生命・敬天愛人

林珮淳指出創造的靈感源於錫安山列國先知洪以利亞對人類的警世預言，也無畏怯地將聖經《啟示錄》與《但以理書》所記載的巴比倫大淫婦與大偶像來形塑「夏娃克隆」，藉以批判科技改造神的原創將帶給人類無法逃避的可怕大災難。有位藝術評論家曾於口試一篇研究林珮淳創作的論文時指出：「要研究林珮淳的作品必須要研究錫安山。」道出了林珮淳創作乃源於她對生命的領悟以及她對創造主的無限敬畏。美國史丹佛大學及捷克查理士大學客座教授林麗真也指出：「林珮淳是一位敬畏神的聰明人，因此所揭舉的藝術思維課題，已觸及哲學和宗教的領域而引起國際藝術界的重視。她的藝術成就自不僅限於一時一地。」足見林珮淳創作態度超然傳達其解讀現代生活與文化的深沉認知與見解，科技系列藝術作品在在揭示逆向反思，並隱含《啟示錄》警世自然反噬的巨大力量，可說是一路走來、一以貫之，以虔誠的信仰與毅力追求富含哲思義理的藝術境界與極致表現。

從蛹到夏娃克隆
林珮淳藝術的女體賦權

郭冠英 | 藝評家

《台灣數位藝術知識與創作流通平台專欄》，2014 年 | Academia. edu

滿牆的紅橙、藍紫、黃綠亮彩線條層層包裹的抽象圓形繁複結構，在 1993 年在台北一個地下室做為替代空間 [二號公寓] 呈現的「生命圖像」系列展覽，也是筆者初次對林珮淳作品的印象。這些蛹狀圖像複雜中不失優雅，雖象徵著桎梏、卻有呼之欲出的彩度，團團環繞幾乎有動感的平面油畫，直覺地令我想到卵，一種只屬於女人的私密切身經驗。時隔 20 年，不論林珮淳的創作如何推陳出新，這些亮彩抽象卵狀物在印象中仍呼之欲出，那也是筆者對女性藝術創作的認知具有相當啟示效果的意象。

從蛹蛻變出來的女性形象

「那個時候是我想要破繭而出的階段。」藝術家回憶著說，一面掀開黑絨布，走進鋪黑地毯的場域，這是 2013 年在台北當代館「後人類欲望」展出的「夏娃克隆」。在環繞空間中的投影中，巨幅夏娃就像在試管裡由睡夢中要慢慢地甦醒一般，她緩緩轉動、蠕動身軀，身上還帶有蛹般的殘留痕跡，彷彿尚未完全幻化成人身。仿聖詩的環境音樂，強化展出現場的聖殿感，夾雜間歇變調的噪音，是末世危機的隱喻。20 年前創造蛹狀圖像的林珮淳，20 年後所創造的「夏娃克隆」，已受到許多國際觀眾在美術館殿堂的膜拜，幻化中的夏娃克隆彷彿吸取來自世界各地觀眾的視線、感知、和慾望投射，而有了自己的生命。

「當我知道我想當藝術家時，我就讓自己成為一位藝術家。我那時不知道「想」有時候無法變成行動。許多女人在成長過程中，並不知道她們可以塑造自己的生命，因此，想當藝術家（但沒有能力察覺自己想要），對其中一些女人來說，只是個幻想，只是像想到月球一樣的幻想。」
—朱蒂 · 芝加哥

「夏娃克隆」系列是林珮淳近年頗受到國際矚目的作品，但她的作品意識卻可追溯至 20 多年前的脈絡。在「蛹」系列時期，當年正在澳洲修習博士課程的她，身兼母親、女兒、妻子、教師、藝術家、研究生多重角色，加上西方藝術學院訓練啟發她對女性意識的自覺，如同許多亞洲女子負笈在異文化環境的進修，很自然地反思台灣本身所受日本父系社會結構的影響。林珮淳在藝術創作中一向表達獨立思考，但不同於西方女性主義習於以身體作為武器來質疑性別不平等，她的創作自早期就用含蓄的東方表達，以美麗的符號呈現顛覆的意涵，如古典漂亮的裹小腳鞋、摩登的高跟鞋，隱喻著雙足的巨痛；「相對說畫」系列用古典女性肖像和蓮花並置，以金色蓮花反諷傳統認定「三寸金蓮」才是賢淑女子的象徵，卻忽略把女人的腳裹成三寸之小的非人性殘暴。林珮淳自早期就習於以美麗的物件作為物化女性的反諷。除了創作，她也為文分析西方女藝術家朱蒂 · 芝加哥的展覽、瑪麗 · 凱莉的產後文件等做為一個女人 /

母親切身經驗轉化的藝術。她也積極投入具體的女權運動，催生了台灣女性藝術協會。20 年對她而言並非是抽象的理念描摹，當年欲破繭而出的林珮淳，今日已身兼藝術家、教育者和理念實踐者多重任務。

大自然 Vs. 人的驕傲

1999 年台灣發生了震撼全島的 921 大地震，這是一股大自然力量的反撲，令林珮淳反省到弱勢者爭取平等並非重點，她反思生命的核心，在人類掠奪自然凸顯了人的貪欲，導致人與自然之間的不和諧，人與人之間 (不論男、女、強勢、弱勢、種族、階級) 等的衝突。自此，她創作了「回歸大自然系列」，以人工、複製、數位、虛擬等議題與科技媒材，反省人類創造科技文明、而與自然的對立關係。如 2001 年創作的卵形《寶貝》用發光素材擬仿在大自然的蛋，呼應她對生育大地的大自然的寶愛概念。

「夏娃克隆」就是在此議題下衍生的產物。2004 年起的「回歸大自然 - 人工生命」系列中，她用 3D 影像批判虛擬的假生命，以互動裝置來建構蛹生成蝶、人與蛹同體、人蛹幻化成人蝶合體的影像，批判人倚仗科技，自認為創世主的驕傲。而夏娃克隆在十年的創造間也不斷演化，每一尊身軀轉動的夏娃，是用 3D 軟體程式構成，細緻、窈窕、長身、並有完美的女性三圍比例上，仍有著蛹的痕跡，似乎尚未完全進化成人、或成精。這個「夏娃克隆」究竟是女性力量的呈現還是反擊？「她是『夏娃克隆』，不是『夏娃』，」林珮淳強調。「她是人用科學技術創造出來的複製『夏娃』。」這點出了「夏娃克隆」不是神所創造的夏娃，而是人用科技創造的複製女體；「夏娃克隆」並非聖經上神所創造出來的「夏娃」，也不具有真正大地之母的生養能力。

在他額上有名寫著說、奧秘哉、大巴比倫、作世上的淫婦和一切可憎之物的母。（啟示錄 17 章 5 節）…你所看見的那女人、就是管轄地上眾王的大城。（啟示錄 17 章 18 節）

「夏娃克隆」的不斷進化是在觀眾的想望中生成，她的進化並隱喻著林珮淳對聖經文本的解讀。「夏娃克隆」額頭上像似蜷曲前髮、暗含著 666 印記，是這尊完美尊榮女神形體所暗藏的毀滅印記。就像啟示錄 17-18 章對末世的重要預言，違反創造大自然力量正在反撲，並以金錢、權力、慾望來完美包裝這股毀滅性的力量，毀滅自然，當然也就毀滅了人類。

林珮淳的作品超脫了性別、文化的界線，國際藝評對夏娃克隆的評析不斷，從聖經典故、女性角色、科幻人 (cyborg)、科技美學等多重角度解讀夏娃克隆這個 complex 誘惑角色的存在意義，被注視、論述下的夏娃克隆因此有了藝術生命，並不斷延伸。看似她已跳脫女權 - 男權、藝術 - 科技的狹隘論爭，但她作品並非遠離「蛹」時期的理想，而是通融包裹這一切，昇華為一個更誘人的詭辯形象「夏娃克隆」（Eve Clone）；這個人類複製的、人類生命之母「夏娃」複製人「夏娃克隆」；這個人性、科幻性、神性與魔性並存的「夏娃克隆」，林珮淳讓我們看到「她」正在幻化中。幾乎百分之百由蛹幻化為人體、同時也是女體 / 母體並存的形象。「夏娃克隆」幾乎完美的形貌，召喚我們內心的慾望：她是男性慾求的完美女體，同時也是女性藉以掌握男性慾望的主體形象，更是人類迷惑於科技改造自然的力量，誘使人類自認為是創世主的貪婪想望。在藝術家的設計下，轉動中的「夏娃克隆」有著金頭、銀身、銅腹、鐵腿、泥腳，是聖經中的偉大形象 (the Great Image)，同時當觀眾碰觸像似聖殿般展場上放置的夏娃克隆半身雕像的頭部，這如同宗教灌頂的手印，會讓「夏娃克隆」因此舞動，就像吸取了現場觀眾膜拜的力量。原本無機的虛擬 3D「夏娃克隆」在人們慾望、思索的投射下有了生命，

因為人們多認為自身的慾望是真的，人們因而渴求她成真，在這期待、渴求當中，我們已被夏娃克隆所控制。

幾乎百分之百由蛹幻化為人體、同時也是女體／母體並存的形象。「夏娃克隆」幾乎完美的形貌，召喚我們內心的慾望：她是男性慾求的完美女體，同時也是女性藉以掌握男性慾望的主體形象，更是人類迷惑於科技改造自然的力量，誘使人類自認為是創世主的貪婪想望。在藝術家的設計下，轉動中的「夏娃克隆」有著金頭、銀身、銅腹、鐵腿、泥腳，是聖經中的偉大形象 (the Great Image)，同時當觀眾碰觸像似聖殿般展場上放置的夏娃克隆半身雕像的頭部，這如同宗教灌頂的手印，會讓「夏娃克隆」因此舞動，就像吸取了現場觀眾膜拜的力量。原本無機的虛擬 3D「夏娃克隆」在人們慾望、思索的投射下有了生命，因為人們多認為自身的慾望是真的，人們因而渴求她成真，在這期待、渴求當中，我們已被夏娃克隆所控制。

「王啊，你夢見一個大像，這像甚高，極其光耀，站在你面前，形狀甚是可怕。這像的頭是精金的，胸膛和膀臂是銀的，肚腹和腰是銅的，腿是鐵的，腳是半鐵半泥的。」— 但以理書 2 章 31-33 節

20 多年來，從早期「生命圖像」系列中掙扎的蛹到「夏娃克隆」，有意識無意識之間，林所具有的女藝術家細緻洞悉、描摹能力、卻一針見血的藝術特質有其一貫脈絡。林藉由「夏娃克隆」具象化啟示錄裏的預示，在完美女神的面容和肉體，蘊含人的貪念和對自然的破壞力，這是與自然母性的生命力背道而馳的。「夏娃克隆」是人倚仗科技／自身智慧的驕傲，與對金錢、權力的貪婪，使人類發明了毀滅人類的武器、用科技破壞自然生態。林珮淳使用科技來批判人性，用數位媒材創造藝術，運用科技工具超越了性別平等的議題，她直指人類與自然的和諧關係，回歸對生命、乃至創造生命的超然力量的尊重。

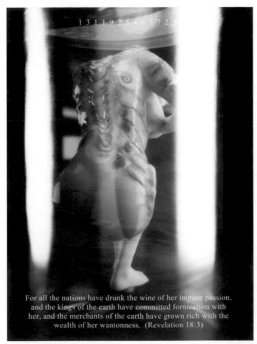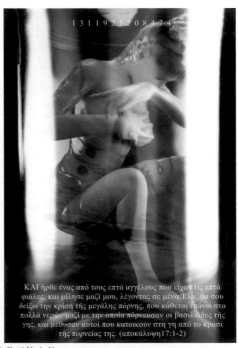

For all the nations have drunk the wine of her impure passion, and the kings of the earth have committed fornication with her, and the merchants of the earth have grown rich with the wealth of her wantonness. (Revelation 18:3)

ΚΑΙ ήρθε ένας από τους επτά αγγέλους που είχαν τις επτά φιάλες, και μίλησε μαζί μου, λέγοντας σε μένα: Έλα, θα σου δείξω την κρίση της μεγάλης πόρνης, που κάθεται επάνω στα πολλά νερά, μαζί με την οποία πόρνευσαν οι βασιλιάδες της γης, και μέθυσαν αυτοί που κατοικούν στη γη από το κρασί της πορνείας της. (αποκάλυψη17:1-2)

夏娃克隆啟示錄文件 Revelation of Eve Clone Documentation

軟硬兼施、面貌兩極的藝術
解讀林珮淳的複合媒體裝置

石瑞仁 │ 藝評家、國際策展人、美術館館長

《藝術觀點雜誌》，2005 年 │ Academia. edu

近幾年來，林珮淳創作不懈且展出不斷，她的作品，除了內容觀照有不同階段的變化，在材料的運用與形式語言的探索等各方面，也明顯有各種相應的新嘗試，而展現了自我突破的意志和不斷更新的活力；最近在台藝大舉行的〈非自然—回歸大自然系列〉個展，更進一步證明了，她已經從早期單純的畫家身份，正式轉型為一個熱衷於符號的思維與探索，矢意於複合媒材創作的藝術家了。

約自 2000 年左右，林珮淳已開始嘗試以電腦後製作的影像結合工業性材料，製作成一種幾何形的單體造型，再發展成可以因應不同的空間場合而做形式變化，而引發不同觀想旨趣的裝置藝術。此次個展，除了提出幾件全新之作以外，她也將其近年發表過的這類作品做了一次較完整的集結，同時又作了一些形式上的重整。這個舊作重整的作法，雖然默默地進行完成，作者也無意把它們當成展覽訴求的重點，但是觀察這些作品前後的差異，注意它們變貌的外在機制和內部因由，毋寧是探討林珮淳近年創作之動態與內涵的一個捷徑。在這同時，我也要指出的是，對於林珮淳作品的討論，特有必要同時著眼於她的創作內容與展出方式，作個比較全整的瞭解。因為對她來說，作與展覽顯然不是前後兩階段分割獨立的活動，而有互相補強與增生，互相詮釋與發展的一種內在關係。事實是，在她前後幾次的展覽之間，除了有思維上的延續與接力，一種舊作循環再生和自我調變的表現機制，也已形成她頗引人注目的一種風格特色了。個人也因此認為，在她那「化簡為繁」的作品衍生模式中，我們若能著眼於創作到展出的整個進程，和各階段創作思慮的重點，而從軟體、硬體、空間這三個面向來切入分析她的作品，也許可以找出一條簡捷而有效的解讀之道。

圖象與符號：一種「軟體型」視覺元素的建構

在林珮淳近年的作品中，首先可以被定義為「軟體」型視覺元素的，無疑要屬那些入目眼熟，而令人立即聯想到自然情境的花卉、雲彩、天光、水影等圖像了。這些平面與白話性格的圖像，不管藝術家是從自然中拍攝得來，或直接從現成的印刷物中擷取運用，顯然都經過了電腦的再加工和一些後設的處理，但我們也注意到了，這種加工的性質是特別強調其「減法」意義的；因為，在藝術家將原來的圖像去背、改色、糊化、局部剪裁及放大輸出之後，雖然事物的徵貌還是依稀可辨，但它們其實已經離開了既有的文本，而變成一種單純的圖形或獨立的符號了；不難想像，藝術家刻意把自然圖形化約成為一種視覺符號，目的是把它們當成一種「軟體」元素，用來放入自己的思想架構及敘述系統中去書寫或傳輸意義的。

從這編輯符號軟體的起手活動中，我們可同時發現與個人偏好或價值立場有關的一個線索，

林珮淳篩選／使用的花種，從來都不是什麼奇花異卉，而往往只是一些素雅平凡的小雛菊和野生的牽牛花之類。她之所以利用電腦進行符號化編碼，看來也不僅是將它們凸顯放大，而更有令它們以弱小平凡的身分，充當「大自然代言者」的一種心機和特別目的。這種心思表現，令人不禁想到了—因徹底擺脫了傳統花卉靜物畫的教條而成名的美國女畫家歐姬芙（Georgia O'Keeffe）。在許多以花為主題的畫作中，歐姬芙刻意將花卉的生理特徵或精華片段放大成一種近乎抽象的迷人畫面，她的理由是：「很少人真正仔細的欣賞過一朵花，因為它們大多長得很小，而現代人又都太忙了！花卉之美唯有通過仔細的觀看才能體會，而仔細的觀看是需要時間的—正如想好好認識一個朋友也是需要時間的—我因此發想，如果能夠把花畫的非常巨大，人們就不致於忽視它們的美感了」。她接著又說：「我相信花卉之美及其生命內涵，是與女性特別相關的事，也是女性藝術家最能夠去探索和開發的」。由此要回頭說明的是，林珮淳在其近作中，將花的形象抽離放大成一種鮮明的符號，將它們植印在半透明的壓克力板上，做成了一個個養眼的獨立發光造型體，並以之組構成一種陣容更大更引人注目的空間裝置，這整個操作過程，除了從起點呈現出與歐姬芙話語的一種呼應關係：就結局看，亦好似針對當前的工商時代而特別提出了一種進階的解套方式。

幾何造型燈箱：另一種「硬體型」視覺元素的建構

順此要談的是，不論是可名狀的圖像或待定義的符號，做為藝術家書寫或表現的一種軟體元素，它們總歸是需要某種「載體」的配合才能顯現其功效的。回想，在較早以前的作品中－如《相對說畫》與《經典之作》這兩個系列，林珮淳已開始利用一些傳統的藝術圖像和經典的教條文字，來進行符號抽離、拼貼、改造與再書寫之類的創作實驗了，但當時是以畫布為載體，並通過系列式的繪畫創作與專題性的展出，來傳達一些與歷史想像或文化批判有關的觀念；直到近年的幾個新作系列中－如 2000 年的「景觀・觀景」及 2004 年的「非自然」，她的藝術路線和表達方式有了巨大的改變，除了刻意在作品中置入一些性格平凡的圖像與符號，同時改用更具有普普意味的壓克力板做為書寫的載體，並在全系列作品中導入了一種「自體發光」的機制。這種轉變已充分反映了她想要從歷史文本返回現實觀照的一種藝術心念；不過，我想進一步點出的是－林珮淳用壓克力板取代畫布，不單純只是想要換換載體；她將壓克力板黏製成金字塔、方尖柱、橢圓化的幾何造形燈箱，也不像只是想玩玩立體雕塑；此中的真正意圖，顯是欲將這個新載體同時打造成一種自具言說力量的「硬體符號」，而這樣做的目的，無非是要在平面的「軟體符號元素」和立體的「硬體符號元件」之間，建構一種平行敘述或相互參照的機制，以賦予作品更多的觀想空間及較多層指涉的意涵。

以《生生不息、源源不斷》一作為例，林珮淳用貼花壓克力板黏製成的三角錐狀立體燈箱，
很能讓人當下聯想到古埃及的金字塔，但也因易有此一歷史聯想，我們正好可以從形與質的
比對中注意到了─金字塔這個以巨石堆造出來的超級硬體符號，及其直接關連到的沙漠、死
亡等具體意象，或間接指涉的嚴肅、陽剛、父權、永恆等象徵意義，在林珮淳的壓克力版本中，
已經完全走樣和變調了！她的壓克力金字塔，以影像的薄膜取代了岩石的肌理，以輕盈花俏
的新姿態取代了沉重嚴肅的老身段，以「小而成眾」的熱鬧陣容取代了「一而獨大」的孤高
感與神聖性；類此，在第一眼的閱讀中，如能同時析解這些燈箱本身也是一種另類「硬體符
號」的原由和性格，我們就會進一步意識到─這件作品其實隱藏了「以新文本柔化老硬體」
的一種企圖，藝術家試圖用母性的溫婉柔情去破解一個父權符號的冷漠僵硬，其目的即在於，
為一個已被定義為死亡紀念碑的硬體重新披上生命的花紋與色彩。

於此，我們也不妨轉換另一個閱讀重點，來測探這些作品能夠引發不同觀想意涵的空間與向
度。我想特別指出的是，林珮淳將金字塔的花崗岩本色改為天空與海水之藍，同時將一些電腦
冷處理過的花卉圖形「入殮」於金字塔中的做法，即使不談歷史文本，而單用直覺觀賞，也
可以解出一些不同的象徵意義。站在黑暗的展場中，目睹一群沒有香味和肉身而只剩模糊「遺
容」的花卉浮現在光明的藍天或藍海之中，當下油然而生的，也很可能是一種「有限 vs. 無限」
的悵然感覺；對此，我們不妨再借用歐基芙發人省思的另一段話做為參考註解：「被陽光漂
白過的骨頭，在藍色的襯托下尤其美麗—- 這種天空與海水之藍，是所有的人為破壞結束之後，
依舊存在於各處的！」

符號體的陣容與陣勢：一種針對空間的思維與行動變化

以上的討論初步說明了，林珮淳打造出來的符號體 (或造型元件)，本身已經具備了可供觀賞
想像的基礎，但是其作品的具體面貌與真實生命力，卻是要走出工作室，到不同的展出場合
去實踐和完成的。從近幾年來於各地陸續展出的情況可以看出，她在應用這種軟硬共構的符
號體時，大致是兵分兩路，而發展出了性格迥異的兩種作品呈現方式：以 2001 年首度出現的
《寶貝》一作為例，這是以壓克力板塑造而成的一種立體燈箱，貝殼的造型中搭配了牽牛花
與綠葉的圖紋，形式簡潔而充滿曲線之美。在戶外環境 (如公園) 或廢墟感的閒置空間中 （如
高雄橋頭糖廠的舊廠房）展出時，林珮淳刻意將這些符號體疏散放置，像「放牛吃草」一樣，
讓它們自由自在地出現於不同的節點 (如躲在路邊的草叢裡，長在夾道樹的樹幹上或枝枒間，
棲息在老屋內的木樑上……)，窺其意圖，就是想讓它們與現場的空間環境進行一種機緣化的「再
結合」，同時，也立意在這些「藝術品」與往來民眾之間，建立一種新的對話關係。

反觀，在比較正規的室內空間場域中（如美術館、藝術中心的展覽場），她則是採取一種嚴
謹制約的方式，而蓄意讓這些造型單體以一種「理性陣列」的姿態集體出現；上述的「寶貝」
一作，這回在台藝大的展出，已經變身為一種截然不同的裝置樣式，正是此一思維與行動方
案的具體呈現。十二個發光的貝殼形單體，像表演舞台上的美麗儀隊，規矩而整齊地排列在
鏡子作成的地面台座上，默默地接受觀眾的檢閱。與之前的「動若脫兔」相比，此時呈現的
毋寧是「靜如處子」的另一種意象和情境。

再以作品《花柱》的呈現為例，這是包含了五個立體發光組件的落地型裝置，看似簡明的符
號與單純的結構造型，其實相當著眼於數 / 理的思維及對比 / 對仗的手法，及一種整體關係的

建構。就形制看，除了在東西南北四個座標點，各立了一根長柱，加上正中央只有半截高度的一根短柱，形成了同時具有獨立味與連結感的一個符號群組；以圖象的運用言，所有光柱都是以綠葉為底層圖案，但是外圍的四柱各有紅／黃／紫／白四種色花的變化和區別，但中央的短柱則同時集結了此四種色花的圖像。個人覺得，這個軟／硬兼施的陣列組合，隱約是宇宙秩序的一種象徵，除了內外之間有著凝聚與放射的雙重意涵，也強調了獨立的元素與元素之間基因相連的關係，和建構一個和諧總體的概念。

名為《花非花》的另一件作品，是四件一組的壁掛型裝置。這件同樣是外觀規矩排列整齊的作品，也許可以從兩個端點切入解讀。首先是圖象的內容及其指涉或敘述作用，只見，林珮淳以媒體、報紙上的文字和照片做成清晰的綠色底紋，而以漂浮／疊置其上的盛開紅花作為主角圖象，但是在花形的部分，卻刻意作了一種模糊化／空洞化的處理。這種令主題失焦／去勢的作法，顯然有其用意。誠如大文豪雨果 (Victor Hugo) 說的：「生命如花朵，愛則是花中之蜜」，林珮淳一方面透過媒體類訊息的鋪陳，描述了現代文明的大活力，同時以模糊空洞的花朵來凸顯象徵的，殆也就是存在於文明大活力與人間大愛之中的一個明顯落差吧？其次要談的是此作的框架樣式與顯現方式，四片直立尖葉的造形 配上小燈泡圍成的鮮銳邊線，直可視為眾人之「眼」的一種變形符號；於此，若把作品自行發光的機制關連到「光是真理的象徵」的一種說法，那麼在《花非花》這件作品中，林珮淳試圖透過密集的符號、失焦的圖像、睜大的眼睛、與真之光的照耀，來詮寫媒體與閱讀者的關係，及呈現訊息與真理的辯證，其意旨也就相當分明了。

概括地說，這個展覽具體陳明了，林珮淳試圖將指涉造化自然的具象符號與指涉人類文明的抽象載體，結合成為一套全新的藝術表現系統。這個系統，訴諸於複合的材料元素、簡練的藝術手法，澄明的外觀形式、多樣的內在性格，追求的則是一種開放言說的機制。從中，我們已可看出，在工作室創作的階段，她的目標許是製作出一種規格化、制式化、可以量產的符號性單體，而這些符號單體的發展，也一路從方正的幾何形塊，經過了尖聳的金字塔造型，演變到到曲線柔美的貝殼形，這除了反映出一種知性推演、進階發展的思想性格，同時也披露了從假借到自創，從陽剛到陰柔的一段心路歷程。同時，我們也可從其近年展覽看出，林珮淳很能針對不同的空間場域，在理性規劃與感性揮灑之間做不同的權衡與調適，為其符號體進行對應的重置與安排；她的作品，也因此有一下子抒情，一下子莊重的雙重性格，並有了超感性與極理性的兩極面貌。當然，人們對其作品的欣賞方式與解讀角度，往往也像上文中所舉例演示的，因為其符號體之陣容與陣勢的種種變化，而有了許多的可能性。

再造一個自然的視野
林珮淳的「回歸大自然」系列

李美華 ｜ 藝評家、國際策展人

不論有多少的藝術原則或者是藝術理論被不斷申明，藝術仍然是一種反應現實的產物，他可以僅僅是對時間的感受，但多數是對時間的一種抵制，或是反對先例的；藝術史看起來僅僅是一種平順的發展延伸，但是藝術並不是呈現直線的進步與發展，這一種反應參雜了個別作品創作時的個人及環境因素，真正的藝術並非如新聞事件般的短暫，而是更注重於深度的原創本質，只有經過歷史的察覺以及長時間敏銳的經驗及感受方能引發藝術家自覺，就因為藝術創造必須有自我的推翻及解構，並且不斷的改變及搖滾，是以過程決不會呈現一種平衡的狀態，所以最可靠的創作是以積極的方法及決定性的心去定義與組合這些過程中零散元素，並以最純粹物體最終呈現在我們面前。林珮淳的系列作品來自一個強烈的潛在觀念，她反應與抵制人類對於自然的降格，並且將這些觀念轉化成為一種從柔軟及美麗所擴散出來的影像。

她的作品直接的宣告了人類對新科技媒材的運用，她的作品顯現了這些新影像的魅力，或許有些人反對這一種新世紀的秩序，或責罵這種假象佔領我們的世界，他們比較願意以一種文人性的說法去大談人類毀壞了環境，不論是如何的來表態，實際情形是世界仍然不斷的往前發展，我們僅能去接受環境中自然的轉變及所帶來不合理存在的事實，這一些轉變事實舉例如下：

• 工業的發展及新技術的發明在過去兩百年間，已經明顯改善了人類生活的品質，但是在二十世紀，憂鬱症及相關病症的人數卻增加了一百倍。
• 在過去兩百年間，有將近一億的人死於戰爭，遠超過歷史紀錄。
• 地球暖化源自於資本主義及消費主義的猖獗，已經改變了地球的氣候形成浩劫的機率。
• 再這同時，貧窮迫害了更多的國家。有百分之八十的財富是掌握在百分之二十的手中
• 更近一步，世界人口在一種急速的增加中，即將造成對人類生存的威脅。

所有的致命的現象來自於人類如盲目般的追求物質擁有，以及感官的享受，並因為缺乏了解的智慧及一種感激之心，以及鈍於理解人類在地球角色。珮淳看出了這一種危機，並且有了極為強烈的慾望去解讀這一種現象，在這一些威脅中，她選擇了一個自然的主題，並將這一個主題轉化成一種視覺上具體的物體呈現，因為要保留這一種活力的本質，她使用了幾何對比的形式，如金字塔型、圓錐、長方體、圓體及球體。人工燈光及媒材定義了非自然的藝術品，如同保羅 塞尚的觀察及再次告解，將自然解讀為圓錐、圓筒、及圓球體三種的幾何形，所有的物體都有正確的透視比例，每一個邊緣延伸到一個相同的接觸點，這一種藝術的本質提供了一種視覺化的架構，形成一種立體的藝術，就是觀者必須自不同的角度去觀看並取得透視的訊號。

另柏拉圖對於模仿的觀念，是要求清楚的表現自然模仿的形式，而不被情緒及知識所引導。在珮淳的作品中，出現一種幾何式的非自然，在解讀她模仿自然的作品形式上，我們當不要以誇張或是多餘的想像去看這些作品，僅僅就這些人為的安靜、穩定的物體放置在空間中，這一些光製造出來的氣氛，在壓克力燈箱下透露出一種藝術家的美德，因為這一些光源是間接的散發出來，造成一種不可思議的微妙的表面浮動，顏色、型態，環境創造出光明及沒限制性的觀念，引領著我們進入一種觀點。在這一系列作品中她並沒有刻意的去創造出一種風格，她的風格就是她自己的寫照。

在作品中，片片花瓣非常精緻的層層相疊，表現出花朵的溫柔與妍麗，這些花朵被種植在透明的固體中，直覺到花朵的爭艷與引誘印象，花朵常被取用在女性議題上，從第一眼看起來，似乎與女性主義無關，但或許仍值得深究其在珮淳作品中發生的可能性。珮淳投注很長的時間於女性議題上，經常取用中國歷史文化的案例及意象去表達一個事件，或許這一點，可以解釋為何她使用花朵在她的作品中。她的玫瑰花瓣一片片的交疊，引發一種誘人慾望及一種異國風情，這些花朵同時表現出一種解放及一種平靜；一種來自人工合成的物質，並植入幾何型態的物體的靜謐，她們是這麼不真實及虛幻如來自外星不明體。

珮淳的作品不僅僅追求視覺上的型態，在「捕捉」這一件空間的裝置作品中，她並沒有放棄色彩去遷就立體的視覺意象，她使用 3D 的蝴蝶投影在暗室中，創造出戲劇性的燈光，以及蝴蝶在花園中緩慢的拍動翅膀及飛舞的整體情境。在這一間暗室中，雖然觀者知道這是一個非真實自然景象，但他們不會去相信這一種初視的印象，這一種半信半疑的態度引發了動手去抓取這一些飛動的蝴蝶精靈的反應，當接觸到這一些映像，在抓取及碰觸的剎那間，理解了這是原來是一種幻象，但卻已採取了行動，所以產生了一種若有所失之感。這件作品成為一種對人性的測試，這蝴蝶及花朵隱喻了對美的探查賞析以及自我對空間認知，外界的混亂僅是我們內心的一種不均衡，那些環繞著我們的物體僅不過是感官的操縱數。

宇宙的架構超出人類的理解，相反的，我們的社會卻是在人類的理智下所築構。所以，人類如果沒有高超的靈性層次，以及不尊崇我們視覺以外的世界，絕對沒法體會人類存在的價值。在這世界很少去談到藝術應該是具預言性的，也就是說藝術可以直接的表達心靈的秘密，這一個秘密並不代表他個人的秘密，而是藝術家扮演著集體的代言者，去表達這一個神秘性。在這世界上，很少有一個集體可以完全直接的了解什麼存在他們的心中，所以當觀察及研究多數的集體就發現多數人是在自我欺騙的一種情境中；許多的先知不斷的告知一個教訓，那

就是無知即等同於死亡，而只有一個方法去解決這一種無知的罪，就是透過藝術，藝術是治療生病及生鏽的靈性的良藥。現代藝術的運動通常參與了自我部分的解構，這一種說法包含了藝術對於再生具有相當影響力的想法。

珮淳的作品反應了藝術家的宗教潛意識以及人文思想，她有直接、明白並且具邏輯性的思考，跟隨著一種對於新世界覺知的敏銳度，表達了她的預言警告性格，經由藝術的解讀達成她的任務及理想，並且貢獻她在靈性上的熱切度。要去了解她的作品，我們不可以忽視藝術家的生活經驗及背景，珮淳有著一種堅毅的性格，強烈的意志力，以及慈悲的情懷，她關心人類的前途，以及世人的生命，她不斷的在不可能中找出一種可能性。

她融合了文學及視覺的表現方式，巧妙的安置了光鮮的彩色情境，從女性主義到消費主義，她的系列作品建構了一個虛幻的妙境，萬花筒式的多彩及變換的幾何圖象，組合了人工的材料，間接的質疑了我們的生活態度及社會的架構，在一種自然的空間中請觀者去接觸她，但又表現出一種距離而不可捉摸。

不論珮淳藝術表現是多麼的不服從規律或是有呈現明顯的愛好傾向，藝術對於珮淳是心靈提昇的力量，不論的當代藝術表現如何的解構或是顯得粗略急燥，以及追求某種虛幻的感覺，珮淳更重視道德及心靈的問題，我們更相信藝術原創精神活化了所有的文明，不論是藝術如何的挑戰哲學科學及政權，但去表現清晰的感知及情緒形象一直都是藝術家企圖目標，創造力滋潤了想像也將會是新文明寶藏的基礎。

創造的虛擬 Virtual Creation

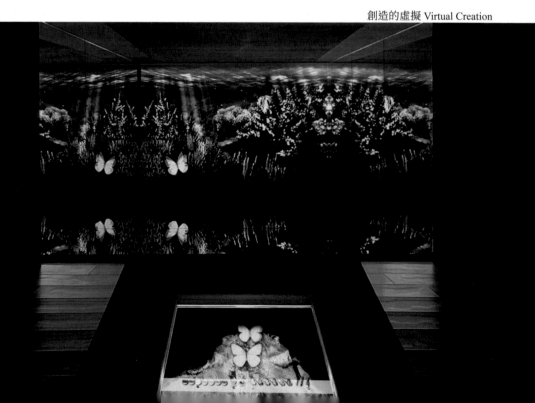

輕盈回歸
林珮淳的創作

張惠蘭 | 藝術家、國際策展人、台灣女性藝術協會理事長

卡爾維諾（Italo Calvino）在『給下一輪太平盛事的備忘錄』中的第一講「輕」裡提到「詩人哲學家乍然敏捷一躍，將自己揚舉於世界重力之上，顯出自己雖有重量，但卻擁有掌握輕盈的奧秘；許多人視為時代活力的東西－ 噪音、侵略、加速、咆哮－ 屬於死亡的領域，就像停放鏽朽舊車的墳場一樣」，近期的創作中藝術家林珮淳如詩人哲學家般敏捷一躍，在這日益沉重的環境中以一種輕盈絢麗的姿態走出文明，回歸伊甸。

初次認識林珮淳是在高雄市立美術館的特展「心靈再現」的展覽廳裡，當時因我們兩人的作品被安置在同一個子題：自然／環境／媒材，更因同一空間中只有二人的作品，所以對珮淳的「生生不息，源源不斷」留下更深刻的印象，當時主要透過她對女性弱勢與被動狀況的反思，藉自然的象徵表達關懷的情緒，她的三角錐的冷峻造型，用以象徵大自然陸海空的海鳥、游魚與花朵的景緻圖像，切割後如標本般漂亮精緻地凝聚在一如廣告箱的壓克力板上，這虛擬的風景畫，帶著超現實感比真實的風景更「逼真」的走進人們的生活與意象中。因此也引發我於澎湖縣定古蹟第一賓館策畫「流動」展覽時邀約的作品，極度的人工與冷峻的造型在澎湖入冬枯黃的草地上泛著人造湛藍的光，伴隨著強烈的東北季風吹拂下的草浪有極為強烈的對比。

近期，珮淳強烈感受到台灣在快速變遷下對生態環境的破壞，更戮力於藝術造型與人工自然的探索，開始對「身分、文化」有許多撞擊，這些系列作品雖然一樣運用著繪畫的基本元素：影像、數位、造形來敘述他個人的美學觀，但此時卻是在台灣的「後工業時代」和「生態危機」之間的矛盾中，所提出的一種對文明的質疑。

921 地震後清境地區邀請我策展，於是于 2001 年有了「清境－夏」自然與人為的對話的展演活動，「寶貝－回歸大自然系列」便是她為清境的步道量身訂作的作品，山上的樹梢有「貝殼」的燈箱造型，燈箱上印有紫、黃交錯的花卉圖樣，她將這些「寶貝」融於步道的樹枝間，清境居民告訴我因為地形的改變，本來山上就留有貝類的化石，「寶貝」是一件文明與大自然交錯所產生的人工美與矛盾性的作品，作品本來隨著展覽結束後就將卸展，但因清境的觀光客大都是從都會抽空上山旅遊，對這種混在樹枝中的藍紫發光體反而覺得親切，隨著在地居民與觀光客的喜愛所以也就將作品留下由在地的民宿典藏認養。接著 2002 年我為台灣女性藝術協會策劃「酸甜酵母菌」，此系列的作品也很有興味的串聯了台北華山烏梅酒廠與高雄橋仔頭糖廠，在期望針對"發酵"的主題，擴張至如何結合"女性"角色與空間，以不同之媒材的多重交叉對話到轉化物質與空間進行創作，人與時間空間慢慢發酵互相滲透。

近期甫於台北當代藝術館展完的「浮光掠影—捕捉」，加拿大籍的藝評人 Pierre Martin 認為這個創作由三個部份組成：「首先是一個需要觀眾活動的空間步驟，接著，也是透過影像移動的時間探索，最後，點出了觀眾的重要性，以及位觀眾所創造需要觀眾眼睛和身體參與的重點。」他感到林珮淳在此創作中的空間運用的複雜與精心，而多層次的發展也顯示出作品的優秀。

在「捕捉」中，我們在一個 3D 的空間裡，蝴蝶的影像則是 2D 但只要我們動時，這些蝴蝶影像便會變成 3D 而且似乎跟著我們，而我們彷彿控制著它們。這使我想起當我還是幼兒時，孩童的心以為其他的人平時全是靜止不動，只有當我與他們互動時才會有動作，這些人工製造的幻象彷彿反映了人類思想的自我為中心的潛意識。連續與不連續間作為媒介的蝴蝶飛行於現實和虛構之間，一方面蝴蝶來自於自然與真實世界，是一種真實的自然，但作品中的蝴蝶所採用的新技術來自人工編碼，來自虛構與想像是一種非真實，它創造出不真實的自然，「捕捉」試著讓觀眾帶著白手套，讓觀眾再次碰觸並感覺到那些蝴蝶，但手套脫下、作品插座拔起後我們的幻象也隨之消失，最終我們得到的只是一個假造的自然。

藝術創作者在觀察自身所處的生命場域裡，提出質疑批判、反映困境、抒發感受，並通過對創作素材的詮釋尋求解答的過程中，對珮淳而言從她早期於 2 號公寓到近期當代館的發表，藝術並非某種單純的自我重複，也不是消極的創作形式演變或者單純製造物體的意義。而其創作的問題，在近期系列中回歸伊甸的本質，並游走於人類心靈的、性別的、社會的、環境到對自然的省思，在反省的過程裡，藝術家尋求現實世界中與自然互動的可能，在珮淳近年來的創作歷程中，她從女性經驗與台灣不同的文化體系中個人經驗出發，她自由的創造了她的藝術形式，藝術家以一種使命感反諷了人類文明的進展，對照出生命情境與環境的反省，審視人類的處境以及與自然的依存關係，並拓及人類生命場域的全面觀照，與其說珮淳想回到自然界的原生狀態，更貼切的說法是她想傳達出一種真理，試圖引領觀者深刻的省思，及早從人類所創造的文明的迷思中覺醒而回歸自然，而這份對自然與造物主的信仰所構成的使命感，化為藝術家源源不斷能量的來源。

寶貝 Treasure

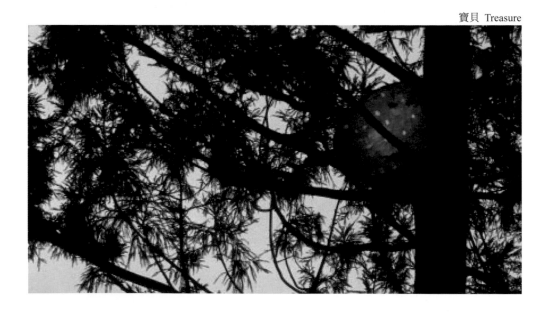

控制幻影
談林珮淳之《創造的虛擬》作品中之科技警訊

曾鈺涓 │ 藝術家、國際策展人

因深受 921 大地震災難的震撼，林珮淳自 1999 年開始從解構性別、文化、社會等議題作品，轉而關注人與大自然的關係，開始「回歸大自然」系列創作。以天空、花草、蝴蝶、海洋作為其作品中的視覺符號，傳遞其對大自然的渴望，並批判科技所帶來的文明滅絕的思維。《創造的虛擬》延續此系列作品的主旨，透過互動、影像與 3D 電腦動畫探討虛擬自然下的人類知覺狀態。

《創造的虛擬》以黑色布幔阻絕空間與外部的連結，並以黑色步道引導觀者進入一個屬於觀者個人的控制室。空間入口處之白色置物架上放置了一雙白色手套，觀者在進入空間前，必須先執起手套，並詳細閱讀生物創造過程步驟。進入控制室後首先映入眼簾為空間前方以投影呈現的巨型水箱，水箱中傳來陣陣的深海水聲，充氣而透明的巨大泡泡規律的放置並充塞於空間地面，展場中心控制台內嵌著一台具觸控螢幕功能的電腦，控制者必須戴上白色手套，並以觸碰塗抹方式，決定蝴蝶的色彩與型態，並在完成創造後，將自己創造的蝴蝶生物體，釋放至前方水族箱之中，蝴蝶在水族箱裡翩翩飛離並消失於螢幕之外。

作品以簡單直覺的互動介面、美麗的 3D 視覺影像以及空間氛圍的營造，讓參與者在觀看初始，驚豔於 3D 視覺畫面的絢爛，並沈溺於互動過程中的愉悅感。達到藝術家藉科技創造之表象趣味性，吸引參與者與之互動，以傳達其科技批判意識。

影像是吸引觀眾與之互動的要素，空間氛圍是醞釀觀者心態轉變的催化劑。當參與者在參與互動過程中，從選擇進入與戴上白手套的過程，即踏入林珮淳所設下的陷阱，引導參與者產生具控制主導力量的想像，並醞釀促使參與者從旁觀態度，轉而為具控制力量的控制者，在面對觸控螢幕中的蝴蝶個體，以造物者的心態進行新蝴蝶物種的變態創造。參與者在心理感知上呈現角色錯置與控制快感，是林珮淳隱藏於螢幕中超真實炫麗影像之後，所欲扎判的真實意義。

科技成為使用者追求快感的工具，人類藉科技延伸自己的能力，並假想擁有造物者的造物權力。第一隻複製羊桃莉出生，使得複製人科技成為可能，在以醫療造福世人的論點之下，醫療複製技術、幹細胞研究成為終結病痛、長生不老的希望 (Klotzko 2004)。然而生物科技所描述的美麗烏托邦世界，卻讓我們更憂慮瘋狂行為後的代價是人性與個人價值的泯滅。

作品中的主角「蝴蝶」，延續林珮淳自 2004 年起多次在作品《捕捉》(2004)、《蛹之生》(2004)、《城市母體》(2004) 的表現主軸，然此「蝴蝶」的意象非僅是表象呈現的繽紛耀目個體，而是

隱喻「自然」的象徵符碼,並建構出科技之自然複製與模仿的虛妄性。以 3D 影像所呈現的看似真實卻是虛幻假象的世界,是對人類自以為是的科技成就之反諷,此大自然幻影存在於每個人心中,讓世人自以為擁有未來,殊不知反而是失去未來的警訊。

不同於加拿大籍藝術家愛德華多 · 卡茨 (Eduardo Kac) 的〈基因轉殖藝術〉(TransgenicArt) 型式,直接以基因工程科技,創造獨特生物體之引人爭議型式。或李小鏡以數位影像合成方式,塑造之驚異並具視覺效果的人獸混種肖像。林珮淳採用溫柔熟悉的蝴蝶影像,結合 3D 動畫與直覺親近人的互動介面,作為概念呈現方式,其強調的並不在於視覺的虛擬再現或是最新科技工具的使用,而是在於透過控制慾望的再現,呈現對科技濫用的警告。影像、場景與電腦控制台之設置,僅僅是一種提供幻象的工具,在引導控制的過程,直覺熟悉的互動介面,挑起了參與者心理的騷動,一種成為控制者的慾望,並在整體過程中,以一種具宗教儀式的行為與沈靜的殿堂型式,將控制慾望與影像聯繫呈現夢想成真的幻覺。

小說家在故事中,提出科技所帶來的文化滅絕警訊。19 世紀,瑪麗雪萊 (Mary Shelley) 在《科學怪人》(Frankenstein, 1818) 中,以瘋狂科學家製造出具強大破壞力量的怪物,強調科技的破壞生命秩序與自然規律的可怕。20 世紀初,赫胥黎 (Huxley) 在《美麗新世界》(BraveNew World, 1932) 小說裡,描繪科技操縱人類思想與情感,使得人類對於科技具有夢想成真的憧憬,並進而產生違反自然不可挽救的無知悲劇。到了 21 世紀,加拿大女作家愛特伍 (Margaret Atwood) 小說《末世男女》(Oryxand Crake, 2003) 中,闡述了一個因為生物科技所造成的,人類幾乎滅絕的廢墟世界,只留下具免疫力、天真的「克雷科人」與到處流竄的狼狗、器官豬、羊蛛等基因改造生物,提出文化滅絕與科技至上的社會階層批判。林珮淳則透過創作,在繽紛的假象下,警告科技對人類生存所帶來的危機與無法承擔的後果。

人類為了經濟利益追求無止盡的物質慾望,不斷的掠奪侵犯大自然,所造成的自然反撲變色後果之憂慮,誠如拉圖 (Bruno Latour) 所認為「……人們生活其中以為科技建構的社會帶來的時代的進步,然而我們並不肯定今日的文明是否比較先進,我們是否比較快樂,或是否比較有創造力(或毀滅力)。」林珮淳持續地在作品中宣揚「走出文明、回歸伊甸」的真理,傳遞著其對文明無限的擔憂與省思,卡茨曾提出「…藝術家的創作不在於科技使用的最新或最晚,而在於以有意義的方式去告知觀者與參與者科技問題與迷思。」觀看林珮淳作品,不能僅從作品符號、型式呈現與科技使用來觀看其表象,而是從其作品中呈現的「過程」所傳達之「警訊」來探討其作品意義,而這個警訊提醒人類隱藏科技美夢下的陷阱,並傳達出人類與大自然的純真與主體性正離我們遠去的憂慮。

參考書目
· Atwood, Margaret,《末世男女》。袁霞譯。台北:天培文化,2004。
· Huxley, Aldous Leonard,《美麗新世界》中文版,黎陽譯,台北:志文出版社。1988
· Klotzko, Arlene Judith,《複製人的迷思》中文版,師明睿譯,台北:天下遠見出版。2004
· Latour, Bruno,〈直線進步或交引纏繞〉,《科技渴望社會》,雷祥麟譯。台北:群學出版有限公司,2004
· SAIC professor Eduardo Kac and students(2000). Behold, Alba. F Newsmagazine, School of the Art Institute of Chicago(Nov. 2000). p13-15. http://www.ekac.org/fdeb.html. 2006.6

你所得並非如你所見
台北當代藝術館林珮淳個展「捕捉」

馬肇石 Pierre Martin ｜ 藝術研究

Academia. edu 國際學術教育網

林珮淳最新的裝置作品「捕捉」目前在台北當代藝術館展出，至十二月卅一日止。這件作品的組成有三個主要的特點，首先是一個空間的構成，需要觀眾的行動介入；再來，是透過影像的移動而產生的時間探索；最後的重點是指出觀眾臨場的重要性，因為這是為觀眾所創造的一件作品，需要觀眾的眼睛和身體的參與。

在展覽入口處，要先拿一副白手套和特殊的眼鏡，如此一來，觀眾就會期待著裡面可能有的驚喜、或是不尋常的事物等著被發現。不過，觀眾也同時感受到他們必須有所行動，而且他們的參與是絕對必要的。因此，當觀眾進入裝置作品展覽室時，會在入口處第一眼見到一個小框架，看起來像是一種塑膠、或是小盒子，裡面有彩色的蝴蝶影像，張大著翅膀，被平放在正中間，如同漂浮在沒有背景的盒子中。因此，給人的第一個印象就像是昆蟲收集者的標本收藏箱，裡面放置一隻死蝶，可能是固定在塑膠中，就像是冰凍在冰塊中一樣，以防牠腐壞。這種感覺因為箱子框架很明顯地存在，而被強調著，同時，也因為在蝴蝶身上裝有明顯而清晰的數位編號，讓這種感覺更加突顯。這個編號像是參考用的，就像是蝴蝶標本收藏者會將珍貴稀有標本的拉丁文名稱或學名寫在小紙片上，然後放在標本上。不過，這些個編號也可以被視為是一個名字，因為是取自一個真實學生的學號，因此，牠終究是 "某人"。

之後，觀眾會發現這隻蝴蝶的影像會隨著你動，而且就像 3D 立體影像，當觀眾走動時，蝴蝶的雙翅似乎也在緩慢地拍動著。觀眾想是新的科技，或許是立體顯像，事實上，是一種新的 3D 影像技術。當觀眾完全進入展覽空間時，會看到 13 隻這種框起來的蝴蝶吊掛在空間的左右兩側，而且所有的影像似乎會跟著觀眾移動而動。我們置身於一個 3D 的空間裡，而這些影像則是 2D 的，但是只要我們動或我們決定要移動時，它們也會變成立體 3D 一樣在動，它們會跟著我們，我們則控制著它們。

不過，我們的目光很快就會被空間後方移動的影像所吸引，這是一部無聲的電影，放映蝴蝶四處地飛舞著，不是很快但也不慢，是自然的速度。牠們的色彩繽紛，令人著迷，吸引著觀眾的注意力。然而，很快地會令人聯想到牠們是框架中的蝴蝶，片中則是當他們還活生生時，在某地方被拍攝下來。如果觀眾戴上在入口處領取的眼鏡，然後往空間後面走，當觀眾越走越近時，就能感受到越多 3D 效果。在離螢幕 2 公尺處，所有的蝴蝶似乎都圍繞著飛舞，觀眾也感受到被牠們所包圍。也就是在這個階段，投射的影像開始擊落到觀眾的全身，此時觀眾才真正感到與這個現象合為一體，就好似處身於一個蝴蝶影像池之中。

由於戴著白手套，你會試著去捕捉牠們，就像牠們是真的一樣，或者只是將手舉起使投射的影像看來更為清楚生動，好像你就是螢幕。在這個空間你也會想移動身體的其他部份，例如手臂、腳和頭部，去捕捉拍擊這些蝴蝶，或是用身體當作螢幕或工具來捕捉牠們。你不再存在於普通的 3D 之中，你可以體驗一個 2D 與 3D 混和的真實虛擬實境，在那裡全身都可以體驗 3D 空間，並且創造 3D 空間。你不再是在展覽空間內，你可以像個孩子一樣與蝴蝶玩耍。到處都是飛舞的蝴蝶，過一陣子你也會被這些不受控制的蝴蝶弄得不知所措。這種滲透效果讓我聯想到站在美國藝術家波洛克（Jackson Pollock）畫作前的感受，他讓觀眾在畫作裡感受到不確定又連續不斷的的探索，使我們專注於單一的動作，卻又而暗中顛覆我們對現實的掌控，這就是他著名的"全畫面"效果（all over effect）。

因此，過一會兒當觀眾退到房間的中央時，就是退回到我們所熟悉的舒適 3D 真實空間。之後，會被來自左邊角落中間部份的聲音所吸引，是來自自然、森林、和昆蟲的輕柔聲響。同時，觀眾會發現蝴蝶的影像從上到下是呈直立的投射，因為牠們從上到下四處飛舞，有點像小型的圓形雕塑，或是依靠在白色閃亮的超現實材質上，像是白色的羽毛，在黑暗中發光，並帶點模糊的色彩，當觀眾走向它時，會很自然地把手放在白色材質上。

緊接著，投射在白色材質上的色彩變成清楚的蝴蝶停在觀眾的白手套上，觀眾感覺好像置身於噴泉中，將手放到水中，突然間感受到水的重量、觸覺和溫度。此時，觀眾感受到手上出現影像的效果，就像奇蹟或夢境，周圍輕和真實的聲音，讓人介乎於真實和虛幻之間。同時，在這個狀態下，觀眾全身處於一個真實的 3D 空間，但可以體驗面前的虛擬 3D 噴泉垂直地流下，並想將手往裡頭浸泡一下，有一點像科幻電影裡，和其他空間、時間及世界連結的通道，只要往裡頭一跳，就可以到達完全不同的世界。很多故事都有運用到這個點子（可能是鏡子、水、光束、交通工具等，從綠野仙蹤裡桃樂絲的冒險，到電影星際奇兵都有）。

觀眾以為已見到作品的全部，其實不然，當雙眼終於適應了展覽空間的幽暗後，若仔細看，會發現一些朦朧舞動的色彩，出現在主入口處的上方，才明白牠們是來自於牆上投射影像的反射，有點像蝴蝶的雙重影像投射在對面的牆上，這是另一特點，也是一種觸碰不到的、美麗得無以名狀的現象，同時，也不是每個體驗過這件作品的人都會發現和看見的秘密。與創作者林珮淳討論後，她告訴我這個現象是個意外產生的，是水平投影機上的透鏡複合系統創造出來的結果，她在完成創作後，看到覺得有趣而保留下來。它讓我想到杜象（Marcel Duchamas）的一件作品《大玻璃》（Le Grand Verre）的故事。有一次在運送杜象的展覽品時，一件雕塑其中一面大玻璃意外地破了，運送者感到非常的抱歉，並提議要更換玻璃，但杜象卻說不需要，讓它保持這樣就好，而且他感到非常高興，因為那個意外，給了這件作品另一個層次的生命，也是它的歷史的一部份。我想對我來說，那些在入口牆上的反射，亦是這件作品另一個生命的層次、也賦予整個創作另一個特點。

所以我們可以指出這件作品發展出四個不同的空間：1) 作品中央的空間是這個世界裡真實的 3D 空間，我們認識這個空間，並且能在當中操控我們的身體、感覺、生命和框架蝴蝶影像的移動。2) 當我們在展覽空間後面部份，變成進入到一個完全 3D 的虛擬空間裡移動：在那裡我們不能完全控制我們的身體，換言之，我們是在另一個世界優游。3) 左側的雕塑部份：這是個全新領域的空間，一個混合的空間，在那裡我們的身體存在這個世界，但是我們的雙手和雙臂可以隨我們所欲，自由穿透到另一個真實。4) 入口處上方的反射，一個秘密且不可觸及

的空間（反射來自於一部由虛構蝴蝶影像創造出數位影像掃描的影像⋯）。

我可以肯定林珮淳在這件作品中空間的運用非常精心和多層面的。對我來說，一件作品優秀與否決定於創作本身多層面的議題發揮，它讓我想起她在 2000 年的創作系列「景觀、觀景系列 - 花園、海景和天空裡」，也同樣以給人印象深刻的空間運用，來達成她的立體作品。這種多層面的思考可以在作品中多層次的意涵裡發現：蝴蝶和台灣本地歷史與生態問題，如污染和保護間的關連、時間和轉化問題（蝴蝶以其特異的從毛蟲轉化成蛹，再變成蝴蝶的態變而聞名）。其含義我們也可以聯想到很多與蝴蝶有關的著名故事，如中國的「梁山伯與祝英台化蝶」或西方故事（我想到有名的法國電影「蝴蝶」）。

最後，那些蝴蝶也是傳達此創作重點的很好媒介，它飛行於不同層次的現實和虛構之間。一方面蝴蝶來自真實、自然，是一種真實的自然，我們伸手可及；另一方面，此作品中所採用的新技術，將影像固定或移動，來自虛構、來自想像，是一種不真實，它創造出不真實的自然，我們無法觸碰。然而，作品在最後又試著讓我們再次觸碰，並感覺到那些蝴蝶，它試著將我們帶回部份的自然裡，這個循環完結了，但我們得到的仍是一個假的自然。你所得並非如你所見。

浮光掠影 - 捕捉 Catching

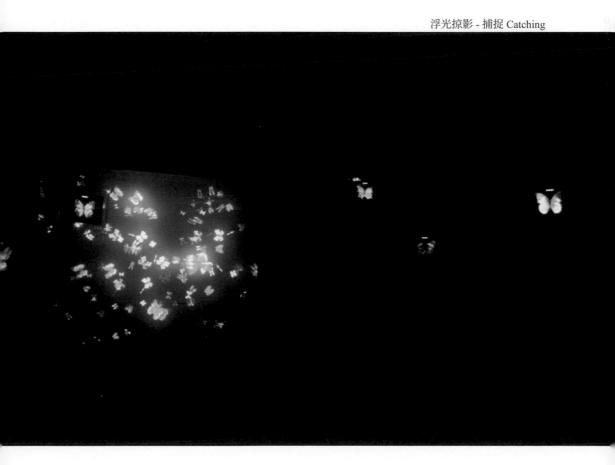

荒謬感背後的內省
評林珮淳「回歸大自然」系列創作

康居易 Susan Kendzulak | 藝術家、藝術學者

《藝術家雜誌》，2008 年 | Academia. edu

最近，全球接二連三面臨了颶風、颱風、地震、海嘯、山崩…等自然災害。就在為文的此刻，「大自然的母親」更被嚴正論及作為 2005 年《時代》雜誌的封面人物，即使大自然並非真實的人物。顯而易見，在人們從自然環境已失衡的事實中逐漸清醒的當下，大自然的破壞力量已然成為人類關心的主流議題。事實上，大自然或許並非原罪，反倒是好戰、製造污染的人類自己本身才是造成這場嚴重災難的始作俑者。

災害前仆後繼，舊殤方褪便即刻為新痕取而代之。大自然的破壞力似乎無窮盡地循環發生，突顯了人與自然抗爭的徒然無功。由於人類不斷製造污染源，科學家預警全球暖化的大自然現象，將會以更頻繁且更強烈的雙重破壞力，使我們現存的脆弱地球急遽加溫、冰冠溶解、海水溫度變高、暴風雨累增，永無止境。許多占卜預言家更認為這就是世界末日的到來，縱使充滿毀滅的瘟疫、洪水等災害的歷史，實屬生命的自然循環。然而，這些科學家的警示還是讓人們莫不驚嘆於生命的複雜，並且感懷仁慈上帝的存在。

居住平衡的生活是許多精神靈修與宗教信仰最關注的課題，《機械生活 Koyaanisqatsi》(美國印第安霍布族 (Hopi) 語言直譯為 Life Out Of Balance) 是導演 Godfrey Reggio 最鍾愛的電影之一，他從世界各地擷取最能適切傳達出都市文明和自然環境與傳統保存間的衝突之影像，藉以彰顯「失衡」的機械生活早已深植在文化領域超過三十年。

不可思議的生存奇蹟及不幸的土地災難是林珮淳藝術創作中最強而有力的兩大素材。她的作品透露出對上帝存在及美好生命的驚呼，並對人類漠視自然環境的無情投以高度關注。一位台灣著名的女性藝術家，轉而以不受政治力干擾的創作語法，來詮釋出九二一地震在她內心所產生的撼動。她探討的是更深層的信念問題以及發現基督，這也是她最終呈現人對自然及回歸自然，特別是回到伊甸的作品主軸。

在大型裝置藝術《城市母體》中，球體裡包覆著利用科技所製造出來的閃爍霓虹燈和交通聲音等都會擬態，透過球體上方的小鏡頭可窺見蝴蝶的影像，從球體延伸出去的金屬導管使蝴蝶透過液晶螢幕變換不同顏色，此外，網路視訊器 (web-cam) 亦吸引了觀眾瀏覽作品的目光，它的目的不僅是紀錄觀賞者，同時亦象徵當人們與此裝置產生連結後，便如何難以從中逃脫。此藝術創作的外形像吸塵器，仿若一個金屬線圈外彈、散落四周的微形機器人，藉此錯置在鐵絲線堆中的家用電器，來隱喻未來派自動化的便捷生活，也許是某種謬誤，同時亦警告人們，繼晶片記憶之後，旋即接踵的可能就是大自然的毀壞。換句話說，「城市母體」與動畫電影

四眼天雞 (Chicken Little) 裡所傳達的，對環境之「杞人憂天」概念雷同。

「景觀‧觀景」是在嘲諷環境的未來。坐在公園長凳觀看整座花園或海邊拍岸浪花是我們普遍皆有的生活經驗，但林珮淳卻將這些圖像安置在無生命的有機壓克力箱內，藉以警示人類若不開始珍惜大自然，未來我們恐怕只能透過人工造假的介面中，才有辦法追憶生命的奇蹟了。

蝴蝶、玫瑰和雛菊是女性繪畫慣用的典型圖騰。即使林珮淳也用這類女性特質的成像元素，然而其作品高度的環境保護訊息，卻更甚於這些元素原本既存的少女、柔弱意涵。她的作品讓人聯想到美國生態作家卡遜女士 (Rachel Carson) 的經典著作《無聲的吶喊》(The Silent Scream)，書中描述人類如何干預大自然，像在植物生長過程中噴灑 DDT 殺蟲劑，假正義之名趕盡殺絕所有惱人的昆蟲，終至使春天變成不再有蟲鳴鳥叫的萬籟俱寂。如同卡遜女士的疾呼：「人屬於自然的一部份，人類對自然的抗爭發難，無疑是對人類自己發動戰爭。雨水，將成為大自然用來對付如原子彈般致命產品的武器，水是我們最重要的自然資源，難以致信人類卻是如此魯莽地對待她。」(www.rachelcarson.org)

林珮淳也是在經營相同的脈絡，以詩般、聰明而富有關懷、不浮誇且深具啟發的語言來傳達省思。套用林的藝術觀，代換成 Carson 式的術語：「毋庸置疑，我們必須更加關注人類現存環境的驚異與現實，一逕地破壞將永遠無法有所體悟。」科學、複製、頹傾的文明趨勢，以及人類對環境的操弄，這些都是林珮淳作品中主要關心的議題，而她巧妙結合美麗與驚駭的手法，更是其發揮個人創造力的極致。

「回歸自然」是一系列的題材，以善良與邪惡兩個極端來詮釋宗教信仰。乍看她的作品予人一種輕快的感覺，細觀之後才發現簡中悲觀成份與對環境的杞人憂天。林所刻畫的這則自然虛擬實境，強烈地警告世人，我們必須群起保護生態環境，否則將只能從虛擬實境中憑弔眼前這片自然景觀了。

利用數位影音錄像捕捉振翼蝴蝶及生動花瓣等自然之美的閃鑠燈箱，實則帶有強烈的隱喻，自然生物原本是最直接具體的元素，卻又似乎並不實際存在她的作品裡。在迪化街公共藝術專案裡，她把狀似將要孵化的蝶蛹般吊燈懸掛在樹枝上，暗喻這個帶有堅硬外殼的蝶蛹，將以更具原始、晶透及多元生物的樣貌破繭而出。「非自然─溫室培育」是件奇異的作品。以透明壓克力如太空艙罩著由花瓣環繞成圓形的花朵，狀似人類的血紅大眼，花蕊中則是一個裸體的 3D 動畫錄像，無論花形或人形都極為寫真，實則是以數位虛擬而成。

《寶貝》這份作品，表面印有花卉圖像，如枕頭狀的燈箱，予人一種溫柔輕盈的感覺，彷彿溫暖夏日躺在柔軟草被上一般。而其他系列作品，貝殼狀的燈箱也有些像飛碟，讓人產生異形的聯想。乍看之下，似乎一切都是極為正確而絕美的，旋即於含糊的瞬間，驚覺一切都是荒謬的假像。

生生不息，源源不斷 Substantial Life

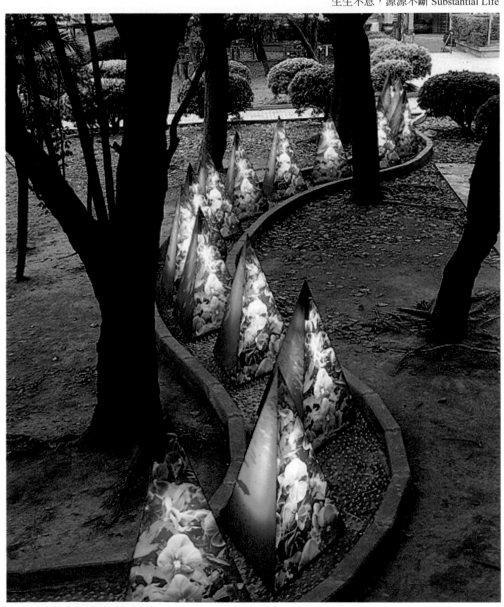

閱讀林珮淳的「回歸大自然」系列

陳香君 │ 藝評家、國際策展人

Academia. edu 國際學術教育網

真假自然・美學誘惑

走進桃園縣文化中心的展覽室，一片片碧海藍天、鳥語花香迎面而來。舒服的方廳裡，閒置著幾張椅子，隨人胡亂休憩，恣意享受明媚的山光水色。對於生活在都市叢林、渴望綠色芬多精人們，這景色，像是滿足山林慾望的視覺饗宴和心靈春藥，美的直教人分不清身在何處、所觀何物。

這令人錯置的青山綠水，並非人們殷切期盼的真實山水，而是林珮淳刻意製作的「景觀」。以假亂真、舒適清新的自然，暗藏著一劑充滿美學誘惑的道德猛藥。這動人的自然，其實是鑲嵌在商業廣告招牌上的人工照片，宣告自然美麗的同時，也憑弔著自然在現代社會中的香消玉殞。林珮淳的「景觀・觀景」，是榮耀自然的紀念，同時也是傷逝自然不歸的祭壇。

資本主義・世紀殺手

孕育人類生命的自然難回。高度的科技化、商業傳播化，預示了自然的死亡，而義無反顧、擁抱科技進步成果的人類，卻對自我與自然間關係的沉淪一無所知。這便是現代資本主義社會中，某些人們基於商業利益，深陷濫用、誤用自然的惡性循環之中卻絲毫沒有一點自覺的寫照。這個道德預言，以最美麗的姿態，弔詭地透過電腦科技與商業傳媒，反覆地出現在本次展出的『景觀・觀景』系列，以及桃園縣跨世紀全運藝術節裡的「源源不斷・生生不息」裝置系列，沉痛的控訴著資本主義剝削自然的邏輯，並諷刺的訴說著人性的無能與黑暗。

而從《源源不絕・生生不息》的都市公園健康步道到裝置「景觀・觀景」系列的文化中心方廳，意味著自然從人造室外空間到人造室內空間的挪移，對照出一種更死絕、更荒錯的自然意象，因此也傳喚出一種更加螳臂擋車的驚語和勇氣。

性/別經驗・諷諭父權

螳臂擋車。的確，在資本主義的龐大機制下，控訴人們對於自然的濫用誤用，如同在父權制度的緊密邏輯裡，要揭示人們對於「女性」這個「集體位置」的剝削一樣，必須要有明知不可為而為之的決心。在林珮淳過去幾年得作品脈絡裡，我們可以明確的看到這樣的勇氣和企圖。

從「女性詮釋」系列和「蛹」系列裡自述性的尋找自我做為女人的位置，演變到《相對說畫》裡控訴台灣、歐美資本主義與父權意識型態對於女性身體的宰制和剝削，乃至《黑(哭)牆，窗裡與窗外》與《向造成228台灣歷史大悲劇的當局者致意》裡抗議國家機器與父權制度不當

統治對女性造成的傷害,以及到《經典之作》裡解構中國孔教意識型態對於女性主體的限制與戕害等等, 完全體現了藝術家從女性主義角度出發,尋找女人發聲位置,以及反思主流機制與意識型態如何影響主體性格的嘗試。在「回歸大自然」系列—《源源不斷‧生生不息》和「景觀‧觀景」—藝術家的女性主義關懷,在自然生態保育上找到了出口。這除了是女性主義者政治|左地干預生態環境機制的一個行動之外,也是出自性別經驗的一種省思。和很多人一樣,藝術家視自然為「大地之母」(Mother Nature),孕育著萬物的生命。這可說是一種性/別的隱喻,自然變成了「女人」或「女體」,而人類對自然的予取予求,正隱含著社會剝削「女人」、「女體」的關係,於是,我們很清晰地看到藝術家創作生涯中,女性主義意識型態上的承接與延續。

回歸大自然 衷情烏托邦

回歸大自然,這個工業革命之後的浪漫主義欲望,或說,中國文人政治失意時的文化通風港,在當前科技高度擴張的時代,似乎已成為一種無可救藥的鄉愁。林珮淳的《源源不斷‧生生不息》和「景觀‧觀景」系列,也引含了對於「自然」這個「純淨烏托邦」的無止盡憑弔及永恆盼望。於是,在藝術家追求「純淨自然」的歷程裡,有憤怒難耐的控訴,也有頑強實現欲求的希望。正如欣喜地看見以往藝術家在探訪「性/別桃花源」的旅途上,不斷剖析深層文化意識如何阻擾航程的嘗試和耕耘,相信藝術家對「自然烏托邦」的衷情渴望裡, 也會有轉換鄉愁的深耕勇氣。

花柱 Flower Pillars

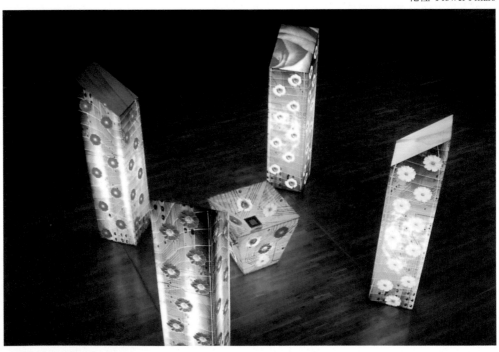

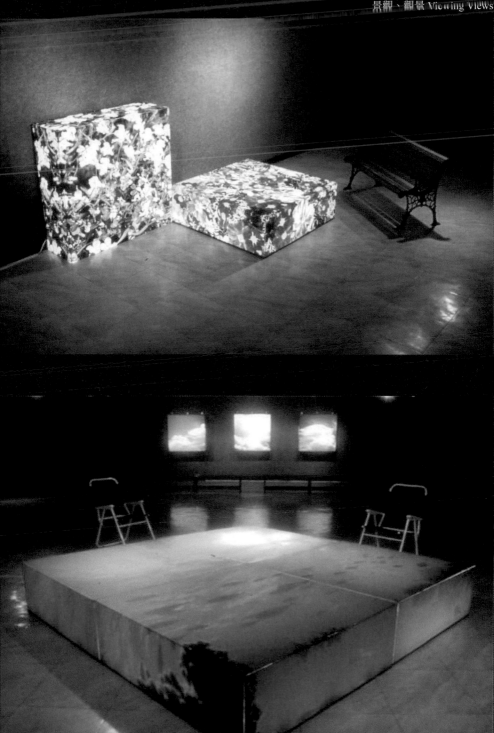

四、夏娃克隆系列

Eve Clone Series

互被動，從克隆之中

林珮淳的「夏娃克隆」系列

林宏璋 | 藝術家、藝評家、國際策展人、美術館館長

《藝術家雜誌》，2011 年 | Academia. edu

林珮淳的作品一直利用虛擬技術創作模擬生命狀態的情境，同時也利用作品評論科技的發展狀態。其近作「夏娃克隆系列」使用全息攝影在昏暗場景呈現女人及撒旦的混合形象，音樂及燈光配合製造類似「全感官」（synaesthetic）的展演經驗，並置聖經啓示錄的文字，在女人／撒旦／妓女／異教徒等等的這些「克隆」身分呈現一個複性單數（pluralisticsingularity）邪惡本質。擬真的陳設保存著克隆版本的夏娃在實驗室科幻場景以檔案方式存在，在觀看的經驗上呈現出一個「誤入」科技廢墟的死亡場景。然而，有趣的是這些夏娃檔案並非靜止不動，而是與觀者的目光對峙的互動，尤其在要離開展間，透過「歪斜觀看」（lookingAwry）全息攝影幻象效果，呈現出一個觀看者成為「被觀看者」的反轉情境，同時也是擬物／克隆（simulacrum／clone）對於人的凝視。

我們知道拉崗凝視心理機制的重點，不是在於主動觀看，也不是主體被引誘進入的觀看模式，而是觀看主、客體位置的調換。在拉崗式的心理分析中所有的凝視的主客體關係在一個被動語態（passivevoice）中完成：我知道我同時在這個畫面中被凝視，這是一種詭譎（uncanny）的看與被看的模式的互主體的網絡。即便沒有發生任何觀看的行為，也可以感覺到他者正在窺視自我的存在。在這個過程，自我成為「他者」，同時也是讓「我」成為他者凝視的物件。這個如同「老大哥」般的他者，讓原本觀看的主體，成為被看的對象，成為一個「物件（客體）」。這個在一般的詮釋過程成為「主、客體」的易位場合中，值得點出的是其牽涉的問題不僅僅是觀看影像間所發生關係，而是觀看者主體與他者的關連，如「他者也知道我是一個知道自己正被看的物件（客體）」。在這之中的視覺驅力，其語態，不僅僅一個主動語態（activevoice）—我看見，也是一個反身語態（reflexivevoice）—我看到自己。而更為重要的是在第三個階段被動語態讓我自己被看見。只有在這個慾望語態中，才能完成整個驅力的模組。換言之，主體重視保有其主動的方式，但只有在讓「我看到我自己看見自己（Isawmyselfseeingmyself）」中，在這個與原本交互的位置中，他者也知道我是一個知道自己正被看的物件（客體）。[1] 在「夏娃克隆系列」中攝入主體的被觀看情境，這個被觀看情境是一個 3D 全息的擬仿物，在製造這些影像的過程中沒有原件，只有套件（module），換言之，在一個無原件的拷貝。更有甚者，即便在作品中試圖利用科技摹仿著克隆女人的樣態，並且利用各式各樣的裝置手法的展現的擬像，無論再如何「逼真」，並非真實的克隆人，而是一個不完的摹仿。換句話說，這個類 3D 的藝術作品模仿了他們所再現的物件，但是其目標並非再現原件。我們只能說在這件作

1 Jacques Lacan The Seminar of Jacques Lacan Book I. edit Jacques-Allain Miller trans John Forester (New York: Norton Co. 1988), 215.

品中對於一個想像物件的模擬過程中，產生了從這個想像物件的體系。因而夏娃的「克隆」僅僅是假裝模仿。如拉崗所言：「藝術是建立了一個與物（The Thing）的關聯，企圖圍繞著它，使它顯現與消逝。」[2] 從這裡我們可以看到攝入主體的被觀看網絡中的凝視大他者，不是陳列中的類女人／撒旦形象擬仿，而是「科技」本身，因為技術使得如此的觀看與進步的可能，同時也是科技藝術中物體世界的呈現。

那麼由這個人與物所開啟的世界是科技藝術的互動性，更正確的說是一個「互被動」。因為在《夏娃克隆啟系列》並非展現一個等待參與者的創造以完成作品的互動情境，相反的，更像是如紀傑克與法福特（RobertPfaller）所言的「互被動性」（interpassivity）[3]，在於讓參與著投射於物件之中，讓物件自我完成整個行動，不需要參與者的投入，所有的物體已經完成了他們意義的迴路。這是在既是「被動」又是「互相」吊詭陳述的意義，讓主體觀看永遠朝向慾望開口的開放性匱乏。而這個開口正是一個「凝視的圈套」於科技所呈現的物的世界：人的本體不在人，而是一個他者的物件體系，或者，人的匱乏就是科技。

這是一方面，在林珮淳的作品中，科技總是以他者的身分顯現的原因，作為存在狀態的它方—「廢墟」，或者一個科技成為人類文明的狀態；同時這個圈套也指向著這些永遠匱乏的能指—女人／撒旦／妓女／克隆等等。林珮淳的作品創造出一個「越過」（traverse）科技的幻見情境，如何能克隆「匱乏」？只有在一個缺陷而不完整的擬像中顯現，讓我們一起陷入的科技作為廢墟的情境：「我看到我自己在看科技狀態」的情境之中，這是一個從「克隆」所開啟的啟示。

2　See Jacques Lacan, The seminar of Jacques Lacan, Book VII. edit Jacques-Allain Miller, trans Dannis Porter (New York: Routledge P, 1988) ,141

3　Robert Pfaller, Backup of Little Gestures of Disappearance: Interpassivity and the Theory of Ritual. http://www.csudh.edu/dearhabermas/interpassbk01.htm, June, 30, 2011

是神的意旨，抑或是人的慾望
林珮淳「夏娃克隆系列」中的反諷與批判性

邱誌勇 | **數位藝術國際策展人、藝評家**

《台灣數位藝術平台》 | Academia. edu

昔有在《聖經‧創世紀》篇章中深刻地描繪著上帝創造亞當，其後從亞當身軀中取下一根肋骨，創造了夏娃；今有林珮淳在「夏娃克隆系列」作品中藉由當代數位科技扮演著亞當的角色，創造了「虛擬」夏娃，並進而以量產的方式大量複製（克隆）。

隨著網際網路的普及，現代人們的日常生活幾乎無法也不可能脫離網路的使用，舉凡遠距教學、線上購物、線上交友、彈性工作等，無一不是透過網路而得以更為便利、快速地完成，其中當代新媒體藝術的創作形式也無可避免地與網路相互構連。威爾曼 (Bary Wellman) 與赫森斯威特 (Caroline Haythornthwaite) 便試圖彰顯網際網路如何成為日常生活的活動重鎮，並指出：網路的發展令人目眩神迷，它似乎創造了更多的可能性；但另一方面而言，人們也必須關注它是否會造成更多的社會問題（次文化、數位落差、社會互動等）。威爾曼與赫森斯威特更強調，在諸多關於網路文化的研究中，總是傾向於將這些現象與日常生活區分開來，然後再試圖論述這些現象如何影響日常生活。然而，他們駁斥這樣的論述方式並認為，網路上的活動其實無法與日常生活相分離；相反地，這兩者之間是彼此交織、交融在一起。[1]

長期以來，在林珮淳的創作中皆存在著一個重要的命題：「藉由批判科技以關注人與自然世界的關係」。無論是早期的《生生不息‧源源不斷》（1999）、《蛹之生》（2004）、《創造的虛擬》（2004），或是「夏娃克隆系列」（2006~今）；無論是藉由虛擬的「蝴蝶」或是「女體」，這些看似有著生命的虛擬創造物，皆是將人類文明世界認知中的生命體，轉化成「擬真」（看似假假，卻比真實還真）的藝術客體。卡瓦拉羅 (Dani Cavallaro) 曾言，網路空間所含藏的「虛擬真實」其實是一個由電腦模擬真實而成的環境，讓物理性的身體可在其中經驗到一種由「人為」所創造出來的真實，亦即：讓人們進入一個虛擬的環境中，但卻可以「如實地」經驗到現實世界中的種種真實感受。[2]

不言而喻地，在「夏娃克隆系列」作品中可以發現一種獨特的「陰性書寫」的策略作為批判論述的痕跡。林珮淳以「女性」（夏娃）作為被創造物，以權力性的科技象徵「陽剛」的一方。在「雄性」科技創造下的夏娃有著美妙的身姿與精雕細琢的形體；然而，此看似純潔的夏娃形體，卻扮演著迷惑眾生的角色，呈現出「介於純潔與邪惡間的陰性女體」。例如：《夏娃克隆啟示錄》以幽暗的陰性空間裝置承載著激烈的視覺震撼，在參與者走進空間之後，人

1 Barry Wellman and Caroline Haythorntheaite, The Internet in Everyday Life (NY: Blackwell, 2002), p. 35.
2 Dani Cavallaro. Cyberpunk and Cyberculture: Science Fiction and The Work of William Gibson (London: The Atolone, 2000), p. 36.

的軌跡便會驅動巨幅夏娃群的動態性，以及時間的流逝（或累積），此一時間並非人們視之

為理所當然的機械時鐘，反而以聖經中的時間觀，透過程式運算，以毫秒運算加以累計。《夏娃克隆啟示錄》的圖像正如《聖經‧啟示錄》（17: 18）中所記載：「你所看見的那女人就是統治地上諸王的那個大城」，而巨幅夏娃群的影像亦呼應著「你看見那淫婦坐著的水流就是指各民族、各種族、各國家，和說各種語言的人」（《啟示錄 17: 15》）。作品以六種不同的語言—英文、中文、阿拉伯文、拉丁文、希臘文，以及希伯來文—代表各民族與各國家，更象徵著政治、經濟、文化、宗教，以及軍事等不同屬性的世界。從中，林珮淳試圖以此種「陰性書寫」批判當代科技文明下，試圖模仿自然、掌控自然，並超越自然的迷思。更重要的是，此一虛擬世界中的夏娃意象，卻著實地反映著當代人們的日常生活（如：沉溺於網路交友或網路遊戲的虛擬性之中）。

此外，在《夏娃克隆肖像》、《量產夏娃克隆》與《透視夏娃克隆》三件作品皆圍繞著另一個聖經中的預言—「印記」。正如〈啟示錄〉中所記載的預言，在末世災難中，舉凡被身上被烙有獸印「666」的人們，將無法逃脫獸的鉗制。因此《透視夏娃克隆》中，以流行的刺青圖騰—龍、鳳、蛇、蠍，暗喻著受「獸」的轄制，一方面呈現當代人們喜愛在身上留下印記的流行現象；另一方面也批判著人反被物宰制的交互關係。而在《夏娃克隆肖像》中則是以十餘種的不同語言呈現象徵符號—「666」，更利用全像攝影術，讓受挾制且婀娜多姿的夏娃，產生魅誘（seduction）的眼神與觀者產生心靈上的互動，亦正亦邪地讓人們產生困惑。更甚之，在《量產夏娃克隆》系列中，以小型數位相框的形式展示出孕育中的夏娃。此種「量產」的方式猶如是處於機械工廠中，缺乏生命、情感與人際關係的生產線一般，令人感受冷清、冰冷與異化，藉以諷刺「複製」中的無意識，並批判「量產」中的無差異性。

上述量產與複製的創作形式，在《夏娃克隆手》與《夏娃克隆手指》兩個系列作品中出現了更加激烈的批判，「肢解」身軀的意象，就像是生產線上尚未組裝完成的「零件」，每一個零件看似獨特，卻又如此地整齊畫一，而以「標本」的樣態存在，更讓人宛如身處冷冰冰的生物（或生化）實驗室之中，毫無情感的景況。總體而言，在科技文明極度昌盛的世代中，林珮淳深刻地批判人妄想做為造物主的角色，以肢解、量產，以及獸印等聖經預言中的隱喻，不斷地提醒著人們必須思考的是：究竟是人們的慾望驅使了科技的精準，抑或是科技的快速發展促使我們的慾望滋生。人是否已經在創造物之後，反被物所綁架。

阿諾 · 豪瑟 (Arnold Hauser) 曾言，藝術不僅反映社會；更與社會相互影響。對豪瑟而言，藝術與生活是密不可分的，藝術也必須保持與現實生活整體間的聯繫，並作為審美行為的基底。如此，藝術方能以最生動、最深刻的方式反映現象。在「夏娃克隆系列」中，林珮淳以複合媒材的藝術表現形式，不僅提醒著人們身處數位科技時代需有的警覺心，也對世人展現出其作為藝術家的批判性格。

透視夏娃克隆 Inspection of Eve Clone

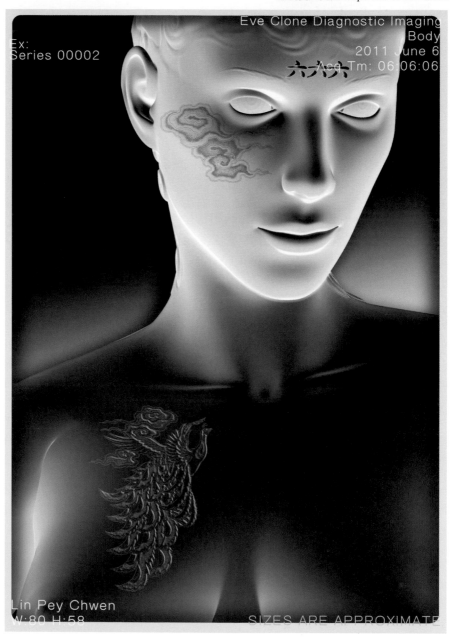

擬皮層與超宗教
林珮淳的 2010-11 年「夏娃克隆系列」

陳明惠 | 藝評家、國際策展人

《藝術家雜誌》，2011 年 | Academia. edu

藝術家林珮淳於 2010-11 年創作其最新之「夏娃克隆系列」作品，此系列乃是藝術家自 2010 年起，以女性 (夏娃) 肖像作為作品主體，再加以聖經內容之啟示，而創作出的一系列立體顯影作品。同時，林珮淳更創作了以 "手" 為主體之一系列立體雕塑新作，與「夏娃克隆系列」相呼應，此最新之「夏娃克隆系列」延續藝術家早期對於女性議題之關注，且同時反應其近期以宗教之象徵與符號，作為其藝術創作的主要靈媒。欲分析林珮淳 2010-11 年的「夏娃克隆系列」作品，我需要回顧其過去近二十年來的創作風格，與分析其近年來藉著媒體與科技技術，所創作出且傳達的獨特藝術形式與象徵。

"夏娃" 作為林珮淳近幾年之作品主體，不難在其過往二十年之藝術創作歷程裡找到端倪。林珮淳開始在台灣藝壇發聲，是其於 1989 年自美國返台後，積極參與 2 號公寓的活動與展演。在作為藝術家與教書之際，她更需在妻子與母親的角色中尋找其自我之藝術空間。直到 1993 年於澳洲攻讀藝術創作博士學位，始正式受到西方女性主義之影響，並在 1996 年返台後，積極參與台灣女性藝術之組織與活動。由林珮淳早期之生命經驗與藝術啟蒙來看，女性主義意識一直是藝術家主要之創作思考根源與影響。然而，林珮淳僅管受到深厚的 "早期" 女性主義之啟蒙，其近年來以數位藝術作為創作媒介之作品，早已擺脫早期女性主義對於父權搖旗吶喊之特質，反而以一種較宏觀的角度，將一個女性藝術家所關心之課題，由強調女權昇華到關懷生命與自然。

這種女性主義的特質，便是所謂的 "生態女性主義" (ecofeminism)，認為資本主義就如同父權一般，將自然／女人視為殖民的對象，因而主張解放自然且重返人之自然性。這種 "超我" 及對於生活大環境之關懷，且對人類自然環境之關注，可以在其 1999 年所創作之作品—《回歸大自然系列》、《生生不息、源源不斷》與《寶貝》等系列，觀察出藝術家對於創作議題之轉變。這種生態女性主義的創作思考模式，直到 2001 年藉著執教於台灣藝術大學多媒體動畫藝術研究所之後，林珮淳的作品更達到另一個層次的轉變：在高度使用科技技術進行創作之際，林珮淳提出對於科技文明之批判，與重申自然之重要性。而這便是數位女體— 夏娃克隆，之被藝術家所選取，作為整個系列發展之主題之背景與緣由。

擬皮層與超宗教

由於藝術、科技媒材、學術研究與科學早構成一種相互影響之跨領域學門，在分析科技藝術之同時，無法僅就科技與藝術本身來探討，而作品形式底下的那層文化意涵、象徵意義，即與社會之關連性，往往是分析一件當代藝術作品，需要解讀之重要項目。本文標題以 "擬皮

層"與 "超宗教" 兩主題，作為含括林珮淳 2010-11 之「夏娃克隆系列」，是就作品之技術面、物質面與象徵性來切入，涉及以數位科技作為主要技術介面而創造 "擬皮層"，而宗教(基督教)提供藝術家作品靈感，但又非直接將宗教題材視覺化，而是以藝術家自己獨特之藝術敏銳力，轉換宗教題材成 一種與藝術更接近之作品，因此以 "超宗教" 描述之。

林珮淳最早的《夏娃克隆 II》創作於 2006 年，其中夏娃克隆是個完美無瑕且毫無體毛之女體，是藝術家創造出的一種烏托邦式的身體：似真似假、介於有機與無機之間的數位人。林珮淳將其與蝴蝶與蛹的形象結合，此交雜人體、蝶蛹與科技聲光之夏娃克隆，透過觀眾與電腦程式／螢幕的互動，進而被賦予生命且逐漸展翅舞動。在迷離的彩色聲光效果下，藝術家在探討人工生命、科學討戰自然之議題。林珮淳 2010 年的「夏娃克隆系列」不同於《夏娃克隆 II》，此夏娃克隆受啟發於聖經〈啟示錄〉之十三章十八節中，上帝預告 "獸名"的數目是 666，且在額頭上刻劃此數字作為印記之典故。《夏娃克隆 II》中的夏娃克隆，是一個表面美麗動人、光彩炫目的人與蝴蝶之交雜體，林珮淳以此作為警惕科技文明對於人類生命之負面影響。而 2011 年在當代館展出的「夏娃克隆系列」，直接以人獸同體之體呈現 "惡"之意象，更直接反諷科技帶給人類之淺藏危害，並挑釁社會對於女性身體之牽制與束縛，且以更積極且直接的方式傳達出來。

林珮淳最新的「夏娃克隆肖像系列」，以 3D 動態全像攝影的高科技技術，將夏娃克隆的頭像與多種禽獸的形象結合，再賦予不同礦物之色澤與質感(金、銀、銅、鐵、泥)，而夏娃克隆額頭上之 666 數字，更以中文、日文、德文、阿拉伯文、埃及文、匈牙利文等文字呈現。藉此，藝術家在呈現人類因為科技文明的極度發展，所帶來對人類自己之負面效應，而此現象呈現於世界各不同民族社會中。夏娃克隆不同礦物質感與色澤之肌膚，呈現人與獸結合之所有不同可能面貌。延續林珮淳 2006 年《標本》的概念，這些夏娃克隆肖像，被放置於以壓克力透明材質所構成之黑框中，仿若是－具具死體之標本，但又因著夏娃克隆眼神會隨著觀者之移動而轉動，這些肖像又似乎是具有生命之活體，一種藉於死體與活體之間的詭譎感，更切合藝術家欲表達科學(無機)與自然(有機)之間的張力與不安。

分析視覺藝術作品，可以由兩大方法進行：符號學 (semiotics) 與圖像學 (iconography)。林珮淳的 2010 年夏娃克隆肖像系列，較適合以圖像學之角度分析之，尤其圖像學常被藝術史學者使用於分析現代時期之前的宗教作品，譬如十字架、耶穌的肖像與其它宗教象徵圖像。宗教題材透過藝術來表現，最早可以追溯到西方中世紀之前，再歷經文藝復興時期，直至二十世紀上半之現代時期，包含：猶太裔英國雕塑家—賈克布‧艾伯斯坦 (Jacob Epstein，1880-1959)。雖然當代藝術家較少直接引用基督教作為創作之靈感來源，不可否認的，宗教仍被視為當代藝術創作之動力與靈感，其中以南非版畫與纖維藝術家—阿賽里亞‧恩巴塞 (Azaria Mbatha，1941-)，藉著聖經故事之敘事性作為其藝術創作題材，而深具代表性 。

與眾多西洋藝術史中以基督教作為創作靈感之經典名作不同，林珮淳作品裡的圖像性是較間接的。林珮淳選擇以夏娃克隆作為此系列之主題，在圖像之選擇上並沒有強烈的宗教色彩，反而藉著 3D 動態全像之媒材特殊性，作品本身具有強烈之當代性與高科技性。夏娃克隆之圖像藉著觀眾來回走動，而呈現 360 度之影像效果，此高科技技術之處理呈現，賦予林珮淳的夏娃克隆一種現代感，而與聖經伊甸園中夏娃溫柔、平凡的肉體形象迥然不同。夏娃克隆的 "擬皮層" 呈現不同礦物金屬質感與色澤，甚至在漆黑的背景中隱隱發光，此夏娃克隆的數位皮

層之圖像性，透露出一股不安全感、神祕性與詭譎感，而夏娃克隆額頭上以不同語言所呈現的 666 圖像，帶有強烈宗教之象徵性，因為 "666" 是基督教裡代表惡魔的數字。然而，誠如許多以特定圖像象徵性作為藝術創作之作品，觀眾必須對此圖像之背景瞭解，小即，觀者必須先具有一定的知識背景，以使其能解讀此圖像之象徵意義，不然，觀眾極容易沉迷於作品中科技技術所帶來之視覺刺激，而忽略藝術家欲傳達之作品意義。

除了以 3D 動態全像攝影技術來呈現不同面貌的夏娃克隆，林珮淳又創作一件以互動式影像來呈現夏娃克隆之作品—《夏娃克隆 III》。林珮淳與其數位藝術實驗室向來以創作互動影像作品而享有盛名，林珮淳再次以其擅長的互動影像技術，將所有不同礦物色擇與質感之夏娃克隆聯結起來，藉著觀眾在此作品前之移動，夏娃克隆會不斷變換不同面貌，且時而正面、側身、時而轉身，隨著夏娃克隆之轉動，夏娃克隆之影像同時高低起伏，仿若隨時會從影像中跳動而出。《夏娃克隆 III》在 2011 年於台北當代藝術館展出時，是以六面投影之大型互動裝置展出。林珮淳利用 3D 電腦動畫科技、kinect 感測器，與電腦互動系統，創造出鬼魅且極具震撼力之最新夏娃克隆影像。此作品以流動的水與光影為背景，夏娃克隆的面貌隨著觀眾之來回走動而不斷轉換，水影與光影也同時跟著變動，這種"人的介入"而導致夏娃克隆影像的轉變，正符合林珮淳所欲表達 "人" 與 "科技" 之間的互動性，與其中曖昧的相互影響與牽制之關係，而正如藝術家所強調的—"上帝創造夏娃，人創造夏娃克隆"，此夏娃克隆之形象更是人與科技交織所創作的結果，而夏娃克隆那充滿詭異之美感，更反映了人工與科技文明對於自然之負面影響。同時，林珮淳欲傳達夏娃克隆之 "人獸同體" 的詭譎特質，與 666 數字在基督教中邪惡的象徵，此作品達到比 3D 動態全像攝影更強烈的效果。

據聖經記載，獸印 666 圖像除了顯示於額頭，亦出現於右手上。林珮淳因此創作了六對不同質感與顏色的手，置於如同醫院放置器官之玻璃瓶中，名為—《夏娃克隆手》。與製作夏娃克隆之理念相似，此六對手具有不同質材：金、銀、銅、鐵、泥、水晶，與不同質感意象：蛇皮、蛹、工業零件、貝殼、木頭等。這些手的 "擬皮層"，是以繁複的手續所創作而成：先以雕塑翻模，再轉成透明樹脂，藝術家特地以藍綠色的雷射燈與水泡打在置於玻璃瓶中的雙手，企圖賦予手鬼魅之神祕性。這種藉著自然之形 (真實人的雙手圖象) 而創作出的非自然之物 (擬皮層)，企圖以繁複的技術塑造一種近乎自然之物體，而近看這些充滿奇異質感與意象的手，似乎象徵著與夏娃克隆同樣的概念—人獸同體。夏娃克隆的擬皮層以二度空間的方式顯示三度空間的形象，透過的是立體顯影之技術，而這些原本就以三度空間呈現之雙手，以裝在玻璃瓶中之形式，似乎呈現一種如同夏娃克隆肖像般的 "標本" 特質。

此六對雙手雕塑的圖象性，雖同樣刻印著獸印 666 數字，但與夏娃克隆一樣並沒有很強烈且直接的宗教象徵，反而因為媒材與呈現方式之特殊感，讓這一系列作品呈現一種奇特的氣質。雙手雕塑與夏娃克隆的肖像作品之交集性在於 "擬皮層" 的概念：後者以高科技技術模擬女體不同色澤與質地的肌膚，前者以雕塑的概念形塑不同質感之膚層，再以雷射燈及氣泡的方式，賦予作品介於死亡與生命之詭譎感。僅管林珮淳的作品不在闡述皮層的文化與象徵意義，但是作品皮層本身散發出來的象徵性是不易忽視的。人的皮層不論粗糙或是細緻，同時是活體與死體，具有自己修復與再生的能力，此種皮層之生物性與林珮淳欲表達之作品特質是符合的：一種透過科學技術來擬造自然之物，以無機之技術來塑造有機之生命體。

法國藝術家及理論家—史蒂芬妮‧度瑪 (Stéphane Dumas) 提出 "創意的皮膚" 之概念，她指出：「"創意的皮膚" 可以做為我們對於外在世界之再現的隱喻… 作為一種因素，皮膚本身是一種媒介、中介質，介於外在世界、人的肉體、有所指涉之身體或是感官之身體。」藉著電腦科技，林珮淳創作一種虛擬的夏娃克隆擬皮層，這是她藉以傳達一種對科技文明之批判，及對於我們外在世界之省思。林珮淳夏娃克隆系列中人獸合一且具不同質感的數位皮層，是其對於我們生存世界裡真實與虛擬之不確定性之反射。

以科學技術來擬造皮層與身體，可以由林珮淳的另一件新作品觀察到—《夏娃克隆手指》。此作品將以透明樹脂做成之手指雕塑，置入於醫學試管中，再配以壓克力黑框於牆面展出。與《夏娃克隆手》相似，林珮淳以綠色投影燈照射這些手指，藉此，一股詭譎之虛幻感，由黝黑之黑框與背景中透出。透過此新作品，林珮淳欲傳達夏娃克隆正在被創造的過程，而此過程是人造的、科學的，且非自然的。藝術家透過科技技術，以反向的方式來倡導 "回歸自然" 之重要性，此作品深刻地與林珮淳過去持有的 "生態女性主義" 之角度，透過人造夏娃克隆之無機基因，再次對於數位科技、人工生命提出批判。

林珮淳在 2011 年八月在新苑藝術所舉辦的個展中，近一步創作且展出《量產夏娃克隆》、《夏娃克隆啟示錄》及《透視夏娃克隆》三件新作。《量產夏娃克隆》將夏娃克隆圖像由 18 件 8 吋小型數位相框於牆面展示，在此作品中，夏娃克隆右手張開五指且輕撫乳房，左手彎起並置於低傾之雙眼前，夏娃克隆雙腳合併、彎曲，且以坐姿之姿態，沉浸在一個仿若是流水之液體中。此 18 件圖像雖然呈現同樣姿態的夏娃克隆，但是與之前的作品相同，她們皆以不同色質與直感呈現，同時以連續 360 度自轉之不同角度呈現。作品與《夏娃克隆手》有極相似之處：皆以一種浸泡於液體，且置於醫學試管或容器之形像呈現。對於此作品，林珮淳在其自述中指出：「量產與規格化，再現以克隆無性生殖技術與原個體有完全相同之生產過程。」夏娃克隆之人工機械式複製性，在此作品表露無疑，且此 18 件數位相框以 "整齊" 之方式呈現，更暗示複製工廠中，人工、無機、無情感生命之特質，更呼應藝術家較早期作品中 "標本" 的概念。

《夏娃克隆啟示錄》可以視為《量產夏娃克隆》之延伸，且以一大型互動投影的形式呈現。此作品同時將數個夏娃克隆之 360 度自轉之影像，藉著兩部同步投影機，藝術家企圖呈現一種如排山倒海般且具震撼性之夏娃克隆影像，另外，林珮淳在夏娃克隆影像頂部，透過特殊程式運算，呈現以毫秒運算之累計數字。數字的累計，是由觀眾進入展場而啟動，而觀眾一離場，數字便自動停止累計，同時影像之色澤逐漸轉呈灰階。林珮淳自從 1999 年之創作 (例如：《回歸大自然系列》) 便一直批判人工與自然相對抵制與牽引之對抗性，而《夏娃克隆啟示錄》作品裡數字與圖像因著觀眾之轉變性，又再次回應藝術家在過去十多年之創作歷程中，對於 "人工生命" 特徵之呈現與思考。另外，在此作品中，林珮淳以六種不同語言 (中文、英文、阿拉伯文、希臘文、拉丁文與希伯來文)，呈現聖經〈啟示錄〉中對於握有權柄並具有惡之象徵之女人之形像。另外，此作品之背景音樂與作品中的視覺元素相同，亦存在著一種詭譎的氛圍，因此，當觀眾置身於此作品中，仿若沉浸於一種超越現實世界之情境，視覺中夏娃克隆美豔且邪惡的形像，加上不斷變換的聖經語句，及聽覺中詭異的音樂，提供給觀眾一種極震撼且罕見之感官經驗。

本文以"擬皮層"作為論述林珮淳作品的主要面向之一，且以作品中的科技性，論述虛擬的夏娃克隆擬皮層如何表達藝術家欲傳達之象徵性。林珮淳的《透視夏娃克隆》一作，呈現雙層之擬皮層概念：夏娃克隆本身由數位皮層所構成，且夏娃克隆的擬皮層之刺青圖像所透露出肉體與科技之間的曖昧性。作品中的刺青圖騰包含玫瑰、龍、鳳、蛇、蠍子等，這些皆是藝術家特地挑選的圖騰，誠如本文先前所提之"圖像學"與藝術家作品之連結，這些刺青圖騰本身的圖像性與藝術家賦予夏娃克隆之象徵性是一致的，皆呈現一種"美麗的陷阱"之意含，同時隱射一種暴力、危險與不安之氣質。《透視夏娃克隆》以紅外線攝影的方式，呈現夏娃克隆身體不同角度與部位，林珮淳並在作品的上方與下方標示作品系列編號、日期、時間與藝術家的名字，仿若是藝術家本人對於夏娃克隆進行的紅外線透視，並賦予"診斷"的編號。林珮淳指出：「刺青的圖騰暗喻刺青、身體與夏娃克隆本質關係，並提出美麗的夏娃克隆表象，在紅外線透視底下，揭露出夏娃克隆暗藏的危險符號。」換言之，藝術家透過紅外線攝影技術的挪用，顯露出夏娃克隆美麗的皮層之下，那股帶著負面的象徵意涵。

分析林珮淳近幾年的作品，無法將其宗教信仰與藝術創作分離。對林珮淳而言，宗教信仰是她創作的泉源，而此種對於宗教與藝術創作的態度，不難在許多當代藝術創作中找出其他例子，包含佛教 (南韓藝術家—白南準 1989 年之錄影裝置作品《佛祖》) 與伊斯蘭教 (伊朗出生之美國籍藝術家—雪林·尼夏 Shirin Neshat 之一系列以回教文化為主題之攝影與影像作品)。僅管 666 圖像本身帶有強烈的基督教象徵之圖像，在解讀林珮淳的作品時，並不適合以"宗教藝術"之角度切入，因為其作品在美學上、技術上，與結構上之專業性，遠勝過其作品圖像本身之宗教性，而作品中"擬皮層"的物質性與作品呈現介於死亡與生命之象徵性，與作品所散發出的詭異、幻化，與不真實感，是林珮淳「夏娃克隆系列」之獨特特質。

夏娃克隆肖像 Portrait of Eve Clone

「夏娃克隆的誕生」
基因生殖實驗室的科技反諷

曾鈺涓 │ 藝術家、國際策展人

《藝術欣賞期刊》，2011 年 │ Academia. edu

1999 年，在 921 大地震災難的震撼中，林珮淳感受大自然創造主的啟示，將創作主軸，從對解構性別、文化、社會等議題，轉向關注人與大自然的關係，近年來，更深入討論基因生殖科技中，人類試圖扮演上帝角色的誤謬，該系列作品不僅發揮女性特有的關懷特質，更將視野從小我轉向大我，以大地之母的姿態，討論人與科技、人與自然間的共生關係，並將此關係納入創作的思考脈絡中。本文將以夏娃為主體，討論該系列創作內涵與其中所展現的意識。

林珮淳「回歸大自然」系列創作，將各種的自然生命，轉換成為虛幻不實的物件，如 1999 年《生生不息、源源不斷》的人工天空與花草所建構的人工美景，2001 年《寶貝》與 2004 年《花柱》、《花非花》中的人工花朵。2004 年《蛹之生》、《城市母體》、《標本》、《創造的虛擬》中的人工蝴蝶，2006《夏娃克隆 I》中蝶人女體「夏娃」誕生。這些生物，看似具生命主體，卻又依附著藝術家與觀者的虛幻控制與參與中創造產生。

從以蝴蝶為主角的作品、到現今以夏娃為主體的系列創作：《夏娃克隆 II》、《夏娃克隆肖像》、《夏娃克隆手》、《夏娃克隆手》、《夏娃克隆 III》、《量產夏娃克隆》、《夏娃克隆啟示錄》、《透視夏娃克隆》等作品。兩個主角：蝴蝶與夏娃，都是藝術家以基因生殖科技的實驗態度，模擬創造出不存在的兩種物種，透過實體展場的空間營造，讓觀者沉浸於其中，並開啟敘事的想像之旅。如《創造的虛擬》中具殿堂靈光氛圍的個人控制室，吸引觀眾透過觸碰塗抹方式成為蝴蝶生物體的創造者，並參與完成創造生命的儀式。

然而，有別於「蝴蝶」的曼妙與多彩，林珮淳的「夏娃」則顯得淒冷。2011 年台北當代藝術館《林珮淳個展 - 夏娃克隆系列》個展中，林珮淳營造虛擬基因生殖實驗室，以博物館冷寂氣氛的空間氛圍，誘惑觀者進入窺探，想像參與創造的歷程，卻只看到被肢解，並保存於標本瓶中的《夏娃克隆手》，與被封存於框架中的《夏娃克隆肖像》

帶著詭異與冷冽笑容的臉，展現曼妙女體的優雅，是林珮淳所建構的夏娃形象，然而夏娃是誰？聖經裡的夏娃，是造成人類背負原罪的始作俑者。根據《聖經•創世記》，神用地上的泥土，依照著自己的形像，創造世界上第一位人，取名「亞當」。其後，神取下亞當的一條肋骨，創造了夏娃。創世紀記載：「夏娃在上帝耶和華的呼喚下來到伊甸園，用右手命令動作呼喚新生命走向生活。」 兩人赤身裸體，手拉手漫步在花叢林間，沉醉在花香鳥語中，沐浴在生氣盎然的大地上，他們盡情享受上帝賦予他倆和諧歡樂的世界，然而，夏娃卻忘卻神一再交代，若餓，園中的果子可以吃，千萬別碰「智慧樹」果實的警語，在蛇的誘惑下偷嚐了禁果，還要亞當也品嚐一個。最後促使上帝將他們倆人逐出伊甸園，並且承受人類的「原罪」。

林珮淳的「夏娃克隆」卻是在一個虛擬基因生殖實驗室裡所誕生的物種,單純觀看「夏娃克隆」的長相與臉部表情,是一位帶著淺淺微笑的美麗豔冶女子,有著特殊造型與髮粧,額頭上的「666 獸印」烙印隱約可見,卻也無損其美麗。在《夏娃克隆肖像》中,「夏娃克隆」頭像雖然被禁錮於一個時空當中,其深邃的雙眼隨著觀者的走動,擺動窺看。《夏娃克隆手》則以標本玻璃罐中封存夏娃各種不同材質的雙手,如蛇皮、樹皮、蛹皮、貝殼與礦石等,顯示「夏娃克隆」是具「非人」皮囊的物種。《量產夏娃克隆》與《夏娃克隆啟示錄》中,夏娃全身像終於被創造出。這些造像的皮囊材質,背上所披覆的鱗片與骨節,清楚顯露了「夏娃克隆」所具有的獸身特質。《透視夏娃克隆》則以透視片型態,透露出隱藏於軀體的玫瑰、龍、鳳、蛇、蠍子等刺青圖騰,凸顯額頭上各國語言之「666 獸印」烙印的邪惡象徵意義。林珮淳創作的「夏娃克隆」,不僅是基因科技創造的產物,背負基因生殖科技的罪惡,成為刻印著獸名印記的女人,更象徵人類自以為是的科技成就之反諷。

英國羅斯林研究所(Roslin Institute)於 1996 年 7 月 5 日以複製生殖科技培養出第一隻複製羊桃莉後,雖然引起全世界震驚,但卻也宣告生物科技將進入至另一個境界。1989 年,美國國家衛生研究院 (NIH) 成立了人類基因體研究中心,由 DNA 雙螺旋結構的發現者華生 (James D. Watson) 主持,1990 年十月一日開始基因體的解讀計畫工程,此計畫由美、英、德、法、日、大陸為首,共有 18 個國家參與為人類遺傳密碼的 30 億個 DNA 進行序列解讀工作,解讀基因體核甘酸序列,並鑑別所有人類基因之功能。1998 年克雷格 · 凡特 (Craig Venter) 成立第一個從事人類基因體計畫的私人公司 - 賽雷拉 (Celera)。2001 年賽雷拉和人類基因體計畫分別在科學期刊「科學」和「自然」公布了人類基因組序列。人類基因體定序被解碼,從此之後,科學家可以按照需求接受訂製,將生物 DNA 中的某個遺傳密碼片段連接到另外一種生物的 DNA 鏈上去,重組出新的遺傳物質並創造出新的生物類型。藉由科技,人類成為具決定生物形貌並進行改造權力的上帝,操弄生物基因圖譜所進行的混種、突變、形變與複製。

林珮淳的作品,從「蝴蝶」到「夏娃克隆」,此兩種看似迥異的物種,所象徵地卻都是人類的虛妄,妄想以科技改變、複製與模仿自然。在其建構的虛擬基因生殖實驗室中,以變形的混種生物:「獸人」,暗喻著基因生殖科技是人與獸的交媾,是人類的墮落與腐敗。混種的變形生物展現了聖經的警示,也呼應了西方的神話與聖經繪畫創作,如波希 (Hieronymus Bosch,1450 ~ 1516) 的作品中出現的鼠首人、鹿首人與魚頭人等變形生物。馬索利諾 (Masolino,1383~1447) 與范德爾 · 爾斯 (Van Der Goes,1440~1482) 的《原罪》畫中,代表邪惡的人首蛇

在這些繪畫中的混種生物雖然僅是作為強化故事象徵寓意的配角，卻都是貪婪與道德淪喪的人類。藝術家以創作警告人類道德沉淪的後果，將使眾人成為惡魔與半人半獸，最後彼此吞噬與毀滅，透過深奧、含糊的謎語與象徵啟示，提醒人類如果不知自省，將失去人性與未來。

德國哲學家海德格曾針對技術哲學提出「本質論」，認為只有透過理解科技與人、與世界的關係，才能瞭解現代科技所啟發的存在世界如何顯現自身，才能理解現代科技的本質。林珮淳的作品體現海德格的「本質論」，以數位媒體為工具媒介，解構與批判科技，操弄觀者的視覺感知，建構了美好卻又虛幻的靈光殿堂。當觀者浸淫於其中，或魅於創作主體的美麗展現，或惑于創作意識的議題操弄，或迷於自我內心的想像世界，然而這些魅惑，都呼應了林珮淳作品中，所欲傳遞出以科技批判科技之意象。

夏娃克隆手 Eve Clone Hands

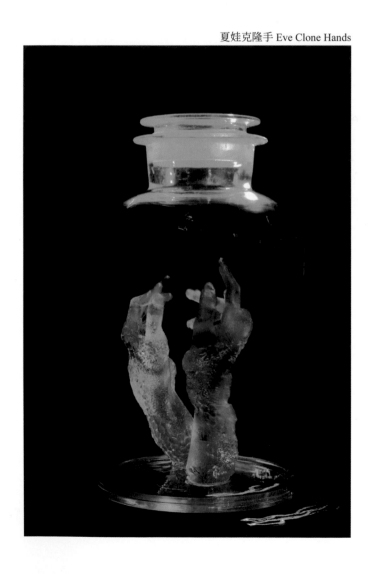

美學的僭越
林珮淳「夏娃克隆」系列

吳介祥 | 藝評家、藝術理論學者

Academia. edu 國際學術教育網

上帝的創造、魔鬼的雕工—美學的遮蔽

對於身體的過度依戀，對於永生的過度渴望，讓人們世世代代持續地追求改造工程。史話裡便有秦始皇派員東行三次，就是為了搜尋長生不老藥，而也有稗官野史提到漢武帝也到處徵詢不死仙液。漢武帝的養士東方朔將呈送到朝廷的不死仙液一口喝盡，讓漢武帝大怒而欲賜死東方朔，東方朔大笑說如果喝下此仙液仍被刺死，君王你還相信世間真有不死仙液嗎？對不朽的幻覺造成的盲目，也成了人性諷刺之靈感。希臘神話裡便有所謂的青春之泉，代表人們對無邪青春的無限渴望和想像，以此想像的創作包括波西 (Hieronymus Bosch) 的慾望花園 (1504) 一作裡無憂洗浴在噴泉池中的男女青春胴體；而十五世紀的西班牙也流傳著探險家 Juan Ponce de León 遠洋從西班牙到美洲尋找到傳說中的青春之泉 (Fountain of Youth)，青春之泉的傳說也引發出教堂的警世創作，這類創作描述了堆疊逸樂在青春之泉的男女，戀棧肉體的癡昧、放縱情慾、違背倫常綱紀的景象。耽溺肉體，警世預言其實不需要以撒旦為威脅，當今的生化科技和美容醫學的侵入性程度，已經證明了人的慾望足已啟動魔鬼般的工程。

林珮淳的數位科技下的創造物若不是美景佳人，就是靈光異相，「夏娃克隆」既是從聖經「獸印」的想像延伸，也以"夏娃"和"克隆"的組合預言自體繁殖的新物種時代，這個時代的來臨代表自然規律的終結，人造人、再造人、被造人再造人…的循環的一旦開啟，誰為何種目的創造甚麼、誰由誰控制，成為無解的矛盾律 (paradox)，人因工程的終極境界也是人常倫理的真空狀態。被科技創造出來的可自體繁殖的夏娃，還被創造者囚禁在虛擬世界中，藝術家扮演了在實驗咒法的女巫，以訓練和操控這些無性的夏娃施展魅惑的能力；又扮演了「科學怪人」裡的 Victor Frankenstein，執迷在科學實驗上，跳過生命始末的神聖原點和終點，逕自僭越了造物者和施弄者的工作。

人因工程的複製和再造，修補工程的移植、延壽和美容醫學，其實都承載了我們這些凡相眾生的願望。儘管有所戒懼惶恐，對科技可能性的無窮幻想、對人體美學追求的永不滿足，對青春魅力不歇止的執迷，還是推動著文明走向未知的冒險。在林珮淳的「夏娃克隆」想像裡，科技顛覆了生命循環的規律，越過打開七個封印的過程，人的作為、神的痕跡、魔鬼的偽裝相混雜揉、渾沌難辨，而我們的罪愆與德行亦無所判定。

科技操控的滿足—美學的撥弄

當今的美容外科手術、美體服務業、瘦身產業全面地照顧著五體不滿足的世間男女，但也讓

人類永遠處在"待改進"的焦慮狀態中。法國女性藝術家奧蘭 (Orlan， 原名 Mireille Suzanne Francette Porte， 1947~) 的創作歷程中，不斷的以自己的身體為對象和媒材，她持續的透過外科手術改變自己的外貌，所有美容手術，包括抽脂、隆鼻、豐唇和填頰，並為自己的眉毛上墊出兩道突起的眉骨，讓自己具有人獸之間的品相。這個以自身體現醫學美容成就的行為，並錄下手術的過程，成為奧蘭的「轉世」(Reincarnation of Saint Orland) 作品。另外，奧蘭也常常自己做扮裝秀，以類似教堂中聖女子雕像的造型出現，卻同時露出一隻乳房的姿態展示身體。這個修改過的身體扮演著聖像，要顛覆聖、褻和靈、肉的層次，而奧蘭利用美容醫學的技術和侵犯性的過程，呈現出人們對於身體的操控慾。我們在對美的貪戀下，在科技和美學的分進合擊下，人類變得擅於被訓練和自我訓練，正成就了現實世界裡失控的控制慾，和失去尺度的美學操弄。

「夏娃克隆」的互動性暗示出全面的控制和被控制、凝視或監看之模式。全像攝影的夏娃跟隨著視角轉向觀眾，一百八十度的轉向，更能表現夏娃面部俯仰角度和欲迎還羞的眼神姿態。在框架中的人像並不是被動的 " 被凝視者"，而是具有挑逗力的夏娃。林珮淳以聖經為腳本，以多重的夏娃代表誘惑，又賦予她們和觀者平等對視的地位，作品的互動設計啟動了觀者的操控權，卻也同時是被夏娃監視的裝置。在虛擬互動的環境下，主客易位，也預示了人因科技喧賓奪主的未來。延續林珮淳一貫的科技與美學真相之探討，「夏娃克隆」展場上，由程式完全打造的絕世美人，猶如正在戲弄著拖帶沉重肉身的我們。

虛擬視界的全面替代—美學的誘惑

戀棧於永生與青春肉體的題材，近年有以徐四金 (Patrick Süskind) 的小說 「香水」 (Das Perfume) 拍成的電影。故事裡，執著於萃取少女芳香的男主角，最後竟為了保留人體香味而變成殺人兇手，男主角的人香實驗到了最高境界，是將少女整個淨泡在液體中。對美的偏執成了變態殘忍的實驗，"美"做成了標本，人性卻成為斷簡殘篇。

「夏娃克隆」裡，擴張了生物學上的"標本"之形式和觀念，在林珮淳的作品裡，標本既是保存的方式，也是物種生成和變種過程的視覺化。超過了生物學和醫學以標本為參考資料的功用，「夏娃克隆」的標本不是已經過去生命的紀錄，而是生命起源的標本。創世紀或開天闢地不再是抽象的、概念的，人類不再是接受的、被動的，而是可從頭計畫、過程可控制的。這種標本喚起了我們對美的膚淺慾望，而在這種慾望的驅動下，人們正在逾越某些規範：可能是物種之間的秩序、可能是人造人的權力、也可能是天律。

創造生命的科技、改造生命的醫學，以及以代替實體世界的影像科技一氣呵成地轉換了創造者與被創造者的地位、轉換了現實界與虛擬科幻界的正統關係。「夏娃克隆」是"虛擬的預示"或"預示性的虛擬世界"，藝術得以以這種雙重假設暗示未來的想像建構，不但虛擬與人工的影像代替了我們對生命的理解，而絕美的數位影像慾望滿足也取代了生命實踐的原動力。

在西斯汀教堂上，米開朗基羅詮釋了上帝僅以手式即創造出了亞當，並不需要接觸；杜勒以類似基督的手式創作自畫像，在圖像學的脈絡下，手既代表了精神上的創造權威、神址的賜福，也象徵屬於人世的天賦才能。被烙印的手，點出了人類歷史進程的最終想像，隨著創造科技的使用，人類必然會要面對自我創造和自我承擔，別無庇佑、沒有應許之地的後果。林珮淳特別提到獸印標本玻璃容器裡的氣泡，令人聯想到新柏拉圖主義的流出理論 (Emanationism)。當

創世論 (Creationism) 被推翻時，我們似乎還能藉著流出理論來詮釋世界的生成、善惡的層次，以晶瑩剔透的短暫漂浮的氣泡，依附我們已不夠堅定的生命原點的美學想像。

美學的僭越

「夏娃克隆」建構的未來預言，有如回文：美學驅動著科技、科技又創造了美學新標準，再度催促著科技從事發展、積極改造。這個預言的世界裡，物種不為繁殖、也不會互相依存而生，只有自我的目的卻沒有最終的目標。林珮淳以夏娃誘惑著我們走進這個虛擬的未來空間裡，經歷了一場人的慾望與魔鬼的煽動之間的搖擺、一場神的意志與人的詮釋之間的辯證。而在夏娃的視線裡，我們都是美學誘惑的俘虜，也都成為美學僭越的共犯。

夏娃克隆肖像 Portrait of Eve Clone

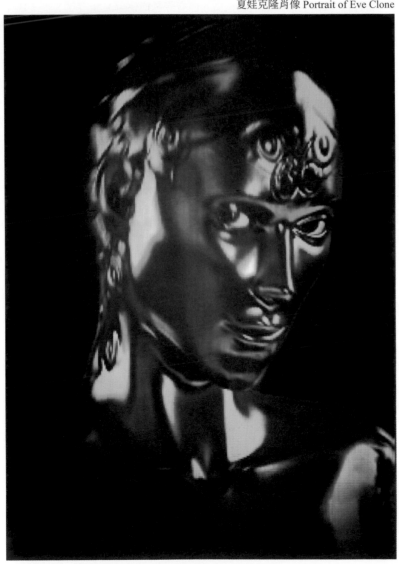

異形佳人
林珮淳「夏娃克隆個展」的驚奇世界

安托列塔‧伊凡諾娃 Antoanetta Ivanova | 藝評家、國際策展人

Academia. edu 國際學術教育網

這是一個極端詭異、清冷又黑暗的展場空間，僅有綠色的雷射光束穿透其間；牆上的肖像，帶著嬌媚的眼神朝我調情。展場中間，放著一排大型醫藥用的玻璃罐裡，放了 6 雙翻模的、向上張開的手，姿態生動鮮活。鄰近的陳列櫥窗裡，放著像手指般的物體，製作地非常精良。冒泡泡的水聲，從一個展間徘徊到另一個展間。不難想像，空氣中彷彿充滿了甲醛的氣味。一股不安的情緒開始在我全身竄動：這裡正在進行什麼邪惡的法術？林珮淳，此次展覽核心的煉金術士，丹爐裡煉的可不是讓人長生不老的仙丹，而是在檢測人類那無可救藥似的追求永生的美麗，以及物質蛻變的欲望。在台北當代藝術館展出的作品，假設了男性一廂情願想要操控人類肉身之軀的慾念，已經達到一種著魔的邊境。林珮淳為我們呈現的這一組新作品，存有男性報復式的操控人類身體的邪惡慾念。

林珮淳是台灣著名的數位藝術家，長期關注人類是如何運用自然或人工的方法，藉以控制生物基因，令它達到某種理想美感的企圖。在這次個展中，她也是貫徹這樣的思維，採用了精密的科技方法，巧妙的翻製 "變種" 的身體部份，並以數位錄像，呈現作品藝術和精神兩者之間的內涵。

展覽的焦點作品，是將她眼中的第一位地球女性—夏娃，創造成一系列的肖像。根據基督教的教義，當上帝創造第一個人類亞當後，上帝創造的第二個人類，就是亞當的伴侶夏娃。夏娃 (Eve) 代表了生命的起源，也被視為是所有人類的母親[1]。有關夏娃的故事不勝枚舉，作家潘蜜拉‧諾瑞絲 (Pamela Norris) 甚至為夏娃寫了一本 "自傳"，書中挑戰了一般人對夏娃在聖經中的角色詮釋—夏娃是很有手腕及控制欲的女性[2]，夏娃通常是臣服於亞當之下。根據諾瑞絲的論文，挑戰了社會對夏娃的描述（透過夏娃，引伸至一般的女性），林珮淳的藝術創作則聚焦於質詢男性主宰夏娃的欲望，給予她刻板而制式化的美麗與完美，並經由父權的信仰系統，持續強行加諸在女性身上。

在藝術的領域裡，有許多女性藝術家處理這種議題的範例；在這些例子中最令人震撼的，莫過於法國藝術家歐蘭（Orlan）[3]，她挑戰了西方世界裡，男性藝術家所創造出來的理想女性美的圖像學結構，且以一種極端激烈的新手法來創造作品：整型行為藝術。在她的作品《聖女歐蘭昇天記》裡 (The Reincarnation of Saint Orlan，1990-1993)，歐蘭嘗試將世界著名的女性肖像的各種臉部特徵，例如達文西：蒙娜麗莎的前額、波提切利：維那斯的下巴、傑洛姆：靈媒的鼻子、

1　創世紀　3:20
2　哈利斯，夏娃：自傳，1999 年紐約大學出版 Harris, P. Eve: A Biography, NYU Press
3　網址：www.orlan.net/

布樹：歐蘿芭的嘴唇、法國楓丹白露派：戴安娜的眼睛。歐蘭經歷了一場十分危險的整型手術，將那些特徵都一一整型在自己的臉部。這是藝術史上第一次，藝術家以自己的臉做成拼貼作品；不僅如此，歐蘭更將整型的過程錄影下來公開播放，將整型診所裡發生的事情都公眾於世，藉此引起大眾對這種極端造作的虛擬肖像的關注，並對現代科學和技術，可能在人類身上創造的影響做了很清楚的聲明。

在這樣的歷史文本裡，林珮淳更進一步地把觀眾帶入一個藏著生物科技和基因工程改造的黑暗房間裡，讓我們看到複製的夏娃，以一系列看似複製錯誤的夏娃的臉、手和手指，陳述有關身份認定的詭異景象。林珮淳聲稱在創作夏娃克隆肖像時，她希望鼓勵大家反照自己過度發展的文明社會。從她的觀點來看，這都是人類自甘墮落的結果。林珮淳所創造的那些夏娃克隆的臉，不但很誘人，還有著野獸般的動物特質，如她的皮膚，以及在光亮的皮膚下，顯得十分突出的角和骨骼。這個主題，延用在放著夏娃克隆手的醫學用玻璃罐標本，以及一系列翻模的手指，這些物件都暗示著夏娃突變的身體。某些標本的表面看似動物的皮膚，有著觸鬚和骨頭。其中一雙手臂，還有著機械零件刺穿了皮肉；另外一雙則看來像從岩石裡冒出來的。以不同文字書寫的"666"，佈滿了作品的表面，對林珮淳而言，這個數字象徵了"所有人種和人類都難以逃脫的魔障"。

看著夏娃克隆肖像，就像夜裡從穿衣鏡看到鬼魅的臉正盯著我們看一般─有種魅惑又嚇人的情境。林珮淳透過全像影像的技術，使她們那雙深邃的眼睛，竟能隨著觀眾在展場裡四處游動。全像影像是種神秘的藝術表現形式，傳統上是以創造影像幻覺，加強視覺暫留的時間，和對全像影像裡物體的記憶。全像影像最獨特的部份是以光為媒材，因此缺少了一個中間的介質；主要的原理是透過光線繞射來記錄一個物體，並經由精密的科學技術再建該物體的形象，為該物體創造了一個光學圖像。全像影像的特徵就是 3D 的視覺效果，並隨著觀眾的位置改變，而顯示不同的圖像，從不同的角度，使它看起來很像真實的立體物件。澳洲的全像影像藝術家寶拉·道森 (Paula Dawson) 形容全像影像是"就像精神的圖像，但卻能與真實的內在結合而重現"[4]。全像影像藝術的美學評論，主要著重於它的複製效果─這個光學圖像與真實之間究竟有多接近。

至此，還有一個矛盾的地方，以及技術上的精巧度，我們必須一併思考；林珮淳的全像影像─它們模仿的對象已經是非物質的虛擬真實。圖像上，林珮淳製作的夏娃克隆全像影像，是

4 道森"魔鏡 魔鏡"藝術展覽自述, 2004 年 4 月 30 日, 新南威爾斯大學藝術學院

源自於 3D 數位虛構出來的異形面貌而創造出來的，經由超高解析度和空間的真實感，使這些臉孔彷彿可隨著她們眼前的觀眾移動，甚至挑戰了使她們能轉頭的高難度技術，她的目的在真實呈現夏娃於複製演化過程中，所歷經的不同階段。這種做法企圖說服觀眾夏娃是位真實存在的女性，即使她是從虛擬實境中誕生的產物。

這一系列作品的總結作品《夏娃克隆啟示錄》是一件大型互動裝置，包括 6 個女性等身大小的影像投影，微微蜷縮在一個充滿液體的玻璃容器內，以一個軸心緩慢地旋轉。它的右手放在胸前心臟的位置，左手則害羞地遮住臉龐，彷彿要遮蔽旁人投射而來的目光。從左到右，每一個都是第一個影像的連續複製，每一個影像都與前一個影像有時間差，因而隱喻了個複製的過程。這件裝置雖然很嚴肅，卻極為緊密；周邊空間充滿了懷舊的宗教咒語的聲音，整個空間氛圍猶如一個教堂。但這裡究竟要信奉、崇拜的是什麼呢？這個人物即不是一個女人，也不是一頭野獸，而是某種突變的生物—它的怪異曾經令人反感和魅惑。光束顯耀了它的存在：一種人工製造物。

從西方基督教對夏娃的描述而衍生出的靈感"她是一位坐在水面妓女，是她引誘了人間之王犯下了淫邪之罪"，她的水成為"人類、種族和語言"，林珮淳展示了一種非原創的，而是來自新科技罪惡的生命形態。聖經裡血肉之軀的夏娃－她原本孕育生命及生產的功能，是不能被控制的，因此被人懼怕—已被新的肉體所取代：一種黏稠、像瓷器、人工訂造和完全包裝起來的夏娃克隆。林珮淳的作品將我們帶入由生化產業所引發的基因決定論的激烈辯證中。2003 年一項達 13 年之久的整體基因物質映射和程序化的計畫，將人類生命的化學物質全部譜寫完成。這就是人類染色體計畫，一個龐大的工作，體現了人類企圖瞭解人體究竟是由那些物質建構而成的。每一個人體細胞都承載了一套劇本，決定了它的發展和功能。這一連串生物的密碼由基因組成，按照染色體的順序排列。基因花費了千年才能發展出適應環境的因素，然後一代傳給一代。

經過人類基因計畫的結論，許多資訊都轉移到跨國企業集團，大量投入醫學的研究領域。當某一天為了潛在的健康因素，需要"關掉"錯誤基因的想法一旦實現，複製生物的人類基因，將引發嚴重的道德與論理的問題：誰可以擁有並控制人類基因的資訊；誰可以接觸這些資訊；它會被如何運用 等等。某些人也許認為目前已經有基因改良的技術運用在食物鏈裡，為什麼停在那裡，為什麼不能允許運用在加強人類基因上呢？

在《夏娃克隆啟示錄》中對未來生命本質的道德困境，透過希伯來文、拉丁文、希臘文、阿拉伯文、中文和英文的聖經經文具體陳述了出來。對林珮淳而言，這些語言象徵了人類演化的不同階段：宗教、文化、哲學思想、政治權力和經濟力，這些都含有邪惡的種子。更進一步的說，林珮淳的啟示錄的警訊，具體呈現在每一個投影螢幕上，那以電腦啟動的時間數字。觀眾一旦進入這個裝置空間，就開啟了計時器，數字便開始累計，展示了最近的編年時間。這個輸入的時間強調了夏娃的人工系統的存在。作品會改變色彩的手法，更加強了這種經驗；當觀眾進入展場被偵測到時，它會從灰色調轉變成像烏賊那樣的螢光色。《夏娃克隆啟示錄文件》更形成了夏娃克隆實際存在的證據。

這整組作品—從《夏娃克隆的肖像》系列和《量產的夏娃克隆》，一組有 18 個版本的夏娃克隆陳列在一個人工調色板上，到《夏娃克隆啟示錄》—這裡展現了一個堅持而普遍的挑戰男性想要扮演上帝的欲望，去控制自然（以及女性如聖經裡陳述的成為生命之源的身體），以達到他自對生命的詮釋。然而，不是這種人工科技的思維將我們推向某種偉大、不可逆轉的傷害：或許，就是世界毀滅嗎？整個展覽在美學上，令人回想起瑞士藝術家吉爾（H. R.Giger）[5]，將冰冷的 "生物力學" 與人類身體和機械融合的作品風格。也許，最著名的科幻創作當屬好萊塢相當受歡迎的電影 "異形"，吉爾的風格將超現實主義的藝術傳統注入 20 世紀末光鮮的視覺語彙，令人驚異或有點變態的異形形體—人類被機械攻佔的黑暗景象。[6] 林珮淳的個展，將這種美學觀延伸到 21 世紀，透過基因工程的願景，以及生物學和人工系統融合，闡述了人類若篡改自然，可能產生的錯誤，會發生多麼可怕的結果。這個展覽可以被視為一個警告：不論人類的技術和科學多麼發達，我們都還只是凡人。

5　網址 :www.hrgiger.com
6　佩托斯 "吉爾的生物力學超現實主義"

夏娃克隆肖像 Portrait of Eve Clone

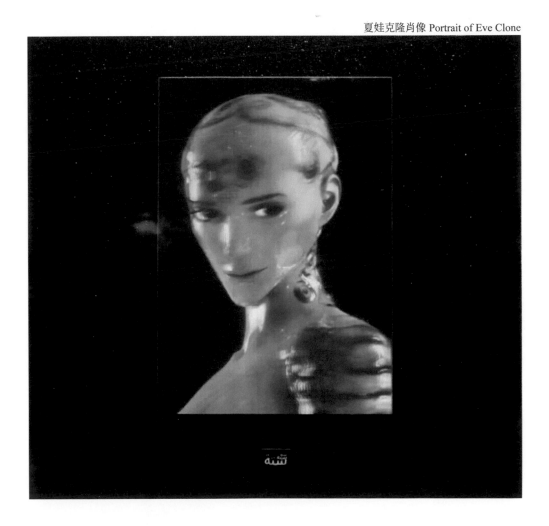

林珮淳—夏娃克隆肖像

蘇珊娜・斐爾茲・陶德 Susana Pérez Tort | 藝術史學家

Academia. edu 國際學術教育網

要瞭解藝術創作的真意，首先必需翻越每一個人為了保護自己，而對外築立的那一道牆，特別是藝術家在他們周邊所設下的藩籬。語言和文字，也許可以成為溝通的橋樑，有助於觀者了解那些看不到的障礙。藝術創作，就像是幾何形式的三稜鏡般，使觀者可以看到許多不同的層面和邊界，而且每一個人都可以依個人的經驗和角度，投射出各種不同的解釋。藝術創作有豐富的語意學，也確實是向大眾介紹藝術家的最佳代言人。

如果我們想大膽地探索"夏娃克隆肖像"這個展覽中，藝術家深層的思維與意義，就必需找到一個進入創作者思維的方式，尋找一扇門，可以打開林珮淳築立在她周邊的那堵無法察覺的牆。這扇門也許可以讓我們了解她的想法、思維、信仰和感情。那扇門也許沒有畫聖吳道子所畫的那麼神奇，只要一拍手就可以讓他穿門消失。林珮淳當然無法如此，也無須從她展出夏娃的肖像及手的展場消失。每一件偉大的藝術品，如那位中國古老傳奇的大師一般，都會留有一個出口，讓觀眾可以藉此從令人產生視覺驚異的高科技 3D 全像影像逃離，避開這純粹科技的部份，來體會藝術家賦予全像影像系列的生命力，而達到藝術家真實的目的。

要在林珮淳的展覽裡探尋一條路徑，並找到那扇神奇的門是很不容易的，我們必須先找到幾個關鍵字做為鑰匙：第一個字就是似是而非 (Paradox)。任何一件藝術創作最可怕的敵人就是老生常談；這一次個展若是將焦點放在那些呈現在觀眾面前的新奇科技的話，那就可能是陳腔濫調了。當觀眾驚訝地的發現，他眼前畫框裡的"肖像"（表面彷彿是由水形成的），可以隨著她的轉動，從一邊移動到另一邊，是相當驚嚇觀眾的。自然、水、在母親子宮裡最原始的液體，可算是最自然的物質，目的是要保護這個即將成形的生命，但是夏娃並不是個被母親呵護的嬰兒；雖然她是上帝所創造的，但她卻是從亞當的一根肋骨誕生出來的。

類似像"夏娃克隆肖像"這樣的展覽，對觀者而言的確是很迂迴難解的。所有的圖像一開始為觀眾提供了鮮活的想像力，但卻將他們丟入一個迷宮中，然後才豁然開朗的揭示藝術的豐華。我們認為這也許就是林珮淳一系列《夏娃克隆肖像》和《夏娃克隆手》，所呈現的指向。作者藉由這次的機會所創造出來的一種寓言式的語彙，並非沒有前例；她之前很多作品也是很吸引人，且令人感到驚異的。

剛才我已經提過，我們需要幾個關鍵字來引導、進入這個展覽觀念的意涵，以便翻越這道"神奇之牆"，接下來，我們應該注意另外一個詞：我們已經提到似是而非，另一個詞就是夏娃 (Eve)，還有肖像 (portrait)、手 (hand) 以及複製 (clone)，包括自然的和人工的。

夏娃克隆

根據林珮淳的敘述，這一系列夏娃的圖像—肖像及手—是依照舊約聖經裡，有關亞當和夏娃在伊甸園的傳統記載。舊約提到這兩位由上帝創造出來的生物，可以自由的支配一切，他們兩者都是伊甸園裡的主人，唯一的條件，就是不可以從知識之樹上偷嚐禁果。但是亞當偷吃了禁果，按照舊約的說法，是夏娃引誘他這麼做的；這些夏娃的複製肖像和手，是否指涉了男人不停的偷嚐禁果？這些夏娃試著警告我們，要遠離那些由即將誕生的人造怪物嗎？夏娃克隆沒有母親，也沒有子宮或可以保護她的羊水，即使是人造的；違反大自然的。

我們可以參與夏娃複製的景象，就好像面對裝有機械裝置的生物賽伯格 (Cyborg)，他"巔覆所有傳統的現代二分法，例如人類—機械；精神—肉體；有機的—化學的；公眾的—私有的；自然的—培育的；男人—女人；生—死；現實—表面，以及真實—幻象"。林珮淳的展覽並不在於呈現一個高科技的技術，而是邀請觀眾，透過這些驚人的圖像，回頭觀想當生物從伊甸園被驅逐以後，不顧一切的發展人工智慧的技術，在未來可能帶給人類什麼可怕的影響。

林珮淳的作品，如"夏娃克隆肖像"與工程及高科技有緊密的連結，同時也以隱約而不顯著的手法，表現了她對性別議題的執著，尤其在她過去的作品裡更可以得到驗證。女性，幾乎在所有文化的歷史上都居於次要的地位，這樣的認知，或許就是激發她選擇了傳奇性的角色夏娃，做為人類的象徵（包括男人和女人）。這位出現在聖經裡的第一位女性，代表了所有女性以及男性。

觀眾也許覺得很奇怪，為什麼從裡面盯著我們看的夏娃，她充滿水質又輕薄的肌理，看起來像是一位西高加索女性—她有雙圓眼、皮膚又白晰。難道藝術家是暗示西方文化終於揭露了對所有女性的想像？史上最古老的化石發現在非洲，那麼屬於地球上的"第一位女性"應該有著黑皮膚才是。當現代化開始發展最先進的科學及技術時，西方文化也曾依賴過中國文化，但是西方女性的外貌卻成為美麗的領導指標。

整個展覽的主角夏娃，是以全像影像的肖像形式展出，展覽中也包括了《夏娃克隆手》，看起來好像是人類廢棄的殘肢，令人震驚。讓我們再回想一下，夏娃的存在是因為男性先存在的結果，她是從亞當的一根肋骨製造出來的。夏娃被指控企圖引誘無辜的亞當；林珮淳的性別哲學，也從她挑選了夏娃做為人工生物的主題而被披露。

藝術家將夏娃處理得像一個蛹，粘滑、等待蛻變成活生生的人，而不是她在聖經裡所描述的那樣，只是亞當的一根肋骨。她在誕生前是一個蛹嗎？那麼我們是否該再一次為夏娃沒有母親而感到懊悔？"夏娃克隆肖像"系列，對亞當和夏娃誕生的傳說，提出了是一個慧點的引述，更隱含了夏娃在聖經被創造的過程中，所產生的性別歧視。

肖像

我們曾經說過需要一些關鍵詞來打開那扇"神奇的門"，讓我們能閱讀"夏娃克隆肖像"，如林珮淳以藝術為語彙而創造出來的文字。那麼我們必須提肖像這個名詞。

裝了框的夏娃圖像，透過全像影像的技術，使觀眾看到一位突變的西方女性，不但有高加索女性的特徵，而且還是以傳統的肖像表現手法來呈現。我們一直在思考，為什麼藝術家要選擇夏娃做為這一系列作品的主題，因為之前已經有類似主題的作品，將夏娃以一種蛹的的演化過程做為表現的手法。此刻，我們必須試著解答，為什麼她將這些夏娃的圖像，以傳統西方肖像的方式來表現。在西方藝術史的傳統上，裝框的肖像，為的是創作一件可以掛在牆上的藝術品。姑且不論希臘和羅馬的肖像，當時的畫像不是以裝框展覽或掛在牆上為目的，也不會有銷售或被貼上標價牌的作法。肖像成為一種藝術品項，是從西方文藝復興時期開始。在西方的黑暗時代，由天主教堂統治的期間，肖像被認為是種自傲的象徵。然而文藝術復興開始以後，社會開始改變，有新的思維與行為標準。隨著新變化，肖像成為新的藝術品項，開始蓬勃發展，並常用畫布來完成肖像作品，對模特兒而言，它也是某種真實的"複製"，而且可以讓顧客開心且驕傲地展示出畫像和自己有多麼相似：當時義大利士紳們，這是這樣的顧客，樂於讓那些大師們為他們創造肖像。這種寫實的表現方式，也是西方現代藝術的一個重要特質，從而發展科學與技術的多種可能性，使"複製"的作品可以畫得更接近真實。肖像代表了人的自負、人文主義，以及以人為中心的思考方式。由此，我們或許可以這樣假設，林珮淳選擇夏娃的肖像—周圍以透明壓克裝框—實際上是將這種在西方藝術傳統上被讚賞的繪畫形式，轉換成人類自以為是的一個同義字；將西方文藝復興與藝術科學和尖端科技結合。於是，林珮淳決定以肖像的形式，將夏娃框起來掛在牆上，雖然是引用了文藝復興的表現手法，但重點還是與現代的科學和技術發展相連結，無論後果如何，或是會將人類引導到何處。現在人工與機械合體、基因工程的實驗、人造物，正處於新的技術、科學以及社會轉變的開端。某些科學家和藝術家—如林珮淳—將他們關心的這樣議題，更加凸顯出來，且更具說服力。事實上林珮淳致力於將藝術與高科技結合，如她的夏娃克隆全像影像，即是在一個黑暗的展間裡以藝術形式，來表達她的議題。

夏娃克隆手

展覽的另一部份是《夏娃克隆手》—這些手被存放在不同的玻璃罐中；在燈光的照射下，看起來很真實，也很殘忍，像是人類身體的殘肢—使她的肖像系列又增加了第二個問號。奧古斯·羅丹 (Auguste Rodin) 是 19 世紀最著名的法國雕塑家，以白色大理石刻了一系列上帝之手，展現造物者在創作夏娃或亞當，將他們握在手上的過程。這些手非常漂亮，它創造了夏娃，或將這一對伊甸園的主人如珍寶般地捧在手上；可以讓我們聯想到林珮淳的創作。然而，羅丹的手和他的亞當與夏娃，都是相當感官的創作。林珮淳的創作與這些白色大理石的手十分不同，她選擇以像幽靈般的綠色的手來面對觀眾，她讓觀者立即聯想到它們是夏娃克隆手。在這些玻璃罐中沒有上帝，而是一個令人驚訝的人造世界。

人造物

在討論本展的技術問題前，必須先強調在這個個展中"為什麼"以及"誰"是這些觀念的演員們，以及這個藝術展覽的標準。在夏娃克隆的高科技藝術語彙之外，首先應該先思考夏娃、肖像和複製、虛擬真實和人造物這些問題。觀眾也許覺得奇怪，為什麼這些夏娃的人造皮膚上都有"666"的字樣，為什麼她們的肌理看來像金屬合成的質感，又帶點凶惡，而不像聖經裡傳統描述的那般，是人類的第一個母親，應該有著天使般的外表。

由 3D 全像影像製成的夏娃，從美麗變成恐怖的怪物。這些圖像會不會是一個引述？闡釋如果任意運用人造技術，而忽視了濫用它所可能造成的危險性？觀眾面對的不是夏娃的肖像，而是"複製夏娃"的肖像，而她們展現出來的是造作的顏色，人造的光彩及肌膚。夏娃儼然是個綜合金屬、塑膠、非人類的生物。

雖然這個展覽有意的選擇冗長的主題、尺寸和形狀明顯的畫布，這些藝術品—如同我們相信它已經自我證明—絕對不是陳腔濫調。林珮淳非常聰明，並有技巧地運用了語言創作的力量：矛盾修飾法 (oxymoron)，如她在過去的藝術創作裡所展現的。矛盾修飾法在這個展覽裡，是對這些人造的虛擬雕像提出疑問。也許值得一提的是，中國有一位名為沈括 (Shen Kuo) 的科學家，早在西方科技都還沒有發現以前，率先發現了光的幻覺，也就是攝影技術的鼻祖，暗箱 (Camera Oscura)；暗箱也是攝影技術能發展起來的第一步，由於它的發明，因而才能造就捕捉光線反射的可能 。值得注意的是，夏娃克隆肖像也是根植於攝影技術。

我並不確定那扇"神奇之門"有沒有為觀眾們打開，但我們必須留意藝術家在這個展覽中所運用的 3D 全像影像的技巧，使影像片裡的動態圖像，能神奇的隨著觀眾的移動而轉動的技術，確實創造了一個虛擬雕塑的魔術。畫框裡的夏娃克隆肖像，不但會轉動，而且也展示了她的背部。3D 全像並非錄像，然而全像影像看起來卻比 3D 的影像更為真實。跨越全像影像的真實性，夏娃克隆肖像的裝置，我們已經討論過，以西方將畫布掛在牆上的傳統呈現，她這種以科技技術來質問科技的手法，巧妙地牽引出人類在面對自然時，那種自以為是的一種反諷觀點。人造漆的表面質感，意圖為這個複製的分身 (clone)，創造一個生命的幻象。林珮淳選擇以西方肖像藝術的傳統，來表現她的夏娃克隆，應該最恰當不過的。她以這個藝術展覽的形式，來說明人類一直追求著危險的妄想，讓我們再一次經驗到她獨具意義的科技藝術符號學。

來自末世的凝視
林珮淳《夏娃克隆肖像》作品評析

潘正育 │ 藝術家、藝術研究

《藝術認證》，2016 年 │ Academia. edu

前言

本文就 2015 年高雄市立美術館策劃的《與時代共舞—〈藝術家〉40 年 X 台灣當代美術》關鍵作品之一，林珮淳的新媒體藝術創作〔夏娃克隆肖像 / Portrait of Eve Clone 〕進行探討。該展覽是由高美館與藝術家雜誌合作，參照同年出版的《台灣當代美術通鑑：藝術家雜誌 40 年版》，呈現了 40 年來的台灣當代美術發展。這件作品在通鑑裡被列為 2011 年的焦點作品，規劃在展覽的四個焦點展區之一：「跨領域‧零設限 (2005-2014)」，其在台灣美術史上的重要性可見一斑。既是眾所矚目，相關的評論自然也不少，不過就筆者所知，對於作品本身各個元素進行比較深入、全面的評析，尚未有之。本文將試從這個面向，細細「閱讀」這件作品。

首先，我們將從作品的語彙下手，亦即以符號學的角度來解析作品所承載的意義指涉。因為篇幅的關係，我們將重點分析作品中源自聖經的幾個符號，接著談論作品所採用的技術和形式所帶來的效應。在本文後半部，我們要轉換角度，從觀看經驗來切入作品，以「凝視」為核心，探討觀賞經驗裡「看」與「被看」的互動關係，試圖從當中揭露作品的本質。除了作為觀者來思考作品，我們也希望透過此一互為主體的關係，多少理解藝術家的意圖，或至少一窺創作者所採取的立場。

從符號說起

索緒爾（Ferdinand Saussure）指出，語言如同文字、點字文…等等，「是一種用來表達意義的符號系統（système de signes）」。[1] 雖然他認為語言是這些符號系統之中最重要的，我們仍然可以說，藝術作為一種表達意義的符號系統，同樣有極為豐富的內涵值得探究。這裡，所謂的「符號」不單是指作品內部所承載的符碼，也應當包括其外在的形式組構，諸如材質、技術、展出方式、當下社會背景，甚至觀者的反應等等。筆者相信，越能夠全面考慮這些因素，越能夠對一件藝術作品有整體性的理解。

〔夏娃克隆肖像〕呈現的是一組多幅的肖像。這些肖像結合了人形與昆蟲或動物的表皮特徵如鱗片、蛹狀或角質突起等等，每個肖像的額頭上並刻畫著不同語言標記的「666」數字。這些語彙將觀者拉進亙古到未來的時空裡，訴說著警世諫言。說這些語彙 – 也就是符號縱橫古今，並不誇張。首先，題名中的「夏娃」，眾所周知，是出現在舊約聖經開篇第一章《創世紀》裡的亞當之妻，人類的始祖。夏娃受了蛇的誘惑，犯下「原罪」，也就是偷食可以開人智慧，

1　"La langue est un système de signes exprimant des idées et par là comparable à l' écriture à l' alphabet des sourds-muets […] etc. Elle est seulement le plus important de ces systèmes."　F. Saussure 1916: p. 32.

使人與神並駕齊驅的禁果。作品中,肖像俊美無瑕的臉龐,隱隱透著神秘的性感,正讓人聯想到這股危險的誘惑。先進科技所建構的全像圖本身,則為我們點明了上述「誘惑」的正體:當代高度發達的科技文明。

另外一個饒有義趣的符號是每一幅肖像都以不同的語言來標記獸名數目。聖經中常以古巴比倫來比喻自大而無知、著迷於發展卻無能控管其結果的人類文明。《創世紀》中提到古巴比倫人曾經試圖建造通天的巴別塔(Babel)[2],藉以昭告自己的偉大。神為了阻止這些傲慢的人,將他們分化成使用不同語言的族群,最後巴別塔的建造工事因為溝通不良,以失敗告終。這個最終難逃滅亡一途的古巴比倫,又常被以「坐在眾水上的大淫婦」是來代稱,「地上的君王與他行淫‧住在地上的人喝醉了他淫亂的酒」,各國從上至下,皆臣服於無限度發展的邏輯當中,無法自拔。所謂「坐的眾水」,就是「多民多人多國多方」[3],意思是惡業遍布全世界。這會不會是吾人當下科技文明的寫照?

也許是拜禁果之賜,人類的科技發展凌駕了信仰。依照麥克魯漢(Marshall McLuhan)的觀點,專業分工(specialization)的結果使得人類的發展極度分化,知識的追求漸漸與道德無涉。浪漫時期以來,「經由切割與分裂而造就的物質控制新技術,將神與自然、神與人分離開來」[4]。貪婪、縱欲的苦果似乎正在顯現,全球暖化,道德淪喪,霧霾,極端主義…世風日下。

數字 666 和肖像皮膚所呈現的獸類質地,影射的即是這個苦果。新約聖經末章《啟示錄》提到,世界毀滅之前,有「獸」聯合地上眾生,與上天征戰。這獸有七頭十角,牠來到地上,要信奉牠的人在手上與前額刻上「666」的印記,此即所謂的「獸名數目」。在末世的戰役中,獸與地上各國一起毀滅。在這裡,藝術家的獨特手法是將「獸」和「人」結合了,不只是前額出現印記,身體也呈現人與獸的雙重特徵。加上作品題名中的「克隆(Clone)」,無法不使人聯想到生物克隆技術、獸器官移植、基因改造…等等 –連串極富道德爭議性的科技議題。

從人類的伊始(創世紀的夏娃)到歷史的終結(啟示錄的獸),《夏娃克隆肖像》藉由聖經的寓意,就這樣貫穿了文明的起點與終點,將人性底層對慾望的追求與繳械,和科學技術肆意發展的隱憂娓娓道來。

2　《聖經•創世記》第 11 章。
3　《聖經•啟示錄》17:1-15
4　"The new Tech of control of physical processes by segmentation and fragmentation separated God and Nature as much as Man" – M. McLuhan 1964: p. 191.

再現技術

這件作品使用的技術名為「全像印刷（Holography）」，一種仍在發展的的嶄新手法。與傳統照片不同，這種手法並不使用鏡頭來「拍攝」景象，因為這樣只能接收單一方向的光。全像術使用感光元件直接紀錄物件表面反射光波的全部信息。這些光波的信息再透過膠片完全重建，稱為全像印刷。從不同的方位觀察全像照片，我們可以看到被攝物的不同角度，因此產生立體視覺。

主觀性的隱匿

全像術與傳統照片的最大不同，在於當傳統照片被裁切時，畫面就跟著截斷，我們在裁下的照片中只能看到部份的影像。如果裁切全像照片，無論是從哪一部份的斷片，我們都仍然可以看到被攝物的全貌。這種令人驚訝的效果是因為全像照片的每一個顯示單位都保存了被攝物的全部影像信息。我們可以把未裁切的全像照片比做一扇大窗，從這扇窗戶看過去，可以見到窗外景象（相當於被攝物）的全貌；如果我們把窗戶的一部份封起來（相當於對照片的裁切），雖然窗戶變小了，只要靠近一點，我們仍然可以透過它看到整個景象。林珮淳的全像作品重建了一個完整的光場，在其平面界質之下，一個含有縱深的場域就「存在」那裡。畫面中的肖像因此是一個全面的複製物，它並不真正受到框格的制約，就好像我們看著鏡子，會感覺鏡中的世界與我們的世界是同樣沒有邊界的。

班雅明（Walter Benjamin）在上世紀 30 年代闡述了相片和電影這兩種新興媒體的人工「複製性（reproductivité）」對文明所造成的衝擊（請見班雅明《迎向靈光消逝的年代》一書）。他認為，複製品消去了原作的「靈光（arua）」，也就是它獨一無二的存在，人們可以隨時隨地享受藝術品，而不必親赴代表文化權威的美術館、演奏廳。今天，「數位複製」的力量又將影像的傳播帶到一個新的境地，「靈光」不再是問題，因為畫面中的事物時常不是來自真實世界，例如信用卡上的一隻全像小鳥，其「真身」只不過是 3D 繪製的圖像，根本沒有現實參照。

全像攝影所帶來的新「問題」，是把西方繪畫追求透視效果的傳統推展到極致 – 空間的完全再現。全面的再現最嚴重的後果是抹去了「觀點」。一直以來，作者的視角是決定一幅作品的關鍵，不論是傳統繪畫、攝影或是傳統文學，皆不出此框架。全像攝影的使用則挑戰了這個框架。藝術家丟出的是一個整體空間，刻意迴避了視角上的主觀性，「觀點」的產生完全取決於觀眾與作品的互動。其結果是，我們再無法以單一面向對作品進行詮釋，詮釋本身因而必須是多角度、無標準答案的，非常近似於網絡超文本的零散、去中心化的狀態。

沈潛的技術

當代藝術創作常講究「精省（économiser）」，亦即在形式上和技術上儘量排除冗餘的語彙，將觀賞經驗凝煉到一個極致的維度。林珮淳在這方面是成功的：3D 呈現的動態影像往往是電子或數位媒材方能做到的效果，這件作品卻不需任何設備或電源就能達成。此外，透過藝術家的設計，不論從什麼角度觀看，畫面中的人物總是凝視著觀者。這使得作品在某種程度上擁有與觀眾的「互動性（interactivité）」，使其儼然成為一件「不插電」的 3D 互動作品。

不插電，不喧嘩，靜靜地在牆上等待來者的注視。如果說全像投影技術[5]是希望把虛擬之物投射出來，召喚到現實世界，一種「呼之則出」的企圖，那麼全像印刷就是讓虛擬物滯留在現實與虛擬的水平面，「呼之欲出」，卻永遠保持著一道曖昧的距離。

事實上，藝術家採取沈潛的態度使用科技，結果不單是讓作品純粹化，其形式本身更成為作品「魅惑力」的主要來源：當代科技產品對於古人來說，大概就是魔術一般的東西。不過就當代的使用者而言，高科技產品至多讓人「炫目」，不至於魅惑，這是因為我們對其背後的技術已經略知一二。科技藝術挾其配備和音聲效果，也常給人一種炫目感。然而「夏娃克隆肖像」所產生的似乎不是這樣的氛圍 - 整個作品構築在一個單純有效的技術上，正因為非常有效又足夠單純，以致於效果蓋過技術本身，使得觀賞經驗更接近魔術而不是科學。即使心中明瞭自己正在觀看的是一件以先端科技所打造的作品，認知系統傳遞給我們的經驗恐怕更加直觀：纖薄的畫面中有一個活靈活現的人物正盯著我看，令人一時不知如何是好。這一次，「技術」躲在視覺經驗背後，搖身變為迷惑觀眾的魔法師，以魍魎一般的目光，靜靜凝視著觀者。

凝視

魅惑的凝視牽動的是視覺和心理感受。接下來，我們便要從筆者的觀看經驗出發，試圖趨近作品的核心。然而，個人觀感可以作準嗎？從現象學的角度，「感受」其實是理解事物必經的方式。胡賽爾（Edmund Husserl）強調，我們要做的從來不是探索事物的「真相（fait）」，而是經由釐清事物的「現象」，來趨近事物的「本質（essence）」。這裡所謂的現象，是一件事物在觀察者的意識流（flux de conscience）中所呈現的樣貌。換句話說，觀察者作為主體，他所經驗到的東西（vécu）並不是不值一提的個人心理作用（這是自然科學慣有的態度，也是胡賽爾所批判的觀點），而是該事物存在的關鍵：本質就存在現象之中。真相雖不可得，我們或能從經驗當中提取某些通則，進而彰顯作品的本質。[6]

當我們觀看作品時，畫面中的人物同時也盯著觀者。這種作法自古就在無數畫作中出現過，咸認人類文明史上人像畫的代表作 - 蒙娜麗莎（La Gioconda）便是一例。差別在於，面對傳統畫作，我們必須站在畫面的正前方，才能感到畫中人正在看著我們。林珮淳作品中的人物眼眸卻是動態地跟隨觀者，目不暫捨，這個情況使得觀眾「被看」的感受更加真切。

作品看觀眾，讓我們不得不關心「主體」的問題，因為只有作為主體，才能觀看。舒茲（Alfred Schutz）提醒我們：社會關係是互為主體的（Intersubjective）（請參考《社會世界的現象學 (Phenomenology of the Social World)》，1967）。以單向的觀察來詮釋一個現象，是片面且不足的，需要把對象的主體性納入考量。這件作品的情況是，觀者作為主體的主導位置往後退卻了，肖像的「主體性」則透過其眼神，介入了兩者之間的關係。事實上，我們並不是認為虛擬的肖像真的具有成為主體的完整條件，而是要將作品中投射出來的眼神做為線索，以便循線探勘「另一端」的主體性，也就是藝術家本身。通過作為創作者的化身（肖像）之眼，我們可望一窺藝術家所在的位置（position）及其創作的意向（intention）。

5　Holographic projection，將 3D 影像投射到現實空間的技術。

6　"La phénoménologie pure ou transcendantale ne sera pas rig e en science portant sur des faits mais portant sur des essences (en science "id tique")；une telle science vise tablir uniquement des "connaissances d' essence" et nullement des faits. E. Husserl Ideen I: 1913 p. 7.

說到眼神，不由得回想起一個有趣的經驗。記得有一次在外島浮潛，當時海中四顧無人，我的週身被混沌的海水包圍。忽然一條大魚出現在僅僅數十公分的眼前，一動不動盯著我看，當下那種戰慄的感覺至今難忘。觀看是自主的行為，反過來說，被一個陌生的他者目不轉睛地盯著看，是非常不自在的。端詳這件作品，這種不自在又一次油然而生。全像印刷依靠的是觀眾視角的變換，也就是說，畫面的變化取決於觀者自身的移動。藝術家巧妙利用了這個特性，讓畫面中的人物「跟著」觀眾，成功讓人感到一種難以名狀的不適，而這份不適並沒有因為知道它是「非真實的存在」而消弭。

再者，因為畫中人物的表情甚是微妙，想要解讀他的眼神（她？牠？它？），感到的卻是莫名的困惑：這道目光毫無保留，冷靜而堅定，讓人倍感壓力；它似柔亦剛，既不透露明顯的惡意，也看不出任何善意。這是一種魅惑，一種魅影般的困惑。微微揚起的嘴角和安然的態度，竟讓我感覺對方對於這次的交會，早有某種難以言喻的 ... 預期，理解或是同情，或者以上皆是。

這份「同情」或「理解」，超過當年那條大魚的好奇眼神所帶來的壓力，令我難以消化。一條大魚至少是已知的，可想像的對象。這股凝視卻是來自一個陌生的，堪稱俊俏的，似男非女的（即使作者以夏娃名之），似獸非人的，無從判斷其來處與意圖的「他者」，更何況他是「假的」，虛擬的。虛擬角色的眼神如何可能造成這樣的觸動？然而這或許不純然是我的錯覺，而是藝術家隱藏在名為創作的屏風之後，對現世眾生，對其所使用的技術本身，乃至對她自身的一種觀看態度。

我們透過作品看到的是作為「他者」的藝術家，在「那邊」凝視著「這邊」。非人類，非真實的表現，意味著藝術家做為異鄉人的立場，而正因為站在這樣的立場，藝術才擁有批判的力量。

參考書目
· Benjamin Walter "L' uvre d' art l'poque de sa reproduction m canis e" ,1936 , r d. In crits français Gallimard Saint-Amand 1991. 中文版：班雅明，《迎向靈光消逝的年代》，許綺玲譯，
· 臺北縣永和市，臺灣攝影工作室出版，1999.
· Husserl Edmund Ideen I 1913 §50; trad. fr. P. Ricoeur : Idées directrices pour une phénoménologie Paris Gallimard "Tel" 1950.
· McLuhan Marshall Understanding media: the extensions of man,1964, Reprinted., London, Routledge coll. ,Routledge classics ， 2008. 中文版：麥克魯漢，《認識媒體：人的延伸》，鄭明萱譯，貓頭鷹出版，2015.
· Saussure Ferdinand de, Cours de linguistique générale,Éd. critique,[Nachdr. der Ausg. 1916].,Paris,Payo, coll. ,Grande bibliothèque Payot ,2005.
· Schutz Alfred,Phenomenology of the Social World,traduit par George Walsh and Fredrick Lehner,
· 1ère édition., Evanston Ill.Northwestern University Press,1967, 255 p. 中文版：舒茲，《社會世界的現象學》，盧蘭嵐譯，台北市，久大 / 桂冠聯合出版，1991.

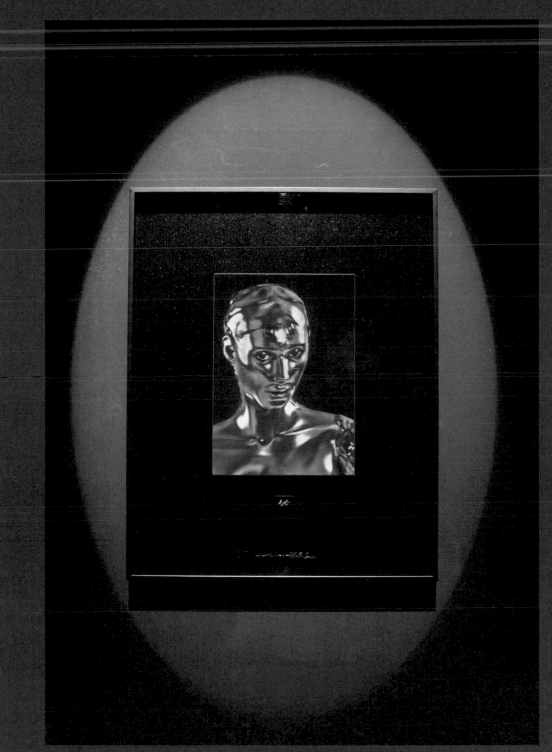

夏娃克隆肖像 Portrait of Eve Clone

夏娃克隆肖像
Portrait of Eve Clone

3D 動畫、動態全像、壓克力鋁框、聚光燈
3D Animation, Moving Hologram, Acrylic Frame, Spotlight
46 x 58 x 4 cm, 2010 ～

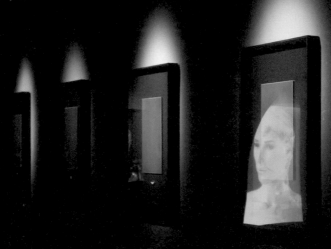

在《夏娃克隆肖像》系列中，以 3D 動畫形塑人蛹及人獸合體的的臉部形象，額頭上印有中文、英文、阿拉伯文、埃及 文等《666》獸印之文字，喻表各族、各民、各國，無論大小、貧富、自主的、為奴的，凡在額上受有獸印的，在末世大災難中皆無法逃脫獸的轄制 (啟示錄 13:16)。所表現的動態全像（Hologram）高科技媒材與壓克力透明材質黑框，展現她各種角度的動態姿勢與眼神，當觀者左右移動觀看肖像時會驚奇的發現她的眼神也注視著觀者，在美貌的底層暗藏著誘惑的危機，這象徵著人類所創造的誘人科技產物反而成了控制人類的危害，藉此反思人類以科技挑戰神的原創，終將面臨被科技反撲的命運。

Emphasizing Eve Clone's facial features through the use of 3D hologram technology, her gestures and expression are presented through a variety of angles. Each face is made of a different skin texture. As viewers look at her from these angles, they will be surprised to find that the Eve Clone continues to stare back and follow the movement of them, hinting at the dangers of temptation lurking beneath her beauty. On the forehead of Eve Clone, the Mark of the Beast, 666, which is presented in many languages, signals that those who are branded with the Mark of the Beast in the coming great tribulation will not be able to escape the Devil's control regardless of race, society, or nation. This was based from the Book of Revelation in the Holy Bible.

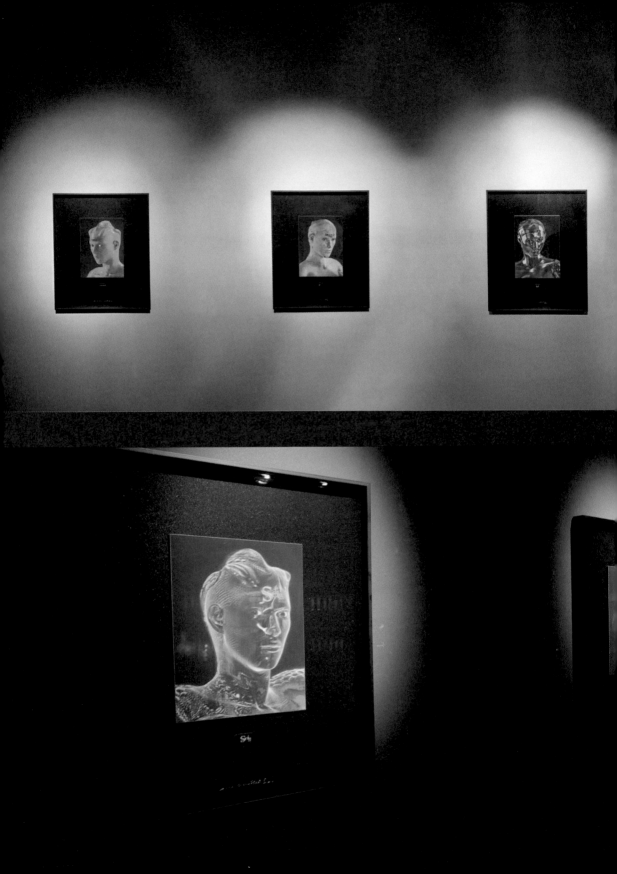

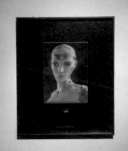
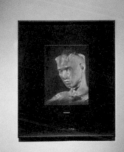
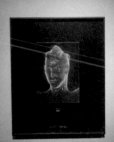

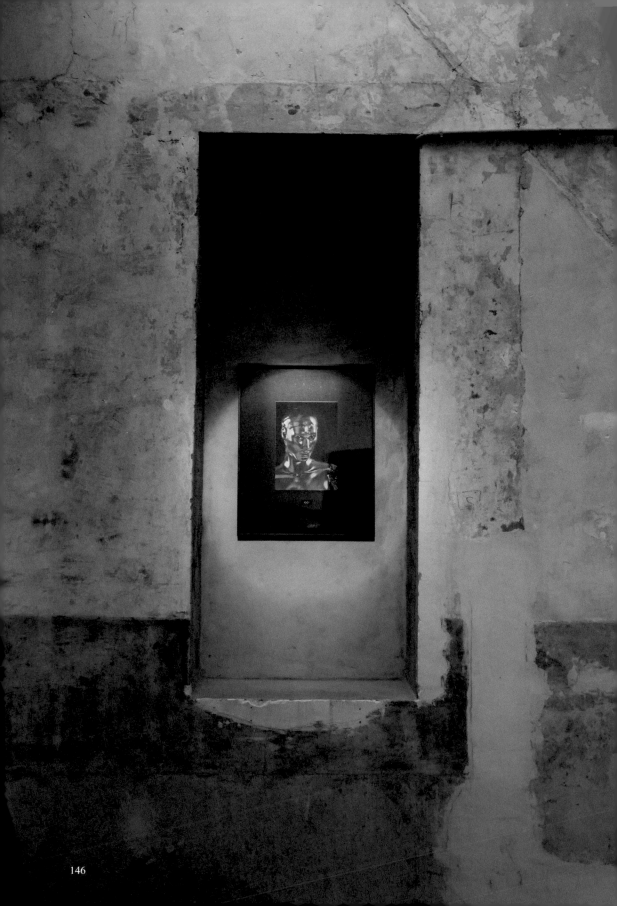

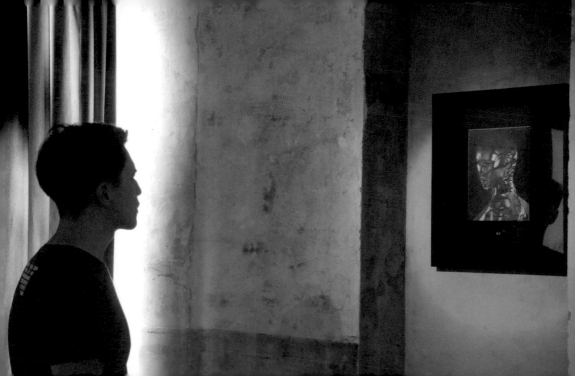

夏娃克隆 III、夏娃克隆 IV
Eve Clone III, Eve Clone IV

六面投影大型互動裝置 依場地而定
3D 電腦動畫、電腦、互動系統、Kinect 感測攝影機、Webcam
3D Animation, Computer, Interactive System, Kinect, Webcam, 2011, 2012

《夏娃克隆 IV》主要以以 3D 動畫、互動的電腦程式系統、紅外線感應器及網路攝影機建立
六個巨型《夏娃克隆》影像分別投影於六角形立體的互動影音裝置，凸顯此異種有如龐然大
物儲存於液體中被培育著，當沒有觀眾時，《夏娃克隆》影像則靜止不動，只有液體的水泡泡
緩慢出現且發出隆隆的水聲，又當觀眾出現在作品前且左右移動時，《夏娃克隆》影像則立刻
轉動姿態且凝視著觀眾，而背景聲也同步發出即時的音效，創造一種因觀眾存在《夏娃克隆》
才會活現且轉動的鬼譎氛圍。又為了模擬水中的透明感，藝術家以網路攝影機即時拍攝每一
投影面對角的場景與觀眾影像，巧妙的創造了《夏娃克隆》影像與展場實景合一的虛實情境。
這足以與觀者作親密即時的大型影音互動裝置，展現了互動新媒體藝術的魅力，如六面投影
體如水族箱存放了六種不同的質感（如金、銀、水晶、蛇皮等）、色澤（藍、綠、紫等色）
與印有不同語言的 666 數字（中文、阿拉伯文、日文、英文等）於《夏娃克隆》額頭的影像，

的確帶給觀者一種莫明的好奇與吸引力，猶如面對龐然大物的異種，一種緊張與不安的恐懼感油然而生，當觀者遠看作品時，《夏娃克隆》是靜止不動的，又當靠近作品時，觀者會驚訝發現《夏娃克隆》突然轉動，且會因著觀者左右移動而改變她的身體姿勢，甚至眼睛會盯著觀者的眼睛，這種與《夏娃克隆》的雙向親密關係，彷彿觀者正控制著她，卻也彷彿觀者正被她吸引無以遁逃。科技正滲透著人類的生活，如手機、網路、電腦、監視系統、身份碼、各種密碼等對人類無所不在的操控、誘惑與監視，這種控制就如聖經啟示錄所記載的獸印 666 一樣：《凡沒有受 666 獸印的就不得做買賣》而無法生存（聖經啟示錄十三章 16 至 18 節記載大災難時，牠又叫眾人，無論大小、貧富、自主的、為奴的，都在右手上或是在額上受一個印記。除了那受印記、有了獸名或有獸名數目的，都不得做買賣。在這裡有智慧：凡有聰明的，可以算計獸的數目；因為這是人的數目，它的數目是六百六十六。

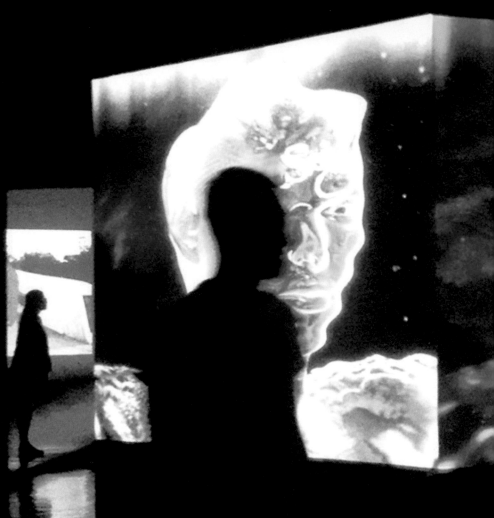

Created using 3D animation, interactive computer programs, infrared sensors, and webcams, Eve Clone IV is an interactive audiovisual installation that features six large-scale "Eve Clones" projected across a three-dimensional, hexagonal arrangement. Incubating in liquid, the Eve Clone is a large alien lifeform that remain motionless whenever viewers are not looking at them. During this time, the only sounds that are present are those of the sounds of bubbles rising in the incubation liquid. As viewers approach and their motion is detected in the vicinity, the Eve Clone vigilantly turns her head to gaze at them. Simultaneously, the sound effects in the background change to create an eerie atmosphere signifying the awakening of Eve Clone by those around her. To simulate the transparent effects of water, real-time recordings of viewers at each corner are used to cleverly merge the Eve Clone images into the exhibition space.

Presenting the charm of interactive new media art, this large-scale interactive audiovisual installation initiates an intimate dialogue between the artist and audience. The six projections are like aquariums that consist of Eve Clones featured in different textures (e.g. gold, silver, crystal, snake skin, etc.) and colors (blue, green, purple, etc). Imprinted on their foreheads is the number, 666, which is presented in many different languages (Chinese, Arabic, Japanese, English, etc). Indeed, this work manages to

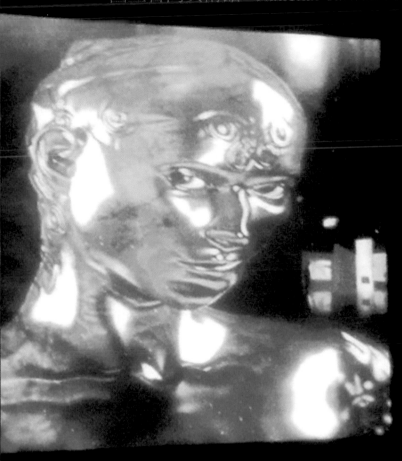

intrigue and captivate the audience with a sense of tension and unease as they face a giant alien life form before them. When looked at from afar, the Eve Clone is silent and still. Yet, when approached, she surprises the audience by suddenly moving, twisting and turning her body along with the motion of viewers. Her gaze follows those walking around her intently. This kind of bilateral intimacy makes it seem as if the audience is somehow controlling the Eve Clone even as they are helplessly enchanted by her gaze. Technology is pervasive throughout modern life – mobile phones, the Internet, computers, surveillance systems, identification codes, and all kinds of passwords, etc... The control, temptation, and surveillance imposed on humanity by the omnipresence of technology is similar to that by the Mark of the Beast, 666, which holds mankind captive as stated in the Book of Revelation: He also caused everyone (small and great, rich and poor, free and slave) to obtain a mark on their right hand or on their forehead. Thus no one was allowed to buy or sell things unless he bore the mark of the beast – that is, his name or his number. This calls for wisdom: Let the one who has insight calculate the beast's number, for it is man's number, and his number is 666. (16 – 18) This is precisely the relationship between mankind and technological civilization that the artist wants to reflect through this artwork. Similar to the Creator, mankind creates technology, which is hoisted as the pride of civilization. Yet, by doing so, mankind faces eternal temptation and enslavement.

夏娃克隆手
Eve Clone Hands

六件立體造形於醫學玻璃罐
醫學玻璃罐、透明樹脂雕塑、雷射燈
Medical Glass Jar, Poly Sculpture, Laser
25cm x 25cm x 43cm x 6 pcs, 2011

啟示錄所記載的獸印六六六，除了印在額頭上外，也會出現在右手上，以立體樹脂雕塑創造六雙印有獸印的雙手，以不同的姿態被置放於醫學用罐中，以模擬器官被存放於福馬林與被實驗的狀態。右手刻有不同材質如蛇皮、樹皮、蛹皮、貝殼、五金與礦石等，以表現基因突變的《夏娃克隆》。

Aside from being imprinted on the forehead, the Mark of the Beast, 666, also appears on Eve Clone's right hand. Placed in six medical jars, hands made of resin are all branded with the Mark of the Beast, simulating organs that are stored in formalin for experimentation. The skins of the right hands are composed of snake skin, tree bark, pupa skin, shell, metal, ore, and other materials, representing the genetic mutations of Eve Clone.

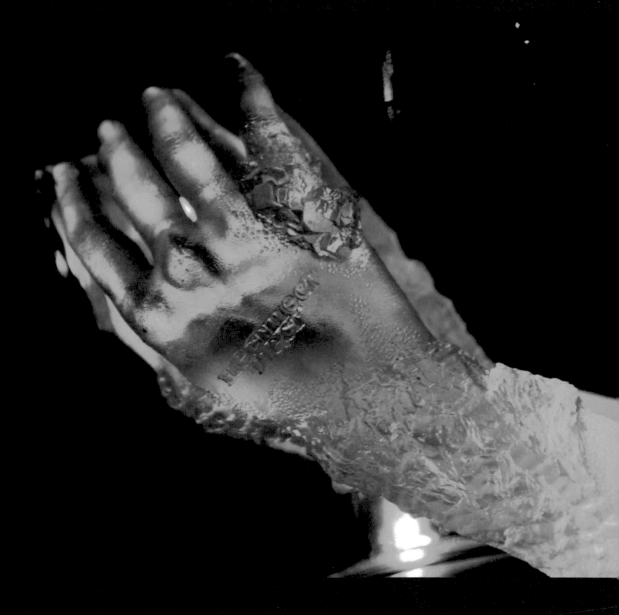

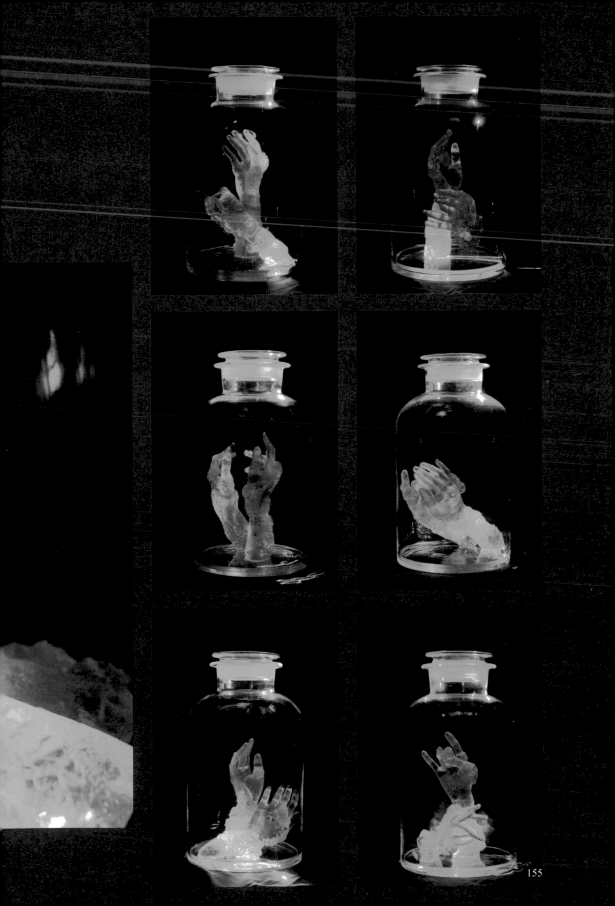

夏娃克隆手指
Eve Clone Fingers

六件立體造形於醫學玻璃罐
醫學玻璃試管、透明樹脂雕塑、壓克力框、雷射燈
Medical Glass Tube, Poly Sculpture, Acrylic Frame
Spotlight 60cm x 30cm x 5cm x 6 pcs, 2011

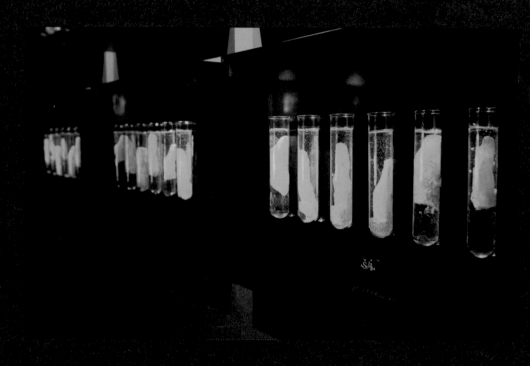

以醫學玻璃試管存放立體手指雕塑，來象徵被複製的基因器官，所存放的每一根手指任意被
切除、扭曲且編有六六六獸印的名牌，整排的試管猶如標本般的被陳列。

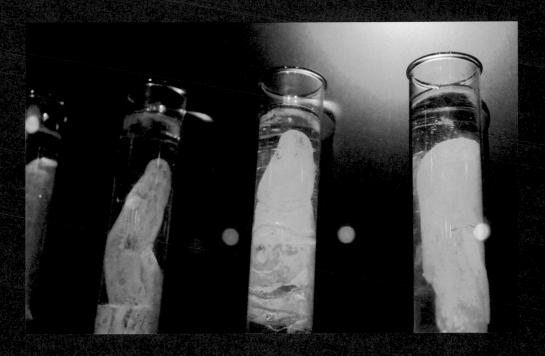

Fingers placed into medical test tubes are used to symbolize organ cloning. Each severed finger is bent and imprinted with the Mark of the Beast, 666. The test tubes are neatly arranged like a specimen presentation.

量產夏娃克隆
Mass Production of Eve Clone

3D 動態影像、8 吋數位相框、18 件
3D Animation
8" Digital Photo Frame, 18 pcs, 2011

每一件數位相框內顯示飄浮在試管內的夏娃克隆，顯示她們正在被蘊釀成形的製造過程，每個夏娃克隆有不同的色澤以及 18 種語言 666 獸印的記號，以 360 度同樣動作的自轉表現複製人產品的特性－量產與規格化。

Within each digital frame, an Eve Clone floats in a test tube, showing its current stage of development in theexperimental process. Each Eve Clone is a different color and has the Mark of the Beast, 666, branded on them in 18 various languages. By freezing the image to capture a 360 degree, self-rotating view of Eve Clone, two characteristics of clones are represented - mass production and standardization.

透視夏娃克隆
Inspection of Eve Clone

數位圖像
Digital Print
76.5 x 53.5 x 2 cm x 6 pcs, 2011

挪用紅外線攝影的意象，顯現夏娃克隆身體：蛹的質感、刺青的圖騰與 666 的獸印獸印。刺青的圖騰有玫瑰、龍、鳳、蛇、蠍子等，暗喻刺青、身體與夏娃克隆本質的關係，美麗的夏娃克隆，在紅外線透視底下，被揭露出危險的本像。紅外線攝影的文字也記錄了夏娃克隆的系列編號、被診斷的日期、時間與診斷者。

20

六六六 Acq Tm

Through infrared photography, the body of Eve Clone is presented, consisting of pupa textured skin, totem tattoos, and the imprinted Mark of the Beast, 666. The totem tattoos consist of images of roses, dragons, phoenixes, snakes, scorpions, and more, alluding to the intrinsic relationship amongst the tattoos, the body, and Eve Clone herself. When seen through infrared lighting, the dangerous nature of the beautiful Eve Clone is revealed. The captions to the infrared photography show the Eve Clone's serial number and her diagnosis date, time, and inspector.

Lin Pey Chwen
W:80 H:58

SIZES ARE APPROXIMATE

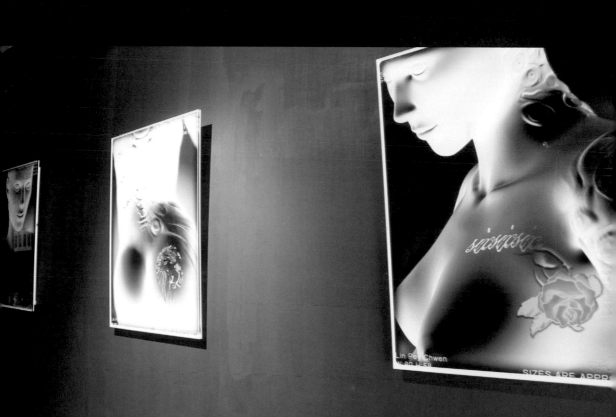

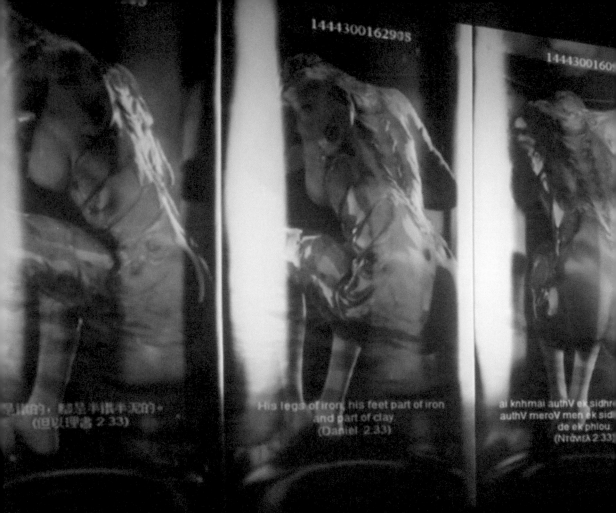

His legs of iron, his feet part of iron
and part of clay.
(Daniel 2.33)

夏娃克隆啟示錄 I
Revelation of Eve Clone I

大型投影互動裝置、動態影像、3D 動畫、互動系統、網路攝影機、電腦、投影機、數位聲響
Interactive Installation, 3D Animation, Computer, Interactive System,
Webcam, Projectors, Stereo, Digital Sound

將聖經《啟示錄》所記載的女人（你所看見的那女人，就是管轄地上眾王的大城。）與夏娃克
隆影像結合，分別以中文、英文、阿拉伯文、希臘文、拉丁文以及希伯來文來呈現，企圖定
義夏娃克隆身分與角色。以大型投影及程式運算之多重影像來展現此具有權柄的女人形象，一
幕幕的夏娃克隆以 360 度連續自轉並重複延遲撥放，影像底部呈現六種語言的聖經啟示錄章
節，藉此批判克隆複製工程的產物將帶來的災難，猶如聖經啟示錄紀載那女人的形象。另外，
為了強調夏娃克隆的生命力，特別以電腦自動運算的數字來表達生命指數，當觀眾進入裝置
現場時，生命的指數就啟動並累計，又當觀眾離去時，生命指數則停止，而夏娃克隆身上的
顏色也逐漸褪去，喻表人工生命的無法自主。

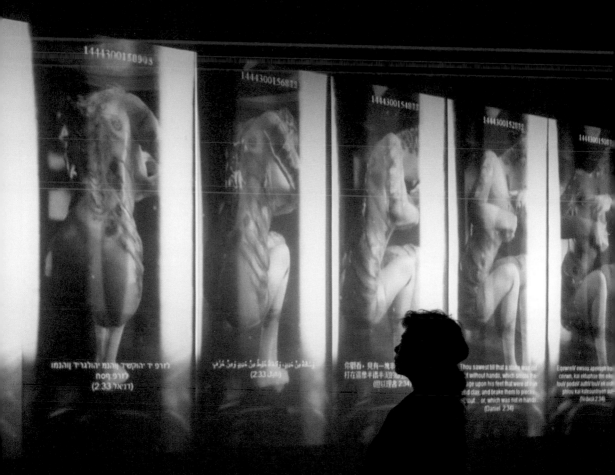

台北市立美術館 Taipei Fine Art Museum

Eve Clone's identity and role is defined by presenting the woman depicted in The Book of Revelation ("The woman whom you saw is the great city, which reigns over the kings of the earth."). Through the use of large projections and computer interactive system, an image of an authoritative woman is shown in a self-rotating view of Eve Clone. The image is cloned and repeated in an delaying format. Displayed at the bottom of the image are chapters of scripts from The Book of Revelations in five different language in Chinese, English, Greek, Latin, and Hebrew to represent the powerful nation in human history. Through this, cloning is criticized for the disasters that it will bring upon the world, just like the image of the woman depicted in the Book of Revelations. Furthermore, to emphasize the vitality of Eve Clone, computer generated numbers are displayed as an indicator of her vital value. When viewers enter the site of the installation, the vital numbers will start to accumulate. As the audience leaves the installation site, the numbers stop and the Eve Clone's skin color begins to fade, signifying that artificial life cannot be self-sustaining. The holy hymn played in the background represents the criticization of Eve Clone's artificial holiness.

uses all, both small and
rich and poor, both free
to be marked on the right
d or the forehead.
evelation 13:16)

Facit omnes parvos et magnos, et
divites et pauperes et liberos et
servos suos cum notis dextras sibi
dari, aut in frontibus suis.
(Revelation 13:16)

Και έκανε όλους,
τους μεγάλους, κ
και τους φτω
ελεύθερους και τ
πάρουν χάραγμα σ
χέρι ή επάνω σ
(αποκάλυ

弗羅茨瓦夫，波蘭 Wroclaw, Poland

在夏娃克隆啟示錄之後，藝術家將夏娃克隆以平面的方式輸出，並註以五種不同語言啟示錄之文字；其目的在於記錄夏娃克隆的生命歷程。

After the revelation of Eve Clone the artist attempt to use the 2D prints to show images of eve clone, her vital value, and the script of different chapters of revelation in five different languages. The purpose is to record Eve Clone's historical thought.

夏娃克隆啟示錄文件
Revelation of Eve Clone Documentation

數位圖像輸出 Digital Image Prints
21 x 29.7 cm x 40 pcs, 2012

新加坡藝術博覽會，新加坡　ART STAGE Singapore

夏娃克隆啟示錄 II
Revelation of Eve Clone II

3D 動畫、動態全像、聚光燈 3D Animation, Hologram, Spotlight
67cm x 53cm x 4cm x 6 pcs, 2013

有別於傳統形式的《夏娃克隆啟示錄文件》之後，《夏娃克隆啟示錄標本》乃試圖以高科技全像媒材的特色，來記錄《夏娃克隆啟示錄》之動態形 像、時間與聖經章節 文字，除了更能真實的儲 存它的原貌外，又能將其呈像於一張平面全像上，討論了時間的被凝固卻又依觀者的視點被瞬間轉動之新式文件觀，是具有人工生命的動態 文件記錄，創造了一種數 位時代的文件新形式，使《夏娃克隆啟示錄》更真實的被記載與建檔。

Following the non-traditional Documentation of Revelation of Eve Clone , Revelation of Eve Clone Specimen continues the attempt to record the dynamic images, times, and Biblical texts of Revelation of Eve Clone using the features of high-tech holographic media. Aside from being able to more truly store its original appearance, it is also able to present it as if across a flat hologram, discussing the new document concept of the solidification of time that instantaneously turns to the moving image according to the viewer's point of view. It is a documentation of the dynamism of artificial life, creating a new form of document for the digital era and enabling Revelation of Eve Clone to be able to be more truly recorded and filed.

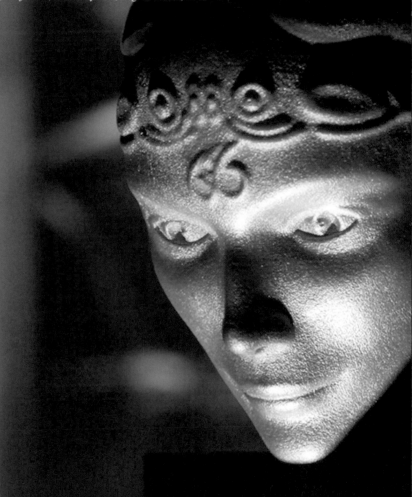

夏娃克隆啟示錄 III
Revelation of Eve Clone III

3D 動畫、3D 列印、互動系統、電腦、投影機、數位聲響
Interactive installation,Moving image 3D Animation,3D Printing,
Interactive Systems, Computers, Projectors, Stereo System, Digital Sound, 2013

Platforma，莫斯科，俄羅斯　Platforma, Moscow, Russia

以大型曲面寬景投影和程式運算之互動影像，聖詩般的背景音樂，和沉浸式的空間氛圍，呈現具有權柄意義與自我複製能力的科技人種—《夏娃克隆》，影像底部呈現聖經《啟示錄》章節之六種語言 (中文、英文、希臘文、拉丁文、阿拉伯文以及希伯來文)，建立《啟示錄》紀載的巴比倫大淫婦形象，以及《但以理》書記載的金、銀、銅、鐵、泥、半鐵半泥的大偶像，企圖定義《夏娃克隆》美麗、危險又被崇拜的身份，尤其巨型的曲面投影所建構的沉浸式空間，以及如聖詩般的背景音樂，而加重了《夏娃克隆》如大偶像般的崇高性，一幕幕的的夏娃克隆以 360 度連續自轉並重複延遲撥放，藉此批判克隆複製工程的產物。另外，為了強調夏娃克隆的生命力，特別以電腦自動運算的數字來表達生命指數，當觀眾進入裝置現場時，生命的指數就啟動並累計，又當觀眾離去時，生命指數則停止，而夏娃克隆身上的顏色也逐漸褪去，喻表人工生命的無法自主。藉此批判人類所發展的科技，雖具有無限的吸引力，但也控制了人類的命運，正走向聖經所預言的末日大災難。

為了表達《夏娃克隆》與科技的密切關係，在展場的中間立有金色的《夏娃克隆》頭部的實體雕塑，觀眾可以手觸碰其頭部 666 符號，《夏娃克隆》影像會逐漸抬頭並舞動身體，如孕育中的嬰兒狀態逐漸成長為更有活力的生命體且進行複製，喻表《夏娃克隆》會著人類的介入而產生變化，也營造出《夏娃克隆》超級偶像式的魅力和性格，一方面暗示科技雖具有無限發展能力，但也因日漸操控人類的慾望，而可能導致人類的淪落，甚至走向聖經所預言的末日浩劫。

作品中所引用啟示錄之文字：

他又叫眾人、無論大小貧富、自主的為奴的、都在右手上、或是在額上、受一個印記。(啟示錄 13:16)

除了那受印記、有了獸名、或有獸名數目的、都不得作買賣。(啟示錄 13:17)

在這裡有智慧。凡有聰明的、可以算計獸的數目．因為這是人的數目、他的數目是六百六十六。(啟示錄 13: 18)

拿著七碗的七位天使中、有一位前來對我說、你到這裡來、我將坐在眾水上的大淫婦所要受的刑罰指給你看。(啟示錄 17:1)

地上的君王與他行淫．住在地上的人喝醉了他淫亂的酒。(啟示錄 17:2)

在他額上有名寫著說、奧秘哉、大 巴比倫 、作世上的淫婦和一切可憎之物的母。(啟示錄 17:5)

天使又對我說、你所看見那淫婦坐的眾水、就是多民多人多國多方。(啟示錄 17:15)

你所看見的那女人、就是管轄地上眾王的大城。(啟示錄 17:18)

因為列國都被他邪淫大怒的酒傾倒了．地上的君王與他行淫、地上的客商、因他奢華太過就發了財。(啟示錄 18:3)

王啊，你夢見一個大像，這像甚高，極其光耀，站在你面前，形狀甚是可怕。(但以理書 2:31)

這像的頭是精金的，胸膛和膀臂是銀的，肚腹和腰是銅的，(但以理書 2:32)

腿是鐵的，腳是半鐵半泥的。(但以理書 2:33)

你觀看，見有一塊非人手鑿出來的石頭打在這像半鐵半泥的腳上，把腳砸碎；(但以理書 2:34)

於是金、銀、銅、鐵、泥都一同砸得粉碎，成如夏天禾場上的糠秕，被風吹散，無處可尋。

打碎這像的石頭變成一座大山，充滿天下。(但以理書 2:35)

The Eve Clone Series stands as a critique of mankind's use of technology to challenge the original creations of the Creator. Can people really entrust their survival to an artificial nature and life? Though faced with the phenomena of El Niño, global warming, melting ice caps, chemical spills, earthquakes, landslides, volcanic eruptions, nuclear disasters, overpopulation, rampant consumerism, mutations, and others, mankind continues to push the frontiers of technology and the science of genetics to alter nature and life. What will the eventual fate of humanity be ? That is the crucial issue in "Eve Clone" series I try to question.

I use the name, Eve Clone, to refer to mankind's use of technology to subvert the creations of God. Using genetic cloning Techniques to create life is akin to mimicking God's creation of Eve. Yet, what will life created under such a pretext of hubris and desire look like ? To portray Eve Clone as a virtual but attractive life form, I use digital media of 3D animation, dynamic hologram, and interactive systems to create a virtual and seductive woman that interacts with viewers in front of artworks. 3D animation is particularly useful in creating bizarre images of humanoid pupae and creatures whose necks and spines have pupa- or beast-like skin and bone textures. The image of this woman's body is shaped like the Venus, and stands as a metaphor for the ideal woman (her creation adheres to the patriarchal standards inherent in the field of technology). Also, I draw from the Bible's Book of Revelation for inspiration. For example, the Mark of the Beast, 666, is seared onto the forehead and hands of the Eve Clone, forming parallels between mankind's reliance on technology and being marked with Mark of the Beast, a devilish number (e.g. modern people are already held hostage by serial codes, product codes, bank accounts, ID numbers, and computer passwords). This is exactly what the Book of Revelation had prophesized: "He causes all, the small and the great, the rich and the poor, and the free and the slave, to be given marks on their right hands, or on their foreheads; (Revelation 13:16) and that no one would be able to buy or to sell, unless he has that mark, the name of the beast or the number of his name. (Revelation 13:17) Here is wisdom. He who has understanding, let him calculate the number of the beast, for it is the number of a man. His number is six hundred sixty-six. (Revelation 13: 18)"

One of the seven angels who had the seven bowls came and spoke with me, saying, "Come here. I will show you the judgment of the great prostitute who sits on many waters, (Revelation 17:1)
with whom the kings of the earth committed sexual immorality, and those who dwell in the earth were made drunken with the wine of her sexual immorality." (Revelation 17:2)

And on her forehead a name was written, "MYSTERY, BABYLON THE GREAT, THE MOTHER OF THE PROSTITUTES AND OF THE ABOMINATIONS OF THE EARTH." (Revelation 17:5)
He said to me, "The waters which you saw, where the prostitute sits, are peoples, multitudes, nations, and languages. (Revelation 17:15)

The woman whom you saw is the great city, which reigns over the kings of the earth." (Revelation 17:18)For all the nations have drunk of the wine of the wrath of her sexual immorality, the kings of the earth committed sexual immorality with her, and the merchants of the earth grew rich from the abundance of her luxury." (Revelation 18:3)

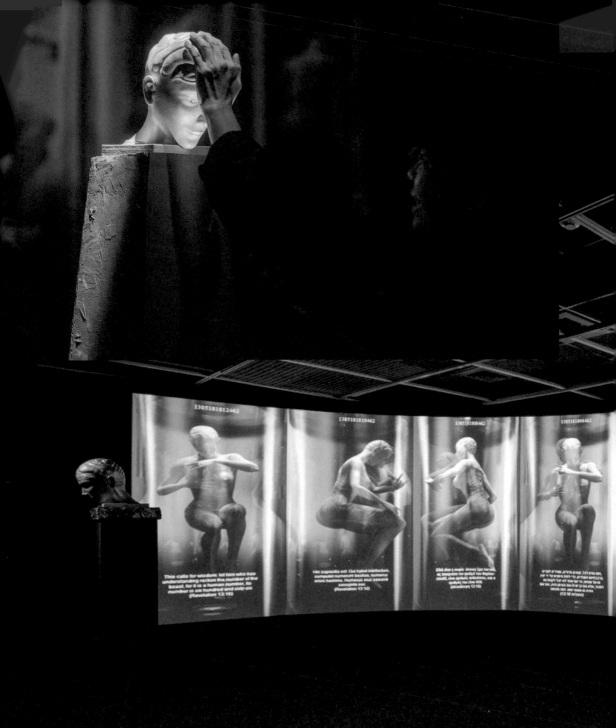

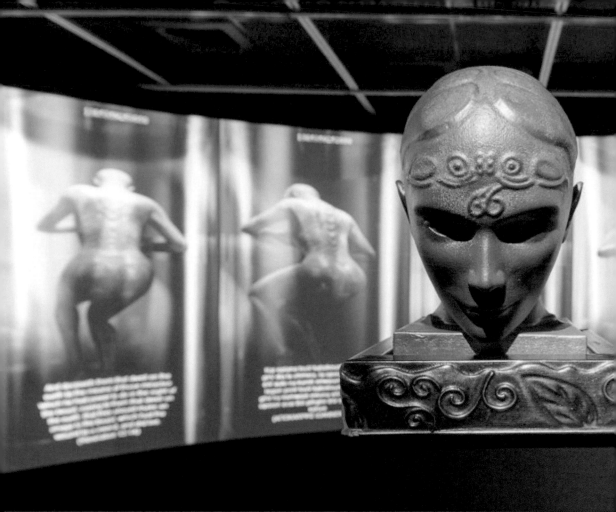

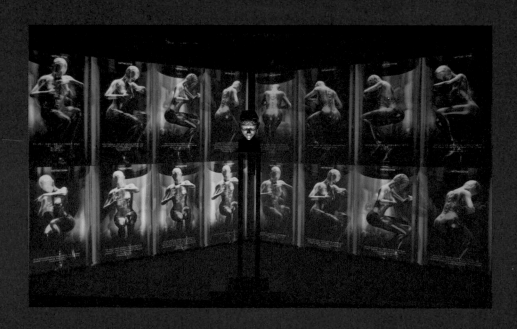

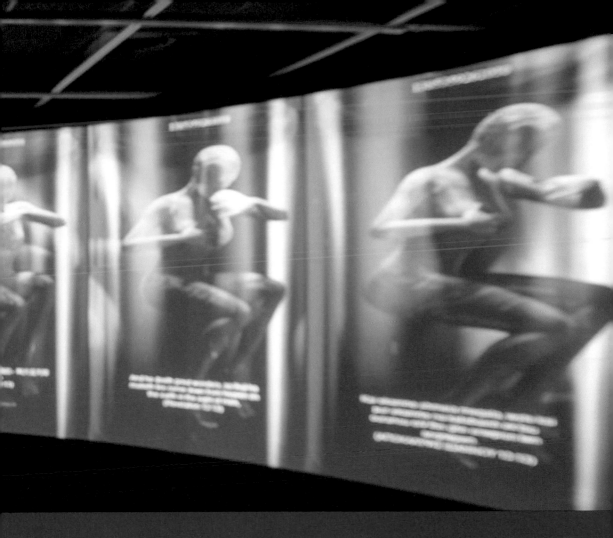

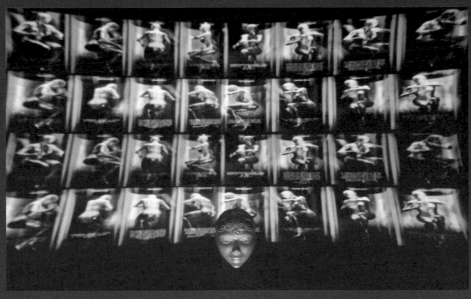

夏娃克隆啟示錄 IV
Revelation of Eve Clone IV
夏娃克隆啟示錄 V
Revelation of Eve Clone V

3D 動畫、數位聲響、單頻道影片
Moving image, 3D Animation, Digital Sound, 2014
08:00

以聖經所記載的金、銀、銅、鐵、泥、半鐵半泥的《大偶像》（但以理書 2:31-33）來形塑
《夏娃克隆》，喻表它是人類所崇拜的科技文明偶像 。影片中的《夏娃克隆》在廢墟中被海
水淹沒，海被染紅變成血，好像死人的血（啟示錄 16:2-4），最後她雖逃出水面後，至終被一
塊石頭砸得粉碎， 於是金、銀、銅、鐵、泥都一同砸得粉碎，成如夏天禾場上的糠秕，被風
吹散，無處可尋。（但以理書 2:34-35)

在影片的末了，那打碎這像的石頭逐漸變成一座大山，充滿天下，背景音樂也以聖歌作結束，
世上的國成了我主和主基督的國；他要作王，直到永永遠遠。（啟示錄 11：15）企圖敘述科
技文明的終極命運，藉此提醒人類所崇拜的科技文明以及象徵科技的權威與榮耀的大偶像，
至終必被神所打碎，人的國終被神的國所取代。

Humanity now opposes the laws of nature and tries to change God"s creation through the development of a technological civilization, including such actions as manipulating nature and employing cloning technology to create artificial life. Although technology brings convenience and enjoyment it may tempt humanity to go down a road of no return. Nature has encountered unrestrained destruction and humanity is facing a series of irreversible disasters through climate change, use of nuclear technology, chemicals in the environment, GM foods, cloning, electromagnetic radiation and computer chips. In order to counter these phenomena, I have used 3D animation to create a hybrid female human, which represents the enticing yet deadly products of scientific experiments. I have named this creature "Eve Clone": Because God created Eve, humans want to clone Eve.

The "great image" in the Bible inspired me to create "Eve Clone", which symbolizes the authority and glory of the technology that humans are worshipping. The image's head was of fine gold, its chest and arms of silver, its belly and thighs of bronze, its legs of iron, its feet partly of iron and partly of clay. (Daniel 2:31-33). I have also marked "666" on Eve Clone"s forehead and right hand—the sign of the beast in the Bible"s Book of Revelations, which symbolizes her control of humanity. (Revelation 13:16-18)

In the video "Eve Clone" is submerged in the sea amidst ruins, the water is stained red as the blood of a corpse (Revelation 16:2-4). Although she escapes from the water, she is ultimately broken to pieces by a stone, becoming like the chaff of the summer threshing floors; and the wind carried them away, that no place was found for them. (Daniel 2:34-35) In the end, the video will show the stone that destroys the image becomes a great mountain. The musical soundtrack is a hymn to represent that the kingdoms of this world become the kingdoms of our Lord, and of his Christ: and he shall reign forever and ever.(Revelation 11:15)The way that the "great image" symbolizes the authority and glory of technology, should remind people that the technological civilization they worship will ultimately be crushed by God.

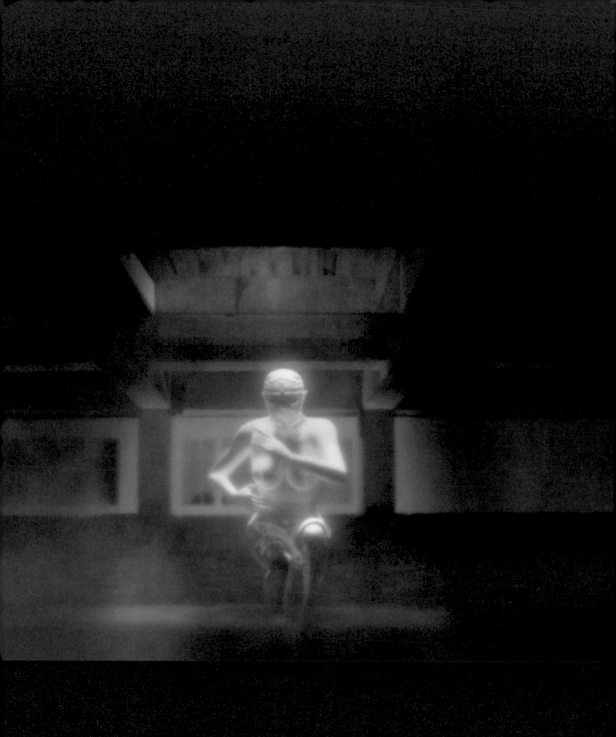

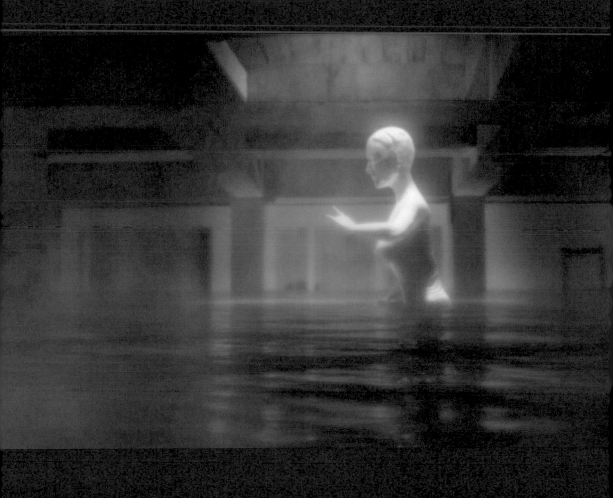

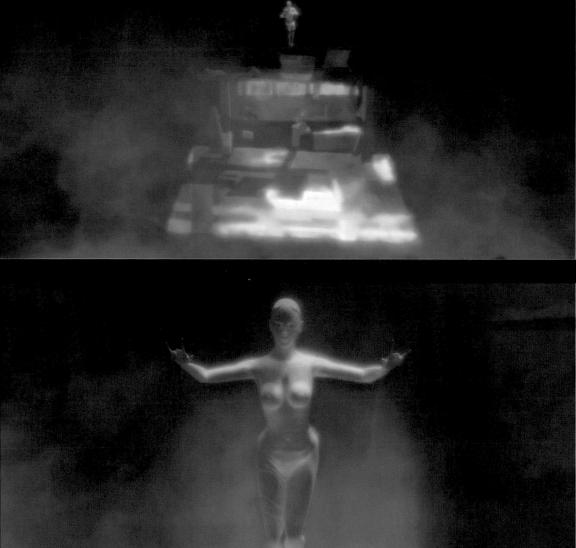

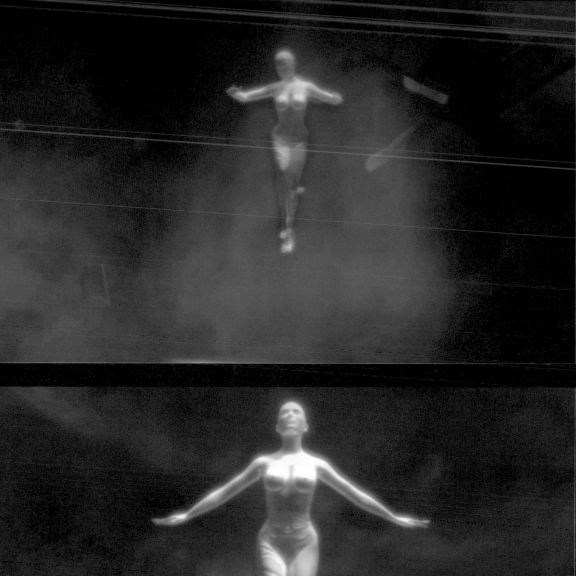
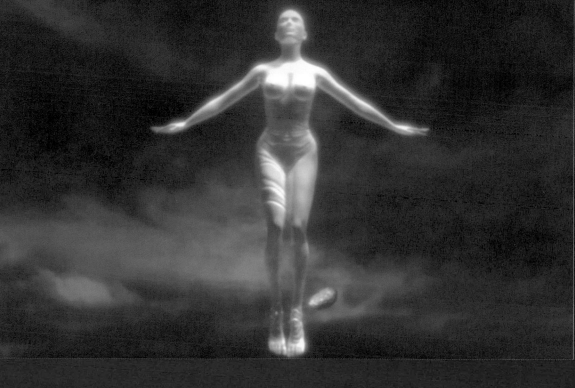

夏娃克隆啟示錄 V
Revelation of Eve Clone V

數位版畫 Digital Print
63 x 77 x 3 cm x6 pcs, 2014

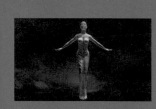

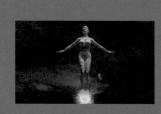

2-6

便去，把碗倒在地上，就有惡而且毒的瘡生在那些有獸印記、拜獸像的人身上。

把碗倒在海裡，海就變成血，好像死人的血，海中的活物都死了。

把碗倒在江河與眾水的泉源裡，水就變成血了。

眾水的天使說：昔在、今在的聖者啊，你這樣判斷是公義的；

徒與先知的血，現在你給他們血喝；這是他們所該受的。

16:2-6

angel went and poured out his bowl on the earth. Then ugly and painful sores

the people who had the mark of the beast and who worshiped his image.

econd angel poured out his bowl on the sea and it turned into blood, like that

, and every living creature that was in the sea died.

hird angel poured out his bowl on the rivers and the springs of water, **and they**

blood.

2:31-35

見一個大像，這像甚高，極其光耀，站在你面前，形狀甚是可怕。

精金的，胸膛和膀臂是銀的，肚腹和腰是銅的，腿是鐵的，腳是半鐵半泥的。

有一塊非人手鑿出來的石頭打在這像半鐵半泥的腳上，

於是金、銀、銅、鐵、泥都一同砸得粉碎，

場上的糠秕，被風吹散，無處可尋。打碎這像的石頭變成一座大山，充滿天下。

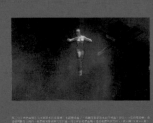

大巴比倫城
Great Babylon

3D 動畫、數位聲音 3D
Animation, Digital Sound, 2015
04:07

此系列企圖將《夏娃克隆》置放於真實的世界，提醒人類《夏娃克隆》現象早就存在生活周遭，若人類仍逆天行道自高比作神，恐無法避免《啟示錄》所預言的大災難。影片中凸顯她站立在紐約市的帝國大廈之頂，從天上鳥瞰的角度來表現高密度的建築與街道，而它正是人類每天忙碌追逐政治、，經濟、文化、科技、宗教、教育、藝術等活動之中心，就是人類所有慾望的象徵，也是人類崇拜的大偶像。因此《夏娃克隆》雙手張開以驕傲的姿態管轄這大城，影片也以她為中心點，且整個城市乃從平行到從天空鳥瞰的視角作環繞，然而神却在天上看著它及這城，最終用火燒掉這大城以及這巴比倫大淫婦及大偶像，而燒它的煙往上冒直到有形質的都被銷毀為止。

In the film, the Eve Clone stands prominently on the top of the Empire State Building in New York City. A bird's-eye view shows the high density of the buildings and streets, as well as emphasizes it is the center where humans busily pursue politics, economics, culture, technology, religion, education, art, and other activities. The Eve Clone also serves as a symbol for the desires of humankind and the idols that it has chosen to worship. As a result, the Eve Clone opens up both hands in a prideful stance as she governs this great city. The film camera revolves around the Eve Clone, switching from a parallel to a bird's eye view of the whole city. However, God watches it and the city from above, and finally sets fire to this Great Whore of Babylon. The smoke surrounding it rises up until all physical form has been destroyed.

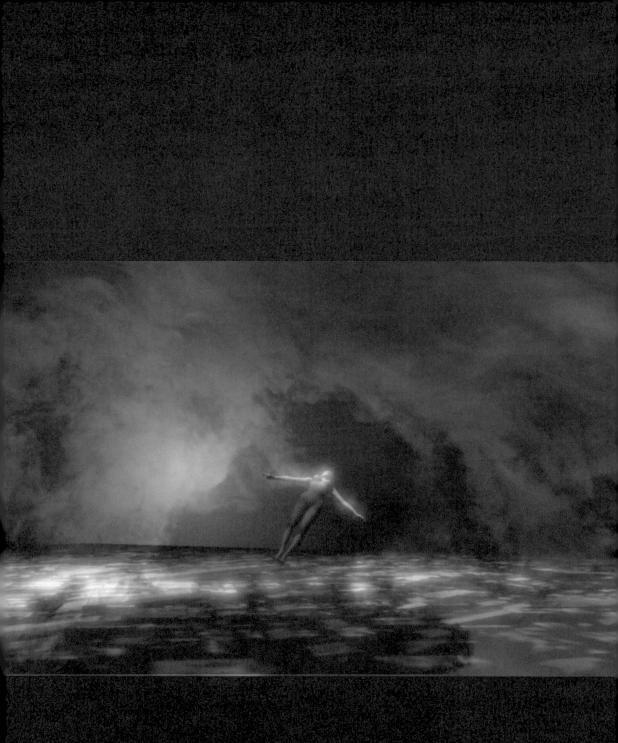

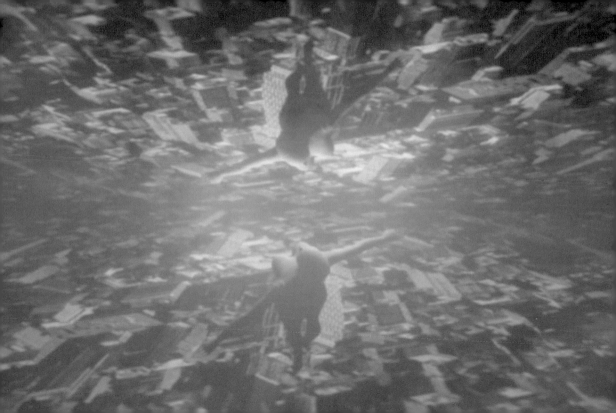

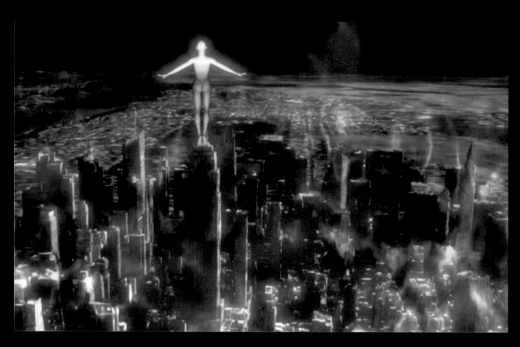

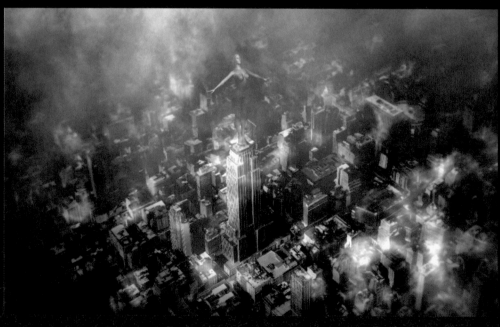

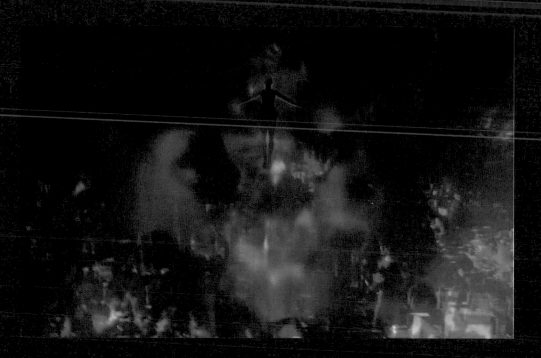

啟示錄 17：18
你所看見的那女人，就是管轄地上眾王的大城。

Revelation 17：18
And the woman whom you saw is the great town, which is ruling over the kings of the earth.

啟示錄 18：1
此後，我看見另有一位有大權柄的天使從天降下，地就因他的榮耀發光。

Revelation 18：1
After these things I saw another angel coming down out of heaven, having great authority; and the earth was bright with his glory.

啟示錄 18：2
他大聲喊著說，巴比倫大城傾倒了，傾倒了，成了鬼魔的住處，和各樣污穢之靈的巢穴，並各樣污穢可憎之雀鳥的巢穴。

Revelation 18：2
And he gave a loud cry, saying, Babylon the great has come down from her high place, she has come to destruction and has become a place of evil spirits, and of every unclean spirit, and a hole for every unclean and hated bird.

2016~

五、夏娃克隆創造計畫
Making of Eve Clone Series

當代美學中的數位女性主義
林珮淳的《夏娃克隆創造計畫》系列

陳明惠 | 藝評家、國際策展人

《藝術家雜誌》，2017 | Academia. edu

女人、科技、藝術

關於女人與科技藝術之間的關聯，可以追溯到 1960 年代中期，英國著名女策展人佳莎‧理查茲特 (Jasia Reichardt) 及其所策畫的《Cybernetic Serendipity》展覽，理查茲特是提出「誰是製造藝術經驗者」(who was making the art experience) 這樣概念的先驅[1]，她提問究竟是藝術家、科學家、還是參觀展覽名眾創造了藝術作品本身，這顯出科技藝術家跨越科技與藝術不同學門之交集，及其相互依賴性。除了理查茲特代表女性在科技藝術領域的極大貢獻，1960 年代之後最著名的女性科技藝術家是美國籍莉莉安‧史華茲 (Lillian Schwartz)，過去多年她與數學家、科學家合作，創造許多影片、動畫、雕塑、2D 及 3D 影像作品，其中包含《Big MOMA》(1984)，此作品拼貼許多紐約現代美術館 (MOMA) 的館藏品圖像，同時呈現不同時期電腦科技的演進及技術以協助藝術家創作。[2] 美國藝術家夫婦喬蕾特‧龐格特 (Collette Bangert) and 傑夫‧龐格特 (Jeff Bangert) 於 1960 年代開始一起創作科技藝術，他們的創作主要以電腦、軟體、數學原理來完成。在歐洲最重要的女性科技藝術家是匈牙利出生，目前工作於巴黎的維拉‧莫納爾 (Vera Molnar)，她於 1960 年代便開始採用數位科技創作，常創作電腦繪圖，並於 1960 年在巴黎設立 Group de Recherche d'Art Visuel (GRAV)，她的電腦繪圖以抽象形式呈現美學及充滿數學感的幾何圖形。[3]

在台灣進行科技藝術創作的女性藝術家不在少數，但經營科技藝術創作多年且作品具有獨特風格的不多，而林珮淳便是這少數傑出女性科技藝術家之一。林珮淳從 2006 年開始創作「夏娃克隆」系列，此系列作品是受啟發於聖經裡的夏娃而進一步被藝術家創作出來。透過長期發展的「夏娃克隆系列」，林珮淳塑造出一種超越生物性的賽伯格，並且是一種結合數位科技與性別象徵之「類女體」。林珮淳所創作出的夏娃，雖然帶有生理女性之基本生物特徵，但她是一種自然與人工結合之賽伯格。完美無瑕且毫無體毛之夏娃，是藝術家創造出的一種烏托邦式的女體：似真似假、介於有機與無機之間的身體。林珮淳足以稱為台灣科技藝術之先驅，且其作品中的女性主義意涵，更是台灣女性與科技藝術領域裡最重要的藝術家。

「後人類」與「數位女性主義」

林珮淳「夏娃克隆系列」系列涉及「後人類」（Post-human 或 Posthuman）與「數位女性主義」

1 Prince, Patric (2003). 'Women and the Search for Visual Intelligence' in Malloy, Judy (ed.). Women, Art & Technology. Cambridge: Massachusetts and London: The MIT Press, p. 5

2 Lillian F. Schwartz, 'Collage', http://lillian.com/collage/, accessed 3 February 2017.

3 Prince, op cit., p. 8.

(Cybersexualities) 議題,以下將簡短說明。「後人類」作為一個學術名詞,自 1970 年代末期即被學者廣泛論述:伊哈布・哈桑 (Ihab Hassan) 1977 年出版的《普羅米修斯作為後人類文化裡的表演者?》("Prometheus as Performer Toward a Posthuman Culture?"),探討科技不僅影響人類醫療科學,它更牽引著我們日常生活的消費文化 [4]。史蒂夫・尼可思(Steve Nichols)於 1988 年出版的《後人類宣言》(Post-human Manifesto)一書,提出現代人已經是處於後人類狀態的主張。西方批判思想於 1970 年代、1980 年代熱絡展開之際,至今已出現許多由「後」(Post-)為字首之學術名詞,包含:後現代(postmodernism)、後殖民(post-colonialism)、後工業(post-industrialism)、後共產主義(post-communism)、後女性主義(post-feminism)、後結構主義 (post-structuralism)、後馬克思主義 (post-Marxism)等,而這些由「後」為字首之詞,皆與「後人類」之概念有所關聯,因哲學思維下的「後人類」亦關懷它者及包含一種不明確感(undecidability)之狀態 [5]。義大利哲學家羅西・布拉多蒂 (Rosi Braidotti) 在她 2013 年出版的《後人類》書中提到:

「在後人類、後殖民、後工業、後社群,甚至倍受爭議的後女性主義之後,我們似乎進入一種後人類的困境,儘管我們處在一種 N 次連續性且以「後」為字首,並且無止境、不清楚的狀態,後人類引介了我們思想上質性的變動,並思考我們的本質,及我們與地球其他生物的關係。」[6]

以「後」(post-) 為字首的文化研究專有名詞,皆具有複雜且分歧的定義。「後人類」的現象包含當代數位文化中「第二人生」(Second Life) 虛擬世界、基因改造食物、機器人、人工生殖技術等。「後人類」顯示一種介於人類與非人類之間的緊張感與不確定性,且呈現一種結合人的身體與科技技術相互關係與影響的現象與想像,這種介於人與科技的概念,回應數位女性主義哲學家唐娜・海若威(Donna Haraway)對於賽伯格之觀點。海若威曾指出:「賽伯格是一種數位空間的有機體,一種混雜機器與有機生物體,同時是社會的真實狀態,亦是一種虛幻的科學想像。」[7] 賽伯格是一種超越現實物質世界裡,既定兩性二元分界之個體,且不具傳統的性別二元論,並呈現解構性別認知、重現身體符碼之後人類現象。

4　全文請參考 Hassan, Ihab. " Prometheus as Performer: Toward a Posthuman Culture? " Georgia Review, 31, 1977, pp. 830-50.

5　Miah, Andy. 'A Critical History of Posthumanism' in Gordijn, Bert and Ruth Chadwick (eds). Medical Enhancement and Posthumanity. Springer Science + Business Media B.V., 2008, pp. 87-88.

6　筆者譯。Braidotti, Rosi (2013). The Posthuman, Cambridge: Polity Press, pp. 1-2.

7　Haraway, Donna J (1991). Simians, Cyborgs, and Women: The Reinvention of Nature. London and New York: Routledge, pp. 149-181.

科技的進步可以實現人在科學小說及對於過去的想像。「後人類」現象呈現一種交雜在人類與非人類之間的焦慮感及不確定性，這種交雜生物性與科技性的混合體也稱作「賽伯格」(Cyborg)，而根據海若威的觀點，它是一種「機械有機體，介於機器與有機體之間，它是介於科幻小說與社會實體之間的生物體。」[8] 關於數位女性主義，思想家克勞蒂亞‧絲屏格（Claudia Springer）在分析 1926 年由德國知名電影導演弗里茨‧朗（Fritz Lang）所執導的表現主義科幻默片《大都會》(Metropolis) 電影，以針對性別與科技之觀點，提出令人省思的看法:「《大都會》在慶祝科技的高效率之際，同時又認為科技的力量若失控，將會帶給人們一種毀滅人性的恐懼。這樣的矛盾心理反應在影片中的性別角色:一個具有女人形體的機器人，代表科技同時對人們產生誘惑，但又同時是個可怕的威脅。這女體機器人的誘人性感特質，最終引發機器工廠裡勞工的混亂叛變。」[9]

在後現代文化中，女性的身體常被用來表現科技與人性的關係崩解。美國哥倫比亞比較文學教授安德魯‧胡森（Andreas Huyssen）也認為現代書寫經常將機器與女人並置，並呈現對於科技過度發展的恐懼，這樣的心理與父權思想畏懼女人是一致的。[10] 林珮淳的「夏娃克隆系列」所創作出的夏娃克隆是象徵林珮淳對於後人類 (尤其是女體) 的想像與詮釋。夏娃克隆不僅呈現女性特質，更帶有宗教的象徵，儘管林珮淳的作品仰賴大量科技、數位技術而創造出來，藝術家其實反諷、批評科技帶給人們社會負面的影響。夏娃克隆的賽伯格化身體，同時呈現林珮淳批判對於美麗女體盲目崇拜的意涵，這便呼應《大都會》影片中以女體做為諷刺科技的負面象徵。

本展覽展出作品包含:《夏娃克隆肖像》、《夏娃克隆創造計畫 I》、《夏娃克隆創造計畫 II》及一系列《夏娃克隆創造計畫》的創作過程資料，其中《夏娃克隆肖像》以 3D 動態全像攝影的形式呈現，將女性頭像與聖經《啟示錄》中所預言的獸像之形像作結合，再賦予不同礦物之色澤與質感 (金、銀、銅、鐵、泥)，藉以諷刺女體因社會價值觀而被物化，文明過渡發展對於人類生活環境所造成之負面性與破壞性，並反諷科技帶給人類之潛藏危害，且挑釁社會對於女性身體之牽制與束縛。

2016 年林珮淳新作《夏娃克隆創作計畫 I》結合夏娃克隆及達文西手繪的男性人體素描及手稿，創造出一種結合數位感及手繪稿之特殊質感，並且透過夏娃克隆與達文西的男體素描稿不斷地交互自轉，作品亦呼應雌雄同體的概念。關於此新系列作品，林珮淳曾說:「此系列主要挪用達文西『維特魯威人』的手稿與我『夏娃克隆』全身每一個發展的過程作結合，回朔再現「夏娃克隆」如何被我以電腦 3D 創造的過程與每一時期的形體。」在此展覽中，林珮淳亦展示數件夏娃克隆與達文西對照的頭部與身體被創造過程的對照圖，包含頭部、身體、手部。這些圖像以上下對照的方式，上方背景是達文西的手繪稿，下方是林珮淳所創作的夏娃克隆，從林珮淳的發想的手繪線條，到由 3DMaya 軟體建構的人形網格，再配以與《夏娃克隆肖像》一樣，不同的金屬感肌膚，透過上下對照，達文西 19 世紀所繪製的人形手稿，與林珮淳於 2016 年透過電腦所創作的夏娃克隆，進行一種跨時空、跨媒材、跨場域的結合與對話。有趣的是，達文西筆下的男體，與林珮淳所創造的夏娃女體在兩個身體不斷翻轉的過程中，逐漸

8　筆者譯。Haraway, op. cit., p. 69.
9　筆者譯。Springer, Claudia (1999), 'The Pleasure of the Interface', in Wolmark, Jenny (1999), Cybersexualities: A Reader on Feminist Theory, Cyborgs, and Cyberspace, Edinburgh: Edinburgh University Press, pp. 36.
10　Huyssen, Andreas (1981-2), ' The vamp and the Machine: Technology and Sexuality in Fritz Lang's Metropolis' , New German Critique, no. 24/25 (Autumn 1981- Winter 1982), pp. 221-237.

結為一體，似乎呈現夏娃克隆便是現代版的達文西筆下的身體。

夏娃與當代美學

遠在「後人類」及「賽伯格」這兩個學術名詞開始被引用及討論，藝術家、哲學家、作家、科學家對於人與機械的交集一直存在著多元與複雜的想像。不論是安徒生童話故事《夜鶯》（The Nightingale，1844 年）中由機械作成之夜鶯、瑪莉．雪萊（Mary Shelley）1818 年《科學怪人》（Frankenstein）裡半屍半機器之怪物，或是以撒．艾西莫夫（Isaac Asimov）科幻故事中的機器人，科技的演變仍是當今我們解讀「後人類」議題之核心。而後人類身體其實也存在我們當代生活中：著名英國仿生義肢流行歌手維多利亞．蒙德斯達（Viktoria Modesta）的美麗、不尋常、充滿生物性及機械性的身體，便是當代「後人類」最好的例證；日本大阪大學石黑浩（Hiroshi Ishiguro）教授創造的美女機器人 Geminoid F，與真實人類的相似度之高，亦令人讚嘆科技可以達到的驚人效果。

林珮淳從 1995 年從澳洲獲得藝術創作博士榮譽歸國之後，便一直創作具有女性主義意識的作品，例如《相對說畫》(1995)、《黑牆、窗裡與窗外》(1997)、《骰子》(1998)、《經典之作》(1998)、《美麗人生》(2004) 等，皆對於傳統父權提出批判。盡管林珮淳於 2004 年《溫室培育》創作開始加入高科技元素，作品的軸心仍舊環繞在濃郁的女性主義色彩。林珮淳從 2006 年開始創作的夏娃克隆作品，開始呈現一種對於後人類與賽伯格的詮釋，以結合一般人對於美麗女體的想像，及互動藝術技術，開啟藝術家至今仍驚艷觀眾的一系列夏娃克隆作品，這個結合科技、想像、女體的後人類或賽伯格身體，儘管是受啟發於聖經，但作品散發出的能量與美學，完全不同於過去以宗教作為核心的藝術創作。

夏娃是聖經裡的重要角色，然而夏娃在女性主義的思維中受到不一樣的詮釋。依據聖經，夏娃是世界上第一個女人，且從亞當的肋骨被塑造出來，且被視為陪伴亞當的伴侶。後來夏娃受到毒蛇的誘惑，引誘亞當吃知識之樹的果實，便與亞當一起被逐出伊甸園。聖經裡的夏娃是世界上第一位且完美的女人，但同時因為他是從亞當的身體裡被創造出來，夏娃 (女人) 便一直被視為較弱勢者、次要的角色。在現代社會，夏娃仍被視為男人理想中的伴侶，而科學家賦予這理想的女人一些想像，甚至再重塑科學家心目中理想的女人，如：《大都會》電影中的女機器人、石黑浩教授創造的美女機器人 Geminoid F。藝術家林珮淳也以夏娃作為創作的核心，再重新詮釋她對於聖經的理解，及對於這「理想」的女性的批判，這樣的創作手法與過去科學家、文學家所創作出來，結合科技與想像的女性身體之意識型態是相似的。

早期女性主義者對於夏娃是第二性的說法，具有極大的批評，並試圖顛覆這樣具父權思維的意識形態。然而，林珮淳的創作不同於早期女性主義對於性別二元論的批判，她對於夏娃所代表的象徵性更具興趣，且透過科技技術所創造出來的虛擬夏娃身體，反應科技帶給我們當代生活的影響，這樣的創作思維，已跳脫早期女性主義者對於父權的顛覆與批評。

本展覽主要展出林珮淳 2016 年創作的《夏娃克隆創造計畫》系列作品，藝術家彷若是現代達文西，但以電腦軟體對於身體作細緻觀察、描繪，如當年達文西仔細解剖人的身體，再一一記錄身體結構般，並藉由科技重構夏娃的身體，同時對照達文西具歷史文本對於身體的觀察，《夏娃克隆創造計畫》系列不同於過去林珮淳早期創作對於父權的解構，也超越過去夏娃作品裡對於現代科技的質疑與批判，而顯現出一種更細緻、更複雜，跨越古今中外不同美學、科技的相互對照，此系列作品足以視為林珮淳以夏娃克隆作為創作系列最具代表性之作。

女人創造女人
林珮淳的夏娃克隆的主體性

林宏璋 │ 藝術家、藝評家、國際策展人

《ARTCO 典藏今藝術雜誌》，2017 │ Academia. edu

拉圖（Bruno Latour）曾說過「創造人」（Homo farber）永遠先於在智人（Homo sapiens）之前，他認同「做」是「知性」的開始，如同是一個開放作品（Opera Aperta / Loose Work），在開放中提到了駁斥了它的消極內涵，並將人的創造本質表現出來的，他認為「創造人」是人的本質表現，同時也是代表自然的異化和客體化的表現。

這種全體藝術（Gesamtkunstwerk）的展演情境，往往是男性的專利，「人造人」在詞首的審略「男」，有個全稱的指示，但是「女人造女人」卻往往朝著例外發展。林珮淳的「夏娃」在一個圖像的虛擬現實實驗室裡中誕生，夏娃不再是「男人造女」的狀態，而是由女性藝術家林珮淳所造，其長相、身段與表情，是一位帶著如摩納莉莎的淺淺微笑，在額頭上有著「666獸印」（the number of the beast）烙印，。在《夏娃克隆肖像》中，「夏娃」頭像雖然被禁錮於一個時空當中，其深邃的雙眼隨著觀者的走動，擺動窺看，對應著完美比例的達文西男人，甚至這個被克隆的女人比例不再完整。《夏娃克隆》並不完美，林珮淳創作的「夏娃」，不僅是基因科技創造的產物，背負基因生殖科技的罪惡，成為刻印著獸名印記的女人，更象徵人類自以為是的科技成就之反諷。這是一方面，在林珮淳的作品中，科技總是以他者的身分顯現的原因，作為存在狀態的它方—「廢墟」，或者一個科技成為人類文明的狀態；同時這個圈套也指向著這些永遠匱乏的能指—女人／撒旦／妓女／克隆等等。林珮淳的作品創造出一個「越過」（traverse）科技的幻見情境，如何能克隆然「匱乏」主體顯現？在林珮淳堆疊的實驗室情境中，各式文件、檔案、投影、及擴增現實中呈現了「科技女性」缺陷而不完整的擬像中顯現。

造像的皮囊材質，背上所披覆的鱗片與骨節，清楚顯露了「夏娃」所具有的獸身特質，這種在人獸塞伯格（cyberg）正是脫離了科技象徵權力的主體性，作為逃離男性閹割情節，如拉崗（Jacques Lacan）所言，每一個男性主體必須受限於閹割情節，而只有（為且僅有）一位「父」的主體是例外於閹割情節；然女性不受此限：不是所有的女性接受閹割情節，而逃離一個被全稱的女性主體表現，被槓掉的女人，充滿著創造的空間及能量。科技定位的策略，或是報導攝影的興起，企圖透過文字與圖像為台灣的社會層面塑像。「女人造女人」的主體是科技書寫的想望（desire）藉由林珮淳的藝術形式表現中。這個克隆主體的想望是解放在男性價值中閹割及家、國的他者，作為一個獨一無二「複奇性」（singularities）的主體表示。

然而，考慮「女性」一詞的含意在例外所開顯的意義，它不正反映了台灣的科技的可能性？這個具有自明性的名詞，除了如前所述的具有後殖民經歷的學者、藝術工作者在不同政治疆

界的科技場域中調適與互動的結果。從台灣的歷史性觀察，科技在地性不是在台灣藝術發展中的一種懸欠（lack）嗎？從「女性」所表現的主體性，表面上是透過以阻抗（resistance）的方式來表徵這種回歸科技定點的姿態。而事實上，「地方」所表現的「科技挪用及轉譯」的意涵，透露在訊息中的理念，正是台灣以現有科技資本，框架在台灣特有的「非男人的主體」（non-muscular subject）的政治領域下，把科技雜化（hybridity）的問題凸顯於本質論的限制。然而，也有可能是藉科技倫理的轉變，利用涵蓋的科技場域中的個別差異性的表現。這種「觀看科技狀態」的情境之中，這是一個從「女人造女人」所開啟的啟示。

「克隆的主體性」本身就是一個詭譎的表現，一方面，它表示一種同一認同（Identity of the same），另一方面，也標出其無主體的一面（identity of none），所有有關認同的追求，在英一字所呈現的語意是唐突而矛盾的（oxymoron）的：首先，既然是「無」認同，那何必要追求（是不是原本沒有「認同」？）。或者說克隆的主體性在於認同的追求本身，如同電影「銀翼殺手」（Blade Runners）中孜孜嚶嚶獵取克隆的克隆偵探，從「無主體性」捕捉一模一樣（the same）of的「無主體」。而這種尋求科技的認同如果答案是肯定的話，是不是說明了這個藝術展覽型式的表現僅僅是科技水平的一部份，而且是宣告了一個「科技」的在地調查，藝術家女性創造了一個一起一模一樣的女性無主體。而這正是在佛洛伊德在《超越享樂原則（Beyond Pleasure Principle）》書中有一段對他的孫子遊戲時所作的觀察：小漢斯（他孫子）拉連接在滾筒上的線，把滾筒丟到他的床外，讓滾筒不見了，同時他發出「O-O-O-O-」的聲音（德文為 fort，為「去」之意）。然後他又從床外拉回這個滾筒，喜悅的對這個小玩具再次出現發出「Da」（這裡）。這是他的整套遊戲—消逝與再次顯現。通常，一般人會注意到這個遊戲的前半部，重複，然則這個遊戲的後半部無疑的會帶來更多的樂趣。對佛洛伊德來說，這是嬰兒透過遊戲去擁有「失去的母親」的表現方式。同時也是一種透過換喻的象徵過程—在來與去之間操縱擁有消失的「事物」。在嬰兒嚶嚶學語時，所想望的「母親」先消失，然後再度出現了。從擴增實景（augmented reality），男性手稿以及電腦投影及銀幕，所表示的現代與科技位置上躊躇科技在地性不就是在象徵過程中永遠得不到「部分物」（object a）嗎？而這種對部分物想望會不會是致死方休的過程呢？我不知道。但是我知道女人創造女人的主體，不斷重複挑戰那型主體的伊底帕斯情節的一再浮現。它來了，它走了，它還會再來，它又來了，因為「女人造女人」就是例外於「男性原則」的詭譎存在。

警世的數位神諭

《夏娃克隆創造計畫》對科技的批判與反思

邱誌勇 ｜ 數位藝術國際策展人、藝評家

警世的數位神諭：林珮淳《夏娃克隆製造計畫》對科技的批判與反思 [1]

藝術家林珮淳的作品《夏娃克隆創造計畫》系列，是對其自 2011 年以來以「夏娃」作為創作主體的藝術作品如《夏娃克隆啓示錄》和《夏娃克隆肖像》等的延伸。與之前的作品相呼應，在《夏娃克隆製造計畫》中，林珮淳延續其對於宗教的領悟，以及對女性的思考，利用科技藝術反諷數位科技對於自然法則的衝擊和破壞並創新性地將將多年來如何創造「夏娃克隆」的過程與達文西的手稿結合，這一元素的加入為作品本身增添了更深刻的文化底蘊，亦即：作品既蘊含著「生態女性神學觀」（ecofeminism），也體現著「女性科學主義觀」。

從 2006 年林珮淳開始以「夏娃」為母題的系列創作開始，便不斷延續著夏娃本身作為背叛神性，讓人類背負著原罪的象徵意義；同時，作為《創世紀》中被神用男性肋骨製造的女性形象，夏娃隱喻著一種女性的誘惑與慾望。黑格爾在《精神現象學》中曾說，慾望激進地構成了意識，這也意味著人類的慾望組成了這個時代人類的集體意識。夏娃作為慾望客體的女體，她展示著一種誘惑力，以及人類作為主體的慾望。而克隆人夏娃，即代表著人類對於當代數位科技的盲目迷戀和想望。之所以將夏娃作為科技本身的形象出現，而非科技載體，林珮淳的思維與女性學家唐納‧哈樂葳（Donna Haraway）的論述亦相互呼應著。1990 年，哈樂威在其文章《賽伯人宣言：20 世紀末的科學、科技和社會主義—女性主義》中曾提出「機械不再是一個有待被賦予生命、受崇拜、被支配的『它』。機械就是我們、我們的過程、我們的身體呈現的一個層面…女性的體現也似乎是被給予的、有機的、必然的；女性的體現似乎意指為人母的技術以及各種象徵性的延伸。」[2] 而《夏娃克隆》恰恰警示著科技與機械從「被支配」到「支配」的主題。

與哈樂葳不同的是，林珮淳對於科技、女性，甚至全人類的發展並非完全正面積極。儘管其透過創作認同科技的發展使得族群與性別的對立性轉化為流動性，是對女性地位和身份的認同。但與此同時，她的作品不僅展現科技對於跨越種族的影響（作品表示多種不同語言，且夏娃的身體呈現不同種族的不同色彩），更體現了她對打破自然與非自然界限的擔憂。因此，林珮淳對於人類與宇宙的關係更具一絲「生態神學」性質。羅伊特（Ruether）認為，對於地球上生活的各種物種而言，人類是遲來者，且在萬物中最後被創造。因此，人類不應成為干擾

1 作者感謝吳韻璇女士（香港中文大學視覺文化研究 研究所 研究生）協助蒐集資料

2 Haraway, Donna. "A Cyborg Manifesto: Science, Technology, and Socialist-Feminism in the Late Twentieth Century". Simians, Cyborgs and Women: The Reinvention of Nature. Routledge, 1990.

大自然與宰割地球的生物。[3] 而林珮淳所展現出的生態女性主義也映射出對於人類唯我獨尊，自私自利濫用科技破壞造物規則行為的鞭笞。

在新作《夏娃克隆創造計畫》中加入達文西的《維特魯威人》（Vitruvian Man），是文藝復興時期探討人與宇宙關係的重要畫作。畫作以達文西通過解剖探索出的比例最標準的男性為藍本，被後世稱為完美比例與自然和諧的人。達文西對於人體標準比例的研究是一次科學與藝術的溝通，而在林珮淳的視角下，解剖活動則成為一種對神創人體的解構與挑戰，也蘊含著深刻的「以人以及男性為中心」的思想。此外，將「人體標準比例」中的男性與「克隆夏娃」所代表的女性相結合，一方面展現了對立之下的共生，更多是一種表現「克隆夏娃」的行為與達文西以解剖創造完美人體過程，都是對神性和自然的挑戰。

《夏娃克隆創造計畫》，採取了包含數位輸出，投影，3D 動畫以及數位影音在內的多種藝術形式，將宗教題材視覺化。包括《夏娃克隆創造計畫I》影片、6 件《夏娃克隆創造文件 II》系列，以及 16 件的《夏娃克隆創造文件 I》。這些作品分別以不同方式呈現了夏娃仍具有獸性的危險形象，以及其人工生命的演化歷程。在《夏娃克隆創造計畫I》的影片中，藝術家將達文西「維特魯威人」的手稿與「夏娃克隆」的身體每一處相結合，影片所呈現的結合過程體現了人類慾望逐步吞噬神創文明，數位科技逐漸取代自然的過程。而在《夏娃克隆創造文件 I》系列中，著重表現「克隆夏娃」與「維特魯威人」頭部與手部的結合。夏娃頭部的「666」標識在基督教中代表著邪惡，也表意著獸數。在《聖經·啟示錄》中記載「獸的數目為六百六十六」，此標識也重複強化克隆夏娃作為人類慾望客體所包含的獸性與攻擊性。

在西方藝術中，以「上帝之手」為核心的形象通常代表著創造與保護，以及違背意旨後的懲罰。克隆夏娃作為人類違背挑戰上帝神性的產物，手在此刻蘊含著警示與懲戒。同時，頭部與手部的著重展示也蘊含著解剖的意味，展現了人類對於自然人體的慾望及控制。而 AR 技術的運用，將「克隆夏娃」靜態輸出轉化為動態影像，使得夏娃彷彿與觀賞者進行交流，進一步強化了觀賞客體與主體之間的交互聯繫，也照應了神學方法論中「客體」認識「主體」需要從「主體」中引申出來，且不可分割。而《夏娃克隆創造文件 II》中的 6 張數位輸出圖則截取了「克隆夏娃」與達文西手稿結合的身體的三部分，用以展現「大偶像」的本質，諷刺人類對於科技盲目的愛戀、依賴與崇拜；同時也呼應《夏娃克隆啟示錄》中以聖經故事《巴比倫淫婦》和《大偶像》為故事藍本的悲慘結局，以暗示性手法彰顯人類濫用科技的後果。作為一位新媒體藝術

3　轉引自楊克勤，《夏娃、大地與上帝》（上海：華東師範大學出版社，2011），頁 246。

家，林珮淳可謂是一位宗教意味濃厚的悲觀主義者，她一方面利用科技創造藝術圖像的同時；也反映著其擔憂科技與人類對於神性和自然的毀滅。因此，其作品展現了她對於這種憂患的惻隱之心。

亞當從失去肋骨，換得生命的伴侶。兩性的本質是為了結合，而不是限制與管轄。透過《夏娃克隆創造計畫》，林珮淳對科技與人類的結合與制約，男性與女性的結合與制約有了更進一步的思考，這些結合以及相互制約一方面是對於「人類中心」說法的進一步反擊，同時也是對二元論的挑戰，展現出藝術家所期待的和諧之美以及科技與自然，科技與人類，男性與女性之間的平衡。林珮淳用藝術化的手法對科技發展所帶來的問題以及社會對女性的束縛做了更為深入的思考與批評。神讓夏娃在亞當身體中蘊育而生，正如人類創造了以人為延伸的科技以及賽伯格，這種美麗的誘惑，是一種時代的進步，也是一種對自然的挑戰和對人性的滅絕，及其矛盾的生存之道。

夏娃克隆創造文件 I - 頭部正面
Making of Eve Clone Documentation I–Front of Head

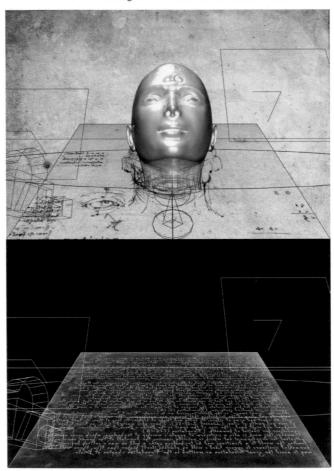

▶ 夏娃克隆創造計畫 I Making of Eve Clone I

林珮淳夏娃克隆創造
過程文件、影片、評
論、展出成果
2006～2017

夏娃克隆創造計畫 I
Making of Eve Clone I

投影、3D 動畫、數位影音、數位聲響
Digital Sound, 3D Animation, Projector, Stereo System , Seamless Paper, Digital spund, 2016
10:00

《夏娃克隆創造計畫 I》此系列乃挪用達文西維特魯威人（Vitruvian Man）的手稿與我「夏娃克隆」全身每一個發展的過程作結合，回朔再現「夏娃克隆」如何被我以電腦 3D 創造的過程與每一時期的形變，從我發想繪製的線稿，到進如電腦以 3DMaya 軟體建構的人形網格，到逐步貼圖、仿人的膚色、仿金屬色、仿全像的綠光色、仿金頭大偶像，以 360 度自轉而展現每一階段的形變，並且把在電腦空間以電腦鏡頭旋轉身體每一角去呈現「夏娃克隆」如何被形塑的過程，從單線構圖、建網格、建骨架、貼材質、刻紋路到調動作的過程⋯⋯，的確可表現它是如何因著人類的創造慾望逐步被建構成為科技軟、硬體的數位產物，此慾望我認為與科學家或人類企圖改造、模仿、挑戰所有神原創的科技文明從發想到一步步的實驗（實踐）的過程很類似。之後我又挪用達文西手稿對人體黃金比例之研究，除了指出「夏娃克隆」的完美比例外，更將達文西強烈創作慾望與驚人的企圖心轉譯在「夏娃克隆」被生產之創造過程上，因達文西解剖人體、解析人體比例、肌肉、血脈、骨頭⋯⋯之大膽行為（當年教徒應被教導身體是神創造的神聖身體，但達文西顯然不以為然，他大量解剖仍未乾且血淋淋的屍體的確非一般的畫家，而是具理性分析人體的科學研究精神之鬼才。）他的素描手稿除了記錄人體比例、形體外，其實也暗示人類是宇宙天地之掌握者（以人為本）之思想，難怪他許多的畫作暗藏抵擋聖經真理的密秘，而我「夏娃克隆」即批判人類以己為中心挑戰神原創之本質，藉此作品討論了藝術與科技之間的聯想、對照與互文的關係。影片中我巧妙的將我夏娃克隆創造計畫文字內容用「達文西鏡像字體」置於人體下方並簽上我名字當成一種密碼。

The series Making of Eve Clone I has appropriated the script of Leonardo da Vinci's Vitruvian Man for the formation process of Eve Clone's physicality. To represent in retrospection the phases in 3D modeling of Eve Clone, that 3D Maya software turns the original line drafts into an entity of human grid with varied shading and mapping, simulated human skin color, metallic color, holographic green light, and gold-headed idol. Such steps in revolving are demonstrated in a chronological order to give prominence to the progressive changes. The body forming techniques are shown through a 360-degree rotation, from line sketch, grid computing, skeleton model-building, application of texture, pattern carving to posture adjustment......; indeed Eve Clone is a digital product cooperated by software, hardware and human desire. Such desire is also employed by scientist or the like-minded inclined to transform, imitate, and challenge the God rules by evolving the experimentation of technology.

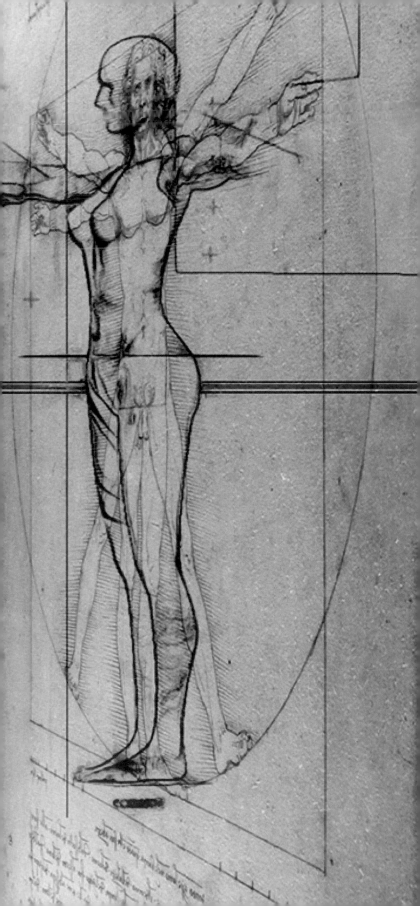

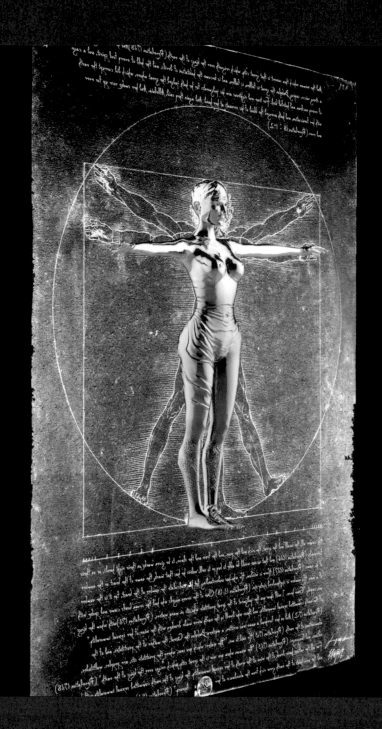

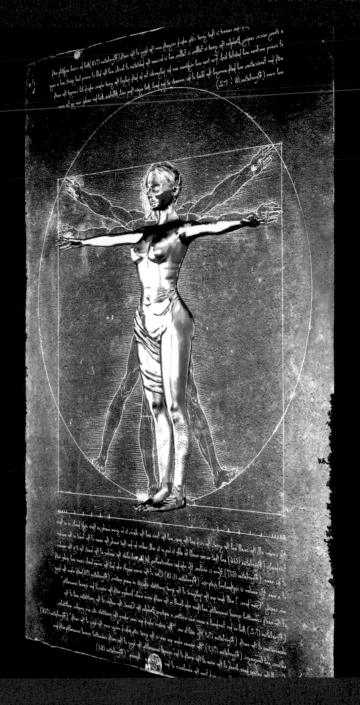

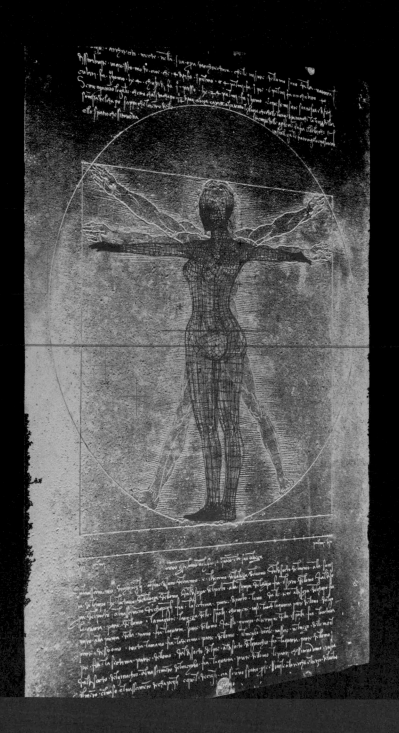

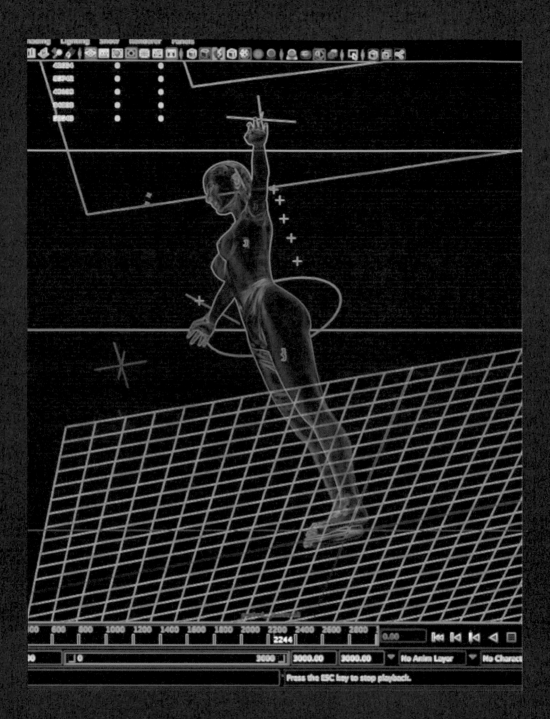

夏娃克隆創造計畫文件 I
Making of Eve Clone Project I

數位版畫・手繪
Digital Print, Hand Drawing
100 x 133 cm x 6 pcs, 2018

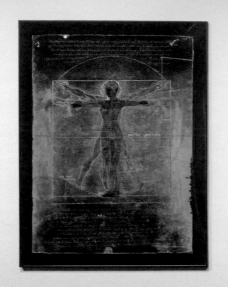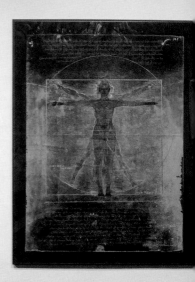

《夏娃克隆創造計畫文件 I》系列的六件作品乃將達文西的「維特魯威人」草圖結合 3DMaya 軟體所建構的「夏娃克隆」網格身體，而原「達文西鏡像字體」也被詮釋「夏娃克隆」的聖經章節所取代，表達數位的「夏娃克隆」就如「維特魯威人」般的完美比例，將達文西創造「維特魯威人」的慾望映射在當今人類以科技創造「夏娃克隆」的本質上。林珮淳特別在作品的重要部位加上金色的手繪線條，如夏娃克隆的輪廓、背景的電腦繪製的線條、網格、icon、控制器等符號，討論科技與人文並置與共存的相關性。

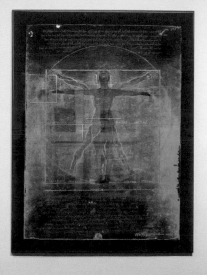

This series is six digital prints with my hand drawing. I appropriated the golden ratio from Leonardo Da Vinci's manuscript as the perfect ratio for Eve Clone while Leonardo Da Vinci's intense desire of creating and prodigious ambition were transcribed on the generative progression of Eve Clone, in correspondence to Leonardo Da Vinci's bold actions, dissecting human body to acquire the knowledge of human proportion, muscle, blood vessels, and bones (dissecting gory human body not only were proximately against the religious morality in human sacred body as God's creation at that time but shed light on his characteristics not merely of a painter but of a gifted rational, scientific spirit.) Leonardo Da Vinci's action of writing and sketching human body proportion and figure left clues of a humanistic value in humans as the ruler of the cosmos, such opposition to Bible could be told from many of his paintings.

夏娃克隆女神的誕生
The Birth of Eve Clone

3D 動畫、數位影音 3D Animation、Digital Sound, 2017
10：00

表現夏娃克隆正等候誕生，從手稿草圖逐漸成為 3D 立體的網格，隨著音樂作 360 度的自轉，
一步步形變成為不同色彩與形象的女體，且愈來愈美麗，直到成為一個理想的女體逐步甦醒，
最後抬起頭驕傲的舞動著，而頭部上方的數字更意味著她的生命值，就如人工演化的快速，
猶如活在當下的真實與活躍。
林珮淳特意從達文西的手稿來詮釋夏娃克隆被創造的內涵，如黃金比例的骨架與完美身體的
比例。

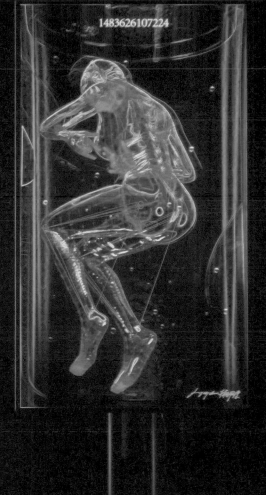

1483626107224

The Birth of Eve Clone uses 3D animation to represent the large statue in The Book of Daniel, a biblical apocalypse: its head was made of gold, its chest and arms of silver, its belly and thighs of bronze, its legs of partly iron and partly baked clay, which symbolizes the glorious and dominant country. Moreover, for exhibiting the evolution and generative process of its artificial life, the artist puts a constantly changing time code on the statue's head, as well as displays the manuscripts and 3D rendering processes to represent the Goddess of Eve Clone is enlivening and living in real time. The background music employ poems to satirize its sacredness, which refers that the technological dominant countries created by human have already become the proud Goddess who was worshiped by humans.

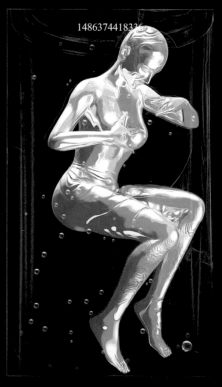

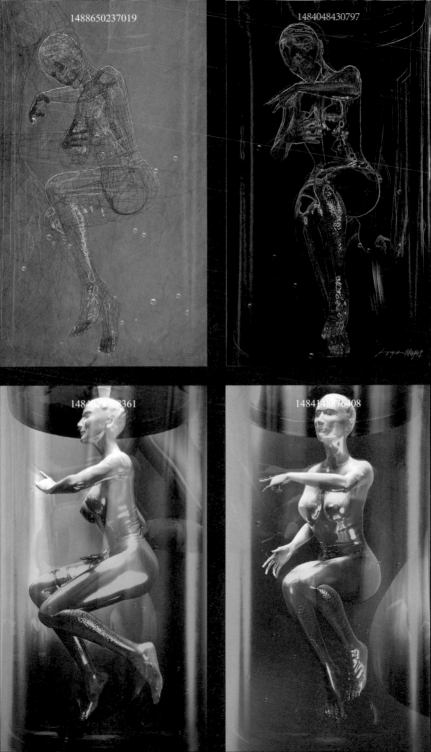

夏娃克隆創造文件 I
Making of Eve Clone
Documentation I

數位版畫、手繪、AR 設備
Digital Print, AR Installation, Hand Drawing
77 x 55 x 3cm x 10 pcs, 2017

在《夏娃克隆創造文件 I》系列則以「夏娃克隆」3D 檔案發展的頭部與手部線條、網格、貼圖等與達文西的頭部與手部手稿結合，表現「夏娃克隆」有如達文西手稿中的人體黃金比例標準。雖然達文西的手稿是描繪男性的臉部，但與「夏娃克隆」臉部比例幾乎相似，作品也刻意保留電腦軟體繪製的線條、網格、icon、攝影機、控制器等符號，表現手稿文件與數位檔案兩者間的互文與對照觀念。在頭部與手部的最後一張，在文件的上半部表現「夏娃克隆」的頭部與右手已經成形，並特別強調金屬色澤與「666 獸印」，而文件的下半部則以達文西鏡像字體寫出的聖經《但以理書》與《啟示錄》的相關章節。最後，利用「擴增實境」（AR）技術，將「夏娃克隆」的頭部與右手從靜態版畫轉換成動態影像，彷彿「夏娃克隆」真的從平面走到現實空間與觀眾對話。以 AR 互動技術來表達「夏娃克隆」就如各種科技產物存在人類的生活週遭裡，因當觀眾拿起「擴增實境」（AR）對著「夏娃克隆」的頭部與手部平面文件時，會驚訝發現平面的頭部與手部在 AR 螢幕內居然動了起來，如「夏娃克隆」的頭部從仰睡逐漸抬頭睜開眼睛且左右轉頭，而手部也以 6 字形的誘人手姿作擺動，喻指「夏娃克隆」其實就與人類同空間與時間活著。此 AR 技術巧妙成了詮釋此觀念最佳的媒介，藉由科技媒材再現科技的無所不在，表達「666」獸印早就出現在人類的生活中了。

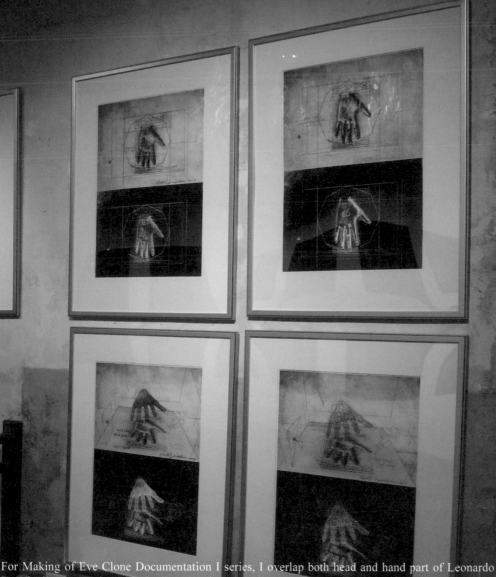

For Making of Eve Clone Documentation I series, I overlap both head and hand part of Leonardo Da Vinci's manuscript with the line sketch and grid of Eve Clone's head and hand part in order to accentuating the golden ratio of Eve Clone. Although Leonardo Da Vinci's manuscript use male as model, the face ratio of Eve Clone is still highly similar with his manuscript keeping signs of computer software which I design that in purpose as contrast of digital file and manuscript document. In the last print of both head and hand, the upper document shows the metallic-colored forming head and right hand with "666 Mark of the Beast" of Eve Clone, and the lower part shows the chapter Daniel and Revelations of Bible in the mirror writing from Leonardo da Vinci. The final touch is AR Techniques that transform Eve Clone from a static print into dynamic video to simulate a vivid Eve Clone interacting with audiences in real world.

夏娃克隆創造文件 I - 頭部正面
Making of Eve Clone Documentation–Front of Head
數位版畫、手繪、AR 設備
Digital Print, AR Installation, Hand Drawing
77 x 55 x 3cm x 5 pcs

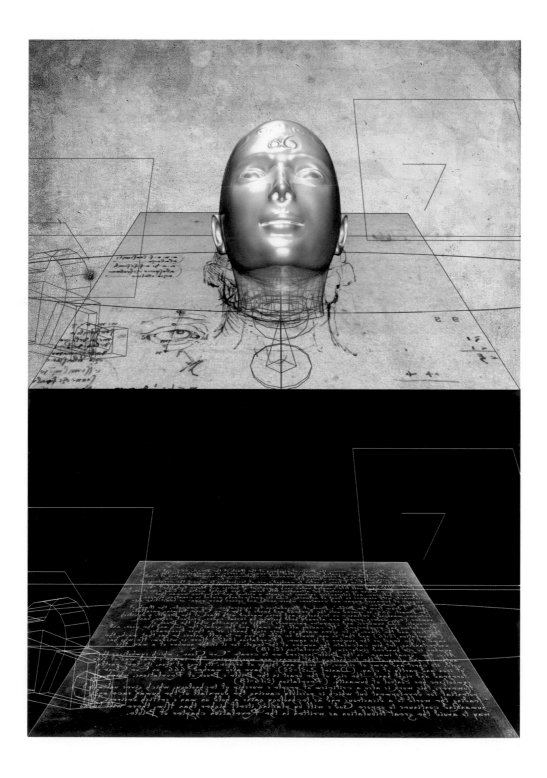

新苑藝術 Galerie Grand Siecle

夏娃克隆創造文件 I- 頭部側面
Making of Eve Clone Documentation – Side of Head
夏娃克隆創造文件 I- 背部
Making of Eve Clone Documentation – Back of Head
數位版畫、手繪 Digital Print, Hand Drawing
77 x 55 x 3cm x 2 pcs

夏娃克隆創造文件 I- 手
Making of Eve Clone Documentation - Hand
數位版畫、手繪、AR 設備
Digital Print, AR Installation, Hand Drawing
77 x 55 x 3cm x 5 pcs

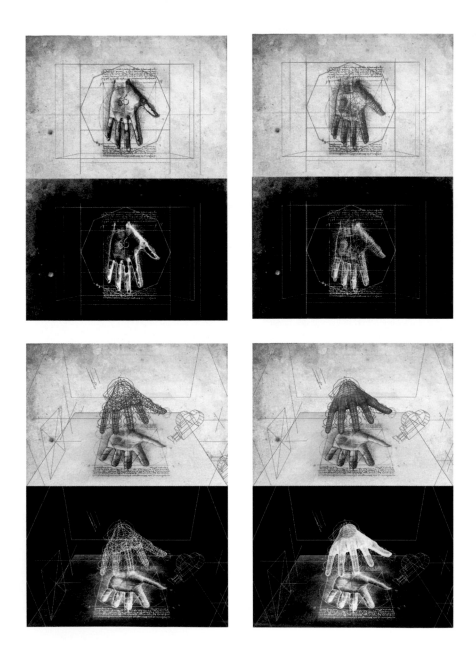

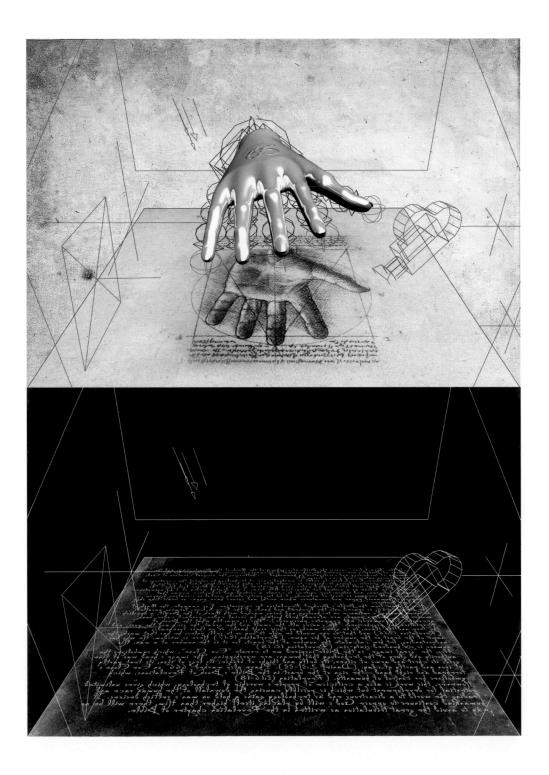

235

夏娃克隆創造文件 II
Making of Eve Clone
Documentation II

數位版畫、手繪 Digital Print, Hand Drawing
74.7 x 105cm x 6 pcs

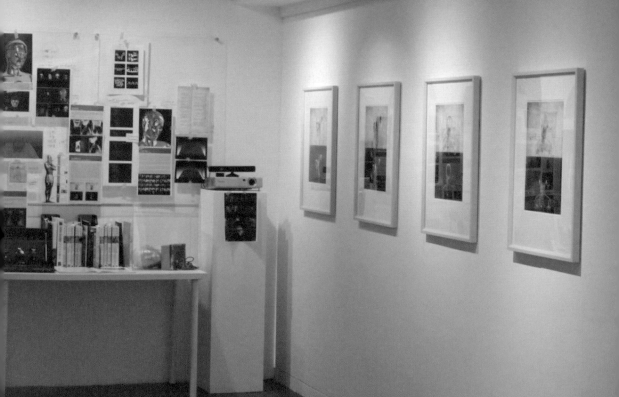

在《夏娃克隆創造文件 II》系列則是將《夏娃克隆創造計畫 I》影片的達文西手稿與「夏娃克隆」電腦網格身體截取三部份，如金頭與銀胸；銀胸與銅腹；鐵腿與半鐵半泥腳部來強調「大偶像」，也放入電腦軟體繪製的線條、網格、icon、攝影機、控制器等符號，以草稿原色與黑白反差作六張的數位輸出，再加入我個人的手寫註釋來描述「大偶像」的本質。

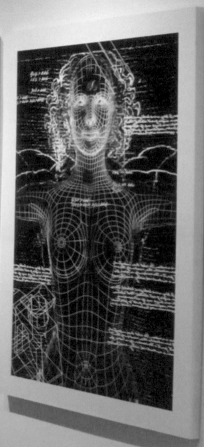

The origin of Documentation of Making of Eve Clone II series is from the animation Making of Eve Clone I. I select three parts of the grid body of Eve Clone such as golden-head with silver-chest, silver-chest with coppery abdomen, iron leg with half iron half mud feet, and combine with Leonardo Da Vinci's manuscript to emphasize "Great Image". Then I add signs like computing line sketch, grid, icon, camera, controller…, and create six digital prints with opposite color which is original sketch color and white line on black base. Last, I add my hand-writing annotation to depict the essence of "Great Image."

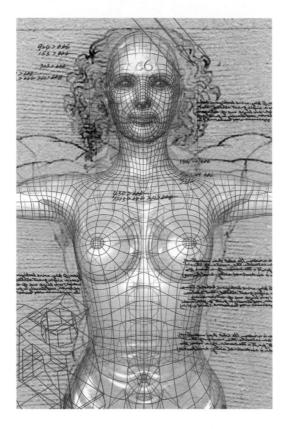
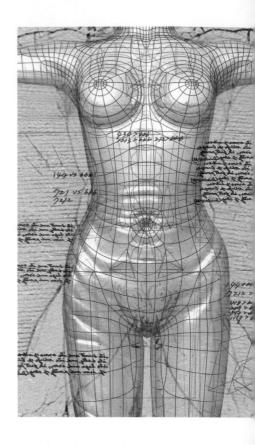
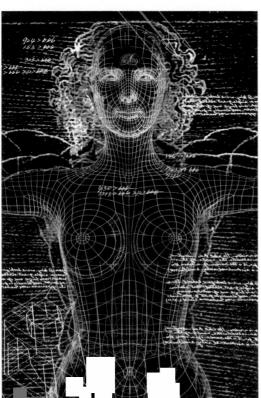

夏娃克隆創造文件 II
Making of Eve Clone Documentation II
數位版畫、手繪 Digital Print, Hand Drawing
74.7 x 105 cm x 6 pcs

六、全英文論述

English Essays

Pey-Chwen Lin's Description of Eve Clone Series

Lin, Pey-Chwen

The concept of Eve Clone series could be traced back to the Women's Interpretation series and the Pupa series which I created in 1993. I intended to express the oppression of the social expectation on a woman's multiple roles, which conjured up the pupa imagery. Not until 1995 when I pursued the doctoral study in Australia did I begin bringing myself into contacting with feminist aesthetics, I jumped out of the oppression and further tried to express in concrete imagery, such as traditional foot binding and modern cosmetic surgery. I reexamined these patriarchal cultural products from female perspective, and further led myself to create the Antithesis and Intertext series to question about the concept of plastic surgery and foot binding, both for women to suffer the unnatural process in order to satisfy the standard of the ideal beauty under patriarchal society. This body re-shaping by technology violates our original figures created by God, yet today's patriarchal technology manages to against the nature. Alerted by the natural disaster, the 921 Earthquake in Taiwan, I witnessed how technology abusing the nature and as a result, the revenge of the nature. The 921 Earthquake awakened my consciousness about revering the nature and returning to the love of universe. In Back to the Nature series, I made the dazzling sceneries of artificial nature, the lifeless butterflies among fake flowers in the man-made garden. In Artificial Cultivation, I started to use the 3D animation to represent the artificially cultivating process to create the female body, from the grid formation to a body with flesh. Thereafter I continually use the 3D animation for the following works: the *Even Clone I* and the *Eve Clone II*. I also set up the interactive installation in the artwork to allow the audiences' motion affect the work. For example, audiences' movement can transform the pupa into the beauty of butterfly, and further transfigure to a beauty of human. The Eve Clone series stimulated a discussion on the coexisted connection between the viewer and the Eve Clone during its metamorphosis of process, as if the viewers give the birth of Eve Clone - The more viewers presenting in the space will generate the greater metamorphosis of Eve; no presence of viewer will result to the Eve returning to the pupa form.

In 2011, I became more aware of the issues of the abuse of biotech, gene duplication and human cloning. I hence used the "Eve Clone" to symbolize the ideal female figure cloned by advanced technology. The cloning an idealistic beautiful body is the extended concept connected to my earlier work, the Antithesis and Intertext series, just now I try to highlight the abuse of technology. The cloning phenomenon shocked me that, not only do we want

to transform our appearances or body shape, but we desire to eliminate the imperfect genes from our DNA. We greedily conduct the experiments of eugenic genes and give life of an ideal beauty under the patriarchal technology. Hence, the naming of Eve Clone directly denotes the human's intention of playing the role of God. I made the portrait of Eve Clone and added 666, Satan's mark of the beast, on its forehead to hint the hidden danger of technology. Purposely, I have the Eve Clone image to contrast with the Eve created by the God. This artificial Eve Clone has become a female Frankenstein, with holographic eerie colors and wriggling movements. This hybrid, mutative object created by humans has become the incarnation of evil that rebels against human nature. Eve Clone is a metaphor of human inventions: the computer, the high-tech, the chemical engineering or the nuclear energy. These advanced technology are, misfortunately, springing back to our daily life unbearably. The vicious Eve Clone with the evil symbol 666 has turned into human's greed, the Whore of Babylon, control over humans' mind.

Both of the *Portrait of Eve Clone, Eve Clone III, Eve Clone VI* represent the coexistence relationship of human's eyes with human's desire. The artificial technology seduces human-beings, and the technology further control over the humans.

From the *Revelation of Eve Clone I* series extended to the *Eve Clone III* and *VI*, these works are made to investigate the artificial life. The time code and colors embedded in Eve could be interactive with the viewers, their movements can generate Eve Clone's life while they entering the exhibit venue (*Revelation of Eve Clone I*). Meanwhile its cloned life could be self-reproduced and co-existed with humans in time, as the time code hinted. In this series I not only added the evil number 666, but also added six dominant languages (ancient Latin, Greek and Hebrew, and modern Chinese, English, and Arabic language) to reinforce Eve Clone's evil yet powerful identity.

In the *Revelation of Eve Clone III*, Eve Clone has gradually become the Great Image worshipped by humans. Additionally, Eve's body has become a large idol of gold, silver, bronze, iron, and clay which are described in the Bible (Daniel). Eve Clone lifts up its head and moves its body while the 3D device embedded in the head inviting the audiences' movements (by raising their hands or touching Eve's head - the act of worshipping). The viewers' movements generate Eve's motion and posture actively.

Each reproductive generation of Eve Clone symbolizes its evolution: *Eve Clone I* is a human-pupa beauty; the *Portrait of Eve Clone* has the imprinted 666; the *Revelation of Eve Clone* turns into the great image featuring its golden head. Through this evolution process of Eve Clone, I am devoted to examine about its controversial, controlling and being controlled relationship with human-beings; I want to explore the destiny of human's unlimited desire. The entire Eve Clone series focus on the discourse of the human-technology relationship, the coexisted and copulation connection, and the tech-worshipping but eventually tech-control-human condition. Finally, the *Revelation of Eve Clone IV* signifies an ending of the human pride; as the patriarchal technology challenges against the nature, eventually the greed will bite back and lead to its end - smashing into pieces by God.

ART STATEMENT
Revelation of Eve Clone III

In this piece, the 3D animation was used to mold the Eve Clone as a techno species with self-cloning ability. Its big eyes and high-bridged nose are mirroring the Western standard (arguably put, the universal standard) of beauty. And so, the Eve's stature was built in a nine-headed figure with tiny waist, large breasts and long legs which are remarkable standard of a beauty in the eyes of the male, the patriarchal technology. Eve Clone, the ideal beauty figure, is therefore reproduced by male reinforced standard. Its skin tone is referenced to the texts in the Bible: gold, silver, bronze, iron and clay. Eve Clone is the great image that the kingdom built by humans' pride: the golden head represents the largest nation, followed by silver, bronze, and iron, while its legs represent the weakest nations. I made this image with an intention to define that Eve Clone is a multinational complex idol which challenges the Kingdom of God. By using of the interactive imagery projected on the wide curved screen with the hymn as the background music, I want to build up an immersive ambient. On the bottom of the images, I inputted the six influential languages mentioned in the Book of Revelation (Chinese, English, Greek, Latin, Arabic, and Hebrew languages). By borrowing the image of the Whore of Babylon (the Book of Revelation) and of the great image of gold, silver, bronze, and iron (the Book of Daniel), I manage to highlight the sublimity characteristics of Eve Clone as the great image. This image provokes about the stunning beauty yet intimidating dangers of the Eve Clone, the human's desire. Continuously, the Eve Clone's rotating movements in 360 degrees will at the same time duplicate another Eve Clone. Moreover, I use the numeral techniques by computing automatically to operate its vital index to emphasize the vitality of the Eve Clone. When the audience entering in the venue, the time code displayed over the image of each Eve Clone will start to symbolize its life (the vital index) in rapid rotation; when the audience left, the vital index stops. I want to emphasize that the time code represents the exact time that Eve Clone coexisting with the humans, as the time code would always forward-counted, not backward. Whenever the Eve Clone is being displayed (for instance, 10 years later), the time code would represent the certain moment and never stay the same index. Meanwhile, the colors on Eve Clone would gradually fade off to symbolize the artificial life, after all, could not be alive on its own. All this process is to posit a question about the man-made technology - its seemingly infinite power. The high technology in turn gains a hold on the hold on the greediness of human, which will lead humans to a disastrous end, as predicted in the Bible.

To demonstrate the intimate connection between Eve Clone and the technology, I used the portrait bust of Eve Clone at the center of the exhibition, and invited the audience to touch it. Sensed by the touching, the Eve Clone would gradually raise its head and slightly moves the body, like an infant growing. The motion of the cloning process of Eve signifies that human's intervention brings life to Eve Clone and creates the charismatic characteristic of it. However, the Eve Clone is also a warning of the technology, as the metaphor of human desire which could lead humans to the catastrophic disaster.

Revelation of Eve Clone IV

I built the Eve Clone to mirror the Great Image described in the Bible (The Book of Daniel 2:31-33). The head of the statue was made of pure gold, its chest and arms of silver, its belly and thighs of bronze, its legs of iron, its feet partly of iron and partly of baked clay. I use this image of Eve Clone to indicate its worshipping, idolized technological essence. With imprinted 666 on Eve Clone's forehead and right hand, I want to symbolize its controlling power over the human-beings.

In the film, Eve Clone was inundated by the rising of sea level above the relics. The sea turned into blood like that of a dead man. (Revelation 16:2-4) Eve Clone finally has managed to escape from the sea, but it was smashed by a stone. Then the iron, the clay, the bronze, the silver and the gold were all broken into pieces and became like chaff on a threshing floor in the summer. The wind swept them away without leaving a trace. But the rock that struck the statue became a huge mountain and filled the whole earth. (Daniel 2:34-35)

At the end of the film, the stone struck the statue gradually turned in to a huge mountain and occupied the land. The hymn as the background music sounds: "The kingdom of the world has become the kingdom of our Lord and of his Messiah, and he will reign for ever and ever." (Revelation 11:15)Through the making of Eve Clone, I want to describe the fate of technological civilization, to shed the light on the result of abuse of power, technology and human pride: God will eventually smash the virtual power and take over the kingdom of the world.

夏娃克隆肖像 Portrait of Eve Clone

God's Inspiration & Human's Creation
Lin Pey-Chwen's Eve Clone Series

Hsiao, Chong-Ray | Art Historian

Artist Magazine, 2017 | Academia.edu

A pious Christian, Lin Pey-Chwen was one of the most important artists of feminist art movements in Taiwan in the 1990s, and she was the chief editor of Women Art Discourse (1998), a quintessential essay collection of the era.

In 2001, at the advent of a new century, she was the chair of the Graduate School of Multimedia and Animation Arts, National Taiwan University of Arts, and she also is the director of the Digital Art Lab. Ten years later, in 2011, she presented her large-scale solo exhibition Eve Clone Series, which impressed the art scene and became one of the most shocking and reflective works combining female arts and digital arts in Taiwan contemporary art.

The first large-scale solo exhibition of the Eve Clone Series presented in the Museum of Contemporary Art, Taipei. In the intervening seven years leading up to the "Making of Eve Clone" exhibited at Galerie Grand Siècle in Taipei in 2017, a whole series of creative concepts and development was created, and this process is still ongoing. It contains the "Inspiration of God" religious sensibility and the artist's criticism about human's desire of creating the artificial life. These works are outstanding and rarely seen in avant-garde contemporary art in recent years.

Eve was the first woman, according to human understanding. God created Adam in His image. Then He thought that it was not appropriate to live alone, so He removed one of Adam's ribs to create Eve. From the beginning, Eve seemed to be destined to be subordinate to men.

Given that Lin is an artist who has long been concerned about feminism, as well as a Christian, it is natural and reasonable for Lin to use Eve as her creative theme.

The first version, *Eve Clone I* (2004), was a 3D animation integrating a rather regular nude girl with the wings from the artist's previous butterfly series. The animated images of Eve spreading her wings were projected on a large screen. In the *Eve Clone II* series in 2006, Eve's wings had metamorphosed into a pupa covering her body. As if in the setting of a gigantic test tube, the viewers' interventions generated many floating bubbles. The number of the viewers determined the number of bubbles and the speed at which the pupa metamorphosed into wings and then into Eve. The *Eve Clone Specimen* series in 2009 used

Lenticular to present Eve with beautiful and vivid wings, as if displaying specimens.

Portrait of Eve Clone series in 2010 revealed a crucial change. Eve was more like the normal woman in earlier series, but in this series, her characteristics as a clone were emphasized, and the descriptions of the "Revelation" in the Bible were integrated. In the gigantic 3D images of a close up of her bust, Eve's originally smooth head and back were presented with mysterious mark: "666," the Number of the Beast in "Revelation", carved in different languages including Chinese, English, Arabic, Egyptian and etc. This work presented a sense of human–beast integration. The beautiful yet cool eyes of Eve Clone changed according to the angle of viewers. The agile turning, looking back, and gazing of the Eve Clone in the cold aqua tone, arranged in a row, strongly impacted and shocked the viewer.

The solo exhibition at the Museum of Contemporary Art, Taipei, in 2011 was centered on *Portrait of Eve Clone*, which was presented as a large-scale interactive projection in a hexagon. The effect of soaking in water (a test tube formula) and background sound effects were added, creating *Eve Clone III*. In addition, *Eve Clone Hands* and *Eve Clone Fingers,* two sculptures of hands and severed fingers carved on resin, were placed in test tubes like medical biological specimens. According to the Bible, the Number of the Beast, 666, appears not only on the forehead but also on the right hand. Therefore, the artist placed six pairs of hands in different gestures with the Number of the Beast in large glass jars, which seemed to be filled with medical formalin to simulate a state of ongoing experimentation. The six right hands were carved with different textures representing snake skin, bark, pupa shell, seashell, metal, and ore to emphasize that the Eve Clones had genetic mutations. The six severed fingers were attached to a plate numbered with 666 to strengthen the impression that test creatures were being objectified, and that their genetic organs were removed and preserved.

At the same year, *Eve Clone IV* (2011) was a next series of *Eve Clone III* and was exhibited at "Yes, Taiwan: 2012 Taiwan Art Biennial" at the National Taiwan Museum of Fine Arts. In addition to the enlarged hexahedron, on-site images were also integrated to tighten the connection between the viewers and the works. Moreover, six color variations were utilized to enrich the feelings of the change in settings. 2011 was a productive year for the artist. In *Eve Clone III*, the use of digital technology and the creative concepts, the creation capacity reached the peak. In the same year, she also completed *Mass Production of Eve Clone*, *Inspection of Eve Clone*, and *Revelation of Eve Clone*.

In *Mass Production of Eve Clone*, Eve became a beast and developed into a whole body in a sitting position. The number of presentations was expanded from the original 6 to 18. They were arranged in a line of digital frames; each Eve Clone had her unique color and was marked with "666" in different languages. Holding the same posture, they rotated 360°, representing the mass production and normalization of cloning.

Inspection of Eve Clone utilized infrared photography to foreground the 666 on Eve Clones and the tattooed totems, including roses, dragons, phoenixes, serpents, and scorpions, all of

which are beautiful but dangerous. The words on top of the images imitated the common serial numbers in infrared photography. They presented a date and time of diagnosis and the person who conducted the diagnosis to strengthen the imagery of medicine and biotechnology.

Revelation of Eve Clone I was a critical starting point of the later series. In this work, the artist compared Eve Clone with the woman in "Revelation" who rules all the kings in the world. As stated in "Revelation 17:5," "And upon her forehead was a name written, 'MYSTERY, BABYLON THE GREAT, THE MOTHER OF HARLOTS AND ABOMINATIONS OF THE EARTH.'" The same script was presented in languages including Chinese, English, Arabic, Greek, Latin, and Hebrew at the bottom of the image. At the top of the image was a number automatically calculated by the computer to represent a life index (Time Code). When the viewer entered the site, the life index was immediately activated and began increasing rapidly. When the viewer left, the life index immediately stopped, and the colors on the Eve Clones gradually faded.

This piece was first exhibited at Galerie Grand Siècle in Taipei. Later, it was often invited for exhibitions such as the "Next Body" digital art exhibition at Huashan 1914 Creative Park in 2011, Art Stage Singapore 2012, WRO Media Art Biennale 2013 in Wrocław, Poland, and "The Apocalyptic Sensibility—The New Media Art from Taiwan" (2015) at Taipei Fine Arts Museum.

Revelation of Eve Clone was developed into the *II, III*, and *IV* series in 2012, 2013, and 2014, respectively. When developing *Revelation of Eve Clone I* in 2011, the artist adopted the form of two-dimensional output, selected the scripts of the Bible in six different languages, and launched the *Documentation of Revelation of Eve Clone* exhibition. *Revelation of Eve Clone II* (2012) presented animated images, time, and scripture in *Revelation of Eve Clone I* with a hologram on a flat surface. This new type of document was employed in an attempt to discuss the idea that "Time is congealed, but the sight of the viewer instantly makes it move." The images were framed in a classical, gorgeous wide frame to contrast the coexistence, attraction, and tension between the classical and the technological.

Revelation of Eve Clone III (2013) was presented on a large scale as wide projections, featuring interactive images calculated by computer programs, background music like holy hymn, and a spatial atmosphere. It also included a sculpture of the head of Eve Clone in front of the projection installation. That was the golden great image recorded in "Daniel" of the Bible. When the viewers raised their hands to touch the 666 mark on the fore head, the Eve Clone images on the projection would raise her head and move her body.

Revelation of Eve Clone IV (2014) altered the setting of the tangible body in the front and that on the screen in the back and made everything into film. In addition, Eve Clone was replaced with a full-body sitting statue and was portrayed as the Great Image described in "Daniel": "…the form thereof was terrible. This image's head was of fine gold, its breast and its arms of silver, its belly and its thighs of brass, its legs of iron, its feet part of iron and

part of clay" (Daniel: 2.31–33). She was submerged in seawater, among ruins. The seawater was tented red and became blood. Finally, she escaped the water but was smashed by a stone, becoming "like the chaff of the summer threshing floors; and the wind carried them away, that no place was found for them…"

The *Revelation of Eve Clone* series concluded with *Great Babylon* (2014). The City of Destruction in "Daniel" became New York City in reality. In the film, Eve Clone stands on top of the Empire State Building, looking down at the crowded buildings and streets, as if Eve Clone were the great image that controls the Great Babylon, only to witness the city being burnt down by a huge fire from heaven, included Eve Clone herself.

In 2015, Lin's Eve Clone series entered a new stage, the *Making of Eve Clone Series*. The artist's focus returned from Biblical stories and prophecies to Eve Clone herself. The artist reflected on the entire process of creating Eve Clone in an act of retrospection how she used sketches, computer software to construct human-like wire frames, and engaged in the process of gradually pasting pictures to imitate human skin tones, metallic tones, the greens of holographic images, golden great images, and 360° rotation to present the transformation at each stage… This was a creative process by God's inspiration and the artist's unconscious entrance into the process of Human's Creation.

In the *Making of Eve Clone Series*, the artist overlaid the Eve Clone on arms opened wide like a cross, looking down on Earth in Great Babylon like the famous Vitruvian Man by Leonardo da Vinci, and revealed the magical similarities between the two. They are similar not only in body proportions but also in the mindset of challenging God's original creation. Additionally, both of them present the contrast and intertextuality between art and technology.

In 2017, Galerie Grand Siècle in Taipei exhibited the major piece on the overlapping of the *Making of Eve Clone I* and da Vinci's manuscript, and several sets of works, namely *The Birth of Eve Clone, Making of Eve Clone Documentation I—Hand, Front of Head, Back of Head, Side of Head*, and *Making of Eve Clone Documentation II*—Golden Head and Silver Chest, Silver Chest and Brass Belly, and Iron Legs and Part of Iron and Part of Clay Feet. Integrating two-dimensional output and computer 3D images, the artist conducted a complete retrospective and organized the processes and details of creating Eve Clone that began in 2004.

Since the first large-scale solo exhibition in 2011, the artist has maintained that her intention in creating Eve Clone is to criticize the over-expansion of technology and humans' getting lost in their ambition to challenge the essence of God's creation. This is a deep retrospective on humans' highly developed artificial life, since reproductive technology was used in 1996 to create the first cloned sheep, Dolly. It is also the continuation of the creative concepts of the artist and of her series since 2004, "Un-Natural—Back to Nature" (international Art Center, National Taiwan University of Arts, 2004) and "Artificial Life—Back to Nature" (Art Center of National Central University, 2006). However, the means by which the artist criticizes over-expansion are precisely the technology that she wholeheartedly criticizes.

Perhaps as Roland Barthes stated, "The best weapon against myth is perhaps to mythify it in its turn and to produce an artificial myth."

Critics have long been adopting the perspective of anti-technology to understand and interpret Lin's Eve Clone series. However, if we return to the beginning. Lin's series artworks are very conceptual including the *Antithesis and Intertext* (1995) in Taipei Fine Arts Museum, have long presented a fundamental mode of thought that is dialectical and intertextual, as reflected in Reality and Falsehood (1996), Viewing View—Back to Nature Series (2000), and Un-Natural (2004). Although the Eve Clone series contained an initial motivation to counter the over-expansion of technology and even included in its creation process religious "revelations" to strengthen the idea, when it reached the Making of Eve Clone stage, we suddenly realized that the once ignored feminist concepts were so naturally and clearly presented in these works. Eve is no longer only a rib taken from Adam's chest. In the self-construction and creation process, Eve Clone and the male figure in da Vinci's *Vitruvian Man* possess the same proportions, thoughts, and values.

Far back in *Portrait of Eve Clone*, the beautiful, cold, and staring eyes called to mind the pair of eyes in Édouard Manet's Olympia, which stare right into the viewer outside the painting.

Through long-term persistence and hard work, Lin has become the most important and outstanding artist among female artists who emerged in the 90s, and she has continued to hold exhibitions. She is worthy of close attention and high expectations.

夏娃克隆創造計畫文件 I Making of Eve Clone Project I

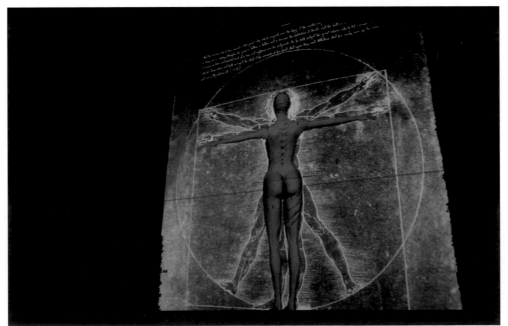

Speaking Subject
Lin Pey-Chwen's Eve Clone

Cheng, Fang-Ho | Art Historian

Artist Magazine, 2014 | Academia.edu

Lin Pey-Chwen is a Christian who fears God and loves people. The creative sparks triggered when Christianity encounters Feminism are aesthetic and philosophical, and they portray a soul that integrates art and religion.

Entering the Magical Heaven

The carefully-crafted, large-scale interactive installation *Revelation of Eve Clone III* (2013) was exhibited at the Museum of Contemporary Art, Taipei. The exhibition space was pitch dark. When the viewer touched the head of the Eve Clone statue, epic music like hymns played, and the Eve Clone image in the panoramic projection was splendid and vivid, rotating at ease. The auditory and visual sensations of the viewer were stimulated. The "Time Code" at the top of the image and the text from the "Book of Revelation" of Bible were memorable, announcing the disaster at the end of the world.

The splendid rotation of a young virgin was in powerful contrast to the text and codes of the punishment from God. Together with the holy hymn, the viewer's senses of sight, hearing, and touch were stimulated, as if the viewer had suddenly entered a magical heaven only to immediately fall into the nightmare of expulsion from paradise. The physical enjoyment and the burning of the soul coexist.

Eve became the most lethal attraction in Lin's digital art creations. Why did she choose Eve as the protagonist of her digital art play?

Eve, the First Woman

According to the Bible, Eve was the first woman. Christianity has long considered nudity a sin, so in the Middle Ages, paintings with nudity could not be presented. It was only in the late 15th century, the Renaissance Period that artists disobeyed the ban from the Church and produced figures of a nude Eve to present to the people. For example, Expulsion of Adam and Eve from Eden (1425–1428) by Masaccio presents Eve looking up with an expression of grief, one hand covering her chest and the other covering her private parts, and Adam covering his face with both hands, the two of them walking out of the Garden of Eden. Temptation of Adam and Eve (1425–1428) by Masolino da Panicale, Adam and Eve (1507) by Albrecht Dürer, Adam and Eve (1526) by Lucas Cranach the Elder, and Adrian Eisenbrandt's Adam and Eve all present the crime and punishment of Adam and Eve, and

presenting them naked implies their fall and shame.

Eve was the first woman on Earth. According to the "Book of Genesis" in the Bible, God created Adam and then created Eve from one of his ribs. Adam and Eve enjoyed everything in the Garden of Eden. However, Eve was tempted by a serpent to eat the fruit of knowledge of good and evil, and Adam was persuaded by Eve to eat the same forbidden fruit. Thus, the original sin of human beings was committed, and both of them were expelled from the Garden of Eden by God.

The Evil Yet Beautiful Eve Clone

In Lin's creation, Eve retains the nude image from the Renaissance period. It is only that Lin did not use oil paint but utilized multimedia art to create an Eve in virtual reality, which she called "Eve Clone." How did Lin utilize her unique female experience and perspective to overturn the mainstream aesthetics constructed by men, and how did she deconstruct Eve into Eve Clone to regain the power of women as the speaking subject?

The forbidden zone of female nudity originally belonged exclusively to male artists. However, female artists of the 21st century would not give in and entered the realm, boldly freeing the female form. Lin believed that western female artists' strategy of using women's own bodies and organs to overturn the concept and image of women in patriarchal culture was sharp, rebellious, and anti-traditional. Their main goal was to rebel against the ideology of female nudes in traditional western art. In other words, from static objects, men created an ideal erotic object for themselves, shaping women into specific modes according to their desires, whereas female artists used the body to protest the long domination of women under the erotic patriarchy and the objectification in male creations.

Deconstructing the patriarchal culture has always been a creative feature in the creations of Lin, a clear-minded and self-aware feminist. Although her Eve Clone series does not directly use her own body as the carrier, as do the works of western feminist artists, the Eve Clones she produced in the name of art speak for the consciousness of her body.

In *Revelation of Eve Clone* (2011–2012), the Eve Clones were naked, half-squatting, head down, holding their chest with both hands, and they had small faces, beautiful eyebrows,

and tender skin, as if they were about to emerge from a chrysalis. They were fully exposed to the viewer, filled with sensual beauty and provocation, completely embodying the female form that men desire. In *Inspection of Eve Clone* (2011), the charming Eve Clone under infrared light seemed more flirtatious than classical Venus. Her forehead, cheeks, breasts, and buttocks were covered with tattooed totems of roses, dragons, phoenixes, scorpions, and serpents. Eve Clone was curvy. Her slender waist, ample bosom, and beautiful hips fit the male ideal of the perfect female body. Lin utilized the most desirable, standard female body for men to encourage reflection on the patriarchal culture of gazing at the female form.

The Speaking Subject

Although Eve Clone was beautiful, she was not only delicate and feminine. Her beauty was full of character and cold. In *Portrait of Eve Clone* (2011–), the head of each framed and preserved Eve Clone integrated both human and pupal characteristics, with residual epidermis from the mesomorph. Her eyes were spirited, full of the evil power of beasts with 666 marks on her forehead.

What was bizarre was that when you looked at her, she was also looking at you. The four eyes met and saw into each other. Only when you turned your gaze away did she do the same. With this portrait of 3D animated holographic high-tech materials, Lin presented female self-expression as a talking subject. This expression was not reminiscent of master–servant relations or superior–inferior relationships. Rather, it was the female body's hidden energy that could tempt the soul. Lin used an untamed body to challenge the male aesthetic. In fact, wouldn't the all-intrusive male gaze cause omnipresent psychological stress in women?

Lin's creations are a continual search for an art expression system that can counterbalance male centralism. She hopes to speak through the body and posture she creates to prove that within women's naked bodies hide their subjective desires. Lin integrated Maurice Merleau-ponty's theory of gesture expression of the body and Julia Kristeva's self-expression system of a "speaking subject" to create Eve Clone with subjectivity. Eve Clone was evil yet beautiful, tempting and controlling, and she spread the concept of apocalypse.

The charms of the female form may lie in ungendered pre-puberty, unbloomed puberty, and the gorgeous and full bloom of the prime, fragrant and charming. As the female body ages, the body loosens like a flower withers. It is the cycle of nature. In *Inspection of Eve Clone* (2011), Eve Clone's body was of flesh and blood and was desirable. She displayed her wonderful body with autonomy. Although she had an impressive figure, her curvy beauty was not unique; what was unique was the self-awakened female consciousness. Only with this consciousness can women truly own their bodies, free of social or cultural constraints. Only then can the male-centered cultural historical view be overturned.

In *Revelation of Eve Clone*, the female body squatted in the test tube filled with fluid. The translucent liquid was like the amniotic fluid in women's wombs when they are carrying a

fetus. It is a special and unique experience for a mother, and it is an experience that men, by birth, cannot experience. That fluid also symbolizes women's fluid desires, like waves,

The Almightiness of Humans Surpassing that of God

The beauty and evil of the female temptation in the Whore of Babylon in the Bible became the theme of the Eve Clone series. Subsequently, gazing/being gazed upon was utilized to turn the object into the subject. Lin's adoption of a female perspective that boldly revealed the female nude to counter the grand narrative of male aesthetics was outstanding. However, what she cared about more was the identity of the clones of Eve.

Cloning is reproduction, and it is asexual reproduction. Eve was asexually reproduced into a group. In *Mass Production of Eve Clone* (2011), she was formed in test tubes, appearing to the world in different colors. However, at birth, she was marked with a clear birthmark, "666," the Number of the Beast, on her forehead, written in different languages, including English, French, German, and Chinese and etc., and displayed to the world as she rotated 360 degrees.

If Eve is like cloned sheep or cloned cattle, mass-produced and standardized, is this kind of scientific research without ethics a blessing or suffering for humans? Prof. Chi Ching-Hui summarized seven reasons against cloning humans proposed by people from various countries from the medical, ethical perspective. First, it destroys human dignity and uniqueness. Second, the science involves uncertainties. Third, it is an act of playing God. Fourth, it is unnatural. Fifth, it destroys family integrity. Sixth, it reduces genetic diversity. Seventh, it may be abused by dictators.

As a pious Christian, Lin holds the same view as theologians. She believes that human clones, which humans want to produce through technology, endanger human dignity. As for whether humans' almightiness has surpassed that of almighty God, Lin, under the shock of technology, utilized the shocking multimedia of 3D animated images to unveil this technological crisis.

Mass-Produced Eve Becoming an Apocalyptic Disaster

When Eve is in a pure test tube free of contaminants and dust, being mass-produced at the whim of scientists, when life can be mass-produced, all mothers in the world face a fatal challenge. The holy occupation of mother is being deconstructed by production in a laboratory, for no reason. How can this be endured for any mother?

When life no longer comes from God, when Adam and Eve are no longer born from sex, natural fertilization, pregnancy, and labor, when technology transgresses women's occupation, the mass-produced Eve Clones by Lin are destined to bear the suffering of the Number of the Beast. The Number of the Beast, 666, in different languages, is everywhere, crossing cultures, languages, words, and national boundaries. Lin said, "No race is going to be able to escape from the constraints of the beast." Since 2010, Lin has repeatedly used her Eve Clone series to spread the prophecy of the apocalypse to fight against clones.

Lin also utilized translucent resin to sculpt *Eve Clone Hands* (2011). Bottles holding hands as if soaked in formalin were marked with the Number of the Beast Mark, and they were covered with horrid mutations such as snake skin, pupa skin, shells, metals, and ores. What each test tube contained were like specimens. The female body was thus cut, severed, mutated, reproduced, and experimented upon. All were denaturalized, and all had become specimens. Will the birth and cultivation of nature continue? Lin keeps presenting unique thoughts. The consciousness of her question and her simulation of scientists' experiments in Eve Clone satirize that if humans continue to produce cloned creatures without fear, disasters will eventually come upon them.

The Number of the Beast, the Contemporary Totem of the "Book of Revelation"

In recent decades, the human genome has been completely mapped, resulting in a boost to genetic engineering. Lin adopted a feminist perspective to interpret scripture from the "Book of Revelation" from the Bible as her creative concerns and criticism. She cited the script, "And he causeth all, both small and great, rich and poor, free and bond, to receive a mark in their right hand, or in their foreheads: And that no man might buy or sell, save he that had the mark, or the name of the beast, or the number of his name" (Revelation 13:16-17).

The Number of the Beast Mark in the "Book of Revelation" is transformed in Lin's works into a visual totem that is both holy yet demonic to criticize scientists who are infatuated with producing human clones. Their competing with God to create humans transgresses their status, and they will disturb the natural cycle of the universe, eventually leading to disaster. This incredible work by a female Christian is natural. As a mother, wife, artist, professor, and daughter, Lin attempted to fight for the primitive energy and attraction of women with multimedia art under the twisted and oppressing patriarchal tradition. As she said, "God created Eve, and I created Eve Clone."

The artistic presentation of the Eve Clone series utilized multimedia such as 3D animated holographs, 3D computer animation, digital art, spotlights and multimedia. Lin decided the particular light and color and the poses of the bodies. The Eve Clones created by Lin did not have to be fierce and domineering. They could be charming and tempting, they could sway their bodies to tempt the viewer, but at the same time, they had subjective consciousness.

The works in the Eve Clone series are artworks shuffling between the erotic aesthetics of the male gaze and female nudes, the holiness of religion and purity, and scientific manipulation and transgression. Lin breaks the fate of the female body, which is destined to be objectified in patriarchal culture, finds the subjectivity of the female voice, and discovers the power of salvation for her religious belief.

Pursuing Gender Autonomy

Most people believe that after women get married and have children, they can have no academic life, let alone an artistic life. Looking back to over 20 years ago, in 1992, Lin was a full-time lecturer at Ming Chuan College. Despite being a mother with a child, to

pursue her ideal, she gave up her stable teaching position and overcame her husband's stern opposition, tolerating the stress from her marriage and shouldering the economic burden of the family, taking her child to Australia to pursue a PhD in creative arts. When she first arrived in Australia, she had to adapt to the local school system, to write some research paper, to create, and to take care of her child. Countless times she was alone in the foreign land, tears in her eyes, carrying her child home from the studio on her back. When she was physically and mentally tired, she deeply felt women's struggle between their ideals and reality, and she was inspired to study western feminism in Australia. Lin became aware of women's situations, understanding the gender-biased social structure, and more profoundly realized female dignity and values. Her female consciousness was inspired. After she obtained her degree, she returned to Taiwan and held the *Antithesis and Intertext* solo exhibition at Taipei Fine Arts Museum (1995). She contrasted the ultimate female beauty standard in ancient times, footbinding, with modern plastic surgery to reflect that for ages, women have been using patriarchal cultural standards as their own standards without knowing it. They cannot control their bodies and minds in reality. This began in ancient times, but it is still prominent today.

Using Female Consciousness to Critique Patriarchal Culture

Famous sayings in western feminism, such as "Why do the hands that write art history all belong to men?" and "Why are there no great female artists in art history?", sustained Lin as she continued to utilize her "female eyes" in her creations to care about female issues and to expand her works to cover social issues. For example, *Black Wall, Inside and Outside of Windows* (1996) was an installation presenting the inner bitterness and difficulties of the families of victims, especially the grief of the women. Another piece, *Regards to the Authorities* (1997), shows a long table of glistening trophies to the government, using installation art to fight against establishing a monument to strongly criticize the dominating power of the government. *Safety Nest* (1997) demonstrates the invasion of society into the safety and lives of women.

As an educator, Lin personally had deep feelings about the loss of educational values. She integrated and output images, using text from Chinese lessons (The Four Books and Five Classics) with photos contrasting the past and the present, and composed *Classic Works* (1998) with text from "Tabor No.8" and "Female History" to emphasize the ambivalence between traditional and contemporary and to satirize the collapse of the Taiwanese education, value, and ethics systems. *Dice* (1998) presents flat acrylic plates with texts of ancient lessons and the round dots of dice to criticize greedy Taiwanese people for seeking wealth through speculation.

Since the end of martial law in the 1980s, the value system in Taiwan has collapsed. With strong compassion, Lin kept criticizing various chaotic phenomena in society, from the government's wrongdoings in the February 28 incident to women being raped, and to Taiwan becoming an island of greed and a heaven for speculators. All these phenomena happened in a society with a patriarchal culture as the mainstream. She kept using her works as her weapons to criticize the society such as *Safety Nest* and *Beautiful Life*.

From the collapse of ethics and morals to the criticism of the evil and greed of human nature, and after the physiological and psychological impact of the 1999 Taiwan 921 earthquake, she started her Back to Nature series in 1999, including works such as *Substantial Life*, *Treasure*, and *Viewing Views*, which utilized technology and media such as manmade, reproduced, digital, and virtual forms to reflect on the oppositional relationship between technological culture and nature. Since the year 2000, more digital technologies have been implemented in her artistic creations. Higher-level interactive technology such as 4D images in solo exhibitions such as "Catching" (2004), Fascination & Frustration (2005), The Beautiful New World (2006), and Artificial Life (2006) were utilized to lodge wise and sensible criticism of artificial nature and artificial creatures.

Lin said, "My creative desire originates from my understanding and compassion of life and my religion." When artists worldwide started to emphasize the body, gender identification, technology, and biological reproduction, and emerging topics such as clones, transgender people, and mutants to exhibit their ample artistic creations and critical capacity, Lin used her religious beliefs and compassion for life, starting from feminine thoughts. She utilized her strength in digital art to invite people into her art realm, making the viewers feel as if they were falling into a black hole of ultimate joy and death, undergoing the trial of devil and God.

Using Art to Reflect Thoughts and to Summon People of This World.

In the ultimate version, *Eve Clone IV* (2014), Eve Clone was finally born from the water-filled test tube to enter this world. However, as soon as she was born, she encountered a flood. She tried to stay afloat, waving her hands left and right, like Jesus suffering on the cross. The moment she broke the surface of the sea, however, a gigantic stone from the sky struck her feet. This fatal blow cracked her half-iron half-clay feet. Subsequently, her iron legs, copper waist, silver chest, silver arms, and golden head all cracked. The grand hymn filled the place, and text from the "Book of Revelation" from the Bible appeared on the screen.

Lin said directly, "Humans eventually will accept God's judgement and see their hubris." She also stated, "Human hearts have changed, becoming utilitarian and selfish. Humans exploit nature, becoming unable to respect God and love people. I created Eve Clone as a metaphor, what I am really criticizing is human hubris and their desire to play the role of God."

If humans keep improving cloning technology to make the birth of humans formulaic, I believe that Lin will continue to use the Digital Art Lab she constructed to keep fighting against humans' reproduction labs. Lin did not hesitate to say that "God loves the entire humankind He created." God created Eve. However, Eve Clone was not created by God and will eventually be destroyed. The creative concepts of Lin's Eve Clone series lie in the dialectic of Eve and Eve Clone, real humans and dummies, and reality and simulacra. Starting in 2011 and gradually developing her ideas through 2014, Lin shows people how a Christian feminist artist uses the utmost technology, 3D digital art, to portray and simulate

the contemporary "Genesis" and the "Book of Revelation" she inferred. In the spirit of "God is love" and "art reflects thoughts", she summons the holy power of religion and art to enlighten the spirit, summoning people to respect the world created by God.

Double Support from Religion

The chrysalis first appeared in Lin's early oil paintings. From a chrysalis oppressed by the patriarchal culture to a butterfly-woman, interbred from a female body and a butterfly, which was concerned with nature, and then to Eve Clone, the human–chrysalis metamorphosed from the butterfly-woman with wings; her works have transformed from static and two-dimensional works to installations and then to digital art. The narrative theme she is concerned with has also gradually transformed from feminism to the subject of "humans" created by God, and to larger issues such as the existence of human life and the quality of life.

In the world of Eve Clone, under the cool female body and various sensual simulations in the eccentricity of technology and humans provokes thought. Technology is not omnipotent. It can be either good or bad. Whether it is used for good or bad affects the energy of the entire universe. To strike a balance between humans and technology, one must eliminate self-centered self-consciousness to perceive the minuteness of humans in this broad universe and thereby respect everything, while at the same time seeing the grandness of the self, living in the richness of the spiritual life, never being driven by insatiable self-consciousness or running in the desires of the material world.

A contemporary female composing digital art in a high-tech era, Lin is a rare and outstanding digital and multimedia artist who keeps surpassing her own creative subjects. In recent years, she has been focusing on the Eve Clone series, exploring the dialectics of nature and technological culture and the biological and ethical issues of human clones. Furthermore, she cares about the philosophical issues of human existence. Her works are unique and critical, and their artistic nature and impact have been affirmed and recognised by international art world.Lin has her pious religious belief. In art, she has found her belief in the female speaking subject. Under the support of her double beliefs, together with her sharp and critical character and her compassionate religious mentality, the combination will make her life more free and magnificent.

References
· Wang, Kin-yuen. "Maurice Merleau-Ponty's Perceptual Art and Feminism Body Discourse." Chung
· Wai Literary Quarterly, 28.12, May 2000.
· Claudia Rehberger. Weibliche Lebens(t)raume. Trans. Yu, Hsiao-wen. Contemporary, 167. Jul. 2001.
· Chi, Ching-hui. "Various Views on Medical Ethics." Institute of Human Resources Management,
· National Sun Yat-sen University. Unpublished Master's thesis. Jun. 2002.
· Lin, Pey-Chwen. "Lin Pey-Chwen—Eve Clone Series" Galerie Grand Siècle. Jan. 2012.
· Lin, Pey-Chwen. Deconstructing Social Phenomena of Taiwan History and Culture from the Perspective of Female Creation. Fembooks Publishing House. Sept. 1999.

Art as a Realm for Implementation of Religious Belief

Chiu, Chih-Yung | Digital Art Critic, International Art Curator

"Taiwan Digital Art Platform ", 2015 | Academia.edu

As an artist–scholar of international fame, Lin Pey-Chwen has long demonstrated a close relationship between her artistic creations and her religious faith. A critical proposition also exists in her works: the concern for the relationship between humans and the natural world, expressed through critiquing technology. Be it her earlier *Substantial Life* (1999), *Chrysalis* (2004), and *Fantasy and Things* (2004) or the ongoing *Eve Clone series* (2006–present), be it the use of a virtual butterfly or the female form, these virtual creations, all seemingly alive, are recognized life forms in human civilization; they are art objects that have been transformed into simulacra (i.e., they seem fictional but are truer than reality.) Since the 90s in the 20th century, inspired by feminist arts, Lin's creative themes and content have originated from her understanding of life, issues that move her, and her religion. She utilizes a female perspective to create a series of works to understand the patriarchy. More importantly, as a pioneer of Taiwanese digital arts, in recent years, Lin has been using technological media such as 3D animation and interactive systems to create an apocalyptic phenomenon. She provides a metaphorical warning to state the criticism that if humans continue to blindly pursue technology culture and satisfy material desires, they will eventually go to human's doom.

The French cultural sociologist Pierre Bourdieu promoted reflexive sociology, stating that sociologists must utilize their own research to understand their fields. In other words, they should transform each dimension of society into their research objects. Adopting Bourdieu's perspective to read this Revelation·Notification: Research Solo Exhibition by Pey-Chwen Lin, one can discover that Lin objectified herself and her creations, and through the habit and implementation of artistic creation and through the relationship between herself and society, she made religion a critical topic in the realm of art implementation. In Revelation·Notification: Research Solo Exhibition by Pey-Chwen Lin, Lin focused on her classic series in her artistic creations of the past 30 years. She utilized the form of documents to reveal the research texts in her past publications and discourses. Through the methodology of creation studies, she completely revealed the process of her art creation. The exhibition theme "Revelation·Notification" and her digital works were based on "The Book of Revelation" and "The Book of Daniel" in the Bible, and she created Portrait of Eve Clone and Revelation of Eve Clone series.

Studying Lin's creations along the thread of history revealed that, whether in her early creations using conventional media (e.g., painting and installations) or her recent appropriation of digital technology (e.g., holographs and interactive devices), her works always profoundly portray the religious philosophy of humans and the Lebenswelt, such as works that deconstruct the objectified female body (Antithesis and Intertext), the February 28 Incident works that deconstruct politics (*Black Wall, Inside and Outside of Windows* and *Regards to the Authorities*), works that deconstruct utilitarianism and satirize people who study to seek fame and fortune (*Classic Works* and *Dice*), works that deconstruct topics like culture and society (*Reality* and *Falsehood, Complexity* and *Thought Origin*, and *Beautiful Life*), and the Eve Clone series, which is critical of technological reproduction and genetic modification. Through the Revelation·Notification: Research Solo Exhibition, the viewers develop a realistic feel for the creator's concern for life, her realizations about life, her respect for God and love for people, and her personal pious religious beliefs.

What is even more special is that all the works in this research exhibition were from Lin's Eve Clone series, which she has continued to create in recent years, including *Virtual Creation* (2006), *Specimen I* (2006), *Eve Clone II* (2006), *Revelation of Eve Clone II* (2012), *Portrait of Eve Clone* (2010–present), *Revelation of Eve Clone III* (2013), *Revelation of Eve Clone IV* (2014), and *Great Babylon* (2014). This series of works utilized the most advanced contemporary creative media (i.e., the Internet, interactive programs, 3D animation, and holography). Through the use of technology, the artist represented the danger of a technological civilization, the illusion of artificial creatures, and the interactive relationship with the viewer (the presence of a viewer triggers metamorphosis.) Lin also placed the Number of the Beast, 666, on Eve Clone's forehead and right hand as a symbol of evil. In addition, she extensively utilized religious allusions from "The Book of Revelation" to define Eve Clone as an incarnation of the Whore of Babylon, implying that under the surface of beautiful and tempting technology is a demon that controls humans.

This use of technology to criticize the evil of technology is similar to the proposition of Michael Heim, a scholar of technological culture. In the essay "The Erotic Ontology of Cyberspace," Heim states that the means through which humans understand the main structure of cyberspace has already determined how the reality exists within it. In other

words, the phenomenon of the reality of the Internet exists in humans' infatuation with technology. Additionally, this infatuation is similar to an aesthetic infatuation. That is, in cyberspace, humans approach the Internet like moths to a flame. However, where the light is dim, one may discover that it is only the illusory light of dreams and desires. The emotions we create for technological products (e.g., computers and the Internet) are far more profound than an aesthetic infatuation in that what we seek is a home where the mind and soul can rest. Our infatuation with the computer does not stop with sensual satisfaction; rather, it is a kind of erotic desire. Computers are not merely for utilitarian use; they are a spiritual crutch. Moreover, our relationship with these information machines is not limited to our use of them for entertainment or as tools; it is a symbiotic relationship. Eventually, it is a marriage of the minds! [1] Heim's concept echoes the creative intention of Lin's Eve Clone series. In other words, she uses the juxtaposition of multiple forms of media such as images, devices, and interactions to shape an inseparable relationship between the virtual Eve and the actual technology, attempting to satirize and criticize a specific situation in which the digital technology (including cyberspace) and real life overlap into "the same" world and further extending the scope to considerations of how to rewrite human bodies into the virtual world of the Internet.

To a certain extent, in the present post-media era, technological progress will eventually lead humans to a de-materialized artificial world. Virtual reality utilizes physiological sensations to lead humans from the physical world to a virtual, imaginary world. [2] Humans can even use virtual technology to create any virtual world imaginable. A virtual environment is determined by the designer, and the designer plays the role of God or the Creator. Once the technological difficulties are overcome, the designer can create any kingdom with him- or herself as the leader. Therefore, it can be observed that Lin's creative connotation implies a criticism of the contemporary collective consensual hallucination; she satirizes humans' longing to play the Creator. Works in the Eve Clone series seem to say that the expectations of technology held by contemporary society are like seeing the world we live in with blind eyes; we always blindly consider the virtual space of the Internet as a world that is different from our world, more desirable and more hopeful. But in fact, these desires all originate from a frantic belief in transcendence (as if to achieve eternal life on the Internet.) We believe that virtual space, this new technology, can break free of the limitations of time and space and physical boundaries, taking people away from this imperfect reality. [3] As Lin points out, Eve Clone is the integration of human and chrysalis or human and beast. Although Eve Clone has a wonderful face and features, just like genetically modified products created in the name of benefiting the human race, they may bring disaster. Lin's creative strategy is to use the superiority of mythicized new media technologies to mock and criticize the myths people worship.

For Lin, her artistic creations, as a realm to implement life, are never separated from her

1 Michael Heim. Reading Digital Culture (London: Blackwell 2001) pp. 70-73.
2 Margaret Morse. Virtualities: Television Media Art and Cyberculture (Indiana: Indiana University 1998) p. 25.
3 Kevin Robins. Cyberspace/Cyberbodies/Cyberpunk: Cultures of Technological Embodiment (London: Sage 1995) p. 135.

religious compassion for the present world and society. She both reminds people to be aware of their being situated in the era of digital technology and expresses her critical characteristics to the world as an artist. Through Revelation·Notification: Research Solo Exhibition by Pey-Chwen Lin, one can see that Lin's creative attitude aloofly expresses her reading of contemporary life and her profound understanding and views of culture. Her technology art series reveals her reflective thinking and imply the warnings in the "Book of Revelation," that nature has an immense power for revenge. This exhibition can be said to be the critical presentation of the use of pious religious beliefs and perseverance to pursue a realm of art brimming with philosophical thought.

夏娃克隆創造計畫文件 I Making of Eve Clone Project I

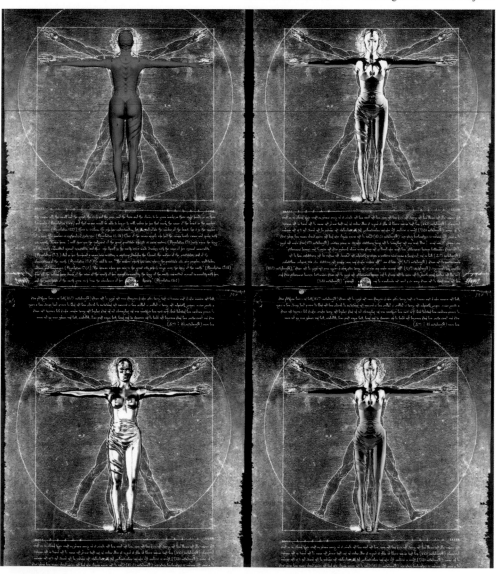

Revelation · Notification
Research Solo Exhibition by Lin Pey-Chwen

Lai, Hsiao-Chiu | Digital Art Critic, International Art Curator

Artist Magazine, 2015 | Academia.edu

Lin Pey-Chwen created her first abstract artwork at the University of Central Missouri. The origins of her style were exhibited at "No. 2 Art Space". While studying for a doctorate in Australia, she was inspired and heavily influenced by feminism, which led her to create a rich diversity of artistic concepts and works.

With continuous review and examination of her own artwork, Lin speculates on the distinct consciousness of creative behavior and feminist determination to hit the viewer's stream of consciousness with her unique artistic perceptions. The exhibition presents major events throughout Lin's chronology alongside her four major art series. The Chronology of Lin's art development was made by Thsai Pei-Yi and Shu Pei-Chun.

As the professor of the NTUA Department of Multimedia and Animation Arts, Lin has worked for years to promote Taiwanese digital art. Recently, her Digital Art Lab organized "Illusion of the Sound of Insects," a special interactive exhibition on digital art. Merging art and science, the exhibition was a critical success that garnered much public attention.

Lin's artwork monitors the social culture of the greater environment, reflects on the destructive power of technology and civilization, and satirizes and critiques human greed and delusion. The profound concepts and explosive power of this artwork has made it a focus of attention in the global art circle.

The Permanent, Unchanging Theme of Life

"Revelation . Notification – Solo Research Exhibition by Pey-Chwen Lin" presents the essence of the artistic spirit and process. Series include "Women's Interpretation", "Deconstructing Patriarchy", "Back to Nature" and "Eve Clone".

While studying abroad, the artist realized that Asian women have historically relied on each other to survive patriarchal oppression. She strongly challenges society's stereotypically narrow space for creation, while realizing that women must break free of systematic restraints to develop individual styles and sow the seeds for an artistic revolution. "Antithesis and Intertext Series" and "Classic Series" present an implied, indirect criticism that nonetheless far surpasses the nudity of Western feminism.

In "Back to Nature Series," artificial nature emits light and energy, serving as a warning that modern civilization is but a shiny veneer that threatens to eventually swallow up and destroy the true, natural world. This exhibition also includes *Virtual Creation* and *Specimen*. In *Virtual Creation*, viewers participate by painting butterflies, inspiring the imagination of life as the interweaving butterflies dance gracefully. Here, Lin critiques artificial landscapes and the erroneous nature of life, prompting viewers to compare the brief illusion of artificial life with the lively authenticity of natural life. Ultimately, viewers will rethink the life theme: that which is permanent and unchanging.

Specimen grieves over the way humans violate and destroy nature, as the simple imagery of nature can never be artificially produced. The series shows the irony of a butterfly specimen, which is beautiful and lively but nonetheless a virtual 3D object and a product of technology.

Eve Clone Series Garnered All the Attention

"Women's Interpretation," "Deconstructing Patriarchy," and "Back to Nature" all contain the "chrysalis" symbol that transforms into a butterfly woman - the technologically-reproduced woman of "Eve Clone." The clone possesses the perfect body of Venus and is branded with a "beast mark of 666. Awakened by technology, it breaks out of its cocoon, gracefully turning its body and sensing that it is surrounded by looks of concern, anticipation, and desire.

Sacred music generates the atmosphere of a temple. However, faint noises can be heard in the music, satirizing that human being try to imitate the Creator by technology. One aims at a lofty goal but falls short, and the consequence of blind ambition is the destruction of the nature. This serves as a metaphor for how society is rife with greed, lust, environmental destruction, and warmongering, as it steadily marches toward the great tribulation prophesied in the Bible.

The focus of attention for the exhibition is the "Eve Clone Series". This exhibition includes "Eve Clone", *Revelation of Eve Clone*, *Portrait of Eve Clone* which presented a unique artistic style, indirect yet precise and penetrating, critiquing genetic modification or human cloning technology and questioning the ethics of exposing the origins of human life.

They portray artificial life as unauthentic and destructive. This part of the exhibition fully displays Lin's concern for all living things, realizations regarding the nature of life, respect for nature, love for humanity, and sincere personal conviction.

The Eve Clone has become a significant topic of discussion around the world, and was featured in a 40 year edition of Chronicles of Contemporary Taiwanese Art. Lin's work has been exhibited at major art museums and exhibitions, including the Contemporary Art Platform in Russia, Queens Museum of Art in New York, Exit and Via Art Festivals in France, Museum of Contemporary Art in Taipei, WRO Media Art Biennale, Taipei and Taiwan Art Biennale.

The Eve Clone Series has also become an international classic, highly sought-after by art museums and exhibitions in the global art field. The global women's museum IGNITE interviewed Lin and posted her photograph on their main page. She was also introduced in a full-color feature in a famous British academic journal on female artists "East Asian Journal of Popular Culture" and "n.paradoxa", as well as invited to speak at Australian AgIdea international conferences throughout the world.

Understanding Life, Respecting Nature, and Loving Humankind

Lin's artistic attitude transcendentally conveys a deep interpretation of contemporary life and culture. Each of the series expresses subversive thought and implicitly warns against the great potential for technology to destroy nature. With a sincere sense of conviction and perseverance, these works present a unified theme, while pursuing philosophical artistry through an ultimate expression.

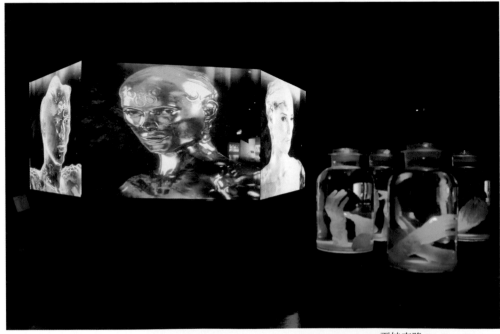

夏娃克隆 IV Eve Clone IV

Visualizing post-human & Cybersexuality
Lin Pey- Chwen and the Eve Clone series

Ming Turner | Art Critic, International Art Curator

East Asian Journal of Popular Culture Volume 2, 2016

Abstract

This article takes post-human and cybersexuality as the main perspectives from which to contextualize the Taiwanese artist Lin Pey-Chwen's (born 1959) Eve Clone series, on which she has been working since 2006. It describes how Eve Clone's virtual body of Eve expresses Lin's perceptions of the symbols and imaginings of the post-human. The latest Eve Clone series explores issues of femininity, but is also related to the religious symbolism that Lin has adapted in the creation of her work. Although using science and digitality to create art, Lin criticizes technical civilization while reclaiming the importance of nature. In *Portrait of Eve Clone*, the cyborg body has been created from the main technical operation of digital technology, and this adaptation of a digital body examines the discourses of both the body and sexuality. Lin's Eve Clone has created a perfect being in cyberspace through artistic aesthetics and new media technologies.

In this article, I will explore the intersectional concepts of the post-human and cybersexuality, both of which contextualize the work of the Taiwanese artist Lin Pey-Chwen's (林 珮 淳) (born 1959) Eve Clone series, on which she has been working since 2006. This series of digital works is inspired by the figure of Eve, reimagined and reconstructed by the artist as a virtual cyborg.[1] The latest work in the series, Eve Clone, continues Lin's exploration of cyberfeminism and the post-human, drawing on religious symbolism, several aspects of which have been major recurring themes in her recent work. In work dealing predominantly with sexuality and digitality, the Eve Clone series can be traced back to Lin's earlier work when she first returned to Taiwan after having studied in Australia during 1995.

The POST-HUMAN and its complexities

Before examining specific works, it is necessary to outline the two key themes – namely the post-human and cybersexuality. Post-human as an academic term has been debated widely since the late 1970s. Ihab Hassan's Prometheus as Performer: Toward a Posthuman Culture?, published in 1977, contends that technology not only influences medical science but also governs our daily consumer culture. Meanwhile, Steve Nichols's Posthuman

Manifesto, published in 1988, maintains that people today are already living in a post-

1　More information about Lin Pey-Chwen's work can be found on her website http:// ma.ntua.edu.tw/labs/ dalab/.

human condition. Related critical theories began to flourish in the West during the 1970s and 1980s, while several other familiar terms prefixed 'post-' may all be related to the philosophical aspects of the post-human, which is a notion that concerns the 'other' while also inferring a sense of undecidability (Miah 2008: 71–94). Meanwhile, Judith Halberstam and Ira Livingston have described the proliferation of academic 'post-isms' as 'simultaneously the necessary or regrettable failure to imagine what's next' (1995: 2). Consequently, the phenomenon of the 'post-human' reveals a state of anxiety and uncertainty resulting from the condition of being between human and inhuman. The post-human takes the shapes of our bodies, but is a hybrid of our biological forms and technology, such as a cyborg, which according to feminist philosopher Donna Haraway is 'a cybernetic organism, a hybrid of machine and organism, a creature of social reality as well as a creature of fiction' (1991: 69). Features of the 'post-human' in Lin's work may also be seen via her imagined Eve, which is itself a cyborg, a mixture of mechanical and biological organisms. Furthermore, according to Rosi Braidotti:

> After the post-human, the postcolonial, the post-industrial, the post-communist and even the much contested post-feminist conditions, we seem to have entered the post-human predicament. Far from being the nth variation in a sequence of prefixes that may appear both endless and somehow arbitrary, the post-human condition introduces a qualitative shift in our thinking about what exactly is the basic unit of common reference for our species, our policy and our relationship to the other inhabitants of this planet.

> (2013: 1–2)

Lin's Eve Clone series may be related to Haraway's concept of the cyborg, where the post-human demonstrates a form of tension and undecidability between the human and the non-human and the idea of the phenomenon of combining the human body with technology. A cyborg is an organism in a digital domain, as well as the mixture of artificial and organic life, while it is also both a social reality and an element of science fiction (Haraway 1991: 149–81).

A cyborg as an individual transcends gender duality in the material world, and by rejecting gender duality cyborgs further deconstruct gender identification and re-present the bodily symbols of post-humanist desire. A cyborg may be fluid and virtual without a physical form, or it may be an image that exists in digital technology, or it may be presented in concrete forms via multi-media technology, such as in Lin's Eve Clone series.

In addition to the phenomenon of the cyborg, the concept of cloning has long been an essential element of Lin's work. A clone is produced asexually via technology or natural birth, and the birth of Dolly, the cloned sheep, signalled the moment at which humans could themselves become the subject of propagation via biotechnology. Lin's belief is that God created Eve, while a human (i.e. the artist herself) created Eve Clone, as a hybridized human or a cyborg. The post-human body is a cyborg body existing in virtual domains on

the Internet, including the 'organic' body of hybridized organisms and the 'non-organic' body stemming from the combination of robots and technology. Lin's Eve Clone responds to this concept of the post-human body, and the ideas of cybersexualities.

Frederick Abraham stated that '[c]ybersexualities emerge from the confluence of postmodern cultural theory, feminist theory, and recent trends in science fiction, and extrapolations from fields related to artificial intelligence, which are largely due to advances in technology' (2010: 3). It is now evident that technology has realized people's imagination of science fiction and fairy tales from the past. Creating the perfect being is quite different from creating a Frankensteinian monster. Lin's Eve Clone series consists of several items including technology, screens, projected images and other materials, which are either virtual or physical, but which are non-biological, and are the imag- ined surfaces created by the artist.

Lin's earlier work and the feminist ideology

When examining Lin's early experiences and inspiration for her art, it is evident that a consciousness of feminism influenced her artworks from the outset, and across Lin's twenty-year career as an artist it is not difficult to see several repeated concerns and themes in her works. In 1989, she returned from studying in America and commenced her energetic participation in the activities and exhibitions of the alternative art space, Apartment 2, where she began to develop a new approach in her work,[2] while at the same time as working as a busy and productive artist and teacher, she also had to negoti- ate the dual roles of being a wife and a mother. Lin then began to be influ- enced by western feminism while in Australia during 1993 when she studied for her Ph.D. in Creative Arts. After returning to Taiwan once more in 1995, she attended several Taiwanese organizations and activities related to feminist art. Although Lin is deeply influenced by feminism from the 1980s and early 1990s, it is worth noting that her recent artworks using digital art do not initially appear to directly criticize patriarchal ideology. On the contrary, with a more macroscopic view, it appears as though there has been a shift in the issues within her works from an emphasis on feminism to caring about life and nature in more general terms.

Lin was inspired to create the beautiful, sensual body of Eve in the Eve Clone series by her earlier work, *Antithesis and Intertext* (1995), displayed at the Taipei Biennial 1997 held at Taipei Museum of Fine Arts.[3] In *Antithesis and Intertext*, Lin arranged five images inside water lilies, depicting a conventional notion of beauty in women's faces in contemporary Taiwan. However, these are western women's faces with large blue eyes, thick eyebrows, blond hair, high noses and full lips. In the bottom left-hand part of the work, large-breasted western women are shown, while high-heeled shoes are represented in the water lilies above. In the top right-hand section of the work, five representative Oriental women's faces grow from the water lilies, illustrating a stereotypical view of ancient beauty. Such Oriental

2 Apartment 2, the earliest artist-run alternative art space in Taiwan, was established in March 1989 by a group of 22 contemporary artists in Taipei. The initiative of establishing Apartment 2 came from the need for an exhibition space among the artists themselves. Lin Pey- Chwen was one of the artists who initiated the project. Apartment 2 closed in 1995 when Taiwan experienced a recession that affected the art market on the island (Liao 1992).
3 E-mail correspondence with Lin Pey-Chwen, received on 10 December 2014.

beauties were said to have 'willow eyebrows, apricot eyes and a cherry mouth' (these are the terms used to describe beautiful women in classical Chinese Literature). In *Antithesis and Intertext*, she criticized 'materialized female bodies' and the male gaze in modern society, which has long been restricted under Confucian values. Being one of the first Taiwanese feminist women artists, Lin's earlier works were created primarily to challenge patriarchal values in Taiwan, and her recent works also follow this route, yet with more critical views about the impact of technology on people's lives.

Such characteristics are part of a broader ecofeminist philosophy with which she is engaged, in which it is generally asserted that capitalism and patriarchy take both nature and the female as colonized objects. Karen Warren has asserted that 'Ecological feminism [takes] the position that there are important connections between how one treats women, people of colour, and the underclass on one hand and how one treats the nonhuman natural environment on the other' (1997: 4). She further argues that 'What makes ecofeminism distinct is its insistence that nonhuman nature and naturism (i.e., the unjustified domination of nature) are feminist issues' (1997: 4). In other words, among the wide variety of feminisms (liberal feminism, Marxist feminism, radical feminism, postcolonial feminism and so on), ecofeminism considers non-human nature and naturism as feminist issues. Consequently, in an ecofeminist vision, the freeing of nature and women will lead to a return to a more caring relationship between human beings and the natural world around us. Criticizing the superego and exploitation of nature is replaced by a caring/custodial approach towards the natural environment, and this approach may be traced in Lin's 1999 artwork *Treasure*:

Back to Nature (1999–2004) which shows the transformation of her artistic concerns in this direction. Back to Nature, consisting of billboard light boxes of digitally printed skies, seascapes and grass in the shape of square boxes, ovals, balls and other irregular forms, creates a kind of artificially fictitious landscape. Since then, Lin has been producing virtual images via technology, which often interact with the audience, yet she also exhibits sculpture-based objects, such as *Eve Clone Hands*, which are physical objects displayed in the gallery space. Her interest in ecofeminist patterns of thought moved to another level in 2001, after beginning teaching in the Department of Multimedia and Animation Arts at the National Taiwan University of Arts. Here, her direct engagement with science and technology to create art led her to a digital rendition of the female body of Eve. Lin remains critical of a technocratic vision of civilization as transcending and improving upon nature and rather seeks to reclaim the importance of nature, using the problematic figure of Eve to reconceive our relationships in a digital and technological world.

Any analysis of works of art made with new technologies cannot be undertaken merely by focusing on innovations in the use of technology in art. The cultural and symbolic meanings behind artworks, and their relationship with society, remain the most significant elements requiring interpretation during the analysis of a contemporary work. The analysis of Lin Pey-Chwen's work also needs to follow this kind of method. Lin's earliest work in the series, *Eve Clone II*, was created in 2006. Eve Clone is represented here as a perfect

female without any body hair, an unreal and quasi body, wholly created by the artist. It is a digital human situated somewhere between the real and the fake, between the organic and the inorganic. Lin combined the portrait with images of butterflies and pupa to create a human body like a butterfly's pupa, and through the interaction between the audience and a computer program/screen using the effects of sound and light the butterfly becomes animated and begins to flap its wings. Through her colourful lighting effects and sounds, the artist explores issues of artificial life in a digital world, while suggesting a conflict in the relationship between science and nature by her juxtaposition of (the perfect) Eve and the short life cycle of a butterfly. *Eve Clone II* was an interactive installation, comprising an interactive device, three-dimensional (3D) computer-generated animation and webcams. In this piece, Eve Clone was created like a cloned human living in a laboratory tube, while the tube in which Eve Clone is hidden also resembles a larva and she looks as though she is in the process of metamorphosing into a butterfly. Lin's statements about *Eve Clone II* explain how

> There are many bubbles in the tube, which can be seen as the nutrients (the computer programmes) for Eve Clone. When audiences view this work, the webcam will be operated to capture their images, which will then be integrated within the bubbles.

> (Chiu 2009: 15)

In *Eve Clone II*, we are confronted by a living cyborg undergoing the process of cloning, and, with the aid of technology, Lin invites visitors to take part in this process, through which the computer generates images of the cyborg Eve Clone, and those of people who are hybridized together to create a unique interactive piece of art.

The form of a larva was first seen in Lin's earlier solo show, Larva Series, held at the National Taiwan Museum of Arts in 1993. Lin has explained that 'in that exhibition, [she] illustrated round shapes to resemble larvae and to depict the desire of breaking through "restrictions", which were [employed] to describe [her] yearning to challenge the patriarchal ideology of Taiwan's society'.[4] Thus, for Lin, larvae have strong symbolic connotations with the suppression of women in patriarchal society.

The EVE CLONE series and its biblical symbolism

To re-emphasize how the work uses both technological and substantial views of feminist ideas, the concepts of the post-human and cybersexuality are used here to offer a different narrative of Lin's work *Portrait of Eve Clone*. While formally innovative in her development of a figure created through or displayed via a post-human creation, Lin also explores how religion (specifically Christianity in this case) offers a different dimension to her portraits. The religious theme is not visualized in traditional iconography, as Lin transforms the religious theme into her art, which is not predominantly a religious reading of Eve. The artist herself was keen to point out that she was recently interviewed and featured by IGNITE, a US-based organization that features stories of women and girls who

4 E-mail correspondence with Lin Pey-Chwen, received on 10 December 2014.

are leading and innovating in science, technology, engineering and mathematics.[5] IGNITE picked up on the religious text evident in the work and described Lin's *Revelation of Eve Clone III*, exhibited at 'Post-humanist Desires', curated by myself and held at the Museum of Contemporary Art Taipei in 2013/2014, as follows:

> The clones are distinguished by various Biblical references: skin tones based on materials referred to in the Bible; hymns as backing music; and a line from the Book of Revelations translated into multiple major languages. [...] Eve Clone is presented as the 'Great Image' of human desire as well as a testament to human greed and attempts to gain virtual power through technological civilisation.

> (IGNITE n.d.)

Furthermore, Eve represents a kind of avatar that strongly re-presents different concepts of the body in Lin's work. The adaptation of a cyborg-like body in her work seems to relate to technophiles' dreams of uploading themselves onto the Internet, refashioning their own bodies, or developing a perfect avatar in cyberspace. Lin's Eve Clone may appear to create the perfect being in cyberspace through artistic aesthetics and new media technologies, but she shows both its dark and strange sides simultaneously. Another critic who has taken an interest in Lin's work is the Australian curator currently based in Taipei, Antoanetta Ivanova, and she has also described the Eve Clone in Lin's work as 'alien beauties' (2011: 9–10). Lin's 2010 version of *Portrait of Eve Clone* is very different from *Eve Clone II*, as this Eve was specifically inspired by the line in the book of Revelation: '13:18. God prophesied that the mark of the beast, 666, will be marked on people's foreheads'.[6]

Another significant body of work in Lin's oeuvre is *Portrait of Eve Clone series*, which was exhibited in The Museum of Contemporary Art, Taipei, in 2011, and which expresses a sense of evil through the half-human-half- beast body.[7] It mocks the potential damage to mankind by its progressive development of technology, and in an active and direct way it reveals social restrictions upon the female body as a trapped beast. Lin explains how:

> I have attempted to represent the luxury and urbanization of artificial landscapes. The frames, glass medical tubes and medical jars show the process of the birth of artificial life, and how it is preserved and experimented upon. The numbers, symbols, sounds and images in my works describe an important 'appropriation' concept. The number shown on the specimen insects, Eve Clone, 666 (the mark of the best), computer time codes, tattoos, scriptures from the book of Revelation in the Bible and holy songs define the artificial life's character and status.

> (2011: 4)

5 'Eve Clone Series: Female beauty, technology, God and nature explored through 3D cloning of the ideal woman. Pey-Chwen Lin, Taiwan', http://IGNITE. globalfundforwomen. org/gallery/Eve Clone- series, accessed on 13 December 2014.

6 E-mail correspondence with Lin Pey-Chwen, received on 14 July 2011, and an interview with Lin in Taipei on15 April 2012.

7 Lin Pey-Chwen's solo show at the Museum of Contemporary Art, Taipei (MOCA) was on display from 24 March to 1 May 2011.

Eve's head is hybridized with many kinds of beasts through Lin's use of 3D dynamic holograms, so the body is rendered in different colours and the textures of minerals. Thus, the skin of Eve, with its diverse textures and colours, displays several possible hybridized forms of human and beast. The number 666 is shown in various languages, including Chinese, Japanese, German, Arabic, Egyptian and Hungarian, all of which are mentioned in the Bible. Through this work, the artist expresses her fears about the negative effects on humans that result from the extreme development of technology.

This particular series is also important because it continues and develops the concept of an earlier work, *Specimen* (2006), in which the portraits of Eve, which have been placed in black frames made of transparent acrylic material, are reminiscent of specimens of dead bodies. Eve's eyes move strangely and follow the viewer as they walk past the frame, and in this movement she seems to be alive and watching her human audience. The work generates a sense of tension and unease, similar to that between science (inorganic) and nature (organic), which is what the artist is asking us to question. As a result of the viewer walking back and forth in front of the work, the figure appears to be seen through a 360-degree image effect. Here, again, the rendering of Eve's skin is critical: the hybridized epidermis is made of different patterns, colours and textures and is presented in a form of cyberspace within the frame of the screen, thus utilizing Lin's dream of presenting her post-human Eve via the lens of digital art forms and holographic technologies.

Further analysis of *Portrait of Eve Clone* through iconography is revealing, specifically because, prior to the emergence of what we now identify as modern art, iconography was the dominant method employed by art historians to analyse religious artworks, focusing on the symbols used and how they were deployed and depicted in the picture plane. Although Christian religious imagery as a direct source of inspiration has not been widely adopted by contemporary artists, it remains valid as it is undeniable that Christianity is still taken as a source of motivation and inspiration for creating critical forms of contemporary art. For example, the Swedish photographer, Elisabeth Ohlson, created her controversial Ecce Homo series based on Christianity. Ohlson employed people who were lesbian, gay, transsexual and transvestite and placed them in religious settings, such as the crucifixion of Jesus and the Last Supper. Ohlson's Ecce Homo deliberately raised issues of sexuality with strong biblical references to challenge people's views towards sexuality and Christianity (Artsfreedom, 2012). The religious references in Lin's works are both direct and indirect; however, the focus on the number imprinted on Eve's forehead is widely recognized as a symbol of the Devil. This is another crucial element, revealing Lin's management of how the work should be read, since, like many works using specific religious symbolism, the audience needs to be able to understand the specific iconography of the images. Members of the audience need to have prior relevant knowledge to understand the particular symbolic transformation or the artist's interpretation of familiar images, or they will easily become immersed in the visual effects of the technology of the artworks, thereby overlooking any meaning the artist wants to express. While the work is undeniably clever in its use of digital technology, the central motif of the three sixes indicates the artist's intended interpretation.

At this point, it is worth commenting on Eve's place in Christian beliefs. Eve is recognized both as the first and as the ideal woman, but she was also manufactured from a part taken from a man, and her creation implies a sexual hierarchy in which she is a lesser being who is always placed second in the scheme of life. In modern society, Eve has often been seen as the ideal woman for man, and is also seen as the purest fantasy form of a woman by scientists who have ostensibly taken the place of God and can now fashion their own Eve if they so wish. Consequently, Eve Clone has been created by Lin to challenge and reinterpret Christianity's estimation of Eve, women and the role of scientists in fashioning human beings.

Sexual hierarchy is a part of Christian theology, and not only is Eve the second sex but, through her disobedience, she is also marked as distinctly inferior to Adam and, thereafter, all men. Thus, the universal bias in the Judaeo-Christian tradition began with the story of Adam and Eve. The objectification of women can also be seen in Greek stories, such as Pandora's Box, in which Pandora removes the lid of the box and unleashes all evils into the world. As Gerald Kreyche states, 'women long have been honoured in theory, but debased in practice' (2004: 82). Kreyche goes on to give an example from the Catholic Church in which Mary, the mother of Jesus, is also called the Queen of Heaven, and yet the Pope will not allow women to be priests. Nuns perform second-class duties for the priesthood, by being house-keepers for pastors, maintaining flowers on the altar, teaching youngsters, etc. Earlier feminist literature challenges this form of sexual inequality, and attempts to offer another picture of Eve, who has long been regarded as second to Adam. Phyllis Trible provides an inspiring and ingenious re-reading of Genesis 2 and 3, and creates a form of mutuality between the sexes (1978: 72–143). She argues that the creation of Adam in Genesis 2 is not necessarily the creation of the male sex, but rather it is the creation of an 'earth creature', which does not identify sexual differences (Trible 1978: 79–82). Sexual identity only appears when woman is created and the 'earth creature' becomes two mutually companionable beings of male and female sexes. Following such perspectives on gender, it is evident that Lin's work is heavily influenced by the ideas of sexuality and gender. Lin's reinterpretation of Eve has gone beyond her earlier feminist criticism of sexual dualism (e.g. *Antithesis and Intertext*). Rather, she is more interested in the symbolic signs carried by her Eve created through artificial life and new technologies, because she represents a threat to our living environment, life and society.

Alongside the various appearances of Eve Clone, made with 3D dynamic holograms, Lin has also created *Eve Clone III*, which makes use of interactive images. Six Eve Clone faces are presented through the combining of six different mineral colours and textures with interactive images within a hexagonal site, made through the use of digital imaging technologies. When the viewer moves in front of the artwork, Eve's appearance seems to change continuously. Sometimes the image shows a frontal view, sometimes the back, and sometimes the image appears to be turning around. After Eve Clone turns around, the image moves up and down as though it is about to leap out of the frame. *Eve Clone III* was shown with six interactive projection devices when it was first exhibited in The Museum of Contemporary Art in 2011, and then at the 2012 Taiwan Biennial at the Taiwan Museum of

Fine Arts. Lin used 3D computer animation technology and kinetic sensors in an interactive computer system to create the mysterious Eve Clone faces. With ambient sound, this work takes flowing water, light and shadows as its background. Eve's appearance continues to change with the movement of the audience, while the reflection from the water and the light also changes. The changes to Eve's image result from people's physical presence in the space and their interference as they move, combining the interaction between humans and technology in a new way. However, it is a relationship of ambiguous, mutual influence and blindness being emphasized in this work, as explained by Lin: 'God created Eve [but] humans created the Eve Clone'.[8] Lin's emphasis on the fact that a human (i.e. the artist) created the Eve Clone indicates the God-like creativity of people resembling the capability of Creator. The Eve Clone image is the result of human creation through technology, while the strange beauty of the Eve Clone reflects the negative influences of artificial and technical civilization on nature. At the same time, Lin expresses the unique characteristics of Eve through a mix of human and beast. There can be little doubt that this interactive work creates stronger sensory effects than those of her 3D dynamic holograms.

The number 666 appears again on Eve Clone's right hand. In 2011, Lin produced *Eve Clone Hands*, six pairs of hands all made of resin, which she placed in the type of glass jars that are commonly used to store organs in hospitals. The skin on the hands is composed of snake skin, tree bark, pupa skin, shell, metal, ore and other materials, representing the genetic mutations of Eve Clone.[9] The properties of Lin's work can be seen in the artist's statement for her solo show held at MOCA Taipei in 2011, in which she quoted Roland Barthes: 'The best weapon against myth is perhaps to mythify it in its turn, and to produce an artificial myth' (2011: 4). The Eve Clone hands are a complex creation. First, Lin made sculpture moulds and then transferred the work into transparent resin. The artist arranged blue-green lasers and bubbles on the hands in the glass jars to invoke a more mysterious atmosphere. Looking closely at the hands with their strange textures and images, it seems that they symbolize the same concept as Eve – a body, or part of a body, which is a hybrid of human and beast. Displaying the hands as 3D objects placed in glass containers emphasizes their properties as specimens, which is to strengthen the idea that Eve Clone is artificial, responding to the impact of technology. Similarly, in Lin's *Eve Clone Fingers* (2011) , she has placed transparent resin finger sculptures into medical test tubes, and then exhibited them in black acrylic frames. As with *Eve Clone Hands*, Lin illuminated the fingers with green light. Through this more recent work, Lin again offers a view of Eve in the process of creation, emphasizing what is artificial and produced through scientific endeavour, rather than something that is natural. Rather, the artist proposes going 'back to nature' through science and technology. Via Eve's inorganic, artificial genes, the work again criticizes digital technology and artificial life as transcending nature, while calling for an eco-feminist approach to a new relationship working with nature.

In Lin's solo show, held at the Gallery Grand Siècle in Taipei in August 2011, she exhibited three new works, *Mass Production of Eve Clone, Revelation of Eve Clone I* and *Inspection*

8 Interview with the artist in Taipei on 20 September 2011.
9 Artist's statement sent in e-mail correspondence from Lin Pey-Chwen, received on 10 December 2014.

of Eve Clone. *Mass Production of Eve Clone* consists of eighteen digital frames of Eve Clone, hung on a wall. *Revelation of Eve Clone I* is a multi-media interactive installation and Inspection of Eve Clone is a body of digital images. Eve Clone spreads the fingers of her right hand and gently touches her breast. Her left hand is placed in front of her eyes, which look downwards. The eighteen images show the same Eve Clone, but like the earlier works they are expressed in different colours and textures. At the same time, across the sequence of works, the figure rotates through 360 degrees, with each frame showing a different angle. The work is extremely similar to *Eve Clone Hands*, in that the figures look as though they are immersed in liquid and placed in medical tubes or jars. For this work, Lin explains how 'mass production and normalisation represent the production process, through which it creates something which is completely the same as the original, using a cloning technique'.[10] Eve Clone's character is exposed in this work as both artificial and mechanical. Expressed through its neat presentation of eighteen digital frames, the work provides a metaphor for artificial and inorganic life characters in a clone factory.

The Taiwan-based critic and curator Lin, Hongjohn reviewed Lin's Eve Clone series, arguing that 'the installation creates a situation of a scifi labora- tory to archive and preserve the cloned version of Eve, as if ruins of technology' (2011: 7). It is interesting to read that, despite the fact that Lin's Eve Clone is created with advanced technology, the work itself actually embodies the idea of the 'ruins of technology'. This concept can also be seen in *Revelation of Eve Clone I* which was shown through a huge interactive display system using two synchronized projectors. With such means, the artist attempted to overlay different and sometimes overwhelming images of Eve Clone. Through a special computer program, Lin displayed against each image an accumulating number, calculated in milliseconds. The accumulation of the number was triggered each time an audience member entered the exhibition space. When the viewers left the space, the number automatically stopped accumulating and the colour of the image would gradually turn to black and white. Lin's works use such techniques to construct her criticism of the confrontation between the artificial and the natural, by showing how each element both parallels and resists the other, and this has been evident since her early work, the Back to Nature Series from 1999. The transformation of numbers and images caused by the presence of the viewers of *Revelation of Eve Clone I* again responds to the artist's attempts during the past ten years to represent different versions of artificial life. In addition, the background music creates an uncanny atmosphere, adding to the viewer's perception that on entering the installation space they are being immersed in an unreal world. Eve Clone's beautiful but evil image and the continuously changing Bible scriptures and the eerie music offer the audience a haunting yet rare sensory experience, designed to stimulate the audience's imagination and perception towards sexuality, the body and virtuality.

The next piece to consider is Lin's *Inspection of Eve Clone*, which reveals two aspects of her quasi skin. First, Eve Clone is constructed from digital skin and, second, the tattoos on her quasi skin show some of the many ambiguities surrounding both body and technology. The tattoos selected by the artist include a rose, a dragon, a phoenix, a snake and a scorpion.

10 Interview with the artist in Taipei on 20 September 2011.

The patterns of the tattoos connect to the idea of taking a specific iconography and transforming its symbolic connotations. Both the tattoos and Eve Clones signify a 'beautiful trap', something alluring and at the same time repulsive, but they also combine within the installation to produce an atmosphere laden with references to hidden danger and evil. *Inspection of Eve Clone* is presented through digital prints, each of which shows different angles and parts of Eve Clone's body using infrared rays. Lin marks the number, date, time and the artist's name at the top and bottom of the work, as though the artist is like a doctor, examining and diagnosing Eve Clone's physical appearance with a medical device. For Lin, 'the tattoo's pattern symbolises and reveals the hidden danger of the beautiful Eve Clone under the inspection of infrared rays'.[11] In other words, through the infrared rays, the artist reveals the negative symbolic meaning of Eve Clone's beauty.

In 2013, Lin exhibited *Revelation of Eve Clone III* (2013) at 'Post- humanist Desire', a group exhibition held at the Museum of Contemporary Art Taipei. Installed in an independent gallery room, this work was a large multi-media and interactive installation, comprising moving 3D animation, interactive systems and a stereo system. When the audience walked into the gallery space, they were confronted with a bank of curved and wide projection screens that showed a series of computer-processed images of Eve Clone, which is created with a simultaneously activated and interactive system, resulting in the movement of Eve Clone and the playing of some calm, religious music in the background. Eve Clone represents an existence that is both beautiful and dangerous, and yet worshipped. Her body echoes the concepts of cloning, reproduction and cyborgs. The ideas of the post-human reveal a state of anxiety and uncertainty resulting from the condition of being between human and inhuman. Features of the post-human in Lin's work can be seen via her imagined Eve, which is itself a cyborg, a mixture of mechanical and biological organisms.

Lin's Eve Clone may appear to create the perfect being in cyberspace through artistic aesthetics and new media technologies, but at the same time she shows its dark and mysterious side. Eve Clone is represented as a perfect female without any body hair, an unreal and quasi body, created by the artist. It is a digital human situated somewhere between the real and the fake, between the organic and the inorganic. The dark and haunting beauty of the Eve Clone reflects the negative influences of artificial and technical civilization on nature via a woman's hybridized body. Here, there is a remarkable similarity to the robot-shaped woman featured in Fritz Lang's celebrated early Science Fiction film, Metropolis (1927), about which Claudia Springer makes thought-provoking comments on cybersexuality and the connection between sexuality and technology:

> [Metropolis] combines celebration of technological efficiency with fear
> of technology's power to destroy humanity by running out of control.
> This dual response is expressed by the film in sexual terms: a robot
> shaped like a human woman represents technology's simultaneous allure
> and powerful threat. The robot is distinguished by its overt sexuality, for
> it is its seductive manner that triggers a chaotic worker revolt.

(1999: 36)

11 An e-mail correspondence from Lin Pey-Chwen, received on 14 July 2011.

Lang's use of the robot in the form of a human woman (who is a fake and evil copy of the character of Maria, a beautiful and essentially well-meaning woman) is particularly telling and interesting in the context of the threat and allure of technology. It is also interesting to note the similarity between the motivation of Lin's creation of Eve Clone (itself another fake and evil copy of an essentially beautiful or perfect woman) and the thrust of Springer's statement. Collapsing the boundaries between humans and technology is often exemplified via sexuality (especially via women's bodies) in postmodern culture. To further illustrate this point, Andreas Huyssen also argues that modernist texts tend to juxtapose machines with women, displaying and projecting fears of overpowering technology onto patriarchal fears about female sexuality (1981–82: 221–37). Thus, it is evident that when humans interface with computer technology in postmodern culture and creativity, the process is not simply about adding external robotic prostheses to bodies; rather, human identities are integrated within the mechanized human forms. Lin's latest animation, *Great Babylon* (2015) , continues the artist's style of utilizing a sensual, yet artificial Eve Clone as the primary subject. Lin has placed Eve Clone in a real-life setting (i.e. the photograph of a bird's eye view of the Empire State Building in New York City) to warn people about the desires and sins they acquire when they vigorously and selfishly pursue success in politics, economics, culture, technology, religion, etc.[12] Opening her arms wide, and standing straight and firmly on top of the Empire State Building, Eve Clone seems like the great creator, a God, looking down on the twisted and surreal streets, which is the world in which we live. Lin's exploitation of a sensual and erotic woman's body to question the 'sins' people are experiencing suggests a kind of human fear about the future, echoing both Springer's and Huyssen's views on cybersexuality.

Conclusion: transcending the RELIGIOUS EVE?

Long before the terms post-human and cyborg had even been coined, artists, philosophers, authors and scientists imagined and interpreted the phenomena in diverse, complicated and multiple ways. Examples include the mechanical bird in the fairy tale The Nightingale (1843) by Hans Christian Andersen, the monster in Mary Shelley's Frankenstein (1818), and the robots in Isaac Asimov's science fiction novels, all of which are imaginary creations between biological bodies and technology. Arguably, there is also a contemporary example of a cloned Eve, in the shape of Repilee, a female robot made by Professor Hiroshi Ishiguro at Osaka University in Japan. It is indeed fascinating to examine the connection between woman, technology and cyborg, and the connection between the female cyborgs of Lin's Eve Clone, Lang's Maria and Ishiguro's robot Repilee, all of which suggest that technology's fantasized other is often in the shape of a woman. Undeniably, the evolution of technology is still an integral part of our interpretation of post-human issues today. Through Eve Clone, Lin demonstrates her own particular interpretation of the post-human, the transformation of the human body, mixed with organisms, robots or nature.

It is worth emphasizing that in any analysis of Lin's works it is hardly possible to separate her religion and faith from the art, because these are at the root of her work. Any valid reading of Lin's work should acknowledge the strong Christian references, but it is not

12 From an e-mail correspondence from Lin Pey-Chwen, received on 24 November 2014.

appropriate to analyse Lin's works solely in terms of its religious connotations. This is a crucial truth of Lin's oeuvre, since it is underpinned with a maker's skill in the exploitation of cutting-edge media, where the aesthetics, Techniques and the professionalism of the construction in her art undoubtedly surpass any religious meanings in the images and works. This is perhaps the major paradox; the heavy reliance on direct symbolic connotations from the Bible, which for some could make Lin's work appear rather traditional and restricted, stands in stark contrast with the use of twenty-first-century technology, and yet this is precisely what is at the root of the message.

Considering the work from a retrospective viewpoint, it is evident that Lin has been challenging the patriarchal order from within the value system itself. Lin created her Eve Clone series (and her earlier works) under a patriarchal ideology. That is, Eve's body represents easily recognizable stereotypes of women found in works of art across the centuries; however, it is interesting to consider whether Lin's post-human and hybridized Eve transcends the religious and symbolic cultural connotations of Eve. It is also evident that there is clear transition in Lin's work from the earlier period when she focused predominantly on a feminist approach to the representation of women in the patriarchal culture of Christianity, to her recent critique of technology.

Acknowledgements

This paper was kindly supported by the Ministry of Science and Technology of the Taiwanese Government (MOST 105-2629-H-006-003).

References
Abraham, Frederick David (2010), 'Cybersexuality & evolution of human nature from "Ardi" to "Andy" or hominids to hominoids', http://www. blueberry-brain.org/chaosophy/Cybersexuality-creativity-bbi-v8a1d.pdf. Accessed 7 November 2014.
Andersen, Hans Christian (1843), The Nightingale, Copenhagen: C.A. Reitzel.
—— ([1843] 1986), Hans Christian Andersen's the Nightingale (trans. Eva Le Gallienne), Honley: Collins.
Artsfreedom (2012), 'Serbia: Row over art exhibition depicting Jesus',
http:// artsfreedom.org/?p=3244. Accessed 10 November 2014.
Braidotti, Rosi (2013), The Posthuman, Cambridge: Polity Press.
Chiu, Chih-Yung (邱誌勇) (ed.) (2009), Kuajie shiyu Lin Peichun shuwei yishu shiyanshi/
Interdisciplinary Horizon: The Exhibition of Lin Pey-Chwen + Digital Art Lab, exhibition catalogue, Taichung: Province University Art Centre.
Halberstam, Judith and Livingston, Ira (eds) (1995), Posthuman Bodies,
Bloomington ad Indianapolis: Indiana University Press.
Haraway, Donna (1991), 'A cyborg manifesto: Science, technology, and socia- list-feminism in the late twentieth century', in Donna Haraway, Simians, Cyborgs, and Women: The Reinvention of Nature, London and New York: Routledge, pp. 149–81.
Hassan, Ihab (1977), 'Prometheus as performer: Toward a posthuman culture?',
Georgia Review, 31: 4, pp. 830–50.
Huyssen, Andreas (1981–1982), 'The vamp and the machine: Technology and sexuality in Fritz

Lang's Metropolis', New German Critique, 24: 25, Autumn– Winter, pp. 221–37.

IGNITE (n.d.), 'Eve Clone Series', http://IGNITE.globalfundforwomen.org/ gallery/Eve Clone-series. Accessed 13 December 2014.

Ivanova, Antoanetta (2011), 'Alien beauties: The haunting world of Pey-Chwen Lin's Eve Clones', in Richard Chang (ed.), Lin Pey-Chwen – Eve Clone Series, exhibition catalogue, Taipei: Gallery Grand Siècle, pp. 9–10.

Kreyche, Gerald F. (2004), 'Second-fiddle females', USA Today Magazine, May, 132: 2708, p. 82.

Lang, Fritz (1927), Metropolis, Berlin: Universum-Film AG (Ufa).

Liao, Jean (1992), 'The non-market Controlled ITPARK and Apartment 2' (originally published in Tz-Li Morning News), ITPARK's website, http:// www.itpark.com.tw/archive/article_list/19. Accessed 9 December 2014.

Lin, Hongjohn (林宏璋) (2011), 'Interpassivity within a Clone', in Richard Chang (ed.), Lin Pey-Chwen – Eve Clone Series, exhibition catalogue, Taipei: Gallery Grand Siècle, pp. 7–8.

Lin Pey-Chwen (林珮淳) (n.d.), artist's website, http://ma.ntua.edu.tw/labs/ dalab/.

—— (ed.) (1998), Nüyilun Taiwan nüxing yishu wenhua xianxiang/Women's Arts: Phenomena of Taiwanese Women's Art and Culture, Taipei: Fembook Publisher.

—— (2011), 'Artist preface: Best weapon against myth is perhaps to mythify it in its turn', in Richard Chang (ed.), Lin Pey-Chwen – Eve Clone Series, exhi- bition catalogue, Taipei: Gallery Grand Siècle, p. 4.

—— (ed.) (2012), Taiwan shuwei yishu dang'an/Taiwan Digital Art e-Files, Taipei: Artist Publishing.

Miah, Andy (2008), 'A critical history of posthumanism', in Bert Gordijn and Ruth Chadwick (eds), Medical Enhancement and Posthumanity, London and New York: Springer Science + Business Media B.V., pp. 71–94.

Nichols, Steve (1988), 'Posthuman manifesto', Games Monthly Magazine, avai- lable on http://www. posthuman.org/page2.html. Accessed 25 June 2016.

Shelley, Mary Wollstonecraft (2015), Frankenstein or the Modern Prometheus – Original 1818 Text, North Charleston: CreateSpace Independent Publishing Platform.

Springer, Claudia (1999), 'The pleasure of the interface', in Jenny Wolmark (ed.), Cybersexualities: a Reader on Feminist Theory, Cyborgs and Cyberspace, Edinburgh: Edinburgh University Press, pp. 34–54.

Trible, Phyllis (1978), God and the Rhetoric of Sexuality (Overtures to Biblical Theology), Minneapolis: Fortress Press.

Warren, Karen (1997), Ecofeminism: Women, Culture, Nature, Bloomington: Indiana University Press.

Suggested citation

Turner, M. (2016), 'Visualizing post-human and cybersexuality: Lin Pey-Chwen and the Eve Clone series', East Asian Journal of Popular Culture, 2: 2, pp. 227–245, doi: 10.1386/eapc.2.2.227_1

Contributor details

Ming Turner (陳明惠) is an assistant professor at the Institute of Creative Industries Design at National Cheng Kung University in Taiwan, and was awarded her Ph.D. in Art History and Theory at Loughborough University in the United Kingdom. She lectured Critical and Contextual Studies at De Montfort University in the United Kingdom from 2009–2012, and was a visit- ing faculty member at Transart Institute in New York from 2009–2011. She has published widely in both English

and Chinese in many international jour- nals and publications, including Journal of Contemporary Chinese Art (2014), Else Art Journal: Art, Literature, Theory, Creative Media (2014), Triennial City (Manchester: Cornerhouse, 2014), n paradoxa (2010, 2012), Women's Studies in the West (Beijing: People's University Press, 2011) and Gender and Women's Leadership (London and New York: Sage, 2010). Turner is also an international curator, and her completed projects include 'Bodyscape: Patricia Piccinini' (Yu-Hsiu Museum of Art, Taiwan, 2016), 'Surface Epidermis: Phil Sayers' (Kaohsiung Museum of Fine Arts, 2015), 'Pop-up Republics' (Asia Triennial Manchester, Manchester, UK, 2014), 'Post-humanist Desire' (MOCA Taipei, 2013–2014), 'Trans-ideology: Nostalgia' (Berlin, 2013), 'Beautiful Life: Memory and Nostalgia' (UK and Taiwan, 2011–2012).

Contact: Institute of Creative Industries Design, National Cheng Kung University, No. 1, University Road, Tainan 701, Taiwan.

夏娃克隆文件 Revelation of Eve Clone Documentation

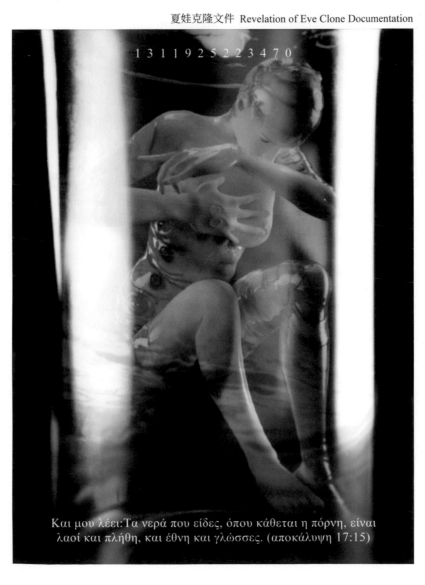

From Pupa to Eve Clone
Lin Pey-Chwen Empowering Femininity

Kuo, Gwen Kuan-Ying | Art Critic, Art Researcher

"Taiwan Digital Art and Information Center", 2014 | Academia.edu

The round figures wrapped in layers in reddish orange, violet, yellowish green lines were circulating around the space. This was Lin Pey-Chwen's "The Image of Life" series in colorful abstract oil paintings showing at an alternative space Apt. 2 in Taipei in 1993. The elliptical pupa image was complex but elegant, hinting imprisonment but invitation in colors. Their spherical structures suggested continuous movements, while the oval shapes reminded me intuitively about eggs, the very private female experience. No matter how innovative progress in Lin Pey-Chwen's art, those colorful pupas have vividly stayed in my memories for 20 years - retaining my first impression, as an oracle image revealed women art in my early career toward to art critic.

Transforming Female Figure

"At that time I was struggling and wanted to breakthrough." Lin recalls her early "the Image of Life" series, and she opens the black velvet and walks in a dark space with black carpet on the ground, only the walls shining through the huge female figure. Now we are entering Eve Clone space at Taipei MoCA in the 2013 "Post-human Desire" exhibition. The projected three-dimensional Eve imagery is constantly growing and surrounding the viewer within the space. Eve is being cloned several times and presented in grand scale, slowly turning her body in a tube as if she is awake. Her gentle movements reveal themselves clearly about her half curled body still leaving chrysalis traces, hinting that she has not been completely transformed into human. The background music on the spot is a in the form of a sacred hymn which strengthens the ambient of a holy site, yet it is mixed with intermittent noises, metaphors of eschatological crisis. Twenty years ago Lin wanted to breakthrough; today she has made Eve Clone, a conceptualization which is being viewed by international audiences at museums globally. Eve Clone has drawn viewers' attention around the world. Their perception and discussion of Eve Clone interactively generate Eve Clone's art life.

"Once I knew that I wanted to be an artist, I had made myself into one. I did not understand that wanting doesn't always lead to action. Many of the women had been raised without the sense that they could mold and shape their own lives, and so, wanting to be an artist (but without the ability to realize their wants) was, for some of them, only an idle fantasy, like wanting to go to the moon." - Judy Chicago

Lin's "Eve Clone" series has attracted universal acclaim from art critics, scholars and art

patronage in recent years, but the original concept can be traced back to the context of Lin's works throughout these twenty years. Those pupas in "The Image of Life" were made when Lin pursued her doctorate degree of Creative Arts from University of Wollongong in Australia, at the same time as she was handling the roles of being mother, daughter, wife, teacher and artist. Inspired by her cross-cultural art education, Lin continually deepens her awareness of the roles and the rights of women as well as women artists in the contemporary world and in Asian societies. In her early works, Lin insightfully expresses her concerns about women issues. However, unlike Western feminists using the body as weapons to pose questions about gender inequality, Lin eloquently uses oriental symbols, such as the beautiful but striking lotus shoes for bound feet, and implies a subversive meaning. She boldly contrasts the imagery of lotus shoes with the modern high heels to signify the great pain women often endure in attempting to execute a convincing façade of an ideal female image. In her "Antithesis and Intertex" series, she juxtaposes classical Asian lady's portraits with gold-lined lotus flowers to underscore the proverb "three-inch golden lotus," a traditional concept of a virtuous lady from a good family, a persona which is usually characterized by a pair of tiny bound feet. Yet this proverb was like a curse on women of the past as it disguised the ignorance of the inhumane brutality necessary to constrict and wrap human feet into three inches. Ironically today's high heels for women serve the same paradox of female-beauty/female-torturing. In addition to her artworks, Lin has contributed articles and has been involved in the wider feminist movement to realize her ideas. She analyzes women's art such as Judy Chicago's exhibition and Mary Kelly's Post-Partum Document by using personal objects of both womanhood and mothership. The female movement Lin and many women art professionals joined in 1990s has gave birth to the Taiwan Women's Art Association. These twenty years to Lin is not abstract in theory, but a combination of women art theory and practice in the real world. Lin has breakthrough the struggle of the cocoon image of life series in the 1990s. Today she has achieved as an educator, artist and activist in the field of woman art and beyond.

Mother Nature Vs. Human Pride

The 921 Earthquake in 1999 had struck Taiwan in all aspects. The force of the nature was a great reminding of the vulnerable human-beings. The natural disaster alerted Lin, she reflected thoroughly about the true meaning of life. What meaningful is not to fight for the

disadvantaged groups but to return to the core value of life. Human voraciously exploits, aggressively pillages our Mother Nature has caused ecological imbalance on the earth. Without the harmonious relationship between nature and humans, it will be unavoidably generating the conflicts and injustice between male and female, the privileged and the disadvantaged groups, and among racial and social classes. These are all oriented from the human pride and greediness. With this understanding, Lin started "Return to Nature" series since 2000 to examine the potential antagonistic relationship between nature, technology and human pride. By using of the artificial, reproduced and digital medium, Lin creates virtual reality to query about how humans have become over dependence on technology. One example is the oval-shaped "Treasure" she made in 2001 represented the idea of cherishing our Mother Nature and to honor her fertility power.

This idea of exploring the relationship between life, nature and human has extended and gave the birth of "Eve Clone." In "Return to Nature: Artificial Life" series (2004), she made three-dimensional interactive images of the pupa turning into butterfly, the caterpillar transforming into human-being, and then transfiguring into human-butterfly. The artificial life in virtual reality that Lin deliberately to build up is to criticize the cloning technology. By taking advantage of technology, human has presumption of superior power next to God; hence unconsciously destroy the harmony of nature.

Meanwhile, the significant Eve Clone has been generated, shaped, and molded in this process. This pupa-human has had her own evolution in the series developed by Lin for about a decade. Eve Clone possesses an elegant, slim but curvy body. She slowly rotates and revolves around in the tubes in front of the audiences. Under carefully observing we can find that Eve Clone's back still left the traces of chrysalis, which suggested that she is not yet a complete "human." Is this pupa-human going to transfigure into a stunning beautiful woman, or an evil spirit-alluring female? Through the moving imagery of Eve Clone, does the artist convey a message for female power, or to against it? "Well, this is Eve Clone, not Eve." Lin emphasizes, "And Eve Clone is made by human, by science and technology." Her words point out that Eve Clone is not the Eve created by God, but an ideal woman image oriented from human desire. Eve Clone, a desirable figure which in fact lacking of the fertile nature as Mother Earth.

And on her forehead a name was written: MYSTERY, BABYLON THE GREAT, THE MOTHER OF HARLOTS AND OF THE ABMINATIONS OF THE EARTH. (Revelation 17:5)

"And the woman whom you saw is that great city which reigns over the kings of the earth." (Revelation 17:18)

The progressing imagery of Eve Clone is actually the desirable projection from the viewers. Her evolution, on the other hand, resided Lin's biblical perspective and interpretation. Hidden in Eve Clone's curly fringe, the "666" characters inscripted on her forehead is the disastrous emblem of this femme fatale figure. The verses of Revelation (chapter 17-18) describes the counterforce of nature, human's growing desire for money, power, and lust

have been resurrected. The insatiable ambition of humans generates the damaging forces to destroy the universe, and of course, human ourselves included.

International art critics about

The complex meanings that Eve Clone connoted the struggles have transcended beyond gender and cultural boundaries. Eve Clone are connoted from various angles by international art critiques, such as biblical interpretation, the femme fatale figures, cyborg theory, the digital aesthetics and so forth. These discussions have extended the artistic life of Eve Clone in profound ways. Apparently Lin's art has moved above the disputations on female-male, art- technology issues. However, her principle has never divorced from her caring for feminism-human rights which has rooted in her early PUPA imagery. The progress in these twenty years is that the artist has maturely wrapped the argument and her artistic ideal into a much more complete yet complex, interesting and intriguing image of Eve Clone. She is the artificial Eve, a clone of the first woman of Mother Nature based on human desires with perfect female figure. "She" symbolizes our flesh desire and fantasy which is now replying on science and technology to accomplish. "She" absorbs our worship to lifeless technology, as our homage to unknown super power as well as destroyable forces. Our mirrored desires have made Eve Clone alive.

Today, Eve Clone is almost completely transfiguring from pupa into an ideal woman figure. Existing in the three dimensional virtual world, our projected hope can never allow Eve Clone lifeless. Her almost perfection figure summons our inner desires. "She" is man's fantasy, and woman's desirable subject to control man as well. "She" represents the power of technology enticing human away from nature, seductively persuades us to believe that "man" is the creator of the universe. The evolving Eve Clone hence generates her gold head, silver body, bronze belly, iron leg and mud feet, the Great Image of Eve Clone. When the viewer touches the head of Eve Clone buste at the exhibiting holy space, through Lin Pey-Chwen's elaborately designed interactive device, this homage gesture from the viewer will arouse Eve Clone starting her movements seductively. Since we humans believe that our desire is real; we crave and anticipate that this perfect female figure would come to life. This computer-generated Goddess is therefore becoming alive because of our desire, aspiration and projection. In our anticipation, Eve Clone has completely controlled over our hope.

"Your Majesty looked, and there before you stood a large statue—an enormous, dazzling statue, awesome in appearance. The head of the statue was made of pure gold, its chest and arms of silver, its belly and thighs of bronze, its legs of iron, its feet partly of iron and partly of baked clay. (Daniel 2:31-33)

From the colorful, imprisoned pupa imagery in Lin's early "Image of Life" series to Eve Clone, Lin Pey-Chwen never stops presenting artworks with sublime objects embedded thought-provoking proposition. For more than two decades, she retains keen insights in her art practices but offers even sharper, inspiring paradox. Eve Clone served as the metaphorical image, the desirable female feature, the oracle about vulnerable human nature,

and highlights the disastrous human pride which is the absolute counter force to the natural fertility. Human's arrogance and greed for the materialistic vanity, fame, and power, gave the birth of Eve Clone. The deathly seductive image of Eve Clone powerfully wrapped the weakness of human nature. The super-power facade of technology has made human over depending on it and obsessed the power which engaged in the deathly weapons and wars. By Lin's hands, the Great Image of Eve Clone conveyed an oracle to remind us the core belief of life, to distinguish the divine essence of the universe.

夏娃克隆啟示錄 I Revelation of Eve Clone I

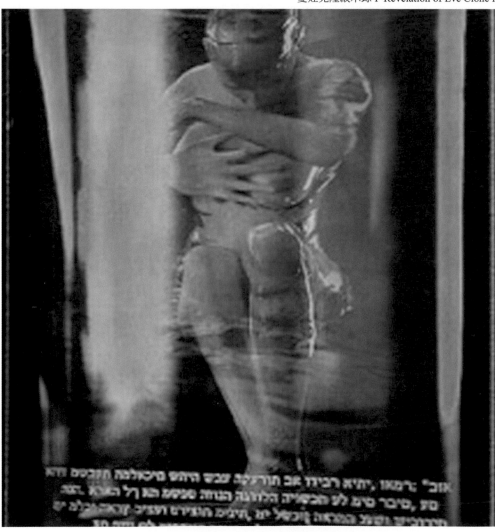

A Clarifying Aspect of the Recreation of Nature

Sense of Pey-Chwen's Artificial Nature

Luchia Meihua Lee | International Art Curator and Writer U.S.A.

No matter how many principles or theories of art have been declared, the fact remainsthat art is a product of reaction. It can simply present the zeitgeist of its time, but most often is a reaction against the times or against art that has preceded it. Art history seemingly is a smooth development. Whereas, one thing is sure, as Herbert declared: art is not progressive. The reaction involved in producing individual pieces of art depends on individuals and circumstances. Real art is not transitory like the news, but deeply original. Only through an awareness of history and long term sensitivity to experience can the artist be led toward self-realization. Since self demolition is necessary, the process of creation can never be in balance, and is always rocking and changing. An aggressive method and decisive mind is a secure way to define the element to form the final solid object that is presented to us.

Pey-Chwen "Artificial Nature" series takes a strong underlying idea – namely, reaction against the degradation of nature by humans - and transforms it into a soft, beautiful, diffused image. Pey-Chwen's work directly announces the new technology with its attractive new image created by humans. Some people object to this new order and rail against it as a fake world; they prefer a more literary way to describe the multitude of senseless ways in which humans corrupt their environment. The reality is that the world keeps moving and all of us must simply admit the changing nature of our milieu.

- Industrial revolution and technological advancement in the past 200 years have yielded astounding improvements in living standards. Yet just in the 20th century, the number of people afflicted by depression-related disease has grown by a factor of one hundred.
- In the past 200 years, over 100 million people have died in war and battles, more than the total of previous such tolls in human history.
- Global warming, caused by rampant expansion of capitalism and consumerism, is changing Earth's climate at catastrophic rates.
- And in the meantime, poverty is ravaging more and more countries as the world migrates to a 20/80 society where 80% of wealth will be controlled by 20% of the people, furthermore, world population continues to rise at rapid pace. Reaching 10 billion within the next 50 years.

All these fatal phenomena come from the blind pursuit of material possession and sensual satisfaction, because of a lack of understanding and appreciation of nature, and the role

of humanity on Earth. Pey-Chwen looks through these risks and has a strong desire to reinterpret them. From these numerous threats, she chooses a subject, and then brings this subject to a visual realization. Since the vividness of original reality cannot be sacrificed, Pey-Chwen uses regular geometrical shapes in her series of installations entitled "Artificial Nature". For example, cylinders, rectangular solids, tetrahedra and spheres are used in her works. Fluorescent light defines the new Non-Nature which the artist creates. As Paul Cezanne observed, art brings nature to a cylinder, cone, and sphere, and other geometric forms; every object has correct perspective, thus every edge converges to a single point. This kind of artistic originality imposes a structured format on our visual visualizations. In forming a response to a piece of art, the viewer must take into account the data to be obtained from many perspectives.

Plato's idea of mimesis is that in mimicking nature our goal should be to express images clearly, not influenced by our emotion or knowledge. In "Artificial Nature," Pey-Chwen's interpretation of mimesis, we should not see an exaggeration or a fiction, but rather notice an artificial color, and a quiet, stable, and colorful object that stands beside or in a corner. Then, the atmosphere created by light under the glass reveals the works' virtue and that of the artist. Because the light is insubstantial, it is spread out and confused; the color seems subtle and floats on the surface. The color, light, shape, and environment together create a bright unlimited perception, thus drawing us enter into a point. In this series of works, she didn't intend to construct any specific genre; her style is herself.

The structure of the universe surpasses human understanding. In contrast, our society was constructed by human reason. Thus, persons who do not have a higher spiritual level and do not respect the invisible world will not care about the value of the existence of human beings. In the Principle of Art, R.G. Collingwood clearly defined art reality and experience. It is rare in our world to mention that art should be prophetic. This means the artist can directly express the secrets of the mind; the secret does not represent him/her self, but the artist acts as a group speaker to articulate a secret. No group can completely know what really exists in their mind. Therefore, they cheat themselves and most of all us when doing research and observing. The lesson is ignorance equals death. There is only one way to redeem this ignorant guilt: art is healing medicine for sick spirits and rusty senses. The movement of modern art always involves destruction of a portion of the self. This contradicts the notion that this movement is simply a powerful influence for renewal.

Reflecting the artist's religious consciousness and humanistic thoughts, Pey-Chwen's work expresses her prophetic and warning character. Through art, she achieves realization of her own mission, and contributes on a spiritual passionate level. Pey-Chwen has direct, frank, transparent ideas, and a logical character, along with keen, sharp, new awareness of the world. To understand the work we cannot ignore the background and life of the artist. Pey-Chwen is characterized by consistency, strength of will, and mercy. She cares about human beings and nature. She always tries to find the possible from the impossible.

She mingles the methods of the literary and visual arts to express concept, and slyly

arranges splendid colors. Indirectly, she questions our way of life, and the structure of society, from feminism to consumerism. Her collected works constitute a voyage through an illusive wonderland. Her kaleidoscopic images, composed of synthetic materials, seem natural and invite the viewer's touch, but always prove to be untouchable.

Flower petals re delicately layered in Pey-Chwen's work to express the beauty and tenderness of flowers. She embeds them in translucent solids in a presentation of the feminine sense. Just as flowers always attempt seduction, so they have long been used as a symbol for female issues. Artificial nature seems unrelated to female issue, but the relationship bears further analysis.

Pey-Chwen has a long history of treating feminist subjects, frequently taking examples from Chinese history or culture. This may explain why she has chosen to employ flowers or leaves in her work. In Artificial Nature, her roses are composed of petals pillowed one upon the next, leading to a seductive and exotic result. These flowers are both free of restriction and calm. Yet, constructed as they are of synthetic materials and embedded in geometric objects, they are also unreal and alien.

Pey-Chwen's work depends not only on its visual aspect, but also on its position in space. In Artificial Nature, she does not give up color in order to solve the dimension problem. Instead, she arranges a beam to spotlight the piece. Thus she crates a space with dramatic light and many images of butterflies slowly moving their wings above lovely flower petals.

Although we know the scenario is unreal, but we won't trust self initial idea. Then, the doubt of intention that raised to catch those flouring sprits. Upon touching the image, we realize it is just as imaged-an illusion. But, we have already taken action. Thus, this work becomes a test of human originality. A butterfly and flower metaphor is probes appreciation of beauty and self-identification of the space. External chaos is simply a reflection of internal imbalance. Those objects surrounding us are the operands of our senses. Perspective, size, and frame are all illusions; true measure in art takes the form of structure, line, color, and proportion;.Another perspective on "Butterfly Piece" can be gained by viewing it from a corner of the space. When another viewer enters the darkened space, only his outline is distinctly visible because he is backlit. This is reminiscent of the situation with the butterfly images that all turned out to be insubstantial – with of course the ironic difference that these fellow audience members are quite real but difficult to perceive.

No matter how often the arts present bias or irregularity, we still need to see art as an effort to renew the sprit. No matter how much artists show violence, destruction, illusion, carelessness, or impatience, most of them concern themselves with spiritual and moral issues, This is vital to all civilizations, no matter their philosophy, political, science and governance. To present an emotionally clear sense image has never changed as the goal of the artist. Creative fertile imagination is a treasure, and will be the foundation for new civilizations.

What You Get Is Not What You See
Lin Pey-Chwen "Catching" at MOCA Taipei

Pierre Martin | Art Researcher

The new installation work "Catching" by Lin Pey-Chwen is presented at MOCA Taipei until December 31st. It is an installation that is built on 3 points. First, it is a process in space that needs the movement of the spectator. Second, it is also an exploration of time through moving images. Finally it point out to the importance of the spectator and it is built for him, it needs the spectator's eyes and body.

At the entrance of the exhibition space you first have to pick up some white gloves and special glasses, so you are waiting for a surprise inside, or maybe something unusual. But you already feel you will have to do something, and that your presence (and your participation) are really needed.

So when you go inside the room of her installation, the first thing you see at the entrance is a small frame. It looks like kind of plastic, or a small box, containing the image of a butterfly in color, all wings expanded, presented flat in the middle of the box, like floating, with no backgrounds. So the first impression is that of an insect collector's box containing a dead butterfly, maybe fix into plastic, frozen anyway in this material like in ice, to keep it from deteriorating. This feeling is accentuated by the frame of the box, which is very present, but also by a very present, clear and digitalized number put just over the butterfly. It's like a reference number, just like butterfly collectors will put the Latin or scientific name of there precious and delicate specimens on a small paper just over it. It also can be seen has a name because this number comes from real student's school numbers, so it is finally "someone".

You then realized that this image of a butterfly moves with your movements and looks like 3D, the wings of the butterfly seemingly flapping slowly as you move. You think about a new technology, maybe an hologram. In fact it's a new technology for 3D images. When you penetrate for good in the room, 13 of those framed butterflies hang on the left and the right of the room. All those images seem to move if we, as spectators, move. We are in a 3D space, those images are 2D, but they seems to move and become 3D only if we decide to move and when we decide to move. They follow us. We control them.

But right away our eyes are attracted by the moving images at the back of the room. The silent film shows butterflies flying in all directions, not really fast but also not very slow, king of a natural pace. They are very colorful, they fascinate us, attract us, and right away

we thing they are the framed butterflies now filmed live somewhere. If we put the glasses given at the entrance, and walk toward the back of the room, the closer you get, the more 3D effects you get. From about 2 meters to the screen all the butterflies seem to fly around you, you fell like surrounded by them. Also at that stage the projected images starts to hit your hole body, you really feel like integrated in the phenomenon, you are like in a pool of butterfly images.

With the white gloves you tend to try to catch them, like if they were real, or you just tend the hand and the projected images will appear very clear, crisp, as if you are the screen itself. You also tend to move all parts of your body in this space, your arms, legs, head, to catch or hit the butterflies, to use your body as screens or tools to catch. You are not in a normal 3D space anymore. You can experience a "real" virtual reality space, where 2D and 3D get mix up, where your hole body experience that 3D space but also create this 3D space. You are not in the room anymore. You can play with it. Be like a kid. The flying of the butterflies being all over, you feel after a while also disoriented, overloaded with the uncontrolled flying of the butterflies. This saturation effect reminds me a little bit the effects in front of a painting by Jackson Pollock and his exploration of indefinite, continuing and saturated movements to burry the spectators in his works and destabilize our control of reality to concentrate on the sole movement. The famous "all over" effect.

So after a while you step back into the middle of the room, back into the comfort of the 3D reality space that we know. Then we are attracted by sounds coming from a piece in the central left corner. Soft sounds of nature, of forests, of insects. There you immediately notice that the images of butterflies are projected vertically, from up to down, because they dance on the ground all around some king of small round sculpture or stand on which white shinning and surreal material, like glittering feathers glow in the dark with some blur colors moving on them. Going toward that you naturally put your hands over the white material, placed just at the right high to do so. Immediately the colors projected on the white material becomes clear butterflies on your white gloves. You feel like being at a fountain, and putting your hand under the water, suddenly feeling the weight, the sensation and the temperature of the water. Here you feel the effect of the images on the hands, the sudden appearance. It is like a miracle, or like a dream. The soft and real sound saround keep you

between reality and fiction. Also in this position your hole body stands in the real 3D space, but you can experiment a virtual 3D fountain flowing vertically in front of you, and decide to dip your hands in, a little bit like in those science fiction movies where you have doors communicating to other spaces, times and worlds, and you just have to jump in to see an arrive to a complete different world. Many stories uses this idea of gates to an other world (could be mirrors, water, beam of lights, transport machines, etc, from the adventures of Dorothy in The Wizard of Oz to the movie Stargate.)

You then think that you saw it all. But no. As your eyes gradually get use to the darkness of the room and if you look carefully, you will notice that some vague and dancing colors appear over the main entrance door. You then realize that they are reflection coming from the images projected on the wall, some kind of ghosts of the butterflies projected on the opposite wall, some secrets that not everybody experiencing the installation will discover and see, an other dimension, a beautiful indescribable phenomenon out of reach. After talking with Pey-Chwen, she told me that phenomenon was an accident, the result of the installation of a complex system of lenses on the horizontal projector, that she saw it after the installation was done and kept it because it was interesting. It reminds me of one story about the work Le Grand Verre of Marcel Duchamps. Transported one day for an exhibition, one of the big glasses of the sculpture was accidentally broken. Transporters were very sorry and proposed to Duchamps to replace the glass. But he said not to so, to leave it like this, that he was very happy because that accident gave another level of life to the work and was part of it's history. I think for me that those reflections on the entrance's wall are also an other level of life of this work an gives another dimension to the whole installation.

So we can point out that that this installation develop 4 different kinds of spaces: 1) the central space of the installation is a real 3D space from this world, spaces that we know and that we control with our body. From that space we can control the perception, the life and the movements of the framed images of butterflies. 2) The back part of the room becomes as we move in a complete bath of 3D virtual space: there we do not fully control the space of our body, we are in an other dimension, swimming in an other world. 3) the sculpture part on the left: it is a frontier space, a mix space, where our body can stand in this world but our hands and arms can penetrate and go to an other reality in and out as we want. 4) the reflexion over the entrance door, a secret and unreachable space (reflections coming from a movie which comes from digital images scanned from invented images of butterflies…).

I conclude that the use of space by Lin Pey-Chwen in this installation is very elaborate and multiple. For me, this multiple levels of development signal a good work of art. It reminds me of her installation Viewing Views – Garden, Ocean, Sky, year 2000, where she also uses space in an effective way to completely make the space work for her.

This use of multiple levels can also be found in the multiple levels of meanings that can found in the work: butterflies and the local history of Taiwan, the link to ecological issues like pollution and preservation, time and transformation issues (butterflies are famous for there extraordinary transformation from a caterpillar to a chrysalis and then to a butterfly).

For meaning we can also think about a great number of famous stories implicating butterflies. Oriental stories like (couple transform to butterflies), or occidental stories (I think about the famous French movie Butterfly).

Finally those butterflies are good vehicle with the central point of this installation, which is to navigate between different levels of reality and fiction. On one side butterflies come from reality, from the nature, something real, real nature. Something we can touch. On the other side, new technologies used in this installation, for fix images or moving ones, come from fiction, from creation, something unreal, that creates unreal nature. Something we cannot touch. But this installation tries to finally make us touch and feel those butterflies again: it tries to bring us back to some nature. The circle is complete. But what we get is still a false nature. What you get is not what you see.

浮光掠影 - 捕捉 Catching

Lin Pey-Chwen's "Back to Nature"

Susan Kendzulak | Artist, Writer

Hurricanes, typhoons, earthquakes, tsunamis, landslides…. recently our world seems to face one natural disaster after another. At the time of this writing, even Mother Nature is seriously under consideration for being named Time Magazine's person of the year for 2005, although Mother Nature isn't a person. This illustrates how the destructive forces of nature are quite a mainstream concern nowadays as people are slowly waking up to the fact that our natural environment is out of balance. And many extend the thought to that maybe nature should not be blamed, but rather us war-mongering, polluting humans who could be the actual perpetrators bringing such wrathful harm upon ourselves.

It even appears that as one disaster fades into memory, it is soon to be replaced by another. These current cyclic events of natural destruction often seem endless and show the futility of life's struggle. Some doomsayers say the end is near, while some scientists predict that natural disasters will strengthen both in frequency and intensity as global warming - mainly due to our polluting ways – heats up our fragile planet, sparking ice caps to melt, ocean waters to heat up, storms to increase, ad infinitum. Reading these scientific predictions makes one wonder at the complexities of life and ponders the existence of a benevolent God. But disasters are also a natural cycle of life, and history is filled with stories of devastating plagues, floods, etc.

Living a balanced life is a major concern in many spiritual and religious beliefs. What the Hopi people call Koyaannisqatsi "life out of balance" and which was also the name of the beloved film by Godfrey Reggio that provided appropriate images from around the world showing the conflict between urbanization and preservation of the natural environment and local traditions show that this concept of "life out of balance" has been around in the cultural sphere for over 30 years.

All of these elements: miraculous life-affirming wonders and calamitous earth-shattering events are a strong theme in Lin Pey-Chwen's art. She marvels at the beauty of life and God's existence, yet is highly concerned about man's callous disregard for the natural environment. One of Taiwan's prominent feminist artists, Lin switched to making less politically driven work prompted by the 921 Earthquake which rattled Lin's spiritual self. She delved deeper into issues of faith and discovered Christianity. As a result the theme of man vs. nature and the return to nature, especially the return to the Garden of Eden is

dominant in her work.

In the large technical piece "City Matrix" a large orb contains flashing neon lights and traffic sounds that mimic the artificiality of the metropolis. Peeping through a small lens at the top one can glimpse a butterfly. Wire tentacles extend from the orb towards individual lenticular panels of digital butterflies that change color via LED screens. In addition, a web-cam captures the audience viewing the work, yet its purpose is not to record the viewer but to symbolize how humans cannot escape the City Matrix as they have also been complicit in constructing it. Shaped like a vacuum cleaner, it appears like a tiny robot figure with wires crazily jutting out. However, this household appliance that went haywire gives a sense of domestic things that go awry while hinting at a futuristic automated convenient lifestyle, yet cautions us that nature may be destroyed leaving just a microchip memory behind. In other words "City Matrix" is a bit like Chicken Little telling us the sky is falling.

"Viewing Views" is a cynical take on our environmental future. Sitting on a park bench to view a flowering garden or the seaside surf is something we often take for granted, but Lin's use of placing these images in lifeless Plexiglas boxes serves as a warning that if we do not start preserving our natural environment, we will only have an artificial one to marvel at.

Butterflies, roses, and daisies seem like typical images that girls choose to draw. Even though Lin uses such feminine-type imagery, her work is not providing a girly, feminine message, but rather an environmentalist message. Her work brings to mind Rachel Carson's classic book "The Silent Scream." Carson, a biologist wrote about how man's intervention of nature, in this case the blanket spraying of DDT pesticides on vegetation, instead of just killing the intended pesky insects, ended up killing everything in its path, ultimately silencing the springtime morning symphony of birds. As Carson stated "But man is a part of nature, and his war against nature is inevitably a war against himself. The rains have become an instrument to bring down from the atmosphere the deadly products of atomic explosions. Water, which is probably our most important natural resource, is now used and re-used with incredible recklessness." (www.rachelcarson.org)

Lin, too, operates in a similar vein: poetic, intelligent and concerned, not hysterical nor apocalyptic. Another Carson quote can even apply to Lin's art: "The more clearly we can

focus our attention on the wonders and realities of the universe about us, the less taste we shall have for destruction." Science, cloning, the potential for science going awry, and humans manipulating the environment are some of the main concerns in Lin's work and she is at her best when she combines beauty with horror.

"Back to Nature" is a recurrent theme, using Christian iconography of the dichotomy of good and evil, yet Lin never creates a garden of Eden. The work seems light and airy at first; however, there is a pessimistic, almost alarmist message. This virtual reality of nature that Lin portrays is a strong admonition to say we must protect the natural environment at all costs otherwise we may only be left with the computerized version.

Installations of sparkling light boxes with digital and video imagery capture the beauty of nature such as fluttering butterflies and vivid flower petals, but contain a powerful underlying message. Nature is a strong theme but paradoxically not an element in her work. The chrysalis-like installation installed up high in tree branches for the Dihua Street Public Art Project contained a sinister aspect like they will hatch. But instead of a pristine, crystalline, translucent and multihued creature unfolding from the chrysalis, a slimy, mucousy hard-shelled harbinger of evil will emerge.

"Artificial Nature Cultivation" is eerie. Looking like a creature's big blood-red eye that is displayed under a plastic dome turns out to be a flower with many petals. In the center is a video of a floating virtual nude. Both flower and human seem real, but are actually digitally created.

In "Treasure," screen prints of floral images on pillow-shaped light boxes give the sense of lyricism and airiness, like sleeping in a daisy-covered meadow on a warm summer day. Yet, the shape of the pieces also looks like UFOs and is another recurrent theme in her work, the idea of mimesis in the hands of an alien force. At first glance everything seems copasetic, then you get the vague intuitive feeling that suddenly everything is all incredibly wrong.

"Artificial Nature Flowers but not Flowers" are installed in a darkened room. The crescent shaped wall pieces look inviting as the blinking colorful lights that frame it are seductive and the large image of blood-red roses against a royal green background really make the viewer want to go closer. Then suddenly an object that seemed so inviting takes on a sinister quality. A chill goes down the viewer's spine as the wall pieces seem to be reminiscent of the pods in the frightful classic movie "The Invasion of the Body Snatchers." Additionally, up close the once beautiful roses now are just a jumble of multi-toned reddish pixels, enforcing the message that the image is a digital fabrication. The green areas are not foliage, but scanned images of online porn, violent computer game characters, and various paper currencies. We see the scourges of society, once we confront the work head on.

In Lin's reconstructed world, the artworks ranging from Artificial Nature (a lightbox with digital printing) to the motion imagery of emblems of beauty: flowers and butterflies to the most recent interactive works such as Eve Clone 2 are indictments of how the virtual realities, rampant commercialism and general urbanization created by us are really the

culprits of ruining life, the beautiful natural life of clean air and water, as we know it. In the latest work, viewers trigger virtual bubbles that 'feed' the cyber-Eve/Barbie clone, with more interactivity providing more vacuous bubbles, thus perpetuating a shallow corporate experience to the expense of the spiritual oneness we could experience directly with nature. This is Lin's way to say that the shopping malls, ads, computers, material goods, etc. are superficial gloss that erode and deter us onto the more meaningful paths of spirituality.

溫室培育 Cultivation

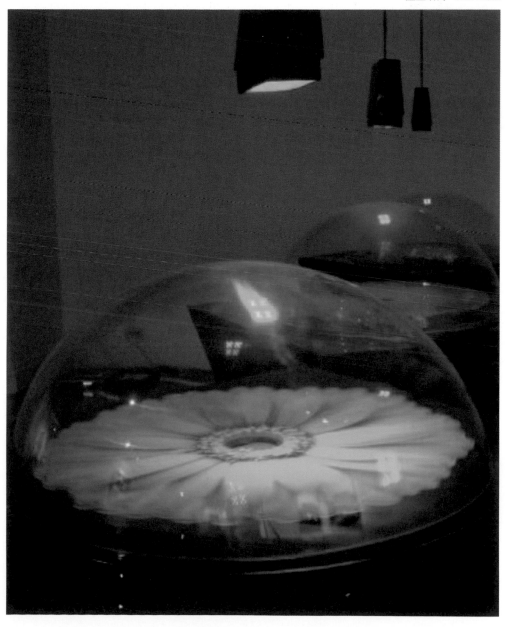

Reading Lin Pey-Chwen's work
"Back to Nature" Series

Elsa Chen | Art Critic, International Art Curator

Spurious Nature, Aesthetic Temptations

Stepping into the exhibition room of Taoyuan Cultural Center, the images of blue sea and sky and floral gardens immediately welcome you. A few chairs idling in comfortable square space, waiting for you to sit on and enjoy the beauty of the landscape. To those from the city jungle dying for bathing in the green Fintogen, the scenery is a visionary banquet and a spiritual aphrodisiac. It is so beautiful that you might for a moment forget where you are and what you are admiring at.

'The displaced landscape' is not the real thing that people desperately look for. Instead, it is a 'spectacle' made by Lin Pey-Chwen. Behind such a refreshing, soothing and yet spurious imagery of nature, there lies a high dosage of moral medicine filled with aesthetic temptations. Such a moving imagery of nature is actually an artificial photograph framed in the commercial signboard. It sends its condolence over the varnishing nature in the modern society while praising the beauty of nature. Lin's "Viewing Views" pays a tribute to nature and at the same time serves as an altar for mourning the death of nature.

Capitalism: the Killer of the Century

No return of nature, the womb of human life. The high technology and commercial communication anticipate the death of nature. Yet people who blindly embrace the advances of technology are ignorant of their devastating interaction with nature. This is a naked presentation of how people are caught in the malicious cycle of abusing and misusing nature based on commercial interests without a slightest awareness. Lin's moral allegory repeatedly appears in the Series of Installation "Substantial Life" and "Viewing Views", by commanding the most beautiful gesture through computer technology and commercial media. Lin lodges a serious accusation against the capitalist logic of exploiting nature and exposing the dark and impotent sides of human nature in a sarcastic tone.

From "Substantial Life" installed in the path of urban park to "Viewing Views" in the indoor space of the Cultural Center indicates the relocation of artificial outer space to the artificial inner space, bringing out an image of nature that is even more desolate and ridiculous. Thus, it summons a kind of warning and courage that is helpless for the worse.

Sexual/Gender Experiences, Sarcastic Comments on Patriarchy

Indeed, helpless. Within the gigantic mechanism of capitalism, an accusation against people who are abusing nature is something like revealing the exploitation of the "collective woman" in the airtight logic of patriarchy. It takes the spirits of Don Quixote. In the veins of Lin's works completed in the past few years, we clearly evidence such an ambition and courage.

At an earlier stage, Lin seeks for the position of the self as a woman in her "Interpretation of the Feminine" and "Chrysalis" Series. Then the "Antithesis and Intertext" Series takes on the accusation against the domination and exploitation of female body by the patriarchal and capitalist ideologies of Taiwanese and Euramerican societies. Lin then moves on to a political Series entitled "Black Wall, Inside and Outside of Windows" and "Regards to the Authorities Making 228 Incident Historical Tragedy in Taiwan" to protest against the harms done to the female victims by the improper rule of the nation-state and patriarchal system of Taiwan. She also deconstructs in her "Classic Work" Series those restrictions on female subjects imposed by Confucian ideology. All these works completely illustrate the artist's feminist quest for the female voices and reflection on how the mainstream institution and ideology construct the subject.

In "Back to Nature" Series, including "Substantial Life" and "Viewing Views", the artist's feminist concern find their way in the arena of ecological conservation. Ecological conservation or Lin is not only a feminist action to politically intervene the ecological environment, but also a reflection based on gender experiences. Like most of the people, the artist regards nature as "Mother Nature", which carries the source of all forms of life. "Mother Nature" can thus be seen as a sexual/gender metaphor and conveniently refer to "woman" or "the body of a woman". That human recklessly demands from nature indirectly mirrors the fact that the society exploits woman and the female body. Hence, we can clearly identify the continuous advocacy of feminist ideology in the career of the artist.

Back to Nature: a Heart for Utopia

Back to Nature, a romantic desire resulted from the Industrial Revolution, or, the cultural shelter for Chinese intellectuals who lost their political power appears to become an impossible nostalgia in the era of high technology. We can also dig out such endless

nostalgia and eternal desire for "Nature", i.e. "the Pure Utopia" in Lin's "Substantial Life" and "Viewing Views". In Lin's quest for "pure nature", there are unavoidably outrageous accusations, slight traces of sorrow over the nature that never returns and the insisting hope of realizing the desire. It nevertheless has been a great pleasure to see the artist continuously analyzing and revealing how the deep cultural consciousness obstructs the journey of seeking a "Sexual/Gender Utopia". At this moment, I sincerely expect the great courage of transcending the sense of nostalgia in the artist' quest for the Nature Utopia.

生生不息，源源不斷 Substantial Life

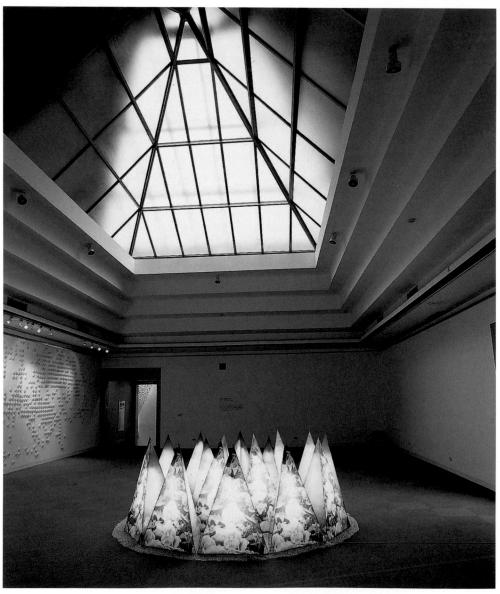

Interpassivity within a Clone

Lin, Hongjohn | Artist, Art Critic, International Curator

"Artist Magazine", 2011

A work of art shows not only its interiority— subject and content—but also reveals its exteriority, border , and extremity. The situation where a work can signify from without is most pronounced by the practice of media art, where the work cannot do without the technology, and vice versa. Therefore, media art can be a technology-specific art to require a certain Tech from the outside. In other words, media art reflects the condition of technology of the times, that is, a requirement for producing a technology-specific work. It is, then, the ontology from perspective of the technology discloses much in line with what Bruno Latour has claimed that the human is homo techno instead of homo sapiens. Media art can show the condition of technology, revealing a Hegelian dialectical interdependency of the master and the slave, and, of the human and things.

Lin Pey-Chwen has been creating visual reality to simulate in her previous works as a commentary for the condition of technology. Her recent "Eva Clone Series," using hologram in dimly lighted installation to fabricate amorphous satanic images of women in a synaesthetic environment where biblical texts are juxtaposed. Morphing identities from women to prostitutes, from Satan to heretics expose the diabolic nature of the pluralistic singularity. The installation creates situation of a sci-fi laboratory to archive and preserve the cloned version of Eva, much as ruins of technology. These images are gazing at spectators even when they are about to leaving the exhibition. A glance of looking awry produces a reversal gaze that projects from the images.

This reversal gaze, as Lacanan psychoanalysis asserts, is not something that can be merely accomplished by the act of looking, nor the seduction from the gazed objects, but rather, an inverted situation between the subject of gazing and the object of the gazed. In Lacan's words, a "passive voice" that fixes the subject within the picture that s/he is gazing, that is, an uncanny intersubjective relation where the self becomes the other even when there is no actual act of looking involved. The big Other fixes the self in the picture as an object, as Lacan once notes "the Other knows the ego know himself as an object being looked at." Within the drive of the gaze, not only exist the active voice and the reflexive voice—I see myself, but also affirmed and accomplished by the passive voice that I see myself being seen. In other words, from the passive mode of gaze can the position of subject act. [1]

[1] Jacques Lacan, The Seminar of Jacques Lacan, Book I. edit Jacques-Allain Miller, trans John Forester (New York: Norton Co. , 1988), 215.

"Eva Clone Series "traps the viewers into a passive mode of looking. These images, being holographic, mimicking the 3D effect, are simulacrums bearing no original but only modules, that is, a copy without the origin par excellence. Moreover, because these images are partially imitated what is being watched is the image of the clone not the actual one—viewers attend the verisimilitudes produced by the technological effect. Therefore, what Lin creates in her work is to feign to beget the system of objects orbiting the simulacrum as a relational indication of its myth, ideology, and reality, as "the object of art is established in a certain relation to the Thing and is intended to encircle and to render both present and absence." [2] We can even go as far as to render the big Other asserted in Lin's work as Technology pursue that makes the Progress possible to present the thing-ness of the human world.

That is the precise reason that the relation to the thing-ness world cannot be the interactive one, but rather as Zizek and Robert Pfaller have said, be interpassive one. [3] It is not the situation of waiting for participants to accomplish the art work, but rather the work has already finished the act, no more participation needed, and the loop of meaning is finished. That is the paradoxical expression why "inter" and "passive" can co-exist. In Lacanian psychoanalytical term, the lack that opens to the gaze, which traps the viewers to remind the subject of the human not from within but without, i.e., the system of things, Technology, as the very lack of the human. Lin's work has marked the site of technology the other place—the ruin. At the same time, it shows the chain of signifiers of the incomplete, such as woman, Satan, prostitute, clone. Lin creates a situation to traverse the fantasy of technology with the art of media—how can we clone the Lack? The answer lies in only when a partial simulacrum completes itself as the passive situation of "I saw myself seeing Technology, " for a revelation from the clones, the absolute world of thing-ness that gazes back the human.

2 See Jacques Lacan, The seminar of Jacques Lacan, Book VII. edit Jacques-Allain Miller, trans Dannis Porter (New York: Routledge P, 1988)141
3 Robert Pfaller, Backup of Little Gestures of Disappearance: Interpassivity and the Theory of Ritual. http://www.csudh.edu/dearhabermas/interpassbk01.htm, June, 30, 2011

God's Will or Human Desire
The Irony and Criticism in Lin Pey-Chwen's Eve Clone series

Chiu, Chih-Yung | Digital Art Critic, International Art Curator

"Taiwan Digital Art Platform ", 2015 | Academia.edu

In the past, "Genesis" in the Bible portrayed how God created Adam and took a rib from him to create Eve. In modern times, Lin Pey-Chwen's Eve Clone series cast contemporary digital technology for the role of Adam and created a virtual Eve. Subsequently, mass production was utilized for large-scale reproduction, or cloning.

As the Internet becomes more and more popular, the daily lives of modern people can hardly be separated from the use of the Internet. For example, distance learning, online shopping, online dating, and telecommuting are all achieved rapidly via the Internet. Likewise, creative forms of contemporary new media art are also unavoidably interconnected with the Internet. Barry Wellman and Caroline Haythornthwaite foregrounded how the Internet became a major place where activities of daily life took place. They stated that people had to pay attention to whether it created more social problems, such as sub-cultures, a digital divide, and social interactions while the development of the Internet was dazzling and seemingly created more possibilities. Wellman and Haythornthwaite emphasized that although most of traditional studies on Internet culture tended to separate these phenomena from daily life and then discuss how these phenomena influenced daily life, activities on the Internet in fact could not be separated from daily life. On the contrary, the two were intertwined and integrated. [1]

A critical proposition has long been shared by Lin's creations: the concern for the relationship between humans and the natural world, expressed through criticizing technology. Be it her earlier *Substantial Life* (1999), *Chrysalis* (2004), or the ongoing Eve Clone series (2006–present), be it the use of a virtual butterfly or the female form, these virtual creations, all seemingly alive, are recognized life forms in human civilization; they are art objects that have been transformed into simulacra (i.e., they seem fictional but are truer than reality.) Dani Cavallaro once stated that the virtual reality contained in cyberspace was an environment created by the computer simulating reality, where the physicality of the body can experience a manmade reality. In other words, cyberspace allows people to enter a virtual environment where they can realistically experience various real feelings in the real world. [2]

1 Barry Wellman and Caroline Haythorntheaite, The Internet in Everyday Life (NY: Blackwell, 2002), p. 35.
2 Dani Cavallaro. Cyberpunk and Cyberculture: Science Fiction and The Work of William Gibson (London: The Atolone, 2000), p. 36.

Undoubtedly, a unique feminine writing strategy as a critical discourse can be observed in the Eve Clone series. Lin uses a female figure (Eve) as the creation, whereas technology with power symbolizes the masculine side. Created with masculine technology, Eve has a beautiful posture and a delicate shape. However, this seemingly pure shape of Eve plays the role of temptress; she represents a female body between purity and evil. For example, in *Revelation of Eve Clone*, the dim, feminine installation presents a vibrant visual shock. When viewers enter the space, their paths drive the group of huge Eves to move and activate (or accumulate) the passing of time. This time is not the mechanical clock people take for granted but a Biblical time accumulated in milliseconds through the calculations of the program. The imagery in *Revelation of Eve Clone* is like the description in "The Book of Revelation" of the Bible, "And the woman which thou sawest is that great city, which reigneth over the kings of the earth" (Revelation 17:18). The gigantic image of the group of Eve Clones also echoes the scripture, "And he saith unto me, The waters which thou sawest, where the whore sitteth, are peoples, and multitudes, and nations, and tongues" (Revelation 17:15). The work used six different languages—English, Chinese, Arabic, Latin, Greek, and Hebrew—to present each nationality and country, and it further symbolized the world of different political, economic, cultural, religious, and military characteristics. From them, Lin attempted to adopt feminine writings to criticize the myth of the attempt to imitate, control, and transcend nature in the contemporary technological culture. More importantly, this image of Eve in a virtual world realistically reflected the daily lives of contemporary people, such as indulging in the virtuality of online dating or online games.

In addition, the three works *Portrait of Eve Clone, Mass Production of Eve Clone,* and *Revelation of Eve Clone III* were all centered on another prophecy in the Bible—imprinting. As prophesized in "The Book of Revelation," in the apocalypse, people who were imprinted with the Number of the Beast, 666, would not be able to escape from the constraint of beasts. Therefore, the work *Inspection of Eve Clone* utilized popular tattoo totems, namely, dragons, phoenixes, serpents, and scorpions, as metaphors for the constraint of beasts. On one hand, this work reflected the fashion trend that contemporary people like to leave imprints on their bodies. On the other hand, it criticized the inverted relationship of people being controlled by objects. The work *Portrait of Eve Clone* presented the symbol "666" in over ten different languages. Holography was also utilized to present the restrained yet graceful Eve with a seductive look in her eyes to generate spiritual interaction with the viewer. This mixture of good and evil confused the viewer. Moreover, in *Mass Production of Eve Clone*, small digital picture frames were utilized to display Eve being produced. This kind of mass production resembled a production line in a machinery factory, lacking life, emotions, and interpersonal relationships. The viewers felt desolate, cold, and alienated. This work satirized the lack of consciousness in reproduction and criticized the homogeneity of mass production.

The aforementioned creation forms of mass production and reproduction were more intensely reflected in the series *Eve Clone Hands* and *Eve Clone Fingers*. The imagery of dismembered bodies called to mind the parts on an assembly line, still uncombined. Each part seemed unique and yet was uniform. Their existing in the form of specimens

intensified the setting of the viewer being in an emotionless laboratory with cold creatures or biochemical creations. All in all, in this era when technological culture is extremely prosperous, Lin profoundly criticized human's fantasy that they could play the role of the Creator. She utilized metaphors such as dismembered body parts, mass production, and the Number of the Beast from the Bible to repeatedly remind people that they must think about whether it was people's desire that drove advancements in technology or the rapid development of technology that triggered the birth of human desire. She questioned whether humans had been kidnapped by objects after the objects were created.

Arnold Hauser once commented that art does not simply reflect society; rather, art and society mutually influence each other. For Hauser, art and life are closely related and inseparable. Art must maintain its connection with the overall reality and life, and it must serve as the foundation of aesthetic evaluation. Only then can art reflect phenomena in the most vivid and profound ways. In the Eve Clone series, Lin utilized mixed media as the form of her artistic presentation both to remind people to be aware of their being situated in the era of digital technology and to express her critical characteristics to the world as an artist.

夏娃克隆 III Eve Clone III

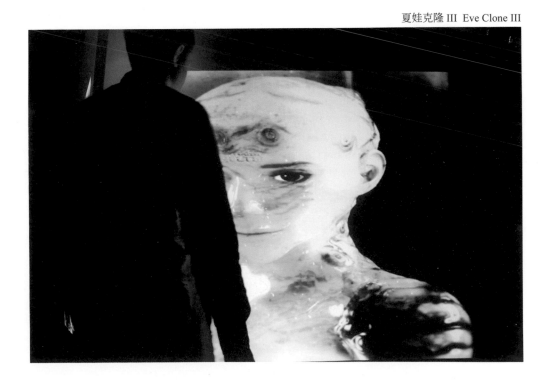

Quasi-skin and Post-religion
Lin Pey Chwen's Eve Clone series, 2010-11

Ming Turner | Art Critic, International Art Curator

East Asian Journal of Public Culture Vol,2, 2016

The *Portrait of Eve Clone Series*, created by the artist Lin Pey Chwen in 2010-2011, is a series of 3D works based on the portrait of Eve with her inspiration from the Bible.[1] The latest *Portrait of Eve Clone* continues to explore the issues of femininity, which was the major theme in her earlier works. It is also related to religious symbolism and the symbols that Lin has adapted in the creation of her work. In order to analyse Lin's 2011 *Portrait of Eve Clone Series*, it is necessary to review the style of her works over the past twenty years and to analyse the special art form and style she has created by her use of media and technology.

Across Lin's twenty-year art career, it is not difficult to see the essential concerns and themes of her works, which have led to the creation of the Eve Clone Series. She began to speak out her own art in 1989 when she returned to Taiwan from America and commenced her energetic participation in the activities and exhibitions of Apartment 2. Although both an artist and a teacher, she also needed to find her own time between the role of wife and mother. Lin began to be influenced by western feminism during 1993 when she studied for her PhD in Creative Arts in Australia. After returning to Taiwan once more, she attended several Taiwanese organizations and activities related to feminist art. When examining Lin's early experiences and inspiration for her art, it is evident that a consciousness of feminism influenced her artworks from the outset. Although Lin is deeply influenced by early feminism, her recent artworks using digital art as the media and do not directly criticise patriarchal ideology. On the contrary, with a more macroscopic view, the issues of her works have turned from emphasising feminism to caring about life and nature.

This kind of feminist characteristic is part of the so-called ecofeminism, which assertsthat capitalism is like patriarchy, taking nature/the female as a colonised object.Consequently, it asserts the freeing of nature and a return to human nature. The superego, a concern for the environment and a care for the natural environment may all be traced back to Lin's 1999 artworks, *Back to Nature* and *Treasure*, which show the transformation of her artistic concerns. This kind of feminist pattern of thought moved to another level in 2011 after teaching in the Department of Multimedia and Animation Arts at the National Taiwan University of Arts. Although using science and technology to create art, Lin criticises technical civilisation and reclaims the importance of nature. This explains why a digital

1 More information about Lin Pey Chwen's work can be seen in her website: http://ma.ntua.edu.tw/labs/dalab/

rendition of the female body of Eve was chosen as the theme of the whole series.

"Quasi-skin" and "Post-religion"

Art, technological media, academic research and science have constructed an interdisciplinary curriculum that influence each other. At the same time, when technological art is analysed, it cannot be explored merely by focusing on technology and art. The cultural and symbolic meanings behind artworks, and their relationship with society, are significant points which should be interpreted when analysing a contemporary artwork. In order to incise in the technological, substantial and symbolical view of the artwork, I use "Quasi-skin" and "Post-religion" as this article's title to narrate Lin's work *Portrait of Eve Clone*. Quasi-skin has been created from the main technical operation of digital technology. Meanwhile, religion (specifically Christianity in this case) offers inspiration to artists. The religious theme is not visualised. As Lin transforms the religious theme into her art which does not predominately about the religion, this is why it is called "Post-religion".

Lin Pey Chwen's earliest work of *Eve Clone II* was created in 2006. Eve is represented as a perfect female without any body hair, as this is an unreal and quasi body created by the artist. It is a digital human situated somewhere between the real and the fake, between the organic and the inorganic. Lin has combined it with images of butterflies and pupa. Eve combines a human body, a butterfly's pupa and technological sound and light, and through the interaction between the audience and a computer program/screen, the butterfly becomes animated and starts to flap its wings. Under the colourful lighting effects and sounds, the artist has explored issues of artificial life and conflicting relationship between science and nature. Lin's 2010 version of *Portrait of Eve Clone* is different from *Eve Clone II,* in which Eve was inspired by the book of Revelation, 13:18. God prophesied that the mark of the beast, 666, will be marked on people's foreheads.[2] In *Eve Clone II*, Eve is a beautiful and attractive hybridisation of human and butterfly, and Lin indicates that the inspiration of this hybridity is from the impact of technology on people. The *Portrait of Eve Clone* series, exhibited in The Museum of Contemporary Art in 2011, expressed a sense of evil through the half-human-half-beast body.[3] It mocks the potential damage to mankind by technology,

2 An email correspondence from Lin Pey Chwen, received on 14th July 2011.
3 Lin Pey Chwen's solo show at the Museum of Contemporary Art, Taipei (MOCA) was on display on 24 March – 1 May 2011. More information about the exhibition can be seen in the website of MOCA: http://www.mocataipei.org.tw/blog/post/27206842

and reveals social restriction on the female body in an active and direct way.

In Lin's latest series of *Portrait of Eve Clone*, Eve's head is hybridised with many kinds of beasts through a use of the high technology of 3-D dynamic holograms. Then it is given different colours and the textures of minerals. The number 666 on Eve's head is shown in various languages, including Chinese, Japanese, German, Arabic, Egyptian and Hungarian. Through this work, the artist expresses the negative effects on humans resulting from the extreme development technology. The effects appear on different races and societies around the world. The skin of Eve, with its diverse textures and colours, displays several possible hybriditised forms of human and beast. Continuing the concept of the work Specimen from 2006, these portraits of Eve, which have been placed in black frames made of transparent acrylic material, are reminiscent of specimens of dead bodies. Nevertheless, Eve's eyes move and follow the movement of the viewer. These figures seem to be alive. The strange feeling between death and life is similar to the tension and unease between science (inorganic) and nature (organic) that the artist wants to express.

There are two basic ways in which the artworks could be analysed: through semiotics or through iconography. Lin's *Portrait of Eve Clone* in 2010-11 is suitable for analysis through iconography, particularly because before contemporary art, iconography, including the cross, Jesus' portrait and other religious symbolic figures, is often used by art historians to analyse religious artworks. Religious themes have long been expressed through art. This may be traced back to the time before the Middle Ages, via Renaissance and to the early twentieth-century period. Although contemporary artists seldom use Christianity as a direct source of inspiration, undeniably Christianity is still taken as a source of motivation and inspiration for creating art.[4]

Different from many classical artworks and artists taking Christianity as the source of inspiration, as found in western art history, the religious reference in Lin's works is more indirect. Lin has chosen Eve as the theme of the series. The figures do not have a strong religious colour. On the contrary, the artwork shows a strong sense of contemporaneity and is created with modern high technology. As a result of the viewer walking back and forth in front of the work, it appears to have a 360-degree image effect. The high technology gives Lin's Eve a modern feeling and Eve's figure is different from the feminine image in the Bible. Eve's quasi-skin shows various metal textures and the colours of minerals. It shines weakly, even against the dark background, so the image of digital skin reveals an uneasy, mysterious and strange feeling. The number 666 on Eve's forehead, written in various languages, retains a strong religious symbolism. However, like many works using specific images as artwork, the audience needs to understand the background of the images. This means that members of the audience need to have relevant knowledge to understand the symbolic meaning of the images, or they will easily become immersed in the visual effects of the technology of the artworks, thereby overlooking the meaning the artist wants to express.

4 For the history of Christianity and art, see: John De Gruchy. Christianity, Art and Transformation: Theological Aesthetics in the Struggle for Justice (Cambridge: Cambridge University Press, 2008).

Apart from the various appearances of Eve, made with 3D dynamic holograms, Lin created an artwork which used interactive images to show her imagination of Eve, and this piece is entitled *Eve Clone III*. Lin presented Eve by combining different mineral colours and textures with interactive images, which is a technology in which she excels. When the viewer moves in front of the artwork, Eve's appearance appears to change continuously. Sometimes the image shows the frontal view, sometime the back, and sometimes the image appears to be turning around. After Eve turns around, the image moves up and down as if it will jump out of the image. *Eve Clone III* was shown with six interactive projection devices when it was exhibited in The Museum of Contemporary Art. Lin used 3D computer animation technology, kinetic sensors in an interactive computer system to create the newest, yet most shocking Eve Clone image. This work takes flowing water, light and shadows as the background. Eve's appearance continues to change with the movement of the audience, while the reflection from the water and the light also changes. The changes to Eve's image result from people's interference, fitting in with the interaction between humans and technology that Lin wants to express. The relationship of ambiguous, mutual influence and blindness is what the artist emphasises -God created Eve and humans created the Eve Clone. The Eve Clone image is the result of human creation through technology. The strange beauty of the Eve Clone reflects the negative influences of artificial and technical civilisation on nature. In the meantime, Lin wants to express the strange characteristics of Eve through a mix of human and beast, and the evil symbolism of the number 666 in Christianity. This work has achieved a stronger effect than that created by the 3D dynamic hologram.

According to the Bible, the mark 666 appears both on Eve's forehead and on her right hand. Therefore, Lin has created six pairs of hands, using a range of materials and colours, which she has placed in the type of glass bottles which are used to store organs in a hospital. This work is called *Eve Clone Hands*. These six pairs of hands were made with gold, silver, copper, iron and kaolin, using different textures, such as snake skin, pupa, industrial parts, shells, wood, etc. The "Quasi-skin" of the hands was created in a complex way. Firstly, Lin made sculpture moulds and then transferred the work into transparent resin. Specifically, the artist arranged blue-green lasers and bubbles on the hands in the glass bottles in order to make them more mysterious. The natural thing (the hand of a human being) created an unnatural thing ("Quasi-skin"). Looking closely at the hands with their strange texture and images, it seems that they symbolise the same concept as Eve - a body which is a mix of human and beast. Eve's quasi-skin expresses three-dimensional space in a two dimensional way through 3D hologram technology. The hands were originally shown in a three-dimensional way, and having been placed in glass bottles, they express the properties of a specimen which is similar to how Eve is portrayed.

Although the mark on the six pairs of hands is 666, for the same as on Eve's hand, in this case it does not have a strong and direct religious symbolism. The mix of sculptures of hands and Eve portraits is the concept of the quasi-skin. The latter mimics the different colours and materialised skin of females through the use of high technology. The former shows different skin textures within a sculptural concept, and then it is animated with a

strange feeling between death and life with laser light and bubbles. Although Lin's work does not narrate skin culture and its symbolic significance, nevertheless, the skin's symbolic references in the work cannot be ignored. Although human skin is either rough or smooth, it is simultaneously both alive and dead with an ability to recover and reborn. The biological characteristic conforms to the one Lin wants to express - a natural thing created by scientific technology and an organic life created by inorganic technology.

The French artist and theoretician, Stéphane Dumas, asserted the concept of the "Creative Skin". She pointed out that creative skin could be a metaphor through which we reconstruct the world. The skin is between the outer world, the human body, a body referring to multiple identities and a sensory body.[5] By computer technology, Lin has created a fake quasi-skin for Eve. It is a criticism of technical civilisation and introspection on the outer world. In Lin's Eve series, the half-human-half-beast skin of different materials is a reflection of how we are uncertain about reality and artificiality in the world.

In Lin's new work - *Eve Clone Fingers*, she has placed transparent resin finger sculptures into medical test tubes, and then exhibited them in black acrylic frames. Similar to Eve Clone Hands, Lin illuminated the fingers with green light, through which a strange feeling appeared from the dark frames and background. Through this new work, Lin wants to express how Eve is in the process of creation, which is both artificial and scientific, rather than natural. The artist proposes the importance of the concept of going "back to nature" through science and technology. Via the artificial Eve's inorganic genes, the work, relating to an ecofeminist perspective, again criticizes digital technology and artificial life.

In Lin's solo show held at the Gallery Grand Siècle in Taipei in August 2011, she exhibited three new works, *Mass Production of Eve Clone*, *Eve Clone IV* and The *Inspection of Eve Clone*. *Mass Production of Eve Clone* consists of 18 8-inch digital frames of Eve Clone, which were hung on a wall. Eve Clone spreads the fingers of her right hand and gently touches her breast. Her left hand is placed before her eyes, which are looking downwards. The 18 images show the same post-Eve Clone, but as with the earlier works, they are expressed with different colours and textures. At the same time, they continuously rotate through 360 degrees and are shown at different angles. The work is extremely similar to *Eve Clone Hands*. They are both soaked in liquid and placed in medical tubes or jars. As Lin points out in her artist's statement, for this work: "Mass production and normalisation represent the production process, by which it creates something which is completely the same as the original, using a cloning technique." Eve Clone's artificial and mechanical clone character is exposed in this work. Expressed through a neat presentation of 18 digital frames, it provides a metaphor for the artificial and inorganic life characters in a clone factory. It echoes with the concept of Lin's early work, Specimens.

Eve Clone IV could be an extension of the *Mass Production of Eve Clone*. It was shown with a huge interactive projector. With two synchronized projectors, the artist attempted

5 Dumas, Stéphane. 'The Return of Marsyas: Creative Skin' in Jen Hauser (ed). sk-interfaces: Exploding Borders – Creating Membranes in Art, Technology and Society (Liverpool: FACT and Liverpool University Press, 2008), p. 19.

to express Eve Clone images which were shocking, with several Eve Clone images being shown synchronously. Through a special-program operation, Lin showed an accumulated number, calculated in milliseconds, at the top of the images. The accumulation of the number began when the audience entered the exhibition space. When the audience left, the number automatically stopped accumulating and the colour of the image would gradually turn back to black and white. Lin has been criticising the confrontation between the artificial and the natural, which parallel and resist each other, since 1999 in works such as the Back to Nature Series. The transformation of numbers and images caused by the viewers in *Eve Clone IV* again responds to the artist's attempts during the past 10 years to represent artificial life. Furthermore, in this work, Lin used 6 different languages (Chinese, English, Arabic, Greek, Latin and Hebrew) to display the image of the woman who symbolizes evil in the Bible. The background music is similar to the visual elements of the work. It creates an uncanny atmosphere, therefore, when the audience walks into the gallery, they feel as if they are immersed in a surreal world. Eve Clone's beautiful but evil image, the continuously changing Bible scriptures and the uncanny music offer the audience a shocking and rare sensory experience.

This article takes Quasi-Skin and Post-religion as one of its main directions. It describes how Eve Clone's virtual Quasi-Skin expresses the symbols the artist wants to convey. Lin's work, *The Inspection of Eve Clone*, reveals the double concept of Quasi-Skin: that Eve Clone is constructed from digital skin and that the tattoos on her Quasi-Skin show the ambiguities surrounding body and technology. The tattoos include a rose, a dragon, a phoenix, a snake and a scorpion, which were specifically chosen by the artist. The patterns of tattoos connect to the idea of iconography which is addressed earlier in this article, and the tattoos relate to Eve Clones' symbolic connotation given by the artist. Both the tattoos and Eve Clones have the meaning of a "beautiful trap", while they both stand as a metaphor for an uneasy atmosphere with violence and danger. *The Inspection of Eve Clone* is presented with digital prints, and shows different angles and different parts of Eve Clone's body with infrared rays. Lin marks the number, date, time and the artist's name at the top and bottom of the work, as if the artist is examining and diagnosing Eve Clone with a medical device. Lin points out that "the tattoo's pattern symbolises and reveals the hidden danger of the beautiful Eve Clone under the inspection of infrared rays." In other words, through the infrared rays, the artist reveals the negative symbolic meaning of Eve Clone's beauty.

Analysing Lin's recent works, it is not possible to separate religion and faith from her art. For Lin, her religion and faith is at the root of her art. The connection between religion and fine art practice is not difficult to find in many contemporary artworks, including Buddhism (e.g. Southern Korean artist Nam June Paik's 1981 Buddha) and Islam (Islamic-American artist Dhirin Neshat's series of Islamic-themed photographs and images.) Although the image 666 has strong Christian symbolism, it is not appropriate to analyse Lin's works in a religious way. In terms of aesthetics, techniques and the professionalism of their construction, her works surpass any religious meanings of the images. The Quasi-skin and the symbolism of being between death and life, in addition to the strange, dreamy and

unreal feeling of Lin's works are the unique characteristics of The Portrait of Eve Clone Series.

夏娃克隆手　Eve Clone Hands

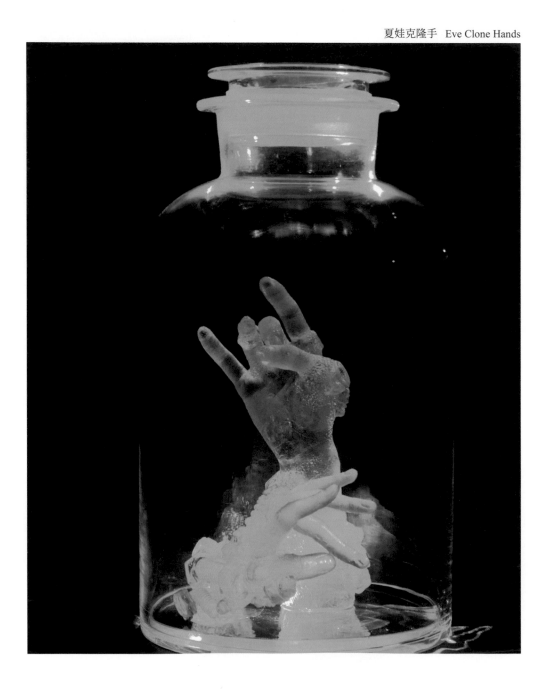

The Birth of Eve Clone
Technological Satire of a Genetic Reproduction Laboratory

Tseng, Yu-Chuan | Artist, International Art Curator

"Art Appreciation", 2011

In 1999, because of 921 earth quick, Lin Pey-Chwen received God's inspiration. She turned her creation's theme from gender, culture and society to human caring and nature. In recent years, she deeply explores the mistake that human try to play God's role within genetic reproduction technology. This series not only shows female's special caring character, but also turns the view from individual to multitude. In a position of nature's mother, it explores symbiotic relation between human and technology and between human and nature. She puts this relationship into her creating. This article will take Eve Clone as the main body and explore the series' concept and conscious.

In Lin Pey-Chwen's work Back to Nature series, she turns many natural lives into unreal things, as the artificial landscape made up of artificial sky, grasses and flowers in 1999 *Substantial Life*, *Treasure*, 2004 *Flower Pillars* and *Flowers But Not Flowers*, *Chrysalis*, *City Matrix*, *Specimens* and *Virtual Creation*. The atmosphered and individual control space attract the audience to become the butterfly's creator via touching and wiping. The audience joins the ceremony to complete creating life. In 2006 *Eve Clone I*, butterfly woman Eve Clone was born. Though these lives look like they have lives, they are produced by the artist and the audience's control and participant.

Differ from a butterfly's beauty and colorfulness, Eve Clone is colder. In 2011 Eve Clone Series Lin Pey-Chwen Solo Exhibition in Museum of Contemporary Art, Taipei, Lin Pey-Chwen created a genetic reproduction laboratory. The museum's cold and lonely atmosphere attempts the audience to enter the laboratory and imagine the creating process, but it only see dismembered *Eve Clone Hands* preserved in specimen glasses and *Portrait of Eve Clone* in frames.

With a wired and cold smile and female's elegance, she is Eve Clone made by Lin Pey-Chwen, but who is Eve Clone? Eve in the Bible is the root of trouble. According to Genesis in the Bible, God used earth's mud, following His own image, to create the first human in the world and named him Adam. Then God took one of Adam's ribs and created Eve. In Genesis, it is written that Eve was called by God and came to Eden, using the right hand to command new life to walk to new lives. The two were naked, holding hands together and walked in the garden. They were immersed in flowers' fragrance and birds' sounds and showered in the lively land. They fully enjoyed the peace and happy world God had gave

them, but Eve forgot what God repeatedly reminded—if hungry, all the fruits in Eden could be eaten, but they could not eat the fruits of the tree of the knowledge of good and evil. Eve was tricked by a snake and ate the forbidden fruit and she wanted Adam to eat it. At the end, God sent them out of Eden and made them burden human original sins.

Lin Pey-Chwen's Eve Clone is a species born in an unreal genetic reproduction laboratory. Purely looking at Eve Clone's face and facial expression, she is a beautiful woman with a smile. She has special hair decoration. The beast mark 666 on her forehead is slightly seen, but it will not ruin her beauty. In *Portrait of Eve Clone*, Eve Clone's head image is imprisoned in a time and a space. Her deep eyes follow the audience and see. In *Eve Clone Hands*, Eve Clone's various material hands are preserved in specimen glass jars, as snake skin, tree skin, pupa skin, shell or mineral. It shows that Eve Clone is an inhuman species. In *Mass Production of Eve Clone* and *Eve Clone IV*, finally the whole body of Eve Clone is created. These portraits' material and the scales and joint on her back show clearly the beast character Eve Clone has. *Inspection Perception of Eve Clone*, in a transparent way, it shows the hidden tattoos or patterns on body as rose, dragon, phoenix, snake or scorpion, highlighting the evil symbolic meaning of the beast mark 666 written in many countries language sealed on forehead. Lin Pey-Chwen's Eve Clone is not only a production made by genetic technology. She burdens the sins of genetic reproduction technology and becomes a woman with the beast mark. Furthermore, she symbolizes the satire to human arrogant technological achievement.

After British Roslin Institute used clone reproduction technology to create the first cloned sheep Dolly in July 5 in 1996, the world was shocked, but it also declared that biology is entering to another field. In 1989, NIH (National Institute of Health) established National Human Genome Research Institute, which is hosted by the discoverer of the double helix structure of DNA James D. Watson. In 1990, it started the making sense of the sequence of genetic project, which is lead by America, Britain, Germany, France, Japan and China. There were total 18 countries to participate the work of making sense of the 30 million DNA sequence of human genetic code, the work of making sense of genetic nucleotide sequence and the work of distinguishing all the functions of human gene. In 1998, Craig Venter established the first private company of human genome project—Celera. In 2001, Celera and the human genome project announced human genome sequence in science magazine Science and Nature. Human genome sequence was decoded. Ever after, scientists could accept order, connecting different DNA chain, recombining new genetic material and create new species. By technology, human become God who own the power to decide and change life form, controlling creatures' gene and do hybridization, mutation and clone.

Lin Pey-Chwen's works, from butterfly to Eve Clone, these two species seem different, but they both symbolize human arrogance, irrational attempt to change, copy and replicate nature with technology. In the unreal genetic reproduction laboratory, Lin uses the hybrid beast-human to metaphor that clone technology is to mate human and beasts. It is human abandonment and corruption. The hybrid shows the warning in the Bible and echoes with western myths and biblical paintings, as the mouse-head human, deer-head human and

fish-had human in Hieronymus Bosch's (1450 ~ 1516)work. In Masolino (1383~1447) and Van Der Goes's (1440~1482) painting Original Sins, the snake-head human represents evil. Though the hybrids in those paintings are minor actors to strengthen the story, they are greedy and immoral human. Through creating, artists warn that human immorality will make human become demon and half-beast human. In the end, they will devour and destroy each other. Through deep and ambiguous riddles and symbols, artists warn that human will lose humanity and future if they don't introspect.

German philosopher Heidegger was aimed at technical philosophy and asserted Essentialism. He thought only through understanding the relationship between human and the world can people realize how the existing world inspired by modern technology reveals itself, and realize the essence of modern technology. Lin Pey-Chwen's works represent Heidegger's Essentialism. In Lin's works, she used digital media as tools to deconstruct and criticize technology, controlling viewers' sense of sight, constructing a beautiful but unreal palace. When viewers are immersed in the work, attracted by the work's beauty, controlled by the work's issue or confused in their imagined world, all captivation echoes with that Lin criticizes technology via technology in her works.

夏娃克降手　Eve Clone Hands

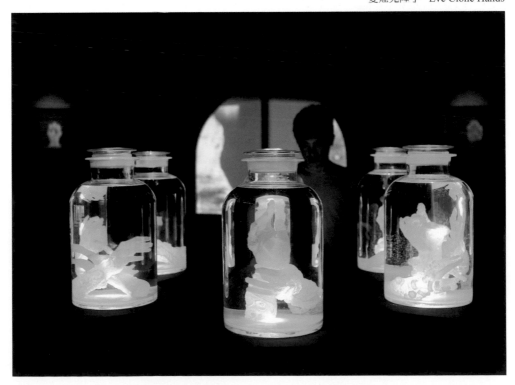

The Transgressions of Aesthetics
Lin Pey-Chwen Eve Clone Series

Wu, Chieh-Hsiang | Art Critic, Art Professor

God's Creation, The Devil's Sculpture: Aesthetics of Pretense

Throughout history, excessive obsession over the body and the desire for eternal life has led humankind to pursue the artificial alteration of themselves. According to historical accounts, Emperor Qin Shi Huang sent agents to the east to search for the elixir of life. Later, Emperor Han Wu also roamed the lands to find the potion of immortality. Dongfang Shuo, Grand Palace Grandee to Emperor Han Wu, drank the potion of immortality in one gulp before it could reach Han Wu. Outraged, Han Wu ordered Dongfang's death. Dongfang laughed and told Han Wu that if he really believed in immortality, how could he order Dongfang's death? The illusion of immortality has become the inspiration for the irony of human nature. The Fountain of Youth in Greek mythology represents humanity's everlasting desire and imagination regarding innocence and youth. An example of artwork that is based on this imaged topic is Hieronymus Bosch's The Garden of Earthly Delights (1504), which depicts an imagined setting where happy, naked, young men and women bathe in a fountain together, and , during the 15th century, Spanish explorer, Juan Ponce de León, even sailed to South America in search for the Fountain of Youth. Myths about the Fountain of Youth also spurred the creation of many Christian prophetic artworks, often in the form of church murals. Such works often depicted naked, narcissistic men and women who were obsessed with their bodies and lived a hedonistic lifestyle that went against all Christian principles. Prophesies about physical indulgences do not have to be presented with demonic expressions. With today's advances in biotechnology and plastic surgery, people have already proven that their desires are capable of inspiring the devilish reengineering of their body.

Lin Pey-Chwen's digital artwork consists of either perfect, beautiful people or alien-like beings. Her "Eve Clones" are an extension of the Bible's "Mark of the Beast." With the combination of "Eve" and "Clone," Lin's works predict the dawn of a new generation for human-made life forms which will mark the end of natural proliferation. Artificial humans, artificial-artificial humans, and humans created by artificial-artificial humans... As a result, an unpredictable cycle will be initiated. What is the goal of creation? Who controls this creation? This is a paradox that has no answer. The ultimate destination of genetic engineering is referred to as a vacuum in ethics.

Able to reproduce itself asexually, Eve Clone is a product of science. She is held captive by her creators in a virtual world. The artist plays the role of a witch who experiments with magic spells to train and harness the charms of the asexual Eve. Drawn into a world of experimentation and science, she also plays the role of Victor Frankenstein in Frankenstein, overstepping nature's boundaries to create lives that do not stem from a sacred origin.

Through genetic engineering, regeneration, life extension, and aesthetic medicines, cloning and re-creations are an extension of our desires. With trepidation, humans are dazzled by the endless possibilities of science, which can answer their insatiable lust for beauty and yearnings for everlasting youth. This propels humanity into unknown territories. Within the imaginations behind Lin's work, Eve Clone, technology subverts the natural cycle of life to embark on seven forbidden journeys. Humanity's actions, God's traces, and the devil's pretense mix together chaotically. As a result, our sins and virtues cannot be judged.

The Satisfaction of Controlling Technology: Fiddling with Aesthetics

The advance of cosmetic surgery, beauty services, and the weight-loss industry caters to those who are not satisfied with their body. However, humanity is casted into the anxiety of "perpetual enhancements." French feminist artist, Orlan (her original name is Mireille Suzanne Francette Porte, 1947~), creates works that transform her own body. By undergoing a series of plastic surgery procedures, Orlan changed her appearance. This included liposuction, rhinoplasty, and cheek and lip fills. More strikingly, she also had her brow bones protrude from her forehead to make her look more beast-like. During these surgical operations, she would record the processes, which later formed her work, Reincarnation of Saint Orland. She also performed custom shows, for which she would pose like a Catholic statue of a female saint with an exposed breast. With her altered body, Orlan would pose as a statue to subvert sainthood, obscenity, spirituality, and flesh. Through invasive surgical methods, she showcases humanity's desire to manipulate their bodies. With our reluctance to part from our obsession with beauty, people become apt at being trained and self-trained in a world of science and aestheticism. This causes our desires to run wildly and uncontrollably. We lose our yardstick for measuring beauty as a result.

The interaction found in the works of Eve Clone alludes to a sense of total control

and submission, and of being stared at or examined. The image of Eve shifts to face the audience at every angle. Viewing the work from every angle along 180 degrees, the audience would see Eve Clone's face from each side, revealing all of her different expressions. Some expressions are shy, while others are seductive. In the frame, Eve resides not as a passive doll that is "being watched," but as a flirting temptress. Drawing from the Bible, Lin creates many expressions of Eve to represent temptation. With Eve Clone's line of sight on par with the viewers, the audience gains control over the interactive aspects of the work. It is also Eve Clone's monitoring device. As always, Lin's works explore the truth about technology and aesthetics. At the Eve Clone exhibition space, images of digitally-created, perfect, and beautiful people are presented that tease us, the viewers, who are bound to our mortal bodies. Under the unreal and interactive environment, hosts and visitors exchange position. It also predicts the future that human is taken place by technology. Extending Lin Pey-Chwen's exploration to technology and aesthetics, at the exhibitive space, the extraordinary beauty made by program treats us as if she is teaching us, who are with heavy body.

A Complete Replacement in a Virtual Realm: The Temptation of Aesthetics

Regarding obsession with immortality and youth, Patrick Süskind's recent novel, Das Perfume, tells the story of a male perfume apprentice who begins to stalk and murder virgins due to his search for the perfect scent. It has also been made into a movie. The apprentice soaks the bodies of the murdered girls in liquid to extract their scent. His obsession for beauty turns into a gruesome and perverted experiment. Although he was able to preserve "beauty," his sense of humanity was lost.

In "Eve Clone," the notion of a biological specimen is exaggerated in terms of form and concept. In Lin's works, a specimen is a means of preserving as well as visualizing a species' mutation process. The specimen transcends the context of medical preservation. The specimen for "Eve Clone" is not a record of a living organism from the past. Rather, it is the beginning of a new form of life. Genesis and the Big Bang are no long abstract or conceptual. Humans are no longer passive and at the mercy of nature. Now, human can create, plan, and control their own appearance. This specimen arouses our superficial desire for beauty. With the drive for this desire, people have transgressed some norms - perhaps, the order between species, the human-make-human power or God's law. With medical science and imaging technologies, human can create and change life, as well as create virtual and alternative worlds. We have become creators. With this, a shift in the relationship between reality and fiction has occurred. "Eve Clone" is a "prophecy for a virtual world" or a "predicted virtual world." With these two assumptions, art is used to hint at an upcoming future. Virtual and artificial images are replacing our perceptions about life. The perfection of digital images is substituting for our drive for life.

On the ceiling of the Sistine Chapel, Michaelangelo interpreted the creation of Adam through the hand of God, which did not necessarily need to be in contact with Adam. Durer used a style similar to Christ's gesture to paint a self-portrait. In the context of iconology,

the hand represents the creative powers of God, His blessings, and mankind's talent. A branded hand highlights humanity's final imaged destination. With the advances of technology, people still have to take responsibility for their creations. There is no protection and no Promised Land.

When Lin mentions the bubbles in the containers for the glass specimens, we can think of Neoplatonism's Emanationism. When Creationism was debunked, people could still rely on Emanationism to explain the world and its various degrees of good and evil. The glittering and translucent, transient bubbles carry our waving sense of aestheticism regarding of life.

The Transgressions of Aesthetics

The prophecy constructed by "Eve Clone" is like a palindrome: aesthetics drive technology, and technology creates a new aesthetic standard. It once again pushes technology to develop and reform. Within this prophesied world, species do not breed or reproduce for the sake of interdependence. Rather, there exist only selfish instincts without an ultimate direction. Lin uses Eve to tempt us into this virtual, futuristic space so that we may experience the swing between human desire and the devil's incitement, the dialectical debate between God's will and people's interpretations. In Eve Clone's view, we are not just all prisoners of aesthetic temptations, but also accomplices of aesthetic transgressions.

夏娃克隆肖像 Portrait of Eve Clone

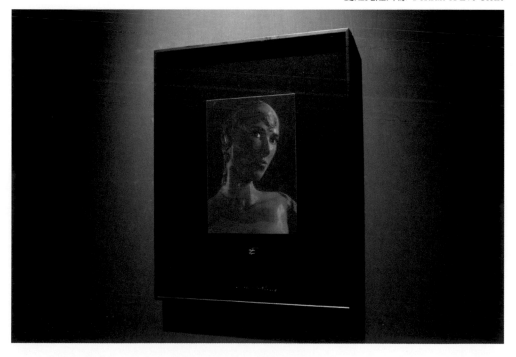

Alien Beauties
The Haunting World of Pey-Chwen Lin's Eve Clones

Antoanetta Ivanova | Art Critic, International Art Curator

The space I am entering is eerily cool and dark, pierced only by the green glow of laser lights. From the portraits on the walls flirty eyes stare in my direction. At the center, set in tall medical jars, are six sets of transparent hand-casts reaching upwards with animated gestures. Finger-shaped objects are presented meticulously in elegant display cases near by. The sound of bubbling water lingers from another room. It is easy to imagine there might be formaldehyde in the air. A sense of unease begins to pervade: what kind of perverse alchemy is taking place here?

For the alchemist at the heart of this solo exhibition, Pey-Chwen Lin, the philosopher's stone is not the promise of the elixir of eternal youth but rather it is the pursuit of eternal beauty gone sinful and the transmutation of materials gone wrong that are being examined. The collection of a new body of works Lin is presenting to us posits a vision of Man's unrequited desire to manipulate human flesh verging on evil.

Pey-Chwen Lin is an established Taiwanese media artist with a long history of investigating the relationship between the natural and artificial in the context of human's attempts to control biological matter so that it can be fitted into certain ideals of beauty. For her solo exhibition she has done so using sophisticated technological means, elaborate casts of 'mutating' body parts and digital video with which to give form to her philosophical and artistic concerns.

Central to the exhibition is the series of portraits of clones of the Earth's first woman–Eve, as seen through Lin's eyes. According to Christian theology, after God created the first man Adam, God created Eve as the second human and Adam's companion. 'Eve' means 'source of life' and is regarded to be the 'mother of all living' [1] beings. Much has been written about the story of Eve. Author Pamela Norris even wrote her 'biography' in which she goes as far as arguing that our interpretation of Eve's Biblical role 'was developed to manipulate and control women' [2] as Eve is often regarded to be subordinate to Adam. Following Norris' theses, which challenges the place society has prescribed to Eve (and through her to women in general), Pey-Chwen Lin's artworks focus on problematising male desire to subject Eve

1 Genesis 3:20
2 Harris, P. Eve: A Biography, NYU Press, 1999

to stereotypes of beauty and perfection, which continue to be imposed upon women by the prevalent patriarchal belief system.

In art there are many examples of female artists who have dealt with this issue. Perhaps the most shocking is the work of French artist Orlan [3] who challenged the iconographic constructs of the Western ideals of female beauty created by male painters by using a radically new method of art-making: plastic surgery performance art. In her work The Reincarnation of Saint Orlan (1990-1993) she attempted to embody particular facial features of famous female portraits such the forehead of Leonardo's Mona Lisa, the chin of Botticelli's Venus, the nose of Gerome's Psyche, the lips of Boucher's Europa, and the eyes of Diana by the French School of Fontainebleau. To sculpt each facial feature Orlan underwent radical and very dangerous surgery. For the first time in art history she treated her own face as a collage. Not only that she also recorded and broadcasted the process. By showing what goes on in the operating theatre Orlan brought attention to the extreme manifestation of the hybrid self-portrait that modern science and technology are, both, imposing upon and enabling us to create.

Within this art historical context Pey-Chwen Lin is taking us even further into the dark chambers of biotechnology and genetic engineering by presenting us with disturbing visions of Eve's cloned identities signified by a series of faces, hands, and fingers made as erroneous copies of Eve's flesh. Pey-Chwen Lin states that in creating *Portrait of Eve Clone* series she wanted to encourage us to reflect on our overly developed civilization that, in her view, is the result of Man's fall from grace. The faces of her Eve Clones are both alluring and beastly with strange animal features such as skins, horns and bones pushing through the shiny metallic color of their skins. This theme is continued in the medical glass specimens of what appear to be severed forearms (*Eve Clone Hands*), as well as a series of finger casts, which allude to Eve's mutating body. The surface of some of the specimens has animal skins, tentacles and bones contained within it. One set of arms has pieces of industrial machinery pushing through their flesh while another looks more as if it is emerging from rock. The '666' characters written in different languages are inscribed throughout the

3 www.orlan.net/

works. For Lin these numbers symbolise 'obstacles from which all races and peoples cannot escape'.

Looking at the Eve Clone portraits is like looking at ghostly faces staring from the dressing mirror late at night–seductive and spooky at the same time. Their hollow eyes follow us wherever we move in the space, an effect Pey-Chwen Lin has achieved through the application of holographic Techniques. Holography is somewhat a mystical form of art practice traditionally concerned with the creation of illusions of presence that can enrich our visual experience of time and memory of the subject recorded in the hologram. What is unique about holograms is that they are made of light and therefore lack material substance. Essentially the light emitted from an object is recorded and through sophisticated scientific and technological means it can be reconstructed so that it can create an optical image of that object. Characteristic of holography is the illusion of three-dimensionality, which presents an image that can shift and change depending on our position to it–in the same way as if it were a real volumetric object viewable from different angles. Australian holographic artist Paula Dawson describes holograms as being like 'mental images and, hence, lend themselves to being associated with internal representations of reality'.[4] Thus the aesthetic critique of holographic art primarily focuses on its mimetic qualities—how well the optical illusion of an image imitates reality.

Within this lies the paradox, and the technical sophistication, of Lin's holograms–they are illusions of an already immaterial virtual reality. Pictorially, the holographic imprints of the Eve Clones are alien faces created digitally in a 3D virtual space. The extremely high resolution and spatial fidelity—the faces appear to turn corresponding to our movement in front of them including the highly challenging to achieve full head turn—are created to suggest the actual presence of Eve in her various stages of cloned evolution. There is an attempt to tell us that her existence, her 'presence', is real albeit she was born virtual.

The concluding work in the series, *Revelation of Eve Clone*, is a large interactive installation of six moving image projections of a life-size female figure, slightly curled up inside a liquid-filled glass container that rotates gently on its axis. Its right arm rests on the heart area, covering the chest, while the left is shyly lifted up towards the face as if to shield its gaze from onlookers. Starting from left to right a copy of the first image is repeated sequentially, with each next version being delayed in time from the previous one, thus, alluding to a process of cloning.

The installation set up is intimate though sombre. The acoustic space is filled with sounds reminiscent of religious incantations. The atmosphere is almost chapel like. But what is it exactly that is to be worshiped here? The figure is neither that of a woman nor a beast but of some mutant creature—at once repugnant and alluring in its strangeness. The ray of light illuminating its presence: an artificial one.

4 Dawson, P, Mirror Mirror, artist exhibition statement, College of Fine Art, University of New South Wales, 30 April 2004

Drawing inspiration from the Western Christian view of Eve as the 'great prostitute who sits on many waters, with whom the kings of the Earth committed sexual immorality' [5] and whose waters became 'peoples, nations, and languages'[6], Lin presents a life-form created not through the original but a new techno-scientific sin. The Biblical flesh-and-blood body of Eve—the one whose primordial functions of carrying life and giving birth are uncontrollable and, thus, were to be feared—is taken over by a new body: a slippery, porcelain like, artificially made-to-order and fully containable Eve Clone.

Pey-Chwen Lin's art work brings us alarmingly close to the heated debate about the value of genetic determinism promulgated by the biotech industry. In 2003 the thirteen-year long project of mapping and sequencing the entire genetic material that orchestrates the chemistry of human life was concluded. Known as the Human Genome Project [7], this massive undertaking manifests humanity's quest to know the building blocks of what makes an individual human being. Each cell in the human body carries a master script that determines its development and function. This biological code is organised in genes arrayed sequentially along chromosomes. Genes take millennia to develop in response to many environmental factors, and are passed on from parent to child.

After the conclusion of the Human Genome Project much of the information was transferred to multinational corporations with vested interests in the medical industry. While the potential health benefits of one day being able to 'switch off' faulty genes are real, the very cloning of biological human matter posits deeply concerning ethical and moral questions: who owns and controls individual genetic information; who should have access to it; how will it be used[8] , and so forth. Some might say that already there are genetically modified organisms circulating the food chain, so why stop there. Why not allow the existence of genetically enhanced humans?

In *Revelation of Eve Clone* the moral dilemmas of the future nature of life are narrated through embedded Biblical texts written in Hebrew, Latin, Greek, Chinese, Arabic and English. To Lin the languages signify stages in the evolution of humanity: religion, culture, philosophical thought, political might, and macro-economy, within which there is always the seed of evil.

Furthermore, the urgency of Lin's revelations is made even more palpable by the display of a real time computer-generated numbers running along the top of each of the projection screens. Upon entering the installation space viewers trigger the counter meter and the numbers begin to accumulate, always presenting us with the most current chronological time. This encoded time emphasises Eve's artificially supported existence. The experience is enhanced by the changing colours of the work, which shift from grey scale when there is no one in the space to luminous sepia hues when our presence is detected. Periodically a Document of Eve Clone Revelation is produced as evidence of Eve Clone's vital status.

5 Revelation 17:1-2, The Holy Bible, The Bible Societies, Hong Kong, 1966
6 Revelation 17:15, The Holy Bible, The Bible Societies, Hong Kong, 1966
7 For extensive information see www.ornl.gov/sci/techresources/Human_Genome
8 Ibid.

Throughout the entire body of work—from *Portrait of Eve Clone* series and *Mass Production of Eve Clone*, in which eighteen versions of Eve Clone are displayed in a palette of techno-colour hues, to *Revelations of Eve Clone*—there is a persistent and pervasive questioning of Man's desire to play God, to control nature (and the female body as the Biblical source of life) in accordance to his own interpretations of it. But is this techno-scientific way of thinking not actually pushing us toward some great, irreversible harm: the end of the world, perhaps?

The overall aesthetic of the entire collection of works is reminiscent of the cold 'bio-mechanical' renditions of merged human bodies and machines seen in the works of Swiss artist H.R. Giger [9]. Perhaps best known for the creation of the science-fiction scenes and characters of Hollywood's blockbuster movie ALIEN, Giger's style evolved the surrealist art tradition into a late 20th century visual vocabulary of sleek, often scary or sickening imagery of alien bodies—a dark vision of humanity overtaken by machines [10]. Pey-Chwen Lin's art extends these aesthetic approaches into the of 21st century by presenting us with a vision of genetic engineering and the merging of biological and artificial systems whereby the potential for error, while tampering with nature, can be truly frightening. Take these art works as a warning: despite all of humanity's technological and scientific advances we remain mere mortals. Eve's biological state of being is sacred to the continuation of humankind.

9 www.hrgiger.com
10 Petros, G., 'The biomechanical surrealism of HR Giger', Juxtapoz, 2001

夏娃克隆肖像 Portrait of Eve Clone

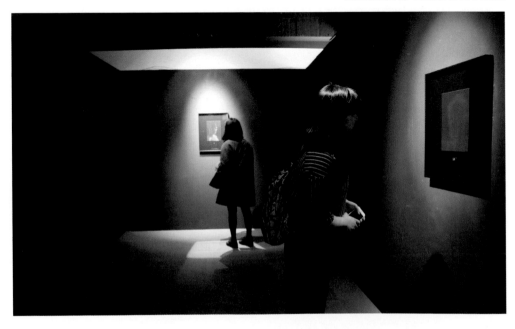

Pey-Chwen Lin
Portrait of Eve Clone

Susana Pérez Tort | Art Historian

Portrait of Eve Clone as Mankind metaphor

In order to approach the meaning of either work of art, we find it necessary to traverse the solid wall which isolates the individuality that all humans - and particularly artists - use to build around their Self. Languages and words may serve as bridges allowing the spectator to get inside that invisible barrier. The work of art, if understood as a geometrical prism, will show different sides and edges to the spectator, and every one of them will project a different meaning, a different interpretation to the one who regards from divergent points of view and criteria. Even despite the fruitful and multiple semantic routes the work of art may propose, Art is actually the best ambassador an artist may have to explain himself before its public.

If we dare to "understand" this Solo Exhibition - Portrait of Eve Clone - with the purpose of following the inner thoughts of the artist, we may have to find a way to get inside the creator's mind and look for a door, opened on the surface of the imperceptible wall surrounding Lin Pey-Chwen's individuality. This door might enable us to approach her ideas, thoughts, believes and feelings. It will not certainly be the legendary Wu-Word- Tzu painted gate which opened with a clap of his hands and let him disappear through it. Lin Pey-Chwen does not propose nor need to leave the room where she shows her Eve Clone's portraits and Eve Clone's hands. Every great work of art, like the one by the old legendary Chinese Master, shows a loophole that may open in order to let the spectator escape from the mere visual spectacular High Technology 3D Holograms and beyond the "mere" technological show, approach the idea which gave life to these series of holograms and only then face the actual purposes of the artist.

Struggling to find a path to Lin Pey-Chwen's exhibition and with the intention to find the "magic door", we come across several words which may serve as keys: One of them is paradox. The more dangerous enemy of any work of art is the commonplace. In this particular Solo Exhibition the commonplace could be the highlighting of the outstanding technology in front of us. The commonplace could be the surprise the spectator may be confronted with, when moving his head slightly from one side to the other in front of the "canvases" in order to see how these astonishing "portraits" seam to move inside the framed surfaces framing the portraits, which seem to have been shaped with water.

Nature. Water.

The original fluid within the mother's womb, conceived as Nature mater piece, to protect the life to come. But Eve was not blessed with the grace of a Mother; though shaped by God, she was born out of the material of one of Adam's ribs.

When attending an exhibition, like *Portrait of Eve Clone*, a winding road rises in front of the spectator and images give life to ideas that places him inside a labyrinth. , then this Solo Lin Pey-Chwen's Solo Exhibition – Portrait of Eve Clone - enlightens a celebration of art. We propose that this is the direction also shown by the artist in her series of portraits and Eve Clone's hands. The metaphoric language devised by the author in this opportunity, is an accurate example of her semiotic technology , as most of her former works are: attractive and biased mazes, inducing the spectator to find its center.

It was already said that some words are needed in order to guide us through the conceptual tissue of this show, so as to traverse the "magic wall". It is then when a second word shall led us to another corridor of the maze: we already mentioned paradox, the following clue word is Eve, ten portrait, hand and last but not least the word clone which consequently includes Nature and Artificiality.

Eve Clone

According to Lin Pey-Chwen's manifesto, the series of Eve Clone's images – portraits and hands - are rooted in the Judeo-Christian biblical tradition of Adam and Eve in the Garden of Eden. The Old Scriptures refer to these two creatures, created by God, who had everything at their disposal. They were both lords and masters of the Garden of Eden with the only condition that they should not try the forbidden fruit from the tree of Knowledge. It is Adam who bites the fruit; but according to the Scriptures, it is Eve who "seduces" him to do so. Are these Eve Clone portraits and hands a way to point out that Men (as Mankind) keep on eating from the forbidden tree? Are these Eve Clones preventing us from the monstrous possibilities artificiality may show ahead? Eve had no mother nor womb or Waters to protect her. Neither does artificiality, the opposite side of Mother Nature.

We may attend the spectacle of Eve Clones as we face cyborgs, beings who "subvert all the traditional modern dichotomies, such as human – machine, mind – body, organic – mechanical, public – private, natural – cultural, man – woman, life – death, reality – appearance and truth – illusion". Lin Pey-Chwen does not actually intend to perform a spectacular high tech show but invite the spectator, to face these creatures as looking back to the creature who was, expelled from the Garden of Even and read in these astounding images, the reckless future artificiality may bring along to mankind.

Lin Pey-Chwen's art work, as Eve Clone Solo Exhibition- is closely linked to engineering and High Technology. The artist shares her commitment to art with gender issues which are present – but never obvious - in her former productions. This awareness of women's second place in almost all cultures history is probably the source that inspired her to choose legendary Eve as a metaphor of Women, Men and Mankind. This first biblical woman

stands for is all women and all men.

We may wonder why Eve - who gazes the spectator from the inner space of her watery and lightened texture, -looks like a Western Caucasian woman. Eve is rounded eyes, white skin. Does the artist mean to say Western culture has finally sealed universal women imaginary? The oldest fossil found in Africa, belonging to the "first woman" on earth is supposed to have had black complexion, but Eve was never shown in that particular way. Western culture has depended on Chinese culture when Modernity gave life to its highest science and technological discoveries, yet Western women appearance has became the leading icon of beauty.

Eve is the subject of the entire hologram portraits shown in this Solo Exhibition, where Eve Clone's hands are included, assuming the shocking appearance of fragments of human wastes. Let's remember Eve was condemned to exist as a consequence of the previous existence of a man, as she was made of one of Adam's ribs, and condemned to be - from the first hours of her life - the incarnation of evil, as Eve is pointed as the one who tempted "innocent" Adam. Lin Pey-Chwen's gender philosophy is present when choosing Eve as the subject of her artificial creatures.

The artist also shows Eve as a pupa, slimy, waiting for the moment she may come to life, independent from her biblical essence as Adam's rib. Was she a pupa before being created? Thus, let us regret once again Eve Clone's motherless. Portrait of Eve Clone series is a brilliant quotation of Adam and Eve legendary birth, underlining the sexism of Eve Clone's biblical creation of Mankind.

Portrait

We have said there are words which may open the "magic door" in order to read "The Portraits of Eve Clone" as a text written in the Art Media Language by Lin Pey-Chwen. Now we shall consider the second clue: portrait.

Eve Clone's framed images become perceptible to the viewer as mutant holograms which assume the features of Western Caucasian woman. They are also shown inside the Western traditional art format of a portrait. We have already wondered about the reason why the artist might have chosen Eve as the subject of these series of works, as she has already done in former pieces of art, where Eve is also in a larvae state. We must now intent to answer why she has devised these Eve Clone's images in the Western portrait tradition. Framed portraits were created as pieces of art to be hung on walls and stand for a canonical Western art tradition. Disregarding Greek and Roman portraits which were not supposed to be hung and neither sold nor be labeled with a price, Portrait, as an art gender is born with Western Modern Renascence. It was disguised during Western Dark Ages, ruled by a Christian Church who considered portraits a sign of self pride. However, Western Modern Renascence shows a social turn with new behaviors and standards, translated to art. Along with the new paradigm, portrait as a new art gender, makes its brilliant appearance and enables to show on a canvas' surface, a realistic "clone" of the model, proudly displaying

the painted resemblance of the delighted art consumers: Italian or Flemish Signori or bankers, who posed before the great masters of the time. The realistic representation was also a characteristic of renewed Western Modern Art, which had at the same time developed science and technological devices in order to make possible painted "clones" of analogical reality. Portraits stand for Modern Men arrogance, Humanism and Anthropocentrism. We may then presume that Lin Pey-Chwen's choice to portrait Eve –surrounded by acrylic transparent frames – is an accurate quotation of the faux paint tables celebrated by Western Art tradition as a synonym of Men conceit. Western Renaissance imbricates art-science and perspective as a primal technology. Therefore, Lin Pey-Chwen's decision to show Eve "inside" framed portraits hanging on a wall, may cite Renaissance, but mainly underlines today's overflowing scientific and technological development, no matter the consequence and wherever it may lead Men to. Today's cyborgs, genetic experimentation and artificiality are in the threshold of a new technological, scientific, and social turn. Some scientist and artist– as Lin Pey-Chwen – need to express their concern.. The fact that this artist devotes her art work to High Technology devices, such as Eve Clones holograms, shown in the darken room of exhibition, that art is her actually her particular way to deal with this issue.

Eve Clone's Hands

The presence of Eve Clone's hands as a part of the exhibition – hands are kept in different vases, lighted, almost alive, artificial and looking like atrocious fragments of a Human body - add to the portraits series a second interrogant. Auguste Rodin, the distinguished XIX century French sculptor, carved a white marble's series of God's hands, showing the Creator in the process of giving shape to Eve or holding both, Adam and Eve, in the palm of his hand. Beautiful pieces of Western sculpture where God holds in his hand the treasure he has given life to. He quotes Creation as Lin Pey-Chwen's, hands, however Rodin's creatures do not seem artificial but plenty of sensuality. Far away from these white marble hands, Lin Pey-Chwen decided to confront the spectator with phantasmal greenish hands that lets the spectator suppose are Eve Clone's mutilated hands. There is no God or beauty present in the vases, but an amazing artificial world.

Artificiality

Previously to any reference to technological issues, it is important to highlight the characters which, as actors in a play, speak up the concepts that have given life to this works of art series. Therefore, beyond the High Tech Art Language devised for Eve Clones, it is important to question about Eve, in a first place, and there upon the reason why she assumes the format of portrayed clones giving way to the idea of Virtual Reality and artificiality. We may also wonder why these Eves bear a "666" on their artificial "skin", why they assume a metallic, synthetic texture and a somehow devilish appearance instead of the angelic resemblance expected for the first woman ever created, as understood by Judeo-Christian tradition.

Devised as 3D Holograms, "beautiful" Eve becomes a monster. Are these images a quotation of the disguised or ignored risks of using and abusing artificiality? We are not confronted with Eve Clone's portraits but with Eve Clone portraits, and they show artificial

colors, with artificial glow and artificial textures. Eve assumes the image of metallic, gelatin, inhuman creature.

Despite the consciously chosen redundancy of the subject, sizes and shapes of the apparent canvases, these works of art are, as have been said, widely far away from the common place. Lin Pey-Chwen has taken profit of the clever and subtle use of a creative resource of Language: the oxymoron, as in former works of technological art. An oxymoron is, in this case, to questions artificiality devising however, virtual sculptures.

It may be significant to mention that Shen Kuo was a Chinese scientist, the first to devise a light illusion, even before it was possible European Western culture. The artifact he created is now considered the ancestor of photography: the Camera Oscura, first step which made possible the capturing of the "magical" reflectance of light. We must notice Eve Clone Portraits's 3D hologram technique is based on photography.

We do not know if the "magic door" has been opened to the spectator, in order to fully enjoy the show. , but we need to say that the choice of 3D Hologram technique confronts the spectator with the outstanding "moving" images that follow the visitor as virtual sculptures. Images are not video recording and as 3D hologram they seem even more real than 3D video sequences. Beyond this accurate Hologram realization, the installation of Eve Clone's portraits – as already said, shown as Western traditional painted canvas hanging on a wall - question Technology out of the engineering of technology, dressed by a subtle irony pointing at human conceit, confronting nature artificiality. Western faux paint table, were created with the intention to give life to the illusion of a duplicate – a clone – of life. Lin Pey-Chwen could not do a better choice when deciding to frame her Eve Clones as Western traditional portraits. Her conviction that Humanity is following a dangerous chimera is once again translated to an art show where we attend to the experience of her meaningful Technological Semiotics.

夏娃克隆肖像 Portrait of Eve Clone

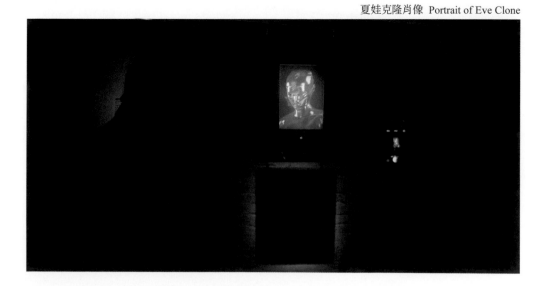

The Gaze from the Apocalypse
An Analysis of Lin Pey-Chwen's Portrait of Eve Clone

Pan, Cheng-Yu | Artist, Art Researcher

IMAG InSEA Magazine | Academia.edu

Introduction

This article discusses Lin Pey-Chwen's new-media artwork *Portrait of Eve Clone*, one of the pivotal presentations in Dancing with Time - Artists: 40 Years × Taiwan Contemporary Arts. The exhibition, co-organized by Kaohsiung Museum of Fine Arts and Artist Magazine in 2015 and based on Taiwan Contemporary Art Historiography: Artist Magazine 40 Year Anniversary Edition (published in the same year), presents the development of contemporary art in Taiwan over four decades. Listed as a pivotal artwork of 2011 in the art historiography and exhibited in one of the four main exhibition areas named "Trans-disciplinary and Unconfined (2005-2014)", Lin's work clearly occupies an important niche in Taiwan's art history. However, as far as the author knows, no in-depth and comprehensive analysis of each element in the work has been conducted so far. Therefore, this article attempts to take a closer "look" at her piece of work from this angle.

Starting from Signs

Portrait of Eve Clone is presented as a set of multiple portraits that marry human figures with exterior features of insects or animals, such as scales and bulged cutin. The foreheads of each portrait are carved with the number "666" in different linguistic signs. These lexicons take spectators through time and space and address moral issues. Suffice it to say, these lexicons, or symbols, are able to travel through time. To begin with, Eve is the well-known wife of Adam appearing in the first chapter, The Book of Genesis, in the Bible, and the forefather of mankind. Lured by the snake, Eve committed the "Original Sin" by eating the forbidden fruit, which would give mankind wisdom and the power to overtake God. In the work, the fine and flawless faces of the portraits that secretly reveal their mystic sexiness are reminiscent of that dangerous lure. On the other hand, the holograms constructed through cutting-edge technologies has laid bare the nature of the "lure": the highly advanced technologies in modern times.

Another intriguing sign is that Number of the Beast is marked in different languages on each portrait. In the Bible, Ancient Babylon is often used as a metaphor for human civilizations' characteristic of arrogance, obsession with development, and inability to control the outcomes. In The Book of Genesis, the ancient Babylonians once attempted to build the sky-high Tower of Babel to showcase their greatness. To stop these arrogant

people, God divided them into different ethnic groups that speak different languages. At last, the construction fell flat due to poor communication. Therefore, the doomed Ancient Babylon is often referred to as "the great whore that sits on many waters" "with whom the kings of the earth have committed fornication, and the inhabitants of the earth have been made drunk with the wine of her fornication." From top to bottom, people of the country succumbed to the mindset of endless development and became trapped. The "many waters" seated upon are in fact "many peoples, and nations, and tongues"[1] , meaning the vices spread across the world. Does it mirror our modern technological civilization?

Perhaps the forbidden fruit enabled technological development to trump faith. From the perspective of Marshall McLuhan, specialization has greatly divided human development, and has gradually detached the pursuit for knowledge from moral values. From the Romantic Period onwards, "The new Technique of control of physical processes by segmentation and fragmentation separated God and Nature as much as Man"[2] . Consequently, the tragic outcomes of greed and indulgence are manifesting themselves, as evidenced by global warming, smog, extremism and declining moral values.

The number 666 and the beast skin of the portraits squarely reflect those tragic outcomes. In the last chapter of the New Testament, "The Book of Revelation", a "beast" joins forces with humans in their war against God prior to the end of the world. Featuring seven heads and seven horns, this beast came to the earth and required those who had faith in him to mark "666" on their hands and foreheads. This mark is known as "The Mark of the Beast". Here, the artist combined the "beast" and "humans", as shown by the marked foreheads and the blended human / beast bodies. In addition, the Clone in the title inevitably leads spectators to think about cloning, animal organ transplant, and gene modification, among other highly-controversial technological issues. From the beginning of mankind (Eve in Genesis) to the end of history (the beast in Revelation), *Portrait of Eve Clone* travels through civilizations by way of parables in the Bible, unfolding the concerns over humans' inherent fetish for lust, as well as the pursuit of unchecked scientific development.

1 Revelation, 17:1-15
2 M. McLuhan, 1964: p. 191.

Image Reproduction Technology

The technology applied in the work is a developing yet revolutionary one called "holographic printing". Different from traditional photography, it does not use lens for "photographing" the object. In this way, only light from one direction can be taken in. By using sensitive elements, holography directly documents all information of the reflected light onto the surface of the object. The information is then fully reconstructed through film, hence holography. By observing holographic photos from different directions, we're able to see different angles of the object, thereby forming a three-dimensional view.

The Stealthiness of Subjectivity

The biggest difference between holography and traditional photography is that while cutting traditional photos, the picture would be cut subsequently, leaving only a partial image in the cut photo. On the other hand, no matter where we cut a holographic photo, the configuration of the captured object remains the same in whichever direction. The surprising effect is achieved in that each display unit of holographic photos preserves all image information of the object. Lin's holographic work reconstructs a complete 3D light field that exists "behind" the planar medium. Hence, the portraits in the picture are out-and-out replicas, unconstrained by frames.

During the 1930s, Walter Benjamin analyzed the artificial reproducibility of photos and movies, two new media in his time (See Walter Benjamin Essais by W. Benjamin) and reckoned that mechanical reproductions wipe off the "aura" of the original work – the mark of its unique existence. Nowadays, the prowess of "digital replication" has even taken the spread of images to another level where the existence of an "aura" is no longer a concern, insomuch as the objects in the picture often do not come from the real world. For example, the origin of a holographic bird on the credit card is no more than a 3D image without any reference to reality.

The new "problem" presented by holography is that it pushes the conventional pursuit of perspective effects in Western arts to its limits, creating a full reproduction of space. The most serious consequence is that this technology removes any predefined "perspective". Traditionally, the artist's perspective has been the key to a piece of work, be it traditional paintings, photography, or traditional literature. Holography challenges this concept. By creating a whole space, the artist deliberately shied away from the subjectivity of the view angle, making the forming of "perspective" fully dependent upon the interaction between spectators and the work. As such, it turns out that we could no longer interpret a piece of work from a single aspect. And this warrants the fact that interpretation must be multidimensional and open to different opinions- a dispersed, decentralized state that is similar to the nature of hypertexts.

The gaze

Next, we start from the author's visual experience, trying to dive into the core of the work. But can personal feelings be used as parameters? Phenomenologically speaking, a "sensation" is in fact the ticket to understanding matters. Edmund Husserl stressed that what

we should do has never been exploring the "fait" (truth) of matters. Rather, we can only get closer to the "essence" through clarifying the "phenomena". The phenomena, as referred to herein, means the way a matter presents itself within the flow of consciousness of the observer. In other words, the "vécu" (real life) that the observer experiences as subject isn't insignificant personal feelings, but the key to the existence of the matter: essence lies within phenomena. Though reality is beyond reach, we could perhaps sort out certain general principles from our experience to manifest the essence of the work.

While we're viewing the work, the figure in the picture looks back at us. This method has been applied in countless paintings from remote antiquity. The difference is that we must stand in front of this kind of painting to feel the gaze of the figure, whilst the gaze of the figures in Lin's work dynamically follows the spectators at all times, rendering the feeling of "being viewed" even more realistic.

Being viewed by the work, we couldn't help but approach the issue of "subjectivity", since viewing isn't possible without being a subject. In the case of this work, spectators, used to stand in a dominant position as a subject, have backed down, while the "subjectivity" of the portraits creeps into the relationship between the both through their eyes. In fact, we do not think that the virtual portraits really have what it takes to become subjective; rather, we use the eyes projected by the work as clues to lead us to the subjectivity on "the other end": the artist herself. Through the incarnation of the creator (the portraits' eyes), we hope to get a glimpse of the artist's position and intentions.

The eyes also conjure up an intriguing experience of mine. One time I was snorkeling around the outlying islands of Taiwan. At that time, not a soul could be seen in the ocean, and I was enveloped by an expanse of murky water. Suddenly, a giant fish appeared right before my eyes and stared silently at me. The tremble I felt at that moment continues to haunt my mind until now. Viewing is a subjective act. In contrast, being stared at by a stranger is downright uncomfortable. As I looked closely at Lin's work, this kind of unease set in again. Holographic printing is dependent upon changes to spectators' viewing angles. By skillfully utilizing this property, the artist makes the figures in the work "follow" the spectators, thereby successfully creating an unspeakable uneasiness.

In addition, the mysteriously profound expression of the figures confounds anyone who attempts to interpret their eyes (she? he? or it?) as they seemed tender but persistent, showing no apparent evil intention; yet not a trace of goodwill can be felt. They are a lure, a ghostly confusion. Surprisingly, the slightly upturned mouth and the calmness makes me feel that these figures have, in an eerie way, some kind of anticipation, understanding or sympathy of our meeting. The gaze comes from an "other" that is strange, justifiably handsome, androgynous (even if it is named Eve by the artist), orc-like, and with vague roots and intentions. Moreover, it is "fake" and virtual.

But how do the eyes of virtual figures create such sensations? Perhaps it wasn't all my illusion. Rather, it is probably because of the viewing attitude towards the masses, the applied Techniques, and herself, adopted of and by the artist, that have been hidden behind

the screen of creation. Through the work, we see that the artist, as an "other", gazes from "there" to "here", an act that is neither human nor realistic, indicating the stance the artist has taken as an outsider. Without the stance, art would never become critical.

References
· Benjamin Walter, "L'œuvre d'art à l'époque de sa reproduction mécanisée", 1936, rééd. In Écrits français, Gallimard, Saint-Amand, 1991.
· Husserl Edmund, Ideen I, 1913, §50; trad. fr. P. Ricoeur : Idées directrices pour une phénoménologie, Paris, Gallimard, "Tel", 1950.
· McLuhan Marshall, Understanding media: the extensions of man, 1964, Reprinted., London, Routledge, coll. « Routledge classics », 2008.
· Saussure Ferdinand de, Cours de linguistique générale, Éd. critique, [Nachdr. der Ausg. 1916]., Paris, Payot, coll. « Grande bibliothèque Payot », 2005.
· Schutz Alfred, Phenomenology of the Social World, traduit par George Walsh and Fredrick Lehnert, 1ère édition., Evanston, Ill., Northwestern University Press, 1967, 255 p.

夏娃克隆肖像 Portrait of Eve Clone

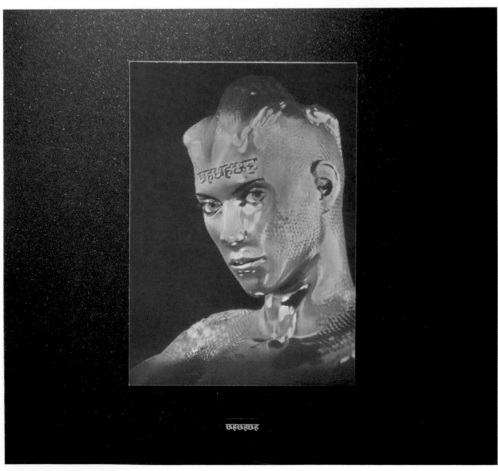

Feminine Creation of Woman
Subjectivty of Lin Pey-Chwen's Eve Clone

Lin, Hongjohn | Artist, Art Critic, International Art Curator

What Bruno Latour recognizes that Homo farber goes before Homo sapiens is the condition that making is the beginning of senses and sensitivity, which can be an open work opera Aperta for human creativity. The history of senses, to put it bluntly, is the disclosure of labors and works, which represent the reification of nature, which objectifies humanity. However, this history this gender coded, which can go to Cyborg, Crones and Android all together can be made by man, and an instance of Blade Runner can be suffice. Is there is an exception that women create women?

Lin Pey-Chwen's Eve is coming of being for the virtual laboratory of a female artist. Eve, in reference to Biblical reference and Michelangelo's Mona Lisa, wears a curious smile with the number 666 imprinted on the forehead. In the cloned portrait, although Eve was imprisoned in a cell, she is always looking back to the onlookers as Lacanian's evil gaze. The figure of the cloned Eve's is not as the same as the perfect proportion of Leonardo da Vinci, partly perhaps because of the "origin sin" of being-a-woman, and partly because of the guilty of asexual DNA procreation. The cloned Eve is immediate irony of the achievement of technology. In Lin's work, technology always appear as the other, which is that others space of human culture and civilization, that is to say, the signifier as the lack, such as the woman as the evil, the weak, or the inferior prostitute. The traverse fantasy of feminine subject through cyber space is shown in her work from the scenario of laboratory where documents, archives, images and augmented realities altogether present imperfection of simulacrums.

With the textures of animal's fins and skins, Eve is morphed to become a monster, which goes beyond the gendered subjects, to mark the discourse of technology, much in the fashion of Lacan's sexation formula. Where masculine subjects are submitted to phallic function with one exception of the Father, there are feminine subjects are not always restricted to the castration complex. That is precisely what Lacan claims that the woman does not exist, simply because there cannot only be multiple subjects that full of energy of creativity that goes beyond a fixed one. Lin's Eve is making from Taiwan through texts and images, a writing of technological sphere through the subversion of male desire in the condition that woman makes woman. The cloned subject is an emancipatory subject that goes beyond family and nation that are maintained by symbolic order as an expression of singularities.

The woman is always an exception can be taken as a reference to Taiwan's local technological stance. Can technology be coded as the trope of the local? Is it not the local always denoted as the lack in contrast to the international? The expression of female technological subject is a resistance for the global transparent translation of universality, which in turn shows the political non-muscular subject demanding hybridity outside essentialism. The differed subjectivity is an ethical question as well as an aesthetic one, which is the inspiration from the stance that "woman creates woman."

Cloned subjectivity is a paradoxical one. On one hand, it shows identity of the same; and the other, of the difference, in short, an oxymoron. Or, the cloned subjectivity is the identity of none, and therefor no need for the quest for identity. Much as the Blade Runner in the movies searches for Android and in the end realizes he is a cloned subject. From the no-subject to the same-subject, Lin renders the local/technological/ feminine a possible politico-aesthetic dimension: a female artist create the subject of the none. Freud told the story of his grandson Hans in Beyond Pleasure Principle : Hans was playing a reel in uttering the sound of fort, and repeated pulled the reel back to the cradle in making Da sound. Through the appearance and disappearance of the objects the submission of symbolic order was asserted in the formation of linguistic being. Moreover, it was through the play of reel, Hans could own the disappearing mother as the substitution for function of metonymy and metaphor. From the augmented realities of Lin's Eve shows the repetitive re-appearance of technological stance where manuscripts, imageries, and screens are placed is a partial object par excellence. Is it the partial object that will never cease to fight to the death? Mind you. The uncertain answer is sure. The feminine subject created by a woman will never cease to defy the matrix of Oedipus complex persistently for a paradoxical exceptional existence outside of masculine subjectivity.

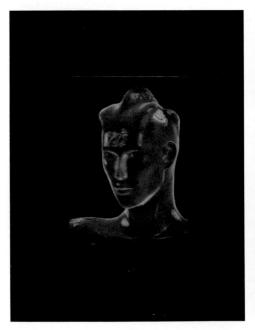
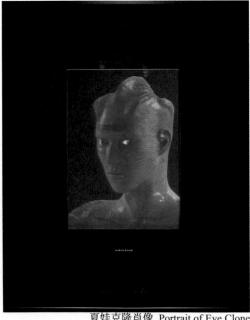

夏娃克隆肖像 Portrait of Eve Clone

The Warning Digital Oracle
The Criticism and Reflection on Technology in Lin Pey-Chwen's Making of Eve Clone

Chiu, Chih-Yung │ Digital Art Critic, International Art Curator

he artist Lin Pey-Chwen's work Making of Eve Clone series is an extension of her works with Eve as her creation theme, such as *Revelation of Eve Clone* and Portrait of Eve Clone. Echoing her previous works in *Making of Eve Clone*, Lin extended her realization of religion and her thoughts on women, using technological art to satirize the impact and destruction of digital technology on the rule of nature. She also innovatively combined her creative process of Eve Clone throughout the years with Leonardo da Vinci's drawing, and the inclusion of this element deepens the cultural connotations in the work. In other words, her work both includes ecofeminism and represents feminist scientism.

Ever since Lin created a series of works on the theme of Eve in 2006, she has been extending the symbolic meaning of Eve's betrayal of God and her imposition of original sin on humans. In addition, as the female image in "Genesis," where God uses the rib of a man to create the female image, Eve symbolizes female temptation and desire. Georg Wilhelm Friedrich Hegel in The Phenomenology of Spirit commented that desire progressively forms consciousness, indicating that human desire composes the collective consciousness of the humans of this era. Eve, as the female body of the object of desire, embodies both temptation and human desire. Eve Clone represents humans' blind infatuation and longing for contemporary digital technology. Lin's concept of Eve appearing as the image of technology itself, instead of its carrier, echoes feminist Donna Haraway's discourse. In her 1990 essay "A Cyborg Manifesto: Science, Technology, and Socialist—Feminism in the Late Twentieth Century", Haraway proposed that "The machine is not an it to be animated, worshipped, and dominated. The machine is us, our processes, an aspect of our embodiment... female embodiment seemed to be given, organic, necessary; and female embodiment seemed to mean skill in mothering and its metaphoric extensions."[1] Eve Clone precisely conveys the warning on the theme of technology and machines changing from the dominated to the dominant.

Unlike Haraway, Lin does not view technology, women, or even the development of all humans in a completely positive light. It is true that she uses her creations to confirm the idea that technological progress enables the opposition of races and genders to become fluid and that her works demonstrate her identification with female status and identity. However,

1 Haraway, Donna. "A Cyborg Manifesto: Science, Technology, and Socialist-Feminism in the Late Twentieth Century." Simians, Cyborgs and Women: The Reinvention of Nature. Routledge, 1990.

in the meantime, her works not only present the influence of technology across races (her works represent multiple languages, and the body of Eve is presented in the diverse colors of diverse races) but also embody her concerns for breaking the boundaries between nature and non-nature. Therefore, Lin's view on the relationship between humans and the universe contains a tint of ecotheology. Rosemary Ruether stated that for many species living on Earth, humans are late-comers, created last among all creations. Therefore, humans should not become creatures that disturb nature and exploit the Earth.[2] The ecofeminism presented by Lin also lashes out at human egocentrism and the selfish abuse of technology to destroy the order of creation.

In her new work *Making of Eve Clone*, she included da Vinci's Vitruvian Man, a critical drawing in the Renaissance Period portraying the relationship between man and the universe. In this work, da Vinci used as the blueprint the quintessential standard male he discovered through anatomy; he was later considered a man of perfect proportions, one who was natural and harmonious. Da Vinci's study on standard human proportions is a communication between science and art. Under Lin's perspective, anatomy becomes a deconstruction of and a challenge to God creating man, which also implies profound thought about human- and male-centeredness. Moreover, her combination of the standard human body proportions presented by the man and the woman represented by Eve Clone illustrates not only the coexistence under opposition. More significantly, it demonstrates that the creation of Eve Clone and da Vinci, the creation of a perfect human body through anatomy, are both challenges to God and Nature.

Making of Eve Clone adopted various art forms, namely digital output, projection, 3D animation, and digital audiovisual media, to visualize a religious topic. It included one *Making of Eve Clone I* film, six pieces from the *Making of Eve Clone Documentation II* series, and 16 pieces from the Making of Eve Clone Documentation I series. In different ways, those works present the dangerous image that Eve still possesses beastliness and the evolutionary process of her artificial life.

In the film *Making of Eve Clone I*, the artist combines every body part of da Vinci's Vitruvian Man with Eve Clone. The process of combination presented in the film represents human desire gradually swallowing the civilization created by God, as well as the process of digital technology gradually replacing nature. In the *Making of Eve Clone Documentation I* series, the emphasis was on the integration of the head and the hands of Eve Clone and the Vitruvian Man. In Christianity, the "666" mark on Eve's head represents evil and the Number of the Beast. In the "Book of Revelation" in the Bible, "The number of the Beast is 666." This mark repeatedly strengthens the beastliness and aggressiveness involved in Eve Clone as the object of human desire.

In western arts, the core image of the hand of God typically represents creation and protection, and the punishment for disobeying His will. Because Eve Clone is the product of humans disobeying and challenging the divinity of God, the hands at this moment

2 Quoted from Yang Keqin. Eve, the Earth, and God. Shanghai: East China Normal University Press, 2011. 246.

imply warning and punishment. In addition, the emphasis on the head and hands reflects the meaning of anatomy, revealing human desire and control over the natural human body. The implementation of AR technology—transforming the static output of Eve Clone into animated images, as if Eve interacts with the viewer—further strengthens the interconnection between the object being viewed and the subject. It also echoes the theological methodology, in which the understanding of an object of a subject must be derived from the subject, and it is inseparable. The six digitally-output pictures in the *Making of Eve Clone Documentation II* series were taken from three parts of the body from the Eve Clone and the da Vinci work to present the essence of the Great Image to satirize human's blind infatuation with, reliance on, and adoration of technology. It also echoes the miserable endings of the Biblical stories "Whore of Babylon" and "Great Image" used in *Revelation of Eve Clone*. Implicit techniques were utilized to foreground the consequences of humans abusing technology. As a new media artist, Lin is a pessimist with a strong religious sense. On one hand, she implements technology to create her works, but on the other hand, she worries that technology and humans will destroy divinity and nature. As a result, her works reflect her concerns and compassion.

Adam loses a rib in exchange for his life partner. The essence of the two sexes is to integrate, not to restrain and control. Through *Making of Eve Clone*, Lin proposes further ideas on the integration and restraint of technology and humans and of men and women. These integrations and mutual restraints are both a further attack on anthropocentrism and a challenge to dualism, reflecting the beauty of harmony and the balance expected by the artist between technology and nature, technology and humans, and men and women. Lin uses the arts as a means to provide profound thinking and criticism on the problems engendered by technology and the societal constraints imposed on women. God makes Eve grow from Adam's body, just as humans create technology and cyborgs as an extension of humans. This kind of beautiful temptation is the progress of an era, a challenge to nature and the extinction of humanity, and the way of existence in ambiguity.

七、創作生涯與作品研究節錄
Life and Art Research Excerpt

從林珮淳《相對說畫》系列
探討女性主體意識中的互文與辯證

許佩純 ｜ 藝術研究、策展人

國立台灣藝術大學藝術學院碩士論文摘錄，2017 ｜ Academic.edu

導論

女性長期在父權體系下依附生存僵化體制的桎梏，始源自女性在傳統與現代的共存時空夾縫裡，受意識形態箝制的「自我」認同所致，艾利斯·楊在〈像女孩那樣丟球：陰性身體舉止、活動力與空間性的現象學〉一文中提到關於「陰性」存在的意思：「指的並不是所有女人因為生物性的女性神祕特質或本質，而是一套限定在特定社會中身為女人之典型處境的結構與狀態，這套結構與狀態同時也限定女人在此處境中如何生活的典型方式。」[1] 依據艾利斯·楊所指稱的結構與狀態，則來自於父權社會將女人定義為物體（身體）的概念，身為女人的基本處境是永遠活在被視為僅僅一具身體、曲線與肉體的可能性中，把自己表現的像是其他主體所意欲、操縱的潛在客體，而不是活生生地呈現出自己的行動與意向。她更進一步指稱：「這客體化的身體所存在的源頭，除在於他人觀看她的態度，但女人本身卻也常把自己的身體視為僅是一件物，她凝視鏡中的身體，煩惱身體在別人眼中看來如何，她修剪、形塑、打造、裝飾身體。」[2] 被客體化的身體存在說明了陰性對身體的自我意識，也揭示了這個意識造成她與自己身體的距離。

身為一位女性藝術研究者，對於女性身體的自主性，一直以來都是有意識在觀察，尤其是對台灣當代女性藝術家在作品中的身體意識建構尤為關注，在研究過程中發現多數的女性創作者較常慣用身體象徵或生活體驗為創作題材，而具女性主義意識的創作，會以「女性身體」或「性器官」去批判父權中心對女性形象的箝制，其目的就是反西方傳統藝術中「裸女畫」背後的意識形態。然而，林珮淳《相對說畫》系列的藝術語彙，如交織引用現代瘦身廣告標語及古代的纏足文獻，在展呈上，透過許多歷史傳統的，或田野調查蒐集的文件資料，在古今符號及文本相互參照中去敘述女性身體的不自主，女性身體被商品化、物質化、使用的「對立」（或對比）的形式，呈現出一種較寫實的直述性文本，而非用「赤裸」的身體符碼，以溫和但犀利清晰的語彙直接命中議題，勾勒出女性建立自我定位及獨特的女性身體主體意識的重要性。

本文透過文獻的梳理及訪談，對林珮淳創作語彙的觀點與論述角度，亦發現作品除了對男性凝視（male gaze）權力體系有所批判外，而到現今消費社會再以商品化、物化等概念的介入而提出修正的看法。如作品中將金素鑾女士自述其纏足經驗的再現痛苦與無奈的書影，藝術家看見女性對於身體的感知，男性對女性纏足的慾求，已被男性中心的意識形態深植於女性

1 艾利斯·馬利雍·楊（Iris M. Young）著，何定照譯，《像女孩那樣丟球：論女性身體經驗》，台北，商周，2007 年，頁 49。
2 同上註，頁 71。

心中，內化成為母女相傳必須忍痛並履行的痛苦經驗。過去中國的女性從小被母親強迫纏足，無力反抗，而母親也是從小在父權的社會中長大，為了符合普遍社會對女性的規訓要求，怕女兒長大無法找到好的婚配對象，更不惜忍痛摧殘女兒的雙足，「纏足」成為一種畸形的「美」，而現代女性則花大錢隆乳、瘦身、塑形，儘管不同的時空轉換，但古今女性身體仍是處於被觀看的位置，被置放在父權社會架構中。林珮淳意圖從作品去解構消費女性身體的視覺慣性，除了大量的文字，並以剪報、仿古畫、車繡這些媒介來表現其藝術觀念，而詳盡的文字自白，更表現了藝術家的女性主體意識，作品在圖與文對話中，塑造出女性從古至今身體一再落入「被改造」的命運，而提出女性的生存定位就只能如此樣板式、自虐式、缺乏自主性的型態裡被界定？而美容塑身廣告標語的應用，除了呈現對照後反諷的效果外，對於資本主義的商業宣傳手段，「策略式」的增強女性「為悅己者容」的附庸心態有所質疑與批判。

最後研究亦發現林珮淳獨特創作語彙特色：去身體、文件的展示、互文與辯證，作品強調女性主義作品不需以女性赤裸的身體來表示，以「女性觀點」解構父權的種種文化箝制，避免女性身體再度成為男性「窺視」的對象，有別於多數女性主義藝術以性器官或裸露身體的直敘方式。林珮淳透過「再現」與「挪用」將物件、媒材、文本方式去敘說，讓觀眾反思作品本身之事實與隱藏在其背後之意涵，而「事實」正是她所要批判的觀念。林珮淳在《相對說畫》作品中，同樣是以「再現」與「挪用」纏足歷史文件與圖像，透過古與今、東方與西方的各種圖像與符號文本，解構父權文化對女性身體要求各種樣板標準，並反思美容塑身與纏足的背後意涵與女性身體無法自主之可悲現象，所呈現的互文與對照圖像即為她批評父權文化的事實，身為女性藝術研究者，一直都十分關注女性藝術創作在主體意識的建構，而在對作品的深入研究後，期望將林珮淳作品中所獨具的四個特色：去身體、文件的展示、互文與辯證的研究與闡釋。本文主要針對林珮淳的《相對說畫》系列為研究，探討作品中女性主體意識的互文與辯證。《相對說畫》系列是林珮淳「解構父權」時期最重要的作品之一，於 1995 年首度個展在台北市立美術館展出，雖屬早期的作品，但此系列在林珮淳的創作轉變上扮演著極為關鍵的作品，作品具有「互文」與「辯證」的多重文本性及後現代的表現特色，創作觀念帶有鮮明的女性主體意識，並影響後期多元的創作風格。

《相對說畫》的創作源自於纏足議題，「纏足」作為作品中的重要符號，本文嘗試以符號學與詮釋學的分析理論基礎，對作品的形式與內容進行多重文本性的分析，並以詮釋學的角度將隱藏於文本後面的隱身與寓意，透過《相對說畫》藝評文獻的回顧，從歷史性的觀看角度，來檢視林珮淳作品中的女性主體意識的形塑與發展為何，最後在「去身體」的女性主體意識

與「反迷思」之身體操演中，去發現作品是如何透過相互辯證去回應社會的現實與批判。

本文主要針對林珮淳的《相對說畫》系列為研究，探討作品中女性主體意識的互文與辯證。《相對說畫》系列是林珮淳「解構父權」時期最重要的作品之一，於 1995 年首度個展在台北市立美術館展出，雖屬早期的作品，但此系列在林珮淳的創作轉變上扮演著極為關鍵的作品，作品具有「互文」與「辯證」的多重文本性及後現代的表現特色，創作觀念帶有鮮明的女性主體意識，並影響後期多元的創作風格。本研究為以下幾個面向：從林珮淳的生涯、創作歷程探究其藝術養成背景，透過與藝術家深入的訪談，了解信仰對其創作的影響，尤其是從純繪畫的《女性詮釋系列》至近期發展的互動裝置作品（夏娃克隆系列），透過電腦數位媒體的特性來表現「人工生命」，都將透過創作歷程的梳理來發現其創作紋理脈絡。研究過程中也發現對女性議題的關注更是與其生命歷程有著緊密的相互影響關係，尤其是到澳洲拿博士學位在當地所受到女性主義藝術觀念的啟發，對於女性處於在性別弱勢的桎梏特別有所感，這也是引發她投入中國纏足議題的創作研究動機，並受到瑪莉·凱利的《產後文件》的啟發。

《相對說畫》的創作源自於纏足議題，「纏足」作為作品中的重要符號，本文嘗試以符號學與詮釋學的分析理論基礎，對作品的形式與內容進行多重文本性的分析，並以詮釋學的角度將隱藏於文本後面的隱身與寓意，透過《相對說畫》藝評文獻的回顧，從歷史性的觀看角度，來檢視林珮淳作品中的女性主體意識的形塑與發展為何，最後在「去身體」的女性主體意識與「反迷思」之身體操演中，去發現作品是如何透過相互辯證去回應社會的現實與批判。

林珮淳創作生涯

家庭、教育、工作

林珮淳 1959 年出生於台灣屏東縣，是家中的長女，下面還有三個妹妹，父親是受傳統教育的公務人員，母親則是潮州國小附設幼稚園的教師，對子女施以傳統的家庭教養，跟多數在父權社會承受性別不平等教育的女性一樣，因為男尊女卑的觀念，承受來自父權體制的價值與信念，對藝術家爾後的創作帶來極為深遠的影響。林珮淳表示她體諒父母也是父權文化下的受害者，且因著信靠主基督，在成長過程中知道如何禱告仰望神克服了父權文化的壓抑。

林珮淳自小就展現出對繪畫的興趣與天份，考進銘傳大學五專部商業設計科而進入藝術設計專業，1980 年畢業後因在設計公司的同事而認識新約教會，成為她生命的轉捩點。之後結婚與先生一起赴美深造，1984 年畢業於美國中央密蘇里州立大學（Central Missouri State Univeristy），並於次年獲得藝術碩士學位。畢業後並未立即返國，1986 年在美國紐約曼哈頓的彼得士公司（Peter's Bag Corp）擔任藝術總監，三年後才回到台灣。在美國這段期間，林珮淳對自己越來越有自信，先生也感受到她的改變，本想繼續留在美國發展，但因先生的工作正好碰上當時台灣新興電腦科技產業蓬勃的發展，決定舉家返台，而林珮淳因具有藝術碩士的學歷，加上又有國外的工作經驗，回台灣後許多學校都邀她去任教，最後她選擇回饋母校銘傳管理學院。1989 年回國任教後，卻因嚴謹保守的校風且面臨升等壓力，以及因加入「2號公寓」藝術團體而渴望能全心創作。1992 年個展於國美館後，認識了澳大利亞國立沃隆岡大學（University of Wollongong）副院長謝·彼得 （Peter Shepher），於是拿著畫冊見彼得討論其創作的理念，看過作品後，彼得即跟林珮淳表示：「妳可以來我們學校念博士，而且我們還會提供妳一個畫室，妳創作只需每年有展覽以及畢業的時候有個展即可」。這個機會剛好符合當時的需求，並且又是自己尋求全時間創作的機會，於是 1994 年在父母支持下，赴澳大

利亞國立沃隆岡大學研讀創作博士，隔年獲得澳洲政府提供的傑出研究生全額獎學金，並獲得傑出人才藝術家永久居留，雖事後林珮淳表示「其實真正念了才發現需做很龐大的博士論文研究」，但也因此奠定了她在女性主義藝術與美學深厚的研究基礎。其實，當年她先生是不贊同她去澳洲，雖然花了一整年的時間溝通，最後在無法得到支持的情況下，她決定跨出人生中由自己決定的第一步，將長年加諸於己身的桎梏置之度外，克服萬難，帶著年幼兒子前往澳洲攻讀博士，並於 1996 年取得博士學位。返國後，1997 年任教於中原大學商業設計系副教授暨創所所長，並活躍於藝術圈，尤其投入女性藝術相關活動與協會，2001 年至 2017 年專任於國立台灣藝術大學多媒體動畫藝術研究系所兼所長，於隔年創立大學部並成立「林珮淳數位藝術實驗室」。創作無數並發表於國內外重要美術館，成為知名具影響力之藝術家，作品列入眾多藝術史書，如《台灣當代美術通鑑》之焦點作品等成就。2017 年從教育界退休，至今專心投入創作及教會的服事。

藝術教育的推動

林珮淳曾任教銘傳大學、中原大學商業設計系系主任兼所長，於 2001 年進入國立台灣藝術大學擔任多媒體動畫藝術研究所所長，前後創立多媒體動畫藝術學系、新媒體藝術研究所。主辦國際 SIGGRAPH Taipei 研討會、台澳國際新媒體藝術研究會暨國際展覽，並榮獲教育部卓越教授彈性薪資之傑出教授榮譽等。她建立的「林珮淳數位藝術實驗室」乃以教學、展覽、表演、研討會、國際交流與競賽等方式，帶領研究生透過多元與跨領域的形式與媒材做實驗的研究與創作如：電腦動畫、錄像藝術、互動裝置藝術、網路藝術、新媒體公共藝術、互動多媒體舞蹈之跨領域創作等進行實驗創作。實驗室作品參加國內外比賽與展覽超過百件，如在國際上史無前例三次入圍法國安互湖數位藝術節並獲評審團特別獎及視覺藝術類首獎；三次獲選義大利威尼斯拉古納虛擬與數位藝術獎；多次入圍 404 國際電子藝術節（展於義大利、阿根廷、哥倫比亞、蘇聯、日本與美國等）；巴西聖保羅國際影展、英國倫敦資訊視覺化協會數位藝術、法國馬賽錄像藝術節、SIGGRAPH ASIA、布拉格劇場三年展等。在國內則帶領研究生發表展覽與跨領域表演近百次，作品獲選台北獎、全國美展、台北數位藝術獎、大墩獎、礦溪獎、KT 科藝獎、桃源創作獎、國美館數位藝術、台北數位表演獎等傑出成果，並帶領實驗室策劃多項重要展覽如台灣數位藝術脈流展、數位魅影國際展、蟲聲幻影互動藝術展等，所培育的學生與成員遍及教育界、業界與藝術界，成為台灣數位藝術教育重要的推動者之一，目前仍以「林珮淳數位藝術實驗室」持續推動數位藝術相關計劃。

展覽及成就

獲中興文藝獎章、澳大利亞傑出藝術人才藝術家永久居留及國內外美術館之邀展，作品展於重要藝術展如：法國 Exit and Via 藝術節、波蘭國際媒體雙年展、新加坡國際藝術博覽會、404 國際科技藝術節、葡萄牙國際版畫雙年展、威尼斯雙年展平行展、Art Basel 平行展、台北雙年展、台灣雙年展等，也個展及聯展於國立台灣美術館、台北市立美術館、台北當代藝術館、高雄市立美術館、關渡美術館、北師美術館、紐約市立皇后美術館、烏克蘭國立美術館、舊金山州立大學美術館、上海多倫美術館、北京 798 藝術村以及國內外知名畫廊及藝術中心等。作品收錄於重要藝術相關藝術史及藝術書籍如：《台灣當代女性藝術史》、《台灣當代裝置藝術》、《台灣當代藝術》、《台灣當代美術大系》、《數位藝術概論》、《台灣美術史》、《數位美學》、《高中美術課本》、《台灣當代藝術名人錄》、《台灣美術史綱》、《藝術概論》、《台灣數位藝術 e 檔案》、《中國當代藝術年鑑》、《亞洲名人錄》、《台灣當代藝術》、《台

灣數位藝術光碟》、《公共電視》、《台灣數位藝術平台》、《台灣當代美術通鑑》等。作品「夏娃克隆系列」更成為全球藝文界爭相邀請展出的國際經典創作，如美國全球女性博物館 IGNITE 專欄、英國牛津大學國際研討會、英國 Loughboroug 大學女性藝術論壇、InSEA 國際研討會、澳洲 AgIdea 國際論壇專題演講、《英國女性藝術美學期刊》重要研究對象。

林珮淳曾任國內外重要研討會主持人、座談貴賓與評審，如：國美館國際數位大展「漫遊者」及「快感」、北美館「One dot Zero」國際影像研討會、文化部、科技部、國家文藝基金會、台北國際數位藝術節、桃創獎、高雄獎、南瀛獎、礦溪獎、大墩獎數位藝術、KT 科技與藝術獎、韓國首爾國際動畫影展、上海國際電子藝術節、日本九洲大學學術交流、馬樂侯文化行政管理研討會等。擔任北美館、台中文化局、高美館典藏委員，出版國內第一本《台灣數位藝術 e 檔案》，目前為台灣科技藝術學會副理事長，以及台灣女性藝術協會榮譽理事長。

信仰對藝術創作的啟發

新約教會

林珮淳小時候是在長老教會長大的，1980 年林珮淳在設計公司上班時，同事萬志鉉問她說：「妳聽過新約教會和江端儀嗎？」於是邀了她到台北教會會所。在與筆者的訪談中，林珮淳提到當時第一次去新約教會的情形，她說：「我那天爬到三層樓時，聽到嘀嘀嗒嗒嗒的禱告聲音，當時我聽到時覺得怪怪的甚至有點害怕，進了會所之後，是非常簡樸的公寓房，許多弟兄姊妹們正禱告中，我肅然起敬感受到一股神聖感。萬志鉉介紹我一位名叫丁靈麗的姊妹，她是銘傳畢業的學姐，負責教會書籍編排及插畫等聖工。她很親切的介紹新約教會『血、水、聖靈全備福音』，以及『方言靈禱』的真理：『又有舌頭如火焰顯現出來，分開落在他們各人頭上。他們就都被聖靈充滿，按著聖靈所賜的口才說起別國的話來』。」[3] 等許多的聖經真理，也說方言就如孩子呀呀學語聲音：「你從嬰孩和吃奶的口中完全了讚美。」[4] 此外，她又指著掛在牆壁上先知洪以利亞的相片（現在弟兄姊妹都尊稱他為阿公）說：「每一時代神都會揀選先知來帶領神子民，這是神做事的法則，而公會宗派沒有全備的福音也沒有先知。當時我一看到先知的相片就起了敬畏的心，尤其看到阿公的相片時，我靈裡就知道他是神所揀選的先知。當時我也不知道錫安山被國民黨非法搶奪，新約教會遭迫害與污名化，這就是神愛我的原因，祂使我很單純接受了水、血、聖靈全備福音而歸回聖靈所重建的新約教會，以及認識了神在末後日子所揀選的先知洪以利亞。」[5]

信仰與創作

回歸神家

信仰在林珮淳創作中具有非常關鍵的影響，尤其是在「回歸大自然」與「夏娃克隆」時期的作品，透過訪談，可以明白其信仰對創作的重要啟發。在訪談中林珮淳提到早年遇見新約教會的過程：「我在新約教會常遇見神在環境中的保守與顯現，尤其我目睹先知預言一發出，神立刻應證，如錫安山被國民黨非法搶奪，先知帶領新約教會有血有淚的七年爭戰，這過程若沒有神負先知一切的責任，任何人都抵擋不了國家暴力，尤其當年是戒嚴時期，先知與

3　筆者於 104 年 2 月 12 日訪談藝術家林珮淳的口述資料。摘引自《新約聖經》，〈使徒行傳 2：3-4 節〉，國際基甸會，1985 年，頁 343。
4　摘引自《新約聖經》，〈馬太福音 21：16〉，國際基甸會，1985 年，頁 63。
5　筆者於 104 年 2 月 12 日訪談藝術家林珮淳的口述資料。

聖徒被迫害且毆打幾乎喪命,但先知不放棄神所賜的聖山產業,一再告訴我們神必定帶我們回錫安,在被迫害的時候早就唱出『踏上歸鄉路』等詩歌,1987年終於先知預言應驗了,真理戰勝強權,新約教會榮耀凱歸錫安山。」[6]

1997年因受到先知帶出「伊甸家園」的信息,要神兒女離開科技文明的毒害,回到神初創的伊甸園自然境界,因此林珮淳領悟了人類所有的問題都是出自人性的自私、驕傲、不敬畏神,甚至違反大自然定律,自以為「人定勝天」的心態所造成的種種亂象與危機,若人類能照著自然的定律過生活,就不會有紛爭、歧視、欺壓的問題,也能與大自然和諧相處達到「天人合一」的伊甸境界。林珮淳多年以「女性觀點」創作了「解構父權系列」的作品,但當明白了「走出文明、回歸伊甸」真理後,在創作上開始轉而思考人與創造主的關係,以及文明與大自然的對立關係,因此明白了人與大自然本不該分割,創作議題更不可與神的指意無關,於是自1999年開始了「回歸大自然系列」創作,以人造、人工、複製、數位、虛擬等科技議題與媒材,去反思科技文明與大自然的對立關係,自此創作開始以科技媒材「再現」更具動感與擬真的大自然影像,藉著動態影像表現虛擬的幻景,以反諷人工生命的不真實。

藝術創作發展風格與歷程演變

林珮淳的創作來自女性意識不斷自我辯論與詮釋,作品的內容與形式跟隨時間的推進,在此依藝術家的創作歷程概分如:「女性詮釋時期」、「解構父權時期」、「回歸大自然時期」、「夏娃克隆時期」。林珮淳創作歷經四個時期的轉變,從以抽象畫為主,受抽象表現主義的影響,是以揮灑的筆觸、對比強烈的色塊,大膽宣洩自我的情感,在其發表過一篇談抽象畫的文章中說到:「抽象畫對於台灣的女性藝術之發展,我認為抽象畫本身就具有女性非常強烈的解放與自主的表現,是對於傳統『閨秀畫』一個很大的對比,雖然抽象畫看不到所謂的社會議題,也沒有性器官圖像的表現,但我認為抽象畫具有女性解放之時代意義。」[7]

當年侯宜人在「帝門藝術中心」策了一個「女我展」,它是個「娥」的雙關詞,有女性蛻變與自主的概念,林珮淳的作品漸漸將抽象畫加入一些符號,如:高跟鞋、包鞋、蛹等,作品中出現的「身體」是表達自身受父權思想壓抑的圖像,尤其在加入「二號公寓」後對社會與文化議題感受加深,且逐漸意識到身為女性同時所擔負的多重角色:妻子、母親、教書,而又要發展當代藝術是很不容易的,尤其當時「二號公寓」多數都還是男性受到藝術界的矚目,林珮淳深覺自己就像蛹般。1992年個展「女性詮釋系列」和「蛹系列」開始有抽象性的紋路夾著高跟鞋與包鞋,並畫有很多一坨一坨的圓形論表蛹與期待破繭而出的符號,利用油彩的厚實,一層一層的筆觸去推疊象徵當時的困惑,而其中女性的身體圖像就是代表林珮淳自身。後來留學澳洲攻讀博士時,大量接觸「女性主義藝術」論述與作品後才逐漸自覺,原來整個人類藝術史在女性主義之前就沒有女大師出現過,甚至更清楚的辯證說藝術史是男性的手與觀點所寫的,作品的好壞是在男性的標準所判斷的,那個時候林珮淳即跳出自身的困惑,開始以女性觀點觀看解構父權文化下男女不平等的現象。

之後留學澳洲的第二年,林珮淳回到台灣與吳瑪悧等開始建立女性論述,並提出一個很重要的觀念:「台灣女性藝術的發展若沒有一個清楚的論述,人家就是把你當成你只是一堆女性聚集在一起聯展而已,因此才有後來的藝術家雜誌的『女性藝術專欄』以及在女書店系列座

6 筆者於104年2月12日訪談藝術家林珮淳的口述資料。
7 林珮淳,〈對抽象藝術的再觀察〉,《現代美術》第58期,台北市立美術館,1995年,頁16-21。

談而發展出的《女藝論》到『女性藝術協會』的建立等具體行動。」[8] 因在澳洲留學時受到女性主義的啟蒙，逐漸跳出了傳統文化的壓抑，用女性觀點「再現」父權文化下的產物並予以「解構」，創作進入「解構父權」發展階段，開始以「纏足」與「美容」的議題，創作了《相對說畫》系列作品，此系列於 1995 年在台北市立美術館個展之後，林珮淳就此被定位為女性主義藝術家，但是她作品並沒有直接用女性身體本身，強悍以身體解放思維作為抗議、批判、反制父權文化，而是透過中國的文化背景，桎梏千年女性身體的纏足對照當代美容塑身，將女性身體所受的迫害與壓抑，透過創作去呈現文化下的思辯。林珮淳在主編《女藝論》時寫了一篇瑪莉·凱利的作品，對於其認為用身體又再次被男性「窺視」，因而不用身體創作，而是用「再現」的語言，如她的《產後文件》作品就是再現了她產後身為母親的角色，觀察兒子從嬰兒的糞便顏色、第一次塗鴉到第一次牙牙學語等文件記錄……來提出母親自主的觀點。在訪談林珮淳時提到此作品對她的影響，在後來的創作都是運用「再現」的概念，透過「再現」去批判父權文化，呈現所要批判的事實，如：《相對說畫》的纏足文獻和美容廣告詞、〈黑牆、窗裡與窗外〉再現了 228 受害人的全家福合照、〈向造成 228 悲劇的當權者致意〉的反諷性獎盃、〈經典系列〉則再現四書五經與讀書人行為的對照、〈美麗人生〉中的清明上河圖是與台灣亂象作結合等反諷的作品等。

1999 年 921 地震則將林珮淳帶入全新的創作領域，此階段為「回歸大自然」時期，其中很大的改變是因為她目睹人類因科技破壞大自然而遭反撲，受到基督信仰與先知的敬天愛人信息啟示帶領回歸大自然。受此啟發她開始以人造自然的炫麗現象，而作了一系列的「回歸大自然」作品。那期間沿用「再現」的手法做了許多的「假自然」，如：壓克力燈箱做的假花園、假天空，因為燈箱是最不自然之外，壓克力更是有毒的化工材料，而城市中到處充斥的廣告招牌，因此林珮淳利用此元素，利用廣告招牌去再現假的自然景觀，大量的數位輸出很多造形的燈箱，刻意以再現的手法呈現人工美，此系列也發展為公共藝術的作品。

之後林珮淳進入台藝大多媒體動畫藝術研究所任教，開始結合科技媒材的元素，同樣去「再現」科技媒材虛擬、擬像或與人互動的本質，藉以批判科技的虛假與危險，如在〈花柱〉建構人工花與人造蝴蝶的遠距傳情的非自然現象，〈溫室培育〉則開始以 3D 動畫來呈現女體從網格狀到有肉的人工培育過程，發展以 3D 動畫第一版的《夏娃克隆》。後來《夏娃克隆 II》更以互動形式來表現觀眾的介入，即可從蛹變為蝴蝶美女到與美女的互動作品，討論人與「夏娃克隆」蛻變的互存關係，如人賦予夏娃克隆生命，觀眾愈多蛻變也就愈大，沒有人時又回到蛹形無法自我的生存狀態。到了 2011 年林珮淳又看到生化科技、複製基因改造或複製人體的極致現象，而《夏娃克隆》即象徵被科技複製的理想女體，這理想的複製美女的標準與《相對說畫》作品中美容塑身仿造西方美女的標準一樣，而蛹化蝴蝶美女符號更可追溯至早期的《女性詮釋》、《蛹》系列作品，以及《相對說畫》中纏足（包鞋）的象徵性，儘管呈現形式更加極致科技，外形也被改造，更直接從 DNA 去掉不理想的基因，或直接以優生基因進行實驗且給予生命，成為父權科技下的理想美女（ideal beauty），更以《夏娃克隆》命名，即指涉科技想扮演神的角色。自此發展了《夏娃克隆肖像》，在她額頭加入可表現其內藏科技危險的「666 撒旦的獸印」，並與神創的夏娃自然的天性作對比與區隔，人創的夏娃克隆成為邪氣的科學怪人（全像的詭異色彩與動態），提出了混種、變種、被人類培養的東西反成為反制人類的邪惡化身，如：電腦、科技、化工、核能等人類發明。

8　摘引自張金玉《台灣女性藝術大事紀年譜建置計劃》結案報告訪談稿，同前註，頁 287-291。

林珮淳從《女性詮釋》系列到《相對說畫》系列的創作，是在一個父權文化底層比較沒有資源的條件下，始終沒有太多發聲的方式，直到《夏娃克隆》系列，女性的議題又開始被拿出來討論，譬如：「夏娃克隆」的身體其實已不再是真實的女性身體，所以當有人問既然支持女性主義但為什麼又把女性身體物化呢？就此林珮淳則認為其所做的夏娃克隆已不是人類，是父權科技用克隆複製的手法所創造的女性身體，所以那個女性身體是有 666 的獸印符號，是科技的是既美麗又危險的象徵，批判人類驕傲的挑戰創造主那個心態與行為現象，猶如在其創作自述中引述羅蘭·巴特的話：「反迷思最好的武器是以他的方式將他迷思化，並製作一個矯揉做作的迷思」。以虛擬的 3D 動畫呈現誘惑、驅動、控制、反制的曖昧關係正是林珮淳所要批判的科技與人類的互存關係。儘管與早期關心女性議題裡面所談的自然的身體不一樣，但同樣是以「再現」手法去批判父權文化下對女性身體的審視標準。林珮淳的創作媒材發展轉變很大，但始終圍繞於幾個關鍵的議題，如：高跟鞋、纏足、蛹形、美的標準等，彼此的脈絡連結是有跡可循，而創作語彙的互文與辯證更是清晰與一致性。

《相對說畫》的「互文與辯證」

1995 年展於北美館的《相對說畫》系列，便以中國纏足陋習與今日美容塑身文化做對照，以絹印、電繡、人工絲、繪製等手法，再現了古畫的美女、纏足文獻以及現代美容塑身廣告的模特兒圖像與標語等，藉以揭示女性身體從古至今仍陷在父權審美標準下的循環中無法自主掌握。

林珮淳的《相對說畫》是以中國過去曾流傳千年的纏足傳統，與現今的流行美容塑身的身體改造，二者都是父權社會對身體所進行一種綑綁與壓迫，但多數女性卻仍是在意者「悅者己容」的意識形態。在此她以「三寸金蓮」與「美容塑身」做對照，透過圖文的引申意涵進行多重文本的辯證，去瓦解男性建構的語言思想，以建立女性的主體性。在描寫古今美女的文字對照中，以標明其美麗的「規格」，如「三寸金蓮」與「現代金蓮」，「瘦小尖彎」與「挺胸細腰」，「香正軟」（綁小腳）與「堅挺軟」（胸部），另外她也直接挪用塑身廣告的標語與歷史纏足圖畫做有趣的對照，如：「男人一手握住女子小腳」的古畫與「男人無法一手掌握」的廣告文字，以一種反諷的效果批判資本主義縱容下的大眾媒體及商業宣傳手段，除了能「策略式」的增強女性「為悅己者容」的附庸心理，更將盲從西方文化的隨從角色以「現代感」、「富智慧」、「新女性」等詞彙來加以粉飾、包裝，使女性消費者相信以高科技可以換取美貌、窈窕身材是現代獨立女性的選擇，而這種摩登的姿態比昔日的纏足「寸步難行」的可憐形象更加令女性「洋洋得意」，而難以洞察這「美麗神話」背後的意識形態陷阱，透過「媒材」被取用的意義提昇為傳達媒材本身觀念的憑藉，這與瑪莉·凱利創作中對於「物質性」的延伸意涵有著相同的宣揚力道。

《相對說畫》系列一

《相對說畫》於 1995 年 10 月首次發表於台北市立美術館 B02 展覽室，透過親自跟藝術家訪談及她的畫冊與博士論文，並參考李宗憬教授的報導文章去重新建構當年展覽的樣貌。作品包含三個系列的裝置藝術及展場中間的纏足與塑身的文件資料。系列一總共由 60 幅 45 x 45 公分的方塊作品拼組而成，系列二與系列三則各由 10 件 200 x120 公分及 90 x 45 公分由緞面文字刺繡與畫布拼組，系列一以展覽廳的正面牆上，由 60 幅 45 x 45 公分的作品，排成 6 x10 幅的正方形畫面組合，畫中的「扇形」與「蓮花」則結合古代中國的仕女、三寸金蓮、現代西方

的金髮美女、高跟鞋等元素呈現。另在藍、紅、紫三色的緞面上，則以金線繡出「古典美人」、「摩登女郎」、「三寸金蓮」、「香正軟」、「挺胸細腰」及「尖挺軟」等文字，作品整體呈現普普風格的編組，並以符號化的手法讓文字與影像並置。

展覽廳左右二側牆上有多幅長方形組成 200 x 120 公分的作品，與 45 x 45 公分的方形橫幅間奏排列成是系列二、系列三。系列二是由二個畫面組成，長幅的上半是扇面形式的女相或男女合相，女相有側身半臥及前俯露胸，下半則是蓮花。另一半則引用當下流行的各種美容塑身廣告語詞，以女紅金線繡出，文字如「女人的美麗了然於胸」，「女人從此胸懷大志」、「讓男人無法一手掌握」、「讓腰部以下曲線全部窈窕」、「塑形提高加大潤澤窈窕」等。系列三以雙幅畫面並陳，其上一半以金線繡出蓮花，另一半則是絹印的三寸金蓮、女仕及古籍中的文字組合而成。

《相對說畫》系列二

在展覽室左右二側牆上各有五幅對稱排列 200x120 公分的作品，系列二是由二個畫面組成，共有十件作品，由緞面刺繡及油畫拼組的複合媒材，油畫長幅的上半是扇畫，內容是仿古代仕女圖的女相或男女合相，女相有側身半臥及前俯露胸，下半則是蓮花。緞面刺繡則引用當下流行的各種美容塑身廣告語詞，以女紅金線繡出，文字如「女人的美麗了然於胸」，「女人從此胸懷大志」、「讓男人無法一手掌握」、「讓腰部以下曲線全部窈窕」、「塑形提高加大潤澤窈窕」等與繪製的作品二相對照，形成一種呼應與對比的效果。

纏足及塑身剪報文件

文件內容陳列林珮淳所做的田野調查，包含 X 光片、解開裹腳布後怵目驚心的照片、訪問纏足婦女的記錄、纏足自述文獻及纏足藥方、塑身廣告的剪報的文件資料，放在展覽廳的二張長桌上。

《相對說畫》互文與辯證的多重文本

作品內容

以羅蘭・巴特的符號學，能指（藝術家的符號）與所指（筆者研究解讀）串連出作品中符號的意指作用（延伸、連結、擴充）的意義對作品的文字與圖像進行解讀，並從扇畫、緞面刺繡、絹版印刷探究表現手法（媒材）的運用。

《相對說畫》系列一是由 60 幅 45x45 公分的方塊作品拼組而成，並以上下、左右的對照的方式，依據藝術家訪談確認共有 7 組的對照模式，第 6-7 組為 1-3 排的相互對照（文字內容一樣，但扇畫內容的頭像、高跟鞋、弓鞋造形與色彩不同）因所用符號元素一樣，因此 6-7 組將不做符號分析，於第二層形式分析中做比對說明。

《相對說畫》系列二左右共有五幅對稱排列 200 x 120 公分的作品，由二個畫面組成，共有十件作品，此系列由於是二十年前的舊作，部分作品被澳洲沃隆岡大學美術館典藏及私人收藏，因此，僅能就其中的五幅原作資料做分析。此系列主要由緞面刺繡及油畫拼組的複合媒材，油畫長幅的上半是扇畫，內容是仿古代仕女圖的女相或男女合相，女相有側身半臥及前俯露胸，女相有的側身半臥，有的前俯露胸，下半則是蓮花。緞面刺繡則引用當下流行的各種美容塑身廣告語詞，以女紅金線繡出，文字：「女人的美麗了然於胸」，「女人從此胸懷大志」、「讓男人無法一手掌握」、「讓腰部以下曲線全部窈窕」、「塑形提高加大潤澤窈窕」對照

相呼應的古畫，形成一種呼應與對比的效果，呈現出作品文字如「女人的美麗了然於胸」，「女人從此胸懷大志」、「讓男人無法一手掌握」「讓腰部以下曲線全部窈窕」「塑形提高加大潤澤窈窕」等。這些廣告詞表現出男性強勢社會中，讓女性為了追求男性意識中的定型之「美」，不惜傷殘自己、犧牲自己以迎合男性強勢欲求的意識，呈現出「女為悅己者容」的苦處，以及令人啼笑皆非的反諷。

在《相對說畫》系列一作品中，由 45 x 45 公分共 60 幅的小方塊作品拼組而成，以三幅一組的拼貼方式排列，並以上下、左右的相互對照的方式，以圖對圖、文字對文字、文字對圖的方式拼組而成一件 270 x 400 公分的大型複合媒材的作品。在彩色的扇畫、藍紅紫的緞面刺繡、以及黑底金字的絹版印刷以拼貼和對比的排列組合，都是具有特定的意涵。如：緞面刺繡是以便宜的人工尼龍布替代天然的絹布，刺繡文字則以便宜、可大量製作的電動繡替代了傳統手工刺繡，而絹印上面則直接將瘦身廣告的標語及纏足的史料以金色油墨印刷上去，扇畫上面則有西方金髮女郎。這些呈現的手法與元素，無論是視覺性，亦或其藝術意涵，如：流行的（西方金髮女郎）廉價的，大量生產的（電動繡及印刷），方塊的拼組方式，日常的元素、重複性的都具有普普藝術的特質。另一個層次是其對比性，如：系列一的左右對比編排（東方與西方、古代與現代、刺繡文字與扇畫）彼此都有意義上的延伸與連結。

而作品中的「再現」與「挪用」在系列一的部分是將古畫或古書、報紙瘦身廣告標題的內容以絹版印刷方式以不同的形式去再現，如：宵娘圖、纏足弓鞋、金素馨女士纏足自述、古書的纏足藥方，以及廣告標語：女人話題甦胸計劃、健胸新術豐胸典範。讓觀者可以透過這些重現或挪用的文本再次去經驗那過去已經存在而具有意義的事實。是意義產生和轉換過程中必要的一部分，在此透過文字、符號、象徵性的圖，以一種迂迴的方式去呈現作品的多重意涵。

最後「解構」與「再詮釋」猶如兩個對立的面向，也像文本的分析，如同剝洋蔥一般，將文本的意義一層一層地剝開，透過殘留下來的痕跡才能得到文本背後的真實意義，而在不斷生成與轉換的意義中，在抹除與留下痕跡的形式中存在。林珮淳的《相對說畫》由原本挪用而來的廣告文字與扇畫圖像拆解重組，重新產生一種新的文本架構，使文本的意義產生新的詮釋語言。

古今符號及文本相互參照

林珮淳擅長從古代文學典故的圖文以及媒體報章的廣告文字以再現及挪用的方式，透過媒材形式的轉換，將古今符號的文本在圖文的相互參照中，將女性的身體符號解構後重新給予再詮釋的意義，以提出女性建立自我定位的重要性。如以昔日三寸金蓮，與現今流行美的改造行為做對照，並以慣用的正反對立邏輯去質疑、引申關於女性主體意識的課題。

古代的圖文

是林珮淳從古畫或纏足史料獲取，以古典的圖繪美女、女性自述其纏足經驗的古畫書影，與車繡的蓮花等符碼組成。這些古典美女，如再現清人吳友如的宵娘圖，表現女行柔弱纖細的形象，另外挪用明清二代如西廂記、金瓶梅等小說、雜劇的版畫插圖風格，其色慾的暗示和文字搭配，如以「香正軟」形容三寸金蓮，以「尖軟挺」形容乳房，明白寫出對女性慾念中嗅覺、觸覺、目視等感官作用。這些女子的纏足、削肩，在在表現出她們的柔弱孊娜，和詩經中形容美女的「碩人其頎」，以及漢唐盛世高大健康的女性形象是不一樣的，而與其相對應俊秀的

男性情人，合成了頹廢偷歡情色世界。至於書影中金素鑾女士自述其纏足經驗的痛苦與無奈，文中敘述金女士從小被母親強迫纏足，無力反抗，而母親也是從小在男性中心的社會中長大，男性中心的意識型態，對女性纏足的慾求，早已深植於女性心中，內化成為母女相傳必須忍痛並履行的痛苦經驗，為了取悅男性，古代女性不惜摧殘自己的雙足，成為一種畸形的「美」。

作品中的文字與材料

以描寫古今美女的文字為對照，呈現出美麗樣版化的「規格」，如「三寸金蓮」 與「現代金蓮」，「瘦小尖彎」與「挺胸細腰」，「香軟正（小腳）」與「堅挺軟（胸脯）」。並挪用廣告塑身廣告標語，與歷史纏足圖畫做有趣的比照（如男人一手握住女人小腳的圖與「男人無法一手掌握」的文）。除了達到反諷此現象的效果，更可透視資本主義縱容下的大眾媒體及商業宣傳手段，它除了「策略式」的增強女性「為悅己者容」的附庸心理，更將盲從西方文化的隨從角色以「現代感」、「富智慧」、「新女性」等詞彙來加以粉飾、包裝，使得女性消費者相信以「高科技」換取美貌、窈窕身材是現代獨立女性的選擇，是很「自然」的世界走向，林珮淳以詼諧移位的解構手法，而其反諷效果則是有悲憫、有慨嘆的，而以刺繡手法強調「女紅」的文化意義，是有挑戰父權制度界定「女紅」為〈女性份內工作〉的企圖，同時她又要藉著「非男性主流的技術」來重申件立台灣女性美學的重要性。自媽祖教民養蠶取絲，中國傳統女性對紡織、縫衣、刺繡等貢獻是毋庸置疑的，這種似乎矛盾的心態，正表現出女性在自我主體性方面的掙扎，一方面不甘被界定為專事於「女紅」的「織女」，一方面又要藉著女性在刺繡方面的成就來肯定其美學地位。

「去身體」女性主體意識之辯證

在姜麗華 ‧ 呂筱渝合著《過程中的女性主體：台灣女性藝術家的陰性特質調查研究》一書中，在「身體的表達形式」的問題 A1 調查結果中提到，台灣 50 年代出生的女性藝術家中，認為沒有使用自己的身體進行創作有二位：(1)「沒有使用自己的身體。」（吳瑪悧）；(2)「不用裸露的身體，除了因東西方對身體解放的文化背景不同，也因著裸露身體會陷入被男性再次窺視女性身體的擔憂（林珮淳）。」[9] 文中提到：「研究者整理發現 50 年代台灣女性藝術家即使在作品中「使用」身體，往往以隱喻、投射等方式，行動藝術者強調做為『人』的存在，而非女人的身體；在受訪對象中，有半數是排斥與拒絕身體被窺視。」[10] 林珮淳則在〈從文化差異探討台灣女性藝術深層、表層發展問題〉中提到：

> 因生長於父權社會深度儒家思想的制約，之後因著西方平權潮流的衝擊而逐漸自覺的典型台灣女性藝術工作者，不可諱言的，我在不同的場合被認定或自稱為「女性主義者」的感受是尷尬不自然的。其實女性主義的精神是以女性的自主自覺去改變（質疑、顛覆）長期被接受的「現況」（現存權力結構），並企圖建立兩性平等的社會秩序，因此在西方社會，「女性主義者」應是一個獨立自主女性的代稱。然而，當我置身在女性運動團體中，原有潛藏於內在的傳統女性模式仍時而干擾我的思想；又當面臨男權過度擴充令人氣憤不平之際，「女性主義」的突現又必須設法壓抑以避免衝突。[11]

9　姜麗華 ‧ 呂筱渝合著，《過程中的女性主體：台灣女性藝術家的陰性特質調查研究》，同前，頁 17。
10　姜麗華 ‧ 呂筱渝合著，《過程中的女性主體：台灣女性藝術家的陰性特質調查研究》，同前，頁 18。
11　林珮淳，〈從文化差異探討台灣女性藝術深層、表層發展問題〉，《現代美術》，67 期，1996 年 8 月，頁 26-31。

從林珮淳這段文中可以發現其在探究台灣社會傳統與現代共存的時空，對於身存夾縫中的女性「自我」的認同提出她的問題，如：他人對「女性主義」的接受與認知有多深？以及兩者間因著固有的「意識形態」所衍生的問題又是什麼？在她認為「藝術領域裡，男性與女性創作者的條件是否有差異？」其實答案仍環繞在最基底、最隱密的文化結構系統裡，社會習俗、流行時尚常常會切斷女人身體和存在超越性之間的聯繫，像是古代中國的裹小腳讓女性連走路都寸步難行，西方當代的高跟鞋、束腹、整形塑身，這些追求女性外在容貌美和身體美被視為將女性主體的客體化與歧視，女性主義視為是對女性的一種貶抑，將女性變成沒有靈魂的性物件，因此女性主義者視男性藝術家對女性裸體繪畫，為一種看不見的專制統治，並試圖去挑戰由歷史所建構的意識型態之視覺再現之反制，而主張女人必須由被動的再現物體變成主動，常以月經、陰道形象、裸露的身體器官或展演，來表現自我的身體，就是要抵制女性必須遵從的規則和某些女性身體標準。然這也容易落入被男性再次窺視女性身體的擔憂，因此儘管林珮淳的創作同樣是透過女性身體去探討主體意識，在創作概念上卻是很清楚排除「被窺視」，她的「去身體」脈絡是透過古今女性身體的文本與符號去批判來自於父權長期支配下的「意識形態」對女性身體的宰制，並且提出藝術史上對「女性藝術」不公平的「認定」（包括藝術史學者、藝評家、美術行政者、收藏家及觀眾的觀點），導致女性藝術發展的限制與條件差異。因此在《過程中的女性主體：台灣女性藝術家的陰性特質調查研究》問題 A5：有些女性主義理論主張「女人必須由被動的再現物體變成有聲音的對象」，應發自內心的聲音，因此許多女藝術家解放先前被壓抑或貶斥的身體，甚至擺脫父權文化中已被男性窺視物化的形象，開始將自身展現為強韌、主動等形象，並描繪她們身體各部分的痛苦或迫害，以及反諷被男性物化女性裸體的作品，而對於基進女性主義者的藝術行為，調查結果顯示，台灣 50 年代出生的女性藝術家表達未支持看法的女性藝術家，其中林珮淳則表示：「基進女性主義者的藝術行為與男性的行為藝術應是同類型的創作，這種藝術語彙是以身體強烈的表達當然具有其重要的意義。本人作品不以身體作行為藝術是因為解構父權的方式有很多種，如瑪莉·凱利的作品，是以再現父權文化的現象做為強烈批判的手法，本人的作品也是類似的語彙做為女性主義藝術的表現。」[12]

「反迷思」之身體操演

羅蘭·巴特曾說：「反迷思最好的武器可能是以他的方式將他迷思化，並製作一個矯揉做作的迷思。」[13] 林珮淳《相對說畫》便宣示了藝術家對於這些問題的意識形態分析與歷史考掘。以身體的符號去談身體的主體意識，透過相關的歷史文獻資料以及當時的商業廣告修辭，在相互文本的補強與參照脈絡中，可以觀察到許多的社會意涵，傳達出強而有力的政治宣傳的力道，揭示了該戰場裡許多看不見的集體社會制約。作品表面上看起來是在表述許多人堅信不移、追求的美感標準，在《相對說畫》作品中的現代金髮美女和中國傳統的古代仕女對於美的標準與追求，便呈現出關於身體美學的不同文化信仰和相應技術，而在此她要提出的就是為什麼許多女性會借助不同的科技發明或傳統醫療，去改造或傷害自己的身體以符合某些樣版美的標準？作品從父權制度與資本主義的機制裡，追溯整形瘦身的原型操作，透露了傳統父權社會裡男性依其喜好所制訂和因襲的女性身體美標準，同時在現代的傳播媒介更挾著資本主義強勢的運作，更無遠弗屆傳送這些樣板標準。

12　姜麗華·呂筱渝合著，《過程中的女性主體：台灣女性藝術家的陰性特質調查研究》，同前註，頁 30。
13　林珮淳創作自述中提及羅蘭·巴特引文，摘引自郭冠英於 2011 年 7 月藝術家雜誌所發表文章〈辛蒂.雪曼：女性觀視的另翼途徑〉。電子文章出處 http://blog.roodo.com/soundwatch/archives/16256573.html

過去中國文化裡不纏足的女性嫁不出去或出門會被笑，現在太矮的男生和太胖的女生依然較不容易找到婚配對象，或有時會因身材而在社會和工作上受到歧視。而這些外在的歧視，很容易便透過類似「女為悅己者容」這種以男性品味為中心的身體情愛機制和追求事業晉升、人緣廣闊的欲望驅動，而接受內化成為個人定位自我的有形和無形判準和實踐。在 1970 到 1990 年代中期，有很多女性主義者紛紛站出來批評這種加諸女人身體和自我上的種種社會暴力機制，1990 年代中期以後減肥瘦身與美容整形業者行銷策略轉向了，他／她們的新口號，對準了個人求美的內化意識形態做文章，宣稱整形瘦身是為了做自己、是為了有自信，是為了追求更順暢的生涯道路，因而「女為悅己者容」有了新註解，這個「悅己者」變成了女生自己。表面上這個轉向，似乎是符合現下女性追求自覺和身體自主權的一種表徵，而媒體宣傳和許多女性名人的現身說法，更不斷強化透過改變／傷害身體可以自我滿足以及取得社會認可的自主形象，但實際上必須被看見的事實是，減肥瘦身與美容整形業者也正利用這種意識假象，合理化將其女性身體和自我認同切割成可被塑形、可生產利潤的區塊行為。他們在分食新女性荷包的同時，依舊執行了某些擁有定義別人身體型態權力的人的美學暴力。而新女性如今所面對的，便是這種更複雜、更細微、更具滲透力的身體和欲望戰場。

評論《相對說畫》相關的藝評文獻

1995 年林珮淳於台北市立美術館發表《相對說畫》系列，對台灣女性議題有深入的思索，針對此系列作品，經統計當時書籍、畫冊、論文研究文章共有十篇，雜誌藝評有十二篇，報紙報導文章有九篇，因多為二十年前書寫的文獻，部分資料未能完整取得，本文僅得以有限的文獻資料，在此以表格詳列清單如下：

藝術書籍、論文10篇

作者	年份	文章名稱	出處
陳香君	1999年	尋找女聲－女性主義與藝術/歷史	《性屬關係－性別與文化再現》，王雅各主編，台北，心理出版社，頁57-63。
姚瑞中	2001年	第五章陰柔美學	《台灣裝置藝SINCE1991-2001》，木馬文化，頁202-203。
謝東山	2002年	女性主義藝術	《1980-2000台灣當代藝術》，藝術家出版社，頁183。
陸蓉之	2002年	相對說畫系列	《台灣當代女性藝術史》，藝術家出版社，頁254。
簡瑛瑛	2003年	相對說畫系列	《女性心/靈之旅，女族傷痕與邊界書寫》，女書文化，頁73。
陸蓉之	2002年	相對說畫系列	《台灣當代女性藝術史》，藝術家出版社，頁254。
陳香君	2006年	身體與我	《記憶的表情－藝術中的人與自我》，東大圖書公司，頁57-63。
徐文琴	2007年	相對說畫	《台灣美術史》，南天書局，頁219。

謝東山	1996年	1996台北雙年展—台灣藝術主體性	《1996台北雙年展—台灣藝術主體性》畫冊,台北市立美術館出版
陳香君	1999年	相對說畫	《林珮淳作品集》,桃園縣立文化中心
王錦華	1999年5月	性別的美學/政治:90年代台灣女性藝術批評意識初探碩士論文	國立台南藝術學院碩士論文,頁112。

雜誌藝評12篇

林純如	1995年11月	從「蓮」的延伸探討女性自我定位與美的定義	藝術家雜誌246期,頁496-497
劉佩修	1995年3月	林珮淳: 說自己的故事	破雜誌
黃寶萍	1995年12月	相對看畫 · 相對說話	藝術家雜誌247期,頁203。
陸蓉之	2002年	相對說畫系列	《台灣當代女性藝術史》,藝術家出版社,頁254。
董成瑜	1995年11月	美與暴力竟一體 林珮淳訴說女性悲哀	黑白新聞周刊109期,頁81-82。
林芳玫	1995年11月	暴力的美學 美學的暴力	銘傳校刊,頁50-51。
徐文琴	1995年11月	林珮淳1995年個展	雄獅美術雜誌297期,頁59。
徐文琴	1995年10月	「蓮」的啟示—林珮淳創作賞析	現代美術62 期,頁64-67。
謝東山	1996年1月	性別與權力—藝術的女性主義與女性主義的藝術	現代美術65期,頁23-28。
張清華	1996年1月	相對說畫打破美麗神話	美華報導324期,頁78-79。
郭冠英	2013年	從蛹到夏娃克隆:林珮淳藝術的女體賦權	台灣數位藝術知識與創作流通平台專欄
賴小秋	2015年6月	啟示與警世	藝術家第481期,頁2-5。
蕭瓊瑞	2017年7月	天啟與創生:林珮淳的夏娃克隆系列	藝術家第506期,頁314-317。

報紙報導9篇

張伯順	1995年11月	林珮淳相對說畫反諷古今女性美	聯合報
林勝興	1995年11月15日	林珮淳的女性詮釋,在台北市美術館呈現	文化通訊

邱心宜	1995年11月4日	林珮淳個展 顛覆女性定位	大學報
鄭乃銘	1995年10月11日	女性的論釋— 讓男人無法一手掌握	自由時報28版
黃寶萍	1995年10月31日	美麗神話相對說畫， 女性主義畫裡看， 林珮淳直探議題	民生報14版
董青枚	1995年11月7日	相對說畫談女性定位 林珮淳1995年個展	民眾日報文化26版
胡永芬	1995年10月27日	普普手法反思女性困境， 林珮淳個展批判美學暴力	中時晚報12版
張啟德	1996年2月17日	美女、金蓮、水蓮，畫家 林珮淳訴說女性悲哀	澳洲雪梨世界日報
李宗懂	1995年12月12日	評介林珮淳《相對說畫》 談女性定位課題	立報新女性9版

藝評文獻清單表（筆者編製）

文獻回顧

《相對說畫》藝評文章從 10 篇書籍、論文中選取 5 篇較具代表性、雜誌藝評 11 篇選 9 篇觀點與本研究有關連，報紙報導 9 篇中僅選 4 篇節錄，期望梳理出林珮淳作品中多重文本的互文與辯證。

書籍、論文

在書籍、論文的文獻資料中，整理出幾個評論觀點：

謝東山在《1980-2000 台灣當代藝術》即針對林珮淳早期創作脈絡做了關照，提出如下觀察：

> 從 1980 年代的抽象表現風格，歷經 1993 年的《女性詮釋》、《文明誘惑》等系列，再到 1994 年的《蛹》系列。林珮淳的創作儘管在形式上有所轉變，但是，以女性本位為出發的創作態度卻始終如一，1980 年代延續至 1993 年的抽象表現主義風格，林珮淳企圖「從純粹外在抽象表現，轉而面向自我內心深處探究挖掘」。在這件作品中，以古典的中國婦女對照金髮碧眼的西方女性形象，以三寸金蓮對照高跟鞋，質疑時下台灣女性所追求的「美」的定義，也諷刺了女性與商品消費機制之間的關係。《相對說畫》一作，延續以蓮花為的隱喻，再探討女性的審美標準、自我認同的問題。[14]

謝東山在上段落中，以結語的方式簡要勾勒帶過，並無深入細部描述，例如作品為大型裝置創作，包含觀念藝術的文件展呈，數個系列，以及多種媒材共構，屬於後現代的風格，一律略過，相對另一位作者，則明顯的更為用心。

14　謝東山，〈女性主義藝術〉，《1980-2000 台灣當代藝術》，台北，藝術家出版社，2002 年，頁 183。

姚瑞中在《台灣裝置藝 SINCE1991-2001》第五章〈陰柔美學〉對於林珮淳 1995 年的作品《相對說畫》則有完整的描述，文章中提到「這個系列作品共有六十幅尺寸大小等同的平面圖像，包括蓮花扇面、古今中外的美女典型、三寸金蓮、高跟鞋等。而畫面主要是以紅、藍、紫三個顏色所構成，在此一格格的絲綢畫面上，再以金色刺繡出關於「傳統佳人」與「現代美女」的標準定義，例如『三寸金蓮』對照『現代金蓮』、『瘦小尖彎』對照『挺胸細腰』、『香軟正』對照『尖挺軟』等字句，或是挪用通俗廣告的文案：『讓男人無法一手掌握』、『讓腰部以下曲線全部窈窕』等煽情的字句，意有所指地對女性被男性所化約的形象提出對比與嘲諷。」[15] 文章中更提到關於女性身體美的標準是由父權社會結構裡的巿場機制所操弄，變成是「商品化」與「物質化」的傾向事實。文中提到：

> 在現代社會強大的消費主義下，女人往往犧牲自己的肉體以換取男人的認同，現今的女性往往不自覺地以為，只要遵從媒體所塑造的完美性感女人典範（樣板），就可以在男性為主導的審美社會中占有一席之地；但這樣的觀點卻是從男性角度所塑造出來的外在美，並不是真正的「美」，從另一個角度來看，這種被大男人所決定的美之標準，對女性而言又何嘗不是一種「暴力」？甚至是一種「酷刑」？因此，問題的重點並不在於「美」本身，而是在於誰所設定「美」的標準。「商品化」與「物質化」的傾向是現今社會的事實，而幾乎所有的商品都是為了服務廣大的消費者所生產，並從中獲取利潤，但大部分具有消費能力的顧客都是男性，（請注意，許多擁有消費能力的女性，其消費能力的供給仍來自於男性，女強人例外），因此在市場的操作法則下，整個產銷系統不可避免地需要製造某些議題來販賣和促銷這些產品（不管是有用的、無用的或是名過其實的商品）；就此點切入，她所要批判的對象並不僅僅是男性沙文主義，而是對產銷權力的宰制進行透視與批判，尤其是針對女性被拿來作為販賣的樣板化手段，提出一個反思的空間，並且進一步透過作品回過頭來解構父權文化。其動機並不是為了顛覆設會原有的價值觀，而是透過此種對照的方式取得女性的自覺，以及在此自覺下所產生的自主性。[16]

姚瑞中對於《相對說畫》上引的闡述，引人注意是藝術社會學觀點，強調資本主義消費社會，「商品化」與「物質化」的本質，以及真正的「美」，其實是「是從男性角度所塑造出來的，……大男人所決定的美之標準，對女性而言又何嘗不是一種『暴力』？甚至是一種『酷刑』？」頗似為女性備受男性約制來做發聲，不過兩性關係過於簡單化做陳述，則易流入男性沙文主義中。

陳香君《記憶的表情─藝術中的人與自我》書中，對《相對說畫》作品所提出的意識形態分析與歷史考掘的問題有精闢解析，看見作品展現出政治宣傳的強勢力道，揭示了該戰場裡許多看不見的集體社會制約，從以下節錄文章可看出作者對這件作品的評論看法，在細部描述作品各別系列後，她繼續寫：

> 藝術家並採集相關的歷史文獻資料以及當時的商業廣告修辭，補強與解釋

15　姚瑞中，〈第五章陰柔美學〉，《台灣裝置藝 SINCE1991-2001》，台北，木馬文化，2001 年，頁 202。
16　姚瑞中，〈第五章陰柔美學〉，《台灣裝置藝 SINCE1991-2001》，台北，木馬文化，2001 年，頁 202-203。

主軸影像的脈絡。在黑色正方格內，是中國傳統典籍以及台灣當時減肥瘦身廣告對於「身體塑形」的美感和技術宣傳。而桃紅色、紫色和藍色絹布正方格，上面則繡著形容三寸金蓮的性感短語。同時在這整面牆的裝置之外，並另有許多長方形的裝置。每一個長方形裝置，又由左右二邊的長方形拼組而成。左邊是呼應形容三寸金蓮的性感短語的現代減肥瘦身廣告標語，右邊則是呼應前提主軸影像的中國傳統兩性相處的圖像。《相對說畫》從父權制度與資本主義的機制裡，追溯減肥瘦身整形熱的原型操作。《相對說畫》裡的影像，透露了傳統父權社會裡男性依其喜好所制訂和因襲的女性身體美標準（女人纏足，男人不必裹腳），同時現代的傳播媒介更挾著資本主義勢力的運作將之無遠弗屆傳送的結果，是這些標準逐漸和社會認可個人以及自我認可的價值體系緊密的結合在一起。[17]

陳香君在該文中，不單是藝術社會學、女性主義或兩性觀，她特別注意到傳統父權制度，以及精神心理層面中社會認同與個人認同議題，為林珮淳《相對說畫》大型裝置創作開起更廣幅與複雜的言說範疇及傳統的關係。

陸蓉之在《台灣當代女性藝術史》中指出林珮淳的《相對說畫》系列，具有明顯的女性主義傾向。文中指出：「從早期的半自動性技法的有機抽象，發展到 1995 年《相對說畫》系列以油畫配合刺繡巨幅複合繪畫，使透露較明顯的女性主義傾向。」[18]

王錦華《性別的美學／政治：90 年代台灣女性藝術批評意識初探》論文研究中，也針對林珮淳《相對說畫》作品提出如下看法，主要引人注意的是對於作品風格上的描述：

> 以「後現代」的手法將「古代三寸金蓮」的女性及文化問題與今日台灣女性追逐另一種美的標準的心態做比較、對照，而提出女性若沒有自己的審視標準，那只有盲從於他人定義下的「美」與「不美」來獲取他人認同或婚姻的保障。1996 年台北雙年展由策展人之一謝東山策劃「情欲與權力」展中將林珮淳作品《相對說畫》納入了「女性主義類」，也是雙年展中邀請最多女性藝術家參展的一個子題類別。策展人謝東山在〈性別與權力〉一文中有提到：「只有當創作者以『女性意識』為創作意識前提時，這樣的藝術才稱之為『女性主義的藝術』，女性藝術家如果以「『男性意識』為前提而創作，那麼這樣的藝術就不能稱之為『女性主義的藝術』」。林珮淳的「相對說畫」結合傳統女紅的手法，有意解構古今中外「女為悅己容」的迷思，並提出女性建立自我定位的重要性。[19]

從以上五篇文章裡，整裡幾個關注的重點，如謝東山看到的「女性與商品消費機制之間的關係，以及探討女性的審美標準、自我認同的問題」。而姚瑞中則看見「女性身體美的標準是由父權社會結構裡的市場機制所操弄，變成是「商品化」與「物質化」的傾向事實。」陳香君則指出藝術家意識形態分析與歷史考掘，作品展現出政治宣傳的強勢力道，揭示了該戰場裡

17　陳香君，〈身體與我〉，《記憶的表情─藝術中的人與自我》，台北，東大圖書公司，2006 年，頁 57-63。
18　陸蓉之，《台灣當代女性藝術史》，台北，藝術家出版社，2002 年，頁 254。
19　王錦華，《性別的美學／政治：90 年代台灣女性藝術批評意識初探碩士論文》，國立台南藝術學院碩士論文，1999 年 5 月，頁 112。

許多看不見的集體社會制約。陸蓉之指作品透露出明顯的女性主義傾向，而在王錦華的論文研究中，也指出「相對說畫」結合傳統女紅的手法，有意解構古今中外「女為悅己容」的迷思，並提出女性建立自我定位的重要性。

雜誌藝評

在雜誌藝評部分，與上述的書籍不同在於大部分皆為單篇專論，焦距明確，相關文獻資料整理如下：

林純如〈從「蓮」的延伸探討女性自我定位與美的定義〉，本篇文章發表於 1995 年 11 月《藝術家雜誌》，文中作者就《相對說畫》作品提出看法，文中指出：

> 不同於 1994 年以前的圖象式的抽象色彩，代之而起是較為寫實的批判性表現。林珮淳認為自己在現階段對許多社會現象感到憤怒和不滿，單純的以抽象語言來宣洩情緒的方式，已經無法滿足她，因此她希望以圖文對應的直接性批判方式，來反映女性在面對社會環境變遷之下，所造成的價值錯亂和迷失自身定位的隱憂，也試圖從女性在傳統和現代所扮演不同角色中，來尋找出問題的關鍵點。在這個階段作品中，似乎試圖提出女性對外在美的定義如果無法解放，那麼更遑論個人內在精神的提昇。因此，作品中質疑美的定義究竟為何？並以此為楔子來延伸當代女性對自我價值得重新思考。作品中提出一種質疑：究竟美的定義為何？女性在現今社會中真的已經擺脫過去被男性「奴化」與「物化」的情況了嗎？抑或女性在過去與現在都仍殘存著「被纏」與「被操控」的病態心裡現象，不同的只是社會結構的改變以及對象的改變（過去：男人，今日：商品消費市場）。作者仍大量使用她過去慣常使用的「對立」（或對比）的形式，不同的是作品改變過去象徵性手法為主導，而呈現出一種較寫實的直述性文本。[20]

林純如文章中，特別提及藝術家「單純的以抽象語言來宣洩情緒的方式，已經無法滿足她」，將林珮淳創作脈絡從「女性詮釋」過渡到「解構父權」做了見證及貼切的勾勒，另文中也提到作品中所呈現的後現代創作語彙「她過去慣常　使用的「對立」（或對比）的形式，不同的是作品改變過去象徵性手法為主導，而呈現出一種較寫實的直述性文本。」

董成瑜〈美與暴力竟一體林珮淳訴說女性悲哀〉本篇發表於《黑白新聞周刊》11 月號，文中特別提到關於藝術家田野調查所展示的文件，是在自己的土地上找素材，呈現藝術家的本土女性主體意識，內容如下：

> 展示櫃上陳列著林珮淳自己做的田野調查，她訪問了纏足婦女的紀錄以及解開裹腳布後怵目驚心的照片與 X 光片。再往前走，則是她這二年來在報紙、雜誌上搜集來的琳瑯滿目的豐胸瘦身廣告。在澳洲，林珮淳接觸了大量女性主義作品，自己的創作也深受影響，為了與西方習用的「花瓣」、「香蕉」等象徵性器官的意象區隔，她在自己的土地上找素材，於是俯拾即是

20　林純如，〈從「蓮」的延伸探討女性自我定位與美的定義〉，《藝術家雜誌》，第 246 期，1995 年 11 月，頁 496-497。

的豐胸瘦身廣告以及早期的纏足習慣，便成了最好的材料。[21]

林芳玫〈暴力的美學　美學的暴力〉本篇發表於 1995 年 11 月《銘傳校刊》與林珮淳個展的文宣品上，文中將林珮淳的繪畫主題詮釋為對暴力的美學與美學的暴力之反思與顛覆。引人注意的是作者林芳玫對於女性過去在歷史以及當今，甚至外國，事實上仍受約制，尚未解放的恍然大悟，她如此說道：

> 這一系列主題是古今中外不同社會形態對女性美的塑造：如古代有三寸金蓮，而現代女人則執著於豐胸瘦身。為了達到一種極為人工化、刻意扭曲自然體態的美貌標準，女人身上必須承受許多肢體暴力。纏小腳無疑是人類文明史上歷時最悠久、範圍最為廣大的一項酷刑，而現代女人為了擁有整胸與細腰，不惜接受外科手術、電流治療、脫水燒等各項技術，這何嘗不是一種暴力的過程？然而，女人受虐的真相一直遭受蒙蔽，我們在文化象徵的層次上，看到得是仕女圖（或是廣告、海報）上娉婷窈窕、纖細嬌柔的女性美形象，這美麗的形象，就是暴力（豐胸瘦身）的果實。沒有暴力，就沒有文明之美，林珮淳的畫在第一層面上而言，呈現的就是暴力的美學。創作主題就是美學與暴力二者的弔詭與辯證。她在畫面上所作的形式安排很明顯的表達出批判意圖，以古典的視覺元素配上現代社會美體塑身業的廣告文句，圖文並置的方式使我們恍然大悟現代女性不見得真的解放了，作品並非單向度的意識形態批判，它蘊含了豐富的曖昧性。[22]

徐文琴〈「蓮」的啟示─林珮淳創作賞析〉1995 年 10 月發表於《現代美術》62 期，文中則對藝術家精妙敏銳的思維提出更直白的見解，對於一味追求時尚　與外在美的現代女性無異是當頭棒喝：

> 她巧妙的將報紙上琳琅滿目的美容廣告及文字與現代及古代圖畫綜合應用，使觀者產生時空上的錯覺，並以此隱喻現代女子在消費文化的主宰之下，犧牲自己肉體以取悅男性的現象，實與古代仕女的纏足行為無異。她的觀察對於一味追求時尚與外在美的現代女性無異是當頭棒喝。林珮淳相信「藝術的呈現在於反應人類的思想與行為。藝術的價值在於『當下』繪畫語言的抒發及省思空間的開拓」。站在女性的本位，為女性藝術家爭取發言的權利並拓展創作的空間，對台灣畫壇的貢獻不容忽視。[23]

徐文琴肯定藝術家林珮淳在台灣女性藝術，以及對藝術創作形式上裝置藝術空間上的拓展，皆給予正面讚譽，十分難得，但也非言過其實。

張清華〈相對說畫打破美麗神話〉1996 年發表於《美華報導》第 324 期，文中所提及與前林芳枚一文，頗為接近，作者寫道：

> 從古畫或史料中挪用的圖文，以及從今日廣告裡抄取的造型與標誌，在在都陳述了隱藏於文化社會裡的真象。尤其當兩部份圖文並列比照時，更不

21　董成瑜，〈美與暴力竟一體 林珮淳訴說女性悲哀〉，《黑白新聞周刊》，第 109 期，（1995 年 11 月），頁 81-82。

22　林芳玫，〈暴力的美學 美學的暴力〉，《銘傳校刊》，（1995 年 11 月），頁 50-51。

23　徐文琴，〈「蓮」的啟示─林珮淳創作賞析〉，《現代美術》，第 62 期，1995 年 10 月，頁 64-67。

難發現，昔日纏足的風俗與今日崇洋，追求西方美的風氣都塑造出女性難逃「被改造」的命運，誠如林珮淳所言：「難道女性生存的定位，就總是也如此樣板式、白癡式、缺乏自主性的形態裡被界定？」[24]

郭冠英及賴小秋的兩篇文章，為晚近發表，以回顧方式，從現今的角度提及林珮淳《相對說畫》這件代表作。相隔約 20 年，在有限篇幅之下，他們又如何說？

郭冠英〈從蛹到夏娃克隆：林珮淳藝術的女體賦權〉2014 年發表於《台灣數位藝術知識與創作流通平台專欄》中，文中也提到《相對說畫》這件作品：

> 林珮淳在藝術創作中一向表達獨立思考，但不同於西方女性主義習於以身
> 體作為武器來質疑性別不平等，她的創作自早期就用含蓄的東方表達，以
> 美麗的符號呈現顛覆的意涵，如古典漂亮的裹小腳鞋、摩登的高跟鞋，隱
> 喻著雙足的巨痛；「相對說畫」系列用古典女性肖像和蓮花並置，以金色
> 蓮花反諷傳統認定「三寸金蓮」才是賢淑女子的象徵，卻忽略把女人的腳
> 裹成三寸之小的非人性殘暴。林珮淳自早期就習於以美麗的物件作為物化
> 女性的反諷。除了創作，她也為文分析西方女藝術家朱蒂 · 芝加哥的展覽、
> 瑪麗 · 凱莉的《產後文件》等做為一個女人／母親切身經驗轉化的藝術。
> 她也積極投入具體的女權運動，催生了台灣女性藝術協會。20 年對她而言
> 並非是抽象的理念描摹，當年欲破繭而出的林珮淳，今日已身兼藝術家、
> 教育者和理念實踐者多重任務。[25]

賴小秋〈啟示與警世〉2015 年 6 月發表於《藝術家雜誌》，林珮淳 2015 年 5 月於清華大學藝術中心完整呈現 30 年來戮力於藝術領域上的創作經典系列，此次個展呈現林珮淳生平大記事與四大藝術創作系列，本篇為策展人所發表的策展論述，文中對於《相對說畫》作品也提出其觀點：

> 藝術家負笈異鄉時意識到東方女性長期在父權體系下依附生存，強烈質疑
> 刻板僵化的社會體制下狹隘的創作空間，她體悟需擺脫僵化體制的桎梏，
> 女性創作風格才能獨立自主，藝術革新精神方能植根，《相對說畫》系列
> 與《經典系列》的批判表現手法含蓄婉約，卻遠凌駕於西方女性主義創作
> 者赤裸的呈現，彷彿長期壓制下的吶喊發聲。[26]

郭冠英及賴小秋兩位作者，基於文章篇幅，無法深入針對作品進行解析，但有趣的是兩位不約而同提及與國際接軌的外來因子，郭冠英說林珮淳「她也為文分析西方女藝術家朱蒂 · 芝加哥的展覽、瑪麗 · 凱莉的產後文件等做為一個女人／母親切身經驗轉化的藝術。」[27] 賴小秋言：「藝術家負笈異鄉時意識到東方女性長期在父權體系下依附生存。」前者指出了藝術家林珮淳，除了藝術創作，也具有書寫者身份，是一位引進西方兩位重量級女性藝術家的作者。

24　張清華，〈相對說畫打破美麗神話〉，《美華報導》第 324 期，1996 年 1 月，頁 78-79。
25　郭冠英，〈從蛹到夏娃克隆：林珮淳藝術的女體賦權〉，《台灣數位藝術知識與創作流通平台專欄》，（2013 年）。
　　文章出處：http://www.digiarts.org.tw/chinese/Column_Content.aspx?n=F70166FBD2F2C
　　C38&p=1411E8E23B639C2D&s=8C461183DBE8BD55。
26　賴小秋，〈啟示與警示〉，《藝術家》，第 481 期，（2015 年 6 月），頁 2-5。
27　郭冠英，〈從蛹到夏娃克隆：林珮淳藝術的女體賦權〉，《台灣數位藝術知識與創作流通平台專欄》，（2013 年）。

藝術史學家蕭瓊瑞在最新一期的藝術家雜誌所發表的〈天啟與創生：林珮淳的夏娃克隆系列〉，文章中除將林珮淳前後 7 年的「夏娃克隆系列」的創作思維與發展有精闢的觀察，並對其作品從早期的《相對說畫》系列到最新的《夏娃克隆創造計劃》系列，針對其創作特質給予如下的觀察：

> 長期以來，評論者也都以「反科技」的角度，來理解、詮釋林珮淳「夏娃克隆」的系列作品。不過，如果我們重新回到林珮淳作為一位創作者，長期的創作思維與手法，包括自 1995 年在台北市立美術館的《相對說畫》以來，她始終有一種二元辨證、彼此互文的基本思維模式，如：真實／虛假（1996）、景觀／觀景（2000）、非自然／大自然（2004）……等；「夏娃克隆」系列創作，固然帶著反科技過度膨脹的原始動機，甚至在創作的過程中，加入了宗教「天啟」的強化，但到了《夏娃克隆創造計劃》，我們驀然發現：一度不再被提及、關注的「女性主義」思維，反而在這些作品中，竟是如此自然而明確地被舖陳、展現出來。夏娃不再只是從亞當胸前取出的一支肋骨，夏娃克隆在自我建構、創生的過程中，和達文西〈維特魯威人〉（V truvian Man）圖中的那個男人，擁有完全同樣的比例、思維，與價值。[28]

從這篇評論中，對於林珮淳長期在藝術創作的堅持與表現給予肯定，蕭瓊瑞認為其創作是台灣近年來前衛藝術創作中罕見的傑出類型與範例，成為當代台灣結合女性藝術與數位藝術，最具震撼性與反思性的創作者之一，成為 90 年代崛起的一批女性藝術創作者中，迄今擁有最強活力與傑出表現的藝術家，且持續開展中，值得密切關注與期待。

報紙報導

在報紙報導部分，共有十篇，因報導文章多為作品內容的報導，因此本章節僅就部分文章作整理摘錄，如張伯順於《聯合報》的報導文章〈林珮淳相對說畫反諷古今女性美〉中提出其見解：「此次個展排除抽象表現方式，藉中國傳統圖案融入現代精神，猛看畫面是傳統色彩，實際卻滿是新意。」而胡永芬在《中國時報》報導文章〈普普手法反思女性困境，林珮淳個展批判美學暴力〉中提到：

> 藝術家要以她的畫，來敘述這個當下女性主義者的反思。藝術家用類似普普的手法把現代金髮碧眼及古代嬌慵孱弱的二種樣板美女、高跟鞋、三寸小腳鞋與蓮花這些重複拼組出現的圖像，對比鮮豔布面上的女紅，繡上「瘦小尖彎」、「金蓮」、「挺胸細腰」、「美女」等字樣。引用女性學會會長林芳玫所言：這是美學與暴力二者的弔詭與辯證。指藝術家在作品中的所有符號與文字的「明諭」都指涉女性被不同時代美學暴力制約的批判，這也是她所相信藝術的呈現在於反應人類的思想及行為，藝術的價值在於當下繪畫語彙表達切身命題的省思與創作空間的開拓。[29]

李宗憓在《立報》則對於林珮淳的《相對說畫》作品發表一篇〈評介林珮淳「相對說畫」談

28　蕭瓊瑞，〈天啟與創生：林珮淳的夏娃克隆系列〉，《藝術家雜誌》第 506 期，2017 年 7 月，頁 314-317。
29　胡永芬，〈普普手法反思女性困境，林珮淳個展批判美學暴力〉，《中時晚報》，第 12 版，10 月 27 日，1995 年 10 月 27 日。

女性定位課題〉，這篇文章對於作品有著頗為細緻的描述，尤其對於展覽現場包括文件寫道：

> 林女士此展覽場另印一張說明文字，一開始就引用女性主義者伊蓮・西蘇
> 陰性書寫的主張：「來瓦解男性建構的語言思想，以建立女性的主體性，
> 女性應該身體力行去寫自己、讀自己、表達自己。」以及另一位女性學者
> 林達・尼德鼓勵「女性藝術家要重新定義自己的界線，說自己的故事，（而
> 非屬於他人的影像或傳說）。[30]

此外，李宗慬也注意到一個有關金素鑾女士的文本，令人動容：

> 至於書影中金素鑾女士自述其纏足經驗的痛苦與無奈，更令人震驚嘆惋。
> 金女士從小被母親強迫纏足，無力反抗，而母親也是從小在男性中心的社
> 會中長大，男性中心的意識型態，對女性纏足的慾求，早已深植於女性心
> 中，內化成為母女相傳必須忍痛並履行的痛苦經驗。[31]

此篇發表在《立報》的報導，是本文收集到相關《相對說畫》系列藝評文獻中，極少數提到
展覽現場包含文件展示的部分，頗難能可貴，尤其關注描述具體個案，十分深刻，為一篇重
要史料性文獻。而黃寶萍在《民生報》的報導文章中，則針對作品中的女性主義議題探討，
提出她的觀察：

> 在這一系列作品中，林珮淳採取了跨越古今、中西對照的觀點，呈現女性
> 對自我角色和社會定位等認知或被詮釋得事實；在此前提下，中國古代女
> 性的審美標準「三寸金蓮」和今日根據西方觀點而來的「讓男人無法一手
> 掌握」等廣告詞，其實同樣反映了女性的身體無論古今中外，都陷在被審
> 視、鑑賞、改造、類化和物化的循環。有不少女性主義論者試圖以尖銳的
> 語言文化來批判此一事實，但尖酸刻薄不是林珮淳的風格，在《相對說畫》
> 系列中，觀眾可以看到林珮淳以溫和但犀利清晰的繪畫語彙，直接命中議
> 題中心。[32]

小結

筆者在藝評文獻的梳理中，就具體客觀的事實描述以及主觀評述，得以對《相對說畫》整體架
構有更清楚的理解，儘管為二十年前的作品，透過多篇文獻紀錄與討論，除再現作品的樣貌
外，其中對林珮淳創作語彙的觀點與論述角度，可以更完整去探究作品之詮釋為何，在不同的
文本分析中，皆肯定作品具明確的女性主體意識，無論是從女性與商品消費機制之間的關係，
或者探討女性的審美標準及自我認同的問題，以及女性身體美的標準由父權社會結構裡的市
場機制所操弄，變成是「商品化」與「物質化」的傾向事實，並指出藝術家在意識形態與歷
史考掘上，作品展現出政治宣傳的強勢力道，揭示戰場裡許多看不見的集體社會制約等，

林珮淳透過內心敏銳感知，以自身的架構去吸納外界的各種創作資源，使之轉化昇華為內在
豐富的思想泉源，在遭遇外在壓迫時，以自己認同的方式去貼切表達出自身所受限於文化習
俗、教育環境、大眾傳媒等無形間散佈的父權中心思想困境，發現女性長期在父權體系下依

30　李宗慬，〈評介林珮淳「相對說畫」談女性定位課題〉，《立報》，新女性 9 版，1995 年 12 月 12 日。
31　同前註。
32　黃寶萍，〈美麗神話相對說畫，女性主義畫裡看，林珮淳直探議題〉，《民生報》，第 14 版，1995 年 10 月 31 日。

附生存僵化體制的桎梏，始源自女性在傳統與現代的共存時空夾縫裡，受意識型態箝制的「自我」認同所致而不自知，以致於自己以「男性的眼光」在觀看，卻誤認為是以「自身的視野」在觀看，或者覺察自己陷入這樣的混淆，卻不知如何自處、如何跳脫觀看的陷阱，作品解構了古今中外「女為悅己容」的迷思，並提出女性建立自我定位的重要性及具批判力道之觀點。

藝評文獻分析

在《相對說畫》的文獻回顧研究整理中，大致藝術評論與報導文章，對焦在下面幾個議題上：

(一) 謝東山看到的「女性與商品消費機制之間的關係，以及探討女性的審美標準、自我認同的問題」。

(二) 姚瑞中則看見「女性身體美的標準是由父權社會結構裡的市場機制所操弄，變成是「商品化」與「物質化」的傾向事實。」

(三) 陳香君則指出藝術家意識形態分析與歷史考掘，作品展現出政治宣傳的強勢力道，揭示了該戰場裡許多看不見的集體社會制約。

(四) 陸蓉之指作品透露出明顯的女性主義傾向。

(五) 在王錦華的論文研究中，也指出《相對說畫》結合傳統女紅的手法，有意解構古今中外「女為悅己容」的迷思，並提出女性建立自我定位的重要性。

(六) 林純如也指出作品中的後現代創作語彙，文中提到「她過去慣常使用的「對立」（或對比）的形式，不同的是作品改變過去象徵性手法為主導，而呈現出一種較寫實的直述性文本。」，「對立」（對比）呼應了與作品題目「相對說畫」的關係。

(七) 而黃寶萍更寫到：「來批判此一事實，但尖酸刻薄不是林珮淳的風格，在《相對說畫》系列中，觀眾 可以看到林珮淳以溫和但犀利清晰的繪畫語彙，直接命中議題中心。」已經著墨到沒有用「赤裸」身體卻很犀利的語彙，可予以肯定她的評論，而這也切中了林珮淳作品與瑪莉‧凱利藝術語彙有著密切關係的觀點，筆者在之前已深論此相關性。

在這相關的藝評文獻論述中，皆突顯了林珮淳的女性主體意識中所欲探討的，如：女性與商品消費機制之間的關係、女性身體被商品化與物質化、父權制度中的社會認同與個人認同、反思女性困境等議題，作品挪用及再現了古今纏足與美容塑身圖文以一種對照的形式，敘述女性身體的無法自主，雖然是以女性身體作為自主意識的探討符碼，但林珮淳不直接用「赤裸」身體去勾勒，而是透過是透過古與今、東方與西方的元素以再現、挪用的轉化方式，從女性的角度，解構了父權社會符號體系的神話傳說、性別差異與權力。《相對說畫》所交織引用當今古代的文本，以一種「互文與辯證」多重文本創作手法，以及與瑪莉‧凱利創作概念的關係，是以「再現」與「挪用」纏足歷史文件與圖像（纏足典故、纏足秘方、男人眼中美的纏足標準、女人被纏足的痛苦故事文字、男人握住女人腳部及女人露出小腳的古畫等文件），清楚的對照當今美容塑身之廣告文字與圖像（如：呈現美女標準的模特兒、誘惑女性消費者的廣告詞、形容可塑造出的身體形狀如五官、乳房、腿部等文字），讓觀眾看到古代與今日的父權文化對女性身體樣版美的要求標準，去反思美容塑身與纏足的背後意涵與女性身體無法自主之可悲現象，則為過去多數評論較少著墨的區塊，因此筆者在研究上，則特別針對這二個範疇作深入的補強，為本研究主要發現。

結論

林珮淳的《相對說畫》透過「纏足」與「美容塑身」的身體改造，表述著在古今中外二者都是父權社會對身體所進行一種綑綁與壓迫，但多數女性卻仍是在意著「悅者者容」的意識型態，這也是她所想要進一步去探究的，因此，在作品中無論是具體的圖像亦或文字的形容，林珮淳特意將女性的身體符號進行解構，僅呈現出身體所欲突顯的某一部位而非全貌，如圖與圖的對比：西方、現代、摩登的臉／東方、古代、古典的臉，現代金蓮／古代金蓮，現代高跟鞋／古代纏足弓鞋，以及文字對文字：尖、挺、軟／香、軟、正、挺胸細腰／瘦小尖彎、現代金蓮／三寸金蓮、出水芙蓉／蓮花美女、摩登女郎／古典美人、女人話題甦胸計劃／金素馨女士纏足自述、健胸新術豐胸典範／古書的纏足藥方等，透過傳統父權對身體的觀看與評價，以及當代媒體廣告中對女性的美貌迷思刻意渲染，將廣告中強調女性完美外表所應具備的條件，包括：三圍呈黃金比例、豐滿的胸部、纖細的柳腰、姣好的身材等成為百分百完美女性的形象，這些塑身廣告除了推銷瘦身產品外，更透過對身體的迷思，假藉女性應該要多疼惜自己、追求完美、自己做主的訴求，說服女性去勇於主動追求美貌，更強調透過努力即可以雕塑出完美比例的身材，如標榜只有懶女人無醜女人等，在這樣普遍誇大的廣告訴求中製造了女性對於美貌及身材比例的焦慮，憂慮自己沒有達到標準，或對自己的容貌或體型感到不安。如此讓廣告及社會來定義其身體，所謂美女的標準，要從多樣的體型當中全部塑造出社會既定的樣板美是有困難的，不論是對於女體胖瘦的標準以及透過打扮增加外型美貌，這一切的現象都顯示了女性的身體總是受壓迫，林珮淳將這些元素經由再現、挪用的轉化方式，具體呈現她所要探討的問題。

如果說纏足的中國女人步履艱難，帶來女性的無能，當代的美貌迷思則是割斷女性的身體與任何可能超越的聯繫，這種意識形態的宰制才是讓女性沒有自主的權力去看待自己的身體主體意識，也就是說女性擁有自己的身體卻沒有身體的自主權，這看似比過往歷史中的身體自由解放了，然而，這種對於身體外觀的論述規範所合乎是父權男性的目光與要求，也正是這種意識型態，促使女人不斷地保養與改善她們的外貌，在此林珮淳以「三寸金蓮」與「美容塑身」做對照，透過圖文的引申意涵進行多重文本的辯證，透過「媒材」被取用的意義提昇為傳達媒材本身觀念的憑藉，這與瑪莉·凱利創作中對於「物質性」的延伸意涵有著相同的宣揚力道。在作品中的所有符號與文字的「明諭」都指涉女性被不同時代美學暴力制約的批判，這也是她所相信藝術的呈現在於反應人類的思想及行為，藝術的價值在於當下繪畫語彙表達切身命題的省思與創作空間的開拓，因此，《相對說畫》系列所訴諸的重點是從「控訴女性身體被物化」到「收回身體自主權」，藉此來顛覆以男性為中心的美學系統去瓦解男性建構的語言思想，以建立女性的主體性。

從《過程中的女性主體：台灣女性藝術家的陰性特質調查研究》一書中，「形而上的心靈探求—內在的感知與永恆的追求」的調查研究中，問題 D1：創作對您的意義與您對藝術有使命嗎？[33] 林珮淳提到自己從小因為很喜歡畫畫，創作時很快樂，但當真的走上藝術創作專業時就更加有使命感，如作品中想提出父權文化中種種的問題，所以創作對她的意義是隨著年齡有所不同。直到了澳洲攻讀博士接觸了女性主義藝術後，才經歷創作上一個很大的轉折，並開始了日後每系列作品都有一種觀點切入，期透過作品去思考人類在性別、政治、文化、社會、生態、生命的問題，尤其從女性的觀點批判許多錯謬的現象。

33 姜麗華·呂筱渝 合著，《過程中的女性主體：台灣女性藝術家的陰性特質調查研究》，同前註，頁 67。

不論在藝術或藝術史中，女性都企圖重建及再解釋過去女性所失去的歷史，在西方不論是第一代或第二代的女性藝術都鼓勵政治上的執行，要將藝術定位於理論與實踐的層次，就必須為自己創造意義，向藝術既定的本質及功能挑戰。而在性別差異與社會建構基準上，波洛克在尋求一種「現代主義男性神話之解構」觀點上提出看法：「（一）對女性藝術家恢復歷史的數據，而反駁成見及伴隨的藝術史領域之解構；（二）創造一理論架構來解釋研究女性的藝術，以及性別差異之理論及歷史的分析。」[34]，文章中提供了女性主義藝術史的模式，不只檢視女性被置放於男性陳腐典型中的地位，更劃出男性世界之外女性所擁有的疆土，並指明了：「研究女性藝術的問題為其女性特質之產品，或僅為被結構女性之反射。而女性特質為一壓迫的狀況是無庸置疑的，但女性以她活出不同的目的，女性主義分析不只要探討她的限制，也及於女性協調及重新設計那地位的具體方式。」[35] 因而，當女性主義者認為，女性為社會的受害者角色是透過女性的身體來控制女性，因而呼籲女性的自我覺醒，而不是臣服於社會或刻板印象的女性角色。因而，在研究林珮淳《相對說畫》時，得到深刻的體悟，藝術創作為社會現實之反射，從作品中可以看見創作者如何從自我的觀點與經驗去審視男性主宰的文化結構，並且去建構有別於傳統的男性「主流的」創作視點及表現的語言，林珮淳擅用解構／建構的反義，分解、顛覆舊的結構與體制，透過形式／反形式、對比／綜合等對立性的方式，去反思女性在社會文化的角色是如何在一個男性規範的關係中去被定義，而父權結構所指涉的是其中女性利益被屈從、附屬於男性的權力關係上，而如何在這種結構底下透視固有文化的迷思與不自覺，則需將自身抽離這結構體系，在質疑中產生對現存制度的另一種審視標準，才能發展出一套屬於女性觀點去批判宰制，重新探索另一種藝術語彙的可能性。

西方女性主義藝術從 1970 年代發展至今，針對女性特質、女性身體及女性在社會文化議題的藝術探討與創作以有諸多的探討，而在近期《過程中的女性主體：台灣女性藝術家的陰性特質調查研究》報告中，亦提到：「整理發現 50 年代台灣女性藝術家即使在作品中「使用」身體，往往以隱喻、投射等方式，行動藝術者強調做為「人」的存在，而非女人的身體；在受訪對象中，有半數是排斥與拒絕身體被窺視。」[36] 文中並提到有些女性主義理論主張「女人必須由被動的再現物體變成有聲音的對象」，應發自內心的聲音，因此許多女藝術家解放先前被壓抑或貶斥的身體，甚至擺脫父權文化中已被男性窺視物化的形象，開始將自身展現為強韌、主動等形象，並描繪她們身體各部分的痛苦或迫害，以及反諷被男性物化女性裸體的作品，來表現自我的身體、性別的認同與破除父權社會中對女性藝術家的宰制等等。在此觀點中得一結論，林珮淳雖然作品是以身體的相關符號去表達其主體意識，但她並不是直接將身體符號赤裸展示，而是經過轉換後，以「再詮釋」的手法去展現她所欲表達的思維，作品與個人的生活或生命經驗有相關意涵，除反思自我存在的意義外，亦從個人出發到思考國族的歷史，甚至透過神的指意討論周遭自然消失的問題。《相對說畫》系列透過古代女性被迫纏足的悲慘命運，以及當代女性寧可忍痛進行美容塑身以獲得認同之不自信命運，在研究過程中，可以看見藝術家如何透過自身生命脈絡的體會試圖去矯正過去的歷史，並且從紀錄中了解女性藝術工作者如何透過組織的力量去建造自己的場域，以女性的觀點從控訴女性身體被物化到收回自主權的藝術活動中顛覆男性美學觀點，從解構父權文化的策略中去建構女性獨到的見解，

34　傅嘉琿，〈藝術史中女性主義之評論〉，《女藝論：台灣女性藝術文化現象》，台北，女書文化，1998 年，頁 292。
35　傅嘉琿，〈藝術史中女性主義之評論〉，同前註，頁 293。
36　姜麗華‧呂筱渝合著，《過程中的女性主體：台灣女性藝術家的陰性特質調查研究》，同前註，頁 18。

這些都是歷經多年的努力才能足以去轉換社會慣有的梏桎。學者賴瑛瑛的分析也清楚地解釋這個現象：「藝術家並不盲目迷失於藝術主義及形式，反而發展出更具個人特色的創作方式。揚棄了學院技藝的準則，亦超越了東西美學的辯證，女性藝術家從生活周遭的事物及經驗出發，以一種生命紀錄的方式呈現每一個階段的現實與理想。在此，藝術除對外在世界的探索檢閱外，藝術創作更也是藝術家個人私密性的自我披露，進以省思生命的真相與本質。」[37]

在研究的過程中，除發現林珮淳作品所獨特創作語彙具有四個特色：去身體、文件的展示、互文與辯證、以及作品與英國女性主義藝術家瑪莉·凱利創作語彙之密切關係。雖然其作品是以再現或挪用為轉喻過的創作語言，但其所要表述的主體意識是十分明確，擺脫父權文化中被男性窺視物化的形象，作品展出強韌的語彙，透過符號的多重文本破除父權社會中對女性藝術家的宰制，儘管不是基進的女性主義路線，但語言同樣有其批判力道，除反思自我主體的意義外，亦從個人出發去思考整個文化意識的脈絡，甚至透過神的指意討論周遭自然生態被破壞消失的問題，其創作意識已從自身的主體延伸至關切整體人類生存的問題。而對於作品發展被視為多變的風格，在此研究中，林珮淳無論是哪個時期的作品，其中貫穿的符號「蛹」，從「女性詮釋」時期的《文明誘惑》系列中的「蛹形」符號，到「解構父權」的《相對說畫》系列的「纏足（包鞋）」，延伸到「回歸大自然」的《溫室培育》系列的蛹開始羽化為蝴蝶，最後發展出《夏蛙克隆》系列的「複製女體」。

林珮淳早期創作所表達得是當代女性難以突破傳統束縛的膠著與困惑，深覺自己就像「蛹」般的期待破繭而出，而當認知到自己的壓抑與困惑是來自於在女性主義運動之前根本就沒有所謂的「女大師」，藝術史是由男性的手與觀點所主導的，在受到女性主義意識的洗禮之後，即跳脫過去的困惑，不再把受壓抑的自我形象以第一人稱表現於創作中，而是以第三人稱的視點去解構父權文化的種種問題，此時創作已擺脫傳統的繪畫媒材，不再只局限於油彩與畫布。在訪談過程中，林珮淳表示：「為了完整表現每系列創作的觀念，總不斷的挑戰新媒材與表現形式，從不將自己的作品局限於某種流派或類型，因藝術是真誠反映每個時期所關懷的議題，單一不變的媒材與形式無法滿足我每一時期的創作思想。」[38]

從「蛹」變為「蝴蝶美女」再到「人工美女」的繁衍過程，除批判人工生命的短暫與虛幻，這科技複製的理想女體的標準與《相對說畫》作品中的古代纏足與當代美容塑身一樣，儘管時代背景不同了，但樣板性的標準依然不斷繁衍，只是複製科技更加極致，不只改造外形，更直接以基因進行混種重組，「夏蛙克隆」非但具備了如維納斯般的完美身形，但身上卻烙印著毀滅的 666 撒旦的印記，透過科技的催化在展場中甦醒，破繭而出，優雅轉身，在驅動、控制、反制的愛昧與慾望交融中，隱喻著人類的貪婪與想要宰制的霸權，在在都顯現了各種壓迫與侵略性，而林珮淳巧妙得在「去身體」的女性主體意識與以一種「反迷思」之操演，透過各種人工、人造的非自然（纏足、整形塑身、人工造景的假生態、複製人），以一種多義的文本詮釋方式，再現一種美麗的假象，以反覆思辯的後現代語境去回應社會的現實與批判。儘管其創作的風格常被視為「多元」的發展，透過此研究亦發現，無論其創作形式如何轉變，卻始終有其脈絡可循，而「蛹」形的串連，那所預表的除了象徵是自我生命的無限可能與延伸，在歷經一次次的蛹化與突破後，創造出自我的主體，不再受制於意識形態的禁錮。

37 賴瑛瑛著，〈台灣女性藝術的歷史面向〉，收錄於林珮淳編，《女藝論：台灣女性藝術文化現象》，
　　台北，女書文化，1998 年，頁82。
38 筆者於 104 年 10 月 21 日訪談紀錄。

The New Eve in Taiwanese Female Artist's Work—Pey-Chwen Lin

Sammi Tseng | Art Researcher

"The Borders of Digital Art", Mansfield College, Oxford, United Kingdom

The 21st century is the era of technology. Obviously, human beings cannot do without the convenience of technology nowadays, such as smart phones and internet. Yet does advanced technology bring progress or regress to human beings? When human beings invent electronic goods, will the developing Tech help us or control us gradually? Indeed, there are a lot of examples in terms of technology and human cloning, e.g. A.I. Artificial Intellgence (2001). There are also relevant literary texts, e.g. Snow Crash and Darwin's Radio.

In addition to literary works and movies, museums have become a place which conveys the "post-human" concept through a wide range of exhibitions. Male or female artists are trying to put their abstract thoughts into concrete art forms. And technology-enhanced exhibitions are displayed to the audiences in the museums.

Therefore, I would analyze the work by a female artist—Pey-Chwen Lin in "Body, Gender, Technology" Digital Art Exhibition. Living in the digital world, technology is everywhere in our everyday life. Art no longer just repeats the footsteps of their predecessors. Artists, especially female ones, are seeking to break through the traditional limitations and standard.

Female artist—Pey-Chwen Lin

I would analyze the artist of "Body, Gender, Technology" Digital Art Exhibition, Pey-Chwen Lin.[1] The Western feminism has been discussed a lot from different aspects, such as female body, women in social and cultural issues, art and education. Lots of new criticism has never been thought before the 1970s. Thus, numerous exhibitions and discourses start to question patriarchal society and those artists try to challenge patriarchal ideology. They strive to turn History into Herstory.

After returning to Taiwan in 1989 from the United States, Pey-Chwen Lin was actively involved in Taiwan's art community. As an artist and a professor, she is also a mother and

someone's wife. After that, she got her PhD in Australia in 1993. Under the influence of Western feminism, she has participated in the art-related organizations and activities since

1 Professor & Director of the Digital Art Laboratory,Department of Multimedia and Animation Arts, National Taiwan University of Arts

1996. And she also served as director in "Taiwan Women' Art Association".[2] Therefore, feminism has become one of the main causes of her creation and it influences her works a lot.

Technology can be seen as humanity's new technical skills. With the help of the computer, Pey-Chwen Lin creates a new Eve. And Lin refocused attention to the most important part: people. These forms of creation and philosophical thought have affected human civilization in the past, and will likewise in the future.

In the preface of the book, Lin Pey-Chwen: Eve Clone Series, Professor Lin, Li-Chen states that:

> Professor Lin's works indeed deliver a sermon. The Word of the artist stems from Biblical prophecies discussed by prophets of all nations and her concern for humanity's ultimate fate depicted in the New Testament. Professor Lin is a Christian who loves God and humanity. She believes in Jehovah and the prophets sent by God. Thus, her artistic concepts are always about the relationship between humans and their creator, and between civilization and technology. In the Eve Clone Series, she seriously ponders the fight between God and evil described in Revelations. The Bible states that: "The fear of the LORD is the beginning of wisdom: and the knowledge of the Holy One is understanding." Professor Lin is a wise woman who fears God. Her philosophical and religious works have attracted the attention of the international art community and are timeless in nature.

Born in 1959, Pey-Chwen Lin has multiple identities as a woman. She is someone's wife, someone's daughter, and someone's mother in the family. Also, she is a career woman. In the past, women are often trapped in the family in Taiwan. Although she has her own career before she married, she is bound by family once she entered a marriage. However, Pey-Chwen Lin doesn't confine herself. She has mentioned that she is brought up in a

2 Established on January 23rd, 2000, the members for this national art group include people involved in professional domains including art creations, art administration, art criticisms and art education, so as to promote and assist females with the research and development in the visual art industry.

traditional family, and she suffered from gender inequality in her childhood. Thus, she felt quite unfair until she went to America for the master degree. In America, she found that the art education is very different from Taiwan's. She first felt equality in the United States and she got delighted. After returning to Taiwan, she taught in her alma mater, Ming Chuan University. During the time, her male colleagues misunderstood her artistic creation. Besides, male colleagues disrespected her opinions in the meetings, so she strongly felt the patriarchal oppression again.

On the other hand, Pey-Chwen Lin' husband supports her at first. However, since Lin's writing style transformed to contemporary art in America, her creation types are more difficult to understand. Thus, her husband began to complain about her career. As the head of the family, Lin's husband controls all the finance. Later, Pey-Chwen Lin had a good chance to further study in Australia. For this plan, she negotiated with her husband for one year. Obviously, it was a hard process. In the process, she restricted from social norms and social ideology. Furthermore, she suffered from her own mood because she had a one-year-old son at that time. After a series of tests, she finally decided to abandon traditional stereotypes, and she made her own decision resolutely. This was obviously not easy for her. While she thought that she is a highly-educated modern woman, her husband asked her to be a "good mother." Actually, she also doubted whether she is wrong or not. Finally, she decided to follow her heart, striving to what she really wanted.

In Australia, Lin started to involve in feminism. Actually, before she went to Australia, she was not familiar with feminism. In the class, her professor thought that Pey-Chwen Lin's work is indeed feminist, and encouraged her to read related books. After that, she usually went to the library and looking for a lot of references. She said that when she read some references, she felt she suddenly saw the light. She was surprised at the Western women's self-confidence and self-autonomy. To her surprise, Western women boldly declared that what they really want. It seemed impossible in Taiwan at that time. After returning to Taiwan, Pey-Chwen Lin established an art association with some female artists. Its purpose is to help young female creators to continue their works after graduating from schools. Women are often silent, especially in art field in Taiwan. Thus, the association aims at supporting and encouraging women. Undoubtedly, Pey-Chwen Lin is quite active in promoting awareness of women.

In her work, Eve clone, Lin pays attention to gender consciousness according to the Christian doctrine. When God created Adam the first human, the second one is Adam's companion, Eve. Eve represents the origin of life. She is also seen as the mother of all mankind. There are numerous stories about Eve. However, it is all the same that Eve is from Adam's rib. It shows that women always play the secondary role. Pey-Chwen Lin's Eve is quiet beautiful and perfect but stereotypical. It's because Pey-Chwen Lin's artworks focus on questioning male desire because patriarchal belief never disappears. About Pey-Chwen Lin's new Eve, when the viewer comes close to the work, he/she will find that Eve is watching you as well. Even the new Eve's head can move around. In my opinion, it symbolized that women are no longer passive. Though you are watching the new Eve, you

are also being watched.

Besides, Pey-Chwen Lin's new Eve is unlike humans. But the new Eve is unlike a beast as well. She is like some kind of mutant creatures. Her weird beauty makes people confused. Its special 3D effects announced her presence, that is, Eve did once exist. Its flesh indeed existed before. Today, through the artist's ingenuity, the new Eve has a different meaning. Through the assistance of technology, Eve has become Eve clone. We may see the new Eve as we face cyborgs. Pey-Chwen Lin tries to subvert all the traditional modern dichotomies, such as life-death, human-machine, organic-mechanical, natural-cultural, man-woman. To some extent, Pey-Chwen Lin not only puts gender element in it, but also seeks to arouse people's consciousness to the progress of artificial intelligence. When the human body combines with the technology, it will result in considerable changes in our society. When we constantly develop technology, we usually ignore its danger. It is just like Eve: the beautiful new Eve may become monstrous. In fact, Pey-Chwen Lin's view is pessimistic toward technology. Thus, her new Eve is a metaphor for the disaster in the future if human beings do not use technology properly.

Works Cited
· The Bible. New York: Warchtower Bible and Tract Society of New York, Inc., 2001. Print.
· Haraway, Donna J. Simians, Cyborgs, and Women: The Reinvention of Nature.
· New York: Routledge, 2013. Print.
· Hayles, N. Katherine. How We Became Posthuman: Virtual Bodies in Cybernetics, Literature, and Informatics. Chicago: University of Chicago, 1999. Print.
· Hopkins, Patrick D. Sex/Machine: Readings in Culture, Gender, and Technology. Bloomington: Indiana University, 1998. Print.
· 林建光，《賽伯格與後人類主義》，臺中市：中興大學，2013。
· 林珮淳，《女 / 藝 / 論：臺灣女性藝術文化現象》，臺北市：女書文化出版，1998。
· 《關聯：互動多媒體跨領域表演創作》，新北市：林珮淳數位藝術實驗室，2011。
· 《林珮淳：夏娃克隆系列－ Lin Pey-Chwen: Eve Clone Series》。
· 台北市：新苑藝術經紀顧問股份有限公司，2012。
· 曾鈺涓 [Yu-chuan Tseng]，《台灣數位藝術脈流計畫：脈波壹．身體．性別．科技數位藝術展"Body, Gender, Technology" Digital Art Exhibition》，新竹市：臺灣科技藝術教育協會，2010。

許佩純論文
「從林珮淳《相對說畫》系列探討女性主體意識中的互文與辯證」節錄

信仰與家庭

林珮淳自述：2003 年 2 月 3 日我們全家在錫安聖山一起早禱，我先生文祥坐我右邊，倍如坐我左邊，我父母坐我前面。當我結束靈禱後，我淚水直流，我喉嚨酸痛，心口也刺痛的邊哭邊重複禱告：「主啊！我願意像祢，主啊！我願意像阿公 (先知)，對神的指意忠貞到底…」因我想到神沒有計較我過去的殘缺、軟弱與敗壞，居然用如此大的愛來愛我與全家，我太羞愧也太感恩了。我幾乎哭得無法禱告了，突然間我的舌頭不自主的跳起來用舌音靈禱，舌頭快速跳動完全沒有停頓，而且好像有一個東西貼在我的臉上，我彷彿與神面對面！我自己嚇一大跳，我居然被聖靈澆灌與充滿，舌頭跳動全身發熱，我雙眼雖閉鎖卻看到一片光芒，彷彿看到主基督和小妹倍慧在光芒中，我鼻涕與淚水湧流不止，主基督向我活活顯現說話，而內容都是阿公所傳講過的話，且連語氣都一樣，我好受震撼，這是我從未有的經驗。我永遠不會忘記五大重點：「1、我必快來。2、你要為我傳福音。3、裝備自己。4、拆毀中間隔斷的牆。5、你要與我作王掌權。」我真不敢相信如此靈恩臨到我與全家，讓我認識創造我們的神的的確確是真實存在的，是昔在、今在、永在的神，而阿公就是神的代言人，阿公所說的話就是神的話，我已大蒙開啟了。

之後我才想到我尚未受洗的文祥坐在我右邊，他一定搞不懂狀況，於是我問他說：「剛剛我被聖靈充滿時，你在做什麼？」他居然說他親眼目睹有一圈的火，而中間有個人。我很驚訝，但對聖經真理不很熟，於是我們全家就決定去爺爺家請他為我們解惑。爺爺翻開聖經告訴我們：教會是主基督的身體，因此凡隔斷弟兄姊妹或家人中間的牆都要拆毀，必須合一才能豐滿被主提接到天上。另外，主提接得勝聖徒後就開始三年半的大災難，災難結束之後，主就把聖徒帶回地上成為基督共和國，基督是萬王之王，而我們每位聖徒就與主作王一千年。另外，火代表聖靈，中間的人就是主耶穌。文祥聽完後，當天下午決定受水浸領受全備福音，神用異象向他顯現，奇蹟似的改變他「不信神」的剛硬。這些事的發生是我作夢都不敢夢的，但的確是真的，我活活遇見了神，我們全家經驗了神的顯現與天大的恩賜，直到如今我不敢違背從天上來的話語與異象。

全家與先知合影

先知洪以利亞成為 ASIAWEEK 封面人物

全家與先知合影

先知於錫安聖山

全家與先知合影

全家於錫安聖山合影

林珮淳獨子邱楷聞於錫安聖山結婚

林珮淳作農夫

先知探望小妹倍慧

全家於錫安聖山合影

於小林河灘與先知合影

全家於錫安聖山合影

全家於錫安聖山與林麗真牧師合影

藝術教育的推動－林珮淳數位藝術實驗室

林珮淳教授於 2001 年擔任「台藝大多媒體動畫藝術研究所」所長時，設立「林珮淳數位藝術實驗室」來整合校內外資源，透過課程、展覽、表演、工作坊、研討會、國際交流等，鼓勵研究生大膽的實驗與創作，如：動畫、錄像、互動裝置藝術、新媒體公共藝術、跨領域創作表演等。另外，也在研究所的課程中，邀請電腦互動程式設計、數位音樂、舞蹈與戲劇表演專業的教授作協同教學，促成不同領域的整合與創作。

2010 年之後，實驗室正式申請新北市文化局藝文團體的立案，在文化局公部門的補助以及李家祥教授的協同指導下，實驗室就更加積極投入互動創作的實驗。作品陸續得到國內外超過百件入選及獲獎成果，國內獎項如：台北獎、台北數位藝術獎、國美館全國美展、桃創獎、新北市新人獎、大墩獎、KT 科藝獎、高雄獎、礦溪獎等成就，以及以實驗室團隊成員共同創作的《Nexus 關聯》及《Happening Rehearsal 偶》互動表演，分別入圍兩屆的台北數位表演獎以及文建會科技結合表演藝術旗艦計畫等榮譽。

實驗室在國際成就上更是輝煌，史無前例三次獲選法國安亙湖國際數位藝術節；三次獲選義大利威尼斯拉古納國際藝術獎；三次獲選 Siggraph Asia 國際展（展於韓國、澳門、曼谷），二次獲選上海國際電子藝術節，以及多次入圍 404 國際電子藝術節（展於義大利、阿根廷、哥倫比亞、蘇聯、日本與美國等）。尤其難能可貴的是，成員陳韻如、詹嘉華在實驗室的協助下，作品《非墨之舞》、《身體構圖 II》分別榮獲法國安亙湖國際數位藝術節之評審團特別大獎及視覺藝術類全球首獎之極高榮譽，為國爭光。

另外，林珮淳教授也帶領實驗室成員策劃多項重要展覽，如：「未來之身：台灣數位藝術脈流展」、「數位魅影國際展」、「蟲聲幻影互動藝術展」等超過 30 項的策劃與展演。實驗室所有成果皆收錄於「林珮淳數位藝術實驗室網站」內，包括作品、論文、獲獎、教材網站、國際交流、展覽與跨領域表演等成果。實驗室成就也被收錄於文化部的「台灣數位藝術知識與創作流通平台」、葉謹睿的《數位藝術美學》、邱誌勇《關鍵論述與在地實踐：在地脈絡化下的新媒體藝術》、王柏偉的《新媒體展演藝術創意構想及其與文化內涵之關係研究》以及林珮淳主編的《台灣數位藝術 E 檔案》等重要出版內。所培育的成員以遍及教育界、業界與藝術界，林珮淳可謂台灣數位藝術教育最重要的推動者之一。

《Nexus 關聯》表演團隊與邱誌勇、李來春、徐道義、張忘、王怡美教授合影

林珮淳與李家祥、王聖傑、張嘉方、朱潔君於威尼斯 ARTE LAGUNA PRIZE 開幕合影

Lin Pey-Chwen Digital Art Lab

"Lin Pey-Chwen Digital Art Lab" was established in 2001 as part of National Taiwan University of Arts' Department of Multimedia and Animation Arts by Professor Lin Pey-Chwen. Many works created by the lab's members with Prof. Jason Lee's technical assistance have gained many awards such as Taipei Art Awards, Taipei International Digital Art Award, Da Dun Prize, K. T. Award, Taipei Performance Art Prize, 404 International Art Festival, International Shanghai Electronic Art Festival, Chinese Character Art Festival, Taipei Shanghai 2 Cities' Cultural and Art Exhibition, International D&AD Student Awards in England, Siggraph Asia, Arte Laguna Prize in Italy, The Special Jury Award and the First Prize in Enghien-les- Bains Digital Art Festival in France. In 2010, Professor Lin led a team to create the interactive performance works "Nexus" and "Happening Rehearsal "have selected by Taipei Interactive Performance Award. "Nexus" even gained a grant from Taiwan's Council of Cultural Affairs' flagship program for technology and performance arts. This work was also nominated during the 12th International Prague Quadrennial. "Lin Pey-Chwen Digital Art Lab" is one of the most important digital art groups in Taiwan with lot of international achievements and reputation.

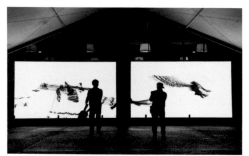 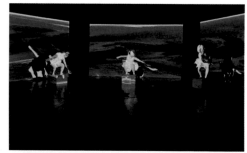

《Soma Mapping II》 《身體構圖 II》　　　　《Happening Rehearsal 偶》

《身體構圖 II》榮獲法國安互湖國際數位藝術節之全球首獎之極高榮譽，
團隊與館長 Dominique Roland 及陳珠櫻教授合影

展覽及成就

林珮淳 1959 年出生於台灣屏東縣。榮獲中興文藝獎章，澳大利亞傑出藝術人才永久居留榮譽、德國紅點獎、文化部公共藝術獎、國立澳大利亞沃隆岡大學藝術創作博士，教育部特殊優秀人才彈性薪資榮譽。曾任國立台灣藝術大學多媒體動畫藝術學系教授兼所長、中國科大講座教授暨規劃與設計學院院長。現任台灣科技藝術學會副理事長、台灣女性藝術協會榮譽理事長及林珮淳數位藝術實驗室主持人。曾出版第一本台灣女性藝術書籍《女藝論》，2010 年起推動台灣數位藝術脈流研究與系列展覽，出版第一本台灣數位藝術書籍《台灣數位藝術 e 檔案》。作品展於國內外重要藝術大展與美術館，如：美國紐約皇后美術館、美國舊金山大學美術館、美國 Godwin-Ternbach 美術館、莫斯科 Platforma 當代藝術空間、烏克蘭利沃夫國立美術館、馬其頓當代藝術館、克羅埃西亞 A Zitnjak 空間、斯洛維尼亞當代藝術中心 (SCCA)，柏林 Rosalux 藝術空間、上海多倫美術館、上海現代美術館、北京 798 藝術村、台灣國立美術館、台北市立美術館、高雄市立美術館、台北當代藝術館、關渡美術館等，以及法國 Exit and Via 藝術節、波蘭國際媒體雙年展、404 國際科技藝術節、義大利威尼斯雙年展平行展、登陸新加坡國際藝術博覽會、巴塞爾藝術博覽會平行展、台北雙年展、台灣雙年展、亞洲女性藝術展等。

作品被收錄於重要藝術相關書籍，如：《英國女性藝術美學期刊》、《台灣當代女性藝術史》、《台灣當代裝置藝術》、《台灣當代藝術》、《台灣當代美術大系》、《數位藝術概論》、《台灣美術史》、《數位美學》、《高中美術課本》、《台灣當代藝術名人錄》、《台灣美術史綱》、《臺灣美術研究講義》、《藝術概論》、《台灣數位藝術 e 檔案》、《中國當代藝術年鑑》、「亞洲名人錄」等，以及報章雜誌與媒體報導超過百項。作品《夏娃克隆系列》榮登於《台灣當代美術通鑑—藝術家雜誌 40 年版》焦點作品、澳洲 agIdeas 國際藝術與設計研討會焦點作品、英國牛津大學國際研討會焦點作品、美國 IGNITE 全球女性博物館專欄報導等。

曾任國內外重要專題講座及主持人，如：國美館「漫遊者」及「快感」國際數位大展座談貴賓、北美館「One dot Zero 國際影像」研討會貴賓、國立清華大學及國內外各大專院校專題演講貴賓、澳大利亞國立澳洲大學 (ANU) 博士學位國際審查委員、澳大利亞雪梨科技大學 (UTS) 博士學位國際審查委員、QS 世界大學排名國際推薦委員、阿根廷 404 國際科技藝術節專題演講貴賓、美國舊金山州立大學專題演講貴賓、蘇俄莫斯科當代藝術空間專題演講貴賓、美國紐約皇后美術館專題演講貴賓、匈牙利國際動畫影展台灣專題策展人、上海國際電子藝術節專題演講貴賓、英國 Loughborough 大學座談貴賓、日本九洲大學演講貴賓、澳洲墨爾本國際設計研討會 agideas 國際評審委員及專題演講貴賓、文化部馬樂侯文化行政管理研討會主持人、文化部與瑞士日內瓦 CERN「藝科倍速 @ 台灣計畫」國際評審委員、台北市文化局影音藝術補助審查委員、行政院文化建設委員會公共藝術審議委員、國家文藝基金會補助審查委員、台中文化局典藏委員、台北市立美術館典藏委員、高雄市立美術館典藏委員、桃園創作獎評審委員、高雄獎評審委員、教育部公費留學審查委員、台北國際數位藝術節評審、大墩獎數位藝術類評審、KT 科技與藝術獎評審、韓國首爾國際動畫影展國際評審委員等榮譽。

Achivements

Pey-Chwen Lin was born in Taiwan in 1959. She received her doctorate degree of Creative Arts from University of Wollongong in Australia in 1996. She is the art professor

and director of Digital Art Lab in National Taiwan University of Arts. Her artworks are presented in many museums and awarded by many festivals such as National Taiwan Museum of Fine Arts, Taipei Fine Arts Museum, MOCA Taipei, Kaohsiung Museum of Arts, Shanghai Museum of Contemporary Art, Shanghai Doland Museum of Fine Arts, Beijing 798 Artist Village, Queens Museum of Art in USA, Lviv National Art Museum in Ukraine and Art Stage Singapore, Taipei Digital Art Festival, 404 Art Festival in Italy and Argentina, Shanghai Electronic Art Festival, Exit and VIA Art Festival in France, WRO Media Art Biennale in Poland, The Tetramatyka Audio Visual Art Festival in Ukraine, Taipei Biennial, Taiwan Biennial and etc., Pey-Chwen's achievements were recorded in many art history books including History of Contemporary Taiwan Woman Artists, Installation Art in Taiwan, Taiwan Contemporary Art, Taiwan Modern Art Series, The History and Development of Digital Art, Art of Taiwan, Digital Aesthetics, Art Island - An Archive of Taiwan Contemporary Artists, High School Art Textbook, Taiwan Digital Art E Files, Yearbook of Chinese Contemporary Art in China, Asian Who's Who in Singapore and n.paradoxa feminist art journal in England and etc. The global women's museum IGNITE interviewed Lin and posted her photograph on their main page. Lin's "Eve Clone Series" has become a significant topic of discussion around the world, and was featured in a 40 year edition of Chronicles of Contemporary Taiwanese Art.

Lin has hosted and judged at notable domestic and international events, such as: Judging Panel Member for Australia Melbourne agIdeas International Design Forum, Curator for Taiwanese Topics in Hungary International Animation Festival; Judging Panel Member for Seoul International Cartoon and Animation Festival, Judge and Seminar Host for National Palace Museum, Ministry of Culture, Ministry of Science, National Taiwan Museum of Fine Arts Digital Exhibitions, Distinguished Seminar Guest at Taipei Fine Arts Museum, Judge and Seminar Host at Digital Art Festival Taipei; Judging Panel for Da Dun Fine Arts Prize, Judge Panel for KT Creativity Award, Keynote Speaker at Shanghai eArts Festival, as well as speaker and host at several other domestic and international universities' seminars. Australia Melbourne agIdeas International Design Forum, Curator for Taiwanese Topics in Hungary International Animation Festival; Judging Panel Member for Seoul International Cartoon and Animation Festival, Judge and Seminar Host for National Palace Museum, Ministry of Culture, Ministry of Science, National Taiwan Museum of Fine Arts Digital Exhibitions, Distinguished Seminar Guest at Taipei Fine Arts Museum, Judge and Seminar Host at Digital Art Festival Taipei; Judging Panel for Da Dun Fine Arts Prize, Judge Panel for KT Creativity Award, Keynote Speaker at Shanghai eArts Festival, as well as speaker and host at several other domestic and international universities' seminars.

Lin has been invited to speak at a number of international academic conferences, lectures, exhibitions, such as: 'Raising the Temperature' International Exhibition and Seminar in Queens Museum of Art (New York, US), Loughborough University Academic Conference and Forum in England, Taipei and Shanghai 2 Cities' Cultural and Art Exhibition Conference; Xi'an 5th Annual China Cultural Industries Expo, Speaker at 404 International Festival of Art & Technology in Argentina and Moscow, Speaker at Melbourne agIdeas International Design Conference in Australia and etc.

林珮淳與蕭瓊瑞教授、陳明惠教授、B.B.Art 創辦人杜昭賢女士合影

林珮淳參展後人類欲望國際大展

林珮淳個展座談，與石瑞仁館長、張惠蘭教授合影

林珮淳獲中興文藝獎章，與先生邱文祥、獨子邱楷閎合影

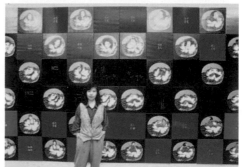

林珮淳於《相對說話》作品前

1989　林書堯 / 造型、色彩與那揮灑的筆觸-女畫家群像

主要表現以壓克力顏料與粉彩綜合的技巧，作品除深受「印象派」對色彩特殊詮釋方式所啟發外，從那灑脫的筆觸也看到如野獸派及表現派般粗曠大膽。畫面有著對比及調和的色彩，色彩彼此充滿引力互交互合。造形的結構取於基本幾何線條—四方、曲線、三角、圓形，又以粗曠筆觸去突破幾何的生硬，給予視覺新衝擊。加上有些糊貼實物提高畫面似條理又非調理的嶄新效果，表現藝術家的情境與心境，雖是無具象的畫面卻有深沉的意境。

（文章節錄自《雄獅美術雜誌 5 月》頁 101-102）

1991　林純如 / 林珮淳的繪畫剖析「超我」「物我」間的意識衝突

當人不再是人，當人不再是一個精神與肉體的完整性，一個有機的統一體，那人也就無法在精神世界上重新找到平衡點，或許作品表面上看來有涉及她所謂「消費文化和女性之間的關聯」，而她真正的重點卻在內心受外力壓制下的反動和一種轉型期的價值崩潰，和游移於新舊間的情緒張力，而她這系列的作品或許也正好印證了詹明信在《反美學》一書中論述的一句話：「精神分裂是一把眼前的一切，交給一個毫無區別差異的世界憧憬。」

（文章節錄自《藝術家雜誌 4 月》）

1992　侯宜人 / 非統性的生命圖象-林珮淳個展

林珮淳畫上意象〈偽作〉組合出自我領域〈真作〉，產生於經由聯想的相關構圖，其圖像始於一個出發點，然後一個接一個發生，構圖乃尋著漩渦方向轉入核心。在漩渦循環流程中，不時出現的形象與其說是受外在觀察的支配，毋寧說是受內在感覺的左右。而這一切感受都收於（或出於）一個位於畫面某處略呈晦暗的卵體內。這整個自我流露過程上的藝術圖象雖多，唯獨那卵形內的人體最能象徵林珮淳的「生命圖象」了。

（文章節錄自《雄獅美術雜誌 261 期》頁 55）

1992　黃貞燕 / 都市的顏色

色彩濃豔強烈，多帶有螢光色調，彷彿各是濃密黏稠、相互混融著的膠質，而那些多半出現在畫幅外圍的曲線，則有著一種迴旋感，它們轉著、繞著，將去捆束畫中物象，這些視覺印象都是從色、線及面的交互作用中，於瞬間生發出來的。畫面是覺效果同質的都會魅惑印象。而如果我們暫時喪失辨識那些圖象的能力，那麼它們也能視為相同的色面和線條。具有熱感的女性肌體，強調著迴轉之曲線性的高跟鞋輪廓，與其說它們如此這般地產生了一種批判、反省的力量，不如將之視為畫家都會經驗的一部份直陳。那些圖象乃是被集中，而不是被結構於畫面上，而色彩與線條的特質，成為傳達畫家感受的媒介。

（文章節錄自《雄獅美術雜誌 267 期》頁 121）

1993　盧天炎 / 激蕩、喧洩、佔有—林珮淳呈現自我圖像生命

創作帶來的魅力，亦如幼時童年作畫的樂趣，自發傾瀉矛盾、壓力、困縛、激情、掙扎的內心圖象，由人形、手、乳房，以至口紅、粉盒、香水、美腿、高跟鞋等。全然不掩的坦陳她是女性，自信的女性、明白的都會女性。她亦強化了女性的特權—軀體的性感、哺育的告白、生產的自尊、孕育的母體驕傲，雖然她也訴說了種種女性受壓抑的內涵，但作品中強烈的宣告寧為女性的滿足，已直驅女性主義的根本精神。

（文章節錄自《藝術家雜誌 4 月》頁 383-386）

1993　林勝興 / 林珮淳開創以「女性消費品觀察女性」的半抽象風格

藉著廣告目錄裡精美的圖片，直接剪貼於畫面中，與蜷曲的人體一起環繞於一圈圈類似卵形的圖畫裡，表現自己內心的掙扎，但所用的色調與理性繁瑣的線條，卻又帶給觀者一種「肉」惑的熱力，一種女性的纖細，曖昧的誘惑感，這種從內心發出的自動性繪畫方式，也成獻出女性藝術家的特質，有人說看她的畫有黏黏的感覺，有人說她畫中類似卵形的圖像，是不斷蠕動、生長、向外擴展的胚胎，這種有體溫、有脈搏跳動的「體內」活動，能感受到林珮淳與她的話有無比的親膩性，以自己的生命圖像來詮釋女性在台灣現階段的現象。

（文章節錄自《自立晚報》1993/1/30）

1995　林純如 / 從「蓮」的延伸探討女性自我定位與美的定義

作品中提出一種質疑：究竟美的定義為何？女性在現今社會中真的已經擺脫過去被男性「奴化」與「物化」的情況了嗎？抑或女性在過去與現在都仍殘存著「被纏」與「被操控」的病態心裡現象，不同的只是社會結構的改變以及對象的改變（過去：男人，今日：商品消費市場）。作者仍大量使用她過去慣常使用的「對立」（或對比）的形式，不同的是作品改變過去象徵性手法為主導的式，而呈現出一種較寫實的直述性文本。

（文章節錄自《藝術家雜誌》10 月）

1995　徐文琴 /「蓮」的啟示—林珮淳創作賞析

作品「蓮花的故事」由 12 片分成四行排列的正方形畫塊組成，畫面互相呼應，「女性詮釋系列」展中所提出的消費文化與藝術結合的風格以及現代的商業社會對女性身心的影響仍然是此展的重要內容，她巧妙的將報紙上琳琅滿目的美容廣告及文字與現代及古代圖畫綜合應用，使觀者產生時空上的錯覺，並以此隱喻現代女子在消費文化的主宰之下，犧牲自己肉體以取悅男性的現象，實與古代仕女的纏足行為無異。她的觀察對於一味追求時尚與外在美的現代女性無異是當頭棒喝。

（文章節錄自《台北市立美術館刊 (現代美術 62 期)(頁 64-67)》》）

1995　林芳玫 / 暴力的美學 美學的暴力

將林珮淳的繪畫主題詮釋為對暴力的美學與美學的暴力之反思、批判、共謀與顛覆。這一系列主題是古今中外不同社會形態對女性美的塑造：如古代有三寸金蓮，而現代女人則執著於豐胸瘦身。林珮淳的畫在第一層面上而言，呈現的就是暴力的美學。她在畫面上所作的形式安排很明顯的表達出批判意圖，以古典的視覺元素配上現代社會美體塑身業的廣告文句，圖文並置的方式使我們恍然大悟現代女性不見得真的解放了，作品並非單向度的意識形態批判，它蘊含了豐富的曖昧性。

（文章節錄自《銘傳校刊 11 月》頁 50-51)

1995　董成瑜 / 美與暴力竟一體 林珮淳訴說女性悲哀

在台北市立美術館地下一樓展覽室，觀眾很自然被那濃烈的色彩與特殊的主題吸引住，畫家使用的素材不就都是生活中隨處可見的？例如「相對說畫系列一」的作品，繡在網布上的文字，其實是瘦身廣告的文案：「讓腰部以下曲線全部窈窕」、「女人從此胸懷大志」、「讓男人無法一手掌握」等等，這些文字又襯著一幅幅纖細嬌柔的古代仕女圖。在澳洲，林珮淳接觸了大量女性主義作品，自己的創作也深受影響，為了與西方習用的「花瓣」、「香蕉」等象徵性器官得意象區隔，她在自己的土地上找素材，於是俯拾即是的豐胸瘦身廣告以及早期的纏足習慣，便成了最好的材料。

（文章節錄自《黑白新聞周刊 11 月》頁 81-82)

1996　張清華 / 相對說畫打破美麗神話

「相對說畫」作品系列是由六十多塊正方形畫塊組成，以重複的蓮花畫題呈現出古典扇面格式，圖案則由古代書畫、今日廣告圖文或臨摹而成。扇畫用古代佚名如「出水芙蓉圖」，意指古今女人用纏足或塑身美容追求符合當代審美標準的效果，「現代金蓮」、「挺胸細腰」、「尖軟挺」等字樣，則是反諷古今女子為達到被認同的標準美所持有的心態和行為。從古畫或史料中挪用的圖文，以及從今日廣告裡抄取的造型與標誌，在都陳述了隱藏於文化社會裡的真象。尤其當兩部份圖文並列比照時，更不難發現，昔日纏足的風俗與今日崇洋，追求西方美的風氣都塑造出女性難逃「被改造」的命運，誠如林珮淳所言：「難道女性生存的定位，就總是在如此樣板式、自謔式、缺乏自主性的形態裡被界定？」

（文章節錄自《美華報導 324 期》頁 78-79)

1997 黃海鳴 / 黑牆，窗裡與窗外

從心裡的層面來說，實際上這是一個近乎無窗、無室外的空間。裡面關著的是連想都不敢想及故意遺忘的家族悲劇？裡面關著的是暗藏於內心不敢為人知的淒苦以及怨恨？是因為窗外一直有人偷窺，只好以偽裝成無生命的裝飾品，來掩蓋祭祀的姿勢及哀怨憤怒？是因為逃避過去也一起把指向未來的生命熱情封死了？該一次挖開舊傷口，放出陳年污血，走出陰靈？窗戶畢竟漸漸的打開，他同時開向過去也開向未來，一束紅色的花從 漂亮但冷酷的銀色網架中瑟瑟地升起。她的作品傳達了受害者妻子細膩的心靈掙扎、哀悽與綿密的愛情。

（文章節錄自《悲情昇華，二二八美展畫冊》）

1998 鄭敏玲 / 林珮淳刻文創作顛覆新聞

利用壓克力刻文結合古畫與電腦合成的新聞圖片，希望觀者能有所省思。展出三十多幅作品中，包括政治、經濟、文化、兩性以及治安方面的熱門焦點，每一幅作品都呈現出幽默、趣味以及令人深思的內涵。

（文章節錄自《台灣時報》1998/11/13）

1998 葉志雲 / 反諷投機風氣 林珮淳以藝術做賭注

運用賭具骰子與四書五經結合創作，徹底顛覆中國聖賢之為用。作品包括一件立體及六件平面，特殊之處是將四書五經之經典文字分別刻於透明的壓克力骰子，呈現尖銳的對比。正負兩相結合，既提供國人反思現代社會的投機亂象，益強烈質疑聖賢經典帶給我們又是什麼？

（文章節錄自《中國時報》1998/11/13）

1999 王錦華 / 性別的美學 / 政治：90 年代台灣女性藝術批評意識初探

國內創作者中最為明顯標榜「女性主義」創作意識的林珮淳，她的「相對說畫」結合傳統女紅的手法，有意解構古今中外「女為悅己容」的迷思，並提出女性建立自我定位的重要性。「相對說畫」針對父權體制與資本帝國對女體控制的批判，接連著傅柯對身體政治的批判性研究，女性主義學者林芳玫即曾由此身體政治的觀點出發，認為這件作品在知性與感性、中國與西洋、古典與現代的弔詭魅力間，呈現女人受虐的真相，並將這件作品詮釋為「對暴力的美學與美學暴力之反思、批判、共謀與顛覆」。

（文章節錄自《國立台南藝術學院碩士論文》）

2000 簡瑛瑛 / 女兒的儀典 - 台灣女性心靈與生態政治藝術

在林珮淳的大型裝置作品〈黑（哭）牆〉中，被遺忘的女性受難家屬及其記錄被「關閉」在簾子後面等待觀視者的發掘，他們的臉容是空白、空缺的，被時間及歷史忽視、遺忘。哭牆正前方擺放受難者女兒阮美珠的乾燥花藝作品，從枯萎死亡祭壇藝術中，找出生命的尊嚴和意義。

（文章節錄自《女兒的儀典 - 台灣女性心靈與文學 / 藝術表現》頁 18）

2001 姚瑞中 / 台灣裝置藝術 SINCE1991-2001

林珮淳 1995 年的作品「相對說畫」是對於女性被整個社會、乃至於家庭所共同形塑、約定俗成的社會制約下，對於女性的角色定位提出反思與批判。她所要批判的對象並不僅僅是男性沙文主義，而是對產銷權力的宰制進行透視與批判，尤其是針對女性被拿來作為販賣的樣板化手段，提出一個反思的空間，並且進一步透過作品回過頭來解構父權文化。其動機並不是為了顛覆設會原有的價值觀，而是透過此種對照的方式取得女性的自覺，以及在此自覺下所產生的主體性。

（文章節錄自《台灣裝置藝術 SINCE1991-2001(木馬文化)》）

2011　葉謹睿 / 人生美麗嗎?談林珮淳反科技的科技藝術創作

展於紐約皇后美術館的《美麗人生》。這一件大型裝置作品，以 32 件國畫立軸形式的巨型數位輸出所組成。利用懸空吊掛的方式，在空間中建構出一個螺旋型的通道。遠看，黃褐的色澤和圓弧的造型，古典、優雅，似乎是一個古色古香的文化迴廊；近看，才發現畫面的構成元素，是無以數計的泛黃社會新聞和廣告。狹隘的通道讓人毫無選擇，陷身其中，你只能摩肩擦踵地去體認那些並不美麗的現代生活社會版。

（文章節錄自《銘傳校刊》頁 53-56)

2015　邱琳婷 /《臺灣美術史》

回到林珮淳的《女史箴圖》，可見畫中一名穿著清涼的檳榔西施，正手拿著酒瓶侍候男客，林珮淳試圖藉此諷喻現代社會中的男性，對於女性身體所流露出的慾望。事實上，若我們比較顧愷之與林珮淳的兩件《女史箴圖》可知，它們各自有其敍述的脈絡；前者著眼於政治脈絡底下的帝后關係，後者則強調商業行為裡的交換關係。因此，如以「女體」為主思考之，則林珮淳的《女史箴圖》則突顯出女性對於身體的主導性，已從男性附加的「道德」約束脫離出來。

（文章節錄自《臺灣美術史》，頁 417-423。)

2018　江足滿 / 外加裝置藝術以反諷「二二八」國族型家暴爲受難者及其（女性）家屬發聲討實質賠償

藝術家林珮淳博士於 1993 年到 1996 年在澳洲求學、創作期間，因研讀了中國婦女史中的纏足真象，而開始對「女性」在文化附屬的地位感到悲哀。...以纏足的小腳纏布鞋的畫面，或是蓮花座上浮現的是西方女子各種嬌美的模樣，中間則以高跟鞋與小腳纏布鞋做對照。這系列乃是林珮淳將中國歷史中因性別歧視意識對女性身體產生的束縛轉化成圖像的代表力作（182）。林珮淳藝術文本正是將改寫經典的範疇朝中華文化中的先秦哲學探索（如翻轉〈周禮〉、《禮經》、《禮記》的〈骰子〉(182-183; 311)系列)等。正如西蘇透過改寫童話、神話、傳說或精神分析理論等對女性主體直接間接的內化教養方式。

（文章節錄自江足滿自採擷 2004 博士論文）

2008　Turner, Ming / Beautiful Life （美麗人生）

was a large-scale installation and was shown in the traditional way of Chinese paintings, whereby paintings are hung from the ceiling and supported by wooden poles at the top and bottom...... When looking more closely at the work, the viewers realisethat the text comes fromrecent newspaper cuttings and noticethat they reflect the problems and circumstances of modern Taiwan.

(Visualising Culture and Gender: Postcolonial Feminist Analyses of Taiwanese Women's Exhibitions,
 1996-2003. PhD Thesis, Loughborough University, pp.230, 231)

2008　Turner, Ming / Antithesis and Intertext (相對說畫）

Lin Pey-Chwen combined Confucian literature, women's portraits and embroidery skills to challenge men's views of beauty in women. In Antithesis and Intertext the idea of using an arrangement of traditional Chinese fans was adopted to install the work.　In the top left-hand part of the work, Lin arranged five images inside water lilies, depicting the conventional notion of beauty in women's faces in contemporaryTaiwan. These are Western women's faces with large blue eyes, thick eyebrows,blond hair, high noses and full lips.

(Visualising Culture and Gender: Postcolonial Feminist Analyses of Taiwanese Women's Exhibitions,
 1996-2003. PhD Thesis, Loughborough University,pp.227-229)

「回歸大自然系列」文獻節錄　**"Back to Nature" Review Excerpt**

2000　陳香君 / 閱讀林珮淳回歸大自然系列

令人錯置的青山綠水，並非人們殷切期盼真實山水，而是林珮淳刻意製造的「景觀」。以假亂真、舒適清新的自然，暗藏充滿美學誘惑的道德猛藥。這動人的自然，其實是鑲崁在商業廣告招牌上人工照片，宣告自然美麗的同時，也憑弔著自然 在 現代社會中的香消玉殞。
（文章節錄自《景觀·觀景》裝置藝術展畫冊，桃園縣立文化中心）

2004　汪雅玲 / 虛擬與複製，探索林珮淳的「非自然」

「非自然」延續之前的創作理念與主軸架構，以數位影像結合裝置的手法，探索環境保育、人與自然，以及自然與文明社會的關係。此系列作品蘊含著濃烈的道德與諷諭的意味。展場裡各式造形的壓克力燈箱有如廣告招牌般，鑲崁於上的花卉影像顯得嬌嬈欲滴，令人目不暇接，繽紛鮮豔，層層交錯的瓣葉，構築了擬花虛境，這些廣告招牌上的自然景色，是一場視覺的宴饗，在讚頌繁花魅力的同時，其虛擬的本質亦如同是一曲哀悼自然在現代社會殞落的輓歌。
（文章節錄自《ARTCO 典藏今藝術雜誌 5 月》（頁 86-87）

2004　鄭乃銘 / 複製自然還是稀釋生命 - 觀林珮淳的「浮光掠影展」

承襲 1999 年的「回歸大自然系列」，以所謂略帶廣告看板式的數位影像與燈箱方式，探討複製自然與都會文明的問題。只是較上個系列深沉地觸探科技過度昌明情況下，生命的複製，一方面越來越被合理化，另一方面也越來越突顯人文深度被稀釋的隱憂。
（文章節錄自《CANS 藝術新聞 12 月》頁 61）

2005　黃海鳴 / 炫麗遊戲中的陷阱與反思—談林珮淳的作品「浮光掠影」—《捕捉》

放在光柵片中的蝴蝶影像並沒有甚麼變化，倒是這一靜一動，平面靜態分佈，與立體飛舞之間產生了相互定位、對照的作用。這裡面隱藏著一種男女之間的奇妙愛情遊戲，包括相互尊重各自的自主性、相互委託各自的自主性，或相互剝奪各自主性等的複雜遊戲。
（文章節錄自《典藏今藝術 150 期 3 月》頁 134-135）

2005　張惠蘭 / 輕盈回歸—林珮淳的創作

這些人工製造的幻象彷彿反映了人類思想的自我為中心的潛意識。連續與不連續間作為媒介的蝴蝶飛行於現實和虛構之間，一方面蝴蝶來自於自然與真實世界，是一種真實的自然，但作品中的蝴蝶所採用的新技術來自人工編碼，來自虛構與想像是一種非真實，它創造出不真實的自然，「捕捉」試著讓觀眾帶著白手套，讓觀眾再次碰觸並感覺到那些蝴蝶，但手套脫下、作品插座拔起後我們的幻象也隨之消失，最終我們得到的只是一個假造的自然。
（文章節錄自《輕盈回歸—林珮淳的創作》）

2005　石瑞仁 / 軟硬兼施、面貌兩極的藝術，解讀林珮淳的複合媒體裝置

她的目標是製作出一種規格化、制式化、可以量產的符號性單體，而這些符號單體的發展，也一路從方正的幾何形塊，經過尖聳的金字塔造型，演變到曲線柔美的貝殼形，這除了反映出一種知性推演、進階發展的思想性格，同時也披露了從假借到自創，從陽剛到陰柔一段心路歷程。
（文章節錄自《藝術觀點雜誌 7 月》頁 80-85）

2005　馬肇石 Pierre Martin / 你所得並非你所見—林珮淳《捕捉》：值得體驗的裝置作品

當觀眾進入裝置作品的展覽室時，會在入口處第一眼見到一個小框架，看起來像是一個塑膠、或是小箱子，裡面有彩色的蝴蝶影像，張大著翅膀，被平放在正中間，如同漂浮在沒有背景的箱子中。因此給人的第一印象就像是昆蟲收集者的標本收藏箱，裡面放置一之死蝶，可能是固定在塑膠中，就像冰凍在冰塊中一樣，以防牠腐壞。這種感覺因為箱子的框架很明顯地存在，而被強調著，同時，也因為蝴蝶身上裝有明顯清晰的數位編號，讓這種感覺更加突顯。
（文章節錄自《CANS 藝術新聞 2 月》頁 60-61）

2005 江淑玲 /「情迷‧意亂」看林珮淳再現的大自然

《花非花》、《花柱》、《溫室培育》三個系列中林珮淳以花朵造型演繹不同主題，有她女性美學的堅持，在虛擬與實擬影像的變動中，點出擁抱科技與批判科技的弔詭處，幻出她對當前社會現象的觀察與批判。而後《捕捉》中翩翩起舞的蝴蝶，林珮淳生動了創作的影像，《城市母體》更將批判的空間拉大，具體指涉奇觀化的城市空間。
（文章節錄自《ARTCO 典藏今藝術雜誌 9 月》）

2005 李美華、侯康德 / 再造一個自然的視野─林珮淳的「回歸大自然」系列

珮淳有著一種堅毅的性格，強烈的意志力，以及慈悲的情懷，她關心人類的前途，以及世人的生命，她不斷的在不可能中找出一種可能性。她融合了文學及視覺的表現方式，巧妙的安置了光鮮的彩色情境，從女性主義到消費主義她的系列作品建構了一個虛幻的妙境，萬花筒式的多彩及變換的幾何圖象，組合了人工的材料，間接的質疑了我們的生活態度及社會的架構，在一種自然的空間中請觀者去接觸她，但又表現出一種距離而不可捉摸。
（文章節錄自《當代藝術新聞 10 月》頁 128-129）

2006 許淑真 / 創造的虛擬

觀眾如處於一種超現實海洋數位擬生態的場景，觀眾經由手指繪製新物種的蝴蝶，電腦被當作是創意的搜尋引擎，滿足於創造新生物的快感。但有趣的是這新物種的蝴蝶像是飛在真空的海域中般，海洋生態並無改變的兀自持續存在著，作品呈現新媒體或生物科技年代的撲朔迷離。
（文章節錄自《藝術中的虛數】畫冊》（高苑藝文中心）

2007 曾鈺涓 / 控制幻影 - 談林珮淳之《創造的虛擬》作品中之科技警訊

《創造的虛擬》以黑色布幔阻絕空間與外部的連結，展場中心控制台內嵌著一台具觸控螢幕功能的電腦，控制者必須戴上白色手套，並以觸碰塗抹的方式，決定蝴蝶的色彩與形態，並在完成創造後，將自己創造的蝴蝶生物體，釋放至前方水族箱之中，蝴蝶在水族箱裡翩翩飛離並消失於螢幕之外。作者以簡單直覺的互動面、美麗 3D 視覺影像以及空間氛圍的營造，讓參與者在觀看初始，驚豔於 3D 視覺畫面得絢麗，並沉溺於互動過程中的愉悅感。達到藝術家藉科技創造之表象趣味性，吸引參與者與之互動，以傳達其科技批判意識。
（文章節錄自《藝術欣賞雜誌 4 月》頁 4-7）

2007 陳宏星 / 當代藝術中美麗發光的省思：林珮淳創作之光

借用了廣告燈箱發光的形體，林珮淳創作了許多美麗的發光系列，如《生生不息，源源不斷》、《景觀‧觀景》、「非自然」系列中的《花非花》及《花柱》、「回歸大自然」系列中的《非自然》等等，為數可觀且極具吸引力的發光體誘惑著觀眾，並引發我們的美感經驗。由於人們早已習慣了廣告燈箱，所以對於它所承載的表象人造自然也不會感到不自然。林珮淳想批判的就是這習慣性的致命吸引力，但方法是製作更多的火光，讓飛蛾般的觀眾繼續撲上來。在耀眼絢麗的光背後，在美麗表象的最底層，潛藏著是林珮淳一顆憂慮的心。對人類因科技所引起的自傲，以及對自然界所帶來的破壞與消耗，藝術家一直是忐忑不安的。或許因為她是位虔誠的信徒，而在上帝所希望救贖的世界中，人類的自傲是不被允許存在的。
（文章節錄自《藝術認證 14 期 6 月》頁 62-65）

2008 康居易 Susan Kendzulak / 荒謬感背後的內省─評林珮淳「回歸大自然」系列創作

「回歸自然」是一系列的題材，以善良與邪惡兩個極端來詮釋宗教信仰。林所刻畫的這則自然虛擬實境，強烈地警告世人，我們必須群起保護生態環境，否則將只能從虛擬實境中憑弔眼前這片自然景觀了。
（文章節錄自《藝術家雜誌》頁 227-228）

2017　Luchia Meihua Lee / A Clarifying Aspect of the Recreation of Nature Sense of Pey-Chwen's Artificial Nature

No matter how often the arts present bias or irregularity, we still need to see art as an effort to renew the sprit. No matter how much artists show violence, destruction, illusion, carelessness, or impatience, most of them concern themselves with spiritual and moral issues, This is vital to all civilizations, no matter their philosophy, political, science and governance.
(Academia. edu.)

2017　Pierre Martin / What You Get Is Not What You See Lin Pey-Chwen "Catching" at MOCA Taipei

Something we can touch. On the other side, new technologies used in this installation, for fix images or moving ones, come from fiction, from creation, something unreal, that creates unreal nature. Something we cannot touch. But this installation tries to finally make us touch and feel those butterflies again: it tries to bring us back to some nature. The circle is complete. But what we get is still a false nature. What you get is not what you see.
(Academia. edu.)

2017　Susan Kendzulak / Lin Pey-Chwen's "Back to Nature"

In Lin's reconstructed world, the artworks ranging from Artificial Nature (a lightbox with digital printing) to the motion imagery of emblems of beauty: flowers and butterflies to the most recent interactive works such as Eve Clone II are indictments of how the virtual realities, rampant commercialism and general urbanization created by us are really the culprits of ruining life, the beautiful natural life of clean air and water, as we know it. In the latest work, viewers trigger virtual bubbles that 'feed' the cyber-Eve/Barbie clone, with more interactivity providing more vacuous bubbles, thus perpetuating a shallow corporate experience to the expense of the spiritual oneness we could experience directly with nature.
(Academia. edu.)

2017　Elsa Chen / Reading Lin Pey-Chwen's work "Back to Nature" Series

In Lin's quest for "pure nature", there are unavoidably outrageous accusations, slight traces of sorrow over the nature that never returns and the insisting hope of realizing the desire. It nevertheless has been a great pleasure to see the artist continuously analyzing and revealing how the deep cultural consciousness obstructs the journey of seeking a "Sexual/Gender Utopia". At this moment, I sincerely expect the great courage of transcending the sense of nostalgia in the artist' quest for the Nature Utopia.
(Academia. edu.)

「夏娃克隆系列」文獻節錄　　"Eve Clone" Review Excerpt

2010　陳明惠 / 電子人、身體與歡愉《台灣數位藝術脈流計畫 - 脈波壹：身體・性別・科技》

林珮淳透過其長期發展的「夏娃」系列，也塑造出另一種超越生物性之電子人，一種結合 21 世紀數位技術與宗教啟示之「類女體」。林珮淳所創造出來的夏娃，雖然帶有女性之基本生理特徵，但她是一種自然與人工結合之電子人，完美無瑕且毫無體毛之夏娃，是藝術家創造出的一種烏托邦式的女體，似真似假，介於有機與無機之間的身體，是以 3D 動態全像攝影的技術，將夏娃的頭像與多種禽獸的形象結合，再賦予不同礦物之色澤與質感（金、銀、銅、鐵、泥），藉此，林珮淳在反諷科技帶給人類之潛藏危害，且挑釁社會對女性身體之牽制與束縛。
(文章節錄自《藝術家雜誌 428 期》頁 293-297)

2010　彭蕙仙 / 林珮淳的創作充滿警世寓言《以科技藝術來批判科技》

對科技藝術，林珮淳的觀點是「運用科技來進行對科技的批判」，因為許多科技呈現的就是人類的驕傲。她最新的創作《夏娃克隆》系列，運用最新的全像攝影技術，製作出「人造的夏娃」，這個夏娃是魔獸，額頭上以各種不同民族的文字烙印「666」標記，點出《聖經》(啟示錄) 談到的大災難。
(文章節錄自《新活水雙月刊第 33 期》頁 14-15)

2010　陳明惠 / 數位符號與性別密碼，重慶「0&1: 數字空間與性別神話」展

作品以 3D 動態全像攝影的形式呈現，將女性頭像與《聖經・啟示錄》中所預言的獸像之形象做結合，藉以諷刺女體因社會價值觀而被物化，文明過度發展對於人類生活環境所造成之負面性與破壞性。
(文章節錄自《藝術家雜誌 421 期》頁 254-257)

2011　葉謹睿 / 人生美麗嗎？談林珮淳反科技的科技藝術創作

林珮淳的創作源自於對生命的體認、感動、關懷以及她對於主的虔誠信仰。與先前的作品相較，《夏娃克隆人》系列運用了更多、也更明確的宗教符號。除了引用創世紀之中的伊甸園故事之外，還在克隆人額頭上以各國語言標示出代表獸印的 666，喻表各個種族和國家，都無法逃脫啟示錄所預言的末日災難。
(文章節錄自《銘傳校刊》頁 53-56)

2011　郝峺音 / 看哪，神的帳幕在人間 - 藝術家林珮淳導讀

長期以來，藝術家的作品中皆存在一個重要的理念：「藉由批判科技以關注人與自然世界的關係」。利用影像、裝置、互動等多元媒材的併置型塑虛擬的「夏娃」，純熟運用新媒體科技的優越性，反諷批判人們所信仰的科技迷思。2011 年夏娃克隆系列展覽深獲好評，未來，有計畫在畫廊界朋友協助下往國際發展。明 (2012) 年 1 月份已經接到「藝術登陸新加坡博覽會」(Art Stage Singapore) 在新加坡展覽的邀展。屆時，夏娃克隆系列將因為場地空間產生更多的展示可能性，用克隆的概念依照展場環境進行佈展。
(文章節錄自《台灣數位藝術知識與創作流通平台》)

2011　陳明惠 / 擬皮層與超宗教《林珮淳的 2010 至 2011「夏娃」系列》

本文以 "擬皮層" 作為論述林珮淳作品的主要面向之一，且以作品中的科技性，論述虛擬的夏娃克隆擬皮層如何表達藝術家欲傳達之象徵性。林珮淳的《透視夏娃克隆》一作，呈現雙層之擬皮層概念：夏娃克隆本身由數位皮層所構成，且夏娃克隆的擬皮層之刺青圖像所透露出肉體與科技之間的曖昧性。作品中的刺青圖騰包含玫瑰、龍、鳳、蛇、蠍子等，這些皆是藝術家特地挑選的圖騰，誠如本文先前所提之 "圖像學" 與藝術家作品之連結，這些刺青圖騰本身的圖像性與藝術家賦予夏娃克隆之象徵性是一致的，皆呈現一種 "美麗的陷阱" 之意含，同時隱射一種暴力、危險與不安之氣質。
(文章節錄自《藝術家雜誌 430 期》頁 224-227)

2011　曾鈺涓 /《夏娃的誕生》基因生殖實驗室的科技反諷

2011 年在台北當代藝術館《林珮淳個展 - 夏娃克隆系列》個展中，林珮淳營造虛擬基因生殖實驗室，博物館冷寂氣氛的空間氛圍，誘惑觀者進入窺探，想象參與創造的歷程，卻只看到被肢解，並保存於標本瓶中的《夏娃克隆手》，

與被封存於框架中的《夏娃 Clone 肖像》。林珮淳的「夏娃」是一個虛擬基因生殖實驗室理所誕生的物種，單純觀看夏娃的長相與臉部表情，是一個帶著淺淺微笑的美麗豔冶女子，有著特殊造型與髮粧，額頭上「666 獸印」烙印隱約可見，背負基因生殖科技的罪惡，成為刻印著獸名印記的女人，更象徵人類自以為是的科技成就之反諷。

（文章節錄自《藝術欣賞期刊》頁 61-63）

2011　邱誌勇 / 是神的意旨，抑或是人的慾望：林珮淳《夏娃克隆系列》中的反諷與批判性

長期以來，在林珮淳的創作中皆存在著一個重要的命題：「藉由批判科技以關注人與自然世界的關係」。無論是早期的《生生不息・源源不斷》(1999)、《蛹之生》(2004)、《創造的虛擬》(2004)，或是《夏娃克隆系列》(2006~ 今)；無論是藉由虛擬的「蝴蝶」或是「女體」，這些看似有著生命的虛擬創造物，皆是將人類文明世界認知中的生命體，轉化成「擬真」（看似虛假，卻比真實還真）的藝術客體。

（文章節錄自《台灣數位藝術知識與創作流通平台》）

2011　吳介祥 / 美學的僭越－林珮淳「夏娃克隆」系列

「夏娃克隆」的互動性暗示出全面的控制和被控制、凝視或監看之模式。全像攝影的夏娃跟隨著視角轉向觀眾，一百八十度的轉向，更能表現夏娃面部俯仰角度和欲迎還羞的眼神姿態。在框架中的人像並不是被動的”被凝視者”，而是具有挑逗力的夏娃。林珮淳以聖經為腳本，以多重的夏娃代表誘惑，又賦予她們和觀者平等對視的地位，作品的互動設計啟動了觀者的操控權，卻也同時是被夏娃監視的裝置。

（文章節錄自美學的僭越－林珮淳「夏娃克隆」系列）

2011　蘇珊娜・斐爾・陶德 Susana Pérez Tort / 林珮淳－夏娃克隆肖像

林珮淳決定以肖像的形式，將夏娃框起來掛上牆上，雖然是引用了文藝復興的表現手法，但重點還是與現代的科學和技術發展相連結，無論後果如何，或是會將人類引導到何處。她這種以科技技術來質問科技的手法，巧妙地牽引出人類在面對自然時，那種自以為是的一種反諷觀點。林珮淳選擇以西方肖像藝術的傳統，來表現她的夏娃克隆，應該最恰當不過的。她以這個藝術展覽的形式，來說明人類一直追求著危險的妄想，讓我們再一次經驗到她獨具意義的科技符號學。

（文章節錄自《藝術評論 布宜諾斯艾利斯，阿根廷》）

2011　林宏璋 / 互被動，從克隆之中－林珮淳的「夏娃克隆」系列

林珮淳的作品利用虛擬技術創作模擬生命狀態的情境，同時也利用作品評論科技的發展狀態。擬真的陳設保存著克隆版本的夏娃在實驗室幻場景以檔案方式存在，在觀看的經驗上呈現出一個「誤入」科技廢墟的死亡場景。然而，有趣的是這些夏娃檔案並非靜止不動，而是與觀者的目光對峙的互動，尤其在要離開展間，透過「歪斜觀看」(looking Awry) 全息攝影幻象效果，呈現出一個觀看者成為「被觀看者」的反轉情境，同時也是擬物／克隆（simulacrum／clone）對於人的凝視。

（文章節錄自《藝術家雜誌 9 月》頁 410-411）

2012　安托列塔・伊凡諾娃 Antoanetta Ivanova / 異形佳人：林珮淳「夏娃克隆個展」的驚奇世界

林珮淳的全像影像——它們模仿的對象已經是非物質的虛擬真實，她的目的在真實呈現夏娃於複製演化過程中，所歷經的不同階段。這種做法企圖說服觀眾夏娃是位真實存在的女性，即使她是從虛擬實境中誕生的產物。聖經裡血肉之軀的夏娃——她原本孕育生命及生產的功能，是不能被控制的，因此被人懼怕——已被新的肉體所取代：一種黏稠、像瓷器、人工訂造和完全包裝起來的夏娃克隆。林珮淳的作品將我們帶入由生化產業所引發的基因決定論的激烈辯證中。

（文章節錄自《夏娃克隆畫冊》頁 21-22）

2014　陳明惠 / 當代藝術中的身體與再現

林珮淳展出另一件作品《夏娃克隆啟示錄 II》以高科技全像媒材的特色來記錄「夏娃克隆啟示 錄」之動態形像、時間與《聖經》章節文字，並進而將藝術家心中虛擬且充滿象徵性之「夏娃」形象，透過科技技術，以一種帶給觀

眾之屏息感在台北當代藝術館之空間震撼展出。林珮淳心目中的夏娃形象是數位、流動且超越實質肉體的，針對林珮淳的創作，1990 年代以來所創作具女性主義意識作品最具張力之形像，同時藉台灣科技技術發達所賜，「夏娃克隆」可謂林珮淳過去 30 年藝術創作中之最具代表性作品。

（文章節錄自《台灣美術雙年展 藝術論壇論文集》，頁 101-103。）

2014 鄭芳和 / 正說話的主體 - 林珮淳的夏娃克隆

夏娃在林珮淳的創作表現中，仍延續文藝復興時期的裸體形象，只是她不是用畫的，卻以多媒體藝術打造虛擬實境的夏娃，她喚名為「夏娃克隆」。究竟林珮淳如何以女性獨特的經驗與觀點，顛覆男性一手建制的主流美學，而她又如何解構夏娃成為夏娃克隆，重新找回女性「說話的主體」權？

（文章節錄自《源雜誌 5-6 月》頁 58-67）

2014 郭冠英 / 從蛹到夏娃克隆：林珮淳藝術的女體賦權

「夏娃克隆」系列是林珮淳近年頗受到國際矚目的作品。但她的作品意識卻可追溯至 20 多年前的脈絡。夏娃克隆在十年的創造間也不斷演化，每一尊身軀轉動的夏娃，是用 3D 軟體程式構成，細緻、窈窕、長身、並有完美的女性三圍比例上，仍有著蛹的痕跡，似乎尚未完全進化成人、或成精。這個「夏娃克隆」究竟是女性力量的呈現還是反擊？「她是『夏娃克隆』，不是『夏娃』，」林珮淳強調：「她是人用科學技術創造出來的複製『夏娃』。」這點出了「夏娃克隆」不是神所創造的夏娃，而是人用科技我創造的複製女體；「夏娃克隆」並非聖經上神所創造出來的「夏娃」，也不具有真正大地之母的生養能力。

（文章節錄自《台灣數位藝術知識與創作流通平台》）

2015 賴小秋 / 啟示與警世一林珮淳創作研究展

「夏娃克隆系列」是眾所矚目的焦點，本展出此系列的《夏娃克隆 II》、《夏娃克隆啟示錄 II》、《夏娃克隆肖像》、《夏娃克隆啟示錄 III》具有其獨特的藝術風格，婉約卻精準犀利，批判複製基因改造或複製人體的尖端科技，深思人類窮究生命源起的秘密是否倒行逆施？質疑人工生命的虛幻與毀滅力量，此展真實讓人感受林珮淳關懷生命，體悟生命，敬天愛人與個人的虔誠信仰。

（文章節錄自《藝術家雜誌》）

2015 邱誌勇 / 藝術作為信仰實踐的場域：評〈啟示與警世一林珮淳創作研究展〉

在林珮淳的創作底蘊中隱含著一種對當代「集體共同幻想」（collective consensual hallucination）的批判，反諷著人類嘗試扮演造物主的想望。在「夏娃克隆系列」中，作品彷彿述說著：當代社會對於科技所懷抱的期許，就好像用盲目的眼睛來看待我們所生活的世界，總是盲目地將網路的虛擬空間視為一個與現在不同。正如林珮淳指出，「夏娃克隆」是「人與蛹」或「人與獸」的合體，雖擁有美妙的臉孔與身軀，但像基改一樣，美其名造福人類，卻可能帶來災害。林珮淳的創作策略，則是利用「迷思化」新媒體科技的優越性，反諷性地批判此一人們所信仰的迷思。

（文章節錄自《台灣數位藝術知識與創作流通平台專欄》）

2016 潘正育 / 來自末世的凝視：林珮淳〈夏娃克隆肖像〉作品評析

透過藝術家的設計，不論從什麼角度觀看，畫面中的人物總是凝視著觀者。這使得作品在某種程度上擁有與觀眾的「互動性（interactivité）」，使其儼然成為一件「不插電」的 3D 互動作品。......不插電，不喧嘩，靜靜地在牆上等待來者的注視。如果說全像投影技術是希望把虛擬之物投射出來，召喚到現實世界，一種「呼之則出」的企圖，那麼全像印刷就是讓虛擬物滯留在現實與虛擬的水平面，「呼之欲出」，卻永遠保持著一道曖昧的距離。

（文章節錄自《藝術認證》）

2016 姜麗華、呂筱渝 / 過程中的女性主體

她的作品旨在探討性別與情慾的文化現象，試圖解構父權文化下的種種議題，同時透過藝術表現女性的自我觀點，質疑父權體制裏的性別視角，並批判現代科技帶給人類社會的負面衝擊。她以科技的符號、數位影像與電腦互動程式，再現「科技文明」的冷漠與「人工生物」的虛幻，藉以反諷人類所創造的自然與生命，皆是虛幻且永遠無法取代造物者的恩典。

（文章節錄自本書，207 頁）

2017 陳明惠 / 當代美學中的數位女性主義：林珮淳的《夏娃克隆創造計畫》系列

早期女性主義者對於夏娃是第二性的說法，具有極大的批評，並試圖顛覆這樣具父權思維的意識形態。然而，林珮淳的創作不同於早期女性主義對於性別二元論的批判，她對於夏娃所代表的象徵性更具興趣，且透過科技技術所創造出來的虛擬夏娃身體，反應科技帶給我們當代生活的影響，這樣的創作思維已跳脫早期女性主義者對於父權的顛覆與批評。

（文章節錄自《藝術家雜誌》）

2017 林宏璋 / 女人創造女人：林珮淳的夏娃克隆的主體性

在林珮淳的作品中，科技總是以他者的身分顯現的原因，作為存在狀態的它方——「廢墟」，或者一個科技成為人類文明的狀態；同時這個圈套也指向著這些永遠匱乏的能指——女人、撒旦／妓女／克隆等等。林珮淳的作品創造出一個「越過」(traverse) 科技的幻見情境，如何能克隆然「匱乏」主體顯現？在林珮淳堆疊的實驗室情境中，各式文件、檔案、投影、及擴增現實中呈現了「科技女性」缺陷而不完整的擬像中顯現。

（文章節錄自《ARTCO 典藏今藝術雜誌》）

2017 邱誌勇 / 警世的數位神諭：林珮淳《夏娃克隆創造計畫》對科技的批判與反思

林珮淳用藝術化的手法對科技發展所帶來的問題以及社會對女性的束縛做了更為深入的思考與批評。神讓夏娃在亞當身體中蘊育而生，正如人類創造了以人為延伸的科技以及賽伯格，這種美麗的誘惑，是一種時代的進步，也是一種對自然的挑戰和對人性的滅絕，及其矛盾的生存之道。

（文章節錄自《Academia. edu 國際學術教育網路期刊》）

2017 楊衍畇 / 跨域的當代末日想像「末日感性」的新媒體人文思維

「夏娃克隆」(Eve Clone) 與觀者對話的詭異觀看關係，觀眾要清楚看到完整的夏娃克隆顯影必須要趨前貼近肖像，當視線角度游移會驚覺她的凝視，觀者愈發想回應她愈會被她吸引，若是稍微後退保持距離，她的影像漸形模糊，對觀者亦無所影響，展場投射燈角度巧妙地營造觀眾由互動的身體感知體會與慾望的關係。林珮淳的末日想像是基於聖經啟示錄對富有權柄的女性之警世批判，形塑帶有獸性的「夏娃克隆」對眾人施展致命的吸引力，反映著藝術家對科技發展衝擊人性的憂心。

（文章節錄自《臺北市立美術館「現代美術」》，2015）

2017 蕭瓊瑞 / 天啟與創生—林珮淳的夏娃克隆系列

如果我們重新回到林珮淳作為一位創作者，長期的創作思維與手法，包括自 1995 年在台北市立美術館的《相對說畫》以來，她始終有一種二元辨證、彼此互文的基本思維模式，如：真實／虛假 (1996)、景觀／觀景 (2000)、非自然／大自然 (2004)……等；「夏娃克隆」系列創作，固然帶著反科技過度膨脹的原始動機，甚至在創作的過程中，加入了宗教「天啟」的強化，但到了《夏娃克隆創造計劃》，我們慕然發現：一度不再被提及、關注的「女性主義」思維，反而在這些作品中，竟是如此自然而明確地被舖陳、展現出來。

（文章節錄自《藝術家雜誌》）

2017 徐婉禎 / 藝術家 40 年林珮淳〈夏娃克隆啟示錄〉(2011) 焦點作品

林珮淳〈夏娃克隆啟示錄〉透過所結合的《聖經》啟示錄內容文字，企圖重新定位「夏娃克隆」的身分角色，使「夏娃克隆」因此被賦予握有權勢的強人形象。當人類的始祖已經可以被複製甚至規格化地量產，我們該視之為福祉抑或苦難？當「夏娃克隆」被林珮淳造出展示，就宿命地難逃作為「物」的命運，生命人造終究是「獸」，林珮淳說：「各族各民將無法逃脫獸的挾制」。……「夏娃克隆」在作品呈現中之被觀看、被定位、被標準化、被物化，正如「女體在父權文化是被觀看、被定位、被標準化、被物化的」，於是作品〈夏娃克隆啟示錄〉也彰顯了林珮淳想重新找回女性「說話的主體」權的意圖，以女性獨特的經驗觀點，重新詮釋大男人主義式的美學價值。

（文章節錄自〈台灣當代美術通鑑〉，《藝術家雜誌》40 年版，2014 年，頁 544~545 。）

2017 Lin, Li-Chen / "Word" and "Tech"

The Eve Clone Series, she seriously ponders the fight between God and the evils described in Revelations. The Bible states that: "The fear of the LORD is the beginning of wisdom: and the knowledge of the holy is understanding." Professor Lin is a wise woman who fears God. Her philosophical and religious works have attracted the attention of the international art world and are timeless in nature.
(Aademia. edu)

2017 Hsiao, Chong-Ray / God's Inspiration & Human's Creation Lin Pey Chwen's Eve Clone Series

Far back in Portrait of Eve Clone, the beautiful, cold, and staring eyes called to mind the pair of eyes in Édouard Manet's Olympia, which stare right into the viewer outside the painting.Through long-term persistence and hard work, Lin has become the most important and outstanding artist among female artists who emerged in the 90s, and she has continued to hold exhibitions. She is worthy of close attention and high expectations.
(Aademia. edu)

2017 Cheng, Fang-Ho / Speaking Subject Lin Pey-Chwen's Eve Clone

Lin has her pious religious belief. In art, she has found her belief in the female speaking subject. Under the support of her double beliefs, together with her sharp and critical character and her compassionate religious mentality, the combination will make her life more free and magnificent.
(Aademia. edu)

2017 Chiu, Chih-Yung / Art as a Realm for Implementation of Religious Belief

For Lin, her artistic creations, as a realm to implement life, are never separated from her religious compassion for the present world and society. She both reminds people to be aware of their being situated in the era of digital technology and expresses her critical characteristics to the world as an artist.
(Aademia. edu)

2017 Lai, Hsiao-Chiu / Revelation·Notification Research Solo Exhibition by Lin Pey-Chwen

Lin's artistic attitude transcendentally conveys a deep interpretation of contemporary life and culture. Each of the series expresses subversive thought and implicitly warns against the great potential for technology to destroy nature. With a sincere sense of conviction and perseverance, these works present a unified theme, while pursuing philosophical artistry through an ultimate expression.
(Aademia. edu)

2017 Ming Turner / Visualizing post-human & Cybersexuality Lin Pey- Chwen and the Eve Clone series

Eve's body represents easily recognizable stereotypes of women found in works of art across the centuries; however, it is interesting to consider whether Lin's post-human and hybridized Eve transcends the religious and symbolic cultural connotations of Eve. It is also evident that there is clear transition in Lin's work from the earlier period when she focused predominantly on a feminist approach to the representation of women in the patriarchal culture of Christianity, to her recent critique of technology.
(East Asian Journal of Popular Culture Volume 2, 2016.)

2017 Kuo, Gwen Kuan-Ying / From Pupa to Eve Clone Lin Pey-Chwen Empowering Femininity
The deathly seductive image of Eve Clone powerfully wrapped the weakness of human nature. The super-power facade of technology has made human over depending on it and obsessed the power which engaged in the deathly weapons and wars. By Lin's hands, the Great Image of Eve Clone conveyed an oracle to remind us the core belief of life, to distinguish the divine essence of the universe.
(Aademia. edu)

2017 Lin, Hongjohn / Interpassivity within a Clone

Lin's work has marked the site of technology the other place—the ruin. At the same time, it shows the chain of signifiers of the incomplete, such as woman, Satan, prostitute, clone. Lin creates a situation to traverse the fantasy of technology with the art of media—how can we clone the Lack? The answer lies in only when a partial simulacrum completes itself as the passive situation of "I saw myself seeing Technology, " for a revelation from the clones, the absolute world of thing-ness that gazes back the human.
(Aademia. edu)

2017 Chiu, Chih-Yung / God's Will or Human Desire The Irony and Criticism

Only then can art reflect phenomena in the most vivid and profound ways. In the Eve Clone series, Lin utilized mixed media as the form of her artistic presentation both to remind people to be aware of their being situated in the era of digital technology and to express her critical characteristics to the world as an artist.
(Aademia. edu)

2017 Ming Turner / Quasi-skin and Post-religion Lin Pey Chwen's Eve Clone series, 2010-11

Although the image 666 has strong Christian symbolism, it is not appropriate to analyse Lin's works in a religious way. In terms of aesthetics, techniques and the professionalism of their construction, her works surpass any religious meanings of the images. The Quasi-skin and the symbolism of being between death and life, in addition to the strange, dreamy and unreal feeling of Lin's works are the unique characteristics of The Portrait of Eve Clone Series.
(n. paradoxa, 2012)

2017 Jane Tseng / The Birth of Eve Clone Technological Satire of a Genetic Reproduction Laboratory

Lin Pey-Chwen's works represent Heidegger's Essentialism. In Lin's works, she used digital media as tools to deconstruct and criticize technology, controlling viewers' sense of sight, constructing a beautiful but unreal palace. When viewers are immersed in the work, attracted by the work's beauty, controlled by the work's issue or confused in their imagined world, all captivation echoes with that Lin criticizes technology via technology in her works.
(Academia edu)

2017 Wu, Chieh-Hsiang / The Transgressions of Aesthetics Lin Pey-Chwen "Eve Clone" Series

Rather, there exist only selfish instincts without an ultimate direction. Lin uses Eve to tempt us into this virtual, futuristic space so that we may experience the swing between human desire and the devil's incitement, the dialectical debate between God's will and people's interpretations. In Eve Clone's view, we are not just all prisoners of aesthetic temptations, but also accomplices of aesthetic transgressions.
(Aademia. edu)

2017 Antoanetta Ivanova / Alien Beauties the haunting world of Pey-Chwen Lin's Eve Clones

Pey-Chwen Lin's art extends these aesthetic approaches into the of 21st century by presenting us with a vision of genetic engineering and the merging of biological and artificial systems whereby the potential for error, while tampering with nature, can be truly frightening. Take these art works as a warning: despite all of humanity's technological and scientific advances we remain mere mortals. Eve's biological state of being is sacred to the continuation of humankind.
(Aademia. edu)

2017 Susana Pérez Tort / Pey-Chwen Lin—Portrait of Eve Clone

Lin Pey-Chwen could not do a better choice when deciding to frame her Eve Clones as Western traditional portraits. Her conviction that Humanity is following a dangerous chimera is once again translated to an art show where we attend to the experience of her meaningful Technological Semiotics.

(Aademia. edu)

2017 Pan Cheng-Yu / The Gaze from the Apocalypse An Analysis of Lin Pey-Chwen'sPortrait of Eve Clone

Through the work, we see that the artist, as an "other", gazes from "there" to "here", an act that is neither human nor realistic, indicating the stance the artist has taken as an outsider. Without the stance, art would never become critical.

(IMAG InSEA Magazine, 2017)

Lin, Hongjohn / Feminine Creation of Woman

Is it the partial object that will never cease to fight to the death? Mind you. The uncertain answer is sure. The feminine subject created by a woman will never cease to defy the matrix of Oedipus complex persistently for a paradoxical exceptional existence outside of masculine subjectivity.

(Academia edu)

2017 Chiu Chih-Yung / The Warning Digital Oracle The Criticism and Reflection on Technology in Lin Pey-Chwen's Making of Eve Clone

Lin uses the arts as a means to provide profound thinking and criticism on the problems engendered by technology and the societal constraints imposed on women. God makes Eve grow from Adam's body, just as humans create technology and cyborgs as an extension of humans. This kind of beautiful temptation is the progress of an era, a challenge to nature and the extinction of humanity, and the way of existence in ambiguity.

(Academia edu)

2017 Sammi Tseng / The New Eve in Taiwanese Female Artist's Work—Pey-Chwen Lin

When we constantly develop technology, we usually ignore its danger. It is just like Eve: the beautiful new Eve may become monstrous. In fact, Pey-Chwen Lin's view is pessimistic toward technology. Thus, her new Eve is a metaphor for the disaster in the future if human beings do not use technology properly.

("The Borders of Digital Art", Mansfield College, Oxford, United Kingdom)

「女性詮釋系列」與「解構父權系列」報導與評論列表

 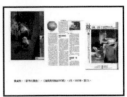

 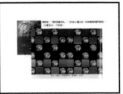

 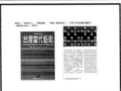

林書堯，〈造型、色彩與揮灑的筆觸-女畫家群像專欄〉，《雄獅美術雜誌》，5月，1989年，頁101-102。

林純如，〈林珮淳的繪畫剖析「超我」「物我」間的意識衝突〉，《藝術家雜誌》，4月，1991年，頁484-486。

侯宜人，〈非統性的生命圖象-林珮淳個展〉，《雄獅美術雜誌》，4月，1992，頁55。

黃貞燕，〈都市的顏色〉，《雄獅美術雜誌267期》，4月，1992年，頁121。

尤美雯，〈1992女性詮釋系列〉，《休閒生活》，4月，1992年。

盧天炎，〈激盪、喧洩、佔有－林珮淳呈現自我圖像生命〉，《藝術家雜誌》，4月，1993年，頁383-386。

林珮淳，〈相對說「畫」-從審美標準探討女性定位課題〉，《銘傳校刊》，11月，1995年。

林珮淳，〈我有(畫)話要說-從古今審美標準探討女性定位課題〉，《藝術家》246期，11月，1995年，頁431-433。

孫麗華，〈林珮淳個展〉，《台灣新聞報》，5月，1989年。

本刊訊，〈林珮淳動感筆觸粗獷大膽畫作首次面對國人〉，《台灣時報》，5月，1989年。

宋雅姿，〈林珮淳創作抽象畫，理性的處理發揮感性的效果〉，《中央日報》，5月，1989年。

鄭乃銘，〈林珮淳創作〉，《自由時報》，5月，1989年。

張慈暉，〈林珮淳個展〉，《大明報》，11月，1990年。

鄭乃銘，〈林珮淳1991系列－女性詮釋與對照〉，《自由時報》，4月，1991年。

盧天炎，〈形與色的掙扎，林珮淳1991系列〉，《大成報》，4月，1991年。

宋雅姿，《抽象系列》，〈林珮淳，現代繪畫富創意〉，《中央日報》，11月，1992 年。

黃寶萍，《女性詮釋系列》，〈女性角色，畫裡探索〉，《民生報》，11月，1992年。

胡永芬，《女性詮釋系列》，〈林珮淳以不變的藝術詮釋禁錮掙扎的女性〉，《中時晚報》，4月，1992年。

鄭乃銘，《女性詮釋系列》，〈女性畫家描繪「異質」心理風景〉，《自由時報》，10月11日，1993年。

林芳吟，《女性詮釋系列》，〈現代繪畫的女性詮釋，林珮淳的繪畫語言與表現形式〉，《大明報》，4月19日，1993年。

林勝興，《女性詮釋系列》，〈林珮淳開創以「女性消費品觀察女性」的半抽象風格〉，《自立晚報》，1月20日，1993年。

本刊訊，《女性詮釋系列》，〈女性詮釋 詮釋女性〉，《民生報》，11月，1993年。

主　編，《女性與當代藝術對話》，帝門藝術中心，10月，1991年，頁14。

劉坤富，〈1992女性詮釋系列－文明誘惑〉，《台灣省立美術館導覽》，4月，1992年。

 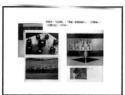

 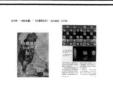

 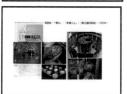

劉坤富，〈從纏小腳到高跟鞋，林珮淳透過畫布反省女性角色〉，《台灣省立美術館導覽》，4月，1992年。

主　編，《女性詮釋系列-文明的誘惑》，二號公寓，12月，1992年，頁33-34。

劉方稜，《女性詮釋系列》，〈林珮淳個展一九九二女性詮釋系列〉，《台灣美術館館刊58期》，5月，1993年，頁5-6。

簡瑛瑛，《安全窩》、《黑牆、窗裡與窗外》，〈女兒的儀典－台灣女性心靈與生態政治藝術〉，《女藝論》，
　　　　林珮淳主編，女書文化，1998年。

陳香君，《相對說畫系列》，〈尋找女聲－女性主義與藝術/歷史〉，《性屬關係－性別與文化再現》，
　　　　王雅各主編，心理出版社，1999年。

簡瑛瑛，《安全窩》、《黑牆、窗裡與窗外》，〈女兒的儀典－台灣女性心靈與生態政治藝術〉，
　　　　《女兒的儀典－台灣女性心靈與文學/藝術表現》，女書文化，2000年。

姚瑞中，《相對說畫系列》，〈第五章陰柔美學〉，《台灣裝置藝SINCE1991-2001》，木馬文化，2001年。

謝東山，《經典之作》、《相對說畫》、《黑牆、窗裡與窗外》，《1980-2000台灣當代藝術》，藝術家出版社，2002年。

陸蓉之，《我看女人世界四系列》、《回歸大自然系列－生生不息、源源不斷》、《向造成台灣歷史大悲劇的當局者致意》、
　　　　《兒童樂園迷宮》、《骰子》、《相對說畫系列》，《台灣當代女性藝術史》，藝術家出版社，2002年。

簡瑛瑛，《相對說畫系列》，〈女性心/靈之旅，女族傷痕與邊界書寫〉，女書文化，2003年。

葉謹睿，《美麗人生》，〈數位藝術的個人電腦紀元〉，《數位藝術概論》，藝術家出版社，12月，2005年，頁59-62。

徐文琴，《相對說畫》，《台灣美術史》，南天書局，2007年。

葉謹睿，《美麗人生》，〈前衛性的創作能量複合式的美感─從紐約看台灣的科技藝術〉，《台灣數位藝術e檔案》，
　　　　林珮淳主編，藝術家出版社，2012。

謝里法，〈台灣美術研究講義〉，藝術家出版，頁272，2016

林純如，〈從「蓮」的延伸探討女性自我定位與美的定義〉，《藝術家雜誌》，10月，1995年，頁496-497。

劉佩修，〈林珮淳: 說自己的故事〉，《破雜誌》，3月，1995年。

林珮淳，〈我有(畫)話要說-從古今審美標準探討女性定位課題〉，《藝術家》，第246期，11月，1995年，頁431-433。

林純如，〈從「蓮」的延伸探討女性自我定位與美的定義〉，《藝術家雜誌》，10月，1995年，頁496-497。

黃寶萍，〈相對看畫‧相對說話〉，《藝術家雜誌》，12月，1995年，頁203。

董成瑜，《相對說畫系列》，〈美與暴力竟一體 林珮淳訴說女性悲哀〉，《黑白新聞周刊》，11月，1995年，頁81-82。

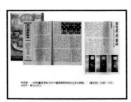

林芳玫，《相對說畫系列》，〈暴力的美學 美學的暴力〉，《銘傳校刊》，11月，1995年，頁50-51。

徐文琴，〈林珮淳1995年個展〉，《雄獅美術雜誌》，第297期，1995年。

徐文琴，〈「蓮」的啟示－林珮淳創作賞析〉，《台北市立美術館刊》，10月，1995。

林珮淳，〈相對說「畫」從審美標準探討女性定位課題〉，《銘傳校刊》，10月，1995。

謝東山，〈性別與權力–藝術的女性主義與女性主義的藝術〉，《現代美術》雙月刊，第65期，1996年，頁28。

張清華，《相對說畫系列》，〈相對說畫打破美麗神話〉，《美華報導》，324期，1996年，頁78-79。

主　編，〈黑牆、窗裡與窗外〉，〈被遺忘的女性: 二二八美展女性藝術家座談會〉，《現代美術》，第71期，1997年，頁68-69。

林珮淳，〈解構父權〉，《美育》雙月刊，第114期，3-4月，2000年，頁58-63。

本刊訊，〈台灣藝術家聯展皇后美術館的接觸〉，《CANS藝術新聞雜誌》，5月，2004年。

本刊訊，〈聯結－台灣藝術家在紐約的連結與對應，在紐約皇后美術館展出〉，《藝家雜誌》，4月，2004年。

陳緯倫，《美麗人生》，〈台灣藝術的奇蹟〉，《藝術家雜誌》，6月，2004年，頁376-379。

陳雅玲，《美麗人生》，〈台灣藝術在紐約〉，《ARTCO典藏今藝術》雜誌，6月，2004年，頁142-146。

陳秋燕，《相對說畫》，《銘傳校友報》，11月，1992年。

林勝興，〈林珮淳的女性詮釋，在台北市美術館呈現〉，《文化通訊》，11月15日，1995年。

張伯順，《經典之作》，〈林珮淳相對說畫 反諷古今女性美〉，《聯合報》，11月2日，1995年。

邱心宜，《相對說畫》，〈林珮淳個展顛覆女性定位〉，《大學報》，11月4日，1995年。

鄭乃銘，〈女性的論釋－讓男人無法一手掌握〉，《自由時報》，10月27日，1995年。

黃寶萍，〈美醜神話相對說畫，女性主義畫裡看，林珮淳直探議題〉，《民生報》，11月，1995年。

董青枚，《相對說話系列》，〈相對說畫談女性定位－林珮淳1995年個展〉，《民眾日報》，11月，1995年。

胡永芬，《相對說話系列》，〈普普手法反思女性困境，林珮淳個展批判美學暴力〉，《中時晚報》，10月27日，1995年。

張啟德，〈美女、金蓮、水蓮，畫家林珮淳訴說女性悲哀〉，《澳洲雪梨世界日報》2月17日，1996年。

鄭敏玲，《經典之作》，〈林珮淳刻文創作顛覆新聞〉，《台灣時報》，11月13日，1998年。

葉志雲，《經典之作》，〈反諷投機風氣 林珮淳以藝術做賭注〉，《中國時報》，11月13日，1998年。

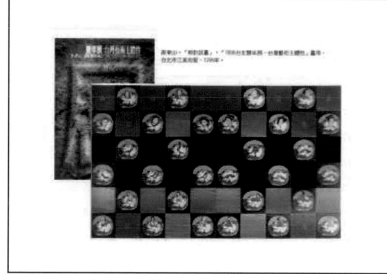

鄭乃銘，《經典之作》，〈賭骰子‧博功名〉，《自由時報》，11月，1998年。

賴珮如，《經典之作》，〈林珮淳，顛覆經典反應社會亂象〉，《聯合報》，11月13日，1998年。

本刊訊，《美麗人生》，〈20位台灣藝術家在皇后藝術館創作〉，《紐約社區報》，美國紐約，4月24日，2004年。

本刊訊，《美麗人生》，〈二十位台灣藝術家在紐約展示〉，《自由時報美東版》，美國紐約，4月20日，2004年。

本刊訊，《美麗人生》，〈台灣藝術家聯展皇后區政要出席〉，《僑報》，美國紐約，4月19日，2004年。

胡盈光，《美麗人生》，〈台灣藝術家聯展皇后區政要出席〉，《世界日報》，美國紐約，4月19日，2004年。

本刊訊，《美麗人生》，〈台灣藝術家聯展形式多元、顛覆美學〉，《明報》，美國紐約，4月19日，2004年。

Editor，《美麗人生》，"A window on immigration-Exhibit at Queens Museum of Art focuses on Taiwanese adaptation"，TIMES, New York, USA, April 22, 2004.

蕭瓊瑞，《向造成台灣歷史悲劇的當局致意》，〈凝視與形塑－後二二八世代的歷史觀察〉畫冊，《台北市立美術館》，1998年，頁82-85。

黃海鳴，《黑牆，窗裡與窗外》，〈悲情昇華，二二八美展〉畫冊，《台北市立美術館》，1997年。

林珮淳，《85年度申請獎專刊》畫冊，《台北市立美術館》，1997年，頁116-119。

主　編，《安全窩》，《意象與美學 台灣女性藝術展》畫冊，《台北市立美術館》，5月，1998年，頁136。

主　編，《向造成台灣歷史悲劇的當局致意》，《凝視與形塑-後二二八世代的歷史觀察》畫冊，《台北市立美術館》，1998年，頁82-85。

林珮淳，《骰子》，〈慾望的省思〉，《歷玖彌新—台灣美術進化觀》畫冊，《臻品藝術中心》，1999年，頁22-24 / 頁34-35。

陳香君，《黑牆、窗裡與窗外》，《紀念之外-二二八事件-創傷與性別差異的美學》，台灣女性藝術協會、典藏藝術家庭，1月，2014年，頁295。

林妙影，《相對說書系列》，〈林珮淳個展〉，《銘傳校刊》，11月，1990年。

謝東山，《相對說書》，〈1996台北雙年展－台灣藝術主體性〉畫冊，《台北市立美術館》，1996年。

「回歸大自然系列」報導與評論列表

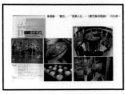

孫立銓，《生生不息，源源不斷》，〈性別與權力的政治性〉，《台灣當代美術大系媒材篇－裝置與空間藝術》，文建會，2003年。

葉謹睿，《寶貝》、《美麗人生》，〈個人電腦紀元的數位藝術環境〉，《數位藝術概論》，藝術家出版社，2005年。

顏娟英、黃琪惠、廖新田，《寶貝》，《台灣的美術》，允晨文化，2006年。

葉瑾睿，《玩‧劇》，《浮光掠影-捕捉》，《夏娃克隆II》，〈科技人是否可以很有創意? 我對數位藝術教育之觀察與建議〉，
　　　《數位美學》，藝術家出版社，2008年。

林志銘，《聆聽光雲#2》，《公共藝術的未來性II 環境與產業觀點之公共藝術》畫冊，南天書局，2009年。

張學孔等人，〈藝術之島〉，《台灣當代名人錄》，台灣當代藝術社，2009年，頁146-147。

劉旭圃，《藝術之島台灣當代藝術名人錄》，12月，2009年，頁146-147。

曹筱玥，〈科技與藝術〉，《藝術概論》，新頁圖書，2010年，頁194。

河　流3，〈大自然交響曲〉，《藝起趣碧潭 2010台北縣公共藝術計畫》書冊，台北縣政府文化局，2010年。

丘永福，《高級中學美術(二)》教科書，龍騰文化，2011年。

蔡瑞霖，《創造的虛擬》，〈瞄拼之眼—「台澳新媒體藝術展」的觀後感〉，《台灣數位藝術e檔案》，
　　　林珮淳主編，藝術家出版社，2012。

吳介祥，《創造的虛擬》，〈藝術的「媒材及媒體」時代〉，《台灣數位藝術e檔案》，林珮淳主編，藝術家出版社，2012。

曾芳玲，《生生不息、源源不斷》，〈心靈再現－台灣當代女性藝術展〉，《藝術家雜誌》，12月，2000年。

鄭乃銘，《捕捉》，〈林珮淳的捕捉〉，《CANS藝術新聞》，2004年12月，頁61。

汪雅玲，〈虛擬與複製，探索林珮淳的「非自然」系列〉，《ARTCO典藏今藝術雜誌》，5月，2004年，頁86-87。

陳永賢，〈自然寓言知浮光掠影－林珮淳的創作語言〉，《藝術家雜誌》，11月，2004年，頁504-510。

江淑玲，〈林珮淳的花非花世界〉，《藝術家雜誌》，5月，2004年，頁514-515。

羅秀芝，〈越界—城市為舞台〉，《ARTCO典藏今藝術雜誌》，8月，2005年，頁101。

江淑玲，〈「情迷‧意亂」看林珮淳再現的大自然〉，《ARTCO典藏今藝術雜誌》，9月，2005年。

陳泰松，《城市母體》，〈恍惚越界，夢看「越界:城市影舞」〉，《ARTCO典藏今藝術》雜誌，9月，2005年，頁109-110。

李美華，侯康德，〈再造一個自然的視野—林珮淳的「回歸大自然」系列〉，《當代藝術新聞雜誌》，9月，2005年，頁128-129。

石瑞仁，〈軟硬兼施、面貌兩極的藝術，解讀林珮淳的複合媒體裝置〉，《藝術觀點雜誌》，7月，2005年，頁80-85。

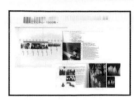 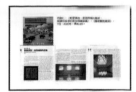 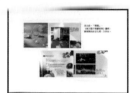

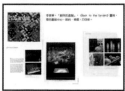 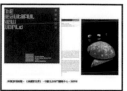

本刊訊，〈野性與生活狂歡，「上海酷：創意再生產」展在上海舉行〉，《藝術觀點雜誌》，4月，2005年，頁126-127。

羅秀芝，〈越界－城市影舞〉，《ARTCO典藏今藝術雜誌》，8月，2005年，頁101。

黃海鳴，〈炫麗遊戲中的陷阱與反思－談林珮淳作品「浮光掠影」－捕捉《ARTCO典藏今藝術雜誌》，3月，2005年，頁134-135。

張兆平，〈走出浮光掠影的迷失〉，《中技社通訊》，2月，2005年，頁57。

馬肇石 Pierre Martin，〈你所得並非你所見－林珮淳《捕捉》：值得體驗的裝置作品〉，創刊號，
《CANS藝術新聞雜誌》，2月，2005年，頁60-61。

曾鈺涓，〈美好幻影的科技虛妄性-林珮淳之《人工生命-回歸大自然》個展〉，《ARTCO典藏今藝術雜誌》，
10月，2006年，頁288-289。

葉謹睿，〈野薑花與塑膠玫瑰〉，《台灣美術雜誌》，國立台灣美術館，10月，2006年，頁37-52。

冬梓堯，〈「異國情調」與資本主義錯身而過〉，《ARTCO典藏今藝術雜誌》，9月，2006年，頁246-249。

主　編，〈林珮淳個展—美麗新世界，自然的魅力〉，《Super City》，北京，2006。

馬　修，〈林珮淳的數位藝術〉，《D・FUN雜誌》，創藝媒傳出版社，9月，2006年，頁67-69。

曾鈺涓，〈控制幻影-談林珮淳之《創造的虛擬》作品中之科技警訊〉，《藝術欣賞雜誌》，
國立台灣藝術大學，4月，2007年，頁4-7。

曾鈺涓，〈虛擬自然的真實困境-談林珮淳之「回歸大自然」系列作品之美好幻影〉，《美育雜誌》，
國立台灣藝術教育館，3/4月，2007年，頁84-89。

趙浩均，〈數位時代的視聽模式〉，《D・FUN》，2007年7月，頁38。

康居易Susan Kendzulak，〈荒謬感背後的內省 評林珮淳「回歸大自然」系列創作〉，
《藝術家雜誌》，10月，2008年，頁227-228。

陳韋臻，《紫浪》、《夏娃克隆》、《標本》，〈翻開女性創作者們內裏的離散與堅持－訪問11位台灣當代女性藝術家〉，
《破報》，8月13日，2009年。

林珮淳，《聆聽雲光》，《光合作用》，第11期，2012，頁4-7。

凌美雪、康俐雯，〈標本〉，〈「藝種入侵」玩弄創意 林珮淳捕捉人造3D蝴蝶〉，《自由時報》，11月22日，2004年。

黃寶萍，〈標本〉，〈林珮淳虛擬自然寓言〉，《民生報》，12月3日，2004年。

 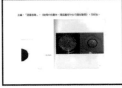 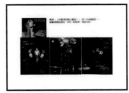

周美惠，《捕捉》，〈3D蝴蝶任你抓-林珮淳新作，批判科技〉，《聯合報》，11月17日，2004年。

林珮淳，〈林珮淳作品發表〉畫冊，《桃園縣政府文化局》，1999年。

林珮淳，〈林珮淳創作論述〉畫冊，《女書文化事業有限公司》，1999年。

主　編，《寶貝》，〈清境一夏〉，2001年，頁8-9。

李清崧，《生生不息、源源不斷》，〈跨世紀全運藝術節-裝置藝術展〉畫冊，《桃園縣立文化中心》，1999年

張惠蘭，《寶貝》，〈清境一夏－自然與人為的對話〉畫冊，2001年。

張惠蘭，《寶貝》，〈酸甜酵母菌〉畫冊，《高雄縣政府文化局》，2001年。

曾芳玲，《生生不息》，〈心靈再現－台灣當代女性藝術展〉畫冊，《高雄市立美術館》，2001年。

林珮淳，〈走出文明、回歸伊甸－林珮淳回歸大自然系列〉畫冊，《台藝大數位藝術實驗室》，2004年。

顧振清，《溫室培育》，〈幻想與物C04台灣前衛文件展〉畫冊，2005年。

羅秀芝，《蛹之生》，〈大同新世界第二屆台北公共藝術節〉，《藝術家作品簡介》，2005年。

主　編，《溫室培育》，〈時間中的動作–臻品藝術中心15週年聯展〉畫冊，2005年。

林珮淳/翁培駿，《寶貝》，《美麗新世界》畫冊，中國北京帝門藝術中心，2005年。

主　編，《溫室培育》《創意再生產國際藝術展》畫冊，上海多倫現代美術館，2月，2005年，頁86-87。

周靈芝，《標本》，〈城市曼波，台北新樂園藝術空間·雪梨Stone Villa交流展〉畫冊，《新樂園藝術空間》，2006年。

主　編，《桐花來了》，〈花間桐遊〉畫冊，客家桐花季，《台北縣政府文化局》，2006年。

孫立銓，《晨露》，〈第三屆半島藝術季〉畫冊，《屏東縣政府文化局》，2006年。

陸蓉之，《寶貝》、《標本》，〈原創動漫美學新世紀〉畫冊，《上海當代美術館》，中國，2006年。

許淑真，《創造的虛擬》，〈藝術中的虛數〉畫冊，《高苑藝文中心》，2006年。

石昌杰/林珮淳，《創造的虛擬》，〈臺澳新媒體藝術展〉畫冊，《台灣藝術大學》，2007年。

林珮淳，《寶貝II》，〈台灣燈會嘉義藝術燈區〉畫冊，《嘉義縣文化局》，2007年。

李美華，《創造的虛擬》，〈Back to the Garden〉畫冊，《皇后藝術中心》，紐約，美國，2008年。

400

孫立銓，《生生不息，源源不斷》，《台灣當代美術大系媒材篇－裝置與空間藝術》，2003年，頁92。

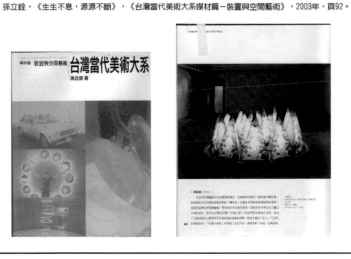

161

李俊賢，《創造的虛擬》，〈超現實的奇思幻境〉畫冊，《高雄市立兒童美術館》，2008年。

主　編，《聆聽雲光(一)》、《聆聽雲光(二)》，《公共藝術年鑑》，2009年，頁148。

邱誌勇，《標本》、《創造的虛擬》，〈跨界視域-林珮淳+數位藝術實驗室創作展〉畫冊，《靜宜大學藝文中心》，2009年。

林志銘，《聆聽雲光》，《公共藝術的未來性II - 環境與產業觀點之公共藝術》，田園城市文化，2009年，頁154-155。

主　編，〈創造的虛擬〉，《虛擬幻境—來到夢奇地》，2009年，頁4-6。

主　編，〈創造的虛擬〉，《2010設計創意新紀元-臺澳當代藝術交流展》畫冊，2010年，頁27-28。

謝里法，〈台灣美術研究講義〉，藝術家出版，頁272，2016

孫立銓，《生生不息，源源不斷》，〈性別與權力的政治性〉，《台灣當代美術大系媒材篇－裝置與空間藝術》，文建會，2003年。

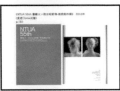

陸蓉之，〈雲端是神話還是現實？〉，《藝術工蜂》大藝出版，2012年。

蕭瓊瑞，〈兩性議題的反思〉，《台灣美術史綱》，藝術家出版社，2012年。

陳瓊花，〈藝術、性別與教育〉，《六位女性播種者的生命圖像》，三民書局，2012。

陳明惠，〈當代藝術中的身體與再現〉，《2014台灣美術雙年展 藝術論壇論文集》，國立台灣美術館，2014。

邱誌勇，《夏娃克隆II》、《夏娃克隆啟示錄》、《夏娃克隆肖像》、《透視夏娃克隆》、《夏娃克隆II》、《夏娃克隆手》，
〈實踐藝術的批判性格體現創作的時代精神，以實驗室為基底，「林珮淳+Digital Art Lab.」開創前衛性的創作能量〉，
《台灣數位藝術e檔案》，林珮淳主編，藝術家出版社，2012。

陳明惠，《夏娃克隆肖像》，〈賽伯人，身體與歡愉─由數位藝術思考〉，《台灣數位藝術e檔案》，
林珮淳主編，藝術家出版社，2012。

邱誌勇，《夏娃克隆啟示錄》，〈身體的未來想像:脈流貳─「未來之身」中的身體意象〉，《台灣數位藝術e檔案》，
林珮淳主編，藝術家出版社，2012。

王伯偉，《夏娃克隆肖像》，〈展演與感受─從「超旅程:2012未來媒體藝術節」談媒體藝術的美學特質〉，
《台灣數位藝術e檔案》，林珮淳主編，藝術家出版社，2012。

林珮淳，《紫浪》，《夏娃克隆標本》，〈生命書寫與自我追尋-12位台灣女性藝術家的對話〉，
《ARTCO典藏今藝術雜誌》，8月，2009年，頁194。

邱誌勇，〈以互動創造遊樂的天堂〉，《靜宜藝術簡報12期》，6月，2009年。

陳明惠，〈電子人、身體與歡愉《台灣數位藝術脈流計畫-脈波壹：身體•性別•科技》〉，
《藝術家雜誌》第428期，2010年，頁293-297。

彭蕙仙，〈林珮淳的創作充滿警世寓言「以科技藝術來批判科技」〉，《新活水雙月刊第33期》，2010年，頁14-15。

陳明惠，〈數位符號與性別密碼，重慶「0&1:數字空間與性別神話」〉，《藝術家雜誌》，第421期，2010年，頁254-257。

葉謹睿，〈人生美麗嗎？談林珮淳反科技的科技藝術創作〉，《銘傳校刊》，2011年，頁53-56。

陳明惠，〈擬皮層與超宗教「林珮淳的2010至2011「夏娃」系列」〉，《藝術家雜誌》，第430期，2011年，頁224-227。

陳朝興，〈林珮淳創作展的閱讀「夏娃克隆」系列後人類文明的生產和焦慮〉，《文化快遞》，第136期，9月，2011年，頁26-27。

曾鈺涓，〈「夏娃的誕生」基因生殖實驗室的科技反諷〉，《藝術欣賞期刊》，2011年，頁61-63。

"Eve Clone" Review List

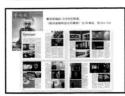

邱誌勇，〈是神的意旨，抑或是人的慾望：林珮淳「夏娃克隆系列」中的反諷與批判性〉，
《台灣數位藝術知識與創作流通平台專欄》，2011年。

謝慧青，〈「後人類慾望」展覽中的未來身體與慾望預言〉，《藝術家雜誌》，第464期，12月，2013年，頁284-289。

曹筱玥，〈科技與藝術的美好相遇〉，《藝術家雜誌》，第452期，1月，2013，頁336-337。

蕭瓊瑞，〈從寫實到造像〉，《藝術家雜誌》，第452期，1月，2013，頁152-153。

鄭芳和〈在說話的主體〉，《藝術家雜誌》，2014年，頁404-407。

吳樹安，〈SNG・展覽直擊 - 騷動新媒體藝術展〉，《今藝術》，第257期，2月，2014年，頁122-123。

郭冠英，〈從蛹到夏娃克隆：林珮淳藝術的女體賦權〉，《台灣數位藝術知識與創作流通平台專欄》，2014年。

鄭芳和，〈在說話中的主體-林珮淳的夏娃克隆〉，《源 yuan magazine》第105期，5月，2014年，頁58-67。

鄭芳和，〈在說話中的主體-林珮淳的夏娃克隆〉，《藝術家》雜誌，2014年11月，頁404~407。

賴小秋，〈啟示與警示〉，《藝術家》，第481期，6月，2015年，頁2-5。

周美惠，〈夏娃克隆，帶你體驗末日氛圍〉，《聯合報》，3月25日，2011年。

主　編，〈林珮淳921反思，回歸神人和好〉，《人間福報》，8月12日，2011年。

Upaper，〈夏娃克隆系列〉，《NEWS 14藝文》，3月25日，2011年。

邱誌勇，《夏娃克隆II》、《夏娃克隆標本》、《標本》、《創造的虛擬》，〈跨界視域-林珮淳+數位藝術實驗室創作展〉畫冊，
《靜宜大學藝文中心》，2009年。

主　編，《夏娃克隆標本》，《出神入化》畫冊，2009年，頁218-219。

主　編，《夏娃克隆肖像》，〈NTUA 55th 臺藝大・跨世紀薪傳-教授創作展〉，2010年，頁185。

主　編，《夏娃克隆肖像》，《2010國際交流作品展》畫冊，國立台灣藝術大學，2010年。

陳明惠，「夏娃Clone肖像系列」，〈0&1：數字空間與性別神話〉畫冊，2010年。

主　編，《百年好合・心存好藝》畫冊，臻品藝術中心，2011年。

陳明惠，《夏娃克隆啟示錄》，《The Next Body建國一百年台灣數位藝術脈流計劃—脈波貳「未來之身」數位藝術展》畫冊，
11月，2011年，頁74-77。

陳朝興，〈林珮淳創作展的閱讀「夏娃克隆系列-後人類文明的生產焦慮」〉，《台北市藝文資訊總攬No.136》，頁26.27。

主　編，〈「夏娃Clone系列展」〉，《台北文化護照》，2011年4月。

安托列塔‧伊凡諾娃(Antoanetta Ivanova)，〈異形佳人：林珮淳「夏娃克隆個展」的驚奇世界〉，《夏娃克隆》畫冊，2011。

主　編，「夏娃克隆系列」，〈台灣報到-2012台灣美術雙年展〉畫冊，2012年，頁92-95。

吳介祥，〈美學的僭越—林珮淳「夏娃克隆」系列〉，《美學的僭越—林珮淳「夏娃克隆」系列》，2011年。

蘇珊娜‧斐爾茲‧陶德，〈林珮淳—夏娃克隆肖像〉，《藝術評論 布宜諾斯艾利斯，阿根廷》，2011。

林宏璋，〈互被動，從克隆之中—林珮淳的「夏娃克隆」系列〉，《藝術家雜誌》，9月，2011年，頁410-411。

邱誌勇，〈身體的未來想像：脈流貳-《未來之身》中的身體意象〉，《D-Fun Plus》No07，11月，2011年。

葉謹睿，〈身體，是甚麼東西?〉，《D-Fun Plus》No08，12月，2011年。

林怡秀，《夏娃克隆》，〈科技反噬的未來寓言〉，《ARTCO典藏今藝術雜誌》，5月，2011。

陳明惠，《夏娃克隆啟示錄》，〈脈波貳：未來之身〉，《藝術家雜誌》，2011年，頁258-261。

莊偉慈，《夏娃克隆啟示錄》，〈朝向虛擬與進化世界〉，《藝術家雜誌》，2011年，頁2-9。

主　編，〈林珮淳的藝術之旅〉，《Tlife台灣高鐵車上刊物》，第26期，2月，2012年，頁2-9。

Ming Turner，〈Quasi-skin and Post-religion: Lin Pey Chwen'sEve Clone series, 2010-〉，
　　　　《英國女性藝術美學期刊N. Paradoxa, Vo.30》，2012，頁33-39。

潘顯仁，〈在場的宣告與行動：「台灣報到-2012台灣美術雙年展」〉，《ARTCO典藏今藝術雜誌》，第241期，10月，
　　　　2012年，頁108-109。

王柏偉，〈身體的位置：台灣數位藝術脈流計畫脈波參「身體-介面」〉，《藝外雜誌》，12月號，2012年，頁76-77。

主　編，《夏娃克隆肖像》，《超旅程2012未來媒體藝術節》畫冊，國立台北藝術大學，2012年，頁78-79。

主　編，《ART STAGE SINGAPORE 2012》，新加坡國際藝術博覽會畫冊，2012年，頁181。

主　編，《Taiwanese‧Korean Contemporary Art Today》畫冊，2012。

羅秀芝，《夏娃克隆II》，《風情萬種-台北信義計畫區當代藝術展》畫冊，國家文藝基金會，2012。

《夏娃克隆》，《艷日秀影-2012屏東女性藝術家聯展》畫冊，屏東縣政府，2012年，頁61-62。

主　編，《TETPAMATNKA》影音藝術節畫冊，2013年。

Eve clone series:Art Concept And Practice, RAISING THE TEMPERATURE, 2014 February, P34-P37。

陳明惠，〈當代藝術中的身體與再現〉，《2014 台灣美術雙年展 藝術論壇論文集》，2014年，頁101-103。

Revelation of Eve Clone No.3, RAISING THE TEMPERATURE, 2014 February, P34-P37

主　編，〈夏娃克隆啟示錄IV〉，《女人—家:以亞洲女性藝術之名》畫冊，9 月，2014年，頁84-87。

林怡秀，〈微共鳴〉，《ARTCO典藏今藝術雜誌》第224期，2011年5月。

郝岫音，〈看哪，神的帳幕在人間-藝術家林珮淳導讀〉，《台灣數位藝術知識與創作流通平台》，2011。

姜麗華、呂筱渝，〈過程中的女性主體－台灣女性藝術家的陰性特質調查研究〉，頁207，2016

Ming Turner, Post-humanist Desire: Visualizing Cyborgs and the Hybridized Body, International Journal of Cultural and Creative Industries Issue3, 2014 July , P89

倪再沁、李思賢、 徐婉禎、范峻銘、安懷冰合著 ，〈台灣當代美術通鑑〉，《藝術家雜誌》 40年版，2014年，頁544~545。

陳明惠，〈當代藝術中的身體與再現〉，《2014台灣美術雙年展 藝術論壇論文集》，國立台灣美術館，2014。

陳瓊花，〈藝術、性別與教育〉，《六位女性播種者的生命圖像》，三民書局，2012。

倪再沁、李思賢、徐婉禎、范峻銘、安懷冰合著，〈台灣當代美術通鑑〉，
《藝術家雜誌》40年版，2014年，頁544~545。

Ming Turner，<Quasi-skin and post-human Lin Pey
Chwen 's Eve Clone > ，n.paradoxa international
feminist art journal，2012年，P33~P39。

余青勳、簡正怡，〈夏娃克隆啟示錄IV〉，
《女人一家：以亞洲女性藝術之名》，9月，
2014年。頁84-87。

林珮淳

1959 出生於台灣屏東縣
學歷
1996 澳大利亞國立沃隆岡大學藝術創作博士
1994~1996 澳大利亞政府傑出研究生全額獎學金
1983~1985 美國中央密大藝術學士 / 碩士
1974~1979 銘傳商專設計副學士

經歷
2001~　　林珮淳數位藝術實驗室主持人
2017~2018 中國科技大學講座教授兼規劃與設計學院院長
2012~2018 台灣師範大學美術系博士班兼任教授
2003~2017 國立台灣藝術大學多媒體動畫藝術學系 (所) 專任教授
2010　　起擬新媒體藝術研究所計劃書並於隔年獲教育部通過設立
2001~2002 國立台灣藝術大學多媒體動畫藝術研究所專任副教授兼所長並成立多媒體動畫藝術學系
1997~2000 中原大學商設系主任暨創所所長
1996~2001 中原大學商業設計系專任副教授
1989~1993 銘傳大學專任講師

個展
2018 「夏娃克隆創造計畫文件 I」, B.B.ART 藝術空間, 台南新藝「變形記」, 台南
2017 「夏娃克隆創造計畫」— 林珮淳個展, 新苑藝術, 台北
2015 「林珮淳個展 - 啟示與警世」, 國立清華大學藝文中心, 新竹
2012 「林珮淳個展 - 夏娃克隆系列 III」, 登陸新加坡藝術博覽會, 新加坡
2011 「林珮淳個展 - 夏娃克隆系列 II」, 新苑藝術, 台北
2011 「林珮淳個展 - 夏娃克隆系列」, 台北當代藝術館, 台北
2006 「人工生命 — 回歸大自然系列」, 國立中央大學藝文中心, 桃園
2006 「林珮淳個展—美麗新世界」, 北京 798 藝術村, 帝門藝術中心, 北京
2005 「情迷 · 意亂」, 新竹教育大學藝術空間, 高苑科技大學藝文中心, 新竹 / 高雄
2004 「捕捉—回歸大自然系列」, 台北當代藝術館, 台北
2004 「非自然—回歸大自然系列」, 國立台灣藝術大學藝術中心, 台北
2000 「解構父權」, 國立台灣藝術教育館, 台北
2000 「景觀 · 觀景—回歸大自然系列」, 桃園縣立文化中心, 桃園
1999 「台灣印象—金曲之作」, 佛羅倫斯 Spazio Diciotto 畫廊, 義大利
1998 「經典之作」, 台中臻品藝術中心, 台中
1998 「安全窩」, 台北市政府, 台北
1996 「真實與虛假」, 新竹師範學院藝術中心, 新竹
1996 「相對說畫」, 澳大利亞當代藝術空間, 澳大利亞
1995 「相對說畫」, 台北市立美術館, 台北
1994 「蓮花的故事」, 長畫廊 / 台中桂仁藝術中心, 澳大利亞 / 台灣
1993 「女性詮釋系列」, 國立台灣美術館 / 台中首都藝術中心
1992 「林珮淳作品發表」, 2 號公寓, 台北
1991 「林珮淳作品發表」, 2 號公寓 / 首都藝術中心, 台北 / 台中
1990 「林珮淳作品發表」, 2 號公寓, 台北
1989 「造形、色彩與揮灑的筆觸」, 美國文化中心, 台北
1984 「林珮淳作品發表」, 中央密大藝術中心, 美國

聯展

2018「大內藝術節」，尊彩藝術中心，台北
2018「巴塞爾藝術博覽會」Art Basel 平行展，瑞士
2018「夏娃克隆創造計畫文件 I」，第 21 屆世界神經放射線醫學會議，台北國際世貿中心，台北
2017「威尼斯雙年展」平行展，威尼斯，義大利
2017「Douro 國際版畫雙年展」，斗羅，葡萄牙
2017「纖動 - 生態作為動詞」國際錄像裝置展，台灣藝術大學有章藝術博物館，新北市
2017「台灣錄像巡映歐陸交流計畫」，馬其頓當代藝術館 / 克羅埃西亞 A Zitnjak 畫廊 / 斯洛維尼亞當代藝
　　　術中心 (SCCA)，柏林 Rosalux 藝術空間
2017「七月外展」，大象藝術空間，台中
2017「擬劇 · 身體改編展」，黎畫廊，台北
2017「七月外展」，大象藝術空間，台中藝術博覽會，台中
2016「類似過於喧嚣的孤獨—新樂園 20 年紀念展」，北師美術館，台北
2016「404 國際科技藝術節」，C++ Gallery，波哥大，哥倫比亞
2016「女性、社會、主體 - 張李德和暨臺灣女性藝術展」，嘉義文化中心，嘉義
2016「數位魅影國際數位藝術特展」，府中十五動畫故事館，新北市
2015「404 科技藝術節」，羅薩里奧，阿根廷
2015「當下當代—台灣藝術計畫」，紐約 Tenri 空間，美國
2015「末日感性：臺灣新媒體藝術展」波蘭返國展，台北市立美術館，台北
2015「與時代共舞—《藝術家》40 年台灣當代美術」，高雄市立美術館，高雄
2015《絮語台灣數字藝術展》，江蘇德基廣場，中國
2015「天津美院 - 臺灣藝大教師交流美展」，天津美院，天津，中國
2014「文化膠囊國際藝術展」，紐約 JCAL 藝術空間，美國
2014「404 國際科技藝術節」，Platforma，莫斯科，俄羅斯
2014「蟲聲幻影」數位藝術互動特展，國立臺灣科學教育館，台北
2014「女人 - 家：以亞洲女性藝術之名」國際展，高雄市立美術館，高雄
2014「Raising the Temperature」國際展，皇后美術館，紐約，美國
2014「Progressive Proof」國際展，舊金山州立大學美術館，舊金山，美國
2013「後人類慾望」，台北當代藝術館，台北
2013「TETRAMATYKA 國際影音藝術節」，利沃夫國立美術館，烏克蘭
2013「波蘭媒體藝術雙年展」，弗羅茨瓦夫，波蘭
2012「404 科技藝術節」，羅薩里奧，阿根廷
2012「台灣數位藝術脈流計畫—脈波參：身體—介面」數位藝術展，台北數位藝術中心，台北
2012「台灣報到 -2012 台灣雙年展」，國立台灣美術館，台中
2011「超旅程 – 2012 未來媒體藝術節」，關渡美術館，台北
2011「未來之身數位藝術展」華山 1914 文化創意產業園區，台北
2011「百家照性別 100 Gender Photographs」藝術展，淡水漁人碼頭藝文空間滬水一方 3 樓，新北市
2010「台灣數位藝術脈流計畫—脈波壹身體 · 性別 · 科技」數位藝術展，台北數位藝術中心，台北
2010「台灣創意七彩大舞台」，南京，中國
2010「創造的虛擬」，國立台灣美術館，台中
2010「2010 好漢玩字節」，高雄駁二藝術特區漢動未來館，高雄
2010「0&1：數位空間與性別神話」，501 當代藝術館，重慶，中國
2009「她的第一次個展 - 台灣當代女藝術家的回顧與前瞻」，中正紀念堂，台北
2009「虛擬幻境 – 來到夢奇地」，臺東縣立美術館，台東
2009《跨界視域》林珮淳 + 數位實驗室創作聯展，靜宜大學藝文中心，台中
2009「月光光 心慌慌非常廟三週年之關鍵報告」，非常廟藝文空間，台北
2009「互動式科技藝術電視牆」，台北當代藝術館，台北
2008「標芝麻開門 · 驚奇多多」，新思惟人文空間，台中
2008「小甜心，伊通公園二十周年慶」，伊通公園，台北

2008 「Mditation In Contemporary Chinese Landscape 國際展」，Godwin-Ternbach Museum，紐約，美國
2008 「Back to the Garden 國際展」，紐約皇后藝術中心，紐約，美國
2007 「BOOM 快速與凝結新媒體的交互作用」台澳新媒體藝術展，台藝大國際藝術展覽廳，
　　　北藝大關渡美術館，台北
2007 「Exit and Via 藝術節」，Creteil，法國
2006 「晨露特展」，國立台北藝術大學關渡美術館，台北
2006 「屏東半島國際藝術季展覽」，屏東
2006 「風情萬種」國際當代藝術展，台北信義計畫區，台北
2006 「城市曼波」，信義區新光三越 A9 館，台北
2006 「藝術中的虛數 i」，高苑科技大學藝文中心，高雄
2006 「杭州國際動漫展」，杭州，中國
2006 「動漫原創展」，上海當代藝術館，上海，中國
2005 「越界—城市影舞」：台北 · 上海雙城記，台北國際藝術村，國立台南藝制術大學，台北 / 上海
2005 「剛柔並濟」女性藝術展，藝象藝文中心，國立台南藝術大學，台南
2005 「時間中的動作」，台中臻品藝術中心，台中
2005 「越界—城市影舞」夏季國際特展，藝象藝文中心，台南
2005 「上海酷」創意再生產國際藝術展，多倫現代美術館，上海，中國
2004 「幻想與物」，CO4 台灣前衛文件展，華山藝文特區，台北
2004 「聯結」，紐約皇后美術館，紐約，美國
2003 「渡 · 十三」，台中臻品藝術中心，台中
2003 「台灣當代藝術」，鳳甲美術館，台北
2002 「酸甜酵母菌」女性藝術展，華山藝文特區 / 橋仔頭糖廠，台北 / 高雄
2001 「寶貝—回歸大自然系列」清境一夏裝置藝術展，清境農場，南投
2000 「心靈再現」，台灣女性當代藝術展，高雄市立美術館，高雄
1999 「歷玖彌新 - 台灣美術進化論」，臻品藝術中心，台中
1999 「跨世紀的躍動」裝置藝術展，桃園縣立文化中心，桃園
1998 「台灣女性藝術展—意象與美學」，台北市立美術館，台北
1998 「凝視與形塑」二二八美展，台北市立美術館，台北
1997 「悲情昇華」二二八美展，台北市立美術館，台北
1996 「一九九六年台北雙年展」，台北市立美術館，台北
1995 「亞洲藝術家聯合作品展」，澳洲長畫廊，澳大利亞
1994 「2 號公寓聯展」，國立台灣美術館，台中
1994 「2 號公寓聯展」，台北市立美術館，台北
1993 「2 號公寓聯展」，阿普畫廊，高雄
1993 「行與色的抽象藝術聯展」，台北家畫廊，台北
1993 「小」聯展，2 號公寓，台北
1992 「本 · 土 · 性」聯展，2 號公寓，阿普畫廊，高高畫廊，台北、高雄、台南
1992 「文字圖像」聯展，好來前衛藝術中心，台北
1992 「情 · 愛」聯展，高高畫廊，台南
1992 「台南文化中心聯展」，台南
1992 「個人主義，第三方位」聯展，台中首都藝術中心，台中
1991 「女我展—女性藝術家與當代藝術對話」，帝門藝術中心，台中
1991 「公寓實驗展」，台北市立美術館，台北
1991 「全國大專教授邀請展」，台北
1991 「2 號公寓聯展」，台北
1990 「2 號公寓聯展」，台北
1990 「台南文化中心聯展」，台南
1990 「形與色的抽象藝術」，台北家畫廊，台北

Pey-Chwen Lin

Education
1996 Doctor of Creative Arts, University of Wollongong, Australia
1984/1985 M.A. and B.F.A., Central Missouri State University, USA

Academic Experience
2017-2018 Chair Professor and Dean of College of Planning and Design,
China University of Technology, Taipei, Taiwan
2003-2017 Professor of Dept. Multimedia and Animation Arts, Director of Digital Arts Lab. National
Taiwan University of Arts
2001-2002 Chair of Graduate School of Multimedia and Animation Arts,
National Taiwan University of Arts
1997-2000 Chair of Dept. of Commercial Design, Chung Yuan University
1996-2001 Associate Professor of Dept. of Commercial Art, Chung Yuan University

Book Publications
2018 "Word and Tech—Revelation and Notification of Pey-Chwen Lin's Art",
Artist Publisher, Taipei, Taiwan
2012 "Taiwan Digital Art E-Files", Artist Publisher, Taipei, Taiwan
2012 "Lin, Pey-Chwen Eve Clone Series", Galerie Grand Siecle, Taipei, Taiwan
1999 "Lin, Pey-Chwen", Cultural Affairs Bureau of Toayuan, Taiwan
2004 "Go Out of Civilization. Back to Eden—Lin Pey-Chwen's Back to Nature Series Catalog",
Lin, Pey-Chwen Digital Art Lab, National Taiwan University of Art, 2004
1999 "Lin Pey-Chwen's Work Concept", Fembooks Publisher, 1999
1998 "Women Art Discourse", Fembooks Publisher, 1998
1995 "Women's Interpretation—Lin Pey-Chwen Solo Exhibition", Capital Art, 1995

Selected Solo Exhibitions
2018 "Making of Eve Clone I ", Next Art Tainan: The Metamorphosis", Tainan, Taiwan
2017 "Making of Eve Clone — Solo Exhibition by Lin Pey-Chwen", Galerie Grand Siècle,
Taipei, Taiwan
2015 "Revelation · Notification - Lin Pey-Chwen Solo Exhibition", National
Tsing Hua University Arts Center, Hsinchu, Taiwan
2012 "Eve Clone Series III — Lin Pey-Chwen Solo Exhibition", Art Stage Singapore, Singapore
2011 "Eve Clone Series II - Lin Pey-Chwen Solo Exhibition", Galerie Grand Siecle, Taipei, Taiwan
2011 "Eve Clone Series I- Lin Pey-Chwen Solo Exhibition", Museum of Contemporary
Art, Taipei, Taiwan
2006 "Artificial Life—Back to Nature", Art Center of National Central University, Taoyuan, Taiwan
2006 "The Beautiful New World", 798 Art Village, Dimensions Art Center, Beijing, China
2005 "Fascination & Frustration". HCTC Artist Space of National Hsinchu University of
Education, Art Center of Kao Yuan University, Taiwan
2004 "Catching—Back to Nature Series", Museum of Contemporary Art, Taipei, Taiwan
2004 "Un-Natural ", International Art Center of National Taiwan University of Arts, Taipei, Taiwan
2000 "Patriarchal Deconstruction", National Taiwan Art Educational Art Museum, Taipei, Taiwan
2000 "Viewing View—Back to Nature Series", Taoyuan Cultural Art Center, Taoyuan, Taiwan

1999　"Golden Song", Spazio Diciotto, Florence, Italy
1998　"Classics Works", Gallerie Pierre Art, Taichung, Taiwan
1998　"Safety Nest", Taipei City Hal, Taipeil, Taiwan
1996　"Reality and Falsehood", HCTC Artist Space of National Hsinchu University of
　　　　Education, Hsinchu, Taiwan
1996　"Antithesis and Intertext", Project Contemporary Art Space, Wollongong, Australia
1995　"Antithesis and Intertext", Taipei Fine Arts Museum, Taipei, Taiwan
1993　"Women's Interpretation", National Taiwan Museum of Arts, Taichung, Taiwan
1992　"Solo Exhibition of Lin Pey-Chwen", Space II, Taipei, Taiwan
1991　"Solo Exhibition of Lin Pey-Chwen", Space II, Taipei, Taiwan
1990　"Solo Exhibition of Lin Pey-Chwen", Space II, Taipei Taiwan
1989　"Shape, Color and Strokes", American Cultural Center, Taipei, Taiwan
1984　"Solo Exhibition of Lin Pey-Chwen", Art Center of CMSU, USA

Selected Group Exhibitions

2018　"Should We Play?", Taipei Art District Festival, Taipei, Taiwan
2018　"GZ-BASEL 2018" Parallel Exhibition of Art Basel,Basel, Swiss
2018　XXI Symposium Neuroradiologicum, Taipei International Convention Center, Taipei
2018　Douro Printmaking Biennial, Douro, Portugal
2017　"GZ-Venice 2017" Parallel Exhibition of Venice Biennale, Venice, Italy
2017　The 3rd Global Print, Douro, Portugal
2017　"Fibering-Eco As A Verb" International Video Installation Exhibition ,
　　　　Yo-Chang Art Museum, Taipei
2017　"Taiwan Videa" 2017 Selection-The Taiwanese Avant-garde Video Screening Project,
　　　　Republic of Macedonia: Museum of Contemporary Art, Skopje/Croatia: Galerija AŽ Atelieri
　　　　Žitnjak, Zagreb/ Slovenia: SCCA-Ljubliana Center for Contemporary Arts /Germany: art space
　　　　"Rosalux" , Berlin
2017　"Dramaturgy·Body Rewritten Contemporary Art", Lee Gallery, Taipei, Taiwan
2016　" Like To Loud a Solitude", MoNTUE, Taipei, Taiwan
2016　" 404 International Festival of Art and Technology", C++ Gallery, Bogota, Colombia
2016　"Women Social Subjectivity —Taiwan Women Art Exhibition", Cultural Affairs
　　　　Bureau , Chiayi , Taiwan
2016　"Digital Attraction International Contemporary Art Exhibition",Taipei, Taiwan
2015　"The Apocalyptic Sensibility: The New Media Art from Taiwan", Taipei Fine Art Museum,
　　　　Taipei, Taiwan
2015　"The MOMENT: The Taiwanese Art Projects", Tenri Cultural Institute, New York City, USA
2015　"404 International Festival of Art and Technology", Rosario, Argentina
2015　"Dancing with Era-40 Years of Taiwan Contemporary Art", Kaohsiung Museum of Fine Arts,
　　　　Kaohsiung, Taiwan
2014　CULTURAL CAPSULES, An International Art & Design Exhibition, JCAL, New York, USA
2014　404 International Festival of Art and Technology, Platforma, Moscow, Russia
2014　"Progressive Proof: SF State exhibit features women printmakers from Pacific Rim", San
　　　　Francisco State University, San Francisco, USA
2014　"Raising the Temperature "International Art Exhibition, Queens Museum of Art, New York, USA

2014 "In the Name of Asia female Artist", Kaohsiung, Kaohsiung Museum of Fine Art, Taiwan

2014 "Mirage & Aural Beauty", National Taiwan Science Education Center, Taipei, Taiwan

2013 "Post Humanist Desire", Museum of Contemporary Art, Taipei, Taiwan

2013 The Tetramatyka Audio Visual Art Festival, Lviv National Art Museum, Ukraine

2013 15th Media Art Birnnale WRO Pioneering Values, The Apocalyptic Sensibility, The New Media Art from Taiwan, Wroclaw, Poland

2012 "Body and Interface", Taipei Digital Art Center, Taipei, Taiwan

2012 404 International Festival of Art and Technology, Argentina

2012 "YES, Taiwan", Art Biennial, National Taiwan Museum of Fine Arts, Taichung, Taiwan

2012 "Transjourney – 2012 Future Media Festival ", Kuandu Museum of Fine Art, Taiwan

2011 "Next Body Digital Art Exhibition", Huashan1914 Creative Park, Taipei, Taiwan

2010 "Taiwan Digital Art Pulse Stream Plan- The First Phase; "Body, Gender, Technology", Taipei Digital Art Center, Taipei, Taiwan

2010 "0&1: Digital Space and Gender Myths", 501 Contemporary Art Center, Chungking, China

2009 "Her First Solo Review and Perspective of Contemporary Women Artists in Taiwan", National Chang Kai-Shek Memorial Hall, Taipei, Taiwan

2009 "Virtual Fantasy", Taidong Museum of Arts, Taidong, Taiwan

2009 "VT Report", VT Art Space, Taipei, Taiwan

2009 "Interdisciplinary Horizon— Exhibition of Lin PeyChwen Digital Art Lab", Providence University Art Center, Taichung, Taiwan

2008 "Meditation in Contemporary Chinese Landscape", International Exhibition, Godwin-Ternbach Museum, New York, USA

2008 "Back to the Garden", Queens Art Pavilion, Flushing, New York, USA

2007 "BOOM: Interplay of Fast and Frozen Permutation in New Media, Taiwan-Australia New Media Art Exhibition", NTUA Art Museum, Kuandu Museum of Fine Arts, Taipei, Taiwan

2007 "Exit and Via Art Festival", Creteil, France

2006 "Morning Dew", Kuandu Museum of Fine Arts, Taipei National University of the Arts, Taipei, Taiwan

2006 Pingtung International Art Festival, Pingtung, Taiwan

2006 "Imaginary Number in Art", Art Center of Kao Yuan University, Kaohsiung, Taiwan

2006 "Animation Originality", Shanghai Museum of Contemporary Art, Shanghai, China

2005 "Border Crossing—The Shadow Dance of Cities ", Taipei Artist Village, Taipei, Taiwan and Shanghai, China

2005 "Shanghai Cool: Creative Reproduction", Shanghai Duolun Museum of Modern Art, Shanghai, China

2005 "Motion with Time", Gallerie Pierre Art, Taichung, Taiwan

2004 "Fantasy and Things", Taiwan Avant-Garde Documenta, Huashan1914, Creative Park, Taipei, Taiwan

2004 "Nexus: Taiwan in Queens", Queens Museum of Art, New York, USA

2003 "Passing 13", Gallerie Pierre Art, Taichung, Taiwan

2003 "Contemporary Art in Taiwan", Fong Chia Museum of Art, Taipei, Taiwan

2002 "Sour and Sweet Yeast", Woman Art Exhibition, Huashan 1914, Creative Park/ Kio-A-Thau Sugar Factory, Taipei/ Kaoshiung, Taiwan

2001 "Journey of the Spirit", Kaohsiung Museum of Fine Arts, Kaohsiung, Taiwan

2001 "Treasure—Back to Nature Series", Chingjing Farm, Nantou, Taiwan

1998 "Taiwan Female Art Exhibition - Image and Aesthetics", Taipei Fine Arts Museum, Taipei, Taiwan

1998 "Reflection and Reconsideration—228 Commemorative Exhibition", Taipei Fine Arts Museum, Taipei, Taiwan

1998 "Sadness Transformed—228 Commemorative Exhibition", Taipei Fine Arts Museum, Taipei, Taiwan

1996 "1996 Taipei Biennial: The Quest For Identity", Taipei Fine Arts Museum, Taipei, Taiwan

1994 "Space II Joint Exhibition—Citation of Taiwan", National Taiwan Art Museum, Taichung, Taiwan

1993 Capital Art Center,Taichung, Taiwan

1993 "Women's Interpretation", National Taiwan Museum of Arts, Taichung , Taiwan

1993 UP Gallery ,Taipei, Kaohsiung, Taiwan

1993 Home Gallery ,Taipei, Taiwan

1993 SPACE II Gallery. Taipei , Taiwan

1992 SPACE II Gallery. Taipei , Taiwan

1992 GO GO Gallery, Tainan, Taiwan

1992 Up Gallery , Kaohsiung , Taiwan

1992 Holly Gallery, Tainan, Taiwan

1992 Tainan Culture Center, Tainan, Taiwan

1992 Capital Art Center, Taichung, Taiwan

1991 Dimension Art Center, Taipei, Taiwan

1991 Taipei Fine Art Museum, Taipei, Taiwan

1991 National Art Education Museum, Taipei, Taiwan

1991 SPACE II Gallery. Taipei , Taipei, Taiwan

1990 Tainan Culture Center ,Tainan, Taiwan

1990 SPACE II Gallery, Taipei, Taiwan

1990 "Colorful Abstract Art", Jia Art Gallery, Taipei, Taiwan

誌謝

感謝所有曾報導與評論我作品的出版社、報章雜誌的媒體記者與所有作者們，尤其本書文章的作者及教授們：石瑞仁、李美華、林宏璋、邱誌勇、吳介祥、陳明惠、陳香君、許佩純、郭冠英、張惠蘭、葉謹睿、曾鈺涓、曾燕玲、鄭芳和、賴小秋、潘正育、蕭瓊瑞、Antoanetta Ivanova, Susan Kendzulark, Susana Perez Tort, Pierre Martin.（依筆劃序）

感謝所有曾邀請我展　的策展人們：王俊傑、石瑞仁、白適銘、白雅玲、李美華、李足新、邱誌勇、林文海、林羽婕、孫立銓、陳明惠、陸蓉之、許淑貞、黃海鳴、黃雅玲、曾鈺涓、張惠蘭、張金玉、曾芳玲、葉謹睿、萬一一、楊衍昀、潘顯仁、賴小秋、鄭乃銘、簡瑛瑛、簡瑛瑛、謝鴻均、謝東山、羅秀芝、羅禾淋、蕭瓊瑞、顧振清、Gina Valenti, Phil Carolus, Susan Belau.（依筆劃序）

感謝曾協助我的師生與實驗室成員們：李家祥、鄭建文、劉驊、楊桂娟、陳威光、王聖傑、胡縉祥、王信翔、吳至正、詹嘉華、蔡昕融、奚岳隆、王伯宇、高鈺濡、王甄淳、彭立洲、蔡秉樺、高軒然、蔡濠吉、江莉萍、龔嘉薇、林宏駿、范銀霞、李葳靜、 郭為苊、蔡佩宜、張嘉方、林奕均、劉彥均、劉祖昇、吳欣怡。

感謝所有曾贊助我與我實驗室作品的創作、國內外展覽、出版、展演、典藏的公部門、學校與私人藝文機構：文化部、外交部、教育部、國藝會、工研院、台北市文化局、新北市文化局、桃園文化局、新竹文化局、台中文化局、彰化文化局、嘉義文化中心、台南文化局、高雄文化局、屏東文化中心、台東文化局、國立台灣美術館、台北市立美術館、高雄市立美術館、台北當代藝術館、關渡美術館、北師美術館、美國文化中心、華山藝文特區、台北國際藝術村、台北數位藝術中心、國立台灣教育館、國立台灣科教館、府中15故事館、國立台灣藝術大學、國立台北藝術大學、國立台南藝術大學、國立清華大學、國立中央大學、國立台灣師範大學、國立台北教育大學、國立新竹教育大學、高苑科大、新苑藝術、臻品藝術、B.B.Art、藝數網、帝門藝術中心、黎畫廊、大象藝術空間、尊彩藝術中心、重慶501當代藝術館、上海當代藝術館、上海多倫現代美術館、北京798藝術村、Arte Laguna Prize, Exit & Via Festival, Enghien-les-Bains Digital Art Festival, Siggraph Asia, Queens Museum of Art, Godwin-Ternbach Museum, San Francisco State University Art Gallery, Douro Print Biennial, 404 Festival, Australia Long Gallery, 2018 Parallel Exhibition of Art Basel, Douro Printmaking Biennial, WRO Media Art Biennale, The Tetramatyka Audio Visual Art Festival, 2017 Parallel Exhibition of Venice Biennale, Skopje/Croatia: Galerija AŽ Atelieri Žitnjak, Zagreb/ Slovenia: SCCA-Ljubliana Center for Contemporary Arts /Germany: art space "Rosalux" Berlin, New York Tenri, JCAL and Queens Art Pavilion.

感謝本書所有作者們的精闢論述；我的牧師林麗真教授的指導；藝術家出版社王庭玫的編輯顧問；張瑞云與詹嘉華的編排設計；所有師長與好友們的推薦。最後，感謝列國先知阿公、我的家人、教會同工與弟兄姊妹們為我的禱告，我願把此書獻給大家以及我親愛的先知阿公、爸爸媽媽、妹妹倍慧，更把我所有的藝術成就歸榮耀給愛我的主，願所有救恩、權能、愛戴、稱頌歸給揀選一人— 山的神，直到永永遠遠。哈利路亞！UNNS！ACP！H！H！A們。

國家圖書館出版品預行編目資料

道與技之間—林珮淳藝術的啟示與警世
／林珮淳 編著 .--初版.--
臺北市：藝術家 2018. 11
416面；17×24公分

ISBN 978-986-282-225-8（平裝）
1. 數位藝術　　2. 作品集　　3. 文集

956　　　　　　　　　107018328

Word and Tech

道與技之間
林珮淳藝術的啟示與警世
Revelation & Notification of
Pey-Chwen Lin's Art

林珮淳 Pey-Chwen Lin 編著

發行人　　何政廣
編輯顧問　王庭玫
編排設計　張瑞云、詹嘉華
出版者　　藝術家出版社
　　　　　台北市金山南路（藝術家路）二段 165 號 6 樓
　　　　　TEL：（02）2388-6715 ～ 6
　　　　　FAX：（02）2396-5708
郵政劃撥　50035145 藝術家雜誌社帳戶

總經銷　　時報文化出版企業股份有限公司
　　　　　桃園市龜山區萬壽路二段 351 號
　　　　　TEL：（02）2306-6842
南部區域代理　台南市西門路一段 223 巷 10 弄 26 號
　　　　　TEL：（06）261-7268
　　　　　FAX：（06）263-7698

製版印刷　鴻展彩色製版印刷股份有限公司
初　版　　2018 年 11 月
定　價　　新臺幣 550 元

ISBN　978-986-282-225-8（平裝）